TEACHING STRATEGIES FOR THE SOCIAL STUDIES:

Inquiry, Valuing, and Decision-making

TEACHING STRATEGIES FOR THE SOCIAL STUDIES:

Inquiry, Valuing, and Decision-making

JAMES A. BANKS
University of Washington, Seattle

With contributions by
AMBROSE A. CLEGG, JR.
Kent State University, Ohio

ADDISON-WESLEY PUBLISHING COMPANY
Reading, Massachusetts · Menlo Park, California · London · Don N

to Cherry,
who has given much

PREFACE

As we move into the last decades of the twentieth century, our nation is witnessing technological advancements which are unparalled in human history. At the same time it is faced with social problems of such an immense magnitude that they pose a serious threat to the ideals of American democracy and to man's survival. Ethnic conflict and polarization, environmental pollution, the increasing gap between the haves and have-nots, widespread alienation among our young people, international hostilities, and perhaps most serious, man's increasing inhumanity to his fellowman, are some of the salient problems which America faces as it stands on the threshold of the twenty-first century. No sensitive observer of contemporary American society can deny the seriousness of our current social problems and the tremendous strains on our social system.

The idea for this book emerged during a time of intense social conflict and confusion, and grew out of the author's deep conviction that the social studies must help children to develop the ability to make sound personal and public decisions if man is to be saved from self-destruction and chaos. The central thesis of this book is that the main goal of the social studies should be to help students develop the ability to make reflective decisions so that they can resolve personal problems and shape public policy by participating in intelligent social action.

This belief about the proper goal of the social studies is based on the assumption that man will always face personal and social problems, and that all citizens should participate in the making of public policy. The theory of social studies education set forth in this book is not only grounded in the democratic ideology, but one of its basic assumptions is that maximum participation of citizens in the making of public policy is essential for the creation and perpetuation of a free and open society. This theory also assumes that individuals are not born with the ability to make reflective decisions, but that

decision-making consists of a set of interrelated skills which can be identified and systematically taught. It also assumes that man can both identify and clarify his values, and that he can be trained to reflect upon problems before taking action designed to resolve them. We have identified the main components of decision-making as scientific knowledge, value analysis and clarification, and the affirmation of a course of action by synthesizing one's knowledge and values.

The organization of this text reflects the basic components of the theory advanced. A rationale for a social studies curriculum focused on decision-making and social action, and the essential components of decision-making are presented in Part 1. Part 2 focuses on social inquiry, and the structures of the various social science disciplines. The organizing concepts, generalizations, and theories of the various disciplines are emphasized in this section because of the author's belief that each of the disciplines provides students with a unique way to view human behavior, one that is essential for sound decision-making. This part of the book concludes with a chapter on interdisciplinary inquiry. Children must view social issues from an interdisciplinary perspective in order to understand the immense complexity of contemporary social problems. Exemplary strategies for teaching the key ideas of the disciplines and for helping children to view social problems from an interdisciplinary perspective constitute a major section of Part 2.

Part 3 focuses on the role of values and valuing in the decision-making process. A value inquiry model is presented and justified, and strategies for implementing value inquiry lessons are illustrated. Part 4 illustrates how social science inquiry and value inquiry are related to the decision-making process and social action. The final part of the book explores effective ways to evaluate social science inquiry, value inquiry, decision-making, and social action skills. The book is designed for use by students teaching or preparing to teach social studies in the elementary and junior high school grades.

The author is grateful to a number of colleagues and friends who helped in the preparation of the manuscript. Preeminent among those is Professor Ambrose A. Clegg, Jr., who wrote Chapters 3, 4, 8, and 14, contributed important ideas to the basic theory presented in the text, and reacted to many of the chapters in manuscript form. Mrs. Mary J. Simpson and Mrs. Elizabeth O. Pearson, of the University of Washington, and Professor Lyne S. Schwab of North Florida State University, wrote many of the exemplary teaching strategy exercises in Part 2 of the book. Anton H. Lahnston, of Boston University, and Mrs. Shirley R. Petery, Instructor at the University of Washington, helped Professor Clegg in the preparation of Chapters 3 and 14 respectively. Professors Dale L. Brubaker, John D. McAulay, and Anna S. Ochoa reviewed the book in manuscript form and made helpful suggestions. Professor Bernice Goldmark prepared an insightful critique of the valuing chapter. However, I assume total responsibility for the contents of this book.

I wish to thank the following individuals for helping me to identify and obtain photographs to illustrate the text: Zita Lichtenberg and Dorothee Brown, Washington State Office of Public Instruction, Olympia; Melba Eyler and Kenneth L. Calkins, Highline Public Schools, Seattle; Donald E. Miller,

Mercer Island (Washington) Public Schools; Rachel Bold and Lowell R. Jackson, Seattle Public Schools; Ray Braga, Northshore School District, Bothell, Washington; Aileen Dahl and William C. Frederick, Shoreline School District, Seattle; and June V. Gilliard and John D. Ellington, North Carolina State Department of Public Instruction, Raleigh. I am also grateful to the gifted cartoonists and their publishers for permitting me to use their works to add perceptive humor to the book. I am indebted to my colleagues in the Social Studies Education Area at the University of Washington, Professors Clifford D. Foster, Francis P. Hunkins, John Jarolimek and Theodore Kaltsounis, and to our present and former graduate students in the Area, for a stimulating intellectual atmosphere which facilitated the birth and completion of this book. I wish to thank the staff at Addison-Wesley for the expertise and care with which the manuscript was handled.

I would like to extend a very special thanks to my wife, Cherry A. Banks, who paid a tremendous price for the completion of this book. She not only graciously tolerated the inconveniences and disruptions in family life which the writing of a book imposes, but served as an essential springboard and critic for the ideas which are contained in this book. She also prepared the index, a demanding and tedious but important task.

Seattle, Washington J.A.B.
October, 1972

CONTENTS

Chapter 4 Social Inquiry: Questioning Strategies

Chapter 5 History: Structure, Concepts, and Strategies

Chapter 6 Sociology: Structure, Concepts, and Strategies

Chapter 7 Anthropology: Structure, Concepts, and Strategies

Chapter 8 Geography: Structure, Concepts, and Strategies

Chapter 9 Political Science: Structure, Concepts, and Strategies

Chapter 10 Economics: Structure, Concepts, and Strategies

Chapter 11 Interdisciplinary Units: Concepts and Strategies

Part 1

THE
GOAL
OF
SOCIAL
STUDIES
EDUCATION

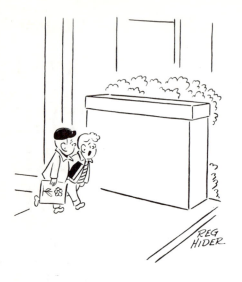

"Thinking doesn't hurt as much as I thought it would."

Drawing by Reginald Hider, Reprinted with permission from *Today's Education.*

INTRODUCTION TO PART ONE

Part 1 of this book discusses some of the salient personal and social problems within American society. It presents a rationale for a social studies curriculum focussed on decision-making. The essential components of decision-making are discussed and illustrated. They include scientific, interdisciplinary, and higher-level knowledge, value analysis and clarification, and the synthesis of knowledge and values. The social studies curriculum described is designed to help students resolve personal and social problems through rational social action.

MAKING DECISIONS ON SOCIAL AND PERSONAL PROBLEMS

SOCIAL AND PERSONAL PROBLEMS IN AMERICAN SOCIETY

In many measurable aspects, our civilization in the United States is the most successful in the history of mankind. Born out of the hopes and aspirations of poverty-striken and alienated Europeans, the American vision resulted in the making of a sparsely inhabited land into the most technologically advanced and prosperous nation on the globe. These material and technological wonders were accomplished in a relatively short time. The United States evolved from an abundant wilderness into a highly complex society in less than two centuries. Compared to the total time that man has been on earth, this time-span is very brief.

Whatever criticisms can be made of the American experience, any observer must agree that its material progress has been bewildering. Our technological advances were symbolized to the world when two Americans stepped on the moon on July 20, 1969. This tremendous accomplishment evoked admiration, coupled with envy, throughout the world and symbolized the will and immense capacity of the American mind. Millions of Americans watched John F. Kennedy's prophesy and dream materialize on their TV screens – many saw the moon-walk in "living color."

As Armstrong and Aldrin walked on the moon, a series of tragic events were taking place in Southeast Asia, on college campuses, and in the urban ghettos, which symbolized the dilemma and crisis that confronted American society as the seventies were about to dawn and the twentieth century began to wane. These unfortunate events indicated that in many areas we were using antediluvian methods to solve urgent human problems in the cybernetic age. Some social problems steadily worsened because they had been virtually abandoned.

The Vietnamese war, student protests, and the widespread use of illegal drugs during the 1960's and 1970's reflected the value crisis in American life. (United States Army; Washington State Office of Public Instruction, Olympia, Washington)

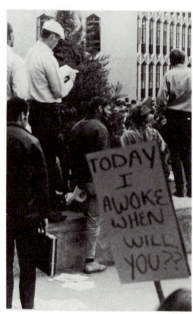

Observers viewed the sixties as one of the most turbulent decades in the American experience. Thousands of American young men died in Vietnam for a cause which remained, at most, nebulous to most Americans. Many Americans felt that our national leaders were unable to clarify and justify our involvement in this tragic conflict. The war brought to the surface many of the latent value conflicts in American life. Many young, white, middle-class

Americans, who had enjoyed the "best" of America, burned their draft cards. Some chose imprisonment to induction. Others deserted by fleeing to Canada and Sweden. Resistance to the war culminated in a series of "moratorium" days during which many citizens left work and marched in the streets to demonstrate their support for the anti-war movement. Attempts by leaders to stem the tide of the resistance by appealing to American citizens to "Support the cause of Democracy throughout the world" often fell on deaf ears.

"Now boys, there are other ways to deal with social problems."

Reprinted from the *Instructor* © March, 1971, the Instructor Publications, Inc. Used by permission.

In addition to the unpopular war in Vietnam, domestic "wars" took place on our college campuses and in black ghettos. College students, attending some of our most prestigious universities, took over college buildings, boycotted and broke up classes, and in a few instances, destroyed university property. They claimed that they were protesting the inhuman universities which were more concerned with soliciting government research grants than teaching students, college professors who neglected their students to write books, and the refusal of the American university to get involved in the most critical and pressing social problems which faced the nation — poverty, war, and racism.

While the campus revolts were initiated by white students, black students started their own rebellions in the late 1960's. They demanded that the university hire more black professors, offer courses on the black experience, and grant credit for field work related to the improvement of the black ghetto.

Initially, colleges and universities stubbornly resisted student demands. However, as the revolts intensified and spread throughout the nation, university administrators responded in varying degrees to the students' demands.

The violent racial outbreaks which occurred in the black ghettos during the 1960's evidenced the tremendous racial crisis and value conflicts which permeated American society. Never since they first landed on American shores had blacks shared the full benefits of the "American Dream." In the 1950's and 1960's, largely encouraged by the liberal Supreme Court decisions made during these decades, blacks began a quest for their rights, a quest unprecedented in our nation's history. This revolt was signaled when four black college students sat down at an "all white" lunch counter at a Woolworth's store in Greensboro, North Carolina on February 1, 1960. Although the black revolt of the 1960's emerged in the deep South, it quickly spread to Northern cities and culminated in racial outbreaks which hit cities from New York to Los Angeles.

The black revolt kicked off intense reactions within the white community. In the late 1960's, many American citizens issued a plea for "Law and Order," and, to many, law and order meant an end to racial riots and the ruckus on college campuses. Mayors in several of our major cities were elected primarily because they promised to bring law and order to the city streets. While a "Law and Order" cult took root, little was done to eliminate the *causes* of violent outbreaks in the cities and on college campuses. Symptoms rather than causes were attacked.

Other momentous social problems plagued our nation as the seventies were ushered in. Many citizens were still poverty stricken in our land of plenty. Environmental specialists revealed painful statistics which indicated that the by-products of industry, the accumulation of waste, and the exhaust from automobiles were poisoning our environment and, at an ever increasing rate, were making it unsafe for human habitation. Some warned that unless drastic steps were taken to halt pollution of the air and water and to work against over-population, the earth's atmosphere would become lethal. The cold war was escalated during the sixties as Red China amassed nuclear weapons. Controversy raged in our nation when proposals were made to strengthen our Atomic Ballistic Missile System.

The problems faced by the individual in modern American society are no less severe than those which permeate the nation as a whole. An appreciation for the extent of personal problems which Americans faced in the late 1960's can be gained from a cursory review of the alarming rates of divorce, crime, suicide, increased alcoholism and the illegal use of drugs during this period. Most social scientists regard increases in these behaviors as symptomatic of an alienated and problem-ridden society. Fromm suggests that high rates in these areas indicate a "lack of mental stability and mental health . . ."[1].

American divorce rates have shown a consistent rise over the last few decades. In 1940, 2.0 persons per 1000 of the total population obtained divorces; by 1968, that rate had increased to 2.9. Twenty-eight percent of all marriages could be expected to end in divorce in 1968. While the divorce rate

increased between 1940 and 1968, the number of persons marrying decreased. In 1940, 12.1 persons per 1000 married, while only 10.3 per 1000 married in 1968.[2] As our society becomes increasingly more technological, comparatively fewer persons marry, and more obtain divorces. Americans are also marrying earlier each year. Each decade our youth are facing adult responsibilities and privileges at a younger age; it may be that they are entering adulthood long before they are of sufficient social and psychological maturity. This could account in part for our steadily increasing divorce rate.

There was a sharp increase in reported crimes between 1960 and 1967. Some of this increase can be attributed to more effective detection and reporting of crimes, but the figures do reflect sharp increases in *actual* crime rates. In 1960, 47 persons per 1000 were arrested for aggravated assault; the number of persons arrested in 1967 for the same crime had increased to 73 per 1000.[3] There were also sharp and notable increases in the number of persons arrested for larceny, automobile theft, the carrying and possession of weapons, and the breaking of liquor laws.[4]

"My generation was of a tougher moral fiber than yours. We were able to avoid facing reality without *using drugs."*

Drawing by J.B. Handelsman. Reproduced by special permission of *Playboy Magazine;* copyright © 1971 by *Playboy.*

The illegal use of drugs created one of the most serious problems of the 1960's and 70's, especially among young, secondary school, and college students. Many drug users during this period were the children of middle-class white Americans and not inhabitants of the urban slum. Many suburban high schools and college campuses became citadels for illegal drug users and pushers.

The number of persons arrested for violating narcotic drug laws increased from 27 per 1000 in 1960 to 72 per 1000 in 1967.[5] The number of new addicts reported increased from 6363 in 1962 to 6417 in 1967. The number of

new heroin addicts reported in 1962 was 5548. That figure increased to 6009 in 1967. The number of persons using morphine, opium, demerol, methadone and other drugs also increased during the 1960's and 1970's.[6] The following news item from an issue of *Newsweek* magazine suggested the widespread use of drugs among high-school students during the 1970's.

THE DRUG SCENE:
HIGH SCHOOLS ARE HIGHER NOW

The drug revolution, barely begun on college campuses a few
years ago, has already swept the nation's high schools. The
use of drugs, particularly marijuana, is now an accepted fact
of life for anywhere from 30 to 50 percent of all U.S.
secondary school students. "I'd compare buying dope
today," says Eric Nelson, one of the brightest seniors at
Newton (Mass.) High School, "with buying the school
newspaper."[7]

During the last few decades the United States has had one of the highest suicide rates in the world. Suicide victims are assumed to be persons who were unable to solve their personal problems. In 1955, 15.52 Americans per 100,000 committed suicide.[8] By 1965, the rate had increased to 22.4 per 100,000. In 1965, 21,507 American citizens took their lives. Rates were considerably lower in many of the technologically less developed nations: 2.0 per 100,000 in the Philippines, 3.4 per 100,000 in Mexico, and 1.8 per 100,000 in Nicaragua (Table 1.1). However, rates were markedly higher in some of the industrialized nations of Western Europe. West Germany exceeded all nations with 85.2 per 100,000. France reported 30.5 per 1000.[9] Using the suicide index alone, it seems that the individual in highly industrialized societies must confront many more personal and psychological pressures than a person does in less technologically developed nations. Apparently man has not successfully used his technological advances to help the individual citizen attain personal

Table 1.1
Suicide rates in selected countries (1965)* (per 100,000 population)

Denmark	38.7	Hong Kong	16.2
France	30.5	Venezuela	12.7
Japan	29.5	Colombia	12.2
United States	22.4	Mexico	3.4
New Zealand	18.2	Philippines	2.0
		Nicaragua	1.8

*Based on data reported in the *Statistical Abstract of the United States.* Washington, D.C.: U.S. Government Printing Office, 1969, p. 81.

contentment. This is one of the greatest challenges facing technologically advanced societies.

Fromm reports evidence which indicates that countries that have high suicide rates also have high homicide rates and a high incidence of alcoholism. In 1968, 14,270 Americans (7.1 per 100,000) were homicide victims.[10] The United States had the highest number of estimated alcoholics of all major nations in 1948.[11]

This cursory review of the social and personal problems which permeated our society at the threshold of the seventies indicates that there is an urgent need for the school to prepare citizens to deal with social and personal problems of immense magnitude.

"The air I breathe is filthy, my food is poisoned, my automobile is a gas-guzzling behemoth, my school taxes have doubled, the Internal Revenue Service plans to take the fillings out of my teeth, my wife is fifty-three and pregnant, my dog bit a lawyer's kid, my son steals, my mother-in-law is a Communist, my daughter ran off with a fink, and now you tell me that if I don't back up and let you have the right-of-way I'll be in trouble."

Drawing by Booth; © 1972 The New Yorker Magazine, Inc.

Some writers and social commentators have viewed with alarm the problems faced by the individual in modern American life. In his severe indictment of American life, Fromm suggests that the individual is alienated in modern society because it fails to meet his social and psychological needs. The individual, he argues, is a servant to the technology created to meet man's physical needs.[12] Whyte, in *The Organization Man*, laments the demise of

individualism in modern society and argues that the individual must conform to groups to the detriment of his personal needs. According to Whyte, we have come close to deifying "The Organization".[13] Anthropologist Jules Henry contends that in his "lopsided preoccupation with amassing wealth and raising [his] standard of living" man has turned "culture against himself," and "... inner needs have been scarcely considered.[14] Both Fromm and Henry bemoan the emphasis on conspicuous and unlimited consumption, unscrupulous advertising, conformity, and the human engineering which they see in our society.

Novelists also have made some frightening commentaries on the emphasis of technology, human engineering, and the loss of concern with human problems and values in twentieth century America. Orwell's alarming novel, *1984*, reminds us that man is capable of creating a completely totalitarian society that can control man's mind as well as his actions.[15] Social commentators such as Whyte, Henry, and Fromm feel that the individual in American society shares characteristics with Winston Smith, the fateful protagonist in Orwell's novel. To these writers, Big Brother is commercial advertising, large corporations, and mass media.

Although we believe that social science can and should result in a better life for man, some writers have correctly pointed out that the control and prediction which can result from a science of man can be used to his detriment as well as for his benefit. In his novel *Walden II*, B.F. Skinner[16] depicts a scientific utopia which raises many baffling value questions about who should control man's behavior. Aldous Huxley, in his shocking and fantastic novel *Brave New World* describes a society where human feelings and emotions result only in tragedy.[17] Humans are hatched in mass by a mechanical process. In his attempt to promote humanistic values in the brave new world, John, the savage from primitive times (our own era), meets a tragic fate. He learns from Mond that in the brave new world only science, not human emotions, could prevail. William Golding's *Lord of the Flies* warns us of the frightening deeds of which man may be capable.[18]

Critics of American society, like the writers whom we briefly discussed above, undoubtedly exaggerate the problems faced by modern Americans. Writers such as Henry and Fromm illuminate the flaws in American life but say little about how life in the United States helps the individual American to satisfy his social and psychological needs. These writers would not deny that life in the United States has some advantages. However, they emphasize the shortcomings of our technological society because they are deeply concerned about preserving individualism and humanistic values in our highly technological society. They feel that the needs and problems of the individual are receiving increasingly less attention. Like the social commentators, novelists such as Orwell, Huxley, and Golding have also depicted exaggerated and extreme societies in order to impress upon us the need to focus our concern on human problems and values.

All these commentaries suggest the need for the social studies to focus on helping children to attain the skills needed to recognize and solve *human* problems, analyze and clarify *values*, and make sound, rational decisions which

can guide social action that will prevent Huxley's brave new world from becoming a reality.

DECISION-MAKING AND SOCIAL PROBLEMS

The problems which Americans faced in the 1960's and 1970's will not necessarily be similar to the ones that we will confront in future decades. The problems we have been discussing are examples of *types* of problems that can perplex and cause confusion in a society. Less important than the *particular* problems which man will face in the future is the fact that he will confront immense social and personal problems and that citizens will have to formulate decisions to guide intelligent social action.

Man's very existence assures the perennial existence of social problems. While the nature of his problems may differ in different periods of history, man has the amazing capacity to create more problems than he seems able to solve

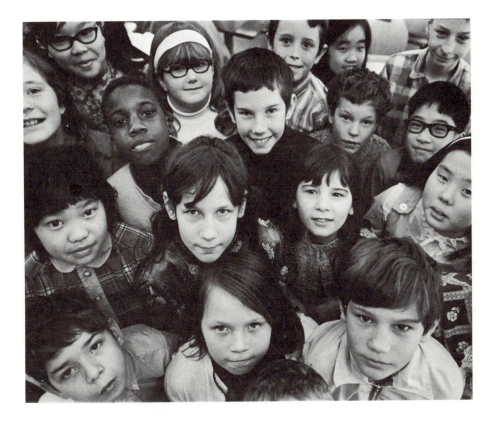

The social studies program should help future citizens to become rational decision-makers so that they can resolve personal problems and influence public policy through effective social action. (Seattle Public Schools, Washington)

in all times and places. It is imperative that the public school, particularly the social studies, help future citizens attain the skill and abilities which will enable them to make the kinds of decisions that will minimize conflicts and assure the existence and improvement of our form of government and the continuation of the human race. We have no convincing evidence to contradict the assertion that man himself is his most dangerous enemy; we are certain that he now has the capacity to destroy himself with little more than the push of an electronic button.

Our perception of the proper goals for the social studies resulted largely from a realization that citizens — housewives, factory workers, businessmen, labor leaders, politicians, welfare recipients, and all others — must each day make public and personal decisions which affect their lives, local communities, and eventually, perhaps, the nation and the world.

Should I take the job at Tony's or the one at Bell's?

Should we buy a new house this year or wait until next year?

Should I leave my family so that they will get more welfare funds?

Should I go into the army, desert to Canada, or go to prison?

Should I vote for Smith or Jones for mayor?

Would Taylor make a better president than Lee?

Is a house which is located in a "changing" neighborhood worth buying?

Should I vote for or against the school bond issue?

These are the kinds of nagging decision — problems with which American citizens must frequently deal.

People are not born with the capacity to make rational decisions. Decision-making is a skill which must be developed and practiced. Most Americans end their formal education when they leave the public schools. If they do not develop the skill to make sound and rational decisions when they are enrolled in the public schools, the chances are that they will never become adept decision-makers.

All curriculum areas undoubtedly help children develop the ability to make certain kinds of decisions. A child may, for example, be exposed to an excellent physical education program which emphasizes recreational sports and games. He will be more likely as an adult to play tennis, ski, and bowl regularly than a person who has not participated in physical education. Similarly, effective instruction in the language arts, home-making, and natural sciences helps children develop skill in making particular kinds of decisions.

The social studies should assume the major responsibility for helping children become adept at making important decisions that affect their relationships with other human beings and the governing of their local communities and the nation.

The social studies should assume the major responsibility for decision-making on problems of this kind because it deals with human relationships and because

no other area of the curriculum has identified decision-making on social and personal problems as its primary goal.

When an individual develops the ability to make rational decisions, he can act intelligently. We believe that the ultimate goal of the social studies should be to develop intelligent *social actors**. *We are assuming that decision-making skills can be developed, that humans can be trained to reflect upon problems before acting on them, and that individuals can learn to act upon the decisions which they have freely made.* We cannot expect individuals to act upon "decisions" which they have been forced to make. In our decision-making model, discussed in detail in Chapter 13 but introduced later in this chapter, the individual must be able to choose freely from many alternative courses of action before we can characterize his response as decision-making.

ESSENTIAL COMPONENTS OF THE DECISION-MAKING PROCESS

Knowledge

Rational and effective decisions cannot be made in a vacuum. Social *knowledge* is one component that is necessary for sound decision-making. If a white couple had to decide whether to sell their house and move out of a "changing" neighborhood that was being *invaded*** by Puerto Ricans, they would need to know something about the history and economics of "changing" neighborhoods to be able to make a rational decision. They could make a more intelligent decision if they knew whether the price of homes actually dropped when neighborhoods became mixed, whether the newcomers in the neighborhood might keep up their property, and whether the quality of the public schools in the community would remain constant or change. By studying historical and sociological information on changing neighborhoods, the couple would be able to make some predictions about what changes may or may not take place in their neighborhood.

Methods and ways of attaining knowledge

Knowledge is a requisite for making sound decisions, and there are many ways of knowing or attaining knowledge. Kerlinger has reviewed four methods of knowing which were set forth by Charles Peirce, an eminent American writer and philosopher. Following is a discussion of the four ways of knowing summarized by Kerlinger.

**Social actor* refers to an individual who makes a deliberate effort to influence his social environment, including its laws, public policy, norms, values, and the distribution of wealth within it. The activities in which he participates is *social action*. Social action may, of course, be effective or ineffective.

**A sociological concept used to describe the movement of a population "into an area for residential purposes. . ." Noel P. Gist and Sylvia F. Fava, *Urban Society*, 5th ed. New York: Thomas Y. Crowell, 1964, p. 155.

1. *The method of tenacity.* Here men hold firmly to the truth, the truth that they know to be true because they hold firmly to it, because they have always known it to be true...

2. *The method of authority.* This is the method of established belief.

3. *The a priori method.* It rests its case for superiority on the assumption that the propositions accepted by the "a priorist" are "agreeable to reason," are self-evident ... The idea seems to be that men, by free communication and intercourse, can reach the truth because their natural inclinations tend toward truth.[19]

4. *The method of science.* Kerlinger quotes Peirce:

 To satisfy our doubts ... therefore, it is necessary that a method should be found by which our beliefs may be determined by nothing human, but by some external permanency – by something upon which our thinking has no effect ... The method must be such that the ultimate conclusion of every man shall be the same. Such is the method of science.[20]

A further discussion of the hypothetical family mentioned above may clarify the meaning of the four methods of knowing set forth by Peirce and summarized by Kerlinger. When trying to decide whether the new residents of their community will take care of their property, the couple may derive knowledge related to their decision-problem by using the *method of tenacity.* They may conclude that whenever Puerto Ricans move into a predominantly white neighborhood they let the property become dilapidated. They reach this conclusion because they have always believed that members of ethnic minority groups are lazy and shiftless.

The couple may have no firm beliefs about Puerto Ricans and other minority groups. They may seek out a source of *authority* to give them information about Puerto Ricans. They may hear a professor of sociology talk about Puerto Ricans on a TV show. The professor states that Puerto Ricans and other ethnic minority groups do tend to run down their neighborhoods. Basing their conclusion on this authority, the couple decides that the new migrants to their neighborhood will not take care of their homes.

The couple may use still a different method for obtaining knowledge about Puerto Ricans. They may drive through a predominantly Puerto Rican neighborhood and conclude that is is self-evident that they will not keep up their property. The couple would be using the *a priori method* of knowing.

It is not difficult to illuminate the limitations of the ways of knowing discussed and illustrated above. Some of the methods have more severe limitations than others. The method of tenacity is not an effective way of gaining knowledge because man is capable of believing and holding firmly to almost anything imaginable. A cursory study of history and anthropology will reveal that man, throughout history, has held beliefs which he later considered bizarre and insane. Beliefs in ancestor gods, shamen, witchdoctors and water witching indicate the tremendous range of human beliefs which have existed in many places and times.

There is no reason to believe that man's capacity to create beliefs is any less today than in previous times. Some people refuse to live on the thirteenth floor of an apartment building; others carry charms, such as a rabbit's foot, for good luck. The beliefs that different racial, ethnic, and religious groups sometimes express about each other indicate that man still has an immense capacity to imagine. It must be said, however, that man's tremendous ability to create and imagine is probably the most important characteristic which distinguishes him from other primates.

The method of authority is perhaps the most valuable of the three methods illustrated above. We could not live organized and productive lives without relying a great deal upon authorities. When a doctor prescribes medicine, we assume that it will help heal our illness. We depend upon authority when we plan trips using a road map, look up words in a dictionary, have our income tax forms completed by an expert, or act upon the advice of a professional counselor.

While authorities are necessary in our highly specialized and technological society, a reliance upon authority is unwise under certain conditions and in some situations. A sociology professor may state publicly that Puerto Ricans will run down neighborhoods although he has little familiarity with Puerto Ricans and their life styles. He may have gained his information from an authority who, like himself, knew little about Puerto Ricans. The professor, a specialist on group formation, may even perpetuate a negative image of Puerto Ricans for personal and political reasons.

Individuals in our society are often perceived as authorities when they lack specific training in a given area, or they may be assumed to have conclusive information about problems when the knowledge in their field is premature and developing. Americans tend to put too much faith in and to expect too much from "experts." Persons with complicated medical and psychological problem often expect specialists in these fields to effect rapid cures. Education students often enroll in methods courses expecting to get conclusive answers to teaching problems from instructional specialists. They are often disillusioned when they discover that experts frequently disagree about appropriate methods and instructional techniques.

When authorities present conflicting information, it becomes difficult to obtain information by using the authority method. The conflicting opinions which experts had of the effects of the pill, the use of drugs, and smoking during the 1960's and 1970's clearly illustrated how authorities sometimes hold divergent beliefs about various phenomena. In our discussion of the nature and teaching of history in Chapter 5, we note how historians often present conflicting interpretations of the same past events.

As Kerlinger points out, the *a priori method* of knowing is immensely limited in deriving knowledge, because what is self-evident to one person may not be self-evident to another. People can hold *opposing* beliefs about the same phenomena, and each will argue that his knowledge is self-evident. One person may argue that it is self-evident that Puerto Ricans keep tidy homes and neat neighborhoods; another person may argue just as adamantly that it is obvious and self-evident that Puerto Ricans will run down their neighborhoods.

The scientific method: A way of attaining knowledge

The limitations of the tenacity, authority, and a priori methods suggest that we need a more reliable way of attaining valid knowledge. We should not be bound either by traditional belief systems or the opinion of authorities. A person should be able to repeat the procedures of the method and derive similar conclusions, and different men who use the same method should derive similar, if not identical, conclusions. In other words, the method should be *public* rather than private. It should be largely independent of the values and biases of the individual using the approach. The method which comes closest to meeting these requirements is the method of *science*.

This is the method used by social scientists. Because it is used by social scientists to derive knowledge in the form of *facts, concepts, generalizations* and *theories*, we will refer to this method as *social science inquiry* or *social inquiry*. Essentially, this method of knowing involves identifying and stating social problems, formulating hypotheses which can guide research, gathering and evaluating social data, deriving tentative conclusions and generalizations, and inquiring into the procedures and methods used. We will defer a detailed discussion of this process until Chapter 2.

If our hypothetical couple were to use the *scientific method* when trying to predict the behavior of the new residents of their neighborhood, they would be required to state their question in a researchable fashion and determine *definitions* for all vague terms in their question or problem. If their problem reads, "Do Puerto Ricans take care of their property?", some attempt would have to be made to define "Puerto Ricans," "take care of," and "property." When a person uses the phrase "Puerto Rican," he might be referring to recent migrants to New York City, Puerto Ricans in their native country, or Puerto Rican Americans of a particular social class or group. Upper middle-class Puerto Ricans may exhibit behavior that differs in some significant ways from lower-class Puerto Ricans (the phrase "social class" is variously defined).

"Take care of" is an ambiguous term which may have diverse meanings. It may mean that the residents of a house pay the monthly rent, protect it from burglary, or keep the lawn mowed. "Property," likewise, could refer to many different items. It could refer to a house, the furniture in it, or the grounds around it. It is conceivable that a person who is meticulous about his furniture would pay scant attention to his lawn. Thus, what initially appeared to be a simply stated question seems more complicated when attempts are made to make the language more precise.

Clarification of terms is absolutely essential in scientific thinking and research. Two researchers may reach different conclusions because they are studying different phenomena even though they use identical terms when referring to it, or they may be studying the same phenomena, but describing it in different ways. Researchers may derive different conclusions about the characteristics of upper-class Indians because they defined "upper-class" and "Indians" differently.

In addition to stating their problem and defining all important terms, our hypothetical couple would then state some of their own hunches about the

behavior of Puerto Ricans. Tentative hypotheses serve the important function of guiding the research activities. The next step would be to gather data from diverse sources, evaluate it, and try to make some *tentative* conclusions about the behavior of Puerto Ricans, especially those who migrate into American neighborhoods that are predominantly white.

Our preference for the *scientific method* of deriving knowledge necessary for decision-making is by now explicit. While it is not a perfect method, we believe that it is the most effective and efficient means of obtaining knowledge. Peirce overstates the values of the scientific method when he suggests that in it "our beliefs are determined by nothing human. . . ." As we will point out in our discussion of values, the scientific method is based upon human values and assumptions. Bernice Goldmark has insightfully pointed out some of the assumptions on which this method is based:

> . . . The scientific method is based on the assumption that truth is neither absolute nor unchanging. Rather, truth is a judgment that, by the agreement of an informed community, produces desirable results . . .
>
> . . . It is on this assumption that we argue that all judgments should be held as hypotheses to be tested, evaluated, and reconstructed. . . .[21]

The scientific method also assumes that man can obtain consensus regarding social generalizations and statements by using a method which is public, systematic, and replicable. *Persons who accept this method and reject the others that we discussed value public over private and idiosyncratic knowledge.* The a priori method, unlike the scientific method, is a private or "internal" method of knowing or "fixing belief." An individual using this method derives conclusions on the basis of what is self-evident to him, and, as we pointed out, what's self-evident to him may not necessarily be self-evident to other persons. The scientific method attempts to derive knowledge which can be independently obtained by persons using the method at different times and places. *However, personal values and assumptions do affect the products of this method.* The problems we select and the questions we formulate are determined by our own values, purposes, and social environment. These factors influence the outcome of scientific inquiry. *However, these factors are comparatively less important in social inquiry than they are in other methods of attaining knowledge.* Kerlinger notes some of the values of the scientific approach to social problems:

> The scientific approach has one characteristic that no other method of attaining knowledge has: self-correction. There are built-in checks all along the way to scientific knowledge. These checks are so conceived and used that they control and verify the scientist's activities and conclusions to the end of attaining dependable knowledge outside himself.
>
> . . . A scientist does not accept a statement as true, even though the evidence at first looks promising. He insists upon testing it. He also insists that any testing procedure be open to public inspection.[22]

Goldmark indicates why she prefers the scientific method to other ways of knowing or fixing beliefs:

It is systematized. To operate with this method is to operate with a structured and consistent system, which is available for reapplication in new situations.

It is precise. Language gains specific meanings in a system, and when meaning is precise, it can be shared. Inquiry method provides an operational definition for each step of inquiry, telling us what to do when judgments are demanded.

It is expanding. The inquiry method requires a consideration of all possible alternatives, thus expanding our frames of reference.

It is testable. Alternatives posed as hypotheses are open to testing.

It is open to public judgment. Testable procedures and their conclusions are open to judgment of the informed public.

It demands responsibility. If procedures and conclusions are open to public judgment, those offering them must be responsible for their judgments; the defense of a decision is demanded.

It is reconstructable. Once tested and evaluated by a competent public, a conclusion and a method can be reconstructed, thus providing for ongoing inquiry.[23]

As we indicated above, knowledge is one essential component of the decision-making process. In discussing the four ways of knowing stated by Peirce, our preference for scientific inquiry was made clear. We prefer this method because it is systematic, self-correcting, open-ended, and public. In order for knowledge to contribute maximumly to the making of rational decisions, it must be derived by an inquiry process. Decisions made on the basis of knowledge derived by intuition or tradition will not satisfy our stipulation of *rationality*.

Before students can make sound and rational decisions, they must learn how to use the modes of inquiry of social scientists to derive social knowledge in the form of facts, concepts, generalizations, and theories.

The rational social actor need not independently derive every bit of knowledge he uses in making decisions and solving problems. This would certainly be impractical. Not much human progress would be made because few rational decisions would be possible. However, the social actor cannot intelligently apply or judge knowledge unless he is aware of the processes used to derive it and is able to use the methods of the social scientist himself to derive knowledge when it is necessary and appropriate (for example, when authorities conflict).

Rational decisions cannot be made unless the decision-maker is able to *judge* the quality of the knowledge which he uses. Decisions are no better than

the knowledge which contributes to their formation. Decisions made on the basis of knowledge which is "self-evident," or inherited, cannot be characterized as *rational.*

In a democratic nation the scientific method should not be the exclusive property of the professional scientific community; it should be shared by all members of the society who are required to make decisions that affect the governing of the nation. Consumers and appliers of social knowledge should have practice in using the scientific method. Skill in using this method will help them develop the problem-solving skills necessary for sound decision-making. They will learn to appreciate the difficulties involved in gathering social data and in deriving conclusions. Social actors who are adept at using scientific inquiry will also become critical and intelligent appliers of knowledge when making decisions and acting.

Inquiry and decision-making

As we have already noted, social knowledge, derived by a scientific process, is only one of the essential components of the decision-making process. Before we discuss other elements of the process, it is appropriate (1) to indicate how *social science inquiry* differs from *decision-making*, and (2) *point out why it is necessary but not sufficient for making rational and sound decisions.* In this discussion we will also suggest how the ends of social science inquiry and decision-making differ.[24]

The basic aim of social science inquiry is to derive social knowledge in the form of facts, analytical concepts, generalizations, and theories. The goal is to accumulate as much knowledge as possible. While the social scientist is primarily interested in producing knowledge, the decision-maker or rational actor is mainly interested in how the knowledge derived by social scientists can be used to help him solve problems and make decisions.

Social science inquiry produces knowledge; in decision-making, knowledge is selected, synthesized, and applied.

However, as we have previously pointed out, the intelligent consumer of knowledge must be familiar with the methods used by the professional social scientist to derive knowledge and able to use the method himself.

Knowledge in social science inquiry tends to be specialized. Each group of social scientists studies only those aspects of social phenomena that they feel are the appropriate concerns of their discipline. They may ignore many crucial components of broad social problems. The economist, historian, anthropologist, sociologist, or political scientist will concentrate on limited aspects of complex social problems such as racial relations, poverty, or war. The social scientist fragments the universe in order to study it from a unique perspective. The rational decision-maker and intelligent social actor must use the knowledge from all the various social science disciplines to help him solve his personal and social problems. In decision-making we select, synthesize, and apply knowledge from diverse sources. *Knowledge from no one discipline can adequately help*

social actors to make decisions about the baffling and complex problems which confront man.

Knowledge alone is insufficient for sound decision-making.

Rational social actors must learn how to synthesize the information they obtain from many sources and *apply* it to complex social problems. Figures 1.1

Figure 1.1
Social actor's decision-problem: What actions should I take regarding the Vietnamese war?

Historian
Analyzes events which culminated in war; illuminates similarities between current and previous wars.

Economist
Studies economic consequences of war on nation's economy. Suggests that war may result in general rise in standard of living.

Political Scientist
Studies the political consequences of the president's actions regarding the war. Concludes that former president's stance on Vietnamese war a major factor that contributed to his declining popularity during the last months of his administration.

Sociologist
Analyzes effects of absentee fathers on family stability and studies structure of protest groups which initiated anti-war campaigns.

Psychologist
Analyzes the conflict created in young men who feel an obligation to serve their nation, but who perceive the current war as immoral and unjustified.

Anthropologist
Studies wars cross-culturally to ascertain the common and unique causes of wars in different cultural contexts. Suggests that other means can be used to resolve international conflicts.

Geographer
Studies the spatial interaction of the nations at war, and suggests how the outcome of the conflict may affect other locations.

through 1.3 indicate how a social actor may attempt to decide what action he should take regarding the Vietnam War. Figure 1.1 illustrates how various social scientists may view the United States involvement in the war. Note how each of the social scientists views the war from a very restricted perspective, while the intelligent social actor attempts to synthesize the knowledge from various disciplines and sources (including his own inquiries) and use it in making a

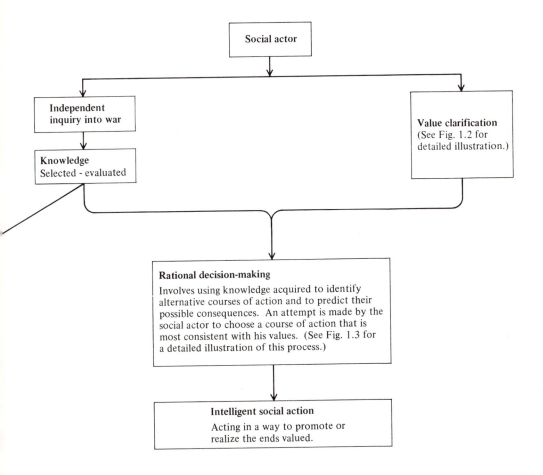

The rational social actor synthesizes and applies knowledge from all disciplines to help him make decisions about the action he will take regarding war. He may also apply knowledge which he has derived from his own inquiries. His synthesis of *knowledge* (in the form of facts, concepts, generalizations, and theories) and *values* results in a *decision* which involves selecting a course of action from many possible alternatives, including inaction.

Figure 1.2
Value Clarification (Vietnamese War).*

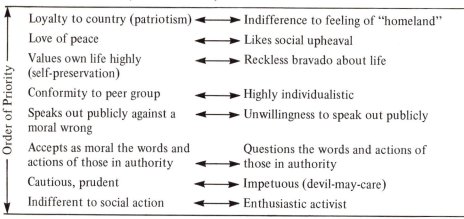

Loyalty to country (patriotism) ⟷	Indifference to feeling of "homeland"
Love of peace ⟷	Likes social upheaval
Values own life highly (self-preservation) ⟷	Reckless bravado about life
Conformity to peer group ⟷	Highly individualistic
Speaks out publicly against a moral wrong ⟷	Unwillingness to speak out publicly
Accepts as moral the words and actions of those in authority ⟷	Questions the words and actions of those in authority
Cautious, prudent ⟷	Impetuous (devil-may-care)
Indifferent to social action ⟷	Enthusiastic activist

Order of Priority (vertical axis label)

*In this example, values are conceptualized as existing on a continuum. An individual's value preferences may vary in intensity periodically, but are generally committed toward one end of a continuum. To act intelligently, the individual must arrange his values into a hierarchy of preference. The level of commitment to a particular value will greatly determine its place in the hierarchy. In Chapter 12 we present a model for teaching value inquiry. The basic steps of this model are outlined in Fig. 1.5.

"Grandpa, what was fresh air like?"

Drawing by Joseph Farris. Reprinted by special permission.

Figure 1.3
The Decision-making Process (Vietnamese War).

A. If I enlist	B. If I protest the war	C. If I leave the country and go to Canada or Sweden
Then I. . .	*Then I. . .*	*Then I. . .*
1. will be helping my country.	1. will be making my views known.	1. will be protesting the war in a dramatic way.
2. will gain the respect of my family and friends.	2. may help to bring about political change in our nation's goals.	2. will be disassociating myself from an untenable course of action by the United States administration.
But I. . .	*But I. . .*	*But I. . .*
3. will also alienate others.	3. may be misunderstood by many.	3. may lose my citizenship.
4. may be helping to perpetuate an "undemocratic regime" in Vietnam.	4. may be falsely identified with "Un-American groups."	4. may be prosecuted and sent to jail when I return.
5. may be wounded or killed.	5. may be making only a futile gesture.	5. may not be able to make a living in a new country.
		6. may have to break most family ties.
		7. may be sent to prison upon my return to this country.

D. If I burn my draft card	E. If I chose to do nothing (inaction)
Then I will have. . .	*Then I. . .*
1. protested dramatically and publicly my opposition to the war.	1. will take my chances of being drafted.
2. brought about a court trial at which I hope to raise the "real issues."	2. may not be drafted at all.
3. encourage others to follow my example.	3. may be drafted.
	4. may be able to finish my college education.
But I. . .	*But. . .*
1. may receive a stiff jail sentence, or	5. Since the above consequences are all very uncertain, my life is likely to be very ambiguous until
2. may subject my family to public criticism.	a) I'm no longer eligible for the draft.
	b) the Vietnamese war is over.

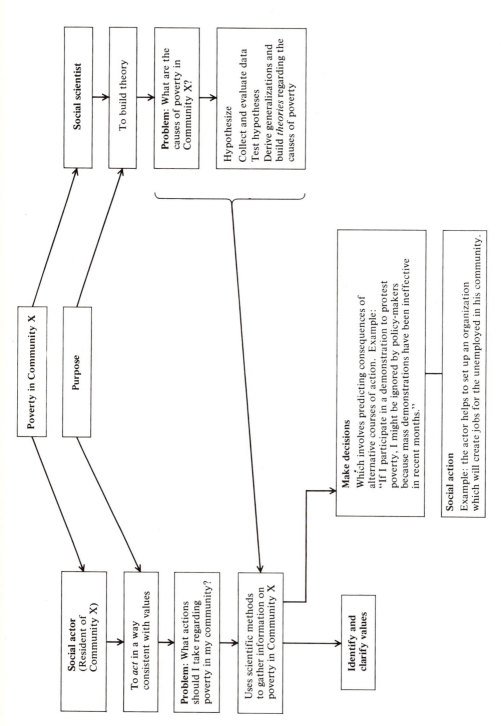

Figure 1.4 How a rational social actor and a social scientist might approach the problem of poverty in Community X.

decision which can guide his action regarding the war. Figure 1.2 shows how the decision-maker tries to clarify his conflicting values about the war. We have yet to discuss the *value dimension* which is a critical component of the decision-making process. Figure 1.3 illustrates how the social actor determines a course of action.

In summary, social science is mainly concerned with accumulating knowledge and building theories; all knowledge is important. It also prepares specialists who study the world from limited and unique perspectives. The rational social actor synthesizes and applies knowledge from the various disciplines and from his own inquiries to help him make crucial decisions affecting his personal and public life. In synthesizing and applying knowledge from the disciplines, he necessarily *selects* that knowledge which will contribute most to the making of sound decisions and intelligent social action. The rational social actor uses the products of social science inquiry to help him make *policy* decisions.

Figure 1.4 illustrates how a rational social actor and a social scientist might evidence concern about poverty in a hypothetical community. Note that their *purposes* and therefore the *main* problems which they formulate are essentially different. The social scientist is interested primarily in building *theory*. As Redfield has pointed out, the social scientist's "main objective is *accurate description*. Social scientists are scientific in that they are concerned with '. . . . what is, not what ought to be".[25] *However, the social actor is interested in both what "is" and what "ought" to be."* He uses scientific methods to gain information which will help him to act in a way consistent with his values. As this figure indicates, his role goes *beyond* that of the social scientist. The social scientist's role ends with the formulation of theoretical knowledge.

Although we realize that social activists frequently make decisions on the basis of emotions alone,

> *people can be trained to think about issues and problems before acting on them.*

As Shaftel notes, "Typically in real life, when we find ourselves in a problem situation we act, *then* we think (often wishing we had behaved differently). Young people should be taught to feel, to think (who is involved, how do they feel, what will happen if . . .), and *then act."*[26] The model of social studies presented in this book describes the mode of thinking and analysis that social actors *can* and *ought* to employ, rather than the kind of thinking exhibited by most citizens.

Structure and the decision-making process

In a significant book published in 1960, *The Process of Education*, Jerome S. Bruner popularized the concept of the *structure* of a discipline.[27] He set forth four hypotheses which have been summarized by Lowe:

1. All disciplines are reducible to fundamental and developmental ideas — that is, structure.

2. These basic ideas can be taught to almost all individuals at any age and any level of ability in some intellectually honest manner.

3. All children can develop a type of "intuitive grasp" of the nature of the disciplines that is now possessed typically only by scholars.

4. Intellectual curiosity is ample motivation for students if they are given the opportunity to think for themselves or to "discover" the structure of the disciplines;. . .[2][8]

Structure not only consists of the key concepts, generalizations and theories within the social sciences, but the unique modes of inquiry which are used within the various disciplines.

The concept of structure heavily influenced social studies curriculum reform in the 1960's. Such new programs as the Taba Social Studies Curriculum, Project Social Studies of the University of Minnesota, and the Anthropology Curriculum Project at the University of Georgia are organized around key concepts and generalizations within the social sciences. The help of specialized social scientists such as anthropologists, sociologists, political scientists, and economists was solicited to identify the structures of their disciplines so that social studies curriculums could be organized around them. Difficulties arose because these social scientists could not often agree about what the key ideas and principles in their respective disciplines were. Some educators and social scientists equated the social sciences with the social studies and tried to make children little social scientists. Nevertheless, the search for structure during the 1960's greatly strengthened the knowledge components of social studies programs at all levels, although other essential areas of social studies were largely neglected during this vital period of reform.

While key concepts and generalizations, and the modes of inquiry used by social scientists received heavy emphasis during the 1960's, little attention was devoted to value inquiry. Few attempts were made by social studies educators to teach children how to apply the key ideas of the disciplines to resolve personal and social problems, or how to influence public policy with intelligent social action. The social problems which our nation faced by the beginning of the 1970's forced the attention of social studies educators on the need to help students analyze their values and to use their social science knowledge to help them act in ways consistent with their value choices. Increasingly, educators recognized that key social science concepts and principles were necessary but not sufficient components of modern social studies programs. A number of writers illuminated the limitations of an exclusive social science approach to social studies education.[2][9]

We believe that decision-making on personal and social problems should be the focus of modern social studies programs. *However, the concept of structure can help us to identify the kind of knowledge which will help children make valid predictions and therefore the most effective decisions.* Knowledge is one essential component of the decision-making process. To make intelligent decisions, children must master the most *powerful* and *predictive* forms of knowledge. We can delineate at least four categories of knowledge – *facts,*

concepts, generalizations and *theories* — factual knowledge has the least predictive value, although facts are necessary for deriving other levels of knowledge. *Concepts* are words or phrases which enable us to categorize or classify a large class of observations, and thus to reduce the complexity of our social environment. *Generalizations*, which state the relationships between concepts, enable us to predict behavior, and thus are highly valuable for making predictions on personal and social problems. *Theories* consist of a system of interrelated generalizations and is the highest form of knowledge; it is the most valuable form of knowledge for making predictions. However, theory learning is more appropriate for senior high-school than for elementary and junior high-school students.

The concept of structure enables us to identify the key ideas of the disciplines. These ideas are the most beneficial kind of knowledge for sound decision-making. Students must not only master higher levels of knowledge (key concepts and generalizations) in order to make intelligent decisions, they must also learn to view their social environment from the perspectives of all the social science disciplines. Thus a curriculum that focuses on decision-making must not only teach children higher levels of knowledge, it must be *interdisciplinary*, and incorporate *key* concepts and generalizations from all the social science disciplines. We view higher level, interdisciplinary knowledge as absolutely necessary but not sufficient for rational decision-making. Although the concept of structure does present difficulties, as will be seen when we discuss the various disciplines in Part 2, we feel that the idea is a fruitful one and that the difficulties it presents reveal more about the scientific status of the social disciplines and less about the merits of the concept.

Value component of decision-making

After he has derived higher level knowledge from his own inquiries and the inquiries of others, the rational actor must attempt to relate the facts, concepts, generalizations, and theories to his own value system before he decides to act. What a person does with the knowledge derived from social inquiry depends largely upon the values which he holds in regard to the decision-problem elements and components.

Thus *value inquiry* is an immensely important component of the decision-making process. Value inquiry should help the decision-maker identify the sources of his values, determine how they conflict, identify value alternatives, and choose freely from them. The student should be encouraged to predict and to consider the possible consequences of alternative values, and be helped to clarify conflicting, divergent, and confused values. Not only are conflicting values pervasive in the larger society, but within individuals there are many divergent beliefs, attitudes, and values.

Our society, for example, treats adolescents in many respects like children, but it expects them to act like adults in certain social situations. We prohibit them from engaging in intimate sexual acts, yet they are encouraged by movies, television, and other mass media to do so. Many Americans who pay lip service to civil liberties feel that certain classes and groups in our society should not

have the same rights which others enjoy if their having these rights interferes in any way with the status quo. Many persons who are active in religions that preach brotherhood are intolerant of other ethnic and religious groups. We could note many other value conflicts in our society, but these serve to illustrate the point.

Before individuals can make sound, rational decisions and act intelligently, they must be helped to clarify their many conflicting and confusing values.

We believe that value inquiry and clarification is one of the most important phases of the decision-making process.

Perhaps the most baffling problems that face both individuals and our society as a whole are the nagging value issues. While we probably have the sophistication and means to solve many of our pressing social problems, we have not done so because we have not yet clarified our value positions regarding them.

Let us return now to our couple, long abandoned, who were trying to decide whether they should move out of a neighborhood which was being invaded by Puerto Ricans. We can illustrate how values may play a significant role in their final decision.

After gathering knowledge about Puerto Ricans who move into predominantly white neighborhoods, both from their own inquiries and those of others, let us assume that the couple concluded that most Puerto Ricans who come to the mainland possess technical skills, unusual talents, earn a steady income, and take pride in their property and neighborhoods. However, they also learn that most whites *perceive* Puerto Ricans quite differently. Because most whites perceive them as people who will destroy neighborhoods, whites usually begin to sell their homes when Puerto Ricans invade their neighborhoods. As a result, the price of property does decline.

Thus, the couple can predict with a high degree of accuracy that whites will start to move out of the neighborhood when Puerto Ricans begin to invade it and that property prices will shortly begin to decline. However, the couple has *beliefs, attitudes, and values* toward different racial groups that will significantly affect their decision. They feel that because our society is made up of diverse racial and ethnic groups, their two young children might one day have to learn how to live with other races. The social benefits which their children can accrue from knowing and interacting with Puerto Rican children will more than compensate for the loss of value in their property. The couple is also very interested in the culture and life style of Puerto Ricans and feel that they would enjoy the opportunity to learn more about this culture by experiencing it. More than the price of their property, they value multi-ethnic and multi-cultural neighborhoods. The couple also feels that their moving out of their neighborhood would be antiethical to their strong commitment to racial and ethnic diversity. This couple's attitudes and values, more than the social knowledge which they acquired, determined their decision and consequent action. However, knowledge enabled them to clarify their values and to know what values they considered most important. While knowledge is

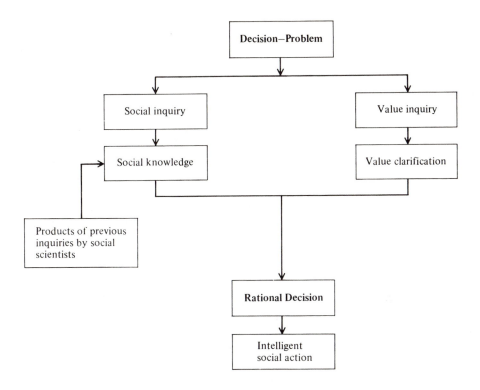

Figure 1.5
A social studies curriculum focused on social inquiry, valuing, decision-making, and intelligent social action.

necessary for sound decision-making, it is not sufficient. A social actor's attitudes, beliefs and values are often the most important determinants of his behavior.

Formulating behavioral objectives for inquiry, valuing, and decision-making

The main goal of the social studies should be to help students develop the ability to make rational decisions and to act intelligently. Knowledge, derived by an inquiry process, and values, analyzed and clarified by value inquiry, are essential components of the decision-making process. The relationship between these components is illustrated in Fig. 1.5. The decision-maker must select, synthesize, and apply knowledge from all of the social science disciplines and clarify his values before he can act rationally on the perplexing problems which confront modern man.

The elementary social studies program must help children gain proficiency in *inquiry, valuing* and *decision-making* skills. Children will undoubtedly develop these skills to some extent without planned and deliberate instruction. However, they will not refine them unless they receive systematic instruction

throughout the elementary and junior high-school years. The social studies must assume the main responsibility for developing these skills because of its content and commitment to the development of intelligent social actors who will take effective roles in the governing of our nation.

Inquiry, valuing and *decision-making* each consists of a *cluster* of interrelated skills, as will become evident in later chapters. Each *cluster of skills* contains elements that are highly interrelated; we separate them in this volume to facilitate discussion and to emphasize the need for systematic instruction in each group of them. Unless we focus on each group of skills separately, the need for systematic instruction in each may not receive the necessary emphasis. Lessons should also be planned to give the student practice in relating each set of skills to the other since the ultimate goal of social studies education is to help the child attain the ability to derive and apply knowledge and clarify his values, so that he can make sound decisions.

The classroom teacher cannot structure successful learning experiences to develop and increase proficiency in skills unless he has clearly in mind the kinds of *behavior* which he will accept as evidence of skill attainment and mastery. Instructional objectives must be specified so that the teacher can determine whether his lessons are effective. It is necessary to define *inquiry, valuing* and *decision-making* behaviorally in order to formulate meaningful instructional objectives and to evaluate lessons designed to develop and refine these skills.

When we state objectives behaviorally, persons other than the author can easily grasp their intent. If we state that a person must *understand* a problem before he can begin to inquire, we have not succeeded in communicating a very specific behavior. *Understand* may mean different things to different readers. However, if we state that a person must be able to *identify* a problem before he can inquire, we have used a word which is open to fewer interpretations.

In the sample objectives which we describe below, we attempt to use words that are specific and open to few interpretations. We will be describing and discussing possible behavioral objectives for social studies lessons in other chapters; the objectives below are examples given to illustrate how the skills we have been discussing can be stated behaviorally.

SAMPLE OBJECTIVES FOR INQUIRY EXERCISES

1. When presented with a problem such as "What are the causes of social conflict," the student will be able to

a) state relevant hypotheses.

b) collect pertinent data.

c) evaluate the data (tell whether it is valid and reliable; state whether it is related to the problem).

d) write a tentative generalization.

e) revise the generalization when presented with additional data related to the problem.

2. When given a document or object related to an unknown social event, the student will be able to

a) state hypotheses concerning its origin and nature.

b) test the hypotheses which he formulates (gather relevant data and determine whether hypotheses should be accepted or rejected).

c) make a tentative generalization regarding the origin and nature of the document or object.

d) revise the generalization when presented with additional data.

3. When given a historical document, the student will be able to

a) state the problem(s) discussed by the writer.

b) state hypotheses concerning the reason(s) the document was written.

c) state hypotheses concerning the audience the writer had in mind.

d) state the writer's conclusions.

e) state what evidence, if any, the writer used to derive his conclusion.

4. When given a collection of related social data, the student will be able to

a) state a hypothesis concerning the relationship of the data.

b) write a generalization based on the data.

c) revise the generalization when given additional data.

SAMPLE OBJECTIVES FOR VALUING EXERCISES

The student will be able to

1. Identify action which indicates conflicting values when given a description of American society.

2. Read an account of slavery and state the writer's assumptions and values.

3. Read the open-ended story, "Finders Weepers," and state the values held by each of the characters.

4. Read news stories and state the value-problems exemplified in them.

5. Read about historical events and state what happened, and what he thinks *should* have happened.

6. State whether he agrees or disagrees with each of a number of controversial statements, and *why*.

SAMPLE OBJECTIVES FOR DECISION-MAKING

The student will be able to

1. Identify and state the decision-problem which the characters confront in the open-ended story, "Finders Weepers."

2. State what courses of action the characters in the story might take to solve their problem.

3. State the possible consequences of each course of action stated in Objective 2 above.

4. State the facts, concepts, and generalizations which will help him to predict the possible consequences of each course of action stated in Objective 2.

5. State the values which would play a part of each of the possible courses of action.

6. State which course of action he would take (if he were a character in "Finders Weepers") and *why*.

7. State how the action he would take relates to his values (whether it is consistent or inconsistent with the values which he professes).

SUMMARY

In this chapter, we identify some of the salient social and personal problems which Americans currently face and argue that the main goal of the social studies program should be to help students develop the ability to make rational *decisions* so that they can resolve personal problems, and through social action, influence public policy. One of the essential components of decision-making is *knowledge*. Rational decisions can be made only when knowledge has certain characteristics. It must be *scientific, higher level,* and *interdisciplinary*. The intelligent decision-maker must not only be able to use and recognize scientific knowledge, but must be able to derive it himself when it is necessary and appropriate. The knowledge on which rational decisions are made must also be powerful and widely applicable so that it will enable the decision-maker to make the most accurate predictions possible. Higher-level concepts and their related generalizations are necessary for making accurate predictions. Thus the decision-maker must be able to derive and apply these forms of knowledge. Knowledge which serves as a foundation for rational decisions must also be interdisciplinary. Knowledge from any one discipline would be insufficient to help us make intelligent decisions on complex social issues such as pollution, war, and racism.

While scientific, higher-level, interdisciplinary knowledge is necessary for sound decision-making, it is not sufficient. The intelligent decision-maker must also be able to identify and clarify his *values*, and relate the concepts and generalizations which he formulates to his values. *The synthesis of knowledge and values constitutes the process of decision-making.* During this process, the social actor uses social science concepts and generalizations to identify alternative courses of action and to predict their possible consequences. He orders his values into a hierarchy, and chooses the course of action which is most consistent with his value position. Finally, he takes action based on his decisions to resolve personal problems or to influence public policy. This process is illustrated in Fig. 1.6. In Chapter 13 we discuss this problem in more

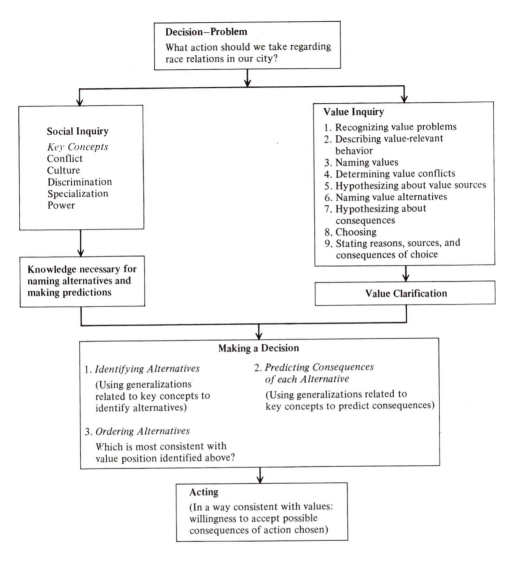

Figure 1.6 The decision-making process.

detail and illustrate how a teacher may use this example to organize and implement a decision-problem unit. The figure is presented at this point in the text to help focus the reader's attention on our theory of social studies education as he reads the forthcoming chapters.

DISCUSSION QUESTIONS AND EXERCISES

1. Study a number of recent newspapers and magazines and clip out articles that describe personal and social problems within our society. Make a list of these problems and try to formulate a system by which they can be grouped. You may use such categories as *racial conflict, political alienation, poverty*, or *war*. What implications, if any, do you feel that these problems have for building social studies programs for the present and future?

2. What difficulties might a teacher encounter when trying to structure a social studies curriculum around social issues and controversy? What steps might he take to minimize such difficulties?

3. Identify a personal or social problem on which you are required to make a decision, such as "Should I go into the armed forces or try to dodge the draft?" or "What actions should I take regarding racial conflict in my community?" If you do not currently face such a problem, select one on which you might be required to make a decision.

a) What *knowledge* components would you need to make a sound decision? For example, if you must make a decision about racial conflict in your community, conceptual knowledge about *discrimination* and *prejudice* will help you to make an intelligent decision. Questions such as "What are the economic consequences of war?" may help you to identify the knowledge components that are necessary to make an intelligent decision. Try to categorize the needed knowledge into *facts, concepts, generalizations* and *theories*. (See Chapter 3 for a detailed discussion of the categories of knowledge.)

b) After you have identified the necessary knowledge components, name the possible *values* which might guide an individual's choice regarding the decision-problem. Such values as *freedom, honesty, individual rights, cultural diversity, justice, equality,* and *human dignity* might be named. List the values as you would prefer them into a hierarchy, placing at the top of your list the things which you value most, at the bottom, those you value least. Did you encounter any difficulties in identifying values related to the problem? If so, why? If not, why not? Did you encounter any difficulties in ranking your values into a hierarchy? If so, why? If not, why not? Do you have any conflicting values regarding the decision-problem? If not, why not? If so, how might you resolve them?

c) How might the knowledge components that you previously identified help you to act in a way most consistent with your values? How might the knowledge components help you to identify alternative courses of action and to predict their possible consequences? If you mastered the knowledge that you feel is essential to make an intelligent choice regarding your problem, what actions, if any, do you think that you might take regarding it? Why?

4. The author makes a distinction between the *social studies* and the *social sciences* and suggests that the main goal of social science is to structure theoretical knowledge and the goal of the social studies is to help children make decisions and act on social issues. Determine the degree to which social scientists agree with the author by analyzing chapters on the goals of the disciplines in introductory social science texts. Ascertain the degree to which other social studies educators agree with the author by examining introductory chapters in several social studies methods books. After completing this exercise, write a brief paragraph on the differences between the social studies and the social sciences, and the implications of such differences for building social studies curriculums for the elementary and junior high-school grades.

5. The author briefly discussed the concept of the *structure* of a discipline and related it to his conceptualization of the decision-making process. Locate several readings on this concept, and compare the definitions given by other writers with the one stated in this book. Select one of the social science disciplines such as anthropology or sociology, examine an introductory college text on it, and try to list some of the key concepts, generalizations, and theories within that discipline. Do different social scientists often agree about what the key concepts within a particular discipline are? Why or why not? Can the concept of the structure of a discipline help us to teach children how to make sound decisions that are related to social problems? Why or why not? If they can, how?

6. Compare the conceptualization of *decision-making* presented in this chapter with those given by other authors. Can the differences be reconciled? If so, how? If not, why not? What modifications would you make in any of these conceptualizations of decision-making? Identify the *assumptions* on which these models of decision-making are based? Do you accept them? Why or why not?

7. Assume that during a primary grade valuing lesson you are reading an open-ended story in which two small boys who desperately needed some money found a wallet that contained ten dollars in cash. At this point the story ends. If, after asking the children what they would do in a similar situation, a child says that he would keep the money and destroy the wallet, what would be your response? What do you feel that your role as a teacher should be in value education? Why? Do you feel that there are certain values which teachers have a responsibility to inculcate in children? If so, what are these values? Make a list of such values and compare it with those of other members of your class. Are there any differences in the lists? If so, why? If not, why not? If there are differences in the lists, what implications does this fact have for your perception of the teacher's role in value education? What difficulties might be encountered in teaching children predetermined values? What alternative ways might a teacher use to approach moral education within the schools? What are the possible consequences of these alternative approaches to value education?

8. The author of this chapter contends that *social inquiry, decision-making* and *social action* should be important components of modern social studies

programs. Using these criteria, evaluate several social studies curriculum guides from various school systems in the Curriculum Library of your college library. Are the guides designed to help teachers plan experiences whereby children can develop skills in all these areas? If not, what skills are developed or emphasized? Which are neglected? Do you feel that the guides should stress skills which they do not? Why or why not? What skills do the guides neglect that you would include? If some skills are neglected, how would you account for their omission? Do the guides describe the strategies for teaching all the skills which they state are important?

9. Compare the theory of social studies education presented in this chapter with that presented in the National Council for the Social Studies publication, *Social Studies Curriculum Guidelines* (1971). What skills do both sources recommend? What skills does one source recommend and the other omit? What skills does each source emphasize? Try to summarize the similarities and differences in these two sources. How would you account for the similarities? Differences? Can the differences be reconciled? Why or why not? If they can, how?

10. During the 1970's, many national social studies projects were formulated to initiate reform in social studies programs. Most of these projects, such as the Taba Social Studies Project, "Man: A Course of Study," and Project Social Studies of the University of Minnesota, produced materials which are now available from commercial publishers. Examine the materials from one of these projects in the Curriculum Library of your college. Using the criteria for social studies curriculums presented in this chapter, determine the extent to which the project emphasizes the skills which the author feels are imperative for modern social studies curriculums.

11. Arrange to visit a school where you can observe a social studies lesson being taught. By careful observation, try to identify the key ideas and other major objectives which the teacher is trying to teach. After the lesson, talk with the teacher to determine whether your ideas are consistent with his.

12. Demonstrate your understanding of the following key concepts presented in this chapter by writing out or stating brief definitions of them:

a) decision-making

b) social actor

c) social action

d) knowledge

e) interdisciplinary knowledge

f) higher level knowledge

g) the method of tenacity

h) the a priori method

i) the method of authority

j) social science inquiry or social inquiry

k) structure

l) value inquiry

m) behavioral objective

FOOTNOTES

1. Erich Fromm, *The Sane Society*. New York: Fawcett World Library, 1967, p. 16.

2. United States Bureau of the Census, *Statistical Abstract of the United States*. Washington, D.C., 1969, p. 60.

3. *Ibid.*, p. 143. 4. *Ibid.*, p. 143.

5. *Ibid.*, p. 153. 6. *Ibid.*, p. 79.

7. *Newsweek*, Feb. 16, 1970, p. 67.

8. Fromm, *op. cit.*, p. 17.

9. *Statistical Abstracts of the United States*, *op. cit.*, p. 81.

10. *Ibid.*, p. 73. 11. Fromm, *op. cit.*, p. 18. 12. *Ibid.*

13. William H. Whyte, Jr., *The Organization Man*. Garden City: Doubleday, 1957.

14. Jules Henry, *Culture Against Man*. New York: Vintage Books, 1963, pp. 4-5, 11.

15. George Orwell, *Nineteen Eighty-Four*. New York: Harcourt, Brace and World, 1949.

16. B.F. Skinner, *Walden Two*. New York: Macmillan, 1948.

17. Aldous Huxley, *Brave New World*. New York: Harper, 1932.

18. William Golding, *Lord of the Flies*. New York: Coward-McCann, 1962.

19. Fred N. Kerlinger, *Foundations of Behavioral Research: Educational and Psychological Inquiry*. New York: Holt, Rinehart and Winston, 1964, pp. 6-7.

20. *Ibid.*, p. 7.

21. Bernice Goldmark, *Social Studies: A Method of Inquiry*. Belmont, Calif.: Wadsworth Publishing, 1968.

22. Kerlinger, *op. cit.*, pp. 7-8.

23. Goldmark, *op. cit.*, p. 214. Reprinted with permission of the publisher. Copyright © 1968 by Wadsworth Publishing.

24. Shirley H. Engle, "Decision-Making: The Heart of Social Studies Instruction," *Social Education*, Vol. 24 (Nov., 1960), pp. 301-304, 306 ff.

25. Robert Redfield, "The Social Uses of Social Science," a reprint by Charles E. Merrill Books, Columbus, Ohio, No. 8013, pp. 1-2. Reprinted from *University of Colorado Bulletin*, Vol. 47, May 24, 1947.

26. Fannie R. Shaftel, "Role Playing: An Approach to Meaningful Social Learning," *Social Education*, Vol. 34, May, 1970, p. 557.

27. Jerome S. Bruner, *The Process of Education*. New York: Vintage Books, 1960.

28. William T. Lowe, *Structure and the Social Studies*. Ithaca: Cornell Univ. Press, 1969, p. 34.

29. See Fred Newmann, "Questioning the Place of the Social Science Disciplines in Education," *Teachers College Record*, Vol. 69, Oct., 1967, pp. 69-74; Shirley H. Engle, "Exploring the Meaning of the Social Studies," *Social Education*, Vol. 35, March, 1971, pp. 280-88, 344 ff; James P. Shaver, "Social Studies: The Need for Redefinition," *Social Education*, Vol. 31 (November, 1967), pp. 588-593.

Part 2

SOCIAL SCIENCE INQUIRY

INTRODUCTION TO PART 2

As we have seen, *knowledge* is one of the essential components of the decision-making process. Decisions can be no better than the knowledge on which they are based. There are many ways of knowing, as is illustrated in Part 1. Sound decisions must be based on *scientific* knowledge. The effective decision-maker must not only be able to identify and apply scientific knowledge, but he must be able to use the scientific method to produce it. An individual cannot intelligently consume scientific knowledge unless he is able to derive it himself when it is necessary and appropriate.

Sound decisions must also be derived from *interdisciplinary* knowledge. Knowledge from any one discipline is too limited to enable the individual to fully understand the immense complexity of human behavior. Because each of the social science disciplines provides us with a unique lens with which to view the human drama, the rational social actor must be able to see man's behavior from the perspective of each of the social sciences.

The knowledge on which rational decisions are made must also be *higher-level and widely applicable* so that it will enable the decision-maker to make the most accurate predictions possible. Higher-level knowledge consists of the organizing concepts, generalizations, and theories that constitute the *structures* of the various social science disciplines.

This part of the book is designed to acquaint the reader with the methods of social inquiry and the structures of the various social sciences. With this basis he can create learning experiences for children which will enable them to master both the *methods* and the *products* of social inquiry. Exemplary strategies for teaching the methods of social inquiry and the nature of the social sciences constitute a substantial part of the chapters in this section.

THE METHOD OF SOCIAL INQUIRY

THE GOAL OF SOCIAL INQUIRY

Consensus does not exist regarding the proper goals of social science inquiry. Most lay people and some social scientists believe that the proper goal of social inquiry is to help man live a better life by *directly* contributing to the solution of the baffling and urgent social problems which he confronts. These advocates contend that social inquiry should concentrate on man's practical problems. According to this point of view, the main purpose of social inquiry is to directly serve policy-makers by helping them to make better decisions.

In recent years, social scientists have become increasingly involved in research activities primarily concerned with providing insights and solutions to current problems. Generous grants and stipends from private and public agencies interested in promoting research on practical problems have been instrumental in attracting many social scientists to applied kinds of research endeavors. Research on race relations, juvenile delinquency, drug addiction, and suicide tends to escalate when these problems evoke increased concern among our citizens and policy-makers. Researchers began to aggressively study children dubbed "disadvantaged" during the 1960's when popular interest in the poor increased and a flood of federal funds became available for the study of the learning problems of lower-class children. Thus, not only do some social scientists and most lay citizens regard the proper aim of social inquiry as the accumulation of knowledge which can be directly applied to current social problems, social scientists do frequently respond to the need for applied research on contemporary problems. To a great extent, social scientists pursue the kinds of research activities which are supported by public and private agencies. Foundations and governmental agencies most frequently support research endeavors which directly seek solutions to current social problems.

While some social scientists believe that social inquiry should be primarily concerned with the practical problems which man confronts daily in his social relationships, *an increasing number of them believe that the goals of social inquiry should be more generic, basic, and comprehensive. They consider the formulation of theoretical knowledge as the basic goal of social inquiry. Facts, concepts and generalizations* are necessary for the formulation of theories.

Social scientists who regard the formulation of theoretical knowledge as the primary goal of social inquiry do not suggest that the product of social inquiry should not be used to help man solve his perplexing social problems. Quite the contrary, they argue that theoretical knowledge can help him understand his social environment, make predictions, and therefore control components in his environs better than knowledge derived from more specific and applied kinds of research endeavors.

Perhaps an illustration will make this position more explicit. Community X is a tense and hostile community because of the mutual suspicion and distrust which exists among the Mexican-Americans and Puerto Ricans. Since the coming of the Mexican-Americans into the neighborhood, animosity between the two ethnic groups has been evident. The community leaders commission a team of social scientists to study the conflict and to make policy recommendations to resolve it. While the recommendations formulated by the research team help to alleviate the ethnic tension in Community X, the knowledge derived from this particular research endeavor may not be applicable to other communities characterized by other kinds of ethnic hostility.

Community Y, for example, one hundred miles from Community X, needs guidelines to reduce ethnic hostility between Orientals and Indians, and Community C is tense because of hostility between Irish and Polish residents. These communities will probably be unable to use the information derived from the study of Community X because the knowledge gained from the study of this community is *specific* rather than *general*.

Social scientists who pursue theoretical knowledge attempt to derive generalizations that will be applicable in diverse situations. In analyzing the causes of ethnic hostility, the social theoretical researcher would analyze ethnic hostilities among different groups and in various social settings, and attempt to derive generalized statements (*generalizations*) about ethnic hostility which could comprise a theory of ethnic conflict. Such a theory would not be developed by one researcher or by one team of researchers, nor would it be developed within a short time period. The findings of many researchers, over time and in different places, would contribute to the formulation of a theory of ethnic conflict. Selltiz, *et al.*, write regarding a theory, "In general . . . the intention of a theory in modern science is to summarize existing knowledge, to provide an explanation for observed events and relationships, and to predict the occurrence of as yet unobserved events and relationships on the basis of the explanatory principles embodied in the theory."[1]

Once a theory of ethnic conflict is formulated (scientific theories are always tentative and never conclusive; they are subject to constant revision and

reconstruction), policy-makers could use it to *understand, explain, predict,* and *control* elements involved in ethnic hostility. Thus, theoretical researchers maintain a persistent interest in building generic social theories rather than a fluctuating and expedient concern for *specific* social problems. As our example indicates, the formulation of theory is a more fruitful and appropriate goal for social inquiry than the *direct* solution of practical problems.

In this book, the building of social theory is accepted as the primary goal of social inquiry. Generic, theoretical knowledge will contribute more to the making of rational decisions than more specific and fragmented knowledge.

THE PROCESS OF INQUIRY

In Chapter 1 some of the essential characteristics of scientific knowledge were discussed. We indicated, for example, that it was public, precise, testable, and systematized.[2] *Science is a process as well as a body of theoretical knowledge.* Many writers regard the process used by scientists to derive knowledge as more important than the knowledge itself. When man uses the scientific process to derive knowledge, he constantly reevaluates scientific propositions. He revises them when the aims of society change, when new data is discovered, or when the assumptions about social phenomena are modified. Generalizations about the nature and causes of criminal and mental behavior changed drastically when social scientists modified their basic assumptions about factors which shape human behavior. A theory relating certain body traits to criminal behavior, held tenable for many decades, has now been largely discredited. However, some psychologists do maintain that physical defects may *contribute* to criminal behavior in indirect ways.[3] Mental illness is now regarded primarily as a social maladjustment rather than a manifestation of a defective biological inheritance.

Because scientific propositions and generalizations are always subject to revision, the method which scientists use to derive scientific knowledge and to test propositions is extremely important. The scientific method allows the scientist to constantly expand, revise, and reconstruct theories. Sociologists, anthropologists, economists, and political scientists use similar but not necessarily *identical* methods to test and to derive knowledge. The kinds of problems studied by different social scientists and the key *concepts* which they employ distinguish them more than the methodology they use. The sociologist's concern for *socialization* and the political scientist's interest in *power relationships within a society* distinguish these two disciplines more than their approaches to the problems which they study. Participant observation, interviews, sample surveys, and case study are methods used to collect data in both disciplines. *In other words, the questions raised and pursued by sociologists and political scientists, for example, and the conceptual frameworks used to view and analyze problems, distinguish these two disciplines more than any other factors.*

Although the methods used by social scientists in the various disciplines have many common characteristics, some of the disciplines employ special methods of data collection or use certain research strategies extensively and others rarely. The social psychologist uses laboratory experiments perhaps more frequently than any other social scientist. The questions formulated and pursued by the social psychologist can be resolved by experimentation more successfully than can most of the questions studied by the political scientist or the anthropologist. The sample survey is used extensively in sociology and political science but less often in anthropology. Population data and aerial photographs are often employed by the geographer but rarely by the economist. Participant observation and field work have been the primary research methods used by the anthropologist. Social psychologists and political scientists make much more extensive use of sophisticated statistics than anthropologists and historians.

Although the basic inquiry process is shared by all social science disciplines, the critical factors which distinguish one social science discipline from the other are the questions that it poses, and the concepts, generalizations, and theories that it formulates and tests. Because elements of our social environment are so interrelated, the theories structured by the various social science disciplines are not always unrelated or mutually exclusive. This point will become more explicit when the nature of each of the social science disciplines is discussed later. Although each group of social scientists sometimes employs unique research techniques, an attempt is made below to present a *basic* model of inquiry that is shared by all social scientists. It is one that children should use, perhaps in a modified fashion, when they formulate social problems and test scientific hypotheses and propositions.

A MODEL OF SOCIAL INQUIRY

Problem formulation

Before a scientist can begin research on any problem or issue, he must have a clear idea of the question that he is trying to answer. The scientist must be confused or puzzled about some phenomena in order for him to identify and state a problem. As Goldmark has insightfully pointed out, the inquirer must also be *concerned* about the problem and interested in its solution.[4] A sociologist who is a specialist in structural institutions may ignore a racial outbreak which occurs across the street from his university. Many researchable questions can be formulated about a racial outbreak, but unless a scientist is concerned about racial outbreaks, he will not formulate questions and pursue answers to the problems. Another sociologist, who is a specialist in collective behavior, may drive a hundred miles to study a racial outbreak firsthand.

Scientific questions must be *complete, precise,* and *researchable.* "What were the children's attitudes?" is a question that fails to meet the criteria stated above. It is neither complete, precise, nor researchable. A researcher attempting to answer it would not know whether to study American children, Russian

children, or children throughout the world. Also, the question does not make clear the kind of attitudes which are of concern to the author. Children have many different attitudes toward various phenomena. They have attitudes toward school, teachers, parents, toys, eating, and many other kinds of persons and things in their social and physical environment. "Were" is ambiguous since it does not specify a time period. Russian children may have had different attitudes toward their social studies books in the early 1940's than they did in the late 1950's.

This is clearly a nonresearchable question since it does not provide the needed guidance to an inquirer. "What were children's attitudes in the nineteenth century?" is also a nonscientific question, since it does not specify the *kind* of attitudes in which the researcher is interested. Yet it is not unlike questions frequently posed by students attempting to do research in graduate school. *Pinpointing and stating specific and clear questions that can guide inquiry activities is frequently a challenging task.* This phase of the inquiry model should not be quickly dismissed by readers who may assume it is self-evident that problems must be clearly stated before they can be answered. Elementary grade students, especially, will need help in identifying problems and in stating them in a clear, researchable fashion.

Let's say the author of the question in the example above is actually interested in determining whether forced integration of the public schools in a medium-sized industrial city modified the white children's racial attitudes. His problem statement might read, "What kinds of racial attitudes did the white students express after the integration of the public schools in city X?" Although this is a researchable question, the research design that it implies will not answer the question he has in mind, but did not accurately state. The design implied by the question is some type of sample survey to determine the kinds of racial attitudes expressed by the children *after* school integration had occurred. Such a survey will tell the inquirer little about the children's racial attitudes *prior* to the implementation of school integration. Faulty question statements can lead to unproductive research designs.

The question which our hypothetical inquirer has in mind can be more appropriately stated as, "What effects did school integration have on the expressed racial attitudes of the white students in grades 4 through 6 in City X?" This question is explicit, precise, and researchable. It also suggests a research design that will answer the question which the research has in mind. It implies that some method will be used to ascertain the children's racial attitudes both *before* and *after* school integration took place, or to compare their post-integration racial attitudes with the racial attitudes of a group of *comparable* children who attend nonintegrated schools.

Often, scientific questions imply a relationship between variables as well as a research design.[5] The obvious variables in the question above are "racial attitudes" and "school integration." The question implies that these two factors might be related. The research study will determine how, if at all, one of these factors influences the other. The variables stated in research questions are frequently classified as *independent* and *dependent* variables. A variable

that *causes* a change in some other variable or factor is the *independent* variable. The variable which is changed as a result of the action of some outside variable is the *dependent* variable. In the problem in our example, "school integration" is the *independent* variable because it is hypothesized that it will cause a change in "racial attitudes," the *dependent* variable. Elementary school children should learn how to identify the main variables stated in research questions, but they should probably not be introduced to terms such as *independent* and *dependent* variables until they are in junior high school. The concepts and ideas, not the terminology, are of prime importance.

Some questions which are explicitly stated may not be researchable because they are not scientific questions. "Should the public schools in Community X be racially integrated?" or "Should the faculty of the public schools in Community X be integrated?" are not scientific questions and therefore cannot be answered with social inquiry. These are *decision-problems* whose answers must reflect a synthesis of knowledge and one's personal values. Scientific inquiry can help us in making decisions and attain goals which we value. Value inquiry can contribute to value clarification. *However, social inquiry cannot determine our values.* Social inquiry can answer the question, "Do integrated schools positively affect student achievement?" The research by Coleman and Pettigrew indicates that black children achieve at higher levels in integrated schools than in predominantly black schools. Social scientists have also dealt with the question, "What effect does school integration have on the racial attitudes of black and white children?" Researchers have concluded that children who attend integrated schools express more positive racial attitudes as adults than children who attend segregated schools.

A black "militant" parent who is violently opposed to having his children bussed to a predominantly white school may, through a process of *value analysis and clarification*, conclude that above all else he values the best possible academic education for his children. Social inquiry will help this parent identify the type of school in which his children will attain the highest academic gains. Through his own inquiries, and by studying the results of inquiries by social scientists, the parent may conclude that his children will achieve highest in the predominantly white school to which they must be bussed. As a result of value analysis and social inquiry, the parent may become less opposed to bussing and integrated schools because he discovers that what he values most for his children can be best attained by bussing them to a predominantly white school.

In this example, social inquiry and knowledge helped the parent to solve a *decision-problem*, but the problem itself was beyond the scope of social inquiry. Depending upon the values and attitudes of the social actor, social inquiry may or may not affect his decisions. In the above example, the parent may have been so vehemently opposed to bussing and school integration that he would have completely rejected the knowledge derived from his inquiry. Daily we can observe people who reject scientific knowledge for a variety of complex personal reasons. Chronic cigarette smokers frequently argue that the data which establish a relationship between cigarette smoking and cancer is too

inconclusive. Drug addicts and alcoholics often contend that their habits are not nearly so dangerous as experts indicate, or they may deny that they are addicted. However, value analysis and social inquiry will help students learn how to accept scientific knowledge, even when it conflicts with cherished values. The chronic smoker can learn to accept scientific facts about smoking, and even though he may continue to smoke, he will realistically accept the possible consequences of his actions. *Social actors who deny the possible consequences of their actions are not rational.*

Elementary school students should be helped to understand both the strengths and limitations of the scientific process and of scientific knowledge. Children should learn in the earliest grades that social inquiry cannot be used to solve decision and value problems, but that scientific methods and knowledge can be used to help the social actor clarify his values and ascertain the means and methods necessary to attain the goals that he values, and to determine the possible consequences of different courses of action.

Children can begin to realize the limitations of social inquiry by distinguishing scientific questions from problems of value and decision-making. Many questions about dogma and beliefs cannot be answered by social inquiry. Questions such as "Is God dead?" "Is there a heaven above?" or "Is Jesus the Son of God?" cannot be verified or disproved by social inquiry because there is little public agreement regarding the assumptions related to these questions or about methods of studying them.

> *Helping children to identify and formulate precise, explicit, and research-able questions is one of the most challenging tasks faced by the teacher in the inquiry-oriented elementary classroom.*

The ability to ask good questions is a developmental skill that should be systematically taught beginning in kindergarten. Questioning strategies are discussed in considerable detail in Chapter 4. Research endeavors and learning experiences can be no better than the questions which guide them.

Formulation of hypotheses

After the inquirer has stated a precise and researchable question, he then attempts to formulate *tentative* statements and propositions to guide his inquiry. Kerlinger has pointed out that we do not actually test questions, but statements related to them.[6]

Let us suppose an inquirer formulates the question, "How did the colonists in North America influence the *culture* of the Cheyenne Indians?" His inquiry will be more focused and fruitful if he has some ideas about ways in which the Cheyenne culture *may* have been affected by the colonists. He may have a hunch that the Cheyennes' foods, habitats, and certain of their religious beliefs and practices were modified when they came in contact with the North American colonists. To determine whether his hunches and ideas are accurate, he would gather information about the Cheyennes' culture which revealed the kinds of foods, habitats, and religious beliefs and practices which were a part of

their way of life *both* before and after the colonists came to North America. The *tentative statements and propositions* which scientists formulate to guide their inquiries are called *hypotheses.*

Hypotheses are immensely important in social inquiry. As the example above indicates, they help to *guide* and *focus* research activities. Cohen and Nagel point out the importance of hypotheses in directing inquiry and note some of their distinguishing characteristics.

> We cannot take a single step forward in any inquiry unless we begin with a suggested explanation or solution of the difficulty which originated it. Such tentative explanations are suggested to us by something in the subject matter and by our previous knowledge. When they are formulated as propositions, they are called *hypotheses.* . . . The function of a hypothesis is to *direct* our search for the order among facts. The suggestions formulated in the hypothesis *may be* solutions to the problem. Whether they are, is the task of inquiry. No one of the suggestions need necessarily lead to our goal. And frequently some of the suggestions are incompatible with one another, so that they cannot all be solutions to the same problem.[7]

In order to guide inquiry effectively, hypotheses must have certain characteristics. First, they must be related to the problem formulated. Hypotheses formulated while an inquirer is studying the problem, "How did the colonists in North America influence the culture of the Cheyenne Indians?" must state *probable* ways in which the Cheyenne Indian culture changed as a result of contact with the life styles of the American colonists. An inquirer studying this problem may formulate hypotheses such as "The Cheyenne Indians used a wider variety of tools after they came in contact with the colonists," and "No fundamental changes occurred in the Cheyenne Indians' religious beliefs and practices when they came in contact with the American colonists." Hypotheses which concern the life styles of other Indian groups after the coming of the colonists to North America would be inappropriate for this inquiry problem.

Hypotheses must also be testable. Hypotheses such as "The Cheyenne Indian culture *improved* when it came into contact with the life-styles of the colonists" and "The colonists shouldn't have forced the Cheyennes to give up important elements of their cultural heritage" are not scientifically testable statements. The first statement is an evaluative proposition. Whether a person would judge it true or false would depend on his conception of *cultural improvement.* The Cheyenne Indian culture probably became more technologically advanced when Cheyenne Indians interacted with the colonists. However, many of their folkways and mores were disrupted by the colonists' influence. Some individuals regard technological progress per se as improvement; others do not.

The second statement is a value assertion and cannot be verified with scientific methods. An individual's values about man, cultural change, and

cultural diversity would determine whether he would agree with this proposition.

Gee discusses criteria which he considers essential for valuable hypotheses:

> First, the hypothesis as formulated should take into consideration all of the relevant facts and should contradict none. Second, it should be plausible, and in general, should not contradict any laws of nature. Third, the hypothesis should be of such a character that it is amenable to deductive application and testing; that is, it should be capable of disproof or verification. Fourth, it should be as simple as possible, for from the beginning, science has demanded not only accuracy and precision, but simplicity.[8]

Effective hypotheses, as Gee suggests, should also be based on *prior* knowledge and existing theories. Good hypotheses are not formulated in a vacuum. They are intelligent and not ignorant guesses. If an inquirer has no knowledge about American Indians, the American colonists, or how one culture influences another, he will be unable to ask an intelligent question about the effects of the colonists' life styles on the Cheyenne Indians' culture, and unable to formulate fruitful hypotheses to guide his inquiry. An inquirer who has knowledge of American Indian cultures, the American colonists, and who is familiar with *theories* related to cultural borrowing and influence, will be able to identify the elements in the Cheyenne culture which were most susceptible to cultural change by foreign influence. For example, the informed inquirer would know that tangible cultural elements, such as tools and habitats, are more susceptible to cultural change than intangible cultural components, such as religious beliefs and folkways. Thus a knowledgeable inquirer can formulate productive hypotheses better than one who lacks specific or general knowledge related to the problem which he is investigating.

Many hypotheses are formulated on the basis of existing theories. An inquirer who is acquainted with the *frustration-aggression theory* will be able to state fruitful hypotheses about why powerless and alienated groups in a society are often the victims of discrimination and maltreatment. This theory suggests that the individual, when denied desired goals (or *frustrated*) tends to express aggression to relieve his frustration. However, it is not always feasible for the individual to direct his agression toward the real source of his frustration. When this is the case, he tends to *displace* aggression on substitute persons or objects who are unable to retaliate when he attacks them. Hypotheses related to this theory are often formulated to help explain discrimination experienced by minority groups or the hostile acts by working husbands who displace aggression on their families.

The fact that most hypotheses tested by social scientists emanate from existing theories indicates not only how hypotheses emerge from present knowledge, but also suggests how the questions and hypotheses which the inquirer formulates are cogently shaped by his *values, perceptions, and background.*

Two social scientists studying the same phenomenon may formulate exceedingly diverse hypotheses because of their different theoretical and value orientations. A Neo-Freudian and a behaviorist psychologist would formulate very different hypotheses if they were both trying to determine the factors which caused an alarming number of our young people to indulge in illegal drugs during the 1960's and 1970's. The Neo-Freudian psychologist would rely much more heavily on the *subconscious* as an explanation than would the behaviorist scientist. The behaviorist psychologist would formulate hypotheses which dealt specifically with observable and measurable kinds of behavior.

Studying the same problem, a social psychologist would tend to look for explanations primarily in the individual's behavior, while a sociologist would be much more concerned with the groups in which the individual was socialized.

Definition of terms: conceptualization

At some stage early in the inquiry process, the inquirer must make some attempt to define his major terms and concepts explicitly. Defining terms so that they have research implications is a major problem for social scientists. Consensus about the meaning of many important concepts and terms in social research does not exist. "Social class," "aggression," "anxiety," and "social behavior," are examples of important constructs in social science which are defined differently by various researchers. When these concepts are used, the researcher must tell the reader how he operationally defined them, i.e., *what criteria he used to determine instances or examples of these constructs.*

Earlier, we discussed the problem, "What effects did school integration have on the expressed racial attitudes of white children in grades 4-6 in City X?" The inquirer studying this problem must determine how he will define "integration" and "racial attitudes" in *measurable* or *operational* terms. In some of the educational research on school integration in the 1950's and 1960's, "racial integration" was considered to exist when a school contained a population of at least 40% black or non-white children, but not over 60% of such children. "School integration" can, of course, be defined differently. An inquirer might be willing to say that a school is racially integrated if it has a population of at least 1% non-white children. The researcher's *purposes* would determine an acceptable definition of an "integrated school."

An inquirer pursuing this problem would also need to determine how he would define "racial attitudes." Social scientists usually operationally define racial attitudes according to the kinds of specific responses made on a questionnaire. Certain types of responses are considered to indicate positive attitudes; others, negative. The limitations of this approach to defining attitudes are fairly obvious. A respondent may give responses which he considers socially acceptable rather than ones which accurately reflect his feelings about different racial and ethnic groups. Operationally defining complex social science concepts is one of the most difficult problems in social inquiry.

In the other problem we discussed, "How did the colonists in North America influence the culture of the Cheyenne Indians?", it would be necessary to operationally define *influence* and *culture*. In this case, *influence* may mean *change, stop, take away from, or increase. Culture* is a broad concept with various meanings. *Culture* consists of all the elements in a people's environment which they have structured for survival. (See Chapter 7 for a detailed discussion of *culture*.) Tools, dishes, mores, folkways and religious beliefs are all part of a group's culture. Since *culture* is such a broad and inclusive concept, an inquirer might find it advantageous to study limited aspects of a specific culture at any one time. Thus, a more fruitful question than the one stated above might be, "What changes took place in the tools and beliefs of the Cheyenne Indians when they came into contact with the North American colonists?" When he attempts to operationally define the terms in his research problem, the inquirer may find it expedient to modify his questions and hypotheses. Terms in some hypotheses may be so difficult to operationalize that the hypotheses have to be abandoned completely.

Collection of data

Questions are answered and hypotheses are tested by the data and information gathered by the inquirer. Social scientists use diverse means to collect data, to test hypotheses, and to derive generalizations and theories. According to Berelson and Steiner, behavioral scientists use three major methods to collect data for analyses: "the experiment, the sample survey, and the case study."[9] Social scientists also make use of historical studies, content analyses, and other techniques.

The *experiment* is a laboratory situation structured by an investigator to determine how variables are related. To determine how one variable affects another, the research attempts to control all variables in an experimental situation. If a researcher wanted to determine the effects of a war movie on attitudes of individuals toward war, he could show the war movie to one group of persons and show a *comparable* group of persons a movie on outdoor life. By comparing the attitudes of both groups both *before* and *after* the viewing of the movies, the experimenter would be able to make some tentative statements about the effects of a particular war movie on attitudes of individuals toward war.

While the experiment is the most frequently used research method in the natural sciences, it is perhaps the least used of all methods in the social sciences, although it is becoming more popular. It is often difficult for social scientists to use the experiment because they study man's behavior. Because of impracticality, ethical and moral problems, and the tremendous expenses involved, social scientists cannot frequently experiment with human beings. Social psychologists make use of the experiment more than any other group of social scientists. Trager and Yarrow's experiment to determine the effects of an intergroup relations curriculum on children's racial attitudes[10] and Litcher and

Johnson's study on the influence of multiethnic readers on children's racial feelings are examples of experiments used in social research.[11]

While the experiment is the most objective of all methods of studying man, it is not perfect. An individual may change his behavior simply because he knows that he is being observed. The experiment itself introduces new variables into a situation. Subjects in an experiment may modify their behavior patterns because they are receiving special attention and not because of the independent variable introduced into the experiment. Notes Kerlinger, "Almost any change, any extra attention, or even the absence of manipulation but the knowledge that a study is being done, is enough to cause subjects to change. In short, if we pay attention to people, they respond."[12] The special effect of an experiment on subjects is known as the *Hawthorne effect*.

The experimental method also has limitations because the situation created in an experiment may be so different from the actual world that the results of the study cannot be extensively generalized. In trying to control all possible variables which may affect the dependent variable, we might create a situation which is so artificial that it has little resemblance to the wider social environment.

Using the experiment in the social studies

Using the experimental method with children in elementary school poses many problems to be sure: moral and ethical concerns about voluntary participation, the immaturity of young children, and protection from undue invasions of personal privacy. Perhaps more important is the inability to control the relevant variables before and after the school day. Nevertheless, there are some types of problems that can be carried out in school by young children using the experimental method. For example, children could attempt to discover the relative effectiveness of television, newspapers, or some combination of those factors on current affairs knowledge. Other studies might involve food consumption in the cafeteria when menus are student-planned versus dietician-planned. Some experimental studies might deal with classroom management under varying conditions of student leadership and teacher leadership.

Role-playing and simulation activities can be effectively used to help children discover how certain situations and variables affect human behavior. One creative teacher used role-playing to help her students discover how discrimination affects its victims. During one class period she discriminated against children with brown eyes; in another, against those with blue eyes. During both experiments, the victims of discrimination became outraged, and the other children developed superior attitudes toward themselves. While a role-playing experiment of this type can be an effective learning experience, it should be undertaken only by a sensitive, veteran teacher who has the support and understanding of the school and larger community. Such simulation games as *Sunshine, Ghetto,* and *Democracy* can also be used to teach children how different situations influence our behavior. While the realm of realistic possibilities for using experimental methods in elementary social studies is

Role-playing and simulation activities can be used to help children
discover how different situations and variables affect human
behavior. (Highline Public Schools, Seattle, Washington)

limited, teachers should be willing to embark on it when the opportunity arises.
Even in role-playing and simulation activities, however, the teacher must take
special precautions to avoid violating the integrity of students. He should solicit
the support of his professional colleagues and the members of the wider
community when an experiment of any type may elicit hostile responses from
parents and other citizens. Often an understanding of the goals of the
experiment by the school and wider community can prevent a small issue from
becoming a major controversy.

The directors of the Michigan Elementary Social Science Education
Program, one of a number of social studies projects funded by the U.S. Office
of Education, attempted to give children practice in using some components of
the experimental method by structuring role-playing activities. Below is a
partial description of this project as summarized by Sanders and Tanck:

> Students work with "behavioral specimens" in all units. The specimens are
> hypothetical cases of social interaction presented either as a reading in the
> Social Science Resource Book, as a recording, *as an episode role-played by
> students in class,* or as descriptions or pictures in the project booklet for
> each unit. Using the project booklets, *students record observations and
> identify inferences and value judgments about the episodes.* Students also
> make value analyses of some specimens and apply social science concepts
> to other specimens in class discussions. In each unit students do some
> gathering and analysis of data about their classmates through *observation,*
> interviews, or questionnaires. Sometimes they have a chance to compare
> their conclusions about specimens or about their own data with findings of

social scientists described in the *Social Science Resource* book. Presentation of basic content and of some specimens is through readings either in the resource book or the project booklets. (italics ours)[13]

The *sample survey* is widely used in social research to gather data. A sample survey consists of a *sample* and a *survey*.[14] If an inquirer wanted to determine how middle-age Catholic men voted in the last presidential election, he would normally study only a part or *sample* of this population. However, he would try to select a *representative* sample. For example, he would select not only middle-age Catholic men who reside in large cities such as New York and Chicago, but would include in his sample some who live in small towns and on farms. Social researchers usually study samples rather than total populations because studying a sample is less expensive, more convenient, and actually results in fewer errors. *Representative* samples, if carefully chosen (such as by a random method), can be typical of whole populations.

Drawing by Currier. Reprinted from *Instructor* © February 1954; The Instructor Publications, Inc. Used by permission.

The *survey* attempts to measure some characteristic of the population chosen for study.[15] In the example above, the survey would be used to determine how a certain section of the population voted in the last presidential

election. Surveys are widely used in political science to determine the voting behavior of various groups. Sociologists use them to ascertain why persons participate in various social events, to test hypotheses related to education and income, and to study many other kinds of problems. In general, sample surveys are conducted in two ways: They may be given to the respondent to complete (either via mail or in person), or an interviewer may call, ask the respondent questions, and complete the questionnaire based on the respondent's replies to his questions. The questions on surveys may be highly structured, offering the respondent only choices available on the instrument, or they may be highly unstructured, consisting of very broad questions which allow the respondent a great deal of freedom in his answer. Some survey instruments are somewhere in between these two extremes. They are usually referred to as semi-structured surveys. While the sample survey is a useful research device, its value is limited because a respondent *may* give the responses which he deems socially acceptable rather than those which reflect his actual beliefs, behavior, or feelings.

Using the sample survey in elementary social studies

As a research technique the sample survey is much easier to use in the elementary school than the experimental method. Children can learn to develop adequate instruments to sample opinions and attitudes among their own classmates, other children in the school, faculty, and adults in the community. An unlimited number of important questions faces every community, and students can learn the techniques for making random surveys and stratified samples on the basis of age, section of town, occupation, religion, ethnic origin, and other important variables. Because surveys can present reliable and valid data when the instruments and the sampling procedures are correctly designed, they offer excellent opportunities for gathering direct, first-hand source data for social inquiry. Children can learn to sample community attitudes on a proposed highway relocation, a new bond issue, or candidates in an election. They can gather important demographic data by sample surveys concerning occupations, types of homes, businesses, religious preferences, traffic counts on major arterials, air pollution, and the use of public parks, libraries, and museums. Many variables can be studied if they will provide meaningful and realistic data on a problem being studied by the students.

Below a teacher describes a sample survey that was conducted by his class during a study of black-white relations in America:

Statements on which people could agree or disagree were drawn up by three students and myself. The next day the three of them presented the list to the class and spent the period enlarging the initial pool of statements. I sat in the back of the class offering suggestions and trying, unsuccessfully at times, to keep my mouth shut. Two students volunteered to type up the statements on ditto masters; I duplicated them and copies of the survey were given to the class to begin the poll the next day. A

problem arose. One student asked how truthful would white people be to a black interviewer, especially a teenager. A good question. This point produced a spirited discussion of whether the results of a poll are influenced by the race of the pollster. Out of this, came three suggestions, none of which I had anticipated. In addition to white people polled by the class, the group decided that the survey should be administered to black people; furthermore, the survey should be given by white students to white people; and finally, names should be picked randomly from the suburban telephone book. Thus three checks were established to neutralize their hunches about the race of pollsters influencing the results. Validating the hunches would depend upon the information turned up by other interviewers and mailed responses.

After arrangements were made, four periods were spent in conducting the survey during school hours, in addition to the time some students spent in polling white shoppers in the suburbs. When the surveys were turned in, the results were tallied, arrangements with the white students were completed, and copies to suburbanites were sent out. What happened during this week was that the students worked in self-selected groups completing each of the tasks. I helped each of the groups, i.e., tallying, licking stamps, making phone calls, and so on. Over a two-week period, we met as a class twice. The remainder of the time was taken up with small-group activity, individuals or pairs working. Not all the students pitched in; a few played around for the two-week period; one or two did nothing, proving, I guess, that there is nothing magical about a particular organizational form.

What is really important here is not the number of kids who didn't fully participate or whether the sample population polled was accurate or whether the conclusions reached by the class on the results of the poll stacked up against recent research; the importance lay in the process of creating, administering, and tallying a poll and measuring its results against the hunches kids had about white attitudes. In other words, an organizational device tapped student resources in teaching skills and knowledge.[16]

Unfortunately, sample surveys are not frequently conducted in the social studies. For a survey designed and implemented by a class to be successful, teachers, parents, and the community at large, must be carefully briefed on the *purposes* involved and reassured that no subtle propaganda or indoctrination for a particular point of view is being "pushed" by a teacher or faction. PTA groups and local newspapers should be fully informed in advance so that the activity will be perceived as a true learning experience and not distorted by misinformation and half-truths. Principals, too, should be kept fully informed and school district policies should support and encourage such a method of teaching.

Perhaps these cautionary notes are all too negative in their tone. We think not. The blunt truth is that most people do not care to look too critically at

their own actions, much less their attitudes, beliefs, or value patterns. Many citizens are quite defensive about having their attitudes or actions examined objectively by school children, no matter how much potential there may be for learning about real and crucial issues. The authors have seen too many schools bitterly criticized and pilloried in the press because they failed to take some of the precautionary measures suggested above. Children *are* young, immature, and impressionable. However, they *can* be helped to develop keen insights into how the adult world thinks, feels, and acts on important problems affecting their lives. We take the position that if elementary schools are to approach the task of teaching social inquiry skills, teachers must provide genuine opportunities for children to gather data about the salient issues in their immediate environment.

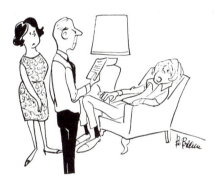

"*I know I flunked four courses, Dad, but I feel I had to do something to protest our involvement in Southeast Asia.*"
Drawing by Bo Brown. Reprinted with permission from *Today's Education*, N.E.A. journal.

Scientists employ the *case study* method when they intensively study the characteristics of one element in a population. This method has been used rather widely by social psychologists and sociologists to analyze in depth the characteristics of cities, and various political and social institutions with special characteristics. The Lynds studied "Middletown" (Muncie, Indiana) over an extended period of time. Voting habits, social class structure, and educational and religious institutions in this midwestern town were analyzed in considerable detail. Similar case studies were *Brasstown* (Hollingshead); *Yankee City* (Warner) and *Elmtown's Youth* (Hollingshead).

Sociologists often study juvenile delinquents, criminals, mental patients, and other persons with special problems. *The case study method is more valuable for deriving fruitful hypotheses than for testing them.* This technique is very limited because the findings that are derived from it cannot usually be generalized, with any substantial level of confidence, to other individuals and

institutions. Despite the limitations of this method, it can be valuable in helping scientists attain insights about certain social phenomena which may not be gained from less intensive research techniques.

In implementing a case study of a particular city or cultural group, a social scientist will sometimes become a voluntary member of the group in order to gain deeper insights into his research subjects. In using this strategy, he usually conceals his identity from members of the group which he is studying. A social scientist may seek a job in an automobile plant in order to study the beliefs systems, and behavior of automobile workers, or he may obtain a job in a school system to study the attitudes and perceptions of classroom teachers. This method is usually referred to as *participant observation*. It is often employed by sociologists and anthropologists. Although the social scientists may attain additional insights by participating in a group, he may become so immersed in the group or culture that his ability to analyze it objectively is severely impaired.

A social scientist may also directly observe a group without participating in it. This method is sometimes referred to as nonparticipant observation.[17] It is frequently employed when behavioral scientists observe research subjects during an experiment.

Using the case study method in the social studies

The case study is easily adapted for use in the elementary school social studies program, and can be effectively used at many points in the curriculum. The methodology of "Middletown" or "Yankee City" offers many possibilities for sophistication as well as simplicity in the typical study of "Our Town" usually found as part of a larger unit on "Our State." Carefully formulated hypotheses can prevent a study of "Our Town" from becoming merely an encyclopedic assortment of trivia.

A number of possibilities exist for students to engage in the participant-observer type study. Students can work for a time in the school cafeteria, the stockroom, the library, or the principal's office to observe work functions and social interactions. They might also serve as street-crossing guards, or members of a student council (if it has genuine delegated authority and responsibility and is not just "window-dressing"). In the larger sphere, it is not at all unrealistic to think of older students, participating in the work of various municipal groups such as the fire or police departments, courts, or social agencies. These activities do suggest, however, that teachers cannot limit social studies to 10:30 to 11:15 on Monday, Wednesday, and Friday mornings. They indicate that students must plan to spend larger parts of the day outside the school itself, actively engaged in social inquiry in the real community — and less time studying the artificial world of the textbook.

Here, too, we feel compelled to offer the precautionary notes that were suggested above in the section on the use of the survey method. Writers of case studies often poke around in dark corners and closed closets. They tend to ask uncomfortable questions. Once again we urge that particular care be taken before such methods are introduced to be sure that all who need or ought to

Profitable inquiry
activities often take
place beyond the walls
of the classroom.
(Highline Public
Schools, Seattle,
Washington)

know about the project are fully briefed in advance and that their support is reasonably assured. This is not said in any spirit of pessimism, but rather to alert teachers to the reality of life and to the differences between engaging in social science research at the college or professional level, and the utilization of some of those techniques in the elementary schools. A political fiasco in the school community has much greater consequences than the quiet demise of a university professor's research project that failed to get the necessary support or cooperation from those involved. However, the task is worth attempting if there are to be any significant changes in the teaching of social studies in the elementary and junior high school.

Social scientists also make use of *descriptive* studies such as *historical methods* and *content analyses*. Writes Borg, "Historical research is the systematic and objective location, evaluation, and synthesis of evidence in order to establish facts and draw conclusions concerning past events."[18] While this is the main approach used in historical inquiry, (discussed further in Chapter 5), it is mentioned here because other social scientists make use of historical research. Political scientists study forms of government used by peoples in earlier times in order to gain more insight on current political

systems. Sociologists analyze how mores, norms, and folkways today differ from those in earlier times. Economists use data about past economic systems to test new hypotheses in their disciplines.

Social scientists also make use of *content analysis* to test hypotheses and to solve problems. Budd, Thorp, and Donohew define content analysis as "... a systematic technique for analyzing message content and message handling ... a tool for observing and analyzing the overt communication behavior of selected communicators."[19] Berelson defines it as a "research technique for objective, systematic, and quantitative descriptions of the manifest content of communication."[20] Social scientists utilize content analysis to help solve such problems as "How does the political climate influence the treatment of ethnic groups in popular magazine fiction?" and "How has the treatment of morals in children's textbooks changed over the last fifty years?"

Using the historical study and content analysis

The methods suggested above lend themselves to use in the elementary school in many ways. Most libraries have an adequate source of materials for local histories. Town records and old newspaper files are also readily available sources. A frequently overlooked source is the tape-recorded recollections of older people who can often vividly recount stories of such events as the first days of the airplane, the automobile, the coming of electricity to rural areas, and the depression of the 1930's. Students can easily arrange to visit older relatives, neighbors, or important community figures and with a portable tape recorder, record large amounts of historical data. This data can then be compared with written accounts of the same events if they are available, or can be cross-checked with the recollections of others to sift out the facts and impressions from the possible distortions of fading memories. Such histories make lively reading because of their localized color. At the same time, the student has a realistic opportunity to use some of the methods of historical inquiry in translating the oral recollections and traditions into a historical interpretation of the era which can stand the test of critical scrutiny by his classmates who have also participated in the inquiry.

The student can use content analysis techniques to evaluate the historical data described above, to compare the treatment of various events as they were treated in local newspapers, and to discover how different versions of history are written about the same events. Activities of this kind are further described in Chapter 5.

The sample survey, the case study method, historical studies, and content analysis were discussed to illustrate that data in social science inquiry and methods of collecting it are diverse and almost unlimited. Some writers consider the experimental approach the only legitimate scientific method. This assertion is rejected in this volume. There are many ways of collecting data in scientific inquiry. This discussion of data collection in social inquiry by no means exhausts all the approaches used by social scientists to gather data. The

"Well, you didn't do all that worrying about my flunking the history test for nothing, Mom."
Drawing by Buresch. Reprinted with permission from *Today's Education*, N.E.A. journal.

intent here is merely to suggest some of the major methods which may be employed and the diversity of techniques that can be and are used to gather scientific information.

Evaluation and analysis of data

The social inquirer must make some attempt to determine the credibility and meaning of the information which he gathers. The tools he uses to gather data have a significant effect on the meaning and utility of the data. If a researcher uses instruments that have been tested and validated by other scientists, he can usually put more faith in his data than a researcher who constructs his own instruments and assumes, without adequate evidence, that they *actually* measure the variables which he is studying.

If a researcher were trying to determine the relationship between children's *general intelligence* and their *leadership ability*, he might develop *criteria* and a rating scale to measure leadership ability, randomly select a group of children, place them in a group situation where they are required to lead, and have observers rate them using the rating scale developed. The researcher may decide to use reading scores to measure *general intelligence*. The data gathered by him would be greatly influenced by the criteria which he derived to ascertain "leadership ability," the rating scale devised, and the reliability of the observers' ratings. His method of measuring general intelligence would be highly questionable because children who act "intelligently" in many situations and while performing many different tasks might not be good readers. *The data used by social scientists to test hypotheses can be no better than the methods and techniques used to gather it.*

When an inquirer is evaluating information, he must carefully examine its source, the methods used to gather it, and attempt to illuminate any inherent

"Are any of our heroes likely to go out of style, like Joe Stalin?"

Reprinted from *Instructor* © February, 1962, the Instructor Publications, Inc. Used by permission.

shortcomings or limitations. The social researcher may encounter documents, artifacts, art works, and other types of evidence whose origin and nature are unknown. He must try to formulate fruitful hypotheses about their origin, relate them to known data, and determine whether they are important for the testing of his hypotheses. Much information which the inquirer encounters will be useless for his purposes. *The questions and hypotheses which he has formulated help him greatly in identifying pertinent and significant information.*

Historical documents may pose special problems for the inquirer. He may not only be required to determine their source and nature, but whether the authors' statements are accurate or untrue. Letters, reports, and other documents must be rigorously examined by the perceptive inquirer.

Testing hypotheses: deriving generalizations and theories

The social scientist begins the research *cycle* with a question, which is usually related to an existing theory or some other body of knowledge. However, questions per se cannot be directly tested. Hypotheses related to the questions are formulated. When the data is gathered and analyzed, the researcher attempts to determine whether his hypotheses can be verified on the basis of the information he has gathered.

A researcher may formulate the question, "How does economic competition influence prejudice?" and the hypotheses: "Prejudice among groups increases when there are a limited number of jobs for which they must compete," and "Prejudice among groups tends to lessen when there is a general rise in the standard of living." Both the question and the hypotheses above are based on the *economic competition theory of prejudice.* This theory attempts to explain prejudice as an attitude emanating from antagonism caused by competition for jobs and other economic rewards.

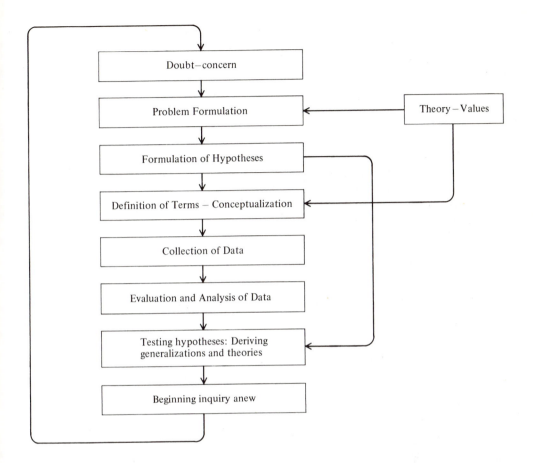

Figure 2.1
A model of social inquiry. Note that in the inquiry model, doubt and concern cause the inquirer to formulate a problem. The problem which he formulates does not emanate from a vacuum, but is shaped by his theoretical and value orientation. Like the social scientist, the elementary school child will need to draw upon *knowledge* to be able to ask intelligent and fruitful questions. In social science inquiry, *theory* is the main source of fruitful questions. While these are the basic steps of social inquiry, they do not necessarily occur in the order illustrated above. This figure indicates that generalizations in social science are continually tested and are never regarded as absolute. Thus, social inquiry is cyclic rather than linear and fixed.

If the researcher analyzes prejudice and discrimination in a number of societies, and finds that there is frequently intense prejudice between groups when there is no apparent competition for jobs, he will be unable to verify his first hypothesis. His data may also suggest that prejudice is frequently intense

during periods of prosperity. His second hypotheses will also be left unverified. However, his failure to verify his hypotheses would not mean that the economic competition theory of prejudice would be abandoned by social scientists. As we suggested earlier, *theories are formulated on the basis of the findings and research of many social scientists*, and *theories are abandoned only after a significant amount of research by various social scientists have found their main propositions unverifiable.* If hypotheses are verified during the process of inquiry, they become *generalizations*, since the statement of relationship between the variables has been verified. Some generalizations are of higher order than others because the relationship is true over a wider range of situations, places, or times. Other generalizations have only limited scope in their application. The concept of high- and low-order generalizations is discussed in the next chapter.

Beginning inquiry anew

If our researcher had found that his data supported his hypotheses, more support for the economic competition theory of prejudice would have existed, but scientists would continue to test the theory's main propositions. Writes Phillips,

> "... although evidence can be brought to bear in support of a theory, a theory with wide scope can never be definitely confirmed. Although the scientist can only demonstrate the credibility of a theory, he can nevertheless proceed to utilize it for purposes of explanation and prediction. Each such use also functions to provide additional evidence for the theory."[21]

The inquirer *continues* the *inquiry process whether the propositions of theories are confirmed or disconfirmed.* Because social science is a rather new field, almost all existing theories in the various disciplines have many propositions that have been only partially verified. Thus, *the model of social inquiry which is described above is cyclic rather than linear and fixed.* See Fig. 2.1.

Assumptions of the scientific method

The scientific method, as was stated earlier, is based upon a set of *assumptions* about the natural world and about man. It is important for teachers and students to be familiar with these assumptions and postulates so that they will be adequately aware of both the strengths and limitations of science. Write Sjobert and Nett,

> Science does not and cannot reach beyond its own assumptions. It is inadequate for dealing with ultimate causes and other problems so dear to human beings. As with all fields of knowledge, an understanding of the premises permits one to comprehend both the weaknesses and the strengths of the scientific method.[22]

Scientific assumptions (or postulates) are propositions accepted by scientists as true (without evidence) because agreement on these statements is essential for communication and for the verification of scientific knowledge.[23] Scientific postulates and assumptions may be changed when they cease to be functional. As Lastrucci has insightfully pointed out, the postulates now accepted by scientists "are preferable to others simply because they seem so far to have produced the kinds of results the scientist is attempting to achieve. . . . *The postulates of science might be changed in time if new knowledge should demand new frames of reference, for new knowledge often changes the status of previous scientific findings*" (italics ours).[24]

Lastrucci has given a lucid and perceptive discussion of the main assumptions and postulates of science. The following discussion is based on his ideas.[25] Science assumes that man's behavior, like that of all other beings, has natural causes which can be determined by systematic study. This assumption rejects the notion that man's behavior is determined by magical or supernatural forces. Thus, a theological study of man's behavior which postulates the presence or absence of "divine grace" as a principal determinant of man's action, is not amenable to scientific study.

Science also assumes that there is enough order, permanency, and uniformity in nature to permit study and generalizations. While this assumption does not deny that changes do occur in natural phenomena, it does suggest that underlying all changes are certain uniformities which can be predicted and assumed to endure somewhat permanently. If natural phenomena changed drastically from day to day, we would be unable to make any generalizations about the world. "Although all things apparently change in time, albeit at varying rates, many phenomena change slowly enough to permit the accumulation of a reliable body of knowledge."[26]

Lastrucci also discusses other basic postulates or assumptions of science:

All objective phenomena are eventually knowable; given enough time and effort, no objective problem is unsolvable. . . .

Nothing is self-evident; truth must be demonstrated objectively. . . . This postulate avers that reliance should never be placed upon so-called common sense, tradition, folk authority, or any of a number of customary interpretations of phenomena. . . .

Truth is relative (to the existing state of knowledge); absolute or final truth may never be achieved. . . .Contrary to fixed systems of thought, proof in science is always relative: to the time, the data, the methods, the instruments employed, the frame of reference, and therefore to the interpretation. . . . In this respect, truth in science is simply an expression of the best professional judgments demonstrable at any given time.

All perceptions are achieved through the senses; all knowledge is derived from sensory impressions. . . . the only reliable knowledge is that which is both objectively and empirically verifiable.

Man can trust his perceptions, memory and reasoning as reliable agencies for acquiring facts . . . (the scientist) believes that although human reasoning is fallible, nevertheless it is the only means he has to interpret the world about him. . . .[27]

In their discussion of the basic postulates of science, Sjoberg and Nett mention many of the same assumptions as Lastrucci.

A minimum set of assumptions . . . which underline the application of the scientific method are (1) that there exists a definite order of recurrence of events, (2) that knowledge is superior to ignorance, (3) that a communication tie, based upon sense impressions, exists between the scientist and "external reality" (the so-called "empirical assumption"), and (4) that there are cause-and-effect relationships within the physical and the social orders. Moreover, (5) there are certain "observer" assumptions: (a) that the observer is driven to attain knowledge by his desire to ameliorate human conditions, (b) that the observer has the capacity to conceptually relate observations and impute meaning to events, and (c) that society will sustain the observer in his pursuit of knowledge. These assumptions, . . . the scientist more or less takes for granted.[28]

Requirements of the scientific method

In addition to having a number of basic assumptions, the scientific method also has numerous requirements which the scientist must fulfill. Berelson and Steiner have candidly and lucidly stated these basic requirements:

The procedures are public. A scientific report contains a detailed description of just what was done, and how, in great detail. This description is adequate if, and only if, another competent practitioner can follow each step of the investigation and repeat it if he cares to.

The definitions are precise. Here again the procedure must be crystal-clear, so that the reader can tell exactly how such broad concepts as "aggression" or "personality" or "social class" . . . were defined.

The data collecting is objective. There must be no bias in securing valid data on the phenomena under study — certainly not the scientist's own desires in the matter.

The findings must be able to be reproduced. Another scientist must always be able to test a finding by seeking to reproduce it under the same conditions. . . .

The approach is systematic and cumulative. Scientists try to unify whole bodies of knowledge through the use of a relatively few central concepts — that is, to build a theory. . . .

The purposes are explanation, understanding, and prediction. The scientist wants to know why and how something happens, and to be able to prove that certain conditions have produced certain results. If he can do that, then he can predict that when those same conditions next occur, they will produce those same results.[29]

SOCIAL INQUIRY: IMPLICATIONS
FOR THE ELEMENTARY CLASSROOM

In this chapter, an attempt has been made to describe how the social scientist formulates scientific questions, tests hypotheses related to them, and derives theoretical knowledge — his ultimate goal. An entire chapter has been devoted to the methods of social inquiry because social actors cannot make *rational* decisions unless they are able to use this method to attain *knowledge*. Of all the ways of deriving knowledge, the scientific method is the most fruitful method which man has yet devised. While *knowledge* (facts, concepts, generalizations, and theories) is immensely important, the *method* which scientists use to derive it is of greater importance.

Scientific knowledge is subject to constant revision and reconstruction, but the method of science has proven to be of lasting value.

Many of the generalizations and theories which man formerly accepted about his physical and social world have now been completely revised.

Elementary school children should master social science *concepts* and *generalizations*, but should be provided opportunities to *discover* them, utilizing the inquiry process; they should not be required to memorize generalizations from a list. Generalizations which children derive from social data are more meaningful and less easily forgotten than those which they are required to master out of context.

Children obviously are not equipped to "discover" all the information which they need to test hypotheses and generalizations. Children, like social scientists, cannot ask intelligent questions or pursue fruitful research unless they possess a certain body of background knowledge. *The teacher, therefore, will often find it necessary to give children information or to use traditional or deductive methods of instruction.*

If a teacher wanted his class to use an inquiry approach to pursue the question, "How did the colonists in North America influence the culture of the Cheyenne Indians?" he might find it necessary to tell the children a story about the Cheyennes, ask them to read a section in their text on the colonists, and show the pupils a movie on the Cheyennes before they could state any *intelligent hypotheses* related to this problem. After the children had done background study related to the problem and stated hypotheses, they would then be able to gather information to test their hypotheses, and derive *generalizations* regarding how cultures influence one another.

Note that in our example above the teacher stated the question which the children studied. In other problems, the children might state the question and the teacher may find it necessary to suggest hypotheses. While children should have practice in performing all the skills delineated in the inquiry model presented in this chapter, *the teacher might, for a variety of reasons, find it necessary to emphasize certain inquiry skills during some problems while de-emphasizing others.* For example, if the curriculum guide requires that fifth grade children study how the American colonists influenced the culture of the

Cheyenne Indians, the pupils would not be free to formulate the main problem for this inquiry. However, they could be given opportunities to state related problems and to formulate *hypotheses* concerning changes in the Cheyenne's culture after contact with the colonists.

In the study of some topics and problems, especially those in basal texts, the teacher may have to search for ways to give the children practice in developing inquiry skills. However, these skills can be developed during any social studies lesson, regardless of the type of material being studied. For example, when fifth-grade children are reading the section on slavery in their American history text, the teacher could give them practice in stating *hypotheses* and in thinking of ways to test them (*data collection*). The teacher could ask such questions as, "How did the slaves resist slavery?" "Do you think that slaves in other times and places reacted in similar ways?" "Can you make some general statements about what you think happens when people are enslaved?" "How could you find out whether your statements are true?"

The teacher could also help the children develop the ability to *evaluate and analyze information* while they are reading a section on slavery. He could ask questions such as,

The author states that the slaves were well treated. What information does he give to support his statement?

Does the author make any other statements which in any way contradict this sentence?

How do this author's views regarding the treatment of the slaves compare with the view of slavery presented in the book which I read to you on Tuesday? Yes, these two accounts do not agree. How can we go about telling which account is accurate?

The teacher could think of many other questions, such as questions related to the author's *assumptions* about slavery, which could be used to give the children practice in evaluating and analyzing information. When children are given practice in inquiry skills during otherwise traditional lessons, *it is important that they be aware of the skills that they are practicing and how they are related to the total inquiry process.*

In an ideal social inquiry curriculum (note, however, that in this volume *social inquiry* is considered as only *one* essential component of the social studies), children would pose a series of problems, state related hypotheses, define terms, collect and evaluate data, and test generalizations related to them. However, the ideal rarely materializes in any human endeavor. Students and teachers who read this book will be required to work with diverse types of social studies programs. However, children can be given practice using inquiry skills in almost any type of program, as we have seen. *Regardless of the type of social studies curriculum in his district, the teacher's goal should be to maximize children's opportunities to solve empirical questions using the scientific method.* Value and decision questions require different skills.

EXAMPLE OF AN INQUIRY PROBLEM
IN AN ELEMENTARY CLASSROOM

Objectives of inquiry problem unit

1. The student will be able to write a *generalization* stating reasons why young people become delinquents.
2. When given case studies describing two individuals, the student will be able to state which individual became a delinquent and *why*.

Problem and hypothesis formulation

The teacher reads *Malcolm X*, a short biography by Arnold Adoff.[30] This book tells the life story of this famous leader beginning with his childhood in Lansing, Michigan. It relates how Malcolm became parentless when his father was murdered and his mother was sent to a mental institution. The loss of both parents made life very difficult for little Malcolm. He went to live with strangers, and felt very rejected in his new home. He also felt that his teachers disliked him because he was black. The book tells how Malcolm went to Harlem and started drinking, using illegal drugs, and gambling. He was eventually sent to prison.

The teacher reads a section from *Durango Street* by Frank Bonham.[31] This is an interesting story about Rufus Henry and the Moors. When he is released from a camp for delinquent boys, Rufus and his sister are attacked by the Gassers, a local gang. Rufus later joins the Moors, a rival gang, and leads them to street victories and finally into more constructive pursuits.

The teacher asks the class:

In what ways were Malcolm and Rufus alike? Why?

In what ways were they different? Why?

How were their actions alike?

Why do you think they did things that were against the law or illegal?

The teacher introduces a new *concept*:

Young people who break laws are called *juvenile delinquents*. Were Malcolm and Rufus juvenile delinquents? Why or why not?

The teacher explicitly states the inquiry problem and writes it on the board,

We will be studying this problem: "What causes young people to become juvenile delinquents?"

The teacher solicits *hypotheses* from the children:

Now that you have heard the stories that I have read, and have no doubt known or heard about some young person who became a delinquent, I would like you to give some of *your own ideas* about why some young

people become delinquents. You do not have to be sure of your ideas, but be prepared to give good reasons for them.

Children state hypotheses and the teacher writes them on the board:

Children become delinquents when they don't have parents. That's why Malcolm X started breaking laws.

Young people break the law when they have only one parent.

Children become delinquents because they drop out of school; that's what happened to the boy that I knew who went to jail.

Young people become delinquents because they join gangs to protect them. That's what happened to Rufus in the story that you read.

Definition of terms

The teacher asks the children questions about the terms and concepts with which they will be dealing so that some agreement upon definitions can be reached. He might propose,

We said earlier that a young person who broke laws was a juvenile delinquent. Would you say that a teenage girl who got her first traffic ticket for speeding while on her way to the airport during an emergency situation was a delinquent?

Collection of data

Teacher:

I have placed all the books I could find about delinquents on the library table in the back of the room. If you can find any other books, please share them with us. Do you have any ideas about where we might find other information related to our problem?

The children respond:

We could try to get a movie and a filmstrip on juvenile delinquents.

Perhaps we could ask a probation officer to talk to us about the problems of juvenile delinquents.

We could watch TV stories about delinquents and make reports on the stories which we watch.

We could role-play some of the problems of delinquents and perhaps gain understandings about how they feel.

Some of us could read library books on delinquents and share what we read with the class.

We could watch TV news stories, listen to news stories on radio, and read news stories in the newspaper about delinquents.

Teacher:

These are all very good suggestions. When we are studying our informational sources, we need to remember that we are trying to determine *why* some young persons commit crimes. Therefore, when we read news stories and other sources, we should try to gather information about the delinquent's family background and not just about the crime that he committed. Let's write down our hypotheses in our social studies' notebooks so that we can use them to help us determine what kinds of information to listen and look for.

The children copy the hypotheses which the class has formulated in their social studies notebooks.

Teacher:

Now we need to determine how we can share our information once we have gathered it.

After much class discussion, the class decided to divide into four committees to gather and present information to the class. Three weeks later, the committees make their presentations.

Committee 1 decided to carefully study the newspaper for news stories. This committee prepared a "newspaper" and duplicated it for the class. They summarized the news stories collected by themselves and other class members. Committee 2 concentrated on the radio and TV. They simulated a TV show and presented their information to the class as a series of TV news programs that included several interviews with delinquents (role-playing). Committee 3 arranged for the class to see a very touching movie relating the poignant experiences of a young girl who became a drug addict. The final Committee, 4, presented a series of role-playing episodes, which illuminated reasons why some children become delinquents.

Evaluation and analysis of data

During the presentation of the Committee reports and the class discussions that followed them, the children attempted to ascertain the validity and reliability of their information. They asked such questions as:

How does this account compare with others which we have read?

How can we go about determining which account is most correct?

How can we find further information about this case?

Does the author cite sufficient evidence to support his conclusions?

How can we check the statistics reported in this article?

Does the author base his arguments on facts or opinion?

Does the author often use emotionally laden words? If so, why?

Testing hypotheses: deriving generalizations

Throughout the inquiry, the children looked at their hypotheses and tried to see how they compared with the information which they were gathering. They concluded that the factors mentioned in their hypotheses often did contribute to delinquent behavior, but that delinquent behavior was usually caused by *many* complex and *not any single* factor. They also concluded that there were no *sharp* differences between the behavior of delinquent and nondelinquent individuals.

Evaluation of unit

The students are required to

1. Write a general statement about the causes of juvenile delinquency, and
2. Read two case studies about two boys who grew up in the urban ghetto.

One of the boys became a delinquent. However, they are not told which one. They are required to *identify* the boy that became a delinquent, and give *reasons* for their answers. The teacher is more interested in the reasons given by the students than whether they correctly identify the delinquent individual.

SUMMARY

The main goal of the social studies program should be to help students develop the ability to make rational decisions so that they can influence public policy by participating in intelligent social action. *Knowledge* is one essential component of the decision-making process. Knowledge which is used to make rational decisions must be scientific. The effective decision-maker must not only be able to recognize and apply scientific knowledge, he must be able to derive himself.

In this chapter, we have discussed the goal and nature of social inquiry, and described a social inquiry model which children can use to test propositions and to derive knowledge. Students must be given systematic practice in each of the skills that constitute this model in order to become adept decision-makers. Although scientific inquiry is the best method of attaining knowledge, it is based on a set of assumptions and postulates, and the kinds of questions on which it can be used are limited. It is important for teachers and students to be aware of both the strengths and limitations of social inquiry.

While children should master key social science concepts and generalizations in the elementary and junior high-school grades, emphasis should be on the *process* of inquiry and not its products, since scientific knowledge is constantly reevaluated and reconstructed. This chapter grew out of the author's concern for teaching children a *process* for testing propositions and deriving knowledge. While the process of social inquiry is one of the most important elements of a modern social studies program, the *products* of inquiry (facts, concepts, generalizations, and theories) are essential for structuring experiences whereby students can learn inquiry modes, and thus help man to solve urgent

personal and social problems. Without higher level predictive knowledge, or the products of inquiry, the decision-maker is not competent to act. In the next chapter, the products of social inquiry will be discussed.

DISCUSSION QUESTIONS AND EXERCISES

1. Within many of the social science disciplines, there is controversy and conflict regarding their proper goals. Some social scientists argue that scientists should become more *directly* involved in the resolution of urgent social problems. They contend that too many social scientists remain in an "ivory tower," isolated from the real world. Other social scientists argue that social scientists can best serve society by pursuing research which will result in the building of systematic theories. What do you think should be the goal of social science? What is the proper relationship between social science and public policy? Give examples to support your answers.

2. Examine several social science books and list at least two or three social science *theories*, such as Durkheim's theory of suicide, Brinton's theory of revolution, or the theory of prejudice developed by Arnold M. Rose. (See Chapter 3 for a detailed definition of a theory.) Do the theories which you have listed have any *policy* implications? If not, why not? If so, what are they? Explain how a theory can be used to help us predict and control behavior. Do you think that theories should be taught in the elementary and junior high-school grades? Why or why not? If you feel that theories should be taught in these grades, take one of the theories which you identified above and develop a lesson plan for teaching it to an elementary or junior high-school class. What difficulties might you encounter in attempting to teach theories to young children? Can these difficulties be overcome? If so, how?

3. What are the essential factors which distinguish one social science discipline from another? Give examples to support your answer. What implications does your answer have for planning social studies experiences for elementary and junior high-school students?

4. What are the *assumptions* of science? Why is social science unable to answer many of the questions in which man is most vitally interested? List several questions which social science cannot answer. List several questions which social science cannot answer, but whose resolution can be aided by the wise use of the scientific method.

5. Why is it important to help children distinguish between scientific and nonscientific questions? Develop a sample lesson demonstrating how you would teach children to make this distinction.

6. Write an empirical question which is nonresearchable because it is incomplete and inprecise. Revise it so that it is researchable. Develop a lesson plan illustrating how you would help children research the question.

7. The model of social inquiry presented in this chapter consists of a series of skills. Plan lessons designed to help children gain proficiency in (a) formulating problems, (b) hypothesizing, (c) conceptualizing, (d) collecting data, (e) evaluating and analyzing data, and (f) deriving generalizations. You may use one or several questions to develop your plans. In our "juvenile delinquency" example in this chapter, we organized a series of lessons around one key question.

8. Locate studies in social science journals or books which represent each of the following types: (a) the experiment, (b) the sample survey, (c) the case study, and (d) content analysis. Name the *independent* and *dependent* variables in each study.

9. Explain and give examples of how a teacher may help children to implement each of the following types of studies: (a) the experiment, (b) the sample survey, (c) the case study, and (d) content analysis. What difficulties might a teacher encounter in trying to help children to implement each type of study? How might these difficulties be overcome?

10. Demonstrate your understanding of the following key concepts by writing or stating brief definitions for each of them:

a) social inquiry (process)
b) knowledge (product)
c) conceptual framework
d) independent variable
e) dependent variable
f) decision-problem
g) hypothesis

h) conceptualization
i) experiment
j) sample survey
k) case study
l) participant observation
m) content analysis
n) postulates of science

FOOTNOTES

1. Claire Selltiz, Marie Jahoda, Morton Deutsch and Stuart W. Cook, *Research Methods in Social Relations*. New York: Henry Holt, 1959, p. 481.

2. Bernice Goldmark, *Social Studies: A Method of Inquiry*. Belmont, California: Wadsworth, 1968, p. 214.

3. Dorothy Rogers, *The Psychology of Adolescence*. New York: Appleton-Century-Crofts, 1962, p. 528.

4. Goldmark, *op. cit.*, p. 116.

5. Fred N. Kerlinger, *Foundations of Behavioral Research: Educational and Psychological Inquiry*. New York: Holt, Rinehart and Winston, 1964, p. 19.

6. *Ibid.*, p. 6.

7. Morris R. Cohen and Ernest Nagel, *An Introduction to Logic and Scientific Method*. New York: Harcourt, Brace and World, 1934, p. 201.

8. Wilson Gee, *Social Science Research Methods*. New York: Appleton-Century-Crofts, 1950, p. 8.

9. Bernard Berelson and Gary A. Steiner, *Human Behavior: An Inventory of Scientific Findings*. New York: Harcourt, Brace and World, 1964, p. 18.

10. Helen G. Trager and Marian R. Yarrow, *They Learn What They Live*. New York: Harper, 1952.

11. John H. Litcher and David W. Johnson, "Changes in Attitudes of White Elementary School Students After Use of Multiethnic Readers," *Journal of Educational Psychology*, Vol. 60 (1969), pp. 148-152.

12. Kerlinger, *op. cit.*, p. 318.

13. Norris M. Sanders and Marlin L. Tanck, "A Critical Appraisal of Twenty-Six National Social Studies Projects," *Social Education*, **34** (April, 1970), pp. 431-432.

14. Berelson and Steiner, *op. cit.*, p. 25.

15. *Ibid.*

16. Larry Cuban, *To Make a Difference: Teaching in the Inner City*. New York: Free Press, 1970, pp. 161-162. Reprinted with permission.

17. Berelson and Steiner, *op. cit.*, p. 28.

18. Walter Borg, *Educational Research: An Introduction*. New York: David McKay, 1963, p. 188.

19. Richard W. Budd, Robert K. Thorp, and Lewis Donohew, *Content Analysis in Communications*. New York: Macmillan, 1967, p. 2.

20. Bernard Berelson, *Content Analysis in Communication Research*. Glencoe, Illinois: Free Press, 1952, p. 18.

21. Bernard S. Phillips, *Social Research: Strategy and Tactics*. New York: Macmillan, 1966, p. 44.

22. Gideon Sjoberg and Roger Nett, *A Methodology for Social Research*. New York: Harper and Row, 1968, p. 28.

23. Carlo L. Lastrucci, *The Scientific Approach: Basic Principles of the Scientific Method*. Cambridge, Massachusetts: Schenkman, 1963, p. 34.

24. *Ibid.*, p. 36. 25. *Ibid.*, pp. 37-47. 26. *Ibid.*, p. 42.

27. *Ibid.*, pp. 42-46. Reprinted with permission.

28. Sjoberg and Nett, *op. cit.*, pp. 23-24. Reprinted with permission.

29. Bernard Berelson and Gary A. Steiner, *Human Behavior: Shorter Edition*. New York: Harcourt, Brace and World, 1964, pp. 6-7. Reprinted with permission.

30. Arnold Adoff, *Malcolm X*. New York: Thomas Y. Crowell, 1970.

31. Frank Bonham, *Durango Street*. New York: E.P. Dutton, 1965.

THE PRODUCTS OF SOCIAL INQUIRY: FACTS, CONCEPTS, GENERALIZATIONS, AND THEORIES

The method used by the social scientist to derive social knowledge was discussed in Chapter 2. The importance of the *process* of social inquiry has been emphasized throughout this book. The results or products of scientific inquiry are also important because *facts, concepts, generalizations,* and *theories* help man to understand human relationships and to make sound personal and public decisions. Even though the products of social inquiry are subject to constant reconstruction or revision (and thus the importance of process), man must at any given time use the most *functional* facts, concepts, generalizations, and theories that can be identified. This chapter focuses on the nature of social knowledge, and suggests teaching strategies that will facilitate the learning of facts, concepts, and generalizations by elementary and junior high-school students.

FACTS

Factual knowledge consists of specific data about events, objects, people, or other phenomena that can be or has been verified by the senses. Facts are the particular instances of events or things which in turn become the raw data or the observations of the social scientists. Facts are usually stated as simple, positive statements.

Albany is the capital of New York State.

There are 5280 feet in a statute mile.

The earth revolves about the sun.

Factual data are often presented in the form of tables and charts, and in almanacs, gazetteers, or similar reference books. These include quantities of diverse data – population of cities, tide tables, the number of votes cast in

recent presidential elections in various states, counties, cities, and so forth. It should be made clear, however, that *facts* are the actual data themselves. When the reader inspects the data and begins to discover trends, or to compare population data for 1960 and 1970, he is then beginning to *interpret* the data and to make inferences about the facts. This is a higher-order intellectual skill, part of the process of generalizing which will be discussed later.

Some statements that appear to be factual assertions are colored by perceptual biases or value judgments that may not be entirely obvious to the reader. Let us take the statement, "Sir Francis Drake was an English hero." Most students studying early colonial history would probably be willing to accept that as a verifiable fact since it is repeated so often in their texts, and there are many popular pictures of Drake being knighted by Queen Elizabeth for his exploits. But what about those exploits? Surely from a Spanish point of view the statement might have been written, "Sir Francis Drake was an English pirate." The gold he brought home to his Queen was taken (stolen?) from captured Spanish treasure ships returning from Mexico. In short, one Queen's *hero* was another King's *pirate*. Similar statements could be made about such relative words as *poverty* and *wealth*, or perhaps *starvation* and *adequate diet*.

Our cultural background tends to bias our perceptions so completely that we are frequently unable to view statements and words from different perspectives. Value statements and inquiry are discussed in Chapter 12. The intent here is to alert the reader to value statements which may, without careful analysis, be considered factual assertions.

Although many classroom teachers still require children to master a great body of facts as ends in themselves, a teacher is not justified in requiring youngsters to do so unless these facts can be used to help them derive concepts, generalizations, and theories. Research has consistently demonstrated that memory and transfer of learning are facilitated when children master generalizations rather than isolated bits of factual knowledge.

CONCEPT LEARNING

A concept is an abstract word or phrase that is useful for classifying or categorizing a group of things, ideas, or events. To illustrate this definition, examine the following list of words:

boy cat dog man rat

What single word or short phrase can you think of that appropriately names or labels the group? At first glance you might be inclined to say *animal*, since all the words describe a kind of animal. If you have recently studied biology, you might add: *carnivore, mammal,* or *vertebrate*, since these are also common characteristics of the group. You might be tempted to include *domestic* though that word would not really apply to *rat* unless we were referring to white rats that might be kept as pets. Teachers who have taught in the primary grades where reading skills are emphasized are quick to use such labels as: *three-letter words, middle-vowel words,* or *consonant-vowel-consonant* (CVC) pattern. You

"I like you, Egglehoffer, you're my kind of bigot."

Drawing by Herbert Goldberg; © 1968 by Phi Delta Kappa.

would undoubtedly discover many other possibilities. The point is that each of these words is a possible label or name for the group since it categorizes each item in the class according to some special characteristic that all share in common. Words that label or name a group of common objects are called *concepts*.

Several important features of concepts should be noted. For example, among the possible concept terms suggested above, *animal* and *three-letter words* are more inclusive than some of the others. Indeed, it might be possible to subordinate some of the terms into a hierarchy such as the following:

I. Animal

 A. Vertebrate

 1. Mammal

 a. Carnivore

A more elaborate example of concept hierarchies is presented in Fig. 3.1.

In some cases, the concept term applies only partly or in a qualified way to all members of the group, such as the term *domestic* in the example above. Lastly, the concept term is abstract; it is not specific or concrete since it refers to an entire class or group of objects.

Learning to use concepts is a vital part of our thinking processes. They enable us to sort out the great variety of objects, events, ideas, and stimuli with which we come into contact each day. Thus, they help reduce the complexity

Figure 3.1
Hierarchial Outline of Concepts from a Curriculum Unit on Water Resources*

(This chart shows how a large number of lower order concepts are subsumed under higher order ones. Students must have an understanding of the lower order concepts in order to fully understand the higher order ones.)

A. Resources
 1. natural resources
 2. human resources
 3. capital resources-technology

B. Scarcity
 1. supply – limited resources
 2. demand – unlimited wants

C. Values
 1. land values
 2. rural-urban (differences)

D. Population patterns
 1. rural
 2. urban

E. Cultural change
 1. technological change (effect)
 2. cultural lag (impact)

 a) *watercycle*
 i) evaporation
 ii) condensation
 iii) precipitation
 b) *watershed*
 i) *topography*
 1) basin
 2) river
 3) ridge
 ii) *climate*

F. Production
 1. economic activity
 2. distribution

G. Decision-making
 1. governmental authority
 2. political strife
 a) self-interest
 b) public-interest

*From Alberta P. Sebolt and Ambrose A. Clegg, Jr., *Water Resources:* Curriculum Model #1, Resource Learning Laboratory, Title III-PACE, Sturbridge, Mass., 1969, p. 5. Reprinted with permission.

of the environment by separating the great amount of data to be processed by the brain to more manageable portions. Reflecting this, our English language is filled with many abstract words often expressing very complex ideas. The social studies curriculum provides a number of examples of concepts:

family	government	cooperation	power
community	republic	cultural change	interdependence
society	federal system	conflict	tradition
nation	democracy	law	social control

In addition, concepts have varying degrees of *abstractness* and can be thought of as existing on a continuum. For example:

Concrete	Abstract
family	nation
fight	revolution
local ordinance	international law
village	megalopolis

Concepts can also be thought of by the way in which their essential attributes are combined. Bruner and others have classified concepts into three broad categories:

conjunctive, disjunctive, and relational.[1]

A conjunctive concept is defined by the presence of two or more attributes, e.g., *White House, cold war, international law*. These attributes are combined in an additive manner.

A *disjunctive* concept involves an *either-or* decision. That is, *either* of two sets of defining characteristics may be present. For example, a *strike* in baseball may be either a missed ball, or a ball that was fairly pitched but not struck at. Similarly, an election law may define a *residence* qualification as "anyone who lives in *or* pays taxes in the city of Mercer Island." Other concepts such as *social elite* might include *several alternative* characteristics that have little or nothing in common, for example, monetary wealth, noble birth (no matter how devalued the title might be), or membership in certain highly respected professions. The problem with such concepts is the arbitrariness of their defining characteristics as in the case of the strike in baseball, the residence qualification of the election law, and the ambiguousness of a set of alternatives as in social elite. Because of the complexities in the *either-or* combination of essential characteristics, children often have difficulty in learning disjunctive concepts.

Relational concepts define a particular association between attributes or distinguishing characteristics. Concepts involving distance and time are perhaps the most common relational ones in social studies: year, century, mile, light-year, outer space, latitude, longitude, great circle route. Other relational concepts are much more abstract: uncle, great-grandfather, mother-in-law, foster parent, kinsman, fellow-countryman. Concepts such as these are particularly difficult for young children to comprehend, because they have not had sufficient experience with the basic facts themselves, or with abstracting the common attributes to establish the particular relation or association involved. For example, it takes considerable practice with a calendar for a six- or seven-year old child to count up thirty days, learn that that period is called a month, and then recognize that there are approximately four weeks in a month. Most adults are satisfied to think of a century as a "very long time" or have only a foggy notion of the concepts, *great uncle* and *grand niece.*

Other Uses for Concepts

Having a repertoire of concepts also greatly lessens the need for constantly learning or relearning as one encounters new situations. For example, the student who has applied the term *monarchy* to his study of the seventeenth century Stuart kings of England can aptly conceptualize the Romanoffs of nineteenth century Russia by using the same term. So also the concept *republic* can be used to conceptualize both ancient Greece and modern America. As we shall see later, however, many of the events, ideas, and phenomena studied in social studies curricula cannot be neatly categorized by a single concept. Only

certain of the discriminating characteristics apply to all examples in the class or category. Thus students must learn to shift, sort, and shuffle their thought categories to find concepts that are functionally more useful or logically more viable. Take, for example, the concept *democracy*: Children who have studied the American form of government have identified and abstracted certain features about the relationship of the people to their government, the principal feature being free, popular elections. Yet as the students then examine many countries that claim to be democracies, they find that some of the characteristics of the American model are completely absent or are perverted by strange distortions of logic so that little more than the title "democracy" remains. For example, consider the governments that are controlled by a military junta or centralized bureaucracy, controlled elections in which the candidates from the official party win by 95% majorities, or countries in which the political opposition is not regarded as the "loyal opposition" but is systematically eliminated by official campaigns of brutality and terror.

It is precisely because many of the more sophisticated and abstract concepts do not admit of easy definition, and because their discriminating characteristics do not apply equally to all members of the class, that they are so illusive and difficult to use with precision and accuracy. This makes it imperative that children learn to distinguish these characteristics carefully and to recognize early the situations in which the concept term applies completely to all members of the category, and when it applies only in a limited way. Later we shall discuss the relative effectiveness of teaching through the use of positive and negative examples of concepts.

Lastly, because concepts have an organizing function, they serve to give a focus or a special view that tends to reduce random observation. For example, if one wanted to study the social structure of a society, he might begin by asking questions about the *groups* the individuals belong to, the *roles* each person plays, the *rules or norms* that govern the society, the *status* of individuals, the *social class* of groups, or perhaps the means and extent of *communication* between and within groups. These concepts, drawn from the discipline of sociology, serve as analytical tools in a guided exploration of a topic. Since their meanings have already been well established, one can easily and quickly ask a series of leading questions related to each concept. These yield data about the society in an organized manner along a series of important dimensions. As we saw in Chapter 2, each of the social science disciplines looks at the problems of its concern with a separate focus, and thus, a differing set of concepts. Figure 3.2 presents some important organizing concepts of the various social sciences which reflect the structures of the disciplines and which are discussed in Chapters 5 through 11.

Interdisciplinary Concepts

Having a knowledge of the basic concepts from the various social science disciplines allows one to consider a problem that spans several disciplines, or is interdisciplinary in its scope. Broad ranging topics such as the city, international peace, or poverty can be considered from a variety of

Figure 3.2
Organizing Concepts in the Social Sciences

Anthropology	History	Psychology
Culture	Change	Self-concept
Culture element	Conflict	Motivation
Culture complex	Revolution	Perception
Enculturation	Nationalism	Frustration
Culture area	Civilization	Attitudes
Diffusion	Exploration	
Acculturation	Historical bias	
Ethnocentrism		
Tradition		
Cultural relativism		
Culture universals		

Economics	Political science	Sociology
Scarcity	Social control	Socialization
Production	State	Role
Goods and services	Power	Norm
Interdependence	Legitimacy	Sanction
Division of labor	Authority	Values
Exchange	Interest group	Status (status-position)
Circular flow of income	Political socialization	Institution
	Political culture	Community
Geography	Political system	Society
Location		Interdependence
Region		
Spatial interaction		
Urban spatial pattern		
Internal structure of the city		
Environmental perception		

Exhibit 3.1
Key Concepts in the Taba Social Studies Curriculum*

Causality

Events often can be made meaningful through studying their antecedents. Hence, to some extent, future events can be predicted.

Events rarely have a single cause, but rather result from a number of antecedents impinging on one another in a given segment of time and space.

Conflict

Interaction among individuals or groups frequently results in hostile encounters or struggles.

Conflict is characteristic of the growth and development of individuals and of civilization as a whole.

There are culturally approved and disapproved means for resolving all varieties of conflicts.

Irrational conflict is reduced by recognition of the inevitability of differences and of the difficulty of determining their relative value.

In most situations, some form of compromise is necessary because of the serious consequences of sustained conflict.

Cooperation

The solution of important human problems requires human beings to engage in joint effort.

The more complex the society is, the more cooperation is required.

Cooperation often requires compromise and postponement of immediate satisfactions.

Cultural change

Cultures never remain static, although the context of the change (economic, political, social, and technological), the speed of the change, and the importance of the change, vary greatly.

Cultural change is accelerated by such factors as increased knowledge, mobility, and communication, operating both within and between cultures.

Differences

The physical, social, and biological worlds (including human beings and their institutions) show extreme variation.

Survival of any species depends on these differences.

Conflicts and inequities often result from assigning value to particular categories of differences, such as white skin or high intelligence.

Interdependence

All persons and groups of persons depend upon other persons and groups for satisfaction of needs.

Behavior of each person and group affects other persons and groups in important ways. These effects on others are often indirect and not apparent.

Modification

As man interacts with his physical and social environment, both he and the environment are changed.

Man has often exploited his physical environment to his own detriment.

Power

Individuals and groups vary as to the amount of influence they can exert in making and carrying out decisions which affect people's lives significantly.

As a strong motivating factor in individual and group action, the desire for power often leads to conflict.

Societal control

All societies influence and attempt to mold the conduct or behaviors of their members. The techniques used include percept, example, and systems of reward and punishment; the specifics of those techniques vary greatly from one society to another.

*Reprinted with permission from the *Taba Social Studies Curriculum,* Menlo Park, Calif.: Addison-Wesley, 1970. The words in bold face type are key concepts; the statements beneath these words are related generalizations.

Exhibit 3.1 (Cont.)
Key Concepts in the Taba Social Studies Curriculum

Marked differences in child-rearing practices often exist among societies.

All societies have some way of punishing adults who do not conform to established ways. The means of punishment include ridicule, shaming, and ostracism, as well as physical punishment and execution.

Written laws are an attempt to clarify the rules by which society operates and to promote an impartial treatment of its members.

Everyone belongs to many groups with overlapping membership, different purposes, and often conflicting demands on members in terms of duties, responsibilities and rights; each, by exerting social controls, shapes the personality structure and behavior of its members.

Tradition

Societies and the groups and individuals within them tend to retain many traditional values, attitudes, and ways of living and dealing with current problems, whether or not that behavior is appropriate.

Certain institutions in societies, such as the family, religion, and education, tend to change less rapidly than do other elements of societies.

Values

Those objects, behaviors, ideas, or institutions which a society or an individual considers important and desires constitute values.

Whether or not a person holds a value can be inferred by others only on the basis of an extensive sample of his behavior.

Societies and individuals often differ significantly in the values they hold.

Values develop through both non-rational and rational processes.

The survival of a society is dependent upon agreement on some core of values by a majority of its members.

The greater the variety of values within a society, the greater the likelihood of disagreement and conflict; in some societies such conflict is accepted as necessary to the realization of core values.

perspectives, each avoiding the parochialness of a single point of view. An example of a set of high-order, interdisciplinary concepts used in the Taba Social Studies Curriculum is given in Exhibit 3.1. These concepts are studied in increasing depth throughout the eight grades.

How Concepts Are Learned

Concept formation is a rather complex intellectual or cognitive task. It consists of the ability to sort out a group of observations on the basis of one or more common characteristics, to abstract and generalize these discriminating features, and to apply a word or phrase to the observation that appropriately names or labels it on the basis of its discriminating characteristics. *In short, conceptualization is the process of categorizing, classifying, and naming a group of objects.*

Children begin to form concepts very early in life; this becomes evident as soon as they can identify correctly a variety of common objects such as chair, light, table, or dog. And of course, we all laugh at the baby who calls every man "daddy," but this merely indicates that while the child can distinguish "momma" from all other women, he still cannot discriminate the unique

characteristics of his father with whom he has probably had less contact than with his mother. By the time most children begin the primary grades, they already have a speaking vocabulary that includes many concept terms. These include concepts for most of the objects in the child's environment, such as the persons in his immediate family, the things in his home, and the food, clothes, and utensils he uses in daily life. Furthermore, television has brought children into frequent contact with many things quite distant from their own environment; they may know more about these than about things that are more immediate and close to them. Children have probably also developed a number of relational concepts such as *inside of, outside of, from, to, up,* and *down,* but also have only the vaguest concept of other important relational concepts as *smaller than, less than, larger, more than, the next one, the one before, double, like, unlike,* and the *number names* for quantities.[2] Nor does he understand just how his close family relatives such as grandparents, uncles, or aunts are related to his own parents and through them to him.

But while these characteristics of concept development may be normative for large groups of the population, teachers should recognize that some children, especially those from rural and inner city areas, may be seriously deficient even in elementary concepts, as noted in the Coleman Report.[3] Federally financed Headstart and Follow-Through programs have attempted to provide some measure of help for these children.

Variables Affecting the Learning of Concepts

A long history of research in the psychology of learning has focused on how people, particularly children, learn concepts.[4] A number of important variables have been identified, each of which has importance if the social studies teacher is to develop strategies of teaching that will make it possible for children to learn a large number of increasingly sophisticated and complex concepts from the various social sciences. These variables include the nature of the learning experience (direct and immediate or abstract and symbolic) through which the concept is taught, the number of instances presented, the sequence of examples and nonexamples, the distinctiveness of relevant cues, and the complexity of the examples. Related to concept attainment are the type and extent of practice (massed or distributed), reinforcement, and verbalization.[5]

Nature of the Learning Experience

As indicated above, many concepts are learned informally before a child enters school. His direct experience with life and the many events and phenomena of his environment provide direct and immediate learning situations. The objects he encounters are concrete and specific often with vivid sensory stimuli. Learning in the school classroom, however, tends to be proximate rather than direct, and more symbolic and abstract than concrete. Because the school setting is more formal and structured, the teacher must provide many opportunities for children to gain experience with the events represented by

the concept. Young children in the primary grades (to follow Piaget's developmental stages) need frequent experience with concrete realities that can be seen, heard, or manipulated. Older children in the middle and upper grades also need experience with the events or phenomena involved, but the materials may be more abstract or symbolic. For example, primary-grade children might use pictures, drawings, or dolls to develop simple aspects of the concept *family*, whereas children in a fifth or sixth grade might use a diagram with a variety of symbols to chart the familial ties in an extended family. The older children would spend considerably less time on this topic since the more basic elements of the concept *family* will have already been developed.

Examples and Nonexamples of Concepts

Concepts appear to be learned most effectively when a number of *positive* examples of the concept are presented. Students are able to discern the relevant characteristics and to make appropriate discriminations when the examples of a *city*, such as Boston, Paris, or Tokyo, are not confused with special cases such as Vatican City or East Berlin. *Negative* examples illustrate characteristics that are opposite from those positively associated with the discriminating features. For example, *liberty* may be illustrated by the excesses of license; the need for *laws* and *regulations* by the possibility of anarchy; *honesty* and *integrity* by the evidence of wrongdoing and corruption. Although it is true that some learning does occur with negative examples,* the learner is forced to spend an inordinate amount of time inefficiently searching for the appropriate clues leading him to the discriminating characteristic. In addition, he must try to remember all the characteristics that do not apply, which usually far exceed those that are included in the concept. Yet, ironically, most classroom discussions that the writers have observed on the concepts of *liberty, law,* or *integrity* have dealt almost entirely with negative examples. This is not to say that exceptions should not be discussed, only that they should not be introduced until the positive aspects of the concept have been carefully developed so that students can easily make the correct discriminations.

Research evidence indicates that concepts are most efficiently learned when a number of positive examples are first introduced and the discriminating characteristics clearly established, followed by a fewer number of negative examples which serve to illustrate the absence of the discriminating characteristic. Since learning is highly individualistic for each student, teachers

*Some approaches to problem-solving are based on the principle of negative examples. "Troubleshooting" frequently employs an elimination strategy in which various possibilities are systematically eliminated or excluded. In more complex situations this strategy requires an intensive knowledge of the relation of component parts to subsystems or assemblies, and an ability to diagnose and relate external symptoms of malfunctioning to the pertinent subsystem.

Many physicians, auto mechanics, or TV repairmen proceed on this basis to determine the chief source of difficulty.

Construction activities can facilitate concept attainment. (Northshore School District, Bothell, Washington)

will have to experiment to find an appropriate balance in their instructional strategy.

Complexity of Examples

Because the social studies curriculum contains so many complex concepts, it is important that we consider three aspects related to complexity: focusing on the essential characteristics, choosing between realistic versus simulated experiences, and progressing from simple to complex concepts.

Suppose, for example, a class is studying the concept *assembly line production*. If we were to start by bringing the class to a factory without any prior class development of the concept, the students would be overwhelmed by the complexity of factors. Which are the *essential characteristics*: the large stores of materials, the protective clothing worn by the workers, or perhaps the great amount of machinery present? Obviously, the teacher would have had to introduce the idea of a moving table on which the product was placed, and as the table was moved rapidly through various parts of the factory different groups of workers added something or made some change in the product until it reached its finished form. This could be done through a short 8mm film loop or a set of animated transparencies, each illustrating several different examples, e.g., auto production, a meat-packing plant, or a dress factory, with a non-example of a local jeweler repairing a watch, or a shoemaker resoling a pair of shoes.

Once the students have understood the essential characteristics, a field trip to see the assembly line in actual operation would be more profitable, since

Models can be used to help children understand concepts. (Donald E. Miller, Mercer Island, Washington Public Schools)

students could then attend to the essential characteristics and not be diverted by the fascinating but irrelevant cues.

Using the same example, let us examine the problem of choosing between *realistic versus simulated experience* when a concept is being presented for the first time. Abundant research evidence from the areas of industrial and military training has indicated that simplified line drawings, models, animated films, or simulated mock-ups are usually far more effective in teaching a concept than the direct observation or involvement. These devices eliminate most of the

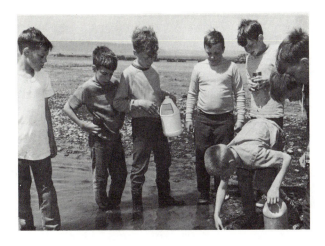

When carefully selected and sequenced, field trips and excursions can enrich the social studies program and extend the meanings of concepts. (Highline Public Schools, Seattle, Washington)

"I thought we were going on a field trip, not a bus trip!"

Reprinted from *Instructor* © December, 1966, the Instructor Publications, Inc., used by permission.

irrelevant cues and emphasize strongly, often by vivid colors, the essential characteristics. As we indicated above, the field trip visit to the factory to see an assembly line is a complex learning activity. Undoubtedly, students will see many new and exciting things for the first time, many having little or nothing to do with the concept of *assembly line*. As Travers has pointed out, humans have a limited capacity to handle the onrush of new information, and the brain tends to eliminate those stimuli which it cannot sort out and relate to other existing impressions and ideas.[6] It is very likely that some students will miss entirely the concept of *assembly line*, and little will have been gained from the field trip. Thus, a teacher must weigh carefully the value of heightened motivation and interest which might be gained from a field trip, versus the value of simplicity and accuracy that is to be gained from the use of a simulated experience when a concept is first introduced.

VARIABLES AFFECTING CONCEPT ATTAINMENT

In the previous sections we dealt with a variety of factors related to the number, type, and sequence of concept examples. These are important factors for the teacher since they deal with the selection and organization of appropriate curriculum materials and learning experiences. Now we shall turn our attention to several psychological factors related to concept attainment. These include the effects of practice (concentrated or distributed over time), knowledge of results, and the need to verbalize the concept.

The effects of practice upon learning have received more attention from psychologists than perhaps any other topic, yet the results appear to be ambiguous and at times contradictory. Nevertheless, the evidence, although by no means conclusive, suggests that practice in concept learning is more effective when distributed over time than it is when concentrated (massed) in a single, short period.[7] This evidence indicates that students should be given frequent opportunities to use the process of concept learning, and that enough opportunities should be provided to develop the particular concept being studied.

Another important variable appears to be knowledge of results (feedback) or reinforcement.* Here too, the psychological research has been extensive, particularly with the advent of programmed instruction and computer-assisted instruction, although here, too, results have been conflicting. Positive reinforcement generally takes the form of a "that's right" or "correct," or some more extended comment supporting the student's response both in class discussion or on test items. The critical question appears to be: How often and how soon should the correct responses be reinforced? Most investigators have found that *immediate* reinforcement of all correct responses[†] facilitated concept attainment, and that delays increased the number of trials needed to learn the concept.[8]

One aspect of reinforcement that has not been carefully examined is the possible reinforcing effect to be found in the way teachers accept, clarify, or use student ideas, and how this relates to the cognitive level being sought in the teaching process. Some evidence stemming from Flander's work in classroom interaction analysis seems to indicate that short teacher responses such as "that's right," "correct," or "okay" are used most often in situations where the nature of the lesson is convergent and the cognitive skill involved requires little more than the recall of a memorized answer. For some teachers, these short responses tend to be a kind of nervous habit. They appear to give them routinely, paying little or no attention to what the student has actually said. In contrast, teacher responses that make use of, expand upon, or clarify student

*The terms *knowledge of results, feedback,* and *reinforcement* are not entirely synonymous or interchangeable. In general, however, cognitive theorists have preferred the terms *knowledge of results* or *feedback*; behaviorists have preferred the more classical term *reinforcement.*

†In one of the few exceptions to this general principle, Sax (1960) found no significant differences on concept acquisition or on retention trials between students who were given 100-percent and 50-percent reinforcement.

responses are used more often in lessons that are divergent in nature and in which students are operating at higher cognitive levels.[9] Given the high-level objectives for social studies predicated in this book, the critical questions should not only be how often and how soon should responses be reinforced, but also at what qualitative level?

One of the factors related to concept attainment is the ability of the student to verbalize the concept, that is, to distinguish orally or in writing the discriminating characteristics and to give the concept an appropriate name. Such a skill is important in social studies if students are to use concepts freely and readily in sorting out large amounts of data and if they are to have a repertoire of powerful analytical terms for making comparisons and contrasts in the process of developing generalizations from several samples of data (see below).

Many children at first have some kind of intuitive grasp of the concept and are able to recognize those items that belong to a group and those that do not. They find it difficult, however, to state the basis for their discrimination and can often give no more reason than "Well, because it just does." In short, they may be able to identify (and possibly use) a concept, but not be able to define it adequately in words.

This problem is due not only to the lack of adequate abstract terms in the young child's vocabulary, but also to the fact that the process of conceptualizing involves three separate tasks: *observing, classifying,* and *defining*, all of which involve separate response modes. Studies have demonstrated that the quality of concept definition improves when students are given even limited amounts of practice in making definitions at the same time they make the discriminations, even when they are not told how good the definition is.[10] Teaching strategies should ensure, then, that children are given adequate practice in naming or defining a concept, at the same time that they identify the discriminating features used in classifying the items in the group. Teachers should recognize, too, that children will grope for adequate words to express the concept and will often use awkward phrases because they have not learned the precise abstract word. One class of third-grade youngsters studying manufacturing agreed on the phrase "things-that-you-make-all-in-a line" as their name for the concept *assembly line*. It was not until a day or two later when the teacher was certain that most of the children had attained the concept that she suggested that they substitute the more technical word "assembly line." For children with low verbal fluency or poor language development it is doubly important that the teacher concentrate upon the skill of defining as well as the skill of discriminating.

A TEACHING STRATEGY FOR CONCEPT FORMATION

In the preceding section we discussed some of the curriculum and the psychological problems related to concept formation. These involved the selection and organization of appropriate examples of the concept along with consideration for the importance of practice, reinforcement, and verbalization. At each point a number of special considerations were suggested for the

Figure 3.3
Developing concepts

Listing, grouping, and labeling

This task requires students to group a number of items on some kind of basis. The teaching strategy consists of asking students the following questions, usually in this order.

Teacher asks	Student	Teacher follow-through
What do you see, (notice, find) here?	Gives items.	Makes sure items are accessible to each student. For example, chalkboard, transparency, individual list, pictures, or item card.
Do any of these items seem to belong together?	Finds some similarity as a basis.	Communicates grouping. For example, underlines in colored chalk, marks with symbols, or arranges pictures or cards.
Why would you group them together?*	Identifies and verbalizes the common characteristics of items in a group.	Seeks clarification of responses when necessary.
What would you call these groups you have formed?	Verbalizes a label (perhaps more than one word) that appropriately encompasses all items.	Records.
Could some of these belong in more than one group?	States different relationships.	Records.
Can we put these same items in different groups?*†	States additional different relationships.	Communicates grouping.

*Sometimes you ask the same child "why" when he offers the grouping, and other times you may wish to get many groups before considering "why" things are grouped together.

†Although this step is important because it encourages flexibility, it will not be appropriate on all occasions.

Reprinted with permission from *The Taba Social Studies Curriculum*, Menlo Park, Calif.; Addison-Wesley, 1970, Vol. 6, p. xxii.

teacher. These are now incorporated into a strategy originally designed by Hilda Taba for developing concepts.[11] As shown in Fig. 3.3 the strategy consists principally of having the teacher ask a series of questions designed to elicit from the students the essential tasks of listing, grouping, and labeling.

Several comments should be made at this point to forestall any misunderstanding. First, the strategy is clearly an inductive one, and as the first of the teacher's eliciting questions implies, the children would previously have had an "opener" or motivating experience such as a story, film discussion, or field trip to provide for an initial input of factual data or observations. Secondly, the strategy is *initially* a teacher-directed one, but evidence from Taba's pilot studies[11,12] and from our own subsequent use of these strategies, indicates that children quickly learn the sequence of questions and soon take charge of the *process* of inquiry themselves. And although the questions are directed ones, they are sufficiently open-ended to allow for a wide range of divergent responses from the students. In subsequent chapters we shall illustrate how this strategy lends itself to use in forming concepts from separate disciplines, as well as for those high-order concepts that are interdisciplinary.

GENERALIZATIONS

Generalizations are statements of the relationship of two or more concepts. These statements may range from very simple to very complex statements. They may also range from high to low order in the universality of the application. For example, let us take two very simple concepts: rain and temperature. What can we say about their relationship? We might be able to make a very *simple* statement such as "When it is cold, rain changes to snow." While most young children will already have had enough experience in their lifetime to validate this statement, a more complex generalization might make a statement about the relationship of rainfall and temperature and their effect upon vegetation. In such cases, it may be possible to generalize that the combination of warm weather, large amounts of rainfall, and fertile soil produces great amounts of vegetation.

Before proceding further, we should look at the anatomy of generalizations. The key point is that the generalization must express a *relationship* between two or more concepts. Verb phrases such as *grows larger, declines, is influenced by, is associated with, causes changes in*, or *varies with* are often used to describe the relationship between the concepts. You may recall that in Chapter 2 we spoke of generalizations as "verified hypotheses." It is a good test of a generalization, therefore, to try to recast the statement into the "if . . . then" form. Not only does this force the relationship element into clearer perspective, but it also requires that the variables (the concepts) be stated in sequence so that their logical cause and effect or other association is plainly evident. Thus, the two examples given above could be rewritten as:

If it is cold, *then* the rain will change to snow.

If there is a combination of warm weather, large amounts of rainfall, and fertile soil, *then* large amounts of vegetation will be produced.

Generalizations help children to understand the social world in which they live. (Clover Park School District, Tacoma, Washington)

We would propose this rule of thumb: *If* a generalization cannot be recast into an "if . . . then" form, *then* it is probably only a statement summarizing factual knowledge.

Generalizations also provide us with useful means of accumulating facts and information in a highly organized and systematic way. They eliminate the need for us to go back to the original statements again and again. In a sense the generalization becomes a kind of shorthand for the knowledge that we accumulate during our life experience.

Some generalizations, of course, are very limited in scope. The data from which they are derived may be limited to the experience of a single individual or they may refer to a single town or region in the United States. For example, we may have "the growth of the lumber industry in the Pacific Northwest depends in large measure upon the annual rainfall." This statement is obviously limited because of the restrictions upon the data from which the relationships were derived. The source of evidence is the annual rainfall and the economic growth of the lumber industry. A very different series of generalizations might be developed if we were to analyze the amount of rainfall in Thailand and its effects upon the rice crop. These two examples require widely contrasting sources of data. If we extend this by adding the sample data on rainfall and

production of rice in Louisiana, and another sample that provides data on the amount of rainfall and the yield of wheat in the Soviet Union, we may begin to get some broad inferences from a series of widely divergent samples about the influence of rainfall and temperature on vegetation.

Other generalizations, however, have universal application throughout man's cultural experience. Empirical data from all times and all cultures can be adduced to support the relationship stated between the concepts. For example,

"In every society rules emerge to govern the affairs of men."

"Culture tends to standardize human behavior and to stabilize societies by developing many interrelated and elaborate institutions."

HIGH- AND LOW-ORDER GENERALIZATIONS

As you can see from the discussion above, generalizations can be classified on the basis of the range of their application. Some are universal in their scope; others are very limited in the situations to which they apply. For convenience we have called these high- and low-order generalizations. In the following paragraphs we have sketched out a progression of generalizations from high to low. As the arrow indicates, these can be read in any direction, from high to low (deductive), or from low to high (inductive). The examples are taken from the Taba Studies Curriculum.

1st Order: Highest-Order Generalizations*

These generalizations have *universal* application. They apply to all men at all times. Generalizations of the highest order are often called laws or principles.

Example:

Interaction between a people and their environment influences the way in which they meet their needs.

2nd Order: Broad-Level Generalizations

These generalizations apply to large regions of the world, cultures, or historical eras; for example, generalizations that apply to all of North America, to the entire Oriental culture, or to the Medieval period.

Example:

Aztec and Yoruba cultures influenced and were influenced by European conquistadores. The material prosperity of the people in Middle and South

*The terms *first order, second order*, and so on are not found in the psychological litera-ture on generalizations. In addition, the terms *principle, law,* or *rule* are sometimes used interchangeably with *generalization*. Our use of numerical order terms is not to add further semantic confusion but to help teachers become alert to the scope and generalizability of the statements, thus making their meaning and usefulness much more readily apparent.

America is influenced by a variety of factors, including the availability of natural resources, worker "know-how," and the people's values.

3rd Order: Intermediate-Level Generalizations

Generalizations at this level are limited to a particular nation or subculture or limited time period, such as France, the Iroquois Indians of northern New York, or the seventeenth century.

Example:

Americans who moved westward from the eastern seaboard during the eighteenth and nineteenth centuries modified their life style to the demands of frontier living.

4th Order: Lowest-Order Generalizations

These generalizations apply only to two or three small samples such as a group of cities in a particular region, the presidencies of Roosevelt and Kennedy, or the decade of the 1920's.

Example:

An abundance of moisture together with a long, warm growing season provide good conditions for growing grapes in the San Francisco Bay area and along the southern shores of Lake Erie.

Summarizing Statements. In contrast to the various levels of generalization outlined above, summarizing statements tend to sum up a series of facts or observations derived from a *single* sample, such as manufacturing in Boston, temperature variations in a single town, or even as broad a topic as the American Revolutionary war. It is well to point out that no matter how much data may be accumulated on any of these topics, this kind of activity still remains a *summarizing* and not a generalizing statement if the data are drawn from a single sample.

From our observations, the compilation of series of facts about some topic is so prevalent, among the practices of social studies teachers and in the organization of many textbooks and materials, that the reader should be cautioned not to regard long factual summaries as generalizations. *It is not until comparisons and contrasts are made with two or more samples and relationships established between important concepts (or variables) that one can be said to be engaged in the process of generalizing. Figure 3.4 illustrates a strategy for teaching children to generalize.*

Learning Generalizations. How do we come to know generalizations? We learn many of them through our actual experience in life. We make a number of observations, form our judgments, and modify them accordingly on the basis of

Figure 3.4
Inferring and Generalizing

This cognitive task requires the students to interpret, infer, and generalize about data. The teaching strategy consists of asking the students the following questions, usually in this order.

Teacher asks	Student	Teacher follow-through
What did you notice? See? Find? What differences did you notice (with reference to a particular question)?	Gives items.	Makes sure items are accessible, for example, chalkboard, transparency, individual list, pictures, or item card. Chooses the items to pursue.
Why do you think this happened? Or, how do you account for these differences?	Gives explanation which may be based on factual information and/or inferences.	Accepts explanation. Seeks clarification if necessary.
What does this tell you about . . . ?	Gives generalization.	Encourages variety of generalizations and seeks clarification when necessary.

This pattern of inviting reasons to account for observed phenomena and generalizing beyond the data is repeated and expanded to include more and more aspects of the data and to reach more abstract generalizations.

Hilda Taba, Mary C. Durkin, Jack R. Fraenkel, and Anthony H. McNaughton, *A Teacher's Handbook to Elementary Social Studies, An Inductive Approach.* Reading, Mass.: Addison-Wesley, 1971, p. 75.

our daily life. In other cases, we accept the statements of adults on the basis of their authority, their age, and their position of knowledge and wisdom.

It is a task of the schools, however, to help students become acquainted with the accumulated wisdom of mankind in a more systematic way than by the process of hit-or-miss socialization through the family or the community. Traditionally, schools have passed on these accumulated generalizations in an expository manner. Teachers have lectured or talked about them; the authors of textbooks have incorporated them as statements of truth. In most cases they have been presented as statements to be learned and accepted with little or no discussion about their derivation or validity. Typically, these have been used in a deductive manner; that is, students have accepted the truth of the statements and then sought examples which illustrate them in particular detail or in local application.

The point of view taken in this text is that children in elementary schools should have maximum opportunities to derive generalizations for themselves. While there certainly is a place for deductive learning, it is our position that this mode of learning has occupied far too large a part of the child's learning experience. In contrast, he has had little opportunity to learn the skills and processes involved in deriving generalizations for himself.

GENERALIZATIONS IN CURRICULUM DESIGN

In planning a unit of study, a teacher usually starts by specifying the end product of the student's learning. This serves as the target or focus for all other planning. Stated in behavioral terms, for example, the learning outcome might be:

Having completed a unit of study on world cultures, students will formulate in oral discussion statements that approximate the generalization:

Cultures vary from society to society. Any given culture changes in the course of time. Some behaviors and institutions within a culture are universal while others vary widely, even during the same period.[13]

Using this as the final goal toward which all activities should point, the teacher can then begin to plan in reverse the content, materials, and learning experiences that would be appropriate to help the student arrive ultimately at this generalization. Figure 3.5 shows a schematic outline of the process. It should be emphasized again that this diagram represents the teacher's planning activity which is to a large measure a deductive process. The children's learning activities, however, start from the bottom of the diagram, and proceed inductively toward the high-level generalization.

A number of lists of generalizations have been compiled by social scientists and educators. A representative sampling of generalizations drawn from some of the recent social studies curriculum projects is presented in Exhibit 3.2. Although the term "generalization" is not used consistently in the project materials, the statements function in the manner described above.

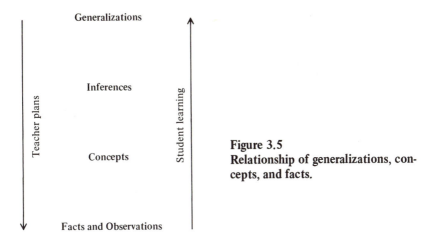

Figure 3.5
Relationship of generalizations, concepts, and facts.

Exhibit 3.2
Sample Generalizations Drawn From Various Social Studies Curriculum Projects

UNIVERSITY OF MINNESOTA PROJECT SOCIAL STUDIES[a]

1. People living in the same physical environment or in the same type of physical environment use it differently depending upon their cultural values, perceptions, and level of technology.

2. All people, regardless of where they live or to what race, nationality, religion or era they have belonged, have many things in common.

3. Culture is learned, not inborn.

4. Governments provide many services which people cannot provide for themselves.

5. Although culture is always changing, certain parts or elements may persist over long periods of time.

6. Improved tools can make possible increased production.

[a]From Edith West, *Teacher's Guide to Families Around the World,* University of Minnesota, 1968, pp. 17, 33, 34, 37, 38, 42.

CONCEPTS AND INQUIRY: THE EDUCATIONAL RESEARCH COUNCIL SOCIAL STUDIES PROGRAM[b]

1. A society consists of individuals and groups in constant interaction.

2. There is a need for authority and power in any communal or cooperative activity.

3. Division of labor is not highly developed in societies that use primitive tools.

Exhibit 3.2 (Cont.)

4. Societies differ not only from place to place but also from period to period.

5. Contemporary America has been influenced by geography and availability of resources, but even more by the conscious or unconscious choices made by our ancestors.

[b]*Explorers and Discovers,* Teacher's Guide, Grade 1, Vol. II, Boston: Allyn and Bacon, 1970, pp. 35, 36, 208. *The Making of Our Anglo-America and the Metropolitan Community,* Teacher's Guide, Grade 3, Boston: Allyn and Bacon, 1970, p. 24. *American Communities,* Teacher's Guide, Grade 2, Second Semester, Boston: Allyn and Bacon, 1970, p. 20.

Note: The term *generalization* is not used to describe these statements; rather, they are called major concepts. In the intermediate grade units they are stated as questions.

MAN: A COURSE OF STUDY[c]

1. Behavior is seldom *either* innate *or* learned, but an integration of the two.

2. Technology is the primary means by which a group uses the energy potential in its environment to overcome the limitations the environment imposes upon it.

3. In all cultures some forms of behavior are more highly valued than others, and the individuals who conform to ideal behavior patterns tend to be rewarded.

4. Men everywhere are born into society and spend their lives in it.

5. First, in every human society, men use tools to exploit the resources of their natural environment.

6. Second, man is a gregarious being who enters into collaboration with his fellow man to satisfy his basic needs, to insure his security, and to improve his well being.

7. Each generation inherits a way of life from its elders that includes social relationships, values, ideas, and a technological system.

[c]*Man: A Course of Study: Talks to Teachers,* Cambridge, Mass.: Education Development Center, 1968, pp. 24, 40, 47, 52, 70, 120.

Note: These are not listed as generalizations in *Man: A Course of Study, Talks to Teachers.* They have been taken from the text and represent guiding generalizations or principles for the teachers. The proper context of each generalization is described in the teacher's manual.

HIGH SCHOOL GEOGRAPHY PROJECT[d]

1. Least cost and maximum profit considerations strongly influence manufacturing location decisions.

Exhibit 3.2 (Cont.)

2. A farmer, in dealing with a biological process, faces economic hazards that a manufacturer does not.

3. As an idea spreads through time and space, its content often changes.

4. Common traits in a cultural heritage can be used to distinguish cultural regions.

5. There are advantages and disadvantages to both large and small administrative units.

6. Boundaries interrupt the flow of people, commodities, and services.

[d]*Geography in an Urban Age,* New York: Macmillan, 1969, "Manufacturing and Agriculture," Unit 2 (Teacher's Guide), pp. iv, v; "Cultural Geography," Unit 3 (Teacher's Guide), p. v; and "Political Geography," Unit 4 (Teacher's Guide), p. v.

Note: The Teacher's Guides do not list these statements as generalizations. Rather they are listed as "main ideas" for the teachers to use in planning.

SENESH'S ECONOMIC PROGRAM[e]

1. The way land is used depends on how much of it is available, its price, government rules and regulations, and its location.

2. There is usually ample land in a small-town neighborhood, and its price is therefore relatively low.

3. In big-city neighborhoods, the price of land is higher than in small-town neighborhoods because more people want to buy the land.

4. The prices of goods and services rise or fall depending on how much of the same or similar goods or services are for sale, and how much of them buyers want to buy.

5. Today many workers have organized into unions to bargain for better wages (more income) and better working conditions.

6. When people do not buy goods, the workers who produce them may become unemployed.

[e]*Our Working World* by Lawrence Senesh, Science Research Assoc., Chicago, 1965. *Neighbors at Work* (Resource Unit), Grade 2, p. 25. *Families at Work* (Resource Unit), Grade 1, p. 46. *Cities at Work* (Resource Unit), Grade 3, pp. 40, 61, 167.

Note: The series *Our Working World* does not use the term *generalization,* rather in each lesson several apparent generalizations are listed for the teacher under "Purpose of the Lesson."

TABA CURRICULUM DEVELOPMENT PROJECT[f]

1. The institutions of a society are economically sustained through a variety of means.

2. Community needs are met by groups of people engaged in many related activities.

Exhibit 3.2 (Cont.)

3. Contact between cultures often brings changes in the social institutions within them.

4. Conflict may develop among groups when goals and expectations differ.

5. The human and natural resources and geographical features of an area influence the material prosperity of the people within that area.

6. The actions of a people are influenced by the values they hold.

[f]*A Teacher's Handbook to Elementary Social Studies, An Inductive Approach* by Hilda Taba, Mary C. Durbin, Jack R. Fraenkel, Anthony H. McNaughton. Reading, Mass.: Addison-Wesley, 1971, pp. 155, 156, 159, 160, 161.

Note: The handbook does not list these statements specifically as generalizations, rather they are listed as "main ideas." However, the handbook does refer to main ideas as "generalizations," p. 12.

"*Sure I worry about my academic standing! But through the inductive approach in the nongraded program, and IPI, I'm able to be cognitive and therefore can goof off every afternoon in the learning center.*"

Reprinted from the *Instructor* © December, 1966, the Instructor Publications, Inc.; used by permission.

Teachers should be cautioned, however, that lists of generalizations are in themselves only lists. When provided in state or local curriculum guides they are intended to serve as *guides*. In most cases, it remains for the teacher to work out the practical dimensions of relating concepts and generalizations to appropriate content, instructional materials, and teaching strategies that are geared to the children in his class. Some of the newer curriculum projects are beginning to spell out these items in more careful detail, and a number of commercial suppliers are now developing relatively inexpensive kits of

materials, often about the size of a large suitcase or foot locker, that contain all the needed materials, books, filmstrips, and equipment.

THEORIES

Theory is the highest form of knowledge and is the main goal of science. When we review the development of theory within the various disciplines in Chapters 5 through 10, you will note a paucity of higher-level theory in social science. There are several reasons why social theory has not blossomed. The social sciences are rather new disciplines. Strong theories develop slowly over a long period of time. Comprehensive empirical theories can be developed only after related and coordinated *empirical* research has been conducted over many decades. The social sciences are not only new, but all of them have a *nonempirical* tradition because they began as branches of social philosophy. The earliest social scientists saw their proper role as normative theorists and policy formers who should prescribe goals for society and tell public officials how to achieve them.

The first social scientists were also "arm chair" theorists who did little empirical research. Early social scientists such as Marx, Comte, and LePlay formulated ideas about man's behavior but rarely did empirical research to test their explanations. As social science developed and some social scientists began to do empirical research in the field, the roles of the "arm chair" theorist and the "field-based empirical researcher" became separated. Often there was little communication between the two areas of specialization. Social scientists have usually been either "theorists" or "empiricists." They have tended to work in isolation; one group formulating "armchair" theories, while the other collected a mass of facts which were unrelated to a theoretical system. Often the terms and concepts in these "theories" were so vague that they provided little guidance to the field researcher who wanted to test the propositions of which they were comprised. Not only did the theorists and the empiricists fail to coordinate their work, but animosity often characterized their relationship. This division of roles still exists to a disappointing extent within social science. Sometimes the theorists and empiricists even show contempt for each other's work and take sides in intellectual and professional battles. Increasingly, however, they are beginning to realize that theorists and empirical researchers must work cooperatively if sound empirical theory is to develop.

It should be noted, too, that education, as an applied social science discipline, is not free of such internal conflicts between theorists and empiricists either. Undoubtedly, the reader is already familiar with the charge that college professors are "ivory-towered theorists" and the counter-charge that classroom teachers are nontheoretical and interested only in "what works in my classroom." As one wag recently put it, "The twin evils currently facing educational research are 'data-free theorizing' and 'theory-free data gathering'."

A search for single explanations to explain man's behavior during the early history of social science also retarded the development of social theory. The first single-factor theories which social scientists used to explain man's behavior

were biological deterministic theories. Reflecting the preeminence of biology in the nineteenth and early twentieth centuries and the influence of Darwin's theory of evolution, anthropologists formulated an evolutionary theory of cultural development; sociologists tried to explain criminal behavior and mental illness with biological variables. As biological determinism was abandoned, social scientists explained man's behavior with other single-factor theories. They began "to attribute the causes of social behavior entirely to the influence of the environment, particularly the economic environment."[14] Karl Marx used economic variables to interpret historical events. Today, most social scientists realize that man's complex behavior cannot be explained with single-factor theories, and that sound empirical theories must encompass a broad range of explanatory variables.

Theory in the social sciences has also lingered because theory is not regarded as the primary goal of research in some of the social sciences, or within certain segments of some disciplines. Many historians, anthropologists, and political scientists do not consider theory construction as the main goal of research in their disciplines. Most historians, as we point out in Chapter 5, consider the colorful description of unique past events as their primary research aim. Historians are reluctant to formulate broad generalizations, yet high-level generalizations are necessary for theory construction. Anthropologists regard the description and comparison of preliterate cultures as their primary research aim. While an increasing number of political scientists (called *behaviorists*, see Chapter 9) regard theory construction as the main task of their discipline, there are many traditional political scientists who believe that their discipline should describe institutions and help public officials make better decisions.

For centuries geography was limited to mapping the exact location of places and giving narrative descriptions of them. Only very recently have geographers attempted to develop broad generalizations and systematic theories of place and space (see Chapter 8).

The search for single explanations in social science is largely past. Most social scientists now accept the fact that man's behavior is so complex that any one-factor explanation of it is bound to be misleading and nonproductive. However, while the normative and nonempirical traditions within the social sciences have decreased in recent years as many social scientists have become more empirical in their approaches, these trends are by no means dead, as will become evident when we review the structures of the various disciplines in Chapters 5 through 10. The normative tradition is vitally alive among traditional political scientists who believe that they should describe the "perfect state." These political scientists are quite critical of the work of their more empirically oriented colleagues and regard much of their work as trivial. While many social scientists do not regard theory construction as their main goal, an increasing number do. Also, social scientists have become much more empirical in their research methods in recent years. Historians, anthropologists, political scientists, economists, sociologists, and geographers often use rigorous methods to gather data and highly statistical techniques for analysis and interpretation. More and more, social scientists are doing research that is built upon a theoretical framework, and thus contributes to the further development

of theory. Of all the social disciplines, sociology has made perhaps the greatest strides in recent years both in using empirical techniques and in building partial theories. In our discussion of social theory below, our examples are drawn primarily from sociology.

The problem of definition

Except for the reluctant acceptance of theory as the main goal of their research, complete agreement about what constitutes *theory* does not exist in social science. Homans has not only harshly criticized the grand "theory" of society formulated by Talcott Parsons*, but has refuted Parson's definition of theory. Parsons defines a theory as a set of "logically interdependent concepts."[15] Homans, on the other hand, defines theory as a set of propositions (or higher-level generalizations)†, each of which explains a relationship between variables (such as x varies with y), and together constitute a deductive system.[16] Homans argues that *concepts* are necessary but not sufficient for a theory. The variables whose relationship is explained by propositions (or generalizations) are concepts. Homans writes:

> Concepts are names for properties of nature, and a theory does not even begin to exist until propositions are stated about contingent relationships of the general form x varies as y between the properties. The reason is obvious: a theory is a deductive system; and no deductions can be made from concepts alone; propositions are absolutely necessary. All sociologists should know this, but it still badly needs saying. Much official sociological theory consists of concepts and their definitions: ... Parsons is particularly good at practicing what he preaches ... his theories seem to consist largely of *conceptual schemes* (italics ours).[17]

Homan's definition of *theory* is more generally accepted by social scientists than Parsons' definition. Zetterberg, in a lucid and seminal book on sociological theory, defines a *theory* as a set of "... systematically organized, lawlike propositions about society that *can be supported by evidence* (italics ours).[18] Timasheff offers a definition of theory which is highly similar to the definitions proposed by Homans and Zetterberg:

> A *theory* is a set of propositions complying, ideally, with the following conditions: one, the propositions must be couched in terms of exactly defined concepts; two, they must be consistent with one another; three, they must be such that from them the existing generalizations could be *deductively* derived; four, they must be fruitful — show the way to further observations and generalizations.[19]

*Parsons is regarded by many social scientists as one of today's most important social theorists.

†The term *proposition* is used in this section on theory as synonymous with *higher-level generalization.*

Summarizing these definitions, we have

1. A theory must consist of a set of interrelated lawlike propositions or generalizations which are testable.
2. The propositions must show the relationships between variables or concepts that are clearly defined.
3. The propositions must constitute a *deductive* system and be logically consistent; unknown principles must be derivable from known ones, and
4. The propositions must be a source of testable hypotheses.

Theory as used in this book refers to these four characteristics of a set of propositions. Although this definition may not be accepted by all social scientists, it is accepted by most of them. It is also used to denote these characteristics in the older sciences, such as physics and chemistry.

Examples of theories

We have discussed the problems of theory construction in the social sciences. However, while no *grand* or all-encompassing theories exist in social science as in the older physical and biological sciences, social scientists have been successful in formulating a number of *partial* theories. *The theories illustrated below are partial because they attempt to explain and predict only a limited aspect of man's behavior.* The first two theories attempt to explain why suicide rates vary among different groups; the last example explains how group expectations determine an individual's behavior. *Grand or inclusive theories try to explain, with a few propositions or models, all group behavior or a total class of phenomena.* Darwin's theory of evolution, Newton's corpuscular theory of light, and Einstein's theory of relativity are examples of grand theories in the biological and physical sciences. We will later discuss attempts to formulate grand theories in the social sciences.

Durkheim's Theory of Suicide[20]

One of the first empirical social science theories, Durkheim used his theory to explain the low suicide rate in Spain. His system satisfies all the characteristics of a theory delineated above.

1. In any social grouping, the suicide rate varies directly with the degree of individualism.
2. The degree of individualism varies with the incidence of Protestantism.
3. Therefore, the suicide rate varies with the incidence of Protestantism.
4. The incidence of Protestantism in Spain is low.
5. Therefore, the suicide rate in Spain is low.

Merton's Theory of Suicide[21]

Merton has formulated and tested a theory to explain the lower incidence of suicide among Catholics than among Protestants:

1. Social cohesion provides psychic support to group members subjected to acute stresses and anxieties.
2. Suicide rates are functions of *unrelieved* anxieties and stresses to which persons are subjected.
3. Catholics (and specified additional groups) have greater social cohesion than Protestants.
4. Therefore, lower suicide rates should be anticipated among Catholics than among Protestants.

Group Expectation Theory[22]

Chinoy reports a sociological theory which attempts to explain why Northerners might develop negative racial attitudes as a result of living in the South.

1. Men tend to behave according to the expectation of others.
2. If men change their associates they are likely, therefore, to acquire the attitudes and behavior of those with whom they have recently established social relationships.
3a. It might therefore be expected that if Northerners with little bias toward Negroes move to the Deep South, they will in time acquire Southern racial attitudes and conform to Southern racial customs, since their new associates will expect such attitudes and actions.
3b. The rate and extent of this change, however, will depend upon whether they associate chiefly with Southerners or with other migrant Northerners.

Grand theories

The *structural-functional* theory of society, set forth by Parsons and others, is an example of an attempt to formulate a grand social science theory.

> The basic perspective of the structural-functional point of view emerges in its prime emphasis on society, and on the interrelations of its institutions, rather than on the individual or groups such as the family. The main question to which it addresses itself is this: How is social life maintained and carried forward in time despite the complete turnover in the membership of society with every new generation? The basic answer it gives: Social life persists because societies find means (structures) whereby they fulfill the needs (functions) which are either pre-conditions or consequences of organized social life.[23]

Another grand theory attempts to explain all group behavior with an equilibrium concept similar to the concept of homeostasis in physiology. The *equilibrium* theory suggests that society maintains a balance by automatically adjusting "when it is upset by internal or external forces."[24] Other theorists argue that far from maintaining a balance, society is characterized by conflict. They feel that man's group behavior can best be explained with the concept of *conflict*.[25] Each of these theories accurately describes certain aspects of man's group behavior, but none of them adequately explain all facets of human society. None are universally accepted by social scientists. Social scientists tend to embrace one theoretical position like a religion and to reject others. Each explanation has been scathingly criticized by some social scientists. Space does not permit a review of these heated and fruitful debates.[26] Each of these explanations is "grand" rather than empirical because each makes assertions and states propositions that lack empirical support and contain concepts that are not clearly defined and thus difficult to measure. There is little consensus among sociologists, for example, about what is "functional" for a society. What is functional for one community in a society may not necessarily be functional for another.

Theory in the social studies curriculum

An analysis of the new social studies projects structured in the 1960's reveals that while most of them suggest strategies for teaching children concepts and generalizations, almost none have suggested ways by which children can discover and master social science theories.[27] Perhaps this reflects the paucity of comprehensive empirical theories that exists in the social sciences. We have not discussed specific strategies for teaching theories to students because there is little available research which can guide the structuring of such strategies. However, we believe that theory learning is appropriate for students in the higher grades, and the authors are currently focusing their research on this problem.

In a recent paper, Cherryholmes argues that theories should guide the formulation of the social studies curriculum.[28] The curriculum builder, Cherryholmes believes, should identify those theories in the social sciences that will best help students to make decisions, and teach the concepts and generalizations that the theories comprise. He contends that only when concepts and generalizations are taught within a theoretical context do they make the maximum contribution to sound decision-making. Cherryholmes feels that ample partial theories exist in the social sciences from which the curriculum builder can select, including such theories as Rogers' theory of personality and behavior, Schlesinger's theory of political ambition, and Lenski's theory of social stratification.[29]

Although there are many partial theories in the social sciences from which the curriculum builder can select, and we feel that this approach to curriculum construction is a promising one, we have no models of curriculums structured around theories. Again, more work must be done in this area before specific

Figure 3.6
The Relationship of The Categories of Knowledge

This figure illustrates the relationship between *facts, concepts, generalizations*, and *theories.*
Note that each category of knowledge is dependent for its development upon the element
below it.

Theory: Durkheim's Theory of Suicide

Generalization: In any social grouping, the suicide rate varies directly with the degree of
individualism.

Concepts: Suicide Rate, Individualism

Fact: Only 7.6 persons per 100,000 committed suicide in Spain in 1965, compared to 16.3
per 100,000 in the United States.*

*Based on data reported in the *Statistical Abstract of the United States*. Washington, D.C.:
U.S. Government Printing Office, 1969, p. 81.

curriculum recommendations can be made. However, during a study of some
concepts (such as suicide, prejudice, political ambition, and social stratifi-
cation), especially in the middle and upper grades, a teacher might draw upon
theories such as those presented above to guide his selection of generalizations
to teach and to help his students to better understand and predict behavior.
Like all forms of knowledge, social theory has limitations. It is tentative and
does not always specify conditions or exceptions. Despite these limitations,
theory is the most powerful form of knowledge which man has yet devised.
Figure 3.6 illustrates the relationship between the various categories of
knowledge discussed in this chapter.

SUMMARY

This chapter has dealt with the *products* of social inquiry: facts, concepts,
generalizations, and theories. These products of social inquiry are subject to
constant reconstruction and revision, and thus the importance of the *process of
social inquiry*. Man must at any given time, however, make use of the most
functional products of learning that can be identified. This chapter has focused
upon the nature of social knowledge and strategies appropriate for teaching
facts, concepts, and generalizations.

Factual knowledge consists of specific data about events, objects, people, or other phenomena that can be or has been verified by the senses. Our perception of some facts may be distorted, however, by biases or value judgments. Concepts are abstract words that are useful for classifying groups of facts, events, or ideas on the basis of similar or common characteristics. Sorting out, classifying, and labelling vast quantities of data within our environment leads us to concepts. These concepts help us reduce the complexity of our world to more manageable proportions. The social studies curriculum provides many examples of highly abstract words used to express very complex ideas, words such as community, society, tradition, social control, power, cooperation, law, and the like. A number of types of concepts were identified (conjunctive, disjunctive, and relational), and appropriate strategies for concept learning were discussed.

Generalizations were defined as statements of relationship between two or more concepts. Statements of the widest application or universality were described as high-order generalizations; those of limited scope, which were drawn from only a few samples of data, were called low-order. Examples were presented showing how high- and low-order generalizations are used to provide major threads of continuity in social studies curricula from grade to grade and between major units of instruction within a grade. Because of the prevalence of isolated fact learning, a distinction was made between the various levels of generalization and a summarizing statement that is confined to data drawn from a single sample or case study. Our caution should be repeated here: *It is not until comparisons and contrasts are made with two or more samples, and relationships established between important concepts (or variables) that one can be said to be engaged in the process of generalizing.*

Lastly, we considered the development of theory in the social sciences and its place in the social studies curriculum. The early differences between the "arm chair theorists" and the "field-based empiricists" were described. Differences were also noted in the importance attached to the role of theory among social scientists and within the various disciplines. Theory was defined as having four essential characteristics:

1. It must consist of a set of interrelated, law-like propositions or generalizations which are testable.

2. The propositions must show the relationships between variables or concepts which are clearly defined.

3. The propositions must constitute a *deductive* system and be logically consistent; unknown principles must be derivable from known ones.

4. The propositions must be a source of testable hypotheses.

Several examples of theories were presented. The relationship between facts, concepts, generalizations, and theory was schematically represented in Fig. 3.6.

The paucity of comprehensive empirical theories in the social sciences was suggested as a partial explanation for the almost complete absence of theory from social studies content. The lack of research by educators on ways in

which children can discover and learn social science theories was also noted. The suggestion was advanced by Cherryholmes that theories should guide the formulation of the social studies curriculum and that the theories selected should be those that would help students most in sound, decision-making processes. Rogers' theory of personality and behavior, Schlessinger's theory of political ambition, and Lenski's theory of social stratification were suggested as examples of partial theory that could be used for social studies curriculum development directed toward effective decision-making.

DISCUSSION QUESTIONS AND EXERCISES

1. Make a list of ten facts that can be or have been verified about some important recent event or problem, e.g., the presidential election campaign, consumer protection programs, a racial conflict, a prolonged strike, or a campus controversy. Are any of these "facts" distorted by biased or prejudiced perceptions of the data?

2. Using the list of ten facts pertinent to any *one* of the events or problems suggested in Question 1, categorize them into groups and label them with an appropriate concept word or phrase. Can some of the items be interchanged between groups? Does this affect the concept term applied to the groups?

3. Using the model suggested in Fig. 3.1, develop a hierarchial list of concepts that might be appropriate for a unit of study on one of the topics in Question 1.

4. The terms *concept* and *generalization* are often confused and substituted for each other. How would you distinguish one from the other?

5. Using some of the concepts that you formulated in Question 2, write four generalizations that might be developed from them (assuming the data are available to support them). Test each generalization by recasting it into the conditional "if . . . then" form to check for the logical relationship among concepts (variables). [The purpose of this exercise is to develop practice in formulating the statement of a generalization, not necessarily in finding the data to verify it.]

6. Examine a current social studies textbook or curriculum guidebook. What evidence do you find that the authors have made use, explicit or implicit, of a set of high-order generalizations that serve to unify the selection of content materials? [Refer to Exhibit 2 in this chapter for examples.]

7. Examine several current social studies textbooks or curriculum project materials. To what extent are students encouraged to compare and contrast material from several sources of data? Is the material organized in such a way that students are encouraged to develop generalization inductively? To what extent are students limited to "summarizing statements" about the materials they are studying?

8. Think back over the social science courses you have had. What major theories from one or more of the disciplines are you familiar with? To what extent do they meet the criteria for theory identified on p. 106 of this chapter? If students were familiar with this theory, how might it contribute to their understanding of concepts and generalizations? How might it contribute to more effective decision-making on social problems related to it?

9. Identify and describe each of the following terms. Give an illustration of how each is used.

a) fact

b) concept

c) generalization

d) hierarchial order of concepts

e) abstract concept

f) concrete concept

g) conjunctive concept

h) disjunctive concept

i) relational concept

j) the organizing function of concepts

k) interdisciplinary concepts

l) positive examples of concepts

m) negative examples of concepts

n) generalizations

o) high-order/low-order generalizations

p) summarizing statements

q) theories

r) "armchair theorists"

s) "field-based empiricists"

t) single-factor theories

u) partial theories

v) grand theories

FOOTNOTES

1. Jerome S. Bruner, Jacqueline J. Goodnow, and George A. Austin, *A Study of Thinking*. New York: Wiley, 1956, pp. 41-43.

2. Robert M. Gagne, *Conditions of Learning*. New York: Holt, Reinhart and Winston, 1965, pp. 137-138.

3. James S. Coleman, *et al.*, *Equality of Educational Opportunity*. Washington, D.C.: U.S. Government Printing Office, 1969.

4. Gilbert Sax, "Concept Formation," in *Encyclopedia of Educational Research*, fourth edition. New York: Macmillan, 1969, pp. 196-205.

5. Frederick J. McDonald, *Educational Psychology*, second edition. Belmont, California: Wadsworth, 1965, Ch. 5, pp. 173-188.

6. Robert M. W. Travers, "Transmission of Information to Human Receivers," *Educational Psychologist*, Vol. 2, 1964, pp. 1-5.

7. David P. Ausubel, *Educational Psychology: A Cognitive View*. New York: Holt, Reinhart and Winston, 1968, pp. 275, 291-292.

8. Gilbert Sax, "Concept Acquisition as a Function of Differing Schedules and Delays of Reinforcement." *Journal of Educational Psychology*, **51**:32-36, 1960. (See also Ausubel, *Ed. Psychol., A Cog. View*. 1968, pp. 317-19.)

9. Anita Simon, *Classroom Interaction Newsletter*, February, 1969.

10. Donald M. Johnson and Charlene A. O'Reilly, "Concept Attainment in Children: Classifying and Defining," *J. Educ. Psychol.*, **55**:71-74, (1964).

11. Hilda Taba, *Teaching Strategies and Cognitive Functioning in Elementary School Children*, Cooperative Research Bureau Project #2404. U.S. Office of Health, Education, and Welfare, San Francisco State College, 1966.

12. Hilda Taba, *Thinking in Elementary School Children*. Cooperative Research Bureau Project #1574, U.S. Office of Education, San Francisco State College, 1964.

13. California State Department of Education, *Social Studies Framework for the Public Schools of California*, Part III. Prepared by the State Curriculum Commission. Sacramento, California: California State Department of Education, June, 1962, pp. 89-109.

14. Caroline B. Rose, *Sociology: The Study of Man in Society*. Columbus, Ohio: Charles E. Merrill, 1965, p. 13.

15. George C. Homans, "Contemporary Theory in Sociology," in Robert E.L. Faris (Ed.), *Handbook of Modern Sociology*. Chicago: Rand McNally, 1964, p. 957.

16. *Ibid.*, p. 953.

17. *Ibid.*, p. 957.

18. Hans L. Zetterberg, *On Theory and Verification in Sociology*. Totowa, N.J.: Bedminister, 1966, p. 22.

19. Nicholas S. Timasheff, *Sociological Theory: Its Nature and Growth*. New York: Random House, 1957, pp. 9-10.

20. Summarized in Homans, *op. cit.*, p. 951.

21. Reported in Alex Inkeles, *What is Sociology? An Introduction to the Discipline and Profession*. Englewood Cliffs, N.J.: Prentice-Hall, 1965, p. 101.

22. Ely Chinoy, *Society: An Introduction to Sociology*. New York: Random House, 1961, pp. 13-14.

23. Summarized by Inkeles, *op. cit.*, p. 35.

24. *Ibid.*, p. 38.

25. *Ibid.*, p. 39.

26. See Homans for a perceptive critique of various grand theories. Inkeles reviews some of the debates surrounding them.

27. For a discussion of these projects see Norris M. Sanders and Marlin L. Tanck, "A Critical Appraisal of Twenty-Six National Social Studies Projects," *Social Education*, **34** (April, 1970), pp. 383-449.

28. Cleo H. Cherryholmes, "Toward A Theory of Social Education." East Lansing, Michigan: Unpublished paper, Michigan State University, Dept. of Political Science, 1971.

29. *Ibid.*, pp. 25-26.

SOCIAL INQUIRY: QUESTIONING STRATEGIES

Of the many methods of teaching, none is more widely used than questioning. The ancient Socratic dialogue is still widely admired as a masterful technique and is looked upon by many as a model to be emulated. As common as the method is, however, little research has been done on the role played in the learning process by classroom questions. Many articles have been written in professional journals urging teachers to ask "good" questions or "thoughtful" questions, or questions that ask "why?" Few specific directions are given, however, to indicate what constitutes a "good" or a "thoughtful" question. Not until very recently have researchers attempted to study systematically the types of questions teachers ask, those raised independently by students, and the relationship of important variables in the questioning strategy to the teaching-learning process.[1] This chapter will examine classroom questions, both oral and written, from a number of considerations: (1) the purpose and function of questions, (2) their use as elements in the teaching strategies related to social inquiry, valuing, and decision-making, (3) various ways of classifying classroom questions, and (4) several simple instruments for observing and analyzing the levels of questioning and for providing feedback to the teacher about his own questioning performance.

THE PURPOSE AND FUNCTION OF CLASSROOM QUESTIONS

Although questions may be used to serve a number of purposes, their most frequent use has probably been as a means of testing students' knowledge, often at the end of a chapter in a book or a unit. The rapid, oral questioning by the teacher has traditionally served as a useful means of review or summary for a lesson, or as a preliminary introduction to new material. To a lesser extent

"I always butter up Mr. Forker by slipping in a couple of boners; he collects them for a book he's writing."
Drawing by Charles Strauss; © 1971, *Today's Education.*

the same function is served by short written tests, or end-of-chapter questions in a textbook. In contrast, the much broader, open-ended questions such as "How do you suppose the Indians got to America in the first place?" serve as motivating devices to arouse curiosity and to focus students' thoughts in a particular direction at the start of a lesson or a larger unit of study. Other types of questions focus upon both the learning process and the content being studied, questions such as "What can you infer from this data? What comparisons or contrasts can you make about the economic aspects of life in the New England town from the material we have about several nineteenth century examples? What can you generalize about the economic life of that period? Are those generalizations still valid today? Can you predict (or hypothesize) what changes might occur in the economic aspects of New England towns (or cities) in the next three decades? How could you validate this prediction (or hypothesis)?"

Although questions of this kind represent an ideal that is frequently discussed and encouraged in the professional journals and methods textbooks, what actually occurs in the classrooms seems to fall far short of these goals. A

Effective questions can elicit enthusiastic student responses. (Washington State Office of Public Instruction, Olympia)

number of recent studies have pointed out that although teachers' objectives are often stated or intended to be at high intellectual levels, the types of questions that teachers ask, whether in oral discussion or as written test items, most often require only the recall of a previously learned answer.[2] We take the position that the teachers' questions should require more than appropriate content responses. They should also require students to use various learning processes such as forming concepts, proposing hypotheses, or developing generalizations. Especially important is the challenge from students and teachers alike:

How do you know?

Where is the data to support that conclusion?

Why do you feel that way?

On what basis do you consider that solution good (or bad)?

In the following pages we shall show how questions such as these can be built directly into the model of social inquiry which we discussed earlier in Chapter 2.

A STRATEGY OF QUESTIONING FOR SOCIAL INQUIRY

The model of social inquiry shown in Fig. 2.1 was composed of a series of elements: (1) expressing doubt or concern, (2) formulating a problem and recognizing the theoretical position or the values implicit in it, (3) formulating working hypotheses, (4) defining or clarifying key terms in the hypotheses, (5) collecting data, (6) analyzing and evaluating the data, and (7) testing the hypotheses and deriving generalizations.

Expressing Doubt: To begin a unit of study that involves social inquiry, the teacher first plans for a situation that introduces some form of incongruity, contradiction, or dissatisfaction so that the students will perceive a problem and see some need to solve it. The nature and scope of the problems will vary, of course, with the age and maturity of the students and their previous experiences, but the essential task remains the same: to arouse the students' curiosity and to motivate them to inquire.

Starting with a Value Question: One approach is to begin with a value question and then shift to a scientific question. Because the value question tends to include a strong element of controversy and emotional tone, it quickly arouses interest and motivation. Several examples follow which show how this shift can be made.

Opening Value Questions: Should we construct a ten-lane freeway through the heart of the central residential district? This will displace 600 or more families. Can they find other places to live which they can afford?

 Following some discussion by the class, the teacher might help to shift the focus of the discussion.

Scientific Questions: How many lanes will be needed on the new freeway to handle the expected volume of traffic to and from the city? By 1990?

 What will be the impact upon the community of efforts to link up a major east-west interstate highway with the principal north-south one? How many homes or businesses will have to be relocated? Will the highway effectively cut one part of the community off from another? Are new shopping centers or playground areas being planned? Are homes currently available for those people whose homes will be demolished?

Opening Value Question: Should Blacks move into white suburbs? After students have given their opinions and have discussed the question for a while, the teacher might shift the focus toward scientific questions related to the original value question.

Scientific Questions: How does the presence of minority groups in a previously all-white community affect the availability of jobs, the quality of education in the schools, the crime rate, etc? What types of discrimination do Blacks face in all-white communities?

Opening Value Questions: After a fight on the playground over the use of the basketball court the teacher might ask the class, "Do you really think the rules are unfair in this school? Do some children seem to get special favors?"

"What are you taking this quarter, the administrative offices or the education building?"

Drawing by Henry Martin. Reproduced by permission of Phi Delta Kappa. Copyright © 1969 by Phi Delta Kappa.

After some minutes of open discussion, during which children would express their opinions and perhaps vent some pent-up anger or frustration, the teacher might attempt to shift the focus by asking scientific questions related to the problem.

Scientific Questions: What are the rules regarding the use of the basketball courts? How is time scheduled? Is there a plan for rotating the courts to prevent one group of boys from using it all the time? What provision is there for settling disagreements once they arise?

Although all the questions posed above are contemporary ones, the same technique can be used to arouse interest in studying problems that have their roots in the past.

Opening Value Question: Should the United States have dropped the atomic bomb on Hiroshima and Nagasaki and caused the loss of thousands of lives and the complete destruction of the two cities?

Students who are sensitive to the implications of mass-destruction of humanity will have many opinions, views, and feelings on this important topic. To prevent the class discussion from becoming a mere exchange of opinions, the teacher must help to shift the focus by asking scientific questions related to the strategic decision made by President Truman and his advisors.

Scientific Questions: What were the strategic considerations involved in the decision? What responses had Japan made to the various peace overtures that had been made? How did President Roosevelt's "unconditional surrender" doctrine affect the strategic thinking of World War II?

Many of the typical topics found in a social studies program can be approached in the same way, topics such as voting rights, "taxation without representation," the westward movement, or the Monroe doctrine. The point is that value questions tend to arouse student interest and motivation and, wherever possible, the teacher should capitalize upon them to begin a problem of social inquiry. In Chapter 12, we discuss other strategies for teaching value-laden issues.

Starting with a scientific question

Not all problems, however, lend themselves easily to starting with value questions. It is also well to rotate one's procedure so a class will not become bored by the same approach to every problem. Here the teacher can skillfully pose what Festinger[3] has called "cognitive dissonance" by introducing a "discrepant event" as an intellectual teaser to arouse curiosity and motivation. Some examples that might be used are:

1. How can the Eskimos live in the extremes of the Arctic climate when people who have recently moved North from temperate zones find great difficulty adjusting to the new climate?

2. Why does the city of Seattle have so little snow when other cities at the same latitude or even lower, such as, Minneapolis, Chicago, Rochester, or Boston, all have so much more?

3. Why can a nation with such a high rate of productivity and so high a standard of living as the United States have large areas, such as Appalachia, where poverty is so widespread?

These examples illustrate ways of using questions to arouse motivation and interest in a problem. Either of the two approaches shown above may be used. Starting with the value question first has the advantage of introducing a strong emotional element which helps to elicit student interest. The teacher must then take steps to shift the focus of the discussion so that it will center upon the scientific questions. Where a value question is inappropriate as a starter or the topic does not lend itself, then a scientific question framed in such a way as to create "cognitive dissonance"[4] by posing a discrepant event may be used to arouse interest and motivation.

PROBLEM FORMULATION

The next stage of the inquiry process is to take the aroused interest and begin to identify the components of a problem. The problem must be one that is researchable, for which there is some possible answer, about which some hypotheses or test questions can be formulated, data collected, and generalizations drawn.

1. Is marijuana harmful? How is it different from alcoholic liquor? What are the social consequences of using drugs?
2. The American shipbuilding industry has been declining steadily since the 1920's. What has the government done to protect its maritime interests and to prevent almost all its import-export trade's being carried in "foreign flag" vessels?
3. What was our town like in the "olden days"? How did it get that way? How did it change as different groups of people came to live in it?
4. How have democratic societies in the past maintained a balance between the need to achieve a consensus on certain common values and the right of people to dissent?

In the framework described in Chapter 2, these problems are identified as *scientific questions*. Working hypotheses can be formulated for each, concepts clarified, data gathered and analyzed, and generalizations derived. Each can be verified by repeated inquiries. Each makes use of data from one or more of the social sciences.

Another approach to formulating an inquiry problem is to pose the same questions as *value questions*, rather than scientific ones. Value questions emphasize the "should" or "ought" of a possible course of action and often imply that some course of action is prized over some other. Here are the same four questions rewritten as value questions:

1. Should we legalize the use of marijuana as we did with liquor?
2. Should the government continue to support the shipping industry but not the trucking industry?
3. Should our town pass a new zoning ordinance to prevent the building of a new low-income housing project?
4. The early Puritans banished Roger Williams into the wilderness of Rhode Island for his "obnoxious heresies." Should we take similar action against some of the most militant radicals today?

Questions such as these readily engage student interest and enthusiasm in the topic. At the same time, however, they are also controversial and come quickly to the heart of conflicting value patterns in the community. Although no responsible school official would deny their rightful place in the school curriculum, they are often relegated to the corner as sensitive topics requiring "special attention." As a result, they are seldom asked in any serious way. Too often, little scientific inquiry has preceded them and no reliable data have been gathered. The teacher is often left with the bland assertion, "each person is

entitled to his own opinion." True, perhaps. But we strongly take issue with the corollary assertion that "one opinion is as good as another." An unsubstantiated or uncritical judgment is certainly not as good as one that has been carefully made by weighing the alternatives, analyzing relevant data, and selecting the choice that is consistent with one's value system. To help teachers avoid this uncritical approach, we will deal with strategies for exploring value questions in Chapter 12. For our purposes here, let us simply say that the value question can be used to formulate a worthwhile problem for investigation.

Theories and values

One further issue should also be raised: that of formulating a problem within a context of a particular theory or value structure. In Chapter 2 we pointed out the different ways in which a behaviorist and a Neo-Freudian psychologist may formulate different problems and hypotheses to explain the same behavior, because of their divergent theoretical orientations. A teacher might help a class to formulate problems within various theoretical frameworks, such as within the context of Crane Brinton's theory of revolution. "Was there a serious economic problem in Cuba prior to the Castro revolution, one that the government was unable to remedy?" This question is based on one of Brinton's generalizations about the presence of a serious economic plight as a prelude to revolution; and, in something of a deductive manner, seeks further data to test the propositions within Brinton's theory.

If the problem were geographic, concerning, say, the development of a city at a particular place, the teacher might help students phrase questions in terms of the city's central location and spatial distance from other cities. "How far is this city from other settlement areas? Is it centrally located and conveniently accessible from all points?" Such questions borrow from the theories of urban geography which attempts to explain the location of cities in terms of space and distance.

In quite the same way, one's value position can also shape the formulation of a problem. The question can be worded so that a normative word or phrase spells out the framework of the question and the dimensions of the problem. Note how the underlined word gives a particular thrust or direction to the following questions:

- What is the most *efficient* route for the construction of this new interstate highway?
- How can school integration be accomplished within the concept of the *neighborhood school* pattern?
- What role did English *pirates* such as Sir Francis Drake play in the decline of Spain as a world power?

Note that in the examples given above, *efficiency*, rather than aesthetic quality or relocation of people, dictates the solution of the highway route. Integration must be accomplished in such a way as to preserve the traditional values of the local school — implying not only the limited use of transportation, but the retention of residential patterns and local control of school policies. Lastly, the

word, *pirates*, assumes that the English were villainous for having seized the Spanish treasure at sea, but makes no similar implication about the Conquistadores, who plundered the Incas and the Aztecs to obtain the gold in the first place. From another point of view, the noble title "Sir" suggests the way in which England's Queen Elizabeth I chose to view the same exploits as heroic deeds in the furtherance of England's national interests.

In summary, the teacher should be alert to implications involved when a problem is formulated in the context of a recognized theory or set of values. To be sure, the problem is immediately given a thrust and direction, and data can be more readily gathered, yet the thrust may be a very confining one and students may not be entirely aware of more viable alternatives. If the value word is strong in its affective element, it may operate as a prejudicial bias, and the results of the inquiry may become little more than a rationalization for a particular course of action one has already favored. To the extent that theories or values serve as frames of references from which to analyze the data or to synthesize explanations for complex phenomena, they are a very useful part of the social inquiry approach. Our point is simply that teachers should help students be alert to the implications and use them with care. They must avoid the trap of falling unexpectedly into a *predetermined* solution to the inquiry problem, thus eliminating whatever significance the problem may have had as an educational experience for examining alternatives, consequences, and values, and for decision-making.

DEVELOPING THE HYPOTHESES

Each of the problems illustrated above is still insufficiently focused to be well researched or to guide the research of the inquirer. Before a question can be fruitfully researched, it must be clearly defined, and related hypotheses must be formulated. In Chapter 2, we discussed the key functions of hypotheses and ways of distinguishing them from other kinds of statements. Here we shall introduce several formats for stating hypotheses.

The simplest way of stating a hypothesis is to use the "research" form. This is no more than a simple statement that states the expected relationship between variables or concepts of a proposition to be tested. For example, a class that is studying industrialization might hypothesize: "The development of new technology results in the growth of new industries and increased productivity." A primary class that is studying local communities might hypothesize, "The larger a community is, the more services it provides for its residents." To be sure, statements such as these look much like generalizations, yet it should be made abundantly clear that they are merely statements whose truth is yet to be tested. For complex problems, it may be that a class will develop several hypotheses, each of which is related to the problem.

A second form for stating the hypothesis is to rephrase the research form into an "if ... then" format. This makes unmistakably clear the conditional and tentative nature of the proposition. The examples cited above might be rephrased to read: "If there is a new development in technology, then there

will be a growth in the number of new industries and in the amount of productivity." The second hypothesis might be phrased: "If the number of people in a community increases, then the community will provide more services for the people." The chief value of the "if . . . then" format is that it requires the student to set the variables (or concepts) in the correct order and makes much more readily apparent any fallacies in the logic of the hypothesis. In addition, the conditional format of the "if" statement allows the students to give fuller reign to their hunches and best guesses. It allows them to send up trial balloons, whereas the research format tends to suggest a more polished and finished result, when what is wanted is only a plausible route for gathering data to test the hypothesis.

Perhaps a word should be added about the problem of the logic of the conditional "if . . . then" hypothesis. Without question, the teacher should be alert to the rules of logic governing the truth of the antecedent "if" clause and the consequent "then" clause.[5] The teacher must also be alert to the problems faced by young children when language becomes confusing because a proposition is stated negatively or double negatives are used when a positive assertion is intended. As a simple rule, it is perhaps best to state the conditional hypotheses in a positive form and avoid the use of negatives wherever possible. If opposite or inverse relationships exist, positively phrased relational concepts should be introduced. Using the example of the community study again, the alternate hypotheses might be: "If the population of a community declines, then the community can provide fewer services to the residents." This is a much simpler form to deal with than a negatively phrased hypothesis, such as: "If the population does not increase, then the community will not increase the services it provides." Not only might the logic be fallacious, but the evidence might not support it either, for many other possibilities may exist under which a community might increase the services it offers.

Apart from the problem of negatives and complex grammatical construction, is the problem of logical fallacies. For most children in the elementary school, the rules of formal logic are much too abstract and complex to tackle in a straightforward way. These might be better left to upper grade classes in the junior or senior high schools. Young children can learn to deal, however, with the problem of the sufficiency of evidence and whether the conclusion is warranted from the data presented. Operating in a simple, inductive framework, teachers can help children question the size of the sample, its representativeness, and the extent to which the evidence presented validly represents the conditions and the conclusions expressed in the hypothesis.

One further problem to be mentioned in connection with hypothesis formation is that of conceptualization or definition of terms. We discussed this matter briefly in Chapter 2, and again in terms of concept formation in Chapter 3. Here, we shall look at it from the point of view of providing operational definitions of particularly abstract or ambiguous words. You may recall that in Chapter 2 we used the example, "How did the colonists in North America influence the culture of Cheyenne Indians?" Because the word *culture* was too imprecise, we rephrased the hypotheses in terms of the changes in tools, beliefs, and practices of the Cheyennes. In a similar way, the abstract concept used in

one of the earlier examples in this chapter might be clarified by defining the term "productivity" as an increase in the number of goods, a reduction in the cost per unit, or the greater availability of the product through wider distribution. Any or all of these definitions might be useful, depending upon the scope of the study and the sophistication of the students.

More illusive is a phrase like *standard of living*, which can have many meanings, depending upon one's conceptual approach. It may refer to the physical conditions of the size of a family's house, the number of rooms, and the number of people who live there. It may also refer to contrast between luxuries and necessities in terms of type and style of clothing, food, use of rooms in a house, or even the level of education. It may also refer to the availability and use of leisure-time activities such as sports, music, or theater. Thus, it is critically important to identify the subconcepts of the more inclusive concept "standard of living" and to define each in some observable way. Here the teacher can help the students clarify their meaning by testing out possible definitions to determine the intended scope of their inquiry. "By *increased standard of living* do you mean that people had more time to participate in local sports, or to attend plays or concerts? Or do you mean that people had larger homes, with different rooms for living and sleeping, and that farm animals were kept outside or in a barn or stable?" Questions such as these not only clarify and sharpen the hypotheses, but guide and direct the collection of data so that valid conclusions can be drawn.

Collection of data

Central to the task of social inquiry is the collection of data that bear upon the problem. As we indicated above, the carefully formulated hypothesis sets the stage to guide and direct the collection of the data. It sweeps away the irrelevant and focuses sharply on the specific questions at issue. If students have defined the terms in their hypothesis carefully, they can then begin searching for appropriate data. It is critically important, however, that the teacher see that sources for data are available for the questions that children are most apt to ask, for nothing is more frustrating to the students than to have developed fine hypotheses, and then have no resources for gathering pertinent data.

Many methods for gathering data are available to the social studies teacher. In Chapter 2, we discussed several of these and showed how the experiment, the case study, the sample survey, and content analysis could all be used in the school curriculum, some more readily than others. Basically, each of these methods asks: *Who? What? When? Where?* and *How?*

- What tools did the Cheyenne Indians have before they came into contact with the white settlers? Afterward? Where and how were they used? What evidence is available? Is the evidence direct or must we make inferences from other data?

- What beliefs did the Cheyennes hold about their origin? Life in an afterworld? Or the forces of nature such as the sun, wind, rains, etc.? What

The Art of
AFRICA
PATIENCE and a
FDDV LEAF
THEY
SHOWED
THE

The teacher must make ample data sources available
for students in order for them to successfully answer
their questions. (Seattle Public Schools, Washington)

evidence do we have? Is it direct? Or must we infer it from some secondary
source?

Similar questions can be raised about the problem of technology and
industrialization, as well as about the size of the community and the number of
services it offers.

As we gather these data, it becomes important to ask questions about the
source of the data and the evidence for them. Is the source a primary one or a
secondary one? Do we have direct evidence or is it based only upon an
inference? If the class is interviewing a parent or town official, is he reporting
his own observations or direct knowledge, or is it a conclusion he has drawn on
his own, or is it perhaps only hearsay (i.e., passing along what someone else has
said.)? All too often, sources for gathering direct evidences are unavailable in the
elementary schools. School textbooks have traditionally been collections of

"I wish I at least knew enough about something to ask questions."
Drawing by Reg Hider; © 1971, *Today's Education.*

factual data, with a large admixture of the author's interpretations and conclusions. And where strategies of teaching were largely expository or deductive, little else may have been needed. Recently, there has been an emphasis upon a multi-textbook approach, but too often this has been interpreted to mean that a classroom would have five or six copies each of several different textbooks, rather than a whole class set of any single textbook. This was merely a division of the same problem since most of the standard school textbooks differed very little from one another in scope or the type of material presented.

Despite the strong preponderance of the single textbook in many school classrooms, there is reason for optimism. Changes are becoming evident in the school textbook industry, and commercial publishers, taking their cue from some of the materials developed in experimental form during the late 1960's, are beginning to produce variable packages of curriculum materials which include original documentary materials (some in edited form), maps, charts, statistical data, transparencies, filmstrips, 8mm closed-loop cartridges, and audio-tape cassettes. Instead of being bound into single, hardbacked texts, various units are being published separately in pamphlet form, often with removable pages so that they can be used in a variety of ways. The catch phrase "multi-text" has now changed to "multi-media." The point is, however, that it is becoming more and more possible for a teacher to have large amounts of data sources readily available in the classroom or in a central materials area. Children need no longer be limited to the single textbook as the only source, occasionally supplemented by library references. Developments such as these make it possible for students to actually gather data at first hand from a variety of sources and to pursue an inquiry mode of investigation in a way that approaches the method of the social scientist.

Collecting and recording the data

One of the problems associated with data gathering in any investigation is the problem of collecting and recording it in some simple and convenient form so that it can be used later for analysis and interpretation. A simple device developed by Hilda Taba[6] and her associates is the data retrieval chart. This is no more than a chart that allows students to log in the data they have found in

Tapes can be a rich source of data for student inquiries. (Seattle Public Schools, Washington)

answer to a series of questions related to the basic concepts involved in the hypothesis. Its chief value is that it can easily be expanded to include more than one data sample; it allows students to ask the same kinds of questions across two or more samples. Thus comparisons and contrasts can be easily made. A data retrieval chart related to the Cheyenne Indian problem is shown in Fig. 4.1. Each of the questions is related to one of the concepts, and the chart forms an easy way for collecting and recording a relatively large amount of data in an abbreviated form. The exact questions to be asked can be agreed upon in a class discussion, and the potential is present for adding additional questions or more concepts as the research progresses. A key point to stress here is the open-endedness of this approach. Students are limited only by the kinds of questions they ask and the sources of data available to them. Additional examples of data retrieval charts are shown in Figs. 4.2, 4.3 and 4.4 and in later chapters.

Deriving generalizations

A strategy for formulating generalizations was outlined in Chapter 3. In this chapter, we call attention to the types of questions asked and the sequence of these in relation to the hypotheses that have been formulated and the data that

Figure 4.1
Data Retrieval Chart: Cheyenne Indians

Analytical concepts and related questions	Before contact with colonists	After contact with colonists

Tools

What kind of tools did the Cheyennes use:

For hunting?
For food?
For farming?
Other uses?

What were they made of?

Where did they get the material?

How plentiful?

Beliefs

What did the Cheyennes believe about:

Origin of their tribe?
Life after death?
The forces of nature?
Did they have a folklore or mythology?
Taboos?

Religious Practices

How did they express their beliefs?
Dances, ceremonies?

Did they perform special ceremonies in honor of the gods?

Was there a special person in charge of ceremonies?

Were there special rites at birth, death, marriage, adolescence?

Did they wear charms, amulets, or dress that had special meaning?

has been gathered. Let us continue to use the problem of the Cheyennes and the hypothesis about the change in their culture after having come in contact with white settlers. When the data retrieval chart (Fig. 4.1) is filled in, it is then possible to ask a series of questions about the data that helps to establish relationships, explanations, inferences, and meaning.

Discrimination of data: What do you notice about the data on the Cheyenne's use of tools during these two time periods? About their beliefs and religious practices?

Comparison and contrast: What similarities do you see? What differences?

Relationships: What things seem to be related to one another?

Explanation: How do you account for this? What may have caused what?

Inference: What does this data mean? Suggest? Or infer?

Generalization: What can you conclude from all this? What can you say that is generally true, based on these two samples of data?

It is important to stress here that the series of questions listed above is designed to result in the formation of inferences and generalizations, which by their very nature, tend to be more abstract than any of the single instances of data, or any summation of them. We stress this because the past practices of teaching have been so heavily loaded in favor of the collection and memorization of vast collections of isolated data. Little or no effort has been made to establish relationships in any meaningful way. What counted most were that the facts were true and verifiable; they could be pointed to with certainty and without equivocation.

In contrast, the process of developing inferences and generalizations takes considerable time and requires much give and take among students and between students and the teacher. Most important, the process must be free of any dogmatic conclusions since the results depend so heavily upon the varied ways in which the students conceptualize the relationship among data, develop explanations, and seek inferences that are beyond the literal meaning of the data. Thus, the strategy has much flexibility and a high degree of open-endedness, provided teachers are willing to accept student ideas and help the student expand on them.

Lastly, a caution should be added about the level of abstraction of the generalization. As indicated in Chapter 3, generalizations may be of high or low order depending upon the scope of the sample from which the data have been drawn and the universality of the application. In the example of the Cheyennes, the generalization is limited both to that group and to the time period of the early contact with white settlers. For the generalization to have a higher level of meaning, data from similar samples of cultural contact must be gathered from other groups and times. If this were to be the major emphasis of study, students might plan to examine in addition to the Cheyennes, the contact and cultural exchange between the Romans and the Goths and Vandals, the Aztecs and the Spanish conquerors, and the New England Yankees and the European immigrants. Figures 4.2, 4.3, and 4.4 indicate how data retrieval charts might look when additional samples of data are used in the study of one's own local community and its past.

While much has been said about the use of high-order generalizations for organizing a curriculum and about the development of theory based upon a well-integrated set of high-order generalizations, teachers must be aware that this is a long and slow process. Most of the work studied at particular grade levels will yield relatively low- or intermediate-order generalizations. What is important, however, is that school or district-wide planning place greater stress upon the coordination between grade levels to maximize the potential

Figure 4.2
Data Retrieval Chart: Our Town

Analytical concepts	Families in our town	Families in an "Old Time" farm village
Family		
Who lives with the family?		
What does each person do?		
Mother Father Children Grandparents Others		
What do families spend money for? Or provide by their own work?		
Work		
Who does "human labor"? For what purposes?		
Is animal labor used? For what?		
Is machine labor used? For what?		
How much time is involved in work?		
Money		
How are people paid for the work they do?		
How do people buy things they need?		

cumulative effect. Only when students learn to build consecutively upon previously developed work will they be able to develop higher-order generalizations or gain experience in synthesizing these into larger packages called theories.

Summary of the discussion on generalizations

We have shown how a deliberate strategy of questioning can be built into the model of social inquiry presented in Chapter 2. Distinctions were made between the need to arouse interest on the part of the student and the identification of the problem itself and its components. Examples were cited of ways of formulating a problem as either a scientific question or a value question. Attention was drawn to the strengths and limitations of casting a problem in the context of a particular theory or set of values and the need for being consciously aware of this factor. Techniques were suggested for narrowing down the problem to focus upon the hypothesis as a framework to guide and direct the search for data. Two possible formats were suggested for the hypothesis: the research form and the conditional "if . . . then" proposi-

Figure 4.3
Data Retrieval Chart: The Changing Nature of Our Town

Analytical concepts	During Indian days	Period of early settlers 1660-1740	Our town a century ago 1870	Our town today 1970
Geographical site				
Boundaries?				
Physical features?				
Climate?				
Natural resources?				
How used?				
Technological development				
What tools used?				
New machines invented?				
Other discoveries?				
Utilization of place and space				
Location of homes?				
Farms? Businesses?				
Mills? Factories?				
Percent of town for each?				
Population distribution				
Farmers? Merchants?				
Mill hands? Ethnic groups?				
Religious groups?				
Density?				
Rate of growth?				
Connecting links				
Main roads?				
Where to where?				
New routes?				
Old or abandoned routes?				

tion. A number of ways were suggested for gathering data related to the hypothesis. Emphasis was placed upon the use of analytical questions which flowed from the basic concepts used in the problem. The data retrieval chart was presented as a convenient method of recording and collecting data for the questions asked in the data-gathering process. Finally, a series of questions were presented that can be used to lead students to make inferences and generalizations. These questions stressed the processes of discrimination, comparison and contrast, relationships, explanation, inference, and generalization. Distinctions were made about the level of generalizations that could be developed in classrooms and the problems related to formulating high-order generalizations and relating these into a comprehensive body of theory.

Figure 4.4
Data Retrieval Chart: Study of the Textile Industry

Analytical concepts	Textiles 1840 to 1970	Textile mill in our town 1890 to today
Technological developments		
What handicrafts were in evidence? Tools used? Skilled artisans? What kinds of machines were used? Were new processes developed? What sources of power were used?		
Work		
How much was done by hand? How much by machine? How much did any single person do? How was the worker paid?		
Capital resources		
What did a person have to own or buy to set up a textile business? How much equipment did he need? Who owned the shop or mill?		
Distribution of population		
Number of people working on farms? Number working in factories? Percent in rural, city areas? Density of population in rural and urban areas? Number and size of families in rural, urban areas?		
Groups		
What special interest groups? Roles they played? Social or ethnic groups?		

HIGHER LEVELS OF QUESTIONING

In the preceding section we discussed a strategy of questioning that was based upon a model of social inquiry. In this section, we shall describe two other strategies of questioning, each of which is based on a somewhat different model of thinking processes. The first is based upon Bloom's *Taxonomy of Educational Objectives: Cognitive Domain;*[7] the second finds its roots in Guilford's *Structure of the Intellect.*[8]

Bloom and his associates originally developed the *Taxonomy* as a tool for classifying educational objectives. They identified six levels of instructional goals. The first deals with the recall of specified knowledge; the remaining five deal with various cognitive or intellectual skills: comprehension, application, analysis, synthesis, and evaluation. A chart showing the operational definitions of each of these categories is presented in Fig. 4.5.

Built into the taxonomy is an assumption that the categories are cumulative and hierarchial.[9] One must have knowledge in order to comprehend. Application requires both knowledge and comprehension. Each of the higher-level categories progresses similarly by including all the categories below it, as shown in Fig. 4.5. The hierarchial notion is based upon the increasing degree of complexity and sophistication of the cognitive processes involved as well as their cumulative character. Although these categories are often described as being at higher levels, one should not infer that one process is better or of greater worth than some other. What is important is that there be a balanced emphasis upon these processes and that students be given the opportunity to learn to develop them as early as possible. All too often, local or state curriculum guides have included instructional goals that required students to analyze, to apply, to synthesize, or to evaluate what they have learned. The teacher's objectives, activities, and test questions, however, have been almost entirely at the knowledge recall level, with a smaller number at the comprehension level, and almost none at any of the other levels. In short, what actually occurs in the classroom often falls far short of the high-level goals called for in the curriculum guides and in the teacher's own plans.[10] Let us see how the operational definition of each category of the Bloom *Taxonomy* can be used to describe a different level of questioning.[11]

KNOWLEDGE QUESTIONS

A knowledge-level question requires the student to recall specific facts, names, places, trends, previously learned concepts, generalizations, or theories. The key factor is that the student is expected to produce from memory some previously learned knowledge.

Classroom situation

Knowledge questions are most often used when students have read material in a text or reference book, watched a film, or completed a unit of study. The question refers specifically to what has been studied previously. The expected or correct answer is usually a verbatim repetition from the text, from a class discussion, or some similar source. Given such settings typical knowledge-level questions include:

1. List the major cities in the northeast region of the country.
2. Give some of the main reasons for the growth of manufacturing.

Figure 4.5
The Taxonomy of Educational Objectives – Cognitive Domain

A Hierarchial Classification of Intellectual Abilities and Skills

Knowledge (memory)

Ability to recall, to bring to mind the appropriate material which may include

terminology
classification
trends
criteria
methodology
generalizations
structure

Comprehension

Ability to know what is being communicated and to be able to make some use of the materials or ideas contained in it.

Such behavior involves:
translation into other terms or forms.
interpretation, a reordering of ideas and understanding of their interrelationships.
extrapolation, the making of estimates or predictions based on understanding tendencies, trends, or conditions described in the communication.

Requires:

Knowledge

Application

Ability to use ideas, principles, and generalizations in new situations.

Involves being able to remember and bring to bear upon given new material the appropriate generalizations and principles.

Requires:

Knowledge and Comprehension

*Adapted from Benjamin S. Bloom (Ed.), *Taxonomy of Educational Objectives: Handbook I – The Cognitive Domain.* New York, David McKay, 1956. Reprinted with the publisher's permission.

Figure 4.5 (Continued)
The Taxonomy of Educational Objectives — Cognitive Domain

Analysis

Ability to identify
the component parts of
an idea and to establish
the logical relationships
of the parts to the
whole. The activity
involved must emphasize
the use of inductive or
deductive reasoning
processes in some form.

Requires:

Knowledge,
Comprehension, and
Application

Synthesis

Ability to draw
upon elements from
many sources and
put these together
into a structure
or unified organization
or whole not clearly
there before.

Requires:

Knowledge,
Comprehension,
Application, and
Analysis

Evaluation

Ability to make
judgment about the
value, for some
purpose, of ideas
or procedures, solutions,
methods, materials.
Uses criteria (determined
by student or given to
him) for appraising the
extent to which particulars
are accurate, effective,
economical, or satisfying.

Requires:

Knowledge,
Comprehension,
Application,
Analysis, and
Synthesis

3. What were Jefferson's views on liberty?

4. Identify the main causes of the civil war.

Key words

A number of key words can be identified in the teacher's questions that give students clues to the cognitive level expected in the reply. There seems reason to believe that the use of this kind of "grammar of the interrogative" can be very fruitful in helping students learn to use higher-level cognitive processes.[1][2] Some examples of key words that usually indicate a knowledge-level question are:

define	identify	recall	state
describe	list	recognize	tell
distinguish	name	show	write

COMPREHENSION QUESTIONS

A comprehension-level question requires the student to understand the meaning of an oral or written communication and to make some use of it. Three important subcategories are included within the larger category of comprehension: *translation, interpretation,* and *extrapolation.*

In a *translation* question, the student is expected to express an idea in similar or equivalent terms. He is not expected to explain or reason with the idea, but only to restate it in a way that approximates its literal meaning. "Tell in your own words . . ." is one of the simplest forms of a translation question.

Interpretation requires the ability to relate things to one another, to reorder, to put into some arrangement or sequence, to establish relationships by comparing or contrasting, to separate essentials from nonessentials, or to demonstrate how an idea or concept can be used in a particular instance.

Extrapolation requires that a student predict or estimate an event from a known pattern or trend. This frequently includes the ability to project trends on the basis of statistical data or occasionally to interpolate when data are missing. But, in a wider, and much more critical sense, it also means the ability to extend the trend or tendency beyond the original limits of the data and make inferences, draw implications, and state the probable consequences of ideas or events. The key factor is the ability to make appropriate inferences as to the probable trend or continued direction of the event, phenomenon, or pattern of ideas that can still be regarded as legitimate extensions of the original data.

Classroom situations

From the explanation given above, one can readily see that comprehension questions have the potential for being a vital part of many classroom activities.

The data retrieval charts introduced earlier in this chapter (Figs. 4.1, 4.2, 4.3, and 4.4) offer many possibilities for teaching children to compare and contrast data, to establish relationships between items, to seek explanations, to state implications, and to make inferences. In primary grades, children might simply point to different items in a picture and explain orally the relationships involved. In a much more sophisticated way, students in an upper grade might use a graph to predict the probable trend of population increase or decline in large urban centers. In contrast to the knowledge-level questions which involve the recall from memory of a previously learned response, all these activities are new experiences for the student. Thus a test question must use materials or situations different from those used previously in class study. To repeat the same question without change reduces it to the knowledge-recall level. Given such conditions, typical comprehension-level questions might include:

1. Explain how "division of labor" takes place in a factory.
2. Contrast the systems of education found in the United States, France, and the Soviet Union. What aspects do they have in common?
3. Explain in your own words the statement attributed to Clemenceau, "Wars are too important to be left to generals."
4. Given census data for 1950, 1960, and 1970 for the ten largest cities in the United States, what trend do you see emerging? What would you predict the population of these cities to be in 1980?

Key words

Some key words usually indicate a comprehension level question, for example,

compare	estimate	give an example of	predict
conclude	explain	hypothesize	rearrange
contrast	explain the meaning of	illustrate	relate
demonstrate	extend	infer	reorder
differentiate	extrapolate	interpolate	rephrase
distinguish	fill in	interpret	tell in your own words

APPLICATION QUESTIONS

In an application question, a student is required to demonstrate that he can make use of some previously learned relationship or idea. An application question differs from comprehension-level questions in that the student is not told specifically how to apply a particular idea, but must be able to select the appropriate idea, concept, or principle and apply it correctly to the given situation. In short, application requires the student to transfer his learning to a new situation with little or no direction.

The construction of model communities enables students to apply concepts and generalizations which they have learned. (Highline Public Schools, Seattle, Washington)

Classroom situations

Application questions most often require students to solve some problem, to construct something such as a model farm or town, to put some skill into practice, or to take some appropriate form of action within the social context of the real world outside the classroom. Primary grade students who have studied transportation routes and the exchange of goods and services, might apply the concepts and generalizations they have learned by constructing a model town and play-acting with toy trains or trucks. Older students can apply ideas and concepts by role-playing a session of the United Nations or a state legislature as it attempts to decide some important issue. Simulation games, such as *Democracy* or *Napoli*, although designed with a set of quite specific rules, require students to apply the principles of the political process to a fast moving and exciting game that comes very close to approximating the real life situation. Finally, the social studies classroom meets the real world when students actually apply what they are learning by engaging in social action situations. This may take the form of participation in a student council (where

it has a truly meaningful role in a school and is not simple windowdressing), writing letters to the editor, collecting signatures on a petition on some local issue, or ringing doorbells in support of a political candidate. Given such settings, typical application questions might involve:

1. Using the sand table, develop a plan for and build a model layout of a medieval manor or estate.
2. Locating as many different kinds of material as possible on the Pilgrims' first Thanksgiving by a fourth-grade class that has been recently introduced to the card catalog and various kinds of reference materials in the school library.
3. Writing a play (or role-playing a scene) that illustrates the controversy about whether or not the United States should join the League of Nations after World War I.
4. Developing a plan for calling the community's attention to the seriousness of the environmental pollution problem. Gather the necessary data and be prepared to present it at a public hearing on the topic. (The class has recently completed a study of pollution of the environment. The community seems unaware of the problem.)

Key words

Some key words that usually indicate an application-level question are:

apply	construct	develop	solve
build	demonstrate	plan	

ANALYSIS QUESTIONS

The analysis level requires that a student break down an idea into its component parts and distinguish these parts with a conscious knowledge of their relationship to one another. This involves the ability to

1. identify or classify the elements of an idea or statement,
2. make explicit the relationships among these elements, and
3. recognize the organizational principles or structure which holds a broad idea or statement together.

At the first level, the student is able to distinguish assumptions from conclusions, to determine whether a conclusion is warranted from the evidence presented, or to detect the presence of an unstated but implied assumption that may invalidate the initial premises. The second level involves the ability to recognize the relationship of part to part, to recognize which facts are essential to support the main thesis, or to distinguish relevant from irrelevant data. The third element is concerned with the ability to recognize the form, pattern, or organizational structure of a statement or set of ideas, and to relate this to the

overall intent or meaning. Thus, a student can recognize various parts, such as the major theme and local variations in a political candidate's speech, the techniques of persuasion in advertising or propaganda, or the viewpoint or bias of a writer in a historical account.

The difference between *interpretation* and *analysis* questions depends on the extent to which the student is *aware of and makes use of the formal processes of reasoning*. At the interpretation level, a student may make inferences and generalizations, state relationships, formulate hypotheses, or deduce conclusions about specific situations from broad generalizations without reference to the formal processes involved. For the same processes to be at the analysis level, the student must be consciously aware of these intellectual processes and the rules of logic for reaching a valid or true conclusion.[13]

Classroom situations

The strategies of teaching for social inquiry, valuing, and decision-making outlined in this book offer many possibilities for analytical thinking. These strategies are essentially inductive and are based upon the thought processes defined above. These are more explicitly defined in the earlier part of this chapter and in Chapter 2. Thus, it is not at all unreasonable or impractical to expect children in the lower grades to be able to distinguish a fact from an opinion, a hypothesis from a generalization, or to determine whether the evidence gathered is sufficient to warrant the conclusion that is drawn. We assume, of course, that the meaning of these terms (or their equivalents) has been carefully developed and that the subject content matter is within the capability of the children. Students at upper-grade levels might be expected to deal with the second and third aspects of analysis, particularly as they learn to detect unstated assumptions in arguments, or identify elements of form and style in primary source materials that indicate personal points of view, biases, or prejudices, as distinguished from objective evidence. They can also learn to identify specific techniques of persuasions borrowed from mass media advertising, now being used so frequently in political campaigns. Commonly available material, such as bumper stickers, lapel buttons, billboards, newspaper ads, and TV spot commercials for political candidates all can be used to illustrate such techniques as the half-truth, the catchy slogan, the appeal to selected values, stacking the deck in favor of one side, the deliberate distortion, and the big lie. For a student to be able to recognize the intentional use of these techniques when he comes upon them in campaign literature or in public statements gives evidence of analytical thinking. Given such settings, typical questions at the analysis level might be:

1. Analyze the following slogans. What techniques of persuasion are used in them?

Our country and our flag: Love them or leave them.

Our nation's flag: Love it or leave it.

Death to all Pigs.

Keep your local police force independent.

Law and Order.

2. Having studied the problem of cultural change following contact between the Cheyenne Indians and the white settlers, a class might formulate the generalization: "A technologically less advanced society will quickly adopt aspects of the technology and belief systems of a more technologically advanced society when such societies come into extended contact." The teacher might challenge this generalization by asking: "What data supports the notion that the change will occur quickly? Or that the belief system will necessarily change because the technology is adopted? Isn't there an assumption that *all* technologically less advanced societies will react this way? Is the data from one case study sufficient to warrant this broad generalization?"

3. Analyze the views of white slaveholders as described by Frederick Douglass, an ex-slave, in his autobiography, *Narrative of the Life and Times of Frederick Douglass*, and by former slaves in Botkin's *Lay My Burden Down: A Folk History of Slavery*. Make a similar analysis of the accounts written by historians such as Ulrich B. Phillips, John Hope Franklin, and Kenneth B. Stampp. What evidences are there in the choice of words, style, or form that indicate the writers' viewpoints about the white slaveholder?

Key words

Some key words that usually indicate analysis level questions are:

analyze	compare	discriminate
categorize	contrast	distinguish
classify	detect	recognize

SYNTHESIS QUESTIONS

To a synthesis question, a student is expected to be able to respond by combining or integrating a number of facts or ideas into some arrangement that is new for him. This often takes the form of a plan, a proposal, or some product such as a story. Synthesis differs from application in that the form of the final product is not specified, nor are the ways in which the elements may be combined. It is this feature that makes the synthesis a unique and creative activity.

In contrast to the types of questions discussed above, where each implies a particular form of thinking process, the synthesis question usually gives no cues to the student and is intended to be broad and open-ended. It does not imply any right answer, but instead assumes a variety of possible solutions, any or all

of which could be acceptable. In short, it seeks divergent, rather than convergent, thinking.

Classroom situations

There are many possibilities for using synthesis questions in the social studies class, but the weight of a tradition concerned with factual answers that can be demonstrated as correct has militated against their use. In the elementary school, the variety of reasons for early exploration can be synthesized into a fictional story or a carefully written paragraph. Other common forms of synthesis include writing a short play, role-playing, preparing a mural, a bulletin board, or a show-case display. Most frequently overlooked, especially in primary grades, is the short oral statement synthesizing (but not merely restating) a group of explanations for some event into a broader proposition. Here, too, is the chance for children to speculate freely and imaginatively upon possible courses of events or actions, using factual data, interpretations, or new relationships to support their conjectures. "What would happen if . . .?" "What are the possible courses of action . . .?"

To be sure, there is probably only a thin line between the creative or imaginative response and that which can be characterized as fantasy. Indeed, the fantasy or science fiction of Jules Verne has become the scientific reality of our own day! Thus, a teacher should be slow to label a student's solution "silly" or "impossible," but rather should ask how the solution is possible or probable. Perhaps the following example will illustrate the difference between creativity and fantasy:

> The owner of a large lumbering company found a new forest in a remote, mountainous area where there were many fine, tall trees that could produce thousands of boards of lumber. But the floor of the forest was so steep that bulldozers or tractors could not operate there. How many different ways can you think of to get the logs out of the forest?

Children's responses might include:

a) a conveyer belt could be built.

b) a helicopter equipped with a towing line and sling could be used.

c) gas-filled balloons could be used to lift the logs.

The child who suggests that "the dwarfs and elves who live in the forest could bring out the logs" would clearly be in the fantasy world of *Snow White and the Seven Dwarfs.* Such responses are more appropriate during the study of fantasy in children's literature lessons.

Given the settings described above, typical synthesis questions might include:

1. What solutions might be proposed for the problems of air pollution?

2. What possible courses of action might have been open to President Truman immediately prior to the beginning of the Korean War?

3. In how many different ways can prisoners in jails engage in rehabilitation programs?

Key words

Some key words that usually indicate a synthesis-level question are:

create	formulate a solution	propose a plan
develop	make up	put together

EVALUATION QUESTIONS

The evaluation question asks the student to make a judgment about the worth or value of something. Is it good or bad, beautiful or ugly, trivial or worthwhile? The student must appraise, assess, or criticize some idea, statement, or plan on the basis of specific standards or criteria that he has developed himself or that may be provided by the teacher or some other source. Thus, the student must indicate the criteria upon which he has made his judgment and supply appropriate data to justify his position. In short, the evaluation level requires much more than an unsubstantiated opinion based purely upon personal whim or opinion.

Classroom situation

There are many situations in which a student can make a judgment, especially in the decision-making mode of inquiry which we will discuss in Chapter 13. If several alternatives are given, a student must select one, using some appropriate criteria. Under these conditions, the evaluation level is heavily cognitive, even though a judgment about worth or value is being made. The distinction between empirical and normative judgments are discussed in Chapters 12 and 13.

Typical evaluation questions might be:

1. "Which policy will result in the greatest good for the greatest number?"
2. "For what reasons would you favor . . .?"
3. "Which of the books would you consider of greatest value?"
4. "Evaluate that idea in terms of cost and community acceptance."

Key words

Key words that would indicate an evaluation level question are:

choose	evaluate	select
decide	judge	which do you consider

A chart for classifying classroom questions based on Bloom's Taxonomy is presented in Fig. 4.6. This chart represents a simple device for recording the frequency and level of a teacher's questions. At the same time, it provides an

Figure 4.6
Classroom Question Classification

		Category Description (Part A)
Category name	Expected cognitive activity	Key concepts (terms)
1. Remembering (Knowledge*)	Student recalls or recognizes information, ideas, and principles in the approximate form in which they were learned.	Memory, knowledge, repetition, description.
2. Understanding (Comprehension*)	Student translates, comprehends, or interprets information based on prior learning.	Explanation, comparison, illustration.
3. Solving (Application*)	Student selects, transfers, and uses data and principles to complete a problem task with a minimum of directions.	Solution, application, convergence.
4. Analyzing (Analysis*)	Student distinguishes, classifies, and relates the assumptions, hypotheses, evidence, conclusions, and structure of a statement or a question with an awareness of the thought processes he is using.	Logic, induction and deduction, formal reasoning.
5. Creating (Synthesis*)	Student originates, integrates, and combines ideas into a product, plan or proposal that is new to him.	Divergence, productive thinking, novelty.
6. Judging (Evaluation*)	Student appraises, assesses, or criticizes on a basis of specific standards and criteria (this does not include opinion unless standards are made explicit).	Judgment, selection.

*Term used in Bloom (1956).
Adapted from Gary Manson and Ambrose A. Clegg, Jr., "Classroom Questions:
Keys to Children's Thinking," *Peabody J. Educ.*, pp. 304-305, March, 1970.
Reprinted with permission.

Figure 4.6 (Continued)
Classroom Question Classification

	Recording Form (Part B)	
Sample phrases and questions	Tally column	Percent of total questions asked

1. What did the book say about . . . ?
2. Define . . .
3. List the three . . .
4. Who invented . . .

1. Explain the . . .
2. What can you conclude . . . ?
3. State in your own words . . .
4. What does the picture mean?
5. If it rains, then what . . . ?
6. What reasons or evidence . . . ?

1. If you know A and B, how could you
 determine C?
2. What other possible reasons . . . ?
3. What might they do with . . . ?
4. What do you suppose would happen if . . . ?

1. What was the author's purpose, bias, or
 prejudice?
2. What must you know for that to be true?
3. Does that follow?
4. Which are facts and which are opinions?

1. If no one else knew, how could you find out?
2. Can you develop a new way?
3. Make up . . .
4. What would you do if . . . ?

1. Which policy will result in the greatest good
 for the greatest number?
2. For what reason would you favor . . . ?
3. Which of the books would you consider
 of greater value?
4. Evaluate that idea in terms of cost and Total questions
 community acceptance. evaluated = Sum = 100%

easy way for observing and analyzing their cognitive level. Key concepts related to each of the categories are used as handy guides to remembering them. Other methods for observing, recording, and analyzing one's own questioning strategies are presented in Chapter 14 in the section "Evaluating Classroom Questions."

As we have seen, Bloom's *Taxonomy of Educational Objectives* can be modified to serve as a guide for developing a strategy of questioning. This model is a hierarchial one that involves a variety of cognitive processes and skills, each of which can be used in the classroom at any grade level. A number of recent research studies have shown the effectiveness of this approach. Farley and Clegg[14] demonstrated that when teachers were trained to use the Bloom *Taxonomy*, they asked significantly more higher-level questions than those without training. In related studies, Clegg and others[15] showed that sixth-grade children could be taught to ask higher-level questions using the same strategies. Approaching the problem somewhat differently, Hunkins[16] has shown that instructional materials using questions at the analysis and evaluation levels resulted in significantly increased achievement in social studies.

EMPHASIZING CONVERGENT AND DIVERGENT QUESTIONS

The strategy of questions discussed above deals with a model based upon a hierarchial set of categories that describes different cognitive processes. Quite a different strategy of questioning has been proposed by Gallagher and Aschner.[17] This strategy is based upon Guilford's model of intellectual processes.[18] Guilford conceived of the intellect as a complex structure of some 120 separately identifiable mental abilities. These are derived from a hypothetical three-dimensional model that interrelated five classes of intellectual operations, four kinds of content, and six types of products or outcomes. These are shown in a cube-like model in Fig. 4.7. The feature of the Guilford model that has probably provoked most interest has been its concern for convergent and divergent thought processes as they relate to creativity. Gallagher and Aschner's subsequent studies on creativity lead them to identify five types of questions often found in teaching situations:

1. *Cognitive-memory*: This category requires the recall of a previously learned or memorized response. It is very similar to the *knowledge* category of the Bloom *Taxonomy* discussed above.

2. *Convergent*: These are questions that tend to channel a student's responses along a single direction. They are usually narrowly defined and often require a single correct or best answer.

3. *Divergent*: These are questions that seek a variety of possible answers or solutions to a problem. They encourage creative or unusual responses

Figure 4.7
Guilford's Three-dimensional model of the structure of intellect.
(From J.P. Guilford, "Three Faces of Intellect," *Am. Psychol.*,
1959, **14**:469-479. Reprinted with permission.)

rather than a single, best solution. Such questions tend to be broad and
open-ended. They lend themselves to a variety of possible answers, all of
which could be acceptable.

4. *Evaluative*: Evaluative questions are those that ask the student to make a
 judgment about the worth or value of something. This category is much
 the same as *evaluation* in the Bloom *Taxonomy*.

5. *Routine*: This last category is a catch-all for questions that deal with
 classroom routines, procedures, or housekeeping activities. "Does everyone
 have a book?" "Is the room too warm?" "Has everyone turned in his
 assignment?"

The studies by Gallagher and Aschner[19] indicate that the cognitive-
memory question was the most frequently used type of question, followed
next by convergent and routine questions. The divergent question, the one
more likely to elicit creative and higher-level responses, was seldom used. These
findings are consistent with those mentioned earlier that reported an almost
exclusive reliance upon the knowledge-level question.

In many respects, this model is somewhat simpler in concept and perhaps
easier to use than the model of the Bloom *Taxonomy*. Two of the categories,
cognitive-memory and evaluation are almost identical in both models. At some

risk of oversimplification, convergent and divergent questions may be thought of as narrow and broad questions. The two models have very few other similarities. They are drawn from different conceptual schemes. The reader should not try to match up parts with one another in order to force an equivalence. Nevertheless, this model does offer an intriguing and viable alternative to the Bloom *Taxonomy* and can help a teacher prepare questions for a variety of intellectual processes.

SUMMARY

In this chapter we have presented several stragegies of questioning.[20] The first one was based upon a model of social inquiry developed earlier in Chapter 2. It suggested a variety of questions that could be used for each of the steps of the inquiry model. Two alternate strategies were presented. One was based upon the six levels of cognitive processes identified in Bloom's *Taxonomy*. Emphasis was placed upon the expected cognitive activity required at each level, and key words that could be used in developing a "grammar of the interrogative" were identified. The second strategy followed a set of categories based on Guilford's model of the structure of the intellect. This strategy emphasized the use of convergent and divergent questions and their role in developing creativity. Although these last two models had some similar aspects, they were shown to be quite different. The reader was encouraged to view them as two different approaches to the same problem, developing a wide range of thought processes.

DISCUSSION QUESTIONS AND EXERCISES

1. Children in the primary grades often study some aspect of their local community. Write out some questions that might be used to express doubt or concern to begin the process of social inquiry: (1) a value question followed by (2) scientific questions.

2. Take several conventional topics such as the Westward Movement, the American Revolution, the Writing of the U.S. Constitution, or the Age of Exploration and prepare an opening value question for each. Then show how the discussion could be shifted by asking appropriate scientific questions.

3. A social inquiry problem can often be begun by introducing a "discrepant event" as an intellectual teaser to arouse curiosity and motivation. Select three such situations and write questions that involve a discrepant event that could be used to start an inquiry study.

4. Select a theory from one of the social sciences with which you are familiar. (Several were described briefly in Chapter 2, and others are discussed in Chapters 5 through 10.) Develop two or three questions that could be used to begin a social inquiry study within the context of that theory. Are there

competing theories within which alternative questions could be raised to cast the social inquiry study in an entirely different light and possibly provoke quite different answers?

5. Write a problem question for social inquiry which can be formulated in the context of a particular value. What other competing or alternative values might be involved? Pose an additional question or two in the context of a competing value.

6. Using the questions you prepared in Questions 1 through 5, write suitable hypotheses for each that could be used in a social inquiry study. Write each first in the research form, and then in the "if . . . then" format.

7. The use of the conditional "if . . . then" form for stating hypotheses has been advocated in this chapter. What are some of the advantages and limitations of this approach? What difficulties related to the rules of logic and semantic confusion should be expected? How can they be minimized?

8. Re-examine the hypotheses you wrote for Question 6. Circle any words that are particularly abstract or ambiguous for elementary or junior high-school students. Redefine these words to make the hypotheses more precise.

9. Using any of the hypotheses you wrote for Question 6, prepare a data retrieval chart for gathering appropriate information. Be sure you identify the major concepts from the hypothesis and that you list under each concept a number of related questions that will help guide the search for data. Identify two or more possible samples (time periods, cultures, nations, etc.) that would provide good sources for making comparisons with the data found (see Figs. 3.1 through 3.4).

10. Classroom questions can be written at a variety of cognitive levels. Take any one of the areas you identified above for social science inquiry. Write a question at the knowledge level of Bloom's *Taxonomy*. Then expand the same topic into six questions, one at each of the levels of the taxonomy.

11. Select another social science inquiry problem different from the one used in Question 10. Write four questions appropriate to it using the four categories from the Gallagher-Aschner system for categorizing questions.

12. Define and illustrate each of the following terms:

a) value question	h) taxonomy
b) scientific questions	i) cognitive domain
c) cognitive dissonance	j) The six categories of the Bloom *Taxonomy* (knowledge, comprehension, application, analysis, synthesis, evaluation.)
d) normative question	
e) research hypothesis	
f) "if . . . then" proposition	k) convergent questions
g) data retrieval chart	l) divergent questions

FOOTNOTES

1. For an extensive review of the literature on the use of questions, see Ambrose A. Clegg, Jr., "Classroom Questions: Theory, Research, and Application," *Encyclopedia of Education.* New York: Macmillan, 1971, pp. 183-190.

2. *Ibid.*

3. Leon Festinger, *A Theory of Cognitive Dissonance.* Stanford, Calif.: Stanford Univ. Press, 1957.

4. *Ibid.*

5. See, for example, Gilbert Sax, *The Empirical Foundations of Educational Research.* Englewood Cliffs, N.J.: Prentice-Hall, 1968, pp. 110-112.

6. Hilda Taba, *Teachers' Handbook for Elementary Social Studies.* Reading, Mass.: Addison-Wesley, 1967. See also her more detailed research study, *Teaching Strategies and Cognitive Functioning in Elementary School Children,* Cooperative Research Bureau Project No. 2404, U.S. Office of Education, San Francisco State College, 1966.

7. Benjamin S. Bloom (Ed.), *Taxonomy of Educational Objectives Handbook I: Cognitive Domain.* New York: David McKay, 1956.

8. J.P. Guilford, "The Structure of the Intellect." *Psychol. Bull.* **53**: 267-93, July 1956.

9. Russell P. Kropp and Howard W. Stoker, *The Construction and Validation of Tests of the Cognitive Processes as Described in the Taxonomy of Educational Objectives.* Cooperative Research Project No. 2117, U.S. Office of Education, Florida State Univ., Tallahassee, 1966.

10. For a critical review of the many studies which have pointed to the relatively low level of classroom questions, see Ambrose A. Clegg, Jr., "Classroom Questions", *Encyclopedia of Education.* New York: Macmillan, 1971, pp. 183-190.

11. For a somewhat different approach to the Bloom *Taxonomy,* see Norris M. Sanders, *Classroom Questions: What Kinds?* New York: Harper and Row, 1966. Sanders has made separate categories of *translation* and *interpretation,* whereas these are but subcategories of *comprehension* in Bloom's original version. Sanders' emphasis upon the use of logical processes in the analysis category is perhaps more rigorous than Bloom's. The book is an excellent guide to developing classroom questions for all levels of instruction.

12. See A. Clegg, G. Farley, and T. Curran, "Training Teachers to Analyze the Cognitive Level of Classroom Questions," Research Report No. 1, Applied Research Training Program, Univ. of Mass., June, 1967. See also G. Manson and A. Clegg, "Classroom Questions: Keys to Children's Thinking?" *Peabody J. Educ.* **47**: 302-307, March, 1970.

13. The definition of analysis given in this text follows that used by Bloom in the *Taxonomy.* Sanders, *op. cit.,* has defined analysis much more rigorously, emphasizing strongly the conscious knowledge and use of formal thought processes and rules of logic. In his book *Classroom Questions,* he gives special attention to such topics as induction, logical fallacies, deduction, and semantics (pp. 101-110).

14. George T. Farley and Ambrose A. Clegg, Jr., "Increasing the Cognitive Level of Classroom Questions in Social Studies: An Application of Bloom's Taxonomy", *Research in Education,* **5**: 93, April, 1970, Eric Document No. ED 034-732.

15. A.A. Clegg, Jr., A.P. Sebolt, P. Benoit, and K.J. Grunden, "Can Children Learn to Raise the Cognitive Level of Their Own Thinking?" A Report of Two Studies, unpublished paper, Seattle, Univ. of Washington, 1971.

16. Francis P. Hunkins, "The Influence of Analysis and Evaluation Questions on Achievement in Sixth Grade Social Studies," *Educational Leadership*, **25**: 326-332 (1968).

17. James Gallagher and Mary Jane Aschner, "A Preliminary Report on Analyses of Classroom Interaction." Merrill-Palmer Quarterly, **3**: 183-194, 1963.

18. Guilford, "The Structure of the Intellect," *op. cit.*

19. Gallagher and Aschner, *op. cit.*

20. For other strategies see Francis P. Hunkins, *Questioning Strategies and Techniques*, Boston: Allyn and Bacon, 1972.

HISTORY: STRUCTURE, CONCEPTS, AND STRATEGIES

WHAT IS HISTORY?

History has at least three separate components. All *past events* can be thought of as history. This aspect of history is sometimes called "history-as-actuality."[1] The *method* used by historians to reconstruct the past is another element of history. The *statements* which historians write about past events are also a part of history. Documents, textbooks, and other historical narratives are made up of historical statements.

A historian's view of the past is influenced by the availability of evidence, his personal bias, purposes for writing, and the society and times in which he lives and writes. Although history consists largely of accounts of events from particular points of view, it is often taught in school as a body of truth not to be questioned, criticized, or modified.[2] Such a parochial approach to the teaching of history stems largely from the classroom teacher's confusion about the nature of history and the widely held belief that history contributes to the development of patriotism. Much confusion about the nature of history would be eliminated if teachers distinguished *historical* statements from *past events*. The *historical statement*, often referred to as the historical *fact*, is quite different from the actual event. The event itself has disappeared, never to occur again. An infinite number of "facts" can be stated about any past event.

When an investigating committee attempted to reconstruct the event in which four students were killed at Kent State University on May 6, 1970, they produced a multi-volume report. Many more volumes could have been written about the event if every *detail* had been described, such as detail is described in a novel. However, the committee was not only unable to *completely* reconstruct the event, but they were not interested in doing so. They were interested only in the facts needed for their purposes.

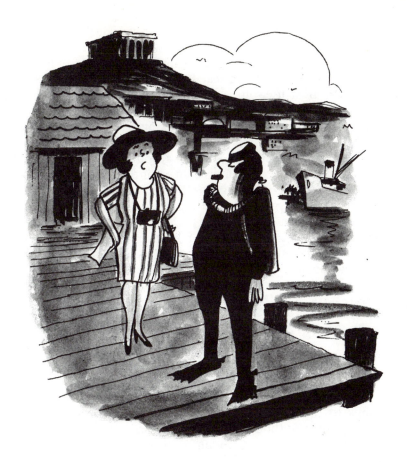

"Here, where Orpheus sang and Sappho sighed, where democracy was born and art perfected; here amidst the beauties Aeschylus knew — you want to go skin diving!"

When future historians attempt to reconstruct the Kent State event, their investigations will be limited by the statements which have been recorded by eyewitnesses, newspapers, magazines, radio, television, and other souces. Like the investigating committee, they will be unable to completely reconstruct the event. Also, they will not use all the "facts" or information which they uncover because their purposes and biases will determine the statements which they will use and regard as valid.

Since the historian can never discover all the information about any single event or present all the data which he uncovers, he must use some *criteria* for selection. His criteria are highly personal. Current needs and purposes

profoundly affect historians' interpretations of history. Becker, the noted historian writes, "The past is a kind of screen upon which we project our vision of the future; it is . . . a moving picture, borrowing much of its form and color from our fears and aspirations."[3] Historical facts are products of the human mind, since the historian must use source materials and artifacts to reconstruct past events.

On April 9, 1775, shots were fired at Lexington and the American Revolution began. Who fired the first shot, the British or the American colonists, is a *problem* for the historian. The two accounts below, written by a British commander and an American colonist, give conflicting accounts of this event. The historian frequently encounters conflicting accounts of events when he is trying to reconstruct the past. He can never find enough resources and artifacts to completely reconstruct past events. Only fragmentary and selected evidence about any past event is available. Even if complete accounts of events were available, the historian would still have to select aspects of them to report in order to write a meaningful narrative. How the historian solves problems such as who fired the first shot at Lexington is largely influenced by his own biases and perceptions.

Account one

Major John Pitcairn, commander of the advanced British party that engaged the Lexington militia, sent the following official report of his activities to General Gage:[4]

> I gave directions to the Troops to move forward, but on no account to Fire, or even attempt it without orders; when I arrived at the end of the Village, I observed drawn up on a Green near 200 of the Rebels; when I came within about One Hundred Yards of them, they began to File off towards some stone Walls on our Right Flank – The Light Infantry observing this, ran after them – I instantly called to the Soldiers not to fire, but to surround and disarm them, and after several repetitions of those positive Orders to the men, not to Fire & c – some of the Rebels who had jumped over the Wall, Fired Four or Five Shott at the Soldiers, which wounded a man of the Tenth, and my Horse was Wounded in two places, from some quarter or other, and at the same time several Shott were fired from a Meeting House on our Left – upon this, without any order or Regularity, the Light Infantry began a scattered Fire, and continued in that situation for some little time, contrary to the repeated orders both of me and the officers that were present – It will be needless to mention what happened after, as I suppose Col. Smith hath given a particular account of it. I am sir

> > Your most obedt
> > humble Servant,
> > John Pitcairn.

Boston Camp
26th April, 1775

Account two

Robert Douglass, who had been at Lexington, swore to the following deposition on May 3, 1827:[5]

> In about fifteen minutes after we entered the tavern, a person came to the door and said the British were within half a mile. I then heard an officer (who I afterwards learned was Captain Parker) call his drummer and order him to beat to arms. I paraded with the Lexington company between the meeting-house and the tavern, and then marched to the common near the road that leads to Bedford; there we were ordered to load our guns. Some of the company observed, 'There are so few of us, it would be folly to stand here.' Captain Parker replied, 'The first man who offers to run shall be shot down.' The Lexington company began to break off on the left wing, and soon all dispersed. I think no American was killed or wounded by the first fire of the British, unless Captain Parker might have been. No one of Captain Parker's company fired on the British, to my knowledge, that morning, and I think I should have known it, had they fired. I knew but two men of the Lexington company, and I never heard any person say that the Americans fired on the British that morning at Lexington.
>
> After the British marched toward Concord, I saw eight men who had been killed, among whom were Captain Parker and a Mr. Porter of Woburn.
>
> Robert Douglass

SCIENCE AND HISTORY

We have witnessed that historians often write divergent accounts of the same events. Historical interpretations of events vary greatly in different times and cultures. It is appropriate to consider whether the severe limitations of the historical method prevent history from being a science and whether scientific *generalizations* and *theories* can be formulated in history.

Berelson and Steiner have identified the commonly accepted requirements of the scientific method. They are reviewed in Chapter 2 (See page 66.). A science is characterized by public procedures, precise definitions, and objective data collection. The approach to knowledge is systematic and cumulative, and the purposes are explanation, understanding, and prediction (or the development of *theory*).[6] These requirements can help us judge the extent to which a discipline can be characterized as a science. However, they describe an ideal science; no existing discipline meets all of them. Nevertheless, some disciplines satisfy them more adequately than others, and thus may be judged more scientific. In the following discussion, an attempt is made to determine the extent to which history satisfies these requirements, and thus to ascertain how "scientific" history is.

Are the Procedures Public? Historians usually give less information about *specific* procedures and methods used to study problems than do the behavioral scientists. Considerably less attention is given to methods used to identify samples, criteria for making judgments about data, and techniques of data

Historical studies should help the elementary school child to understand his past and present and become an effective decision-maker in tomorrow's world. (Washington State Office of Public Instruction, Olympia)

analysis. Clear statements of hypotheses formulated and tested are not usually identified. However, historians *do* identify the problem studied, examples of evidence, general conclusions, and they give a list of references and sources.

Most historians contend that they *attempt* to use the method of inquiry which is used by the behavioral scientist (discussed in Chapter 2 in considerable detail), although they admit that this method must be modified in historical research. Krug, Commager, and Haskins contend that the historical method is

to some degree scientific.[7] Krug states, ". . . historical inquiry is based on the scientific . . . method, but the final conclusions are intuitive and highly individual; in a word, they belong to the world of art."[8] According to Commager, "history uses or aspires to use the scientific method . . . it tests all things which can be tested, and holds fast to what it finds to be true, insofar as it is able to make any findings at all."[9] Gottschalk, the eminent historian, suggests that the historian's method is a combination of science and art:

> Scrupulous weighing of extant evidence . . . is only a limited part of the historian's work, for his ultimate purpose is not alone the dispassionate study of historical vestiges but also a reconstruction of mankind's past, of past beings and doings, of the course of human events. . . .
>
> A patent gap thus separates history-as-actuality from knowledge history, and that gap can be filled only by an *imaginative* process, the reconstruction of events as they must have been or, at least, *probably were* from the inadequate clues still available in their vestiges. This is the *creative* . . . act, and hence akin to art.[10] [Italics ours]

Are the Definitions Precise? The concepts which historians use, such as *nationalism, patriotism, medieval,* and *Renaissance,* are not very precise, since a great deal of consensus regarding their meaning does not exist among historians. Although most of the concepts and definitions used in the other social disciplines which purport to be sciences are also imprecise, the behavioral scientists, such as psychologists and sociologists, do make more systematic efforts to formulate *precise* definitions than do historians. Also, the behavioral scientists make more concerted attempts to *operationalize* definitions than do historians.

When reporting his studies, the sociologist carefully defines how such concepts as *role, status,* and *norm* are defined and measured. The historian more often uses such terms as *monarchy* and *conquer* without specifying their exact meanings or illustrating how he identified examples of the concepts. A great deal of the disagreement among historians may stem from their tendency to use identical concept terms to describe different phenomena. Two historians may reach divergent conclusions about *nationalism* in nineteenth century Russia because they used different definitions of the concept, and therefore considered different samples of behavior as examples of *nationalism.*

Is the Data Collection Objective? Objective data collection is an ideal and not a reality in all disciplines. Historians are acutely aware of the effects of bias on their research. Becker has referred to the researcher's bias as the "personal equation" and argues that it inevitably affects the scientist's conclusions:

> . . . the historian cannot eliminate the personal equation; of course, no one can, not even . . . the natural scientist. The universe speaks to us only in response to our purposes; and even the most objective constructions, those . . . of the theoretical physicist, are not the sole possible constructions, but only such as are found most convenient for some human need or purpose.[11]

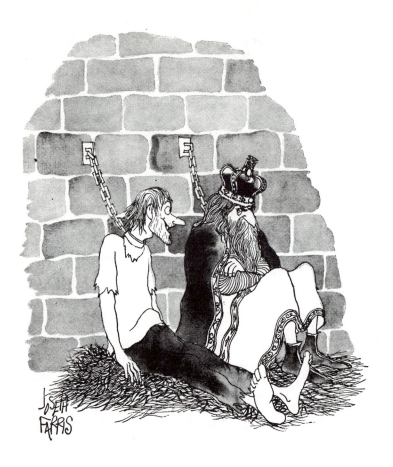

"Gee! I've never sat next to a king before."

Drawing by Joseph Farris. Copyright © 1970, Saturday Review, Inc.

While objectivity remains an ideal in history as in all other disciplines, historians seem to have less faith in their ability to attain objectivity than the behavioral scientists. Commager writes lucidly about bias in history.

There is bias in the choice of subject, bias in the selection of material, bias in its organization and presentation, and inevitably, bias in its interpretation. Consciously or unconsciously, all historians are biased; they are creatures of their time, their race, their faith, their class, their country-creatures, and even prisoners.[12]

Perhaps an overstatement, it cogently illuminates the role of bias in the writing of history. Recognizing the inevitable effects of bias in history, Commager attempts to formulate a realistic canon of objectivity:

> Perhaps it is sufficient to say that the historian must be honest according to his lights; that he should never consciously distort his evidence, even by literary artistry; that he should be ever on guard against religious, racial, class, or national preconceptions; that he should try to see every problem from all possible points of view; that he should search diligently for all the evidence, and not be content until he has exhausted the available resources . . .[13]

Can the Findings Be Reproduced? It is difficult for a historian to reproduce a study done by another historian because, as has been noted, specific information about procedures and methods used in historical research is not usually explained in sufficient detail. Although many different historians study such events as the American, French, and Russian revolutions, rarely do they formulate specific hypotheses about these events, test them using clearly delineated public procedures, and derive conclusions which can be tested by other historians using the same methods. It is also difficult to reproduce historical studies because the concepts are imprecise. Although it is difficult to repeat the same processes in leading to a description of historical events, a historian can study the same event reported by others. However, rarely do historians use the *exact* methods and procedures to study identical events or problems, as is done in other disciplines.

Is the Approach Systematic and Cumulative? In the behavioral sciences, the findings by various researchers are systematically tested by their colleagues. Before statements and generalizations are judged valid, they are confirmed by the work of a number of researchers. While historians frequently study problems which have already been studied, no *systematic* effort is made to reproduce studies and to test findings and generalizations derived by others. Sociologists and the psychologists attempt to identify a body of *concepts* and *generalizations* that can be tested and verified by many researchers, and thus contribute to the building of *theories*. Historians typically study and describe *singly* past events, and approach them in a somewhat personal fashion. *Most historians describe events rather than attempt to test generalizations and theories.*

As we noted, when historians study the same problems and events they often derive highly divergent conclusions. Although conflicting findings are also reached in other disciplines, they are more germane to history. Krug sagely points out:

> Disagreements about data evaluation are not peculiar to historians. Social scientists differ not only about the phenomena of the past, but seldom agree even about events in contemporary society in spite of the opportunity for visual examination and re-examination of witnesses . . .

Sociologists trying to analyze a race riot do not often agree either on the diagnosis or the remedies proposed, and distinguished economists seldom if ever agree on the best ways to prevent inflation or eliminate unemployment.[14]

While Krug exaggerates, he illuminates the fact that disagreements about conclusions occur in other disciplines as well as in history. However, there is considerably more agreement about conclusions and generalizations in the behavioral sciences.

Are the Purposes Explanation, Understanding, and Prediction (theory)? In Chapter 2 we noted that the primary goal of social inquiry is to derive theoretical knowledge that will enable us to explain, understand, and predict phenomena. While this goal is accepted by most disciplinarians who consider themselves scientists, historians have serious doubts about their ability to derive valid generalizations, and are even less optimistic about their ability to formulate theories. Writes Krug, the historian-educator:

Most historians are unwilling, in view of the always incomplete character of their data, to make sweeping claims for the conclusions reached in their investigations. Second, very broad generalizations are often untenable because of the limited sources of information and the complexity and variability of the subjects of important historical studies. Third, historians must use their creative imagination and thus a good dose of *fiction* (sic) in their reconstructions of the past, and consequently, any attempt to formulate scientifically and generally applicable generalizations is bound to fail. Fourth, few broad historical generalizations can be proven empirically.[15] [Italics ours]

Most historians regard the *reconstruction* and *description* of past events as their primary and proper goal. They also believe that the narratives they construct should be *interesting* and *appealing*. According to one historian, ". . . history is a branch of literature and . . . it serves some of the purposes and is governed by some of the principles of literature . . . While it is true that unless history is reasonably accurate and fair, it should not be read, it is equally true that unless history is well written it will not be read."[16] The purpose of history, argues Krug, is "the *imaginative* reconstruction of the past which is scrupulous and scientific in method, but *artistic* in its conclusions . . ."[17]

Because historians are primarily interested in description rather than the formulation of generalizations and theories which can help us to explain, understand, and predict phenomena, they frequently study specific and unique events rather than a large class of different events which have common characteristics.

Behavioral scientists, unlike the historians, primarily study a wide range of social phenomena and try to see trends and relationships among them.[18] Historians who are primarily interested in describing the past in an intriguing and literary fashion – the bulk of them – are often called *literary* or *descriptive* historians.

Some historians are more scientific in that they believe that history, despite the limitations inherent in its method, *can and should strive to formulative systematic bodies of knowledge in the form of concepts, generalizations, and perhaps theories.* This group is sometimes referred to as *scientific* or *theoretical* historians. Notes Commager:

> The scientific historian is not really interested in recreating the past for its own sake, nor at pains to stir the imagination of the reader; indeed he is rather inclined to distrust the picturesque or the dramatic and even the individual. It is reason he wants to excite, not imagination, and as for the past he does not want to recreate it but to explain it.[19]

HISTORICAL CONCEPTS

In Chapter 1 we defined *structure,* in part, as the key concepts, generalizations, and theories which are unique to the various social science disciplines. These knowledge components enable the social scientist to view human behavior from restricted perspectives. Children must study these higher levels of knowledge in order to become adept decision-makers and rational social activists. Thus an important part of the social studies curriculum should consist of helping children learn the key concepts and generalizations within the disciplines. Conceptual approaches to instruction enable students to view behavior from diverse disciplinary perspectives and to understand higher levels of knowledge. Other elements of *structure* are the modes of inquiry used by social scientists to solve social problems and to derive concepts, generalizations, and theories. Students should use scientific modes of inquiry to derive higher levels of knowledge.

One of the basic assumptions of this book is that conceptual approaches to social studies instruction are sound, and that we can identify key concepts within the various disciplines. These we can use as organizing frameworks for social studies units and lessons. However, it is difficult to plan conceptual lessons in some of the disciplines either because the leaders in the field have not focused much attention upon their special concepts or, more frequently, disciplinarians are unable to agree about what the key concepts within their disciplines are.

Despite the difficulties involved in identifying the key concepts within the disciplines, conceptual approaches are sound. The difficulties involved in identifying key social science concepts indicate the level of scientific development of the social disciplines rather than the invalidity of conceptual approaches to instruction. However, despite our belief in conceptual approaches, identifying key concepts in *history* which can guide instructional planning poses major problems. While the behavioral sciences use specialized conceptual frameworks to view human behavior, history's uniqueness stems from the fact that it views behavior which has taken place in the past, and it is interested in the totality of man's experience. Because it is concerned with the past, it uses a modified mode of scientific inquiry.

Whereas the sociologist and the political scientist are primarily interested in *socialization* and *power* respectively, the historian may be, and sometimes is, interested in how each of these concepts is exemplified in past human behavior. *History, then, is a truly interdisciplinary field since historians, in principle, are interested in all aspects of man's past behavior. Thus it is difficult to speak about unique historical concepts.* Yet every discipline makes use of the historical perspective and has historical components. When a sociologist studies *norms* and *sanctions* in colonial America, and the economist describes how the colonists produced *goods* and *services* they both are studying history.

A cursory study of lists of "historical" generalizations will reveal how history employs concepts that originate in other social science disciplines. Note these two examples which were taken from a list of historical generalizations prepared by a state department of education:[20]

1. *Communities today differ from communities of earlier times.*
2. *The rate of cultural change varies from one country to another.*

The key concepts within these two statements are *communities* and *cultural change. Community* and *cultural change* are organizing concepts in sociology and anthropology, respectively.

Some sources suggest that *change* is a key historical concept. It is true that we cannot verify empirical statements about *change* without the use of historical data. However, when we speak of change, we must also use some other variable or concept. *Change* describes the status of variables at different points in time. Thus *change* is a *relational* concept because it shows the relationship between two variables (see Chapter 3 for a review of different kinds of concepts). Although change is a historical concept, we must recognize that we can't study *change* unless we talk about it in concepts and variables usually associated with other disciplines. For example, we can write generalizations about *cultural change* (anthropology), change in *goods and services* (economics), or change in *regions* (geography). Both historical data and concepts within other disciplines are necessary to state and test generalizations about *change.* In the teaching strategies part of this chapter, for example, we describe strategies for teaching *change* related to the sociological concepts of *transportation, schools,* and *entertainment,* and the geographical concepts of *exploration* and *regions.*

As suggested, we can show *change* only by using concepts unique to the other social sciences. However, we can make some generalized statements about change that cut across disciplinary lines. For example, we can study change in *transportation, schools, entertainment, exploration,* and *norms,* and make some statements about the factors which are related to *change* in general. We can hypothesize that change constantly takes place, that people usually find it more difficult to adjust to social change than to technological change, and that change is sometimes abrupt. *Statements about generalized change can be justifiably claimed by history since historical data are necessary to test all empirical statements about change.* However, let us repeat, we cannot test

statements about change without using concepts and variables from other disciplines.

Whereas the behavioral scientist uses specialized conceptual frameworks to view human behavior, *the historian can and sometimes does use many conceptual frameworks to study past human behavior.* The historical perspective should be concerned with the *totality* of man's past. In reality, however, historians do not deal with the totality of man's past experience, but usually study past behavior primarily from the perspectives of political science. To a lesser extent historians use geographical and economic concepts to view the past. A glance at the table of contents of any history book will reveal historians' preoccupations with political science concepts. Historians are primarily interested in *wars, revolutions, nationalism,* and the rise and fall of different types of *government.* Historical periods are often described in terms of the contemporary political events, such as "The Civil War and Reconstruction," and "The Facist Regimes." In most historical accounts little attention is given to sociological, psychological, anthropological, or economic concepts and theories. However, anthropological concepts (such as *culture* and *civilization*) are sometimes used to classify and describe periods when the historian wishes to stress the cultural achievements of a particular period, such as "The Golden Age of Greece," or "The Renaissance." Economic concepts are employed when the historian feels that economic factors were perhaps the most important variables influencing behavior during a particular period, such as "The Great Depression, 1929-1935."

Recently historians have been criticized for their preoccupation with political events. They not only tend to stress political events in their accounts, but they emphasize the roles of great leaders and largely ignore the roles which the masses of people have played in shaping historical events. In the United States, most history is politically biased, and it emphasizes the contributions made by Western man to the development of civilization. It stresses the importance of Anglo-Saxons and largely ignores the contributions and struggles of Nonwestern man, of blacks, Indians, Chicanos, and other ethnic minorities.[21] As we will document later, history also tends to be highly nationalistic and ethnocentric. Recently, historians have been making aggressive efforts to include the contributions and struggles of all our ethnic groups and to use concepts from the other social sciences to explain past behavior. Stanley M. Elkins, in *Slavery: A Problem in American Institutional and Intellectual Life,* uses a number of psychological concepts and theories to explain the behavior of the slave and master.[22] The trend toward more highly interdisciplinary history will undoubtedly continue as more historians become familiar with concepts from various social sciences.

The concepts discussed above are related to the *content* (product) of history. We have noted the difficulty involved in identifying substantive historical concepts. However, history consists of more than its products or conclusions. History is also a *process.* The mode of inquiry used by historians to solve historical problems and to derive generalizations is also a part of the *structure* of history. While the concepts within history are interdisciplinary, the

method of inquiry used by the historian to solve historical problems is unique because the historian is the only social scientist whose research is limited to the reconstruction of past events. His problem is complicated by the fact that past events have taken place and will never reoccur. The sociologist can always study a new family situation, and the political scientist can observe a future national election.

It is important to teach concepts and generalizations about *historical method,* as well as concepts which are related to historical *conclusions* (products). In the teaching activities which begin on page 182, we state two generalizations related to historical research, and describe strategies for teaching them. The generalizations are

1. *A historian's view of the past is influenced by the availability of evidence, his personal biases, purposes for writing, and the society and times in which he lives and works* and

2. *Historians use a variety of resources and materials to reconstruct past events and to find out about the past.*

The study of historical *method* (historiography) should constitute a substantial part of a modern historical studies program. A study of the historian's method will enable the students to gain an appreciation of the difficulties involved in reconstructing the past, strengthen their inquiry skills, and enable them to become more intelligent consumers of history.

We have argued that all historical concepts are interdisciplinary, and have tried to make our reasoning clear. We should also point out that historians, as a group, have written very little about the concepts which they use, the nature of these concepts, and their place in a modern social studies program. Writes Fenton, the historian-educator,

> most historians are not comfortable with concepts. Despite the publication of Edward N. Saveth's *American History and the Social Sciences,* an analysis of the uses of social science concepts in the interpretation of history, most historians still do not think naturally in terms of conceptual apparatus. Lists of concepts evidently have not proved to be maximally useful to historians or they would be acknowledged more fully in the literature. Like generalizations, concepts make up a structure of history. Like generalizations, they are not the most useful structure.[23]

Fenton argues that the *analytical questions* which historians ask constitute the heart of the discipline.[24]

Although historians have written little about the concepts they use, we attempt below to identify some of the concepts, belonging to other disciplines, which historians use most often. Most of the concepts deal with the *products* (conclusions) of history; one relates to historical inquiry. These concepts can be used to help students look at a problem or topic from a historical perspective when they are studying interdisciplinary units.

Change

This concept means that phenomena in our social and physical environment are constantly becoming different each day, week, and year. It is extremely important for students to understand the factors that cause change, and be able to adjust to and accept change. Historical data must be used to develop this concept effectively, although it is clearly interdisciplinary. The teacher can use concepts within all the social science disciplines to help students understand the dynamics of social and cultural change. By comparing the *cultures* of native American groups, such as that of the Hopi Indians now and 100 years ago, children can clearly see cultural change. Changes in the distribution of *power* can be highlighted when students study the events that culminated in the formation of the United States Constitution. A study of *family* life in a colonial village and in a metropolis today will clearly show how the city has influenced family life.

Conflict

Throughout history, disagreements and hostility have arisen between individuals, groups, and nations when those concerned had divergent goals or different ideas about how similar goals could be best attained. While *conflict*, like *change,* is an interdisciplinary concept, historians spend much of their time documenting the antagonisms and battles which resulted. Conflict can be both functional and dysfunctional for a society. Much positive social change results from wars and conflicts. The American Revolution and the Civil War resulted in changes which many Americans considered functional for the development of our nation. The South after the Civil War, and Japan after World War II are examples of how conflict can disrupt a society.

When teaching this concept, the teacher could have the students read accounts of different kinds of conflict — wars, revolutions, riots, rebellions, verbal battles, etc. — which have taken place throughout history at different periods. They should then be encouraged to generalize about the causes of conflict, the consequences, and the factors which contributed most to their resolution. Concepts from several of the social science disciplines will help students understand *conflict. Cultural* conflict, conflict in the struggle for political *power*, conflict which arises from the *scarcity* of goods and services, and *value* conflicts are types of conflicts that elementary and junior high-school students can profitably study from the perspectives of history and anthropology, political science, economics, and sociology, respectively.

Revolution

A *revolution* is, of course, a type of *conflict*, and is a concept which belongs within the scope of political science. However, we are discussing it here because it is a special type of conflict and is of primary concern to the historian, as Crane Brinton's brilliant study of revolutions indicates. A glance at the table of contents of almost any history book will also reveal the historian's interest in revolutions. Also, as we pointed out earlier, the concepts which historians use

most often are related to political science, since most of our written history is political history. A revolution takes place when an existing government is abruptly overthrown, and a more radical group assumes power. Interesting units and lessons can be organized around this concept, especially in the middle and upper grades. Students can derive generalizations about the causes and sequence of events during a revolution as they study the English (1668), American (1775), French (1789), and Russian (1917) revolutions. A teacher may begin a study of revolutions by reading literary accounts, such as selections from George Orwell's *Animal Farm*, or a selection from a novel dealing with the American Revolutionary period. The students can also consider the question as to whether protest movements such as the "Black Revolt" were revolutions.

Nationalism

Nationalism is another political science concept in which historians have shown a great deal of interest. Nationalism exists when the leaders and individuals within a nation take actions intended primarily to strengthen and develop it, and to inculcate loyalty among its citizens. Nationalism is in some ways an ethnocentric doctrine. Nationalists are not very interested in international relations, but primarily in the development of their own nation. In their study of the development of nationalism throughout history, students will be able to conclude that while nationalism is necessary if a nation is to develop successfully, extreme nationalistic feelings sometime result in conflicts and wars. The extreme nationalism which existed in Japan and Germany prior to World War II are cases in point.

Civilization

Civilization is perhaps best defined as the total culture of a people, nation, or period. Civilization is an anthropological concept (anthropologists prefer the term *culture*) that has been used often by historians. But as we have noted, historians have not often considered the *total* experiences of man as civilization, but only those developments in Western and Eastern nations that, in the opinions of the historians, had highly developed arts, music, literature, and forms of government. Daniel Roselle has criticized Kenneth Clark for defining *civilization* too narrowly in his popular book *Civilisation*, and for omitting the experiences of the common man. Writes Roselle, ". . . he seems to deliberately bypass what he considers the commonplace, the cheap, the uglier aspects of human expression. More than that, he excludes them from any significant place in 'civilization.' "[25] Continues Roselle, "Civilization involves *all* mankind. Therein is its weakness — and therein is its strength that will overcome that weakness."[26]

Although historians have largely ignored the experiences of the common man in their accounts of "civilization," we feel, like Roselle, that civilization includes the *total* experiences of man. When a class studies the Renaissance, the students should not only read about great individuals like Michelangelo and

daVinci, but should learn about the *cultures* of the masses during this period of history. The modern world cannot afford an ethnocentric and restricted conceptualization of civilization.

Exploration

Historians devote a great deal of attention to men who travelled into lands which were unknown to them. *Exploration* is a geographical concept. In extolling the virtues of European explorers, historians have sometimes distorted or omitted any discussion of the cultures of the peoples who inhabited the lands before the coming of the Europeans. Most children learn in their history books that Columbus discovered America. Long before Columbus landed in North America, the Indians had developed rich and diverse cultures. While Europeans at that time did not know much about these peoples and their cultures, they were certainly aware of themselves. It is somewhat ethnocentric now to claim that Columbus discovered America. When using historical data to teach children the concept of *exploration*, the teacher should help them to understand that although many regions of the world were unknown to Europeans, great civilizations existed in the New World before the Europeans arrived. Children should, of course, become acquainted with the achievements of European explorers, but it is equally important that they learn about the conflict and forced acculturation which took place after Europeans came into North America. The result was the destruction of many North American aboriginal cultures and the virtual genocide of many Indian tribes. Historical accounts that do not deal with these painful realities of our past are distorted and tell only part of the story.

Historical bias

No matter how hard he tries, the historian is always unable to completely reconstruct a past event. Many of the sources and artifacts which he does uncover contain contradictory and inconsistent information. He must judge the accuracy and authenticity of the data. His selection of data is greatly influenced by his personal biases, the nature of the data, the audience for which he is writing, and the culture and times in which he lives. Because of the severe limitations inherent in the historical method, it is extremely important for children to learn how history is written so that they will be discerning readers of the conclusions they find in their textbooks and in other sources. The importance of teaching children the method of historical inquiry has been stressed throughout this chapter. Strategies which can be used to teach this concept are described later.

HISTORICAL GENERALIZATIONS

Scientific historians contend that even though historians often disagree about facts and interpretations, and are unable to completely reconstruct past events, *enough consensus on historical statements can be derived to make possible the*

formulation of at least lower-level generalizations. Haskins argues that historical generalizations can be formulated because "historic events follow the same natural laws as the objects of science."[27] Even though descriptive historians tend to distrust generalizations, a historian cannot describe a single event or institution without making some kinds of *generalized* statements. "The serfs in France were angry" and "The kings of France were arbitrary" are types of generalizations about the French Revolution. The first statement describes, or claims to describe, a characteristic which most serfs had in common. The latter statement describes a characteristic that the French kings shared. If a historian wanted to make this a higher-order generalization, such as "The Monarchy in eighteenth century Western Europe was arbitrary," he would be required to study the characteristics of other eighteenth century European kings. Haskins is optimistic about historical generalizations:

> We can now ascertain general tendencies or patterns in religious move-
> ments and in the course of revolutions. Though the specific events in the
> English, American, French, Russian and other revolutions are not exactly
> alike, general patterns which resemble "laws" are apparent.[28]

Gottschalk edited a book on generalizations in history and concluded that "historians . . . frequently make generalizations, whether knowingly or unknowingly,"[29] and that at least six categories of "generalizers" could be identified:

> (1) those who make generalizations only if they are unaware that they are
> doing so and try to eliminate the ones of which they are aware; (2) those
> who make generalizations knowingly but intend to limit their generaliza-
> tions strictly to the exposition of the historical subject matter under
> investigation and of that subject matter only in its own setting; (3) those
> who make a deliberate effort to go beyond the historical subject matter in
> hand in order to indicate its interrelations with antecedent, concurrent,
> and subsequent events and who thus risk broad interpretative syntheses
> but still limit their interpretations to interrelated trends; (4) those who,
> with a similar readiness to go beyond the subject matter in hand, draw
> parallels and analogies to it in other times or places of the past, whether or
> not otherwise interrelated; (5) those who venture propositions about past
> trends or analogies in such general or abstract terms as to leave the
> implications, if they do not indeed state explicitly, that their propositions
> may well be extrapolated to events in the future; and (6) those who
> propound philosophies that are intended to provide a cosmic under-
> standing of the course of human events past and to come.[30]

All historians make generalizations, even those who claim that history should only describe events and not attempt to generalize. However, those historians are often unaware that they are generalizing. Other historians are aware that they make generalizations, but try to limit them to the period which they are describing.

Most historians make generalizations unknowingly, or deliberately make only limited ones. Scientific historians, few in number, make a *deliberate* attempt to formulate generalizations which can apply to a large range of trends and events. This group of historians sometimes makes very generalized statements which seem to have implications for future events. During his study of the British, American, French, and Russian Revolutions, Crane Brinton derived the following generalizations, which seem not only to describe past events, but to imply possible characteristics of future revolutions:[31]

In a revolutionary state, vocal critics emerge who create a myth about the coming of a utopian society and decry the evils of the existing regime.

In revolutionary societies, moderate leaders take over after the old regime is overthrown; the moderates are eventually overruled by extremists.

When extremists take control of the government during a revolution, a reign of terror ensues.

Brinton, like other scientific historians, would not argue that these conditions will always emerge whenever and wherever a revolution occurs. However, he does suggest that the probability is high that if a revolution occurs in a society similar to those which he studied, the conditions described by these statements may emerge.

PHILOSOPHIES OF HISTORY

While descriptive and narrative historians are described by Gottschalk's categories (1) and (2), and scientific historians by categories (4) and (5), almost all present-day historians deny the validity of philosophies of history which attempt to identify *fixed* and *dominant* patterns in past and future events. Even though philosophies of history are not generally accepted by today's historians, historical philosophers have attained much fame and eminence in modern times.[32]

Kant, Hegel, Marx, Spengler, Toynbee and other historians have formulated and popularized historical philosophies.[33] Kant felt that "history was a constant progress towards rationality."[34] He argued that while man would make mistakes, he would eventually create a rational and humane society. Kant believed that such a society was destined. According to Hegel, each historical period was profoundly influenced by a pervading idea. Hegel also believed that "history was the progress of reason through the all-powerful Providence of God . . . [it] represents the reality of God."[35]

Karl Marx argued that economic competition between the upper and lower classes was the most important factor in shaping historical events.[36] Marx predicted that the proletariat or working classes would eventually rise up and overthrow the ruling classes world-wide and that capitalism was destined to fall. Most of Marx's predictions have not materialized, and his philosophy has been largely discredited. Oswald Spengler asserted that the life of a civilization was

like that of a plant or animal because it goes through the birth, life, and death cycle. Arnold Toynbee posited a philosophy similar to that of Spengler's.[37]

While philosophies of history, such as those formulated by Marx, Hegel, and Toynbee, have stimulated thought and controversy, they have contributed little to the building of generalizations and theories which can be scientifically tested and verified. They are largely the product of historians' armchair views of the world rather than the result of empirical research.

Historical philosophers have formulated views of history and attempted to demonstrate that past events were consistent with their views. By looking for evidence to document one dominant pattern in historical events, the philosophers ignored or treated lightly that evidence which was contrary to their perceived patterns.

Gottschalk argues that philosophers of history should not be considered historians because "[they] are more or less consciously special pleaders, belonging to the disciplines of theology, philosophy, or political speculation rather than to that of history as a branch of learning, no matter how well they use historical knowledge and no matter how much more important they may be to the world than academic historians."[38] Commager seriously questions the validity of philosophies of history:

> As we contemplate these and many other philosophies of history we are forced to conclude that the efforts to compress the incalculably vast, infinitely complex, and wantonly elusive stuff of history into any single framework, or to express it in any single formula, is doomed to futility. This conclusion in turn suggests not so much that men have failed to solve the enigma of history as that there is no solution and possibly no enigma.[39]

Although scientific historians may be able to identify general trends in historical events (such as the general characteristics of certain types of revolutions and religious movements), it is unlikely that historical philosophers will ever be able to identify one dominant pattern or cycle in historical events that can be scientifically verified. The human animal is far too complex for his behavior to be explained by single factors.

To identify generalized trends and characteristics of events may be the limit of what the historian can realistically accomplish. These general trends and characteristics, however, may enable us to make some predictions and tentative statements about future events. This is far from suggesting that by studying the past the historian will be able to predict the future. However, to argue that the study of man's past behavior may enable us to make some tentative statements about his future behavior is scientifically sound. One of the major assumptions of science is that man's behavior is somewhat patterned and systematic, and that there is some order in the universe. As we stated in Chapter 2, science assumes that there is enough order, permanency, and uniformity in nature to permit generalization. *It seems logical that if man's behavior has some order in the present, and if we expect him to exhibit*

patterns in his future behavior, that some kind of consistency in his past behavior can be identified and explained.

HISTORY AS A MODIFIED SCIENCE

An attempt was made to determine the extent to which history satisfies the criteria of science identified by Berelson and Steiner, and generally accepted by the scientific community. For each criterion discussed, it was concluded that history satisfies it less than the other social disciplines. Since no science completely meets these requirements but holds them as ideals, and because most historians regard some of them as ideals, history is considered a *modified science* in this book.

History is scientific because historians attempt to use the scientific method of inquiry, although they use it differently than most other disciplinarians. We can also argue that history is scientific because most historians consciously strive to approach historical problems objectively.

However, history has a number of nonscientific characteristics. Most historians concentrate on *unique* problems and events and not on patterns and trends. No conscious attempt is made by the majority of historians to formulate a systematic body of knowledge in the form of scientifically valid concepts, generalizations, and theories. The historian must also act non-scientifically when he fills in the gaps created by lack of concrete evidence, and tries to recreate events *imaginatively,* and write in a literary style.

However, historians who formulate broad statements to describe events and look for evidence to support them are behaving scientifically. Although historians and historian-educators have formulated a number of generalizations which can be used for instruction in the elementary school, scientific theories are almost nonexistent in history. Briton's attempt to identify and verify a system of interrelated generalizations about revolutions is one of the few efforts by a historian to formulate a scientific theory. It is possible that with the current emphasis on science, future historians may show more interest in generalizations and theories. However, *given the gross limitations inherent in the historical method, the possibility that the historian will ever be able to formulate valid and predictive theories seems remote.*

The above dicussion regarding the relationship between science and history is not intended to suggest that history's nonscientific aspects make it lack value. There are many ways of knowing; the scientific way is *one* method which is appropriate for some problems but not for others. This discussion is intended to clarify the nature of history so that the teacher, when preparing and implementing historical lessons, will not make claims for history which are unwarranted.

HISTORICAL STUDIES IN THE ELEMENTARY SCHOOL

Many educators and lawmakers contend that history should be taught in the public schools because it contributes to the development of patriotism and democratic attitudes. Nearly all fifty states require the teaching of American

history because it is believed to contribute to good citizenship. Writes Jarolimek:

> A knowledge of history supported by actual experiences in the practice in good citizenship in the school and the classroom *unquestionably* contributes to strengthening of loyalties and helps children identify with their rich historical background. (Italics ours)[40]

Lewenstein also writes about the contribution which history can make to the development of patriotism:

> . . . [A] knowledge or understanding of history can affect attitudes of loyalty and patriotism toward one's country. . . . The need for developing loyalty and patriotism in the schoolchildren of America is a primary reason for including the study of American history in the curricula of the schools at all levels of education.[41]

Notes Krug, "The study of the nation's past is considered by many, *and with good reason*, one of the best means of re-enforcing national unity and of instilling love of country and patriotic devotion." (Italics ours)[42]

Although it may be possible for history to *contribute* to the development of patriotism and to the making of good citizens, numerous difficulties have resulted from regarding history instruction *primarily* as a means for developing patriotic citizens. One serious problem is that there is no public agreement regarding the kind of patriotism that history develops, and what characteristics a good citizen exemplifies. Many social studies teachers and textbook writers consider patriotism a blind and uncritical acceptance of our past and present.

Because of this questionable conception of patriotism, schoolbook history has for years consisted largely of carefully selected events which show the most positive and harmonious aspects of our past and the most glorious deeds of our national heroes. The shortcomings of our nation – all human societies are imperfect – have been grossly neglected. As Clegg and Schomburg pointed out:

> . . . schoolbook history tends to be the approved recorded narrative of the past. In the terms of the anthropologist, history in the elementary school consists largely of passing down myths and legends of our national heritage as part of the initiation of youth into the culture of the society.[43]

The turmoil and strife pervasive in our society during the 1960's suggests that we have been rather unsuccessful in initiating our youth into our society and in developing "good and patriotic citizens," however we might define these lofty terms. It would be naive to suggest that schoolbook history *caused* the major social problems of the 1960's. However, school history did little to help prevent or solve them; the sugar-coated view of American history which children are fed in school contributed greatly to the cynicism and distrust which was so evident during the 1960's and 1970's when college students were setting fires in university buildings and boycotting classes. Our youth rightfully becomes bitter and hostile when they discover that the "truths" which they learned in their history books are half-lies.

The critical times in which we live demand a new concept of "patriotism." To perpetuate democratic ideals and a just society, we need citizens who not only are acutely aware of the characteristics of a democracy, and committed to its ideals, but who are aware of the *inconsistencies* in our ideals and actual behavior. Only if they are aware of such inconsistencies will they be able to help close the gap between the ideal and the real. Clearly, citizens who are uncritical and nonreflective will not be able to improve our nation. *A patriotic and effective citizen is one who has developed an appreciation for the democratic process by being allowed to use it, is aware of the struggles, shortcomings, and successes which Americans have experienced to make democracy a reality, and is willing to act in ways that will maximize democratic opportunities for all in our nation and in the world.*

When children are saturated with half-truths and sugar-coated success stories about our nation and national heroes, they conclude that the building and perpetuation of a democracy is a carefree and easy job. They must learn that struggles, pain, agony, and sometimes bloodshed are necessary to build and maintain a just and humane society. That we have not yet attained this cherished goal should be realized by children. However, they should also know that much progress has been made and that they must help complete the job.

Children should also know that our great national heroes were human as well as famous. Lincoln signed the Emancipation Proclamation, but he also supported the movement to deport blacks to Africa. Children cannot easily identify with "heroes" who are unhuman, because they seem too different from themselves.

One of the realities which children must eventually learn to accept is that all human beings, no matter what they accomplish, are fallible. It is a disservice to lead them into thinking otherwise. These comments are not iconoclastic, nor do they suggest that children cannot gain inspiration and learn accepted and cherished values from reading well-written history and biography. Most of us, at one time or another, have been inspired by the stories of great men's lives. However, the most successful biographies are those which portray the subject not only as a hero, but also as a human being.

SCHOOLBOOK HISTORY

Like the schoolbook histories in most other countries, our histories are written largely to show the "best" of America and the shortcomings of other countries, especially nations perceived as enemies. Schoolbook history is primarily *political* history. Several studies in recent years have focused on national bias in the textbooks of various nations. In 1966, a team of British and American historians studied the treatment of the American Revolution, the War of 1812, and World War I in a sample of school history books in these two nations. This committee concluded that books in both countries are replete with national bias. Billington, summarizing the report writes:

> . . . nationalistic bias persists, and in somewhat more dangerous form than the monstrous distortions of a past generation. Today's bias is more subtle,

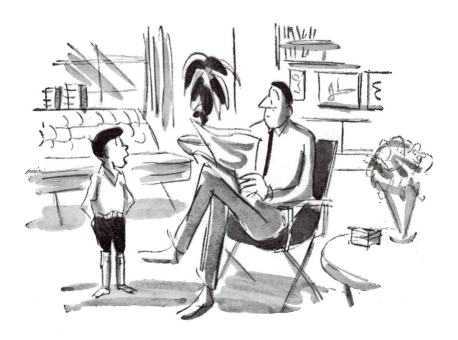

"I was looking at some of your old textbooks. You must be terribly misinformed."

Drawing by Doris Matthew. Copyright © 1968, Saturday Review, Inc.

more persuasive, and far less easy to detect, partly because it often mirrors subconscious prejudices of which the textbook author himself is unaware. Today's textbooks plant in the minds of their readers a belief in the overall superiority of their own countries, not simply an exaggerated image of the virtues of past leaders.[44]

Three professional organizations, The American Historical Association, the National Council for the Social Studies, and Phi Delta Kappa sponsored a study in 1966 to determine the treatment of the United States in a sample of school history books in various countries, including Argentina, Australia, China (Mainland and Nationalist), Finland, France, Germany, and the Soviet Union.[45] The report indicates that the treatment of such topics as the *American Revolution, Slavery and the Civil War,* and *American Culture* differs in the textbooks of various countries, and that the views of the United States reflect the other country's form of government and the type of diplomatic relationship it has with the United States. The following excerpts from text-

book accounts of the American Revolution from Russia, England, and the United States are illustrative:

RUSSIA

In fighting the War for Independence in North America, the bourgeoisie led the popular masses of the colonies against the English landed aristocracy and against the colonial yoke of England. This war of the colonies for independence was a bourgeoisie revolution which overthrew the landed aristocracy and brought to power the American bourgeoisie in union with the slaveholders.

The American bourgeoisie used the struggle of the popular masses against the English as a means of achieving power; then, having come to power, like the English bourgeoisie of the seventeenth century, they oppressed the popular masses. In North America under the title "sovereignty of the people" (democracy) a so-called bourgeois democracy (in actual fact, the power of the bourgeoisie) was established.[46]

ENGLAND

For several years now the rebel agitators had been organizing the Sons of Liberty in most of the towns and cities. They were groups of men and boys, who used any new British tax law or regulation as an excuse to riot and attack the homes of British officials and those who sided with the government.

When the Massachusetts Committee of Correspondence sent word of the doings at Lexington and Concord through the Colonies, blaming the British for firing first, whether they did or not, the Sons of Liberty ran rampant. They stormed the houses of people on the British side, tarring and feathering the owners. They threatened the British governors, who fled from them to British warships. Volunteer soldiers from all over New England hurried towards the rebel camps outside Boston. Soon the city was under a nine-mile long siege.

Early in May the New Englanders struck in another direction. Near the Canadian Border, at Ticonderoga, between Lake George and Lake Champlain, there was a tumbledown fort. A band of outlaws under a giant leader, Ethan Allen (they called themselves the Green Mountain Boys from their home in the Green Mountains of New Hampshire) set out to capture Fort Ticonderoga. On the way Allen was joined by a fiery, energetic Connecticut apothecary turned army captain, Benedict Arnold. Allen's Green Mountain Boys captured the forty-five redcoats in Ticonderoga "in the name of Great Jehovah and the Continental Congress," surprising them while they slept.

Hundreds of Americans, loyal to the Crown, had been flocking into Boston for safety ever since Concord and Lexington. (General William) Howe could not leave them behind for rebel vengeance. They were packed into British ships in the harbor, bound as they said "for Hell, Hull, or Halifax." They were the first thousand of 100,000 Americans who went into exile

rather than live outside the British Empire. They called themselves Loyalists. The rebels called them Tories and traitors, stole their goods, and looted and confiscated the homes they left behind.[47]

UNITED STATES

Trouble Over Trade. When the colonies were founded, the British said, "These colonies will help make us rich. We will buy raw materials from the colonies for a low price. We will sell manufactured products to the colonies for a high price. This trade with the colonies will help make England rich."

The British passed several *trade laws.* With these laws they tried to force the colonies to send all of their raw materials to England. With these laws they tried to force the colonists to buy manufactured goods from English merchants.

The colonists did not think these laws were fair, and there were many bitter arguments over them. One Massachusetts merchant said angrily, "Why should I buy cloth from England when I can get it cheaper in France? England has no right to make such laws. The King is trying to take away our freedom."

Trouble Over Taxes. England kept many soldiers in America. She said that they were needed to protect colonists from the Indians.

The British felt that the colonists should help to pay for this army. In order to get money, the British decided to *tax* some of the articles imported by the colonists. For example, the colonists raised no sugar. The British decided to make the colonists pay a tax on much of the sugar they imported.

Later, the British passed a law called the Stamp Act. This law said that a stamp must be put on every important paper, such as wills, and even on newspapers. These stamps had to be bought from representatives of the British government.

What Did the Colonists Do About The Trade Laws and the New Taxes? A colonist in Virginia spoke out. "We have been making our own laws here in Virginia for almost 100 years," he said. "The British *Parliament* has no right to tax us. I, for one, won't pay."

In other colonies people felt the same way. They refused to obey the trade laws. They would not pay the stamp tax. In some towns the colonists burned the tax offices. In others they held parades, set fire to images of the King, and ran the tax collectors out of town. The colonists who opposed England we called *patriots.* Those who continued to obey the British laws and who remained loyal to England we called *Loyalists.*

Finally, the British Parliament did away with all the new taxes except the one on tea. "We will keep the tax on tea," the British said. "That will show those foolish colonists that we have the *right* to tax them."

Many colonists quit drinking tea rather than pay the tea tax. An English company sent several boatloads of tea to America. But people in a number of towns refused to let the ships be unloaded.[48]

NEW GOALS FOR HISTORICAL STUDIES

The tenuous nature of history and the seeming failure of traditional history instruction make it evident that historical studies in the public schools need new objectives. Because of the momentous problems which man will face in the future, the development of inquiry skills and the formulation of historical generalizations should be the primary objectives of historical studies. These skills will help children now in the elementary and junior high-school grades to influence public policy in tomorrow's world. These objectives imply a different kind of instructional program for the elementary and junior high-school child. Students should not only study the *products* of history as found in their schoolbooks and other sources; they should also solve historical problems using the methods of the historian.

By using the historical method, children will derive generalizations which can help them understand man's behavior in the past, present, and future. Historical generalizations will also help them appreciate the pervasiveness of *change* in the modern world, and learn how to cope with it.[49]

Helping children understand and use the methods of the historian should be important objectives of the social studies program, since we cannot teach what actually happened but must teach perspectivistic historical accounts. By using this approach to history, teachers will help students to discover that written history is largely made up of accounts of events from particular points of view. Studying the methods of the historian will also help students realize that there are many ways of looking at identical events and situations. Their own reasoning and critical powers will be used and strengthened. If students are taught to treat history as assured knowledge, they are likely to believe that any information in print is sufficient evidence of its credibility.

Learning the methods of the historian is also valuable because history is not only an account of the past but a *method of inquiry*. It develops through a process whereby we ask questions and attempt to find answers. In addition it involves evaluating the importance and authenticity of artifacts and documents and using them skillfully to comprehend the past. Just as baseball players cannot really become skillful watching baseball games, students cannot really understand history by simply reading accounts of history as written by historians. They must become involved in applying the method of inquiry.

The rationale underlying student involvement in this method is not to make them professional historians. We involve students in this process so that they will learn to appreciate the difficulties inherent in reconstructing past events. We trust that their powers of reasoning and discrimination will develop, and that they will read history more critically. Practice in the historical method will also increase the students' problem-solving skills. For example, they will learn to pose hypotheses, collect data, determine the authenticity of sources, and draw conclusions from the data collected.

Most historians refuse to generalize intentionally, and the generalizations which they state are often limited to specific events. After studying a sample of American history textbooks Cox concluded, "Most history textbooks . . . seem

deliberately to avoid generalizations. And when included, generalizations are ordinarily confined to a particular historical context."[50] One of the major assumptions of this book is that students should be exposed to social data, and through an inquiry process, derive generalizations which can help them make intelligent decisions on social issues.

Despite the limitations inherent in the historical method, and historians' reluctance to generalize, students in the elementary and junior high-school grades can derive historical generalizations. However, historical generalizations must consist of concepts from other disciplines, such as *civilization, nationalism, conflict*, and *exploration*. Historical generalizations state how social science concepts were related in the past. Higher-level generalizations are more difficult to formulate in history than in the behavioral sciences because of the gross limitations of the historical method. While children should be taught how to derive and test historical generalizations, they should be keenly aware of their *limitations*. For example, when a student derives this statement after a study of the French Revolution, "*During a revolution, moderate leaders take over after the old regime is overthrown; the moderates are eventually overruled by extremists*," he should know that while this generalization correctly describes the events which occurred during the French Revolution, a revolution which occurs in a society significantly different from the one in France in 1789 may be characterized by a different sequence of events.

Since most history textbooks are organized chronologically and give insufficient attention to generalizations, the teacher and other members of the social studies staff of his school will need to *identify* the historical generalizations which they wish students to learn during the year, and then to select the appropriate materials and teaching strategies. The generalizations chosen for study may be somewhat limited by the topics and content which the teacher is required to teach in a particular grade.

However, the required content for any particular grade does not severely limit the generalizations which a teacher might help children derive during the year. For example, children are required to study American history in the fifth and eighth grades in most schools. Topics in American history can be used as data for developing a large range of generalizations. Consider the following:

a) *Revolutions sometimes occur when a group of people feel that they are mistreated or exploited by another group.* (Topic: The American Revolution)

b) *Contact and trade between groups tend to affect the cultures of both groups.* (Topic: The Colonists and the Indians)

c) *When a group of people have been enslaved or repressed in other ways and their conditions are beginning to improve, they tend to rebel in violent ways.* (Topic: Slavery and Slave Rebellions)

In recent years a number of school district curriculum committees and social studies project directors, with the assistance of social science specialists, have attempted to identify major generalizations in the various social science

disciplines to use for instructional purposes. Also, some social studies professional books contain lists of generalizations.[51] These lists include generalizations which vary greatly in degree of applicability. Some are of a very low order; others purport to describe universal events and situations. Many are not empirical statements at all, but value assertions. (The reader can review Chapter 3 for a detailed discussion on the nature of scientific generalizations.)

The teacher should realize that a list of statements whose author claims are *generalizations* may be normative statements, statements which lack empirical support, and statements that contain many dubious concepts. Lists of generalizations are only *lists*, and should be used only to plan and guide instruction. Children must derive generalizations for themselves if they are to have any meaning. Memorizing meaningless generalizations is not essentially different from memorizing lists of unrelated facts, a practice which most of us now publicly damn. We should not repeat the same kinds of mistakes when teaching children key concepts and generalizations.

In our discussion of historical concepts, we argued that although history uses concepts from other disciplines, we can formulate generalizations which show how these concepts were related and exemplified in past human behavior. Because history, in principle, is concerned with the *totality* of man's past experience, it is a truly interdisciplinary discipline. It can and sometimes does employ concepts from all the social science disciplines to explain the past.

We have identified a number of generalizations below which can be considered historical in nature, and indicated the social science concepts and disciplines to which they are related. This list of historical generalizations can be used to guide the planning of historical studies in the elementary and junior high-school grades.

CHANGE (History–Sociology)

Human society is characterized by change.

CONFLICT (History–Political Science)

Wherever human beings have lived, conflicts between individuals, groups, and nations have arisen. Although conflicts obviously have negative effects upon a society, they are often the impetus for effective social change.

REVOLUTION (History–Political Science)

Revolutions tend to occur in societies where organized groups perceive their conditions, which are beginning to improve, as intolerable, public officials as unresponsive to their needs, and legitimate channels for alleviation of grievances as ineffective.

CIVILIZATION (History–Anthropology)

Wherever man has lived, he has developed a system of artifacts, beliefs, and behavior patterns which enabled him to satisfy his physical and social needs.

Historical studies will enable students to see how regions have been used and changed by different cultural groups. (Seattle Public Schools, Washington)

EXPLORATION (History–Geography)

The explorations which men have made into what were to them strange territories have resulted in tremendous cultural exchange as well as conflict between different cultural and ethnic groups. In general, cultures that were more technologically advanced have destroyed civilizations that were less technologically developed.

HISTORICAL BIAS

A historian's view of the past is influenced by the availability of evidence, his personal biases, purposes for writing, and the society and times in which he lives and writes.

STRATEGIES FOR TEACHING
SELECTED HISTORICAL CONCEPTS AND GENERALIZATIONS

When the teacher plans a social studies unit in the elementary and junior high-school grades, he should make sure that the students are provided opportunities whereby they can view the problem or topic being studied from

Household items used by early Americans can help children to derive important historical generalizations. (Shoreline School District, Seattle, Washington)

the perspectives of several of the social science disciplines. Although a unit problem may be primarily sociological or anthropological, students should also look at it from a historical perspective. When students are studying the concept of *socialization*, for example, they can compare the *roles* of the child in a colonial farm family with the roles of a child in a city family today. While studying the concept of *region*, they can investigate ways in which particular regions have been used and changed by different cultural groups. A study of *scarcity* of land resources during the settlement of the West and today will reveal painful facts about ways in which we have exploited our natural resources.

Almost every concept or problem studied in the social studies curriculum can be profitably viewed from a historical perspective. It is necessary for the teacher to identify and state historical generalizations for his unit during the early phases of unit planning in order to assure that historical components will constitute essential parts of it. The emphasis should be on historical generalizations and not on a mass of unrelated facts about specific events. It is difficult to justify requiring children to memorize a mass of facts unless these facts can be used to help them grasp higher levels of knowledge. In the exercises which follow, we select three historical generalizations and illustrate how the teacher may plan lessons to help the students derive them. The

strategies are exemplary only. The creative teacher will think of many other ways to help children grasp these generalizations.

GENERALIZATION: *A historian's view of the past is influenced by the availability of evidence, his personal biases, purposes for writing, and the society and times in which he lives and works.*

Primary grades

1. After a class field trip, ask each of the children to summarize in one or two sentences what happened. Write their responses on the board. Ask them how their responses are alike and different, and *why* they are different. Help them to discover that their own personal feelings and experiences shaped their perceptions and memory of the field trip.

2. Ask the children to write or state in one sentence what happened during the art period yesterday, or some other day. Have them compare their responses and see how they are alike and different. Ask them why they wrote or gave *different* versions of what happened.

3. Read the children a story, and ask them to summarize what happened in one or two sentences. Have them compare their responses to see how they are alike and different. Ask them *why* they are different.

4. If the children are in their second year of school, ask them to describe their previous year in one or two sentences. Have the pupils compare their responses, and ask them why, since they were in the same room, they gave different versions of the year's experience.

5. After a role-playing session in the classroom, ask each student to write or tell in one or two sentences what happened in the role-playing situation. If the children are unable to write, put their responses on the board. Have the class compare them.

6. Show the class a picture which shows black slaves happy and singing. Show them another in which the slaves are bound in chains and looking sad. A third picture might show slaves being sold on a slave market. As you show each picture, ask questions such as, "What is happening in this picture?" "Do these people look happy or sad?" "Why?" When you have finished, ask: "How are all of these pictures alike?" "How are they different?" "Why do you think that they are different?" "How can we tell which artist is telling the truth?" The pupils might be asked to write a caption for each of the pictures.

7. Read several short conflicting versions of the life of a person such as Abraham Lincoln or Crispus Attucks. Ask the class why different versions are written about the same man. Ask them which version they think is most nearly

correct and why. Ask them to tell how we can go about finding out which version is probably nearest to the truth.

8. Read a short story of the American Revolution. Emphasize the Battle of Lexington. Tell the children about the controversy regarding who fired the first shot. Read them the conflicting documents which British and Americans have written about the event. Ask them whether we can determine what really happened, and if so, how.

Intermediate and upper grades

Older children may be exposed to the notion of bias in history by comparing the treatment of the American Revolution, the War of 1812, and World War I in British, Canadian, and American textbooks. Many American publishers have offices in foreign countries, and are willing to help teachers and other professionals obtain copies of foreign textbooks for classroom use at regular cost plus air postage. Collecting foreign social studies textbooks for use in historical studies is an interesting and exciting project.

Most teachers will find it necessary to restrict themselves to those books which are published in the English language. The foreign language department in your school or the local high school or college might be willing to work with elementary teachers on a textbook translation project, however. Also, in many foreign countries, such as Japan, Canada, Australia, Nigeria, and India, English is an official language and textbooks can be obtained in English. When using foreign textbooks with children, it is best to duplicate the selections from the books which you wish to use with the class. This will not only help preserve the books, but will enable students to state hypotheses about the country from which the book came. This strategy will also encourage students to focus on specific events and topics.

Another effective technique is to have students study the treatment of controversial topics, such as slavery and the Civil War, in textbooks written at different time periods and in different regions of the United States. The teacher may be able to obtain old textbooks from senior citizens in the community, retired teachers, or from public or school libraries. State history textbooks are especially valuable for illustrating how regional influences shape the treatment of controversial topics. A list of approved state histories and their publishers is available from each state department of education.

These books can be ordered directly from their publishers at regular retail prices. The author has recently obtained copies of the elementary school state histories of Georgia, Louisiana, Florida, Arkansas, Alabama, Texas, and Mississippi to study the treatment of several controversial topics in these books. As was hypothesized, most of them glorify their state heroes, and reflect the biases of the South when topics such as minority groups and the Civil War are discussed. However, the treatment of many issues do not differ significantly from the typical schoolbook history of the United States.

Students could be given two conflicting accounts of an event, such as illustrated below, and asked questions such as those which follow the selections.

One of the selections is from a junior high-school black history text; the other from a state history of Mississippi.

ACCOUNT I

All colonies had regulations to govern the slaves' behavior. These regulations were called Slave Codes. The purpose of the codes was to control the slaves in order to keep them from starting rebellions. The codes in colonies where there were large numbers of slaves were generally more severe than the codes in colonies where there were fewer slaves.

Under the slave codes, blacks were not allowed to own property or weapons. They could not form groups unless a white person was present. They could not buy or sell goods, or leave the plantation without permission of their master. In towns and cities, blacks were required to be off the streets by a specified hour each night. A slave could not testify in court against a white person. A slave who was charged with a crime against a white person was therefore unable to defend himself. Any slave who violated the laws was likely to be severely punished, perhaps even by death.

Slaves in the South were not allowed to marry. Sometimes they were not even allowed to choose their own mates. Children could be separated from their parents when the parents or the children were sold to new owners. Some children born to slave mothers had white fathers. These children were classified as slaves. [52]

ACCOUNT II

Slave treatment. While there were some incidents involving the abusing of slaves, public opinion and state law generally assured the slaves of good treatment. Plantation owners usually cautioned their overseers against using brutal practices. Naturally, there were some abuses on large plantations, especially when the owners did not live on them. Most people, however, favored kind treatment of slaves.

The courts were especially watchful in the interest of the slaves. In 1818 the state supreme court freed two slaves who had been sold . . . by a resident of Indiana. They were freed on the grounds that slavery was not legal in the state of Indiana. Also, a . . . white man was sentenced to hang for murdering a slave in 1821.

A planter usually took a keen interest in his slaves, attending to both their spiritual and their physical needs. It was the planter who ordinarily assumed the responsibility for the souls of his slaves. Sometimes "Sunday schools" were held on the plantation by the planter's wife, and the Negro slaves usually attended their master's church, where they sat in a "slave gallery." [53]

QUESTIONS ON ACCOUNTS I AND II

1. How are these two accounts alike?
2. How are they different?
3. Why do you think that they are different?
4. Who do you think wrote the first account? The second account? Why?
5. Which account do you think is more accurate? Why?
6. Which author supports his statements with facts? Gives specific examples?
7. Read other accounts on the treatment of slaves, and write a paragraph in your own words about how the slaves were treated. How do your conclusions compare with the accounts written by the two authors above?

Role-Playing

Stage a role-playing situation for the class (using several members of the class as participants). Ask each student to write what he saw happen in the situation. The accounts should be written independently. When the reports have been written, ask the class to compare them to see how they are alike and how they differ. The class should use their accounts to answer the following questions:

1. Can different accounts be written about the same event?
2. What does the answer to Question 1 tell us about the writing of history?
3. Are two people who witness an automobile accident likely to give identical reports of it?
4. Are two historians who read the same documents about a particular historical event likely to write identical accounts of the event? Why or why not?
5. Are two people who participate in or observe the same historical event likely to write identical accounts of the event? Why or why not?
6. What are some of the factors that cause historians to write different accounts of the same events?[54]

GENERALIZATION: *Historians use a variety of resources and materials to reconstruct past events and to find out about the past.*

Primary grades

1. Ask each child to tell or write as much as he can about last Christmas or some other special day, such as his birthday. The children will remember some things about the day, but will have forgotten much of what happened. Ask them how they may go about filling in the gaps of their memories. They could talk to relatives and friends, and look at home photographs to try to *reconstruct* what happened on that day. Some of their older toys may help them remember certain details. The children should discover that we can use a variety of resources (including people and things) to help us find out what happened in the past.

2. Show the children pictures of a one-room schoolhouse, a spinning wheel, a wagon train, an oil lamp, and other items used by early Americans. Ask them to identify the objects in the pictures and to tell what they reveal about early Americans.

3. Have the children write very brief histories of their families and tell what resources and materials they used.

4. Upper primary grade children may write short histories of their home and school. They could discuss the resources which they found most helpful.

Intermediate and upper grades

The community offers an excellent laboratory for students to use in their search for answers to historical queries. One effective and interesting approach is to have students formulate hypotheses about the first residents of their community. The class then divides into groups to test their assumptions. One group visits the director of the museum to obtain data for the study; another group interviews the local newspaper editor. He may refer them to early copies of the newspaper and other documents in his possession. This research can lead to interviews with senior citizens about the legendary beginning of the community. Additional artifacts may be discovered in their homes. A third group visits the historical society and other public and private civic agencies. Such inquiries are welcome, and the students may obtain additional information.

After all possible community resources have been surveyed and available artifacts examined, the data should be compared and the validity of the hypotheses tested. The students must determine which sources of evidence are most credible. Determining the authenticity of the various sources will be most important, of course, when information is in conflict. When the data have been carefully evaluated, the students may have to reject many of their hypotheses. The conclusions reached by the class may be compared with the community's history as written by local historians. If discrepancies exist between the accounts, the students should attempt to determine whether the author's account is more reliable. This may be done by checking the background of the author, the sources that he used in writing the account, and if possible, by interviewing persons in the community.

Many other community topics can be studied by the class. Lord lists the following as possible topics: the people in the community, the beginnings of the community, the town, business and industry, trade and communication, labor, the professions, education, the arts and crafts, government, and recreation. [55] The students may formulate the following historical questions about these aspects of the community: What was the first business in the community? How did this business affect the settlement of the community? When and why were the first steps taken to organize a labor union in our town? What were the first professions in our community? How did they get started? When and why was the first system of government set up in our town? How does it relate to the government that we presently have?

Lord gives some sound reasons for encouraging students to publish local histories: "... partly as a reward, a prestigious public recognition of the students' work; partly as a contribution to knowledge of the history of the community, precious little of which may be in print."[56] He lists the following publishing outlets as possibilities: the school newspaper, a book or booklet, a statewide magazine for junior historians, the journal of the local historical society, and the local newspaper.[57] "If all else fails," he writes, "the school mimeograph machine or the typing department can turn out a number of copies for the school and local libraries and perhaps for sale to interested people."[58]

Lord is obviously writing about polished and sophisticated localized histories. However, in the elementary or junior high-school grades, a fifth grade class may undertake the study of a limited aspect of the community's history and ditto it for the class. The students could write or print on ditto stencils. They could also make copies for other classes in the school or perhaps distribute copies to interested persons in the community. Writing up the results of a community study provides an excellent opportunity for the teacher to teach language arts combined with social studies skills. The children should be encouraged to use acceptable punctuation, correct spelling, and an interesting writing style. The art teacher might help the children with drawings, cartoons, and other illustrations. However, the teacher should not focus so much attention on the appearance of the final product that the main purpose of the study is minimized or neglected.

GENERALIZATION: *Human society is characterized by change.*

Primary grades

1. Show the children pictures or models of a stage coach, buggy, a man on horseback, Indians in a canoe, and an early train. Ask them to tell how all the pictures are alike (they are all forms of transportation). Show them pictures of modern cars, airplanes, ships, and spaceships. Ask them how all of these pictures are alike (they show modern forms of transportation). Ask the children the following questions:

a) How is the second set of pictures and models like the first?

b) How it is different?

c) Why is it different?

d) How might transportation in the future differ from transportation today?

2. Read a story about a one-room schoolhouse in early America. Show the class a picture of such a school. Ask them how their school is similar to and different from the early school, and why it is different. Have them describe what they think schools may be like in the future. The teacher could extend this exercise by showing pictures and reading stories about life on an early American farm and life on a modern farm, and asking the children questions

Models of early American communities will enable children to better under-
stand the concept of *change*. (Seattle Public Schools, Washington)

similar to those described above. The pupils could also study and discuss pic-
tures and models of early and modern factories, clothing, furniture, and ma-
chines. The children participating in these exercises should be able to conclude
that man constantly changes his physical and cultural environment.

3. Read a story or book about family entertainment in colonial America. Ask
the children to make drawings showing the kinds of things their families do
together for fun. When they compare their families' recreations with
entertainment in the colonies, they will be able to state how family
entertainment has changed. Ask them what kinds of entertainment families
might have in the future.

4. Have the children draw pictures of helpers in their community, such as the
postman, milkman, and firemen. Read a selection about life in a colonial
village, and life in a small rural town. Ask them to state why there were fewer
community helpers in early American villages than in modern cities. This
exercise could be extended by asking the class to illustrate by drawings means
of communications in their communities. The teacher could read a selection on
early forms of communication and have the children compare traditional and
modern means, and hypothesize about the differences.

Intermediate grades

1. Read the children a description of their state when it was inhabited by Indians before the coming of the white man. Mention the kinds of foods eaten, hunting, farming, clothing, work, play, and other aspects of the Indians' physical and cultural environment. Ask the class to hypothesize about the time and location of the society described. After the students have had an opportunity to give their ideas about the culture, have them read a selection on life in their state. Eventually, the children should know that both selections describe their state but at different times and when inhabited by different peoples. Ask them to hypothesize about why the changes took place.

2. Have the children portray through role-playing and drawings the achievements of early state and national explorers. Assign readings on modern pioneers, such as leaders in space and medicine. Ask the class to state ways in which the early and modern pioneers are alike and ways in which they are different. Ask them to describe future pioneers.

Upper grades

1. Ask the class to show, with outline maps of the world, how the physical boundaries of nations have varied during different times in history. Ask them to state reasons why the physical boundaries of countries change, and to predict what changes they think might occur in political boundaries in the future. They should be asked to give reasons for any predictions made.

2. Have the students read a story on life in a colonial settlement. Show a movie or filmstrip on modern American cities. Ask the children to tell how transportation, foods, clothing, entertainment, community services, values, life styles, and other aspects of life in these periods are similar and different. They should also state reasons for differences. Ask them to predict what changes might occur in American life styles in the future, and to state reasons for their predictions.

SUMMARY

History consists of three components: (a) the past, (b) statements about the past, and (c) a method of inquiry. It is important for the teacher to understand how these aspects of history differ in order to organize effective lessons in historical studies and to help children view social problems from the historical perspective. The historian is never able to totally reconstruct past events because of the lack of available data. Further, he is not able to use all the data that he locates. To write a meaningful narrative, he must select from the data which he uncovers what he regards as most valid and reliable. His selection of data to include in his accounts is influenced by his personal biases, purposes for writing, and the society and times in which he lives and writes. Because history is highly influenced by the biases of historians, it is extremely important for

children to develop skills in historical inquiry so that they will become more intelligent consumers of history.

History differs from the other social disciplines in several ways. It includes elements of both science and the humanities. The historians' interest in writing exciting narratives and their tendency to describe unique events, relate the discipline closely to the humanities. However, history is "scientific" because historians use the scientific method in modified form, and value objective description. Objectivity is an ideal within the discipline. Thus history is considered a *modified* science in this book.

History is distinguished from the other social sciences not by its special concepts but by its concern for the past and its mode of inquiry. Although the other social sciences are characterized by their tendency to view human behavior from special conceptual frameworks, history, in principle, is concerned with the totality of man's past and thus is in one sense a highly interdisciplinary discipline. While this is the case in principle, in practice historians most often use political science concepts. Modern historians, however, are using concepts from the other disciplines more and more frequently to explain the past. This trend will undoubtedly continue as historians become more familiar with concepts in the behavioral sciences. Because historians attempt to reconstruct the past, they experience unique research problems. While all social science disciplines have historical components, history is the only discipline primarily concerned with the past. To help children view problems from the historical perspective, the teacher should teach concepts and generalizations related to the conclusions (products) of history, as well as those which relate to history as a *process*.

DISCUSSION QUESTIONS AND EXERCISES

1. Locate several accounts of controversial historical events such as the American Revolution, Slavery and the Civil War, or the War of 1812 that were written in different periods of history, in different states, and in different countries.* After the accounts are located and analyzed, answer these questions: (a) How are the accounts alike? (b) How are they different? (c) Why are they different? (d) What *generalizations* can you make about the controversial historical event(s)? (e) What generalizations can you make about the *nature* and *writing* of history?

*Donald W. Robinson has edited a book, *As Others See Us: International Views of American History* (New York: Houghton Mifflin, 1969), that contains accounts of such events from textbooks in use throughout the world. A Southern view of slavery can be found in the classical book by Ulrich B. Phillips, *American Negro Slavery* (New York: Appleton, 1918). The following books also contain useful documents for this exercise: John L. Thomas (Ed.), *Slavery Attacked: The Abolitionist Crusade* (Englewood Cliffs, N.J.: Prentice-Hall, 1965); Eric L. McKitrick (Ed.), *Slavery Defended: The Views of the Old South* (Englewood Cliffs, N.J.: Prentice-Hall, 1963); and David F. Kellum, *American History Through Conflicting Interpretations* (New York: Teachers College Press, 1969). Many history anthologies contain documents which can also be used to complete this exercise.

2. Obtain a copy of a fifth-grade American history textbook in your curriculum library. Study the treatment of the American Revolution in it. How would you use this account to help children learn how history is written?

3. Write three lesson plans to teach the following generalizations to children at the *primary, intermediate,* and *upper grade* levels:

> *A Historian's view of the past is influenced by the availability of evidence, his personal biases, purpose for writing, and the society and times in which he lives and works.*

What difficulties might you encounter in teaching this generalization at these three levels? How might these difficulties be overcome?

4. Study the treatment of blacks, Chicanos, Amerindians, and Puerto Ricans in a sample of American history textbooks written for the elementary and junior high-school grades. What *generalizations* can you make about the treatment of these groups in the sample of books which you studied? What implications do your generalizations have for teaching history in the elementary and junior high-school grades?

5. Locate an account in a history textbook of a historical event, such as the exploration of the New World, the founding of the colonies, or the American Revolution. Using the account you locate as your only source of data, plan a lesson for the intermediate grades illustrating how you could use the account to teach children how to formulate *hypotheses*. Extend the lesson by listing the kinds of sources and questions that you could use to help the students test their hypotheses.

6. Carefully study the Table of Contents of a history textbook and list the major *concepts* which are discussed and illustrated in the book. After listing the concepts, classify them according to the discipline to which you feel they belong. For example, *revolution* is usually considered a political science concept, *culture* an anthropological concept, and *scarcity* an economic concept. To which discipline do most of the concepts belong? What implications do the results of your investigation have for the teaching of history in the elementary and junior high-school grades?

7. Carefully study a chapter on any topic in an elementary or junior high-school history book. List the major *generalizations* which the author makes about the topic. Determine the *level* of each of the generalizations. For example, are most of them higher- or lower-order generalizations? (See Chapter 3 if you need to review the levels of generalizations.) Can you use the generalizations you have listed to teach children to generalize at higher levels? Illustrate your response with an actual teaching plan.

8. Write a generalization related to each of the following concepts: *socialization, scarcity, change, revolution, culture, region,* and *power.* Illustrate, with a teaching plan, how you would use historical data to help children to derive each of your generalizations.

9. How is history like and different from the other social science disciplines? What implications does your response have for the teaching of history in the elementary and junior high-school grades?

10. What do you think should be the primary goal(s) of historical studies in the elementary and junior high-school grades? How can the unique characteristics of history facilitate the attainment of these goal(s)?

11. Demonstrate your understanding of the following key concepts by writing or stating brief definitions for each of them. Also tell why each is important:

a)	history-as-actuality	g)	historical problem
b)	historical statement	h)	structure in history
c)	history as process	i)	civilization
d)	historical concept	j)	historical philosophies
e)	historical generalization	k)	history as modified science
f)	historical bias	l)	schoolbook history

FOOTNOTES

1. Louis Gottschalk (Ed.), *Generalizations in the Writing of History.* Chicago: Univ. of Chicago Press, 1963, p. v.

2. James A. Banks and Ermon O. Hogan, "Inquiry: A History Teaching Tool," *Illinois Schools Journal,* Vol. 48 (Fall, 1968), pp. 176-180.

3. Phil L. Snyder (Ed.), *Detachment and the Writing of History: Essays and Letters of Carl L. Becker.* Ithaca, New York: Cornell Univ. Press, 1958, p. 59.

4. Allen French, *General Gage's Informers.* Ann Arbor: Univ. of Michigan Press, 1932, pp. 53-54. Reprinted in Peter S. Bennett, *What Happened in Lexington Green? An Inquiry into the Nature and Methods of History.* Menlo Park, Calif.: Addison-Wesley, 1970, p. 14. Reprinted with permission.

5. Ezra Ripley, *A History of the Fight at Concord.* Concord: Herman Atwill, 1832, p. 35. Reprinted in Bennett, pp. 16-17. Used with permission.

6. Bernard Berelson and Gary A. Steiner, *Human Behavior: Shorter Edition.* New York: Harcourt, Brace and World, 1964, pp. 6-7.

7. Mark M. Krug, *History and the Social Sciences: New Approaches to the Teaching of Social Studies.* Waltham, Mass.: Blaisdell, 1967, p. 45; Henry S. Commager, *The Nature and the Study of History.* Columbus, Ohio: Charles E. Merrill, 1966, p. 12; Ralph W. Haskins, "History," in John U. Michaelis and A. Montgomery Johnston, (Eds.) *The Social Sciences: Foundations of the Social Studies.* Boston: Allyn and Bacon, 1966, p. 34.

8. Krug, p. 45.

9. Commager, p. 12.

10. Gottschalk, pp. v-vi.

11. Snyder, p. 56.

12. Commager, p. 53.

13. *Ibid.*, p. 37.

14. Krug, p. 18.

15. *Ibid.*, p. 26.

16. Commager, pp. 6-7.

17. Krug, p. 13.

18. *Ibid.*, p. 47.

19. Commager, p. 9.

20. *A Conceptual Framework for the Social Studies in Wisconsin Schools.* Madison: State Superintendent of Public Instruction, *Social Studies Bulletin No. 4, Curriculum Bulletin No. 14,* undated, pp. 12-24.

21. James A. Banks, "A Content Analysis of the Black American in Textbooks," *Social Education*, Vol. 33 (December, 1969), pp. 954-957, 963 ff.

22. Stanley M. Elkins, *Slavery: A Problem in American Institutional and Intellectual Life.* New York: Grosset and Dunlap, 1963.

23. Edwin Fenton, "A Structure of History," in Irving Morrisett (Ed.), *Concepts and Structure in the New Social Science Curricula.* New York: Holt, Rinehart, 1967, pp. 52-53.

24. *Ibid.*

25. Daniel Roselle, "Editorial Reflections: A Review of *Civilisation* by Kenneth Clark," *Social Education*, Vol. 35 (May, 1971), p. 427.

26. *Ibid.*, p. 428.

27. Haskins, p. 34.

28. *Ibid.*, p. 36.

29. Gottschalk, p. 113.

30. *Ibid.*, p. 113. Used with permission.

31. Crane Brinton, *The Anatomy of Revolution.* New York: Vintage Books, 1962. These generalizations are adapted from but not quoted from Briton's book.

32. Krug, p. 28.

33. *Ibid.*, pp. 28-34.

34. *Ibid.*, p. 28.

35. *Ibid.*, p. 29.

36. *Ibid.*, p. 30.

37. *Ibid.*, p. 32.

38. Gottschalk, p. 124.

39. Commager, p. 89.

40. John Jarolimek, *Social Studies in Elementary Education.* New York: Macmillan, 1967, 3rd ed., p. 327.

41. Morris B. Lewenstein, *Teaching Social Studies in Junior and Senior High Schools.* Chicago: Rand McNally, 1963, p. 148.

42. Krug, p. 22.

43. Ambrose A. Clegg, Jr. and Carl E. Schomburg, "The Dilemma of History in the Elementary School: Product or Process?" Reprinted in Jonathon C. McLendon, William W. Joyce, and John R. Lee, (Eds.), *Readings on Elementary Social Studies: Emerging Changes.* Boston: Allyn and Bacon, 1970, p. 104.

44. Ray Allen Billington, "History is a Dangerous Subject," *Saturday Review* (Jan. 15, 1966), p. 59.

45. Donald W. Robinson (Ed.), *As Others See Us: International Views of American History.* Boston: Houghton Mifflin, 1969.

46. *Ibid.*, p. 43.

47. *Ibid.*, pp. 26-27.

48. O. Stuart Hamer, Dwight W. Follett, Ben F. Ahlschwede, and Herbert H. Gross, *Exploring Our Country*. Chicago: Follett, 1962, pp. 190-91. Copyright © 1965. Reprinted with permission.

49. Jarolimek, p. 329.

50. C. Benjamin Cox. "American History: Chronology and the Inquiry Process," in C. Benjamin Cox and Byron G. Massialas, *Social Studies in the United States: A Critical Appraisal*. New York: Harcourt, Brace and World, 1967, p. 57.

51. Michaelis and Johnston, *op. cit.*, pp. 312-314.

52. James A. Banks, *March Toward Freedom: A History of Black Americans*. Palo Alto: Fearon, 1970, p. 16. Used with permission.

53. John K. Bettersworth, *Mississippi Yesterday and Today*. Austin, Texas: Steck-Vaughn, 1964, pp. 143-144. Reprinted with permission.

54. James A. Banks, *Teaching the Black Experience: Methods and Materials*. Palo Alto: Fearon, 1970, p. 57.

55. Clifford L. Lord, *Teaching History with Community Resources*. New York: Teachers College Press, 1967, pp. 20-28.

56. *Ibid.*, p. 33. 57. *Ibid.*, pp. 33-34. 58. *Ibid.*, p. 34.

SOCIOLOGY: STRUCTURE, CONCEPTS, AND STRATEGIES

THE SOCIOLOGICAL PERSPECTIVE

The conceptual frameworks, perspectives, and questions pursued by the various social sciences are their most distinguishing characteristics. The methods used to gather and report data are highly similar in each of these disciplines (discussed in Chapter 2), although some research techniques are used more frequently in some disciplines than in others. Each discipline possesses a specialized set of *concepts, generalizations,* and *theories* often referred to as the *structure* of the discipline. The structure determines the questions that a discipline asks, the data collected, and the interpretation of its findings. The concepts, generalizations, and theories within sociology are concerned primarily with the nature and interrelationships of human *groups*, such as organizations, institutions, communities, and societies. Inkeles defines sociology as "the study of systems of social action and of their interrelations."[1]

Basic to sociology are a number of assumptions about the characteristics of groups and their effects on an individual's behavior. Sociologists assume that an individual needs the group for his survival, that his behavior is largely shaped by group norms and sanctions, and that the group equips the individual with the behavior patterns and characteristics needed to adapt to his cultural and physical environment. Groups have independent characteristics and identities. They are more than an aggregate of individuals. Groups possess a continuity which transcends the lives of individuals. Although sociologists are primarily concerned with group influence on individual behavior, they do not deny that other factors influence a person's actions. Faris writes,

> . . . without denying a range of freedom for individual choices, and therefore a function for individual responsibility, the accumulated body of

sociological knowledge points to a large and powerful force through which any society guides the behavior of its members . . . Human behavior cannot be completely explained by knowledge of individuals, however thorough.[2]

The following example illustrates how sociological concepts about groups and their interrelations help sociologists to formulate and focus questions, pursue research, and interpret findings. If a sociologist were trying to determine the causes and effects of divorce in modern American *society*, he might start by asking what *roles* each spouse is expected to fulfill in marriage, and what *norms* and *values* are associated with these roles. He would also be interested in the *sanctions* which are used to assure that role expectations are fulfilled, and the conditions under which these sanctions break down. He would investigate how industrialization and urbanization have affected traditional roles, norms, values, and sanctions. The researcher might also try to determine whether the divorce rate varies in different types of *communities* and within different *social classes*. He would probably be interested in how each spouse is *socialized* for the marriage role, and the effects of divorce on an individual's *status* in society, as well as on other *institutions*. The italicized words are *concepts* which the sociologist would use to help him determine what to study about divorce and to some extent how to study it.

A psychologist, anthropologist, and economist would use different concepts and ask different questions about divorce. A psychologist might investigate the extent of *tension* and *aggression* in marriages that end in divorce. An anthropologist could compare the consequences of divorce in different *cultures* throughout the world. An economist might investigate how divorce rates affect the *money* and *wealth* in a society.

IS SOCIOLOGY A SCIENCE?

Berelson and Steiner point out that a science is characterized by public procedures, precise definitions, and objective data collection. The approach to knowledge is systematic and cumulative, and the main purpose of a science is to build theory.[3] These criteria will enable us to determine the extent to which sociology can be characterized as a science.

Public procedures in sociology

The research methods used by the sociologist are usually made *public*. The procedures used, the nature of the sample, and the hypotheses tested are generally reported in sociological studies. However, as a number of sociologists note with disappointment, frequently samples in sociological research are not *representative* of the populations to which the findings are generalized, and the relationship of the findings to theory is not made clear. Much sociological research is nontheoretical. Later this problem will be discussed in more detail.

Definition of concepts

Although sociologists have succeeded in identifying a number of key socio-logical concepts (see pages 200-206), and in obtaining consensus regarding their importance, these concepts are often defined differently by various researchers. Most leading sociologists are very concerned about the problem of definitions in the discipline. Herbert Blumer, an eminent sociologist, contends that key sociological concepts are "vague, ambiguous, and indefinite" and that efforts to make terms more precise have been largely fruitless.[4] Zetterberg writes candidly about the problem:

> Sociologists have spent much energy in developing technical definitions, but to date they have not achieved a consensus about them that is commensurate with their effort. At present there are so many different competing definitions for key sociological notions such as "status" and "social role" that these terms are no more valuable than their counter-parts . . . in everyday speech."[5]

Chinoy attributes the conceptual disagreement in sociology to the rapid development and newness of the field.[6] Sociology did not really emerge as a separate discipline until the nineteenth century. As sociology matures and becomes more scientific, we can expect more conceptual consensus to develop.

Sociological concepts such as *role, mores, custom, community, value,* and *society* are rarely defined in identical ways. This causes research problems. Two sociologists who are studying the role expectations of the wife in *lower-class* American society might reach different conclusions if they define *role* and *lower-class* differently. Another problem arises when the *grand theorist*, who is not a researcher, defines terms differently than the sociologist who does research. Although the concepts above are rarely defined identically by socio-logists, they are not often given *completely* different meanings. There are "shades" of similarities in the definitions of key sociological concepts. The fact that there is some level of agreement about the meanings of central concepts in sociology suggests that the *sociological perspective* can make a substantial contribution to helping elementary and junior high-school students solve social problems and make decisions about important social issues.

Objectivity in sociology

Most sociologists accept scientific *objectivity* as an ideal, but realize the diffi-culties of attaining complete objectivity in a social discipline. However, they do not feel that research *bias* prevents sociology from becoming a science. Writes Faris, ". . . the fact that all men have values does not mean that prejudice bears on every possible issue, and it does not have to render impossible a value-free science."[7] Most sociologists are less optimistic about a value-free sociology than Faris, but believe that the sociologist should be aware of his biases and try to minimize their effects on his research. Fichter reports as follows:

The sociologist, as scientist, tries sincerely to avoid moral judgments about the cultures and societies that he studies . . . Probably no sociologist can entirely purify his lectures and writings from the values that he personally holds . . . even the secular scientist, which every sociologist must be, cannot divorce himself completely from the culture in which he is himself involved. His own personal values in some way reflect the social values of the culture in which he has been socialized.[8]

Because they are perceptive students of socialization, sociologists are acutely aware of how society's values and norms shape an individual's view of the world. However, the acceptance of this fact does not prevent them from striving to make sociology as objective as possible.

Sociology: a generalizing discipline

Sociologists assume, with other behavioral scientists, that man's behavior is patterned and systematic, and have set as their major goal the discovery of lawlike propositions which can contribute to the building of *theories* that can be used to explain, predict, and control human behavior. The sociologist, unlike the historian, is not necessarily interested in single cases, events, or phenomena. Whereas a historian might write a biography of an individual who was a noted leader, a sociologist would study a number of leaders in order to form generalizations about leadership ability.

In other words, the sociologist is primarily interested in studying *classes* of phenomena and their *common* characteristics. A sociologist might study a famous family such as the Kennedy family, but he would also study other upper class families, such as the Rockefeller family, so that he could make some *generalized* statements about eminent upper-class American families. Sociology is a *generalizing* discipline. While sociologists often use the case study method to study single cities, persons, and events, they usually try to derive hypotheses from such studies that others can test using a larger population.

The status of sociological theory

Since the ultimate goal of science is to develop theory, the kinds of theories within a discipline is a revealing barometer of its scientific status. As we noted in Chapter 5, the possibility is remote that history will ever be able to develop theories because it has difficulty formulating empirical generalizations. (Theories, of course, consist of sets of interrelated generalizations.) In most of the older sciences, such as physics and chemistry, most of the knowledge in the field is explained by a small number of highly interrelated and complementary grand theories which are accepted by all specialists in the discipline. *Grand theories* are very abstract and inclusive theories that explain most of the facts in a discipline and relate most of its general laws and principles into a coherent system. Although there is considerable consensus among sociologists that theories are needed to organize and systematize the findings, concepts, and generalizations in the discipline, there is very little agreement regarding which theory or theories can best explain man's group behavior.

There exists in sociology no set of propositions commonly held by all sociologists, couched in identical or easily convertible terms and allowing them to present the known facts and generalizations as logical derivations of a few principles. On the contrary, the development of sociology has been characterized by the rise of an unusually high number of conflicting theories. Although this state of things has not yet been overcome the struggle is no longer so acute as it was at the end of the nineteenth century.[9]

There are several reasons why there are no grand, empirical theories in sociology as there are in the physical sciences, such as physics and chemistry. Sociology is a rather new discipline. When it emerged, a search for single explanations and a nonempirical emphasis dominated the discipline. Both these traditions have adversely affected the development of sociological theory. Auguste Comte, the "father of sociology," and the early sociologists who followed him, searched for simplified, one-factor "theories" that could explain man's group behavior in the same way that "gravitation explains the solar system under Newtonian mechanics."[10] Comte felt that sociology or "social physics" should not only use the research methods of the physical sciences, but that some of the physical science models would prove useful for the analysis of social phenomena. Reflecting the eminence of biology in the nineteenth and twentieth centuries, sociologists tried to explain man's behavior with biological deterministic "theories."

Comte, like his followers, was also an "arm chair" sociologist; he did no empirical research.[11] Because early sociology was a part of social philosophy, "it tended to have a speculative and evaluative rather than an empirical investigative emphasis."[12] As the discipline developed, the theorist worked in his study and formulated "theories" without ever attempting to test them with empirical data. Often the terms and concepts in these "theories" were so vague that they provided little guidance to the field researcher who wanted to test the generalizations that comprised them. Throughout sociology's brief history, rarely has the grand theorist and the empirical researcher been the same individual. While this division of labor still exists to a disappointing extent within sociology, an increasing number of sociologists realize that unless the work of theorists and empiricists becomes coordinated — indeed unless theorists become empiricists and empiricists become theorists — sociology will never develop the theoretical strength of which it is capable. Sociologists such as George C. Homans, Paul F. Lazarsfeld, and Robert K. Merton are both theorists and empiricists. However, they are partial and not grand theorists. More sociological theorists will begin to do empirical research, and sociologists will probably be able one day to formulate grand empirical theories. Writes Bierstedt,

A theory unsubstantiated by hard, solid, and sometimes intractable facts is nothing more than an opinion or a speculation. Facts by themselves, in their isolated and discrete character, are meaningless, useless, and

frequently trivial. One may paraphrase Immanuel Kant . . . and say that theories without facts are empty and facts without theories are blind.[13]

Sociological theory has not reached a higher level of development because sociologists must often do research which does not contribute to the building of theory. Social science research is expensive, and in order to do any kind of research, sociologists often conduct studies on social problems in response to requests by foundations and governmental agencies. Such agencies tend to support research that will most directly help alleviate or eliminate social problems, and are much less interested in contributing funds for basic or theoretical research. Problems in juvenile delinquency, divorce, race relations, and in other areas are often studied by sociologists, even though such research often does not have a theoretical base and thus does not directly contribute to the building of theory. We illustrated in Chapter 2 why theoretical research can best contribute to the explanation and control of behavior, and thus to the solution of social problems.

Although sociologists face many problems in trying to build theories, and no grand or all encompassing theories exist in the discipline that are accepted by all sociologists, the search for single explanations and the nonempirical emphasis in sociology are things of the past. Modern sociologists use highly rigorous methods to gather data, such as mathematical models and complicated statistical techniques. Methodological advances in modern sociology far exceed the development of theory. However, sociologists have been successful in formulating a number of partial theories. Probably the first sociological theory that was tested empirically is the theory of suicide formulated by Emile Durkheim and stated in his book *Suicide*, published in 1897.[14] Modern sociologists have also structured partial theories which deal with such concepts as racial discrimination, riot behavior, and urbanization. Sociology consists of a number of such theories which can serve as a rich source of concepts and generalizations. These can be incorporated into a sound social studies program for the elementary and junior high-school grades.

SOCIOLOGICAL CONCEPTS

The key concepts, generalizations, and theories of disciplines were labelled "structure" during the social studies revolution of the 1960's. When educators first embraced the concept of structure, they felt that many of their pedagogical problems had been eliminated because now they had an alternative to teaching a mass of unrelated and quickly forgotten facts. Jerome S. Bruner was probably the most influential person in the structuralist revolution.[15] Mark M. Krug distinguished himself as one of its severest critics.[16] The revolution seems here to stay, and research supports the idea that children fare better when they master higher levels of knowledge, such as concepts and generalizations. Mastery, transfer of learning, and memory are facilitated. Comprehension is also improved because concepts enable children to categorize and make sense out of what might otherwise become a mass of meaningless facts.

The concept of *socialization* will help children to
understand how profoundly their behavior is shaped by
the persons in their environment. (Highline Public
Schools, Seattle, Washington)

However, the structuralist movement has some difficulties that were not
adequately foreshadowed or appreciated during the early years of the
movement. When educators solicited the help of social science specialists to
identify the *key* concepts and generalizations in their disciplines, they
discovered, to their dismay, that content specialists couldn't agree about what
constituted the *key* ideas in their fields. They also discovered that disci-
plinarians frequently disagree about the definitions of concepts which they all
consider extremely important to their disciplines. Sociologists, like all other
social scientists, disagree about what the key concepts in sociology are, and
about their definitions, as we have seen. However, the sociological concepts
presented below seem to be those most sociologists would consider among the
key ones in sociology. There would be less agreement about their definitions,
but an attempt has been made to be as faithful as possible to most sociologists.

Socialization

Sociologists assume that man is not born human but is made human by the
persons in his environment. Socialization describes that *process* which makes
man human. This concept assumes that man is born plastic, and that he is
capable of becoming many things, including animal-like. Associations with
other humans equips the child with the behavior patterns and communications

skills needed for survival in his community and society. This is an extremely important concept for elementary and junior high-school children to master because it will help them understand how profoundly their behavior is determined and shaped by the persons in their environment. We can easily see how persons are influenced by others, but it is frequently difficult for us to understand why *we* are Democrats, Republicans, aggressive, or complacent. Of course, sociologists wouldn't blame the groups around us for all our faults or give them credit for all our virtues, but they do concentrate on studying group influences on behavior. Psychologists and social psychologists study how personality influences behavior.

Role

Roles are sets of behaviors regularly expected of individuals. Each day, almost everyone must function in many different roles. Often these roles conflict. Elementary school teachers are expected to be prepared to teach social studies on school days, yet a teacher may have family responsibilities in the evening, such as cooking or entertaining, that prevent her from being properly prepared the next morning. An understanding of the roles which people are expected to fulfill will help children better comprehend the diversity of their own social roles and obligations.

Norm

A norm is a standard or code which guides behavior. Norms tell us when our behavior is right or wrong, proper or improper. In our society, people are expected to dress differently for church than they do for the beach. Men usually rise when a lady enters the room. Children are usually not supposed to swear in the presence of adults. Norms not only vary in different times, but they sometimes vary between different social class groups and within different subcultures in the same society. In general, middle-class men are expected to do more housework than lower-class men, and lower-class men are not normally expected to show ladies as many "niceties" as their middle-class counterparts.

Sanction

Sanctions are awards and punishments used by groups to assure that norms are followed and that role expectations are fulfilled. Groups use a wide variety of pressures and controls to ensure that norms are obeyed. Gossip, embarrassment, and esteem are frequently used as sanctions. The blatant housewife on the block who has several known lovers becomes the victim of gossip because in our society married women are not supposed to have boyfriends. The student who gets caught cheating on an examination is embarrassed when the teacher catches him. Wives who take care of their children, and students who get high grades are praised because these behaviors are legitimate and consistent with institutionalized norms. Individuals violate norms everyday, but more often we conform to them because during socialization we inculcate most of the norms and values of our culture. Elementary school children will not find it difficult to name and discuss the sanctions which govern their daily lives.

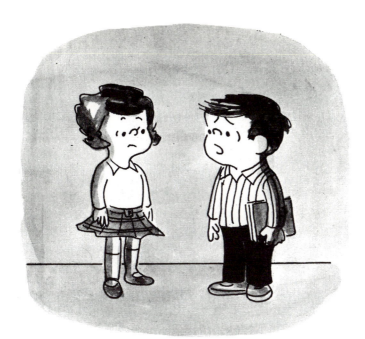

"The guidance counselor tells me I've been playing the educator role when I should be playing the learner role. What's a role?"

Reprinted from *Instructor,* © February, 1972, the Instructor Publications, Inc. Used by permission.

"Do you really want me to brush my hair back? I have an obscenity painted on my forehead."

Drawing by J.B. Handelsman. Reproduced by special permission of *Playboy* magazine; copyright © 1970 by *Playboy*.

Values

Values are those aspects of a culture to which the groups attach a high worth or regard. The norms and sanctions in a society are expressions of its values. Middle-class men are expected to rise when a lady enters the room because courtesy to females is valued among middle-class Americans. Human life is highly valued in most Western societies. Thus the sanctions for taking a human life are severe. Severe sanctions are associated with *mores*. Each society has only a limited number of mores or fundamental moral views that are accepted without question. They are considered essential for the survival of the group. Some behaviors are valued much more than others; thus we can conceptualize a hierarchy of values in a society. In our society, human life is valued much more highly than courtesy to females. In some non-Western cultures, appeasement of the gods was valued higher than human lives. Among the Aztec Indians, handsome young men were sacrificed to the gods. It was a high honor to be chosen for the sacrifice. The sociologist is interested in studying how values vary among different cultures and subcultures, and how values are shaped and inculcated during socialization. *However, they are not interested in taking value position on social issues.* Their job is explanation, analysis, and comparison. A discussion of the teaching of value analysis and the taking of value positions on social issues is presented in Chapter 12.

Status or status-position

The prestige, rewards, and power in society are not evenly distributed. Some individuals are more powerful and influential than others. A person's status or status-position reveals how important he is considered by the groups in his society. The President of the United States is considered much more important than a United States Senator; school teachers tend to have more esteem in most communities than factory workers, even though factory workers often make higher salaries. Higher status individuals often have societal obligations consistent with their status.

Sociologists usually talk about two kinds of status, *achieved* or *ascribed*. A senator's status is achieved because he won votes; Queen Elizabeth's status is ascribed because she was born into a royal family. Children enjoy studying about why some people are considered more important than others. They often discover that a person's status is not necessarily consistent with his contributions to the society.

Institution

A set of related roles which are organized to attain a specified goal constitutes an institution. School is an institution that is organized to attain a certain goal – the education of children. It is made up of roles, each of which has a definite function and expectation. Roles include superintendent, principal, teachers, and students. All societies are composed of economic, educational, and political institutions. Sets of institutions make up social systems.[17]

Sociological concepts and generalizations provide
students with useful lens with which to view their
community. (North Carolina Department of Public
Instruction)

Community

A community exists when a group of people frequently interact, live in close
geographical proximity, and share a sense of belonging. "The essence of
community is a sense of common bond, the sharing of an identity, membership
in a group holding some things, physical or spiritual, in common esteem,
coupled with the acknowledgment of rights and obligations with reference to
all others so identified."[18] A *neighborhood* is a small community.

Society

The largest unit which sociologists study is a society. It is more inclusive than
institutions or communities. A society is a self-sufficient unit and is capable of
an independent existence. Self-sufficient, non-Western tribes may be accurately
categorized as societies. They produce all their foods and clothing, govern
themselves, take care of their defense needs, and could probably exist if other
societies perished.

A . . . way . . . to think about whether a group qualified as a society would
be to imagine that all other communities in the world except this one were
suddenly to disappear. If there were a good chance that the surviving
community would go forward in substantially its present form through
subsequent generations, then it qualifies as a society.[19]

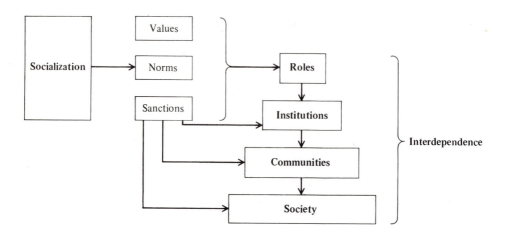

Figure 6.1 Concepts in sociology.
(Figure 6.1 illustrates the relationship of some of the key concepts in sociology. Through socialization, the individual acquires the values and norms which shape the roles he must fulfill in human groups. Sanctions are used to assure fulfillment of role responsibilities; he also learns these during socialization. Sets of related roles constitute institutions, such as political, economic, and educational institutions. Institutions exist within communities. Society is the all-encompassing group. All units are guided by norms, values, and sanctions; all are interdependent.)

Interdependence

In all human societies man lives in groups, and people help each other attain the goods and services, as well as the nontangible elements needed to function in society. In primary groups such as the family, the mother feeds and takes care of the young, and gives them emotional support as well. Father also contributes to the family – often more than by paying the bills. He typically does the "heavy" work around the house in Western, industrialized societies. The children also perform designated roles in a family, although few essential ones in urbanized societies. Most communities and neighborhoods depend on other units in society for essential goods and services. Societies also help each other. Children should learn that in this increasingly small world, people help one another to meet their needs. This concept is extremely important to the sociologist, as well as to the economist.

SOCIOLOGICAL GENERALIZATIONS

In assessing the status of theory in sociology, we indicated that sociology was characterized by a dearth of empirical theories, and suggested some possible reasons for the current status of sociological theory. Theories are made up of

empirical statements which are called generalizations or propositions. Sometimes generalizations are called *principles* or *laws*, but these terms are usually reserved for generalizations with the widest possible applicability.[20] Since almost every generalized statement in sociology is limited in some fashion, empirical propositions in sociology are not often called laws. Sociological generalizations often break down under certain conditions and situations, or lack much empirical support. However, at least some sociological laws exist, but there is little consensus about how many there are because sociologists don't agree about what constitutes a law.[21]

Most sociologists assume that man's behavior is patterned, and that social laws and propositions can be formulated and empirically supported. The rare sociologist who rejects these assumptions represents a cry in the wilderness. Sociologists have been rather successful in formulating propositions with varying degrees of applicability and empirical support. When a sociologist investigates the causes of riots in Chicago in a particular year, he may conclude that "substandard housing, unemployment, and political alienation were the most important causes of the riot." While this *finding* can be generalized to Chicago, it cannot be used (other than as a hypothesis) to explain the causes of riots in other cities until it has been tested in many different settings and locations. Thus, findings are low-level generalizations.

Sociology consists of many findings which are not part of a theory, but which are used for suggesting hypotheses to explain social phenomena in many different situations. Many sociological propositions, although not part of a theory, can be widely generalized and have a great deal of empirical support. *Thus, the status of generalizations in sociology is far better than the status of theory.* "Social problems" research has been more successful in producing propositions than in helping to relate them to theory. The generalizations (and related concepts) which follow can and have been used to guide sociological studies in the elementary and junior high-school grades.[22] It should again be noted that the learning experiences which are planned for children are far more important than a *list* of generalizations. Generalizations should be used to *guide* the instructional program; they should not constitute it.

SOCIALIZATION*

All characteristically human behavior is learned from other human beings through group interaction.

GROUPS

Man lives in social groups of two or more individuals. (These groups help him to satisfy his needs.)

The group exerts social control over its individual members through the use of sanctions (rewards and punishments).

The group enforces its norms by the use of sanctions.

*The words and phrases in capital letters are *concepts*; the statements below them are related *generalizations*.

SOCIAL ORGANIZATION

All societies develop social institutions which may be defined as complex sets of folkways, mores, and laws which are integrated around the major functions (or needs) of the society.

Societies develop specific institutions to carry out their basic functions.

Institutions are characterized by division of labor and specialization.

Every person is expected to play some role in each of the institutions of his society.

Every society consists of smaller social units such as social classes, racial and ethnic groups, communities, clubs, associations, and neighborhoods. Each of these participates in a different way in the total culture.

SOCIAL CHANGE

All societies are in constant change.

No society is completely harmonious: some form of social disorganization is present in all societies.

CONFLICT

In all societies conflict develops between persons and groups. Controlled conflict sometimes leads to social change which facilitates the attainment of desired goals.[22]*

STRATIFICATION

All members of a society are ranked into levels of prestige and power which are called social classes.

HUMAN ECOLOGY

Man's social relationships and behavior are affected by his spatial distribution in geographic space.

COMMUNICATION

Communication is basic to the existence of culture and groups. Individuals and groups communicate in many ways other than by language. However, every type of communication involves symbolism of varying meanings.[22]†

INTERDEPENDENCE

Individuals, families, neighborhoods, communities, organizations and other groups help each other to meet their basic needs.[22]*

Studying the family from a sociological perspective can be informative
as well as enjoyable for children. (Donald E. Miller, Mercer Island,
Washington Public Schools).

DISCRIMINATION

Groups are often the victims of discrimination and prejudice because of age,
sex, race, religious, or cultural differences.[22]*

SOCIOLOGICAL STUDIES IN THE ELEMENTARY SCHOOL

The first four grades in the elementary school usually consist of social science
content which is primarily sociological. Usually, in kindergarten, first, second,
and third grades, institutions such as the home, school, community and family
are studied. These institutions are most often taught with a topical rather than
a conceptual approach as recommended in this book. When social studies units
are planned in the elementary grades, the teacher identifies the topics (or
lower-level concepts) to be taught, such as "Our Family," and then formulates

teaching strategies. Too often, the end result is the mastery of a mass of unrelated and disorganized facts that are quickly forgotten.

The family is an institution that can be analyzed and studied from diverse perspectives. Psychologists look at it very differently than do sociologists. More effective units are structured when the teacher identifies *key or organizing* concepts and generalizations that he wishes the children to master before he selects content, lower-level concepts, materials, and teaching strategies. This procedure allows the teacher to freely select content samples that are more meaningful to children, timely, diverse, and more appropriate for a greater variety of ability levels. If, for example, third-grade children are expected to study the concept *norms*, the teacher can use a variety of content samples to illustrate how norms are formed and how they shape behavior. Norms in such institutions as the family, school, and community could be examined.

This ideal way to plan instruction often is not practical for many teachers. In designated grades the teacher is frequently required to plan units dealing with specific topics and lower level concepts, perhaps the home and school in kindergarten, and the family in first grade. If the teacher finds himself in this kind of situation, he should carefully study the content he is required to teach, and identify key concepts and generalizations that the content can be used to illustrate. Higher-order or organizing concepts, such as *norms* and *values*, can be illustrated with a wider variety of content than can lower-level concepts such as, "Our Town," which is referred to above as a topic. (See Chapter 3 for a discussion of levels of concepts.)

The social studies program should be sequential, but scope and sequence should be based on the development of central, organizing concepts and generalizations rather than on topics or lower-level ideas. A conceptual approach to the study of institutions such as the family and community will help militate against the superficial way in which these institutions are typically presented in the primary grades. When the teacher is trying to help pupils master the concept *role*, he can use materials on families from many different groups to increase their understanding. The teacher may use a variety of content samples to help students discover that Mother's role in a middle-class and ghetto family may be quite different. Likewise, the *values* and *norms* in these types of families may differ greatly. Too often when young children study the family, they examine only samples of idealized, fictionalized families of white surburbia, where Father carries a brief case to work and Mother stays at home during the day and does housework. Children should be helped to discover that in most families Father does not carry a brief case; and that, in many, Mother is a breadwinner as well as a housekeeper.

Since any content can be studied from many different perspectives, the teacher should select organizing concepts from several disciplines when planning social studies units. However, one discipline may be emphasized more than others in a particular unit. When studying the family, for example, sociological concepts may be stressed since sociology is the study of human groups (the family is a group). However, economic and political science concepts will also help children understand important aspects of family life. Chapter 11 explores effective ways to plan interdisciplinary units. The point

emphasized here is that teachers should have key, organizing concepts and generalizations in mind when they plan and teach units even if they are required to work within the limits of previously identified content. As we noted before, the conceptual approach to social studies instruction greatly facilitates comprehension, transfer, and mastery of content.

Sociology is rich with concepts and generalizations that can be used throughout the elementary and junior high social studies program to help students better grasp traditional subjects, understand their social environment, and make decisions on important social issues. A study of institutions such as the family and school can help very young children comprehend essential aspects of *socialization*, a key sociological concept. These institutions can also be used to teach such concepts as *values, norms,* and *sanctions* since roles in all institutions are guided by norms and sanctions. A sound unit on community helpers can aid pupils to understand such central sociological concepts as *institution, status,* and *role.* The concept *society* can be taught when intermediate and upper-grade pupils study the United States and various nations of the eastern and western hemispheres.

In the next section of this chapter the author has identified a number of key sociological concepts and generalizations, and suggested a few possible ways to teach them. An infinite variety of strategies could be used to teach each of the ideas identified. However, these activities are illustrative. They are intended to serve as a springboard to teacher creativity and to illustrate the substantial contribution that sociology can make to the elementary social studies program.

STRATEGIES FOR TEACHING SELECTED SOCIOLOGICAL CONCEPTS AND GENERALIZATIONS

GENERALIZATION: *The group enforces its norms by the use of sanctions.*

Primary grades

Read the following situation to the class and ask the questions which follow:

> During recess, the boys in Miss Jones' class hurried outside to play with the big, red ball that Miss Jones had just bought for her pupils. Miss Jones had wanted the boys to play a game with the girls that morning, but the boys, lead by Joe, had begged her to let them play with the big, shining ball. When she pulled the ball out of the closet, Joe and Johnny grabbed for it. They ran toward the large play area which was a distance from where Miss Jones usually stood to watch the children play. Joe and Johnny threw the ball to each other and to their friends. Carl, who was not too well liked by some of the leaders in the crowd, didn't get a chance to catch the ball very often. When Carl and Joe were struggling for the ball, it ran out of the playground into the street. It was crushed by a speeding car. Stu ran and told Miss Jones exactly what had happened.

1. Did Joe and Johnny treat Carl in a way that would have been approved by Miss Jones? Why or why not?

2. When children are playing, what are some ways that adults expect them to act? (List statements [norms] on the board or butcher paper.)

3. Did Stu act in a way that the other boys would approve? Why or why not?

4. When children are playing, what are some things that they expect each other to do and not to do? (List norms on board or butcher paper.)

5. What are some things that Miss Jones might do to make Joe and Johnny treat Carl differently? (List *sanctions* on board.)

6. What might the other boys do to make Joe and Johnny treat Carl differently; (List *sanctions* on board.)

7. What might the boys do to stop Stu from tattling? (List *sanctions* on board.)

Intermediate grades

Read the children the story of Joan of Arc. Ask them to state the kinds of behaviors and beliefs she exemplified that those in authority would not tolerate. The concept of *mores* could be introduced. Mores are protected by very strong sanctions, some as extreme as death. Ask the children whether they can identify mores that we have today.

Have the children read novels and accounts of the Salem witch trials in colonial America.* Help them to identify why people were dubbed witches, and why they were persecuted. Ask the class: "What behavior codes (norms) did people called 'witches' violate? What punishments (sanctions) did the group give 'witches?' "

During a study of the Middle Ages, read to the class selections dealing with the many aspects of chivalry. Help the children idenfity the kinds of behavior expected of men and women during those times, and the sanctions that were used to enforce them.

Have the class read books and selections dealing with life in America during the settlement of the West. Ask them such questions as "What did the community probably think of women who went to taverns? Why? Of women who carried guns? Why? What would the people have said about a woman who wanted to run for public office?"

Upper grades

Read the following case and ask the questions which follow:

Albert Roberts' parents live in a beautiful, large house in one of New York City's most exclusive suburbs. Mr. Roberts, his father, is a very successful lawyer who drives to and from the city every day. Mrs. Roberts is a housewife

*One source is Elizabeth G. Speare, *Witch of Blackbird Pond*. Boston: Houghton Mifflin, 1958.

and Sunday school teacher. Albert was a straight "A" student in elementary and high school. He was able to get most of the things that he wanted from his parents. When he left home to attend Green University, his parents gave him a new car. When Albert came home for Christmas vacation, his hair was longer than his sister's. He was smoking strange cigarettes which had a peculiar odor. His clothes were dirty and ragged. His parents were very upset when they saw him. They told him that he could not stay at home during the vacation period unless he cleaned up, cut his hair, and stopped smoking the strange cigarettes.

1. What did Albert do that his parents did not think a young man should do? (Solicit norms.)

2. How did they show their disapproval? (Solicit sanctions.)

3. Have you ever done anything of which your parents strongly disapproved?

4. What did they do to show their disapproval?

Ask the children to list:

1. The kinds of behavior they usually expect of

a) parents
b) teachers
c) brothers
d) sisters
e) ministers
f) store clerks
g) the postman
h) the principal
i) senior citizens
j) neighbors
k) close friends
l) strangers
m) relatives

2. The kinds of behavior they do not expect of the individuals and groups named above.

3. The kinds of behavior which they display to show disapproval of nonexpected behavior from the persons and groups named above.

4. The kinds of behavior which the individuals and groups named above expect of them.

5. The kinds of behavior that the persons and groups named above would display to show disapproval of the children's nonexpected behavior.

GENERALIZATION: *In all societies conflict develops between persons and groups. Controlled conflict sometimes leads to social change.*

Primary grades

Place the following role descriptions on index cards. Give each card to a child in the class, and have the pupils act out the role descriptions. The class should discuss the questions which follow the role-playing situation.

JACK

Your name is Jack. You always do your homework. You get good grades. James never does his homework. He often does not know how to do it. He is always asking you if he can copy your work. You are not too good at playing ball. Sometimes James helps you out when you are on his team. Even though he helps you on the baseball field, you don't want him to copy your work. When he asks you if he can see your paper, you tell him "No" and walk away!

JAMES

Your name is James. You like to play outdoors a lot. You often don't know how to do your homework. You often feel that you don't have time to do it. You feel that Jack is a bookworm who always knows how to do his homework and has time to do it. You think that he should let you copy his homework because you help him when he plays baseball on your team. When you ask him to let you see his paper he says "No!" You get angry and tear it up!

1. Why didn't Jack want James to see his homework?
2. Why did James tear Jack's paper?
3. Did James solve his problem? Why or why not?
4. Have you ever been in a situation similar to Jack's? James's? If so, what did you do?

Read the following situation to the class and ask the questions that follow:

> Mrs. Thompson told John to go to the principal's office because she was sure that he had taken Elaine's money. Johnny cried and screamed and said that he did not take Elaine's money. He said that his mother gave him the money that was in his desk. Cathy and Sue said that they saw Johnny take the money. Ted and Joseph said that they saw Johnny with his money before Elaine came to school.

1. Why does Mrs. Thompson feel that Johnny took Elaine's money?
2. Why is Johnny upset?
3. Have you ever been in a situation similar to Johnny's? If so, what did you do?

Show the children pictures showing the conflicts that occurred during the sit-in and freedom-ride movements in the South, the civil rights marches, race riots, and the desegregation of the schools. Ask questions such as the following:

1. What is happening in this picture?
2. Why are people angry?
3. What might happen next? Why?

Read the following situation to the class and ask the questions that follow:

> Pedro, a Puerto Rican boy who lives in New York City, was running down the street toward his apartment when the police stopped him. He was very

"I don't care what happened to your Mommy and Daddy at Berkeley. I'm telling you the policeman is your friend!"

Drawing by Tony Saltzman, © 1970 by Phi Delta Kappan.

scared because he had never been stopped by a policeman before. He suddenly remembered the many bad things that he had heard that policemen did to other boys in his neighborhood. The policeman told Pedro that he had to go with him because he had just tried to break into a house down the street. Pedro, overcome with fear, screamed very loudly.

1. Why was Pedro afraid of the police?
2. Why did the policemen think that Pedro had broken into a house?
3. How might Pedro solve his problem?

Intermediate grades

Show the class a movie detailing the conflict which occurred between the American colonists and the American Indians during the settlement of the American frontier. Have them read factual and fictional accounts of the wars and other conflicts which took place, including the many treaties which the colonists made with the Indians and broke. *The Matchlock Gun* by Walter D. Edmonds, a story describing in gripping detail a conflict between Indians and a mother and son, is an appropriate book for children to read during this activity. (They should read it critically because it presents only one point of view.) Ask the pupils to state reasons for the development of hostility between colonists and Indians, and to identify how this hostility was manifested and handled. The teacher could have the students role-play American Indians and colonists

to help them develop understanding and empathy for all participants in these conflicts.

Have the class dramatize the conflict at Lexington between the British and the American colonists. Read the pupils documents written by persons on both sides of the conflict. Ask the children to identify the causes of this conflict, how it might have been avoided, and to state both the negative and positive consequences of it. The children could also examine paintings which show various views of the Lexington confrontation. The teacher might use a filmstrip to summarize this activity.

Ask the children to read selections on the American Civil War in their textbooks and in other sources. Help them to identify and state the causes of this conflict and its consequences as stated by historians. The children could compare the causes and nature of this conflict with other conflicts which they have studied, such as the American Revolution, and the wars between the colonists and the Indians. Other American and World wars could also be studied and analyzed as examples of conflict incidents. The causes of World War I could be compared to the causes of World War II, the Korean war, and the Vietnamese conflict.

Upper grades

Show the children pictures of riots such as the Haymarket riot, the draft riots during the Civil War, riots on college campuses, and the racial riots which struck our nation during the early 1900's, the 1940's, and the 1960's. Ask them to state ways in which all the pictures are similar and different. Solicit responses regarding what is happening in each of the pictures. Follow this exercise with discussions of readings on the various riots. Help the children to identify common causes of the riots, and to distinguish how they differed both in causes and in outcomes. Ask them to state both functional and dysfunctional consequences of each of the riots. Pose questions such as the following:

1. Why do people riot?
2. Do riots ever bring about needed social change?
3. When do people resort to violence in order to bring about social change?
4. Can you think of alternatives to riots as a means for bringing about social change?

Assign readings on the French, English, American, and Russian Revolutions. Help the students to identify and state common causes of the conflicts, similarities in sequence of events, and the consequences. They should also be asked to state differences in the revolutions. Ask them to state which consequences of the conflicts were functional for the societies involved, and which were dysfunctional. Also, ask them to hypothesize about how the conflicts could have been resolved without battle.

Place the following role descriptions on index cards. Assign the roles to children in the class. Have them study and role-play the situation. Then discuss the questions which follow.

SITUATION:

For one week the student group, Change, has lead demonstrations on campus protesting the University's ROTC Program and the firing of Dr. Wright, a controversial professor. Students have occupied buildings, disrupted classes, and held several rallies on campus. The city police and the state national guard were called in yesterday. Today, two representatives of Change and three representatives of the University meet in an attempt to resolve the campus conflict. Present are:

> Ken Beam, President of Change
> Joyce Head, Secretary of Change
> President Washington, President of the University
> Dr. John Bacon, Dean of Student Affairs
> Mr. Thompson, Chairman of the Board of Trustees

KEN BEAM

You are Ken Beam, the radical president of Change. You want the University to restore the contract of Dr. Wright, the fired professor, and to get rid of the ROTC on campus immediately. You will take nothing less.

JOYCE HEAD

You are Joyce Head, Secretary of Change. You are radical, but less so than Ken Beam. You want Professor Wright rehired and ROTC banned on campus, but you are willing to give the University more time than Ken. You are particularly upset because you feel that Dr. Wright was one of the best teachers on campus.

PRESIDENT WASHINGTON

You are the president of the University. You want to listen to the students, but feel that they should not make *demands*.

DR. JOHN BACON

You are Dr. John Bacon, Dean of Student Affairs. You want each side to understand the other. You also want everyone to like you.

MR. THOMPSON

You are Mr. Thompson, Chairman of the Board of Trustees. You feel that radical students should be expelled from the University. You are sick and tired of campus violence!

1. What is the main cause of the conflict in this situation?
2. Was the problem solved? If so was the solution realistic? What might be its consequences? If not, what solution do you think would work? Why?

Select committees to do surveys of the racial riots that occurred in American cities during the 1960's and 1970's. Pupils should make a list of all changes which were made in institutions such as city governments and

universities after the riots. Students and blacks did gain a few concessions from institutions after these confrontations. The teacher should help the students to discover that conflict sometimes leads to social change.

SUMMARY

Sociology consists of a system of concepts, generalizations, and theories that can help students in the elementary and junior high-school grades make decisions that are related to social problems. Although only partial theories exist in sociology, these consist of many concepts and generalizations that can help students understand the variables which shape human behavior. Sociology is primarily concerned with group influences on individual behavior, and the relationships between different groups. In order to make sound decisions on social issues, students must understand the structure of human groups, and the interrelationships between groups. They must also be familiar with the ways in which their own behavior is shaped by the groups in which they are socialized.

Children can be introduced to sociological concepts and generalizations in the earliest grades; these key ideas can be further developed and expanded in later grades. There are many opportunities for the teacher in the primary grades to introduce sociological concepts, because the topics which are traditionally studied in these grades are primarily sociological. The family, community, school, and neighborhood are usually studied in primary-grade social studies. The teacher can help his students to understand these institutions by organizing his units around key sociological concepts. When students study an institution such as the family, they can be introduced to such key concepts as *socialization, role, norm, sanction,* and *values.*

The family plays a major role in socializing the individual and in preparing him to satisfy his societal needs. Each individual within a family has roles he is expected to fulfill. Norms tell him whether he is performing his roles properly, and sanctions are used to reward the individual for properly fulfilling his role expectations and to punish him when he fails to fulfill them. Both norms and sanctions reflect the values that are found in institutions such as the family. Although key concepts such as *socialization, role, norm, sanction* and *values* can be introduced in the primary grades, these ideas can be developed at a more sophisticated level in the higher grades with different content samples. When students study such topics as large urban centers, our state, United States history, and the Eastern and Western Hemispheres, they can learn key sociological concepts. When they study large urban centers, students can compare or contrast the ways in which socialization in the city family differs from that in the rural or less urbanized areas. The roles, norms, and sanctions which are present in urban institutions can also be examined. When studying the history of the United States and regions such as the Eastern and Western Hemispheres, students can determine the ways in which roles, norms, and values differ within various periods of American history, and the many ways in which individuals are socialized in different parts of a region.

While certain units during the year might emphasize concepts from various disciplines, every unit should contain sociological concepts because of sociology's focus on group interactions and the ways in which the group influences an individual's behavior. Students must often view human behavior from the perspective of sociology in order to understand the complexity of human relationships.

DISCUSSION QUESTIONS AND EXERCISES

1. Examine an introductory college textbook on sociology and make a list of (1) key sociological *concepts* discussed in the book, (2) key sociological *generalizations* discussed in the book, and (3) key sociological *theories* discussed in the book. Make a lesson plan for teaching one of the key concepts and several related generalizations to a group of students in one of the following grade levels: (a) primary grades (b) intermediate grades (c) upper grades.

2. Select a sociological theory from a sociology college textbook and illustrate, with a teaching plan, how you would teach the theory to a group of upper-grade students. What problems do you think you would encounter in teaching the theory to a group of students? Why? How do you think that the problems could be resolved?

3. Select several sociological concepts and related generalizations and develop a teaching plan using literature as your only source of data. What strengths would the teaching plan have? What limitations? How can the limitations be overcome?

4. What is the unique nature of sociology? How does it differ from the other social sciences, such as anthropology, political science, and economics? What implications does the unique nature of sociology have for planning a social studies program for children in the elementary and junior high-school grades?

5. Examine several primary units in the curriculum library of your college that deal with such topics as the family, the community, the neighborhood, and the school. What key sociological concepts are stated in these units? Are the concepts accurate? Will the activities contained in the unit develop the concepts which are supposedly taught? What key sociological concepts could you add to the unit to enable children to gain a better perspective of the ways groups influence the behavior of individuals? What teaching strategies would you use to develop the key concepts that you would add to the unit?

6. Structure a unit on the family for the primary grades and plan teaching strategies to teach the concepts of *socialization, role, norm, sanction, value,* and *interdependence.* Which of these concepts is the easiest for young children to understand? Which is the most difficult for them to understand? What special methods will you use to assure that the children will gain an understanding of the most difficult concepts?

7. What do you think should be the primary goal(s) of sociological studies in the elementary and junior high-school grades? How can the unique nature of sociology facilitate the attainment of these goal(s)?

8. Study an account in a history textbook that deals with an event such as the American Revolution, the Civil War, or slavery. Illustrate, with a lesson plan, how you would teach children to view the event from a sociological perspective. What key sociological concepts would you select to help children view what happened from a sociological perspective? What hypotheses will the students be able to formulate after reading the selection? What data could they use to test their hypotheses?

9. Select a current social problem dealing with an issue such as race relations, ecology, war, or poverty. Illustrate, with a teaching plan, how students could use sociological concepts in order to better understand the situation and make decisions regarding the issue. While completing this exercise, review the decision-making model presented in Chapter 1.

10. Demonstrate your understanding of the following key concepts by writing or stating brief definitions for each of them. Also tell why each is significant:

a) structure of sociology

b) sociological theory

c) sociological concept

d) socialization

e) role

f) norm

g) sanction

h) values

i) status (status-position)

j) institution

k) community

l) society

m) interdependence

FOOTNOTES

1. Alex Inkeles, *What is Sociology? An Introduction to the Discipline and Profession.* Englewood Cliffs, N.J.: Prentice-Hall, 1965, p. 17.

2. Robert E.L. Faris, "The Discipline of Sociology," in Robert E.L. Faris (Ed.), *Handbook of Modern Sociology.* Chicago: Rand McNally, 1964, p. 5.

3. Bernard Berelson and Gary A. Steiner, *Human Behavior: Shorter Edition.* New York: Harcourt, Brace and World, 1964, pp. 6-7.

4. Quoted in Joseph B. Gittler and Ernest Manheim, "Sociological Theory," in Joseph B. Gittler (Ed.), *Review of Sociology: Analysis of A Decade.* New York: Wiley, 1957, p. 2.

5. Hans L. Zetterberg, *On Theory and Verification in Sociology.* Totowa, N.J.: Bedminster, 1966, p. 30.

6. Ely Chinoy, *Society: An Introduction to Sociology.* New York: Random House, 1961, p. 13.

7. Faris, p. 20.

8. Joseph H. Fichter, *Sociology*. Chicago: Univ. Chicago Press. 1957, p. 8.

9. Nicholas S. Timasheff, *Sociological Theory: Its Nature and Growth*. New York: Random House, 1957, p. 10.

10. Paul Hanly Furfey, *The Scope and Method of Sociology*. New York: Harper, 1953, p. 28.

11. *Ibid.*, p. 28.

12. Inkeles, *op. cit.*, p. 99.

13. Robert Bierstedt, *The Social Order: An Introduction to Sociology*. New York: McGraw-Hill, 1957, p. 24.

14. Caroline B. Rose, *Sociology: The Study of Man in Society*. Columbus, Ohio: Charles E. Merrill, 1965, p. 15.

15. Bruner set forth his seminal ideas in Jerome S. Bruner, *The Process of Education*. New York: Vintage Books, 1960. And in *Toward a Theory of Instruction*. New York: W.W. Norton, 1966.

16. See Mark M. Krug, *History and the Social Sciences: New Approaches to the Teaching of Social Studies*. Waltham, Mass.: Blaisdell, 1967. This book contains a scathing critique of the structuralists. See especially Chap. 7, "The Structure of the Social Studies — New Curriculum Approaches."

17. The author has drawn heavily from Inkeles for the definitions of *institution, community, social system, neighborhood,* and *society.* However, all direct quotes are so indicated.

18. Inkeles, *op. cit.*, p. 69.

19. *Ibid.*, p. 70.

20. Zetterberg, *op. cit.*, p. 14.

21. *Ibid.*, p. 13.

22. All of the generalizations on pages 207-209, except the ones designated, were taken from the Advisory Committee on the Social Studies, *A Guide for Concept Development in the Social Studies*. Denver: Colorado Department of Education, 1967, "Sociology" insert. Used with permission. The generalizations marked with an asterisk were written by the author; the one with a dagger is from John U. Michaelis and A. Montgomery Johnston, *The Social Sciences: Foundations of the Social Studies*. Boston, Allyn and Bacon, 1965, p. 334.

ANTHROPOLOGY: STRUCTURE, CONCEPTS, AND STRATEGIES

THE ANTHROPOLOGICAL PERSPECTIVE

Anthropology literally means the science (logos) of man (anthropos). Man's behavior is studied in all the social sciences. However, anthropology is concerned with both his behavior and physical traits. Anthropology's interest in the relationship between culture and man's biological traits is one of its distinguishing characteristics. Man's long period of dependency, bipedal locomotion, large brain, and ability to symbolize are among the biological traits that enable him to create and acquire culture.

All the concepts, generalizations, and theories which constitute the structure of anthropology are related to those activities, artifacts, and belief systems which anthropologists call culture – a phenomenon unique to man. Although many animals are social and live in groups, man is the only one that has culture. The dominant interest in the concept of *culture* and the "holistic" method of studying it also distinguish anthropology from the other behavioral sciences. Anthropologists use a holistic approach when studying culture; they study all aspects of a culture system. Culture, they assume, is an integrated whole. Therefore, culture traits cannot be understood in isolation from this whole. When an anthropologist studies a society, unlike other scientists who are concerned with limited parts of it, he collects data on all its aspects, including its history, religion, geography, economy, technology, and language. To derive valid generalizations about a culture complex, such as marriage within a society, the anthropologist feels that he must be familiar with all the society's other institutions.

The *comparative* approach to culture, interest in preliterate societies, and affinity with history and the humanities are also unique characteristics of anthropology. Most social scientists study complex industrialized societies.

"By standing upright, we free our hands for making tools and weapons, building cities, creating civilization!"

Drawing by Sydney Harris. Reproduced by special permission of *Playboy* magazine; copyright © 1970 by *Playboy*.

However, anthropologists most often study preliterate cultures because they believe that generalizations and theories must be tested on populations in all culture areas before they can be verified. They also concentrate their work on preliterate societies because it is easier to study whole cultures in small, homogeneous societies than in complex, modern ones. Isolated, preliterate societies serve as laboratories for anthropologists. However, anthropologists have also studied industrialized societies such as the United States and Japan.

The formulation of the concept of culture and the study of preliterate societies are the two most significant contributions that anthropology has made to social science and the modern world. Many traits and characteristics that had been considered "human nature" were later discovered to be traits unique to Western industrialized societies when studies by such eminent anthropologists as Ruth Benedict and Margaret Mead were published and popularized. Social scientists assumed that adolescence was a universally traumatic period until Mead's seminal analysis of the tranquil adolescent period in Samoa was published in 1928.[1]

Many of the problems studied by anthropologists in preliterate cultures logically fall within the bounds of other disciplines (such as political institutions within the Hopi Indian culture), but they have been researched by anthropologists partly because they have been ignored by other scientists.

Historical approaches and elements are probably more important in anthropology than in any of the other behavioral sciences. Throughout the brief history of the discipline, anthropologists have shown a keen interest in the historical origins of culture traits, and later a concern for unique and particular cultural elements. One area of anthropology, *archeology* or

prehistory, is devoted exclusively to reconstructing early man's history. Anthropology is also closely akin to the humanities. Books such as Benedict's *Patterns of Culture*, Mead's *Coming of Age in Samoa*, and Kluckhohn's *Mirror for Man*, read more like novels than scientific treatises. The language in these books is colorful and engaging, but the generalizations are frequently made without supporting evidence. When evidence is reported, it is often meager and selective, not systematic and complete.

The fields of anthropology

Because of the broad scope of the discipline, anthropologists usually specialize in one of the subfields of anthropology. Although most of the areas are closely related, some are linked primarily by their common interest in man. *Physical anthropologists*, who study the evolution of man and his relationship with other animals, particularly other primates, are more akin to biologists than social scientists. However, social and cultural anthropologists depend upon physical anthropologists for information regarding man's unique biological traits which are essential for the formation of culture. Weston LaBarre, in an intriguing book, *The Human Animal*, argues that man's biological drives are ·the basis for many human institutions, such as the family. He writes:

> The anthropoid and the man male alike stays to form a family not because of extraneous cultural or moral fiats after the fact, but because biologically speaking *he wants to*; not because of any tender and special *ad hoc* paternal instinct toward the helpless little ones but because of powerful organic drives within him toward the female.[2]

Physical anthropologists have also shown a great deal of interest in the *races* of man. They use various schemes for classifying and identifying races.

Cultural anthropology is often considered the main area of the discipline because it is concerned with the study of whole cultures, including culture change, acculturation, and diffusion. An area called *social anthropology* has also emerged, primarily in England. *Social structure* rather than culture is the key concept in social anthropology. Its leading exponents refer to it as "comparative sociology," and contend that social anthropology searches for laws and generalizations while cultural anthropology is concerned primarily with tracing the history of cultural traits. They regard cultural anthropology as primarily historical and social anthropology as mainly explanatory.[3]

Other areas of anthropology include *ethnography*, the accurate descriptions of living cultures; and *ethnology*, which is mainly concerned with comparing and explaining the similarities and differences in culture systems.[4] *Linguistics* is devoted to the description and analysis of the languages used in various cultures. Anthropologists have discovered that the language systems of cultures reveal much about the beliefs, ideology, and behavioral patterns of human groups.

Archeologists, or prehistorians, attempt to reconstruct the history of historyless peoples by digging up artifacts and other culture elements. Elementary and junior high-school students will find the techniques and methods used by the archeologist interesting as well as revealing. In recent years, archeologists have used a number of chemical processes both to locate artifacts and to determine their age. When applications of these processes revealed how very old our earth is, the archeologists made a significant contribution to scientific knowledge.

SCIENCE AND ANTHROPOLOGY

In Chapter 2 we reviewed the criteria formulated by Berelson and Steiner which can be conveniently used to judge the scientific nature of a discipline. We used these criteria to evaluate the scientific status of history and sociology in Chapters 5 and 6. It is appropriate to consider the structure of anthropology in light of these criteria.

A science uses procedures which are public. In ethnographies and books, anthropologists usually devote little attention to their research methods. This is partially due to the fact that anthropology has developed few systematic methods for studying cultures. The two most frequently used are participant observation and interviewing. When he studies a culture, an anthropologist goes to live with the people, learns their language, and takes an active part in the daily affairs of the community. He goes hunting with the men, participates in the ritual ceremonies, and helps with the harvest. He takes field notes while he is actively participating in the culture. These notes tend to be highly impressionistic and idiosyncratic. Sometimes the anthropologist must take notes several hours after he has observed or participated in an event; thus the subjectivity of his methods is increased.

His interviewing tends to be highly informal and nonsystematic. While the sociologist or political scientist randomly selects subjects for an interview, the anthropologist interviews persons with whom he can establish good rapport, or persons from whom he feels he can get accurate and detailed information about various aspects of their culture. The accounts he gets from different subjects are often conflicting and contradictory. The anthropologist attempts to minimize errors in his data by observing as well as by interviewing, and by making cross-checks with other informants when he detects contradictory information. Anthropologists have made little use of the written questionnaire, largely because most of their subjects are not literate.

Anthropologists frequently do not make their procedures public because they are often highly individualistic. Data collection in the discipline tends to be less objective than in the other behavioral sciences. Some of the difficulties they face in collecting data are inherent in the discipline itself; others reflect a tradition in anthropology that tends to regard with suspicion data-gathering procedures which prevent anthropologists from directly

observing the "wholeness" of cultures. Anthropologists sometime argue that the methods which the field worker uses to gain certain insights and perceptions cannot be easily repeated. Notes Honigmann,

> ... interpersonal ties, the essence of ethnography, bring out distinctive behaviors in the people being studied by the anthropologist which cannot be predicted to occur should another observer form a different kind of relationship with those same people. ... Nor is it easy to test the reliability of an ethnography when the writer through empathy acquires insights into the socially standardized sentiments of his people, sentiments which they themselves scarcely can verbalize.[5]

However, Honigmann believes that objectivity and reliability should remain important goals for anthropology, "Despite these limitations on attaining the goal, ideally reliability is quite highly valued by anthropologists. Therefore attempts are made to control subjectivity and to report facts in such a way that they can be verified readily."[6] He suggests that because anthropologists try to be objective, ethnographies are usually "formidably cold and aloof, despite the intimacy of the social life with which they deal."[7]

Anthropologists have been heavily attacked in recent years because of the lack of objectivity and public procedures evident in their ethnographies and books. A number of anthropologists, such as Pelto, are very concerned about the methods used in the discipline:

> Social anthropologists have sometimes written their reports and books ... with a cavalier disregard for presentation of the evidence used to arrive at general conclusions. Some ... have maintained that their generalizations ... cannot be demonstrated objectively with systematic evidence ... [they] have, at times, been somewhat careless, even secretive, about the nature of their field work and observations.[8]

Anthropologists have accepted many of these criticisms and have attempted to make their methods more objective and public. In several recent studies, they collected data by using psychological tests, life histories, systematic sampling techniques, and questionnaires.[9] Anthropologists have borrowed methods and techniques from the fields of sociology and psychology.

One development which has helped to objectify the discipline as well as to save many hours of field work is the Human Relations Area Files, which include a large range of information on a variety of topics about cultures throughout the world. By using these files, the anthropologist can randomly select samples from many cultures and test hypotheses dealing with such topics as child rearing practices, magic and religion, and marriage rites.[10] Some anthropologists, however, feel that this procedure is invalid because it does not permit them to study "whole" cultures.

THE DEVELOPMENT OF ANTHROPOLOGICAL THEORY

Status of anthropological theory

In Chapter 3 we defined a theory as a set of interrelated propositions or laws that can be verified. We also distinguished between grand theories, which attempt to explain all the facts in a discipline, and partial theories, which explain only some of the facts. We pointed out in Chapter 2 that the building of theory is the primary goal of a scientific discipline. *There is little evidence in anthropological literature to suggest that anthropologists accept theory building as their primary goal. Rather, it seems that the description and comparison of preliterate cultures, and the tracing of the origins and diffusion of culture traits are their major concerns.*

Cultural anthropology is primarily historical and descriptive rather than theoretical. By comparing cultures throughout the world, anthropologists have derived a number of fruitful hypotheses and generalizations which have a great deal of empirical support. However, empirical theory in anthropology is practically nonexistent. Pelto suggests why anthropology is largely atheoretical;

> The formative period of a science must include collecting of much descriptive information; trial and error testing of methods and theories . . . organization of preliminary classifications of "types" of subjects to be studied; and many other steps. In the later "mature phase," general principles and scientific laws can be developed. *Much current anthropological study is still in the data-gathering and exploratory phases.*[11] [Italics ours]

Jacobs and Stern comment on the status of anthropological theory:

> The development of theory . . . has been hampered by . . . a variety of factors, among them some naive and mechanical forms of evolutionary theory; some equally mechanical forms of diffusionist theory; the dogma that there could be no laws of cultural development with the result that none were sought; and the preoccupation of many recent cultural anthropologists with psychological processes which has diverted attention from other problems of accounting for cultural patterns.[12]

Evolutionism

During the brief history of anthropology, a number of "grand," nonempirical explanations and schools of thought have emerged; these are referred to as theories in anthropological literature. The first of these schemes was developed during the 1800's by "arm-chair" anthropologists who depended upon explorers, traders, missionaries, and other curious travelers for accounts of life in preliterate societies. These accounts were often impressionistic statements by ethnocentric observers rather than accurate cultural descrip-

tions. Even Charles Darwin, who wrote an account after visiting Tierra del Fuego, was guilty of ethnocentrism:

> The astonishment which I felt on first seeing a party of Fuegians on a wild and broken shore will never be forgotten by me, for the reflection at once rushed into my mind — such were our ancestors. These men were absolutely naked and bedaubed with paint, their long hair was tangled, their mouths frothed with excitement, and their expression wild, startled and distrustful. They possessed hardly any arts, and like wild animals lived on what they could catch; they had no government and were merciless to everyone not of their own small tribe.[13]

Early anthropologists searched for single factor, all-embracing theories which could explain the historical development of cultures throughout the world. Heavily influenced by Darwin, whose *Origin of Species* was published in 1859, they formulated an evolutionary theory of cultural development. According to this unilinear theory, all human cultures had experienced the same developmental stages; each higher phase represented more progress. Preliterate cultures, such as those of the Australian aborigines and the Polynesians, typified the earliest stages of human cultural development; Western European civilization was the highest stage of culture which man had attained. Between these two extremes were several developmental levels. Edward B. Taylor, Lewis H. Morgan, and Sir James Frazer were leading exponents of the evolutionary movement.

Although the evolutionary theories were later to be severely attacked and totally rejected by anthropologists for many years, the early anthropologists made a number of significant contributions to the discipline. Their formulation of the concept of *culture* and recognition of the possibility for a science of culture were great gifts to anthropology. They did little field research, but the controversy and debate that arose over their theories stimulated much research by others. Although they devised schemes which were more akin to dogmas than theories, early anthropologists did show interest in theory construction.

Historicism

Franz Boas (1858-1942), working in the United States, led the attack against the evolutionary theorists. Boas felt that because each culture is unique, it was impossible to discover grand and general trends in the historical development of culture. He and his students produced ethnographies which indicated that the development of culture traits had not been uniform and unilinear, contrary to the schemes developed by Taylor, Morgan, and Frazer. Within the same culture area could be found traits associated with each of Morgan's developmental levels. Boas advocated studying the historical origin of each culture trait, and felt that this could be done only by extensive field work. Although Boas started a tradition of empirical field work which is still an essential component of anthropology, he showed a blatant disregard for building a theory of culture in his vigorous search for the historical origins of particulars.

Diffusionism

In Europe a number of theories developed to challenge evolutionary explanations, collectively referred to as diffusionism. These theories held that cultural traits and elements had been invented in only a few areas of the world, and had spread from these areas to all other culture regions. The extreme proponents argued that all cultural inventions had emerged in one area, such as Egypt, and had spread from there to other regions. A more moderate point of view suggested that cultural inventions had occurred in several regions. While modern anthropologists believe that most culture elements within a society were borrowed, they feel that many inventions have occurred in all culture areas.

Functionalism

All the theories discussed above are historical because they attempt to explain the *origins* of culture elements. Bronislaw Malinowski, a British anthropologist, believed that there was a need for theories that explained behavior in existing societies and that were not primarily concerned with the historical development of culture traits. He felt that historical explanations were insufficient, and did not permit the formulation of cultural laws. Malinowski developed a theory which suggests that every element in a culture exists to fulfill the needs of individuals. Magic and religion are found in all societies because they help man to explain unknown factors in his environment and to cope with uncertainties. Every cultural system is an integrated whole, and each culture element fulfills definite functions. Malinowski suggested that all cultures were required to meet at least three kinds of needs: (1) primary or biological needs (2) derived or instrumental needs, and (3) integrative or synthetic needs.[14] Radcliffe-Brown also advanced a functional theory, but his theory had *social system* as its key concept rather than *culture*. Although the theories advanced by Malinowski and Radcliffe-Brown stimulated much discussion and debate (Malinowski remained a controversial figure until his death), their theories still consist largely of untested propositions.

Configurationalism

In her classical book *Patterns of Culture* (1934), Ruth Benedict (1887-1948) argues that cultures do not consist of separate elements, but are organized wholes. She further states that cultures as wholes can be characterized according to the dominant ideologies, values, and ideas embraced by the individuals within them. Benedict calls these dominant ideas and ideologies "themes" of cultures. She documents her concept with ethnographic data on several American Indian groups. Benedict states that the Pueblo Indians value moderation and characterizes their culture as "Apollonian." The Plains Indians, unlike the Pueblos, often go to extremes. She calls their culture "Dionysian."[15] Studies such as those by Benedict, which attempt to characterize whole cultures, are known as configurational studies, and the school of thought is sometimes called configurationalism.

Since the publication of *Patterns of Culture*, Benedict's ideas have been criticized. Some anthropologists pointed out that she overgeneralized from limited data and that her sample of societies was not carefully chosen. Morris E. Opler is one of her most noted critics. Opler believes that the "theme" concept is valid, but suggests that cultures have multiple and not one dominant theme or ethos.[16]

Psychological approaches

A more recent development in anthropology has been an effort to study the relationship between the individual and his culture. This area of anthropology is usually called "culture and personality." Margaret Mead was one of the first anthropologists to illustrate how culture shapes the personality of the individual. Prior to her work, anthropologists concentrated their studies on the origins of culture traits and the analysis of cultures as wholes. In her series of studies of life on islands in the Southwest Pacific, Mead consistently demonstrates how the child's earliest experiences, such as toilet training and weaning, shape his personality.[17] The emphasis on experiences in early infancy has remained a dominant trend in culture and personality studies, largely because psychological anthropologists have borrowed most of their theory from Freud's works. According to these theorists, the child's personality is formed largely during his first five years of life.

Psychological anthropologists use the concept of *basic personality* (or *modal personality*) to describe the general type of personality found within a culture. They argue that a basic personality emerges within a society because of the commonality of early childhood experiences. The basic personality within a culture is manifested in all its institutions, such as religion, magic, and mythology.[18] Abram Kardiner used this concept to analyze the personality structure among the Alorese, inhabitants of Indonesia. He described their early childhood experiences as harsh, tense, insecure, and lonely. Kardiner concluded that their harsh childhood experiences were reflected in their religion since their attitudes toward the supernatural were primarily negative.[19]

Culture and personality theorists have been praised for pointing out the important influences of culture on the development of personality. However, they have often been harshly criticized for overemphasizing the importance of infancy in personality formation, overgeneralizing from limited data, and using questionable research techniques.

ANTHROPOLOGICAL CONCEPTS

As in history and sociology, the concepts in anthropology tend to be vaguely defined, and used differently by various anthropologists. Anthropological concepts are more standardized than historical concepts, but less refined than those in sociology. We find less agreement among anthropologists than among sociologists about what the key concepts in their discipline are and what they mean. However, anthropologists do agree that *culture* is the most important concept in the discipline, although there is considerably less agreement about

"Now that we've invented it, we've got to find some way to control it."

Drawing by Herbert Goldberg; © 1968, Phi Delta Kappa.

what culture is. After surveying anthropological literature, one observer noted 164 different definitions of the concept.[20]

> The word "culture" is perhaps anthropologists' most distinctive word; how confusing therefore that there should be such vagueness and such differences of opinion over what it means. More commonly, references in theoretical writings is to learned habits shared by members of . . . communities. . . . But within this broad definition there are many different usages.[21]

Some anthropologists point out that while the development of well-defined concepts is a goal in the discipline, anthropology lacks standardized concepts because of the newness of the field.

> No two anthropologists think exactly alike, or use precisely the same operating concepts or symbols. The science is too new, and the struggle to give sharp meanings to what are usually everyday terms still too wide open. . . .[22]

Although anthropologists often define the same concepts differently, there is usually some degree of similarity in their meanings. However, occasionally two anthropologists will mean completely different things when they use a concept such as *pattern*. This, however, is more the exception than the rule. In the key anthropological concepts discussed below, the author has attempted to describe the way in which they are most frequently defined by anthropologists.

Culture

Culture comprises the behavior patterns, belief systems, artifacts, and other man-made components of a society. It includes the foods that people eat, the

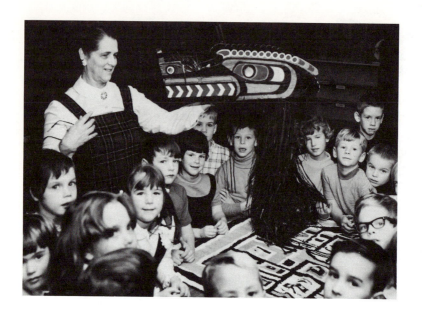

A wide variety of culture elements are vital to a rich program in anthropological studies. Here a teacher shows her pupils a tribal head mask and an Indian blanket. (Washington State Office of Public Instruction, Olympia, Washington)

tools they use, their clothing, myths, religion, and language. It consists of those elements that man uses to adjust to his physical and social environment. It is his solution to the problem of survival. Man's unique biological structure and ability to symbolize, makes him the only animal able to create and acquire culture.

Since culture is man-made, students will be able to conclude that cultures vary greatly in different parts of the world, in different societies, and among different peoples. Pupils should also be helped to discover that a cultural system is an organized pattern or whole. Any drastic external or internal changes are likely to disrupt it.[23]

Culture is the key concept in anthropology. Since all the other concepts are related to it, culture should be given special attention and focus in anthropological studies in the elementary and junior high school.

Culture Element (Trait)

The smallest unit of culture is a trait or element. Culture traits may consist of behavior patterns or artifacts. Each culture consists of many borrowed as well as invented traits or elements. A tool such as the ax, a custom such as tipping the hat when greeting a lady, and a word such as *house* are all culture traits.

Each trait in a culture has at least four characteristics: form, use, function, and meaning.[24] Children will find it necessary to use this concept when they study the processes of diffusion and acculturation.

Culture Complex

A set of functionally interrelated culture traits is a culture complex. The marriage complex in American society usually consists of a period of courtship, a formal engagement, and an elaborate ceremony. Often culture traits are in the form of complexes when they spread from one culture area to another. Most often the borrowing culture selects from the culture complex those traits within it which are most consistent with its needs. This happened when Catholicism was introduced to the New World blacks in South America. Mixture of new and old culture traits is called *syncretism.*

Enculturation

Enculturation is the process by which an individual learns to participate in the culture of his society. This concept is similar to *socialization*, a key sociological concept discussed in Chapter 6. However, socialization focuses on learning that is guided primarily by group norms and expectations.[25]

Culture Area

A culture area is a geographical region which shares a number of culture traits and complexes. When an anthropologist maps out a culture area, he usually selects as guides those traits and complexes by which he can most easily distinguish one area from another. Among the culture areas in the New World that anthropologists have identified are the Eskimo, the Pacific Northwest Coast, the Plains, and the Southwest. Several distinctive characteristics of the Eskimo area are the snow house, seal as the primary food, and the family as the unit of political life.[26] Children can use outline maps to designate culture areas and to delineate the important characteristics of the people.

Diffusion

The spreading of culture traits from one culture area to another is called diffusion. A concept related to diffusion is *invention*, the process of independently developing a new culture trait or artifact. Anthropologists have discovered that most of the traits that make up a culture were borrowed, not invented. However, all cultures have made independent inventions. Many of the words, customs, behavior patterns, and artifacts which are very important components of our American culture were invented in other culture areas.

Inventions within subculture areas of our society have also diffused into the wider culture. Jazz, invented within the black subculture, is now an important element of American middle-class culture. It is extremely important for children not only to understand the amount of culture borrowing which

takes place in all societies, but to understand that many subculture groups in the United States have enriched our cultural heritage.

Acculturation

The culture exchange which takes place when two unlike cultures experience extended contact is called acculturation. Acculturation often takes place when powerful groups capture or subjugate less powerful ones. Much culture exchange took place when the American colonists invaded the areas inhabited by American Indians. It is extremely important for children to understand that acculturation is a two-way process. While most Americans are aware of how the Indian cultures were affected by Anglo-Saxon culture, our great cultural debt to the Indians is less well known and acknowledged.

Acculturation is a selective process; cultures accept only those elements from a foreign culture which will blend with their own culture elements. When they use traits from another culture, they modify them. Forced cultural change can disrupt a culture, since cultures are organized wholes. Many of the forced cultural changes which the Indians experienced had a profoundly negative effect on their life styles. If the teacher and his students make extensive use of this concept in the early grades when they are learning about Indian and Eskimo groups, the study of these peoples will be less superficial and ethnocentric than it currently is in too many classrooms.

Ethnocentrism

Every group tends to think that its culture is superior to all others. Anthropologists have reported studies of many different groups who use words that refer to themselves as "The People," the implication being that outside groups are less than human. An understanding of and acquaintance with this concept by elementary school children might help them better cope with the pervasive ethnocentrism which exists in our world today.

Tradition

A behavior pattern or belief which has been part of a culture for a long period of time is referred to as a tradition. Traditions in our society include decorating a tree for the Christmas season, eating turkey on Thanksgiving Day, and wearing a ring to indicate marital status. Some anthropologists use the term *custom* to describe these culture traits.

Cultural Relativism

The cultural relativist assumes that because each culture has unique features, what is considered normal behavior in one society may be judged abnormal in another. Thus standards of one culture cannot be used to judge behavior in another. "The values expressed in any culture . . . are to be both understood and valued only according to how the peoples concerned set up their view of

life."[27] Ruth Benedict, an eminent anthropologist, felt that this concept would help develop tolerance of other peoples and cultures:

> Social thinking at the present time has no more important task before it than that of taking adequate account of cultural relativity. . . . We shall arrive then at a more realistic social faith, accepting as grounds of hope and as new bases for tolerance the coexisting and equally valid patterns of life which mankind has created for itself from the materials of existence.[28]

In recent years, this concept has come under heavy attack because it can obviously be abused. It can be used to justify the destruction and exploitation of human lives. However, students should be aware of the concept since it can help them to see that behavior in other cultures which they may consider bizarre is often quite meaningful and functional to the peoples who practice it. They should also be aware of the limitations of this concept.

Culture Universals

Anthropologists have learned that certain culture elements and traits are found in all societies, although these traits exist in many different forms. These elements are called culture universals. The family, differentiation between male and female roles, and the incest taboo are found in all cultures. A central problem in anthropology is to determine the causes of these universal culture traits. Anthropologists suggest that many culture universals exist because of man's biological needs. They hypothesize that the incest taboo, for example, exists in all cultures because sexual relations between parents and progeny would be disruptive to the family; the child depends on the family to satisfy his basic needs. Oliver offers an explanation of universals:

> . . . anthropologists are still attempting to identify and account for the habits shared by all mankind — for such there undoubtedly are, owing to mankind's *common genetic heritage*, to certain "situational" universals (e.g., the co-existence of males and females, the prolonged period of human infants' helplessness), and to the *world-encircling diffusion* of certain habits of thought and action.[29] [Italics ours]

This important concept will help children realize that man everywhere faces similar problems of survival, and that while there are many differences in his cultural responses to them, all human beings share many cultural traits.

Race

Race is a group of people who share a number of biological traits or "a population sharing a distinctive combination of physical traits that are the result of distinctive genetic combination.[30] Because of the exploitation based on race, children should study this concept, one of the key concepts in physical anthropology, but one usually grossly neglected in most schools and textbooks. While children are studying about race, they should be helped to discover the fact that most of the significance of race is social rather than physical. They

should also know that different anthropologists structure different racial groups and categories.

> Because of the personal element involved in judgments . . . there are many different schemes of race classification, some containing as few as three major races (Mongoloid, Negroid, and white), others as many as ten or more.[31]

ANTHROPOLOGICAL GENERALIZATIONS

Most anthropological generalizations are based on cross-cultural samples and deal with the discipline's key concept, *culture*. A number are also interdisciplinary because anthropologists study many problems that are of interest to other scientists. The following generalizations can be used to guide anthropological instruction in the elementary and junior high school grades.

> Every society consists of a man-made system of artifacts, beliefs, and behavior patterns, called *culture*, that enables the individuals within it to meet their needs according to their physical and social environment.

> Because of his unique biological traits, man is the only animal able to create and acquire culture.

> Culture is an integrated whole. Changes in one part are reflected in all its components.

> Making and using symbols is an essential component of every culture.

> Cultures use a diversity of means to attain similar ends and to satisfy common human needs.

> Every culture consists of a variety of borrowed culture elements.

> Cultures are selective in the traits they borrow; societies adapt borrowed culture elements to their own particular life styles.

> Culture exchange takes place when groups with diverse cultures come into prolonged contact. Cultural change may disrupt a society.

> In all human societies magical and religious practices arise to help man explain perplexing phenomena in the universe, and to attain a sense of control over his environment.

> All societies have traditional ceremonies and rituals to signal and mark important status changes in a person's life (rites of passage).

> Cultural inventions increase in a society as it becomes more specialized.

> In most societies, the social significance of race is far greater than the physical differences between various racial groups.

> The culture under which a person matures exerts a powerful influence on him throughout his life.[32]

> All societies have a set of traditions that help to maintain group solidarity and identity.

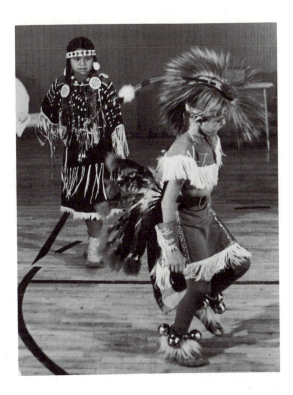

Experiencing other cultures in dramatic and role-playing activities can help children to understand and appreciate man's diverse cultural heritage. (Washington State Office of Public Instruction, Olympia, Washington)

ANTHROPOLOGICAL STUDIES IN THE ELEMENTARY AND JUNIOR HIGH SCHOOL

Many units in the primary and intermediate grades consist of content dealing with preliterate societies which could be profitably studied from an anthropological perspective. Usually when pupils are taught about Eskimos, Indians, and Africans, the exotic and strange behavior of these peoples is stressed. As a result, children often conclude that these groups are not very human because these groups are so different from themselves and because they do many things that seem inhuman or absurd, such as sending the aged into subzero weather to freeze to death or dancing to make it rain. Most young children think that behavior that is very different from their own is bizarre. Too often social studies units reinforce children's misconceptions about other cultures, rather than help them to understand the meaning of "puzzling" behavior to the people who practice it. Crowder describes a typical Indian unit in the primary grades,

. . . a unit on Indians . . . featured a wigwam constructed of burlap or paper, stories and songs, and a war dance. Such instruction probably did more harm than good because it gave a highly romantic, misconceived notion and was so general that a child would come away thinking that all Indians lived in teepees, walked in soft-soled shoes on beautiful green meadows, beat their drums, etc. . . .[33]

In addition to emphasizing the exotic traits of preliterate cultures, much of the materials currently used in the schools is inaccurate. Books often talk about Africans and Indians as if these groups were highly homogeneous. Because of the great diversity of cultures which exist among African and Indian groups, it is difficult to make accurate low-level generalizations about Africans and Indians. Africa has more than 800 native languages. Pueblo Indian culture contrasts rather strikingly with that of the Plains Indians. An accurate presentation of Indians or Africans will reflect the great variety of cultures which make up these groups.

Units on Indians and Eskimos, if approached from an anthropological perspective, can help children broaden their understanding of what it means to be *human*, and enable them to better understand their own culture and life-style. Children should be helped to discover that although man is born with the physical capacity to become human, an individual becomes human only by learning the culture of his group. Anthropologists call this learning process *enculturation*. Since cultures are man-made, there are many ways of being human. Our middle-class American life style is one way: the Pueblo Indian culture represents another. Studying these important anthropological generalizations teaches children to appreciate man's great capacity to create a diversity of life styles and to adapt to a variety of environments. Writes Weingrod,

. . . the recognition that there are alternative ways to live, no less dignified nor noble than our own, is a lesson that anthropology may impart . . . It is at once an humbling and widening experience to learn that others have met and resolved some universal problems in a manner other than the familiar ones. If one can come to appreciate difference, then much indeed will have been learned. To accept and live together with difference is no easy task.[34]

During their study of preliterate cultures, students can learn that although human beings have many of the same basic needs — such as love, protection, and food — different cultures have devised a great variety of means to satisfy them. The rain dances of the Hopi Indians, the witch doctor among some African groups, and water witching in the United States all represent attempts by man to control and manipulate his environment. Once children understand preliterate man's behavior, they will be less likely to consider it exotic and bizarre. With understanding may come tolerance. Writes Lisitzky,

Any acquaintance with anthropology is . . . bound to awaken a feeling of pride in the human race, in the inexhaustible fertility of its power to create cultures. With that comes tolerance. We may not care to adopt the customs of another culture for ourselves, but they are never again so likely to strike

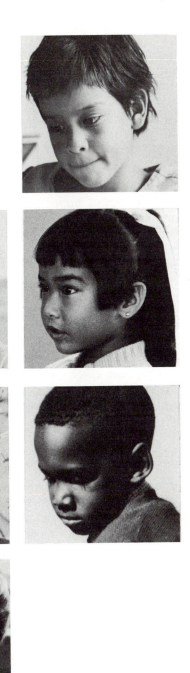

Anthropological studies can help these children to better understand and appreciate their own cultures as well as those of children who belong to other ethnic groups. (Washington State Office of Public Instruction, Olympia; Clover Park School District, Tacoma, Washington)

us as "wrong" or "ugly" or "immoral." We see that they were come by precisely as we came by ours, that it is only a matter of how one is brought up. What may possibly seem wrong is the act of needlessly imposing by force the customs of one culture on another.[35]

While the teacher should help children see and understand differences, he should also make them aware of the many ways in which all human groups are alike. For example, all human societies have families, a system of government, the incest taboo, and a rather clear division of male and female roles. However, these institutions often take diverse forms. Nevertheless, the teacher should not emphasize differences to the neglect of important similarities. Children should know how closely they are related to all human groups — both biologically and culturally. Anthropologists call the many ways in which all human cultures are alike *culture universals.*

Anthropology can also help children better understand their own culture. By studying about other ways of being and living, children will see how bound they are by their own values and prejudices. The fact that most Americans think that romantic love is the most important part of marriage indicates how much we are creatures of our culture. Individuals in some cultures would be shocked by the idea that marriage could be based on such flimsy grounds. Writes Kluckhohn,

> Studying preliterates enables us to see ourselves better. Ordinarily we are unaware of the special lens through which we look at life. . . . *Anthropology holds up a great mirror to man and lets him look at himself in his infinite variety.*[36]

The teacher can use a conceptual approach to the study of preliterate societies to militate against perpetuating stereotypes and misconceptions. He can begin by identifying a number of key anthropological concepts which will serve as an organizing framework for his units. Once he has identified a number of organizing concepts such as *culture, enculturation, culture area,* and *diffusion*, he should select several generalizations related to these concepts, such as *Cultures employ a diversity of means to attain similar ends and to satisfy common human needs* and *Culture exchange takes place when groups with diverse cultures come into prolonged contact.* After key concepts and generalizations are identified, the teacher can select teaching materials and devise appropriate teaching strategies.

If the teacher selects the first generalization named above, he could identify three cultures for content samples, such as the Hopi Indians, the Pueblo Indians, and the Netsilik Eskimos, or he could select one of these groups and use the middle-class American culture as a comparison group. Selecting a small number of cultures and covering them in depth is better than selecting a large number of cultures and covering them superficially. Selection of content samples should be based primarily on the materials available, interests of the children, recommendations in the district curriculum guide, teacher competency and interests, and the prior experiences of the children. If

Figure 7.1
Data Retrieval Chart: Comparison of Cultures

Concepts and related questions	Hopi	Pueblo	Netsilik Eskimo
Food What foods are eaten? How are they obtained?			
Protection What kinds of shelter exist? How are they made?			
Recreation What do people do for fun?			
Esteem How do people gain recognition?			

the children have studied the Hopi Indians in a previous year, it would be better to select the Cheyennes for the new unit.

When teaching the generalization *Cultures employ a diversity of means to attain similar ends and to satisfy common human needs*, the teacher could construct, with the pupils' help, a data retrieval chart similar to the one illustrated in Fig. 7.1. The teacher could begin by asking the children to name some needs that all human beings have. In their responses they may include food, protection from extreme weather, love, esteem, recreation, and a need to explain the origin of the universe and man's place in it. Their responses could be used to structure categories on universal human needs. Once these categories are structured, the class can identify a number of questions related to the categories which can be asked of each of the cultures studied. The names of the cultures should be listed on the chart. The students should participate in a variety of activities — such as reading, role-playing, and viewing films and filmstrips — in order to gain the information needed to complete the chart. Once the chart is complete, the children will be able to derive the generalization identified above.

RECENT DEVELOPMENTS IN ELEMENTARY ANTHROPOLOGY

In recent years efforts have been made by social studies educators and anthropologists to improve the quality of anthropological studies in the elementary and junior high school. Several of the major social studies projects

The construction of cultural artifacts can make other cultures more meaningful to pupils. (Highline Public Schools, Seattle, Washington)

of the 1960's were devoted entirely to creating new materials and teaching strategies for elementary school anthropology. One of these projects, heavily influenced by the ideas of Jerome S. Bruner, produced a course for the intermediate grades called *Man: A Course of Study*. Bruner describes the emphasis in the course:

> The content of the course is man: his nature as a species, the forces that shaped and continue to shape his humanity.
>
> Three questions recur throughout:
>
> What is human about human beings?
>
> How did they get that way?
>
> How can they be made more so?[37]

In order to develop a better understanding of what makes man human, the students start by studying the salmon, herring gulls, and baboons. The Netsilik

Eskimo is studied as an example of a human culture. The course consists of a wide variety of instructional materials, including films which were made especially for the Project. It deals primarily with the first question raised in the quote from Bruner. Dow writes regarding the objectives of the course:

> . . . we have tried to help students gain a new perspective of another way of life. We hope that at the same time they will develop a vocabulary for thinking about the human condition in ways that will assist them in coping with the immense cultural distances which divide the modern world.[38]

The Anthropology Curriculum Project at the University of Georgia has also developed materials for use in the elementary grades. Main concepts in the curriculum include *race, culture, kinship,* and *religion.* For the teacher, the scholarly papers which deal with *key anthropological concepts and generalizations* are an important component of the program. Student texts and study guides are also parts of the curriculum. Although the project contains some excellent materials for developing key anthropological concepts such as *culture, enculturation* and *acculturation*, it introduces the student to more low-level concepts than is appropriate. For example, in the fourth-grade materials the student must not only master the concept of *diffusion,* but he is required to learn the meanings of *primary, secondary, selective,* and *stimulus diffusion.*[39] Fourth-grade children can profit from mastering the concept of *diffusion,* but it is unrealistic to expect them to be able to distinguish between different kinds of *diffusion.*

One of the strongest features of the project is the comparison materials on the Arunta, Kazak, and American cultures. These cultures are compared regarding their social organization, religion, and economy. These materials will provide the teacher with effective guidelines for building comparable units on other cultures. The teacher may use many of the other quality materials in the Georgia curriculum as well as in *Man: A Course of Study* as models for developing his own materials and teaching strategies.

STRATEGIES FOR TEACHING
SELECTED ANTHROPOLOGICAL CONCEPTS AND GENERALIZATIONS

Generalization: *The making and use of symbols is an essential component of every culture.*

Primary grades

Show the class these symbols. *Then ask the questions which follow.*

1. Look at these signs. Have you ever seen them before? Where? What does each mean? Can you think of other signs? (Recalling meanings of specific symbols.)
2. Did you always know what the first sign means? How did you find out what it means? (Cultures pass on meanings of symbols.)
3. Do these signs help people? How? (Symbols help man to adjust to his environment.)
4. What would happen if we didn't have these signs?

Ask the following questions:

1. Did anyone ever tell you that you were a little monkey? Why would anyone call you a little monkey? Would you like to be called by that name? Why or why not? (Example of a symbol.)
2. Draw a line between the animal and the thing he stands for (Matching symbols with meaning).

mouse	courageous, brave
lion	quiet, tiny
elephant	clever
fox	good memory

3. Isn't it funny that we think of animals in these ways? Do you think that a mouse is really quiet? Think about the other animals and the words we use to describe them. Do these words and animals fit? (Questioning the relationship between the symbol and its meaning.)
4. Did you ever hear a story about a house where "nothing was stirring not even a mouse"? Why don't we say, "where nothing was stirring not even a horse"? Which phrase makes the house seem quieter? Why? Does it help to use animal names to tell about things? How? (Examining the use of symbols in descriptions.)

Read the class a story about Indians or Eskimos that tells about totem poles and include characters who have animal names such as Running Bear or Crazy Horse.

Ask the children to write a story in which they use animal names to describe characteristics of people and things. (Application: Using symbols.)

Ask the following questions.

Do you ever pretend to be a driver of a car or a fisherman in a boat? Do you sometimes walk around the house in your mother's or father's shoes? Do you ever pretend to ride horses or drive trucks and trains? Why? (Identifying feelings that are symbolized in action.)

Read the following excerpt from *David, Young Chief of the Quileutes, an American Indian Today*.

Some Quileute Indian children "play in a canoe, pretending to be fishermen like their fathers or seal and whale hunters like their grandfathers and great-grandfathers.[40]

[Show the class on a map (in front of book) where the Quileutes Indian Reservation is located. Show the pupils the picture of Indian boys in a canoe on page 35 of the book.]

Say to the class: The Kiowa Indian children play Indian camp by having toy tepees for the girls and stick horses for the boys. They sometimes even dig a long ditch along the sides of the camp to protect their play camp.

Ask: Why do you think the Indian children do these things? (Identifying feelings symbolized in action.)

Tell the class: England is a country that is on the other side of the Atlantic Ocean. [Show on a globe.] There, when a person is old enough, he *gets the key*. The boy (or girl) is given the key to his house when he is big enough.

Ask the following questions:

1. Would you like to be big and have a key to your house?
2. Would your parents give a key to a one-year old? Why not?

Say: We would call the key a symbol of being big because you get one only when you are old enough to take good care of a key and will not lose it. You get a key when you are big. (Determining the reason for particular meaning of symbol.)

Ask: Can you think of other symbols of being big: If we had no symbols of being big, would you ever know if you were grown up? (Remembering, predicting, and hypothesizing result of loss of symbols.)

Ask the children to act out, tell a story, draw pictures, or write about someone's acting in a way that shows or symbolizes what he would like to be. (Applying knowledge.)

Intermediate grades

Tell the class: Every year in Mexico, as in many other countries, there is a retelling of the story of Jesus's birth. In a symbolic journey, a girl and a boy, representing Mary and Joseph, walk each night for nine days. On the last day an innkeeper gives them shelter and Jesus is born.

Ask the following questions:

1. Is Jesus really born each time the boy and girl walk through the journey in the story? (Recognition of symbolic nature of the action.)
2. What do people in other countries do to symbolize the birth of Jesus? (Memory, comparison of similar symbols.)

3. Why do you suppose the people have this festival every year? (Determining meaning of symbolic tradition.)
4. Have you ever seen a cross? What does a cross mean? Why do some people wear a cross? (Analyzing a concrete symbol.)

Read the following excerpt from *Chippewa Indians: Rice Gatherers of the Great Lakes*:

> Since Little Wolf (a Chippewa) was a mide (mee-day = medicine man), his face was painted entirely red to show his rank, and a green line was drawn from his left temple across his nose and down his right cheek. Because he could foretell the future, two dark lines were painted upward from his eyes. Lines from his ears indicated that he knew what was happening at great distances. He wore a round sea shell at his throat to show that extra power had been sent into his body many times. Two red lines painted on his arms and hands meant that he could touch people at great distances and work his will upon them.
>
> Older Brother eyed him with awe and respect. If only he could earn such markings! It would take a long time to learn all that wisdom. For the present Older Brother's face remained unpainted . . . The family formed a procession behind Little Wolf and Older Brother and they all walked slowly to the Midewegan.[41]

Provide additional examples such as:

> For the Kiowa Indian a similar situation existed. A boy looked forward to the time when he could do brave things. A boy had a white shield to start with. As he did brave things and gained knowledge, his shield would be painted like his father's shield.

Ask the following questions:

1. In scouting, boy scouts, girl scouts, and campfire girls receive emblems for each skill attained and demonstrated. How is this practice similar to the markings of the Indians? How is it different? (Comparing symbol systems.)
2. Military organizations also use symbols to designate achievement levels. How are military symbols similar to the ones we have discussed? How are they different? (Comparing symbols.)

Ask the children to complete the following activities:

1. Select flags from three African nations. Investigate the meanings or symbolism behind each color used and also the meanings of the designs on the flags. (Identifying symbolic meanings.) Each student will discuss with the class the flags he selected, indicating all symbols involved.
2. Discuss things you could feel loyal to, like your family, friends, class, city, state, religion, and country. What other things could you feel loyal to? What could be symbols of the things you named? (Identifying feelings, creating symbols.)

3. Select something you feel you are loyal to and create a flag, using symbols to express important aspects of it. (Identifying feelings, creating symbols.)

Tell the class: Before you had money to buy some of the things you wanted, you could collect things and trade them for items that you didn't have.

Ask: What things could you collect when you were smaller? What could you trade them for?

Read the following to the class:

> Other people trade too. In East Africa cattle are traded for other things — most of the time for wives. A man shows two things when he gives cattle to his in-laws: first, how much he values her and second, how wealthy he is, since the wealthier he is, the more cattle he can give. In addition, the giving of cattle makes it difficult to divorce a man, since the woman's family must give back the cattle if a divorce takes place. On the other hand, if the husband is not good to the wife's family, they can make him give them another cow each time one of the original cows dies. Cattle represent a closeness between families in this society.
>
> Shell money has been used in many societies for barter. The pygmies in the Congo use shells or iron hoes in their exchanges with the Negroes. Silver bars were used in business classes of some cultures until the Turks figured out that they could be made into smaller pieces (coins) for the average people.

Ask: How could the people described above get things they didn't have? How can we get things we don't have? (Recalling the symbolic economic system.)

Say to the class: "The older Quileute Indians remember when they traded for things without using money like bills and coins. One woman in the book, *David, Young Chief of the Quileutes*, said that she liked it better when they could trade. She said that something could always be found to trade, but that it was not always possible to find a job so a person could earn money."

Ask: What symbolic things would you prefer to stand for buying power? (Valuing question.) What would happen if a society had nothing that stood for buying power? (Predicting and hypothesizing about a society without a symbolic economic system.)

Upper grades

Read to the class the following summary of an Eskimo anthropologist's report of one aspect of American life:

> Many peoples in the world pay close attention to time, but none more than Americans. Though it might be denied, time seems sacred in the United States.
>
> This is apparent from the American language. It is generally regarded as sinful to "waste time." One of the greatest American philosophers has

said: "Dost thou love life? Then do not squander time, for that is the stuff life is made of."

But to be specific. Nearly all Americans carry idols that represent time. Larger idols that show time are displayed throughout American igloos and in public places.

Even when busy, Americans often gaze at such idols and regulate their lives according to them. They start when they get up in the morning, and they hardly stop until they go to bed. Many students and workers seem more interested in the time idol than they are in their tasks.

If time worship can be considered a religion, Americans may be the most religious people on earth.[42]

Ask these questions:

1. What did the Eskimo anthropologist say about Americans and time? (Memory.)
2. Do Americans worship idols of time? Why or why not? (Analyzing symbolism about time.)
3. Do you agree with the Eskimo? Why or why not? (Evaluating the interpretation of symbols.)
4. What does this selection tell you in regard to making assumptions about other people? (Evaluating method of interpretation.)

Read the following to your class:

Northwest Indians used to celebrate important social events with a "potlatch." Potlatches were held when a child was born, or when someone died. They were also held when someone got married. In this case the wives were bought from the father-in-law by having a potlatch for him. Once a man had given things to someone else at a potlatch, the other person was then supposed to repay the gift and actually give back more than he got.

In Melanesia it was called a Kula. At a Kula two wealthy people competed to see who could give away the most things to the other. The one who gave away the most won, since he showed that he was so wealthy that he could give away the most things.

One Kiowa Indian (a Great Lakes Indian) described how he felt about giving things away:

We come into the world with nothing in our hands and a cry on our lips. If a man is strong he can strip himself down to the place where he was born and still get back whatever he needs from his own skull.[43]

Ask these questions: What did the Northwest Indians and Melanesians do when they wanted to celebrate something? What did they get out of giving things away? Why? What did it symbolize if you could give away things to celebrate an event? What do we do when we want to celebrate something? (Recalling

identification of symbols.) In what ways do we celebrate when we get married? How are these ways different from the Indians who have a potlatch? How are these ways similar? (Comparing symbolic systems.)

Say to the class: Words are symbols. They stand for ideas and values people have. Ask your parents and your grandparents what words they used to describe things they liked when they were your age. What words do people your age use for things they like? Are they the same as they were when you were five years younger? Why or why not? Do you think that you will use different symbols or words for things you like when you are five years older? Why or why not? (Changing of symbols through time.)

Find out how people from different countries greet each other. We greet each other with "Hello," "Hi," "How are you?"; in parting we may say "Goodbye," "Peace," or "Keep the faith." The Navajo say "Ya ta hey"; it is used to say "Goodbye" or "Peace." The Jewish people may say "Shalom" which also means "Peace be with you," or it can mean "Hello" or "Goodbye." The Chinese say "Nî Hău Ma" for "How are you?"

Ask: How are these symbols alike? Different? What would we do without them? (Comparing of symbolic systems.)

Read the following to the class:

> People used to go into general stores and sit and talk around a warm, black pot-bellied stove. Finally a woman might say, "Let's get down to brass tacks." She meant that she wanted to buy some cloth and that she didn't want to stay and talk any more that day. What did the brass tacks have to do with her statement? The clerk had brass tacks stuck into the counter one yard apart so that he could measure the cloth more easily and accurately.
>
> An old Quileute Indian would tell his young friends how many fingers each side of a canoe had to be. The top edge was one finger wide, the side two, and the bottom three. These measurements made the canoe withstand rocks.

Ask:

1. What symbols did people have to stand for amounts of things for measuring? (Identification of symbols.)

2. What little tricky symbols do you use for things you need to measure? Why do you use them? (Creating new symbols, or recalling ones previously created.)

3. If somebody asked you to measure a room in inches would you actually measure it in inches or would you measure it in some other unit and then convert the answer to inches? Why? (Applying knowledge.)

Ask the class the following questions:

1. Have you ever heard of someone's holding up a black fist? (Recall of symbol.)

 What does a black fist mean today? Has it always meant what it means today? Why or why not? (Identification of meaning through time and changes with time.)

2. Have you ever seen an Afro (or Natural) hair style? What do you think that it symbolizes or means to the person who wears it? What does it mean to you? Has it always meant what it means today? Why or why not? (Same as above; also distinguishes meaning of the same symbol for two different people.)

3. There has been a change through time in the symbols for peace. Indians had a few peace symbols. Can you name one? (Pipe and broken arrow.) Can you name three symbols for peace used later in this country? (Dove, Eagle with olive branch, ⊘ , and two fingers making a V.) Find out ways in which peace is symbolized in other societies. Create your own symbol of peace. (Identification of meaning, recall of symbols, comparison of symbols with same meaning; and application of knowledge by creating a new symbol.)

Generalization: *Cultures employ a diversity of means to attain similar ends and to satisfy human needs.*

Primary grades

Show the children pictures of various shelters, foods, and clothing from different cultures. Ask them what each picture shows. Have them group pictures according to similarities. Ask them to name each group of pictures. Help them to discover that food, shelter, and clothing are necessities for all human beings, even though they appear in different forms. Ask them to envision their lives without one of these three necessities. Ask this question again, omitting another of the group. Then ask the students why the items pictured in each group are necessary to their lives.

The teacher might display pictures of various modes of transportation from different cultures, showing a steamboat, camel, airplane, space capsule, donkey, dogsled, automobile, bus, ocean liner, barge, and train (emphasizing diversity). Ask students to organize the pictures on the bulletin board into categories. They may organize them according to the number of people transported, appropriate climate, or kind of transportation. Ask the students to explain their categories, and to identify the common characteristic of all the pictures. They might want to build models of various modes of transportation.

To help children see that different cultures use different tools for the same purposes, find either a film or filmstrip illustrating man's use of tools in a particular culture. Appropriate choices might be tools of early man, the

Eskimos, the islanders of Micronesia, or the early Egyptians. After previewing the film, find pictures of the tools used today in industrialized society that perform the same functions as those used by the culture shown in the film. Show students pictures of tools with which they would be familiar. Have them identify their uses. Then show the film or filmstrip, directing children to identify tools which perform the same function as those seen in the pictures. The film may have to be shown two or three times for children to make necessary comparisons. Children may want to draw pictures of the tools used in the film and match them with the pictures the teacher has shown them.

Intermediate grades

To help students understand how forms of exchange are a necessity in any culture and yet vary significantly among cultures, show examples of money used in various countries and pictures of banks and other places where money is obtained. Then show pictures of trading posts and markets where barter is the method of exchange.

Ask students: What goal is common to all the pictures? What are the differences between the two sets of pictures? Why do some people use goods and others money as a medium of exchange?

To further clarify the concept of barter, show students a film about a culture such as that of the Navahos or Mexican Indians with whom barter was a means of exchange. Discuss the similarities and differences between the two systems of exchange, and the advantages and disadvantages of each.

Have each student read a biography or story portraying someone in another culture. Ask students to think about the following questions as they read:

1. What experiences does the person in the story have which are similar to yours?
2. Which are different?
3. Why are some different?
4. In what overall ways is the person you read about similar to you?
5. What does this story tell you about human beings in general?

After each student has read a book, form the class into groups of three or four students each and ask them to answer the above questions. Also ask them to compare the answers of each person in the group and to look for similarities within the group. Have each group report its conclusions to the class. Discuss the findings of the class. Help them to identify similar experiences of individuals across cultures and to explain why these experiences have common components.

To give students a new look at diversity of means to attain a common end, have students look in the telephone book of their town or city or one nearby to determine what restaurants specialize in food from other countries. Ask cooks

from the restaurants listed or a member of the ethnic community represented by the restaurants to visit class and tell the students what kinds of foods are representative of their countries and how they are prepared. Then ask the science teacher to explain what human needs must be satisfied to maintain adequate health. Divide the students into groups according to countries and ask them to answer the following questions:

1. What basic foods make up the diet of people in their country?
2. Which foods have carbohydrates, protein, and fats?
3. What percentage of their diet consists of each of the three main food components?
4. How are foods usually prepared: e.g., fried, boiled, dried?
5. Are the foods generally high or low in calories?

Then have each leader report his group's findings. Record them on a data retrieval chart. Have the students compare and contrast their findings to determine whether a general pattern exists in the diet of all the ethnic groups studied.

Ask the children what they must have as human beings to survive. List their answers on the board as human needs. Then suggest that they find out how human beings in other cultures fulfill these needs. Divide the class into groups, identifying each group with a culture. Have the class construct a large data retrieval chart listing human needs in the left column and culture areas on the top row.

Needs	Hopi	Melanesians	Masai of Kenya
Food			
Clothing			
Shelter			

As students find information, it should be recorded on the chart. After each group has recorded its findings, have the class use the chart as a basis for comparing and contrasting how different cultures fulfill the same needs.

Upper grades

Suggest that a group of students read *Walkabout* by James Marshall. It is the story of two British adolescents who are stranded in Australia as sole survivors of a plane crash. In the children's search for help, they encounter an Australian aborigine to whom they are able to communicate their need for food and shelter. The story poignantly brings out the cultural differences while at the same time pointing out the common ground of basic human needs. Ask students to consider the following questions as they read:

1. How did the British children first react to the Australian aborigine?

2. On what basis did the children initially establish communication with the Australian?

3. How did the relationship change over time?

4. What were some of the ways that the British young people and the Australian aborigines differed in satisfying their basic needs?

Most students have not considered the activities and duties of childhood as a necessary preparation for adulthood. To help them become familiar with the functions of different child-rearing practices, ask them to collect pictures of children in many lands and cultures. The pictures should be studied with the following questions in mind:

a) What are the children in each picture doing?

b) How are the activities of the children in all the pictures similar? (They may want to categorize activities into many groups.)

c) How do the activities of the children relate to what adults do?

After the students have been introduced to the concept of socialization in childhood, ask each of them to choose a culture or a country in a certain period of history. Each can then analyze the relationship between the duties and activities of children in the culture to those of the adults in that society. The same should be done for groups within our own culture. Questions such as these could be considered: What jobs do children do to prepare for adulthood? What traditions do they become familiar with? How do the roles of boys and girls become differentiated? As a culminating activity, students may want to develop a picture essay indicating their conclusions about how different cultures prepare children for adulthood.

SUMMARY

Anthropology is distinguished from the other social sciences because of its focus on *culture* – the behavior patterns, belief systems, artifacts, and other man-made components of a society. Anthropologists use a "holistic" approach when they study culture; they believe that valid generalizations can be made only when all the elements of a cultural system are studied as an integrated whole. The comparative study of preliterate cultures is also a unique characteristic of anthropology. The main research method used in the discipline is participant observation. The anthropologist lives in the cultures that he studies. Because of the nature of the discipline and its traditions, anthropology is not as empirically rigorous as behavioral sciences such as sociology and psychology. Anthropologists are more interested in describing particular cultures than they are in formulating empirical theories about many different cultures. Anthropological generalizations are often interpretative judgments rather than empirical propositions. The participant observation method does not facilitate the making of hard generalizations. Thus anthropology is akin to both the humanities and history. Theory development has been retarded in the

discipline because of its research aims and methods and a nonempirical tradition involving the search for single-factor theories to explain the emergence of individual cultures.

Despite the scientific status of anthropology, its focus on *culture* and its concern for preliterate cultures make it an excellent vehicle for helping children broaden their conception of what it means to be human and understand how bound they are by their own cultures, prejudices, and biases. In all societies, men tend to think that their way of doing things is the right way or the only way. Such chauvinistic ethnocentrism is especially detrimental in our increasingly small and interdependent world where men of many different cultures, races, and ideologies must learn to live together if the human race is going to survive the challenges of the twenty-first century. Anthropology can help children to learn that there are other ways of living and being which are just as valid as the ways with which they are familiar. With understanding, tolerance sometimes comes. Anthropology merits a special place in the schools because of the unique lens which it can give students to view other humans as well as themselves.

DISCUSSION QUESTIONS AND EXERCISES

1. Why is anthropology considered a social *science*? In what ways is anthropology scientific? In what ways is it nonscientific?

2. What characteristics distinguish anthropology from the other social sciences? What special contribution can anthropology make to helping children become effective decision-makers and social activists?

3. What is the "holistic" approach to studying culture? Find and summarize a study in anthropology that is an example of the holistic approach to studying culture. What are the advantages of this approach? What are the limitations of this approach? What implications does the holistic approach have for teaching the concepts of *culture* in the elementary and junior high school grades?

4. Read one of the classic books in anthropology such as *Mirror for Man* by Clyde Kluckhohn, *Patterns of Culture* by Ruth Benedict, or *Coming of Age in Samoa* by Margaret Mead, and answer the following questions:
 a) What key concepts and generalizations are discussed in the book?
 b) What kinds of data are used to support the generalizations made by the author?
 c) What methods of research were used to gather the data discussed by the author?
 d) How does the writing style of the book compare with that in studies you have read in other disciplines? (For example, is the book more interesting than books that you have read in other subject areas?)
 e) What were the major strengths and limitations of the book?

f) In what ways can the information reported in the book help you to plan and organize a unit on *culture* for children in the elementary and junior high school grades?

5. Read *Four Ways of Being Human* by Gene Lisitzky, and plan a unit to teach the concept of *culture* to a seventh-grade class in which you use this book as the main source of information. In what ways is this book ideal for helping children to learn the concept of *culture*? What other sources could you use to help make the main point of this book more understandable to children?

6. Examine a primary-grade social studies unit in your curriculum library which deals with the cultures of preliterate groups, such as some American Indian, Eskimo, or African societies. What key concepts and generalizations are developed within the unit? Are the concepts and generalizations accurate? If not, in what ways are they inaccurate? Are the facts that are used to teach the concepts and generalizations accurate? Are the activities that are designed to teach the concepts and generalizations effective? What concepts and generalizations would you add or take out of the unit in order to make it more effective? What learning activities would you add or take out of the unit to make it more effective?

7. Assume that you are a member of a social studies curriculum committee in a school where a new social studies program is being developed for grades K through 8. You have been given the task of identifying the key concepts and related generalizations in anthropology that you feel should be taught in all grades and the content samples to be used to teach them. List the key concepts and generalizations you would choose and the content samples you would recommend for use at each grade level. Also state a rationale for your particular choice of concepts, generalizations, and content. Make an annotated list of the references you used to develop your plan.

8. Select one of the following generalizations and write a series of activities (similar to the ones in this chapter) that can be used to teach it to children in the (A) primary grades, (B) middle grades, and (C) upper grades.

a) The making and use of symbols is an essential component of every culture.

b) Cultures use a diversity of means to attain similar ends and to satisfy common human needs.

c) Culture exchange takes place when groups with diverse cultures come into prolonged contact. Cultural change may disrupt a society.

d) All societies have traditional ceremonies and rituals to signal and mark important status changes in a person's life.

9. Examine an introductory college textbook in anthropology and list the key concepts and generalizations within it which could serve as a guide to a social studies curriculum committee.

10. Assume that you are an anthropologist who is studying a "typical" white, middle-class suburban community.

a) State the key concepts you would use to guide your analysis of the culture within the community.

b) List key questions related to the concepts that you would raise,

c) State related hypotheses.

d) Indicate how you would test your hypotheses.

Can students in the upper elementary grades implement an anthropological study of their community? If you think that they can, tell how. If you feel that they cannot, state why.

11. Demonstrate your understanding of the following key concepts by writing or stating brief definitions for each of them. Also tell why each is significant.

a) holistic method

b) comparative approach

c) cultural anthropology

d) social anthropology

e) ethnology

f) ethnography

g) evolutionism

h) historicism

i) diffusionism

j) functionalism

k) configurationalism

l) psychological approaches

m) basic personality

n) culture

o) culture element

p) culture complex

q) enculturation

r) culture area

s) diffusion

t) acculturation

u) ethnocentrism

v) tradition

w) culture relativism

x) culture universals

y) race

FOOTNOTES

1. Margaret Mead, *Coming of Age in Samoa*. New York: Mentor Books, 1928, 1949.

2. Weston LaBarre, *The Human Animal*. Chicago: Univ. Chicago Press, 1954, p. 104.

3. M.N. Strinivas (Ed.), *Method in Social Anthropology: Selected Essays by A.R. Radcliffe-Brown*. Chicago: Univ. Chicago Press, 1958, pp. 4-11.

4. Ralph L. Beals and Harry Hoijer, *An Introduction to Antrhopology, Second Edition*. New York: Macmillan, 1959, p. 15.

5. John J. Honigmann, *The World of Man*. New York: Harper, 1959, p. 50.

6. *Ibid.*, p. 50.

7. *Ibid.*, p. 51.

8. Pertti J. Pelto, *The Study of Anthropology*. Columbus, Ohio: Charles E. Merrill, 1965, p. 43.

9. *Ibid.*, p. 44.

10. *Ibid.*, pp. 45-46.

11. *Ibid.*, p. 50.

12. Melville Jacobs and Bernhard J. Stern, *General Anthropology: A Brief Survey of Physical, Cultural and Social Anthropology*. New York: Barnes and Noble, 1952, pp. 109-110.

13. Quoted in Godfrey Lienhardt, *Social Anthropology*. New York: Oxford Univ. Press, 1964, pp. 12-13.

14. Felix M. Keesing, *Cultural Anthropology: The Science of Custom*. New York: Rinehart, 1958, p. 152.

15. John J. Honigman, *Personality in Culture*. New York: Harper and Row, 1967, pp. 8-9.

16. Morris E. Opler, "Themes As Dynamic Forces in Culture," *Am. J. Sociol.*, Vol. 51 (1945), pp. 198-206.

17. Mead's studies include *Coming of Age in Samoa*. New York: William Morrow, 1928. *Growing Up in New Guinea*. New York: William Morrow, 1930. And *Sex and Temperament in Three Primitive Societies*. New York: William Morrow, 1935.

18. Pelto, *op. cit.*, p. 26.

19. Honigman, *Culture in Personality, op. cit.*, pp. 109-111.

20. Alfred K. Guthe, "Anthropology," in John U. Michaelis and A. Montgomery Johnston (Eds.), *The Social Sciences: Foundations of the Social Studies*. Boston: Allyn and Bacon, 1965, p. 171.

21. Douglas L. Oliver, *Invitation to Anthropology: A Guide to Basic Concepts*. New York: The Natural History Press, 1964.

22. Keesing, *op. cit.*, p. 138.

23. James A. Banks, *Teaching the Black Experience: Methods and Materials*. Belmont, Calif.: Fearon, 1970, p. 37.

24. Beals and Joijer, *op. cit.*, p. 680.

25. *Ibid.*, p. 687.

26. John J. Honigmann, *The World of Man, op. cit.*, New York: Harper, 1959, p. 139.

27. Keesing, *op. cit.*, p. 181.

28. Ruth Benedict, *Patterns of Culture*. New York: Mentor Books, 1959, pp. 239-240.

29. Oliver, *op. cit.*, p. 55.

30. Douglas Oliver, "Cultural Anthropology," in American Council of Learned Societies, *The Social Studies and the Social Sciences*. New York: Harcourt, Brace and World, 1962, pp. 135-155.

31. *Ibid.*, p. 153.

32. Michaelis and Johnston, p. 327. (See fn. 20 for citation. However, this reference does not refer to the Guthe Chapter, but to original material by the editors.)

33. William Crowder, "Teaching About the American Indian," *Civic Leader* (April 22, 1969), p. 4.

34. Alex Weingrod, "Anthropology and the Social Studies," in Martin Feldman & Eli Seifman, (Eds.) *The Social Studies: Structure, Models and Strategies*. Englewood Cliffs; Prentice-Hall, 1969, p. 268.

35. Gene Listzky, *Four Ways of Being Human*. New York: Viking, 1956, p. 20.

36. Clyde Kluckhohn, *Mirror for Man*. Greenwich, Conn.: Fawcett, 1965, p. 19.

37. Quoted in Peter B. Dow, "Man: A Course of Study: An Experimental Social Science Course for Elementary Schools," *Man: A Course of Study Talks to Teachers.* Cambridge, Mass.: Education Development Center, Inc., 1969, p. 4.

38. *Ibid.* p. 7.

39. Anthropology Curriculum Project, *The Concept of Culture.* Athens: Univ. Georgia, 1965, No. 16, pp. 46-47.

40. Ruth Kirk, *David, Young Chief of the Quileutes: An American Indian Today.* New York: Harcourt, Brace & World, 1967, p. 34.

41. Sonia Bleeker, *Chippewa Indians: Rice Gatherers of the Great Lakes.* New York: William Morrow, 1955, p. 106-107. Used with permission.

42. *Anthropology in Today's World: Case Studies of People and Cultures.* Middletown, Conn.: American Education Publications Unit Book, 1965, p. 7. Used with permission.

43. Alice Marriott, *Kiowa Years*, Anthropology Curriculum Study Project. New York: Macmillan, 1968, p. 74.

44. *A Journey to the Arctic*, adapted from *The Netsilik Eskimos* by Knud Rasmussen. Cambridge, Mass.: Educational Development Center, Inc., 1967.

GEOGRAPHY: STRUCTURE, CONCEPTS, AND STRATEGIES

Geography is a key part of the elementary school social studies program. While there still remains some of the old heritage of "strange lands and exotic people,"[1] serious efforts have been made in recent years to update the quality of teaching and the sophistication of the content studied.

To help put geography in its proper perspective, let us turn to a consideration of geography as a discipline, and the methods of study, concepts, generalizations, and theory connected with it. We shall then illustrate many ways in which the structure of the discipline and the methods of investigation can be appropriately taught in the elementary schools within the framework of inquiry, valuing, and decision-making that we have discussed earlier.

GEOGRAPHICAL PERSPECTIVES

Unique to the geographer is his concern for *place*. He is interested in many kinds of places: mountains, valleys, cities, river systems, barren deserts, dense jungles, and icy, polar regions. He is concerned with the climate of those places, the movement of people in and out of them, the growth and decline of cities, the use man makes of the resources available to him, the pattern of highways, railroads, and airline routes. More specifically, the geographer is interested in the features that give a place its special character and differentiate it from other places. He is also concerned with the interrelationships between places and in discovering the connecting links in the spaces between places. In short, the geographer strives to develop descriptions and explanations that carefully integrate man and the place and space in which he lives.

*"And so, as the lowering smog slowly blankets our view,
we say farewell to the world's most breathtaking skyline."*

Drawing by Robert Day. Copyright 1970, Saturday Review, Inc.

FIVE TRADITIONS

Geography, unlike the other social sciences, has had a very long history dating from the time of the ancient Greeks. Out of this tradition has come a variety of distinct perspectives or research interests shared by many geographers. While each is quite different in its approach to the study of place and space, five are recognized and accepted by most geographers as being well within the mainstream of the discipline. Taken together, these five traditions reflect the broad scope of the field and the pluralistic approach used by the geographer in his pursuit of knowledge.[2]

1. Physical geography or the Earth Science Tradition is the study of the surface of the earth, particularly the arrangement and function of natural features. This study includes the obvious features such as plains, valleys, mountains, and rivers, as well as the study of the earth's crust (geology); the weather and climate of the atmosphere above the earth (meteorology); the action of bodies of water such as waves, tides, and currents (oceanography); the vegetation that covers the earth; and the animal life that inhabits the earth.

This approach has always been a strong one among geographers, particularly as they sought to collect and systematize the rapidly expanding knowledge of the world brought back by travellers and explorers. In large measure, these early studies and reports were descriptive.

2. Regional Geography or the Area Studies Tradition is the study of an area or region of the earth's surface that is homogeneous in terms of some specific criteria such as location, manufacturing, land forms, climate, economic activity, cultural trait, or ethnic origin of the people.[3] The regional geographer asks: What are the key features that give the region its character? How are these key features or criteria related to other features in the same or adjacent areas? What is this given place or area like in its totality? Thus, the regional geographer attempts to present as inclusive and comprehensive a picture of an area as possible. His approach is integrative and "holistic." The regional approach is widely used in the elementary and junior high schools. Three types of regions are most commonly studied: *physical regions*, in which the land features are basically alike (e.g., rugged mountainous land, coastal plains, or river valleys); *cultural regions*, in which some aspect of man's culture or level of technology predominates (e.g., the corn belt of the midwestern states or the manufacturing region running in a great arc from Buffalo to Chicago); and *political* regions, which are grouped along the lines of territorial boundaries (e.g., the middle-Atlantic states, Latin America, or Scandanavia.)

3. Cultural geography or the Man-Land Tradition is the study of the relationships between man and his environment. In this approach, sometimes called human geography or ecological geography, the geographer is specifically interested in the interrelations of man's cultural development and the environmental conditions in which he finds himself. Thus, as James has pointed out, the importance or use that man makes of the physical and biotic features of the earth is a function of the attitudes, objectives, and technical skills of his culture.

Emphasizing the diversity of that significance to man, James continued: "The physical environment has different meanings for different groups of people, or for the same group at different stages of development."[4] Thus, coal could be considered as a "valuable natural resource" only when men had discovered it, learned what to do with it, and had the technology to produce it in usable quantities. Considered more broadly, the economic pattern of an area, the transportation routes of a region, or the settlement patterns of a nation cannot be studied and interpreted meaningfully apart from a consideration of the land and its physical features. Conversely, the activities of man are constantly modifying the natural environment in a variety of ways by changing the course of rivers, bringing water over long distances to arid soil, leveling hills and woodlands for tracts of homes, and polluting the air, the rivers, and the highways with the wastes of our industrial civilization.

4. Spatial Geography or the Locational Theory Tradition is the study of spatial relations and spatial analysis which centers on the location of places and the patterns of distribution. This tradition seeks to explain why features such

as cities, mountains, or human populations are arranged as they are on the earth's surface, and why there are differences in the densities, dispersions, and patterns. Another major part of this tradition is the geometry of the earth's surface, which includes the study of maps and the design of map projections (cartography), and the precise location and mapping of places and surfaces of the earth (geodesy and geodetic survey).

In recent years, spatial geography has tended to concentrate upon developing theories of location. Spatial geographers have studied the central location of towns, the spatial interaction or movements of trade, people, and ideas, the spatial structure of urban areas and their relation to surrounding areas. In marked contrast to the regional or cultural geographer, the spatial geographer is more likely to use quantified data and advanced statistical methods to determine the simultaneous interaction of a cluster of variables relating to economic activities. Perhaps more than any of the other geographic traditions described above, spatial geographers have attempted to develop high-order generalizations and to weave these into comprehensive theories about the location of place and space. This difference might be ascribed, in part, to the difference in emphasis of the traditions. The spatial geographer often uses mathematical or schematic models to express the generalizability of some factor.[5] In contrast, the regional geographer uses a descriptive and analytical method, stressing the special character of an area considered as a whole.

5. *The Historical-Geography Tradition* is the study of the geographic change of a region as it has occurred over time. In contrast to the four approaches already described, the historical geographer uses time as his main dimension for studying spatial distributions and patterns on the earth's surface. He is chiefly concerned with how various features of the landscape appeared in the past and the physical and human patterns that have combined to bring about a change in that landscape. Physical patterns, of course, are relatively enduring while cultural patterns are always in the process of comparatively rapid change. Thus the geographer shares with the historian the dimension of time – but in quite a different way. Whereas the historian is interested in specific dates and particular events and people of the past as part of the story of man, the geographer is interested in dates and events only as they provide explanations for the broad changes that have occurred in the arrangement of space on the earth's surface.[6] For example, a historian might consider the return of Lenin from exile as a key event in the Bolshevik Revolution of 1917, whereas a geographer might consider the elimination of private landholdings and the establishment of collective farms during the 1920's as marking a significant change in the geography of Russia.

In many respects the historical geographer is at home with several of the traditions described above, particularly the cultural and regional traditions. His concern is basically with the "man-land" concept, and the scope of his investigation is essentially regional. He provides an insight into the character of an area as viewed over the dimension of time.

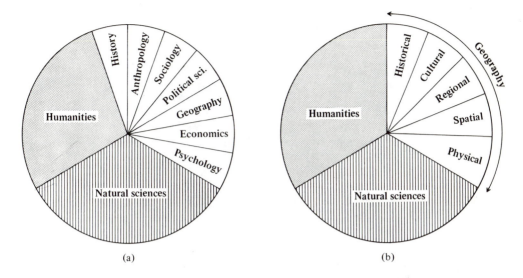

Figure 8.1
(a) Geography as one of the social sciences. (b) The range of geography
within the social sciences.

In summary, these five traditions or approaches to geography – physical,
regional, cultural, spatial, and historical – represent a broad continuum of
research interests and methods of investigation within the mainstream of the
discipline of geography. They borrow freely from one another at various times.
Taken singly, each represents a distinct and valid method of study; taken
together, they reflect the broad scope of the field and the pluralistic approach
used by geographers in their pursuit of knowledge.

GEOGRAPHY AS A SOCIAL SCIENCE

As a discipline, geography spans almost the full range of the social sciences.
Physical geography, when viewed as earth science, certainly borders upon,
perhaps even belongs with, the natural sciences. Historical geography, on the
other hand, so closely resembles the work and method of the historian as to
border upon the humanities at the other end of the continuum. Regional and
cultural geography are perhaps midway in the scale, while modern spatial
geography with its strong emphasis upon economic activities and mathematical
models ranges much closer to the natural science end of the continuum. The
span of geography within the social sciences is represented in Fig. 8.1.

Children should be introduced to the globe in the primary grades because it is a more accurate representation of the earth than a flat map. (Shoreline School District, Seattle, Washington)

GEOGRAPHY AND THE SCIENTIFIC METHOD

In view of the wide-ranging scope of the discipline and the varied methods used by its investigators, can geography be called a science? If one thinks of "science" only as carefully designed experimental testing under rigidly controlled conditions, perhaps not. But such an outlook really bogs the more important question: Do geographers use a scientific method as they investigate the distribution of space on the earth's surface? Let us examine this question briefly, using the criteria of Berelson and Steiner[7] which we discussed in Chapter 2 of this book.

The geographer proceeds in an orderly and systematic manner, defining clearly and precisely his terms and providing as objective as possible a method for collecting data. His procedures are public, that is, they are reported in professional journals or public meetings and are subject to scrutiny and careful review by other geographers and the public at large. The design of the study is clearly stated so that it can be repeated by others under similar conditions to test out the findings. *The main purposes of the geographer's research are description, explanation, and prediction.* He describes in great detail various places on the earth's surface; he seeks to explain the relationship of places to

events, people, and other places; he attempts to predict what will happen when these same factors interact under similar conditions elsewhere, or the likely results if one or more of the factors is modified in some way. The geographer's approach is systematic and cumulative, attempting to bring together large areas of knowledge, expressing his findings in terms of concepts, generalizations, and theories.

To be sure, geographical studies vary widely within the boundaries described above. The tradition from which they stem also has much to do with the research method they employ. For the most part, geographers have emphasized description and explanation. Only recently with the advent of sophisticated methods and computerization of data have geographers emphasized statistical prediction and model building. And although geography has developed many important concepts and generalizations, it has developed few systematic theories capable of explaining and predicting complex spatial interactions or patterns of distribution.[8] Given the dominant position held by the regional approach and the man-land tradition throughout much of the nineteenth and early twentieth centuries with their strong emphases upon description and explanation, the absence of a large body of systematic theory is understandable. But some geographers have openly expressed a strong suspicion, if not hostility, toward the increasing use of statistical analyses of distributional systems and spatial intersections. Although Broek recognized the value of complex quantitative methods and the formulation of theoretical models, he nevertheless raised the specter that geography would become an "abstract science of spatial relations" devoid of a more humane approach to the study of mankind.

> The search for general laws, necessarily at a high level of abstraction, goes against the grain of geography because it removes place and time from our discipline. Geography is not concerned with universalized economic or social man, living on a planet as bare as a billiard ball. To the contrary, geography probes into the complex reality of localized patterns accumulated from the pluralistic history of mankind on the diverse terrestrial scene.[9]

Thus, geography differs considerably from economics, sociology, and psychology, which have placed a much greater emphasis upon the development of systematic theory. This is not to say that geography is any less scientific; it is only to say that its methods and concerns have been quite different from some of the other social sciences.

RESEARCH IN GEOGRAPHY: THE REGIONAL METHOD

Although many of the research techniques we have been discussing in Part 2 are common to all social scientists, one method is of particular importance to the geographer. This is the *regional method* of study. In its broadest sense, the regional method refers to the study of a portion (area) of the earth's surface to determine the areal associations and variations of the place. In practice, the

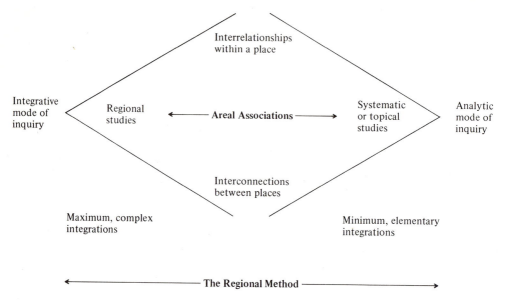

Figure 8.2

regional method includes two quite distinct approaches: (1) the *systematic* or *topical* study of some particular feature such as the location of vineyards or aerospace industries, and (2) the *regional* or *area* study of a particular part of the earth's surface such as the Mississippi delta or the metropolitan area surrounding New York City. Despite the distinction of two approaches, it is perhaps more nearly correct to say that the regional method is used at every level of geographic study and involves activities along a continuum extending from the systematic or topical approach at one end to the broad regional or area study approach at the other end, as indicated in Fig. 8.2. The central focus of the regional method is upon areal associations, viewed from both the interrelations of features *within* a place, and the interconnections *between* places.

In reality, the geographer tends to move in both directions while undertaking a single study. To the extent that he must focus upon particular geographic features and determine their relationship to other features, he is engaging in systematic or topical study. To the extent that he seeks to relate these features to the total environment of the region, and to establish linkages with other regions outside this one, he is engaging in regional or area study. In short, the *regional method* combines both a holistic and synthesizing approach, as well as a systematic and analytic approach, to the study of regions.

Two cautions should be noted, however. *First, no parts of the earth are completely homogeneous or entirely uniform in the distribution of the*

particular feature that may be used to define a region. Thus the region's character will be determined by the extent to which it interacts with other features both within and adjacent to the region. *Second, any region is no more than an intellectual conceptualization; it does not exist in nature as an objective fact, although we sometimes act as if it did.* Sometimes the basis for these conceptualizations may be misleading or erroneous. For example, where does North America begin and end, or why is Asia sometimes divided from Europe at the Ural mountains? Can cultural areas be identified by climatic features such as Aristotle's system of the frigid, temperate, and torrid zones? (The myth of the superiority of the white man's culture, based on its location in the temperate zone, has persisted well into the twentieth century.) Thus, both teacher and students must be continually alert to challenge the validity of the criteria that have been chosen to define regions which they study.

TOOLS AND TECHNIQUES OF THE GEOGRAPHER

We have discussed the regional approach as the principal *method* of investigation of the geographer. To aid him in his work, the geographer uses two principal tools or techniques: (1) globes, maps, and projections of various kinds, and (2) the quantification of data. To be sure, these same tools are used in varying ways by all the social scientists, but they are the special stock-in-trade of the geographer.

Maps, globes, and projections

Mapmaking, or *cartography*, is a highly specialized skill and art, and is a well recognized subfield within the discipline of geography. For the most part, the geographer uses maps for two purposes: (1) to locate people, places, borders, or the distribution of things (e.g., rainfall, crops, forestry, or cultural patterns), and (2) to express relationships often in the form of ratios and to display them visually on locational maps (e.g., density of population, percentage of farmland in certain crops, literacy rates, nutritional value of diet, or the ratio of births to deaths per 1000 of a population). Over a long period of years cartographers have designed a wide variety of map projections and special purpose maps. The major problem that cartographers have had to face is how to portray accurately the round earth on a flat sheet of paper.[10] The globe, of course, is the best representation of the earth, but every effort to peel it apart and represent it on a flat map results in some measure of distortion whether in area, shape, distance, or direction. To counteract the effect of these distortions, cartographers have developed a wide variety of methods for projecting points on the globe onto a flat piece of paper so as to minimize a particular distortion.

Many types of projections have been developed through the years, but most are a combination of the special features of one of the three main types: the azimuthal or flat plane, the cylindrical, or the conic. Today, projections are developed by complex mathematical equations solved by computer. These same computers can also store vast amounts of geographic data gathered from

"They're studying Australia, the land down under."
Reprinted from *Instructor,* © February, 1954, The Instructor Publications, Inc., used by permission.

field surveys, censuses, etc., and when programmed for a particular projection, print out at high speed a graphic representation of the data. Thus, maps, globes, and special projections, now aided by the technology of the computer, have taken on special importance as a tool of the geographer.

Quantification techniques

Geographers have always used measurement as an important part of their work. They have measured altitude, surveyed land, made maps, related agricultural production data to land usage patterns, and the like. Most atlases reflect these studies in maps showing the distribution of such relationships over various parts of the earth. At the simplest level, these studies are based upon percentages or ratios of one factor to another. In more complex situations, correlational analysis attempts to measure by sophisticated statistical techniques the relationship of two or more variables in different land areas. For example, the correlation between the rental cost of land and the distance from the central business district (CBD) can be expressed graphically as a curve or gradient, as shown in Fig. 8.3. Note that the cost of rent of a single family dwelling decreases *directly* as the distance from the CBD increases. Because this decrease is constant or uniform it is expressed as a straight line. Present computer

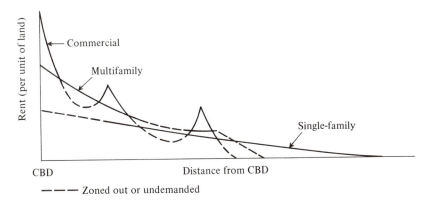

Figure 8.3
A graphic representation of the correlation of two variables: rent and distance from the central business district. The figure shows an ideal urban rent gradient. Competition for land results in an ordering of land use for commercial, to multi-family, to single-family residential. In some cases, the highest value use is not permitted, and there is often demand for single-family homes even where that use pays less rent than other uses. Commercial activity peaks at different locations, since business districts seek local markets to dominate. (Reprinted with permission from Richard L. Morrill, *The Spatial Organization of Society*. Belmont, California: Wadsworth Publishing, 1970, p. 165.)

programs can now calculate in a few seconds the complex interaction of a number of related variables. Statistical techniques, such as this, make it possible to compare data from one city to another in an attempt to develop generalizations about urban development in a country.

Another quantitative technique is the scatter diagram. This is a simple form of correlation data reflecting two variables plotted on a chart. The strength, direction, and shape of the relationship can be seen in the clustering or dispersion of the various points. Although it is not mathematically precise as the correlational analyses described above, it is a useful form of approximate representation of the correlation of the two variables. In Fig. 8.4, for example, inferences about the level of nutritional health and well-being can be made from the scatter diagram showing the percentage of people of various cities whose daily caloric diet is at specified levels. The point is that these relationships are ordinarily not clearly identified unless they can be quantified and plotted in some visual or symbolic way.

The quantitative techniques for correlational analysis described above are standard measures well known among social scientists. During the past decade, however, an entirely new group of quantitative tools borrowed from advanced mathematics has been introduced into the discipline of geography. These

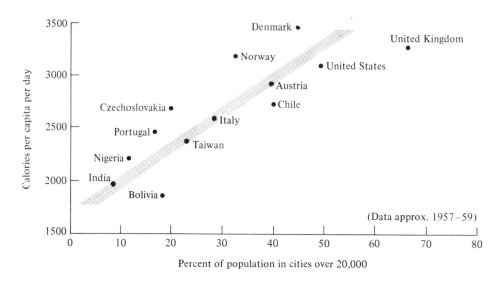

Figure 8.4
Example of a scatter diagram. Although admittedly somewhat selective in the choice of
countries, the diagram serves to illustrate the high positive correlation between proportion
of population in cities and food intake, the latter as an indicator of level of living. Courtesy
of Russell B. Adams, Department of Geography, University of Minnesota. (Reprinted with
permission from Jan O.M. Broek, *Geography: Its Scope and Spirit*. Columbus, Ohio: Charles
E. Merrill, 1965, p. 61.)

include the development of mathematical models, the use of systems theory,
and the introduction of linear programming and game theory to develop
probable solutions to problems.[11] In all these, the computer is an essential tool
for solving complex problems.

In the preceding pages we have examined two major aspects of geography
as a social science; its research method and the techniques and tools of the
geographer. We have seen that the regional method, comprising both area
studies and topical studies, represents the principle method of research for the
geographer.

GEOGRAPHY: A GENERALIZING DISCIPLINE

In Chapters 2 and 3 we discussed the role of theory in science as being useful
for describing, explaining, predicting, and controlling phenomena in the world
about us. We described theory as being made up of interrelated sets of
high-order generalizations which, taken together, we can use to explain and
predict complex events. Let us examine now the extent to which geography is a
generalizing discipline and then examine some of the major theories in
geography.

Individual versus general studies

Essential to any discussion of geography as a generalizing discipline is a recognition of the long-simmering debate over the merits of individual or unique studies as opposed to more general ones that develop general principles. Professor Richard Hartshorne,[12] a prominent philosopher of the science of geography and its methodology, has noted that even in the study of particular categories of phenomena, geographers have not tended to study generic types of mountains, valleys, or other features, but have studied individual ones in great detail, much of their work being descriptive and interpretive. Similarly, Hartshorne contended, geographers have not developed general principles or laws relating to various regions and their common integrating factors.

In attempting to explain this situation, we might review the major criteria for developing generalizations and principles in an inductive manner.[13] First, the investigator needs to have many similar cases available for study. But in geography how many lakes, plains, or urban areas can one find that are essentially alike and that have similar relationships to their environment? Secondly, generic relationships can best be established when dealing with a small number of variables, all subject to the same laws. In geography, however, the investigator must observe highly complex associations without the advantage of control, manipulation, or replication, all essential features of the scientific method. For example, studies of climate or land erosion may evidence considerable regularity when studied over a long period of years, but the geographer has no hope of being able to control, vary, or duplicate any of these events. Other features, such as the development and change of great river deltas, or the cultural transformation of a landscape throughout history, would be impossible to replicate, much less attempt to control or manipulate, except on the smallest and most limited scale. Even then, this kind of study would probably have to be simulated by some form of a working model, or more likely today, through the construction of a computer-generated mathematical model.

A third consideration is the extent to which phenomena studied in geography are cultural and are influenced by the combined action of large numbers of people. It may be possible to analyze the human factors in terms of generic characteristics, forces, and responses, but here again such forces or responses cannot be controlled or replicated. While generalizations may be based upon the inferred presence of large-scale forces or responses, they cannot take account of the contribution of individuals whose unique role cannot be transformed into generalized principles. How does one formulate geographic generalizations about the unique contributions of explorers such as Magellan, or Henry Ford's contribution to the development of roads and highways? Thus, the geographer often finds himself in a difficult position. He is quick to recognize the need for general laws and principles if these can be developed, yet the conditions under which he must work do not lend themselves readily to the development of testable generalizations and laws. Hartshorne's comment is quite appropriate: "Judged by what it does, geography is evidently concerned

Children can study the concept of *location* in the primary grades;
this concept can be further developed in subsequent grades.

with attaining the maximum understanding of individual areas, whether or not
it can attain scientific laws about regions."[14]

Simulations, models, and theory

Models and simulations are simplified representations of reality. Yet in another
sense their very abstract quality makes of them rather high-order generaliza-
tions, because they represent the continuing interaction and functioning of a
whole series of discrete variables. Taken as a whole, the model or simulation
represents a theory in being. It is first developed from an empirical base, and
then is applied to reality to test its validity. To the extent that it adequately
explains and predicts events in the real situation, it is then a highly useful
device. In a recent article applauding the increasing use of systems analysis,

simulations, and model building, Professor George W. Carey[15] added an important caution on theory construction: "Theory is of vital, indeed crucial, importance to geography, and the systems approach offers much promise, *but there is danger whenever the overarching reach of theory straining for generality exceeds the potential of data to verify it.*" This cautious note probably sums up the position of most geographers toward geography as a generalizing discipline. Let us turn our attention to the development of particular theories in geography.

THE DEVELOPMENT OF GEOGRAPHIC THEORY

As we indicated in the previous section, the nature of geography is such that geographers tend to be more concerned with developing maximum understanding of individual areas rather than with the formulation of broad laws and principles that have universal application. Consequently, there has been comparatively little growth in the formation of theory that systematizes sets of high-order generalizations or principles into a comprehensive explanation of complex phenomena. In this section we shall look first to the contributions of several early theorists, and then turn to a brief consideration of three prominent theories in geography today: (1) location theory, (2) central place theory, and (3) spatial structure theory.

Early theorists

We already know about the contribution of the ancient Greeks, particularly of men such as Eratosthenes and Ptolemy, to the early development of geography. Their theories on the size and shape of the earth, and earth's place in the solar system, were of tremendous importance and did much to encourage travel, exploration, and discovery on our own planet.

In more recent times, two German geographers stand out as important contributors to the development of geographic theory: Alexander von Humbolt (1769-1859) and Carl Ritter (1779-1859). Von Humbolt is often referred to as the founder of modern geography. He travelled extensively through Latin America, the United States, and central Asia, and was a keen observer of physical and biological features. He drew profiles of continental cross-sections, related vegetation to altitude zones, and was the first to draw a map using isothermal lines, that is, lines connecting points of equal temperatures. By presenting explanatory descriptions of areas and by comparing them with similar areas in other lands, he set the tone for scientific geography and moved away from the mere collection of place names, locations, and isolated facts of a political or statistical nature.

In contrast to von Humbolt's work in physical geography, Ritter tended to emphasize the human experience of man as seen in the various regions of the world. He hoped to accumulate enough data to make possible the development of systematic principles, and so he undertook a comprehensive study of the

earth based upon elaborate descriptions of various regional divisions. What systematic theory he did develop was not along the lines of von Humbolt's attempt to interrelate the various features of the earth's surface, but rather along teleological lines that dealt with the order of the world and the Divine plan that placed man into various parts of that world. Ritter was criticized for obscuring his scientific observations of the earth as the home of man with his religious philosophy of the Divine purpose, although this approach was still quite common in the early half of the nineteenth century, for the strong break between science and religion was yet to come. Despite these limitations, Ritter laid a strong foundation for the regional method as the primary method of investigation for the geographer, striving constantly to show each region of the earth as a whole and also as an area composed of a complex interrelationship of individual elements. In this respect, his contribution to geographical theory has been of great significance.

Location theory

How can we explain why things are located where they are? Is there some relationship, for example, between the location of cattle grazing lands and the distance to a meat packing center? Or if we wanted to locate a new branch of a business, or a manufacturing plant, could we determine an optimal location? Such questions as these are the concern of geographers (and economists, too) who are now able to turn to a rather well-developed body of knowledge, called *location theory*, for appropriate answers or ways of finding answers.

Location theory has at various times been a rather broad umbrella for studies derived from the related fields of economic, urban, and transportation geography. Essentially, it is the study of the geography of man's economic activities. Put more broadly, it is the study of the effects of place and space on the organization of economic activities.

Location theory arose principally out of economic geography rather than out of the human or cultural side of geography. Two of the earliest "classics" in the field of location theory were concerned essentially with economic location. The first of these was von Thunen's study in 1826 on the agricultural location of farms in Germany. He developed a simple model of the structure of the land as a function of rent and distance. The second "classic" was Alfred Weber's study in 1909 on industrial location, also done in Germany. Weber attempted to develop relationships between costs, transportation, and the location of the sites for raw materials, production, and distribution centers. Current work in location theory tends to emphasize four major aspects in determining the optimal location of economic activities: (1) external factors such as time, cost, and distance, (2) physical features of a particular site, (3) time and distance factors that affect the "action space" of individuals as they move to and from home, office, branch offices, market areas, etc., and (4) the determination of the optimal location by using mathematical models and computer simulations.

Central place theory

Central place theory has played a key role in studying the location of towns and cities in urban geography. Based upon a study of the agricultural towns in south Germany, Christaller[16] discovered that small villages tended to cluster about larger towns or cities in a rather regular hexagonal pattern. These larger towns served as the center for many important marketing, social, and cultural activities. The development of the railroad and, more recently, the interstate network of freeways and airways have greatly changed the growth and importance of many towns and cities, thus making Christaller's earlier concept of hexagonal trade patterns obsolete. Although many modifications have been made in central place theory, it remains an important component in the study of urban geography.[17]

Spatial structure theory

A third theory in geography that has considerable importance, especially in urban geography, is the spatial structure theory. In many ways this is an outgrowth of the central place theory in that it conceives of space on the earth's surface as being ordered in a hierarchy of use and function. An expansion of the central place theory is that cities and towns are arranged in a functional hierarchy of ascending order, from the smallest hamlet through the town, the city, and finally to the large metropolitan center. Such theoretical patterns provide useful ways for examining and determining the ordered use of land and the patterns of various land usage. The use of spatial gradients provides a convenient and relatively accurate index of land use and cost. The identification of hierarchies enables one to make appropriate choices among potential market areas with recognition of the predictable advantages and limitations of each.

Each of the three major theories – *location, central place,* and *spatial structure* – has come to play a useful role in describing, explaining, and predicting the complex events of the organization and interaction of place and space, especially as they relate to the field of urban geography. Let us now discuss a number of the concepts that are central to the work of the geographer, the ones that can serve as organizers for planning a unit of study. Then we will show how the various concepts can serve as building blocks for developing generalizations related to the five traditions discussed in the first part of this chapter.

GEOGRAPHICAL CONCEPTS

The broad areas of location theory and spatial interaction, urban spatial patterns, cultural diffusion, and environmental perception represent some of the more prominent emphases in many of the newer geography education programs. Other concepts could have been included, of course, and some of these are listed at the end of this section. Using the model of social science

"No wonder we're lost. This map is upside down!"

Reprinted from Instructor, © June, July, 1971 by the Instructor
Publications, Inc., used by permission.

inquiry that we presented earlier in this book, teachers can plan units of study
with concepts such as these as the main organizing elements. A number of
illustrations are provided in the final part of this chapter, showing how these
concepts can be developed at various grade levels using the inquiry models we
have developed in this book.

Location

One of the most essential tasks of the geographer is the location or
identification of place and space. From earliest times, geographers have been
concerned with the precise location of towns and rivers, great bodies of land or
water, and other features. Systems of latitude and longitude, the distance
between places expressed in miles, and measures of area all help to define or
identify the location of particular places or spaces on the earth's surface. But
the concept of *location* also includes several other closely related subconcepts
which greatly extend the rather narrow meaning of precise location described
above. These are *site, situation,* and *environment.*

 Site refers to the location of a place in terms of its local internal features
and resources. This may be the presence of a number of steep hills in a town, a
winding river, sheltering hillsides, or the juncture of two main railroad lines.

Such internal features are often key factors in studying the growth of a city, or related phenomen such as settlement patterns, development of industry, etc.

Situation refers to the larger context of a site. It is the location of a place as seen in interaction with the areas surrounding it. Thus, *situation* might refer to the location of a town within a valley and its surrounding hilly or mountainous country, or to the location of a larger city and its relation to the suburbs and rural land surrounding it, or perhaps to a seacoast city such as New Orleans and its relation to the Gulf of Mexico, and the network of rail, air, and waterways that connect it to many other surrounding places. Thus, whereas *site* deals with the *internal* features of a place, *situation* deals with the *external relations* of the place and its interaction with other places.

To refer to the totality of both site and situation, the term *environment* is often used. In its broadest context this includes the physical, biotic, and cultural features of the landscape and their interactions. It is interesting to note the changing usage of this concept. A century ago geographers used the word "environment" almost exclusively to refer to the physical or biotic surroundings of a place. Among geographers today its connotation is widely accepted to include man's cultural activities and their effects upon the earth's surface. Current usage of the term *environment* in the context of pollution and conservation of natural resources refers largely to the physical and biotic surroundings of the earth. For children in the elementary school, the term *environment* should be used in its broadest connotation and should certainly take into account the influence of man's *cultural developments* and progress as part of the total picture of the earth's surface.

Spatial interaction

Closely related to the concept of location is the concept *spatial interaction*. Whereas location tends to refer to the identification of a particular place, *spatial interaction* refers to the relationships established between places in space. It is concerned with the varying degrees of mutual dependence of places, one upon another. Two closely related subconcepts are essential to the understanding of spatial interaction. These are *circulation* and *accessibility*. *Circulation* refers to the patterns of movement of people, ideas, and products in and around various places. Thus, the geographer is concerned with various features of the earth's surface as they hamper or aid in the movement of people, ideas, or economic trade, and the patterns of movement that may be created. Mountains, deserts, or great swampy areas may at one time have been barriers to movement of men and goods, but modern technology now provides means for overcoming each of them. In another sense, large navigable rivers, broad open highways, and the high seas provide free and easy circulation to distant points. But in many remote, rural, and underdeveloped areas of the world, the lack of transportation facilities or the physical features themselves combine to sharply limit or restrict circulation patterns. Another aspect that has taken on increasing importance in recent years is the bypassing effect of interstate freeways and superhighways. Many smaller towns and cities now find themselves almost entirely cut off from the movement of goods, people, and

ideas by freeways which skirt widely around them to provide high-speed movement, uninterrupted by local traffic. In many ways it is a repetition of the decline of those towns that were too small or too unimportant to become a stop on the main line of a major railroad.

Closely associated with *circulation* is the concept of *accessibility*, i.e., the ready and easy entry into and exit from the circulation patterns. Cities which are intermediate stops along a railroad, airline route, or navigable river, convenient ports of call along coastal seaways, or ones with entry and exit cloverleaves along a superhighway, are all examples of places with good accessibility to the pattern of circulation. In contrast, many islands, even in heavily populated parts of the world, have only limited ferry service to the mainland and many remote places are connected to the outside only by irregular flights of local bush pilots. In addition, it is not uncommon for people whose towns have been bypassed to have to drive twenty to thirty miles to enter or leave a modern freeway. Thus, in examining the interaction of places in space, the geographer can use the concepts of *circulation* and *accessibility* as a means of organizing data and analyzing relationships in meaningful ways.

Urban spatial patterns

In considering the spatial patterns in an urban area, the geographer makes use of a large number of important concepts. The concept of *city*, for instance, is a place that provides many centralized and specialized services for its surrounding area. The space or distance that people travel to reach the city to work in it, to shop, or to spend their time is considered its *sphere of influence*. Conversely, this concept applies to the space or distance to which newspapers and goods (both wholesale and retail) are delivered from the city, the range of phone calls made to and from the city, etc. In short, how far out beyond the corporate limits of the city does its influence extend? The space included within the *sphere of influence* is variously known as the hinterland, the trade area, the supporting, or tributary area. Students in elementary school can easily grasp the concept of *sphere of influence* by looking to see what newspapers are carried in local stores or delivered to their homes each day. The teacher might ask them why some newspapers are delivered to homes each day while other papers can be bought only at newsstands or stores downtown. (The newspapers of large metropolitan cities can usually be found in newsstands within a radius of 75 to 100 miles.) The teacher might also ask where people go to buy things that can't be found locally, or perhaps where most people go to work.

A concept of key importance to the urban geographer is the concept of towns and cities as *central places*. Viewed as a kind of common market place, the town is organized to provide a variety of goods and services centralized within a single area. People will come from a considerable distance to buy in this market. But the distance people are willing to travel is proportionate to both the time and cost of the journey and the cost and availability of goods. Thus, the demand for goods and services decreases as distance from the seller increases. At some point, then, people prefer to travel to some other town where goods are available at a lower cost in terms of time and money. This

point of equilibrium can also be established where the profit ratios of the merchants of one town are about equal to the profit ratios of another, and neither town has a competitive advantage. Thus, towns and cities can be seen as *central places* from three distinct perspectives: (1) the agglomeration or concentration of services they provide, (2) the central point of an area or zone of maximum distance people are willing to travel to reach the town, and (3) the central point of an area within which there is a profit to be made from the goods and services the town provides.

Not every city fits the model of a central place within a spatial hierarchy. Some cities do not have a central location nor provide centralized services, but they may have a special feature around which an urban area has developed. They are referred to as *special place* locations. Examples of such *special place* locations are recreational centers such as Aspen or Vail, Colorado; mining centers such as Anaconda, Montana; or political capitols such as Washington, D.C., or Brazilia.

Closely related to the concept of towns as central places is the concept of *spatial hierarchy*. As geographers studied more closely the concept of towns and cities as central places, it became evident that an interlocking network of urban areas existed, ranging from the small hamlet and village through the town, to the city, and to the major metropolitan centers of trade, finance, or industry. This interlocking network is based upon the interaction of town with city, and city with metropolis — in the flow of people, goods and services, and cultural developments between one area and another. The concept of an interlocking network of towns and cities is called a *spatial hierarchy*. It is somewhat analogous to the simpler concept of sphere of influence but on a far greater and more complex scale. Used as an organizing concept, *spatial hierarchy* has great value; it can help students learn how and where to look for data about the function of cities and to predict possible relationships about their interactions.

Lastly, there is the concept of *urban sprawl*. This refers to the gradual growth of a city from urban to suburban to rural areas, and the building up of the areas in between. It is the outward extension of the city through a series of concentric rings. Current efforts at urban renewal suggest some reversal of the outward movement pattern and a trend of return to the central area of a city closer to the central business district. Town houses are seen by some as a desirable alternative to the long, congested commuting trip from the suburbs.

What happens when urban growth becomes so great that the *urban sprawl* from one city gradually merges with that of another large city, and there is almost a continuous belt of urban development stretching many miles? Such a combination of large metropolitan areas has come to be known as a *megalopolis*. A gigantic urban sprawl stretches for more than 600 miles from southern New Hampshire to northern Virginia, and includes the cities of Boston, New York, Philadelphia, Baltimore, and Washington, D.C. This is the largest *megalopolis* in the world. Although the area involved represents only 1.8% of the total area of the United States, it contained 37 million people in 1960, or about 21% of the entire population of the United States.[18]

Megalopolis, therefore, is a concept of an *urban area* or *city* on the grandest scale imaginable.

Internal structure of a city

So far we have discussed the location of cities and their external relations with other cities. Let us consider briefly several concepts related to the city itself. The *internal structure* of a city comprises the arrangement of the parts of the city and the function of those parts. The basic pattern of the streets of the city, its *layout,* refers to the grid pattern of the streets as in Denver or the radiating spokes as in Washington, D.C. or in Paris, or to the riverine pattern of Nashville, Tennessee. One of the most useful concepts is the *central business district* (CBD) which is the area marked by the convergence of transportation and commerce linkages. It is the major market center, the trade or business district. It is often referred to as "downtown" in contrast to the less commercial and more residential area often called "uptown." In recent years competitors of the CBD are the huge suburban shopping centers that mark the outward expansion of the city and serve as nuclei for the urbanization of residential areas.

The *circulation network* consists of the major streets or rapid transit lines (buses, streetcars, subways, elevated trains, etc.) into, out of, and around the city. New freeways provide fast and easy access to the suburbs and beyond, but also block off and isolate parts of the city by huge moats of concrete. Recently, helicopters and air-taxis provide entirely new routes in the circulation network of the largest cities.

Another important concept for analyzing the internal structure of a city is its *land use patterns.* Most cities have clearly identifiable zones or sectors of differentiated use, such as the industrial area, the wholesale districts, the theater district, residential areas, the port or terminal transfer area, the retail sales-banking office area, and the like. The location of these sectors often depends upon the location of transportation facilities for the movement of people, goods, and services to and from the area. The change from fixed means of transportation, such as railroads or streetcars, to the more mobile cars, busses, and trucks has produced a series of newer sectors. The older ones have been left to decay; the result is the growth of slums.

Finally, there is the *social variation* in the internal structure of a city. In cities all over the world minority groups of differing national origins, color, or religion can be found set apart from the rest of the populace in distinctive ethnic areas or "ghettos." Whether they congregate willingly for reasons of social and cultural identity, or because of discrimination, different ethnic cultures and traditions, or use of a language other than English, may characterize a neighborhood for several generations. These districts are often among the poorest in the city. Color, however, has been a far more insidious barrier to movement within or out of the city than religion, language, or national origin has ever been. The restriction of Blacks to certain areas of the cities by a variety of legal, economic, and social pressures has created one of the most urgent social problems of the decade.

The study of man's cultural development and diversity must be
an integral part of a sound program in geographical studies.
(Washington State Office of Public Instruction, Olympia,
Washington)

Another aspect of social variation is the level of wealth or income which
clearly divides residential areas into upper-, middle-, and lower-income home
districts, each with different levels of density, availability of living space,
provision of public services, etc. Similarly, the retail trade area falls into
districts based upon the wealth or purchasing ability of its clientele.

High-fashion shops tend to be uptown, whereas stores carrying low-cost goods, pawnshops, and second-hand stores tend to be in the older, decaying parts of the city.

Cultural diffusion

An important anthropological concept used by geographers and often neglected in school geography is *cultural diffusion*. This refers to the distribution of some cultural trait such as language, education, ethnic origin, religion, or technological development within a particular area. The geographer interested in cultural diffusion asks: "Where are such traits found?" What is their dispersion? What is their density? Is the pattern of movement relatively fixed or highly mobile over time and space? What features of the earth's surface appear to be related to the diffusion (or restriction) of a particular cultural trait?"

Many studies have traced the immigration and settlement patterns of French-Canadian and Scotch-Irish mill workers in New England, or of German and Scandanavian farmers in the midwest. Others have traced the concentration or the spread of religious groups, the clustering of elderly citizens in certain areas, and the diffusion of rock-'n'-roll music.[19] While avoiding invidious comparisons, the alert and sensitive teacher can easily help children in the middle and upper grades to identify neighborhoods where a different language is spoken, to plot out the circulation range of a Spanish edition of a newspaper, to study the changing patterns of participation in such recreational activities as skiing, soccer, or camping, or to analyze the incidence of serious crime.

Environmental perception

The renewed concern of the geographer for a better understanding of man and the environment has brought him into close contact with similar interests among psychologists and sociologists. Each has been concerned with the broad question: How does man view the world around him? The feelings, attitudes, images, or ideas that result from man's cognitive structuring of his physical and social environment are referred to as his *environmental perception*. Geographers are especially interested in the differences in perception that different groups have of the same environmental area and in the distribution of such perceptions over space.[20] For example, the perceptions of resource managers (city planners, zoning commissioners, conservationists, forest wardens, etc.) are often quite different from those of the resource users, the people most immediately concerned. Note that the common restrictions on the uses of watershed areas and water systems are often viewed quite differently by campers, naturalists, boaters, hunters, industrialists, loggers, and those officials responsible for the reservoir and water works. Similar problems exist when parts of the land, especially urban areas, are perceived differently by various groups of people: the rich, the poor, Blacks, whites, and various other ethnic groups. Terms such as "across the tracks," "silk stocking neighborhood," and "snob hill" are common in our language and usually have negative connotations. Many towns and cities have sections where particular ethnic

groups have located. These areas are often referred to in a derogatory way as "coontown," "Jewtown," and the like. Mayors who are anxious to drum up tourist trade may describe their city as an "exciting, fun city" but residents concerned with an alarming increase in crime may describe the same city as a "frightening jungle." A new group of geographers, called social geographers, has recently given considerable attention to how different groups of people such as ethnic minorities, new residents, children, elderly people, and hospital patients view their environmental surroundings and how these views may change as people move from place to place over time.

These concepts used by contemporary geographers have been selected from the broad areas of location theory, spatial interaction, urban spatial patterns, cultural diffusion, and environmental perception. They were chosen because they represent some of the newer emphases in many current geography education programs. Other more familiar concepts, such as change, population (including movement, density, and sequent occupance), scale, the regional concept, and areal coherence, were alluded to or discussed in some detail earlier (see pages 260-263). We turn now to a consideration of the development of generalizations in geography.

GENERALIZATIONS IN GEOGRAPHY

As we indicated earlier in this chapter, geography as a discipline has traditionally been more concerned with the development of descriptive and explanatory studies than with the formulation of empirical generalizations of wide universality. While there has been no lack of concepts within the discipline, the concepts have served principally as organizing elements for analytical studies. During the social studies curriculum reform movement of the 1960's, a number of geographers interested in school programs worked with social studies educators to develop lists of generalizations that might be used as major themes for developing new curricula in geography. The following are illustrative of such lists:[21]

1. The shape and tilt of the earth causes an unequal distribution of sunlight or energy from the sun. This variation influences the circulation of the atmosphere and causes differences in climate and natural vegetation.

2. Weather, climate, and movements of the crust of the earth affect the surface and cause regional differences in landforms, minerals, drainage, soils, and natural vegetation.

3. Soils are altered by nature and man. Nature combines the action of climate, vegetation, and animals on parent materials to produce regional variations in soil.

4. The natural environment may set the broad limits of economic life in a region, but it is man who determines its specific character within the limits of his culture.

5. The extent of man's utilization of natural resources is related to his desires and to his level of technology.

6. The processes of production, exchange, distribution, and consumption of goods have a geographic orientation and vary in part with geographic influence.

7. The nature of the organization of economic processes within an area (spatial organization) results from the kinds of resources, the stage of technology, and the socio-political attitudes of the population.

8. The sequence of human activities and culture patterns is related to geographic location and accessibility and to the particular time in which human beings live. People in different stages of civilization react differently to similar environments.

An examination of the foregoing generalizations indicates that their level is not of a very high order. They express only the simplest relationships and many are no more than definitional statements.

In contrast to these low-level statements and generalizations, many of which are almost self-evident, there is a growing body of intermediate-level generalizations that have been based upon empirical research in urban geography. Note, for example the following statement by Morrill:

> Competition for land results in an ordering of land use from commercial, to multi-family, to single-family residential. . . . Commercial activity peaks at different locations, since business districts seek local markets to dominate.[22]

This statement is supported by a graph showing the ideal urban rent gradient for each land use, comparing land rental and distance from the CBD (see Fig. 8-3). Morrill uses a similar set of gradients or curves to show the effect of successive waves of urban expansion upon residential housing:

> As a place grows, single-family homes spread outward from a small commercial core. The inner, older homes become replaced by the growing commercial core, and a surrounding zone of apartments — the older of which may later be displaced by expanding commerce.[23]

The point we wish to make is this: in contrast to the relatively simple and almost self-evident statements presented earlier, these latter ones developed by Morrill are empirical generalizations. They are based upon quantifiable data. Statistical measures were used to determine the relationship of the concepts (or variables) involved. They lend themselves readily to verification and to replication in other settings.

GEOGRAPHY IN THE ELEMENTARY SCHOOLS

Geography has long been a part of the elementary school curriculum. Together with history, it was the mainstay of the social studies program. Geography has been taught in a variety of ways: as a separate discipline with its own textbook and separate content matter; as part of a multidisciplinary approach with

The making of contour maps can evoke interest in geographical studies as well as increase children's understanding of geographical generalizations. (Highline Public Schools, Seattle, Washington)

special emphasis upon geography at one or more grade levels; and as related knowledge in a broad, interdisciplinary study.

During the 1930's and 40's, it was not at all uncommon to find a sixth-grade class studying the geography of South America and at the same time the history of the medieval period of Europe, using different texts and sometimes even with a different teacher in a departmentalized kind of program. This program was due partly to state laws in some parts of the country, which required so many minutes of geography per week. During the 1950's, efforts were made to combine history and geography in what was variously described as a fused, correlated, integrated, or core program. Children might study the New England region, for example, looking at its historical and geographic aspects together. In the curriculum reform period of the 1960's, however, emphasis turned to geography as a separate discipline, and geographers and social studies educators gave increased attention to the improvement of geography education in the schools. This interest also caused the profession of geography to take stock of itself and to decide whether school programs would reflect the best of modern geography or to give up its traditionally pre-eminent place to the increasingly persistent demands of the other social science disciplines. As Kennamer[24] has noted, programs in school geography

tended to lag considerably behind the developments in the discipline, and many teachers were using materials and approaches such as the old environmental determinism, long since discarded or not representative of the current work of the geographers. In contrast to the flood of new curricular programs that emerged by the early 1970's in other social science disciplines, such as economics and anthropology, very few separate programs in geography were formulated. Instead, professional geographers often served as advisors or participants in some of the more broadly based inter- or multi-disciplinary programs that produced segments or units of study dealing with some aspect of geography. Such projects included The University of Minnesota Elementary Social Studies Program, the Social Science Program of the Educational Research Council of America (formerly known as the Greater Cleveland Social Science Program), and the Providence, Rhode Island, Social Studies Curriculum Project. In these projects geography served as a basic integrating discipline in grades K-8. Each of these programs developed units of study with key concepts and major generalizations from the discipline of geography to complement other aspects of a larger, more interdisciplinary approach.[25]

The single major geography project to be developed during this period was *The High School Geography Project* sponsored by the Association of American Geographers. The project developed a course for secondary school students composed of units that reflected the diverse aspects of geography, including *The Geography of Cities, Manufacturing and Agriculture, Cultural Geography, Political Geography, Habitat and Resources* and *Japan.*[26] These units are characterized by a wide variety of the social-inquiry, value-inquiry, and decision-making processes we have been describing in this book. Students are presented with many opportunities to gather data, make inferences, hypothesize, evaluate, and make realistic decisions in simulated policy-making settings. In addition, a wide variety of learning materials are used, including simulation games, transparencies, 35mm slides, and maps that can be formed in a variety of ways using lego-type parts that can be placed anywhere on the board. Regrettably, there is nothing comparable at the elementary school level, although some elementary teachers familiar with the HSGP have successfully adapted parts of it with different content materials for use with younger children.

Many of the newer social studies textbooks clearly show a departure from the older emphasis upon physical geography and strange, exotic lands. One textbook series for elementary schools written by professional geographers reflects a strong emphasis upon modern developments in geography with such titles as *Towns and Cities*, stressing urban geography; *Regions Around the World*, emphasizing the regional approach to geography; and *The United States and Canada*, combining both an urban geography and a regional approach to the study of these two countries.[27]

To summarize these recent developments, then, here are some of the characteristics of the "new geography" that readers might expect to find in current social studies programs. First, a more clearly defined conceptual approach to the study of the discipline with basic concepts, major generali-

Figure 8.5
Regional Studies

Geographic Tradition	Generalization	Grade Level
Earth Science	Regions can be distinguished according to physical characteristics.	Primary
Area Studies	People tend to locate within a region in those areas that offer potenital for supplying goods and services.	Intermediate
Man-Land	Man's perception of possible areas in which to settle is influenced by his culture and its level of technology.	Primary
Location Theory	Locations functioning as distributors of goods and services within a region are usually centrally located and are part of a hierarchical system with this function.	Upper
Historical Geography	Through time, functions of locations may change because of technological developments.	Intermediate

zations, and some tentative statements of theory spelled out in curriculum guides. Second, the inclusion of units of work that reflect newer emphases in geography such as urban studies, spatial organization, environmental perception, and comparative regional analysis. Correspondingly, there would be a reduced emphasis upon the traditional descriptive *regional geography* and world survey with its emphasis upon physical geography. Third, an increased multimedia approach, depending on maps, photos, census data, and field trips along with the preparation of exercises and problems that allow students to use the processes of social inquiry, valuing, and decision-making that we have stressed throughout this book.

INQUIRY AND DECISION-MAKING STRATEGIES FOR TEACHING GEOGRAPHY

Geographic traditions

Considering the diverse geographic traditions discussed in this chapter, an enlarged view of geographic studies can be seen to include the interactions of man, space, and time. Each of the traditions described, even though it has a special focus, may be used to add understanding to man's perceptions in another tradition.

In the exercises to follow, "Regional Studies" has been selected as the primary focus. From each of the five traditions, one generalization has been provided. (See Fig. 8.5). For each generalization, classroom activities are suggested for either primary, intermediate, or upper-grade levels. However, the format used could certainly be adapted to other levels.

Teaching strategies

The activities follow the basic pattern of the social inquiry, valuing, and decision-making strategies outlined in Chapters 2, 12, and 13 of this book. Two special approaches to the social inquiry strategies are used that are representative of the regional methods of the geographer. One is called the *analytic mode* or the systematic approach where students derive and use basic concepts such as *landforms, region,* or *central place* as the basis for the study of a region, one they will use for making comparative analyses with other regions of the world. The second is called an *integrative mode* or holistic approach where students study the total picture of one particular place like the "Mississippi Valley," the "Southwestern Desert Areas," "Our City," or "Fruit Orchards and Migrant Farm Workers." This integrative mode is essentially a case study approach in which the student attempts to bring many factors to bear in a comprehensive synthesis. This is typical of many of the regional studies done by geographers. These two approaches to the regional method of the geographer discussed on pages 265-267 are shown schematically in Fig. 8.2. The decision-making strategies involve the use of knowledge derived from the two modes of social inquiry, plus the identification and clarification of relevant values that may bear upon the formation of important decisions affecting a student's personal and public life. The decision-making process is sometimes called the policy mode of inquiry.[28] The two modes of social inquiry, analytic and integrative, and the decision-making strategies, are used in the set of sample lessons for each of the generalizations. The activities described below utilize these strategies because of our belief that social studies education builds on the knowledge of the social sciences and the clarification of people's values. This, then, is one way to help individuals act responsibly and rationally in their ecosystem.

PRIMARY GRADES: EARTH SCIENCES

Regions can be distinguished according to physical characteristics.

Analytic mode (concept – physical region)

1. Concept formation. The teacher shows students pictures of several different geographic regions (for example: tropical rain forests, deserts, tundra, Mediterranean regions, marine West Coast regions).

He asks: "What, in general, are we looking at? What is alike about all these pictures?" (The pictures are all places.) He goes on to ask,

"Are these places the same kind or different?" (Different)

"What makes you think they are different?" (They look different.)

"What are the differences?" (Hot, cold, dry, wet, plants, no plants.)

The teacher at this point could ask the students to provide a label, or name, for the kind of difference. To reinforce this new label, he could inform the

Figure 8.6

	Tropical	Tundra	Desert	Marine West Coast	(etc.)
Climate					
Vegetation					
Land forms					
Habitation					
Water sources					
(etc.)					

students that other people thought about this, and they called these kinds of differences "physical" differences in regions of the earth. The younger children could begin by discussing the physical regions and how they are physically different.

As the teacher and students discuss each region, the information they point out can be recorded in a data retrieval chart, such as the one shown in Fig. 8.6. This chart can be used to determine possible generalizations about regions.

2. Generalizing. The teacher might then ask for the students to state a generalization about regions by asking, "What can we say, in general, about regions?" (Regions vary greatly from one another in their physical characteristics.)

In this way students have come to an understanding of one criterion used in distinguishing regions, i.e., their physical appearance. The next mode, the integrative mode, will help students see one physical region as much as possible in its totality.

Integrative mode

(Select one example of a wet tropical forest for which materials will be available. Examples: Amazon Rain Forest, portions of the Hawaiian Islands, other tropical islands.)

1. Observing, inferring. The teacher shows one picture on the overhead projector. (Check your audio-visual department for color lift directions. This technique will allow you to transfer magazine pictures from the paper to transparent contact paper.) The teacher shows a picture of one specific wet tropical region, like the Amazon area, and asks, "What can we tell about this place from its picture?" (It probably rains a lot; it has a lot of plants and trees; there are probably only a few people there; there might be a big river there.) The teacher asks each student his reason for thinking that his idea is true and records the idea on the board.

2. Integrating. After they have done as much research and inferring as they can from the picture and from other sources like reference books, letters from people in the area, and stories about the area, the teacher asks, "What are the specific and special things that work together to make the Amazon region what it is?"

The integrative mode is designed so students perceive the totality of one particular place, people or time, as opposed to the analytic mode where students are focused on one aspect like regions, or land forms, or cultural adoptions. In a sense, the integrative mode is a kind of geographic case study of a region. This case study could be focused on one point in time and/or it could focus on one region throughout time. Both perspectives, the integrative and the analytic, build together to increase the student's knowledge of himself and the ecosystem of which he is a part.

Policy mode or decision-making

The usual focus of decision-making is a value-laden issue or problem that is particularly relevant to the children. An unfinished story, a role-playing situation in which a decision has to be made, or a real issue in the children's lives can be used to present the problem and its setting.

Step 1. The children have derived the generalization that regions can be distinguished by their physical differences. They have also focused on one specific place, perhaps the Amazon region, to view in as complete a way as possible, the integration of important aspects of that place. Now, for the policy mode, the teacher may present the students with a problem-solving situation in which a policy needs to be determined. This can be presented in the form of a role-playing situation where they as a group, and as individuals, need to decide whether or not they would like to live in the place they studied earlier. This would include determining what they would do for food and shelter and what they would need to take with them.

Step 2. The teacher could select a few children to be explorers or recent visitors of the new place. These children could dramatize how they visited the new place and what they did to find out all they could about it. They would then come back to the rest of the class and tell them all about the kind of region in general and the particular place they suggested for a new home, village, or town.

Step 3. When the total group knows what the first group found out, they can begin to discuss the possible choices they have and what the consequences of each might be. The teacher can enter into the dramatization by asking the whole group first, "What choices do you have?" (Some go, some stay; all go; all stay; some go first, others come later if it works out well.) Each of their responses can be listed on the board in the form of a chart, as shown in Fig. 8.7. The teacher then asks, "What would happen if you followed Alternative 1?" and so on through all the choices until the students think through the consequences of each choice. The teacher now gets at values by asking "What

Figure 8.7

Choices (or alternatives)	Results (or consequences)	Value Implied
1. Some people go.	1. Only a few would experience the new land.	1. Caution.
2. All go.	2. Everyone would experience the new land.	2. Exploration.
3. All stay.	3. No one would experience the new land.	3. Tradition, security.
4. Some go first, others come later.	4. Some would experience the new land, and if the situation worked out successfully, the rest would also experience it too.	4. Caution, but also new experiences.

things are most important to you?" "Can you explain why?" "Which choice would you make then if such and such were most important to you?"

Step 4. The children can individually decide now and communicate their choice and their reasons by drawing, painting, or building displays of their choice, or by writing their choice down, or by tape-recording their choice.

Step 5. After each child has made a choice, the children can dramatize the situation of a council making this decision for the group. One way this can be done is by a subgroup of the whole, while others observe, and later all can discuss how the subgroup handled their policy choice. If many subgroups can have a chance to try to handle the group decision, they can either do it one group at a time, or all subgroups can work on it simultaneously in different areas of the room. However the children tackle the problem, the important thing is that they observe themselves and others in a problem-solving situation. Their gaining skills in decision-making will be more successful if discussions are held about how people can work together in determining policies. Children need to have the capacity for self-observation and some way, such as an audio or video tape, to record their discussion. The teacher can ask the children, "What did people in our class do that helped everybody get closer to deciding what they wanted to do?" (Help point out specific problems, possible solutions, and consequences; listen to other people; explain their ideas clearly and as quickly as possible so that others could get a chance to take part.)

In the decision-making approach, children must practice the specific skills of problem-solving, whether by group or individually. Eventually each individual will be able to function as an active participant in his society, helping to make the policies. When decision-making follows the analytic and integrative modes, the children are not talking off the top of their heads, but do indeed have some knowledge upon which to determine and evaluate their possible solutions. In the higher grades the knowledge is more sophisticated and complete; however, the practice is particularly important in the primary grades

where the children are beginning to form patterns of behavior, one of the most important of which is how to handle decisions.

INTERMEDIATE GRADES: AREA STUDIES

Many people tend to locate within a region in those areas that offer potential for supplying goods and services.

Analytic mode (concept – goods and services)

The purpose of this activity is to help children to determine the needs people have, i.e., goods and services, and to develop the idea that these needs affect where people locate within a region.

1. Concept formation. Ask the children what things are necessary to their way of life. List their responses on the board. Then have them group these things. Use a star for one group, an "x" for another and so on. They might have several groups when they have finished. Then ask them to group the groups they have made until everything is separated into two groups that lend themselves to the headings "goods" or "services." The children might call the groups by other names, like "objects" and "things people do." Suggest to them that other people have tended to use the words "goods" and "services" for those two categories.

2. Data collection – goods. Now ask the children where people got these goods a hundred years ago. Ask them also where they think the goods were originally made at that time. The last of this sequence of questions would be, "How were the goods brought to wherever the people were who bought them?"

3. Data collection – services. Have the class look at the services. Ask, "Are there any that come from somewhere else?" Some, like mail come from outside the area. Others, like fire and police protection, are within the area. Ask the class, "How did these services get to the people who wanted them?"

4. Generalizing. The responses from both Items 2 and 3 above can be written on the board. These, then, were an important part of the means of supplying goods and services one hundred years ago.

The teacher can help the students keep track of the information they collect here by use of a data retrieval chart such as the one shown in Fig. 8.8. Ask the following sequence of questions to lead students to generalize that (1) people have needs, (2) that it often requires transportation to get these needs satisfied, and (3) that people tend to locate in regions that offer potential for supplying their needs.

"What can we say about people's needs and how what they need gets to them?" (What people need must be available or be transported to them.)

Figure 8.8

	Goods	Services
Boat		
Foot		
Telegraph		
Horse		
Wagon		

"Since people need things that must be transported to them, where in a region do you think people would locate?" (Where it's easy to deliver things.)

"Think back a hundred years. What kinds of places were easily reached? (Places on rivers and on the coast.)

The teacher now encourages the students to make hypotheses about where people might locate, referring to the area shown on the map in Fig. 8.9, which represents one region of the United States in 1840. After each student indicates on his copy of the map where he thinks a half-dozen, say, towns will grow and/or continue to grow, the teacher will ask the students to explain their choices. Then, to check out their hypotheses, the teacher shows the map in Fig. 8.10 on the overhead projector. This second map presents the same region as it had grown by 1890, fifty years later. The teacher then asks how well the students' hypotheses explained the way the towns did develop.

Integrative mode (topic – a specific port town)

The purpose of this activity is to focus on one specific region and observe the role of its river in determining where people settle. The teacher can use Memphis, Minneapolis, St. Louis, Detroit, Pittsburg, or whatever example for which materials are available.

Note also, that for this particular set of activities the teacher might decide to deal with the integrative mode first, before dealing with the analytic mode. A rationale for this might be that the students have a weak background in some of the concepts upon which the generalization depends. By beginning with the integrative mode, a case study, the students will increase their familiarity with the concepts before needing to deal with them in a more abstract form.

In focusing on this river town, whichever one is studied, the students will observe how people can get goods and services more easily because of the river. They will observe the complete integration of the lives of the people and their needs with the role of the river.

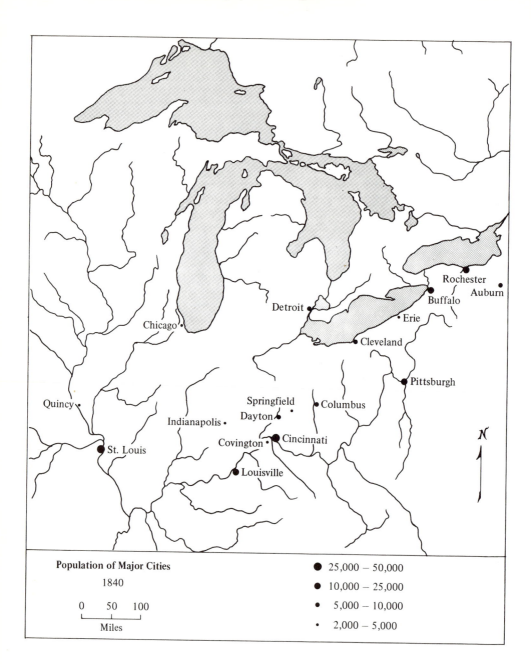

Figure 8.9
From *Geography of Cities,* Unit 1, "City Location and Growth." New York: Macmillan, 1970, p. 6. Reprinted with permission.

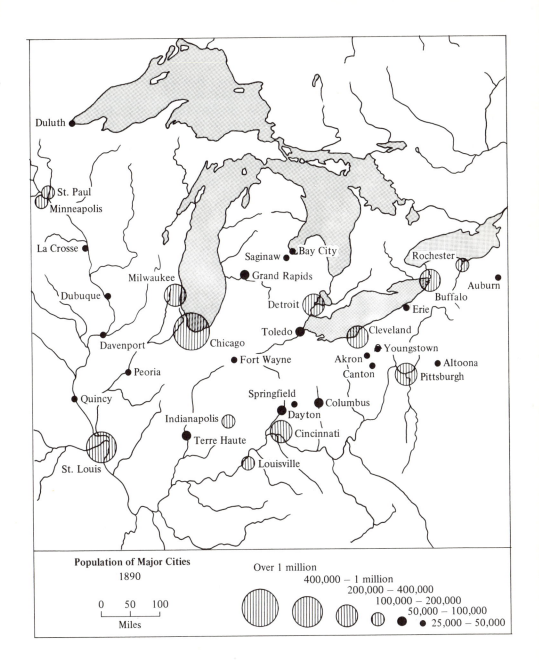

Figure 8.10
From *Geography of Cities,* Unit 1, "City Location and Growth." New York: Macmillan, 1970, p. 8. Reprinted with permission.

1. Concept diagnosis. The first objective for the students is to determine topics on which they want information about the city in question. The teacher might ask, "What kinds of information do you think you should have about the city, based on what you know about cities in general and about this city in particular?" These categories of knowledge can function as areas for committee research and for labels on a data retrieval chart to be constructed.

2. Data collection. The teacher can then assist the students in recording their data on a chart so that they can utilize it in generating hypotheses about the way the parts of the city are integrated (see Fig. 8.11).

Figure 8.11

	Education	Agriculture	Technology	Food	Shelter	Clothing	Entertainment
City A							
City B							

3. Generalizing. The third stage of this investigation about a particular city is the discussion of patterns that seem to appear in the data retrieval chart. The teacher asks whether the students see any patterns about the way things work together, and the whole class evaluates the possibility of patterns and the implications each pattern might have for the whole city or for individual parts of it. In free-flowing ways they can explore the values involved in the pattern.

Policy mode or decision-making

1. Definition of problem. This strategy follows quite naturally from gathering data regarding one particular city and from observing the relationships between people, goods and services, and regions. The purpose here, as it is in geography in general, is to understand the interactions of man, space, and time. In this instance the teacher may present to the class a specific problem related to the way man values the existing relationships of man and space and time. For example, the problem could be, "Given that man has overcome his dependence on river transportation and considering the level of technology that exists today, what are the best ways he can plan locations of future cities?"

2. Proposing solutions – value clarification. Once the problem has been defined, the teacher can structure the class in some way of large and/or small groups, or can allow the class to form its own structure in tackling the problem. By the intermediate grades, if the valuing process has been used before by the teacher, the students can go through the steps on their own and only later resume in a larger group to discuss their chosen solutions. For classes that are going through this process for the first time the teacher could ask "What are the possible alternatives available?" These could be listed vertically under the label. "Alternatives." The teacher could then ask "What would the consequences be for each alternative suggested?" and some beginning ideas could be sketched out.

This kind of problem is open enough so that each student can approach it on a level of sophistication that is appropriate to him. Some individuals might want to research carefully the alternatives and probable consequences; others might wish to use whatever information they have available at the time. The only requirement is that the individual think through alternatives and consequences, and be able to provide a rationale for his choice or lack of choice.

There is serious question in the decision-making strategy as to whether or not, even for purposes of evaluating and of diagnosing, a student should *have to* communicate every value and choice he makes. In other situations communication skills are visible, situations, for example in which a student expresses a value held by someone else, a character in a story or a person in current events. Teachers need to exercise discretion in asking students to express their values publicly when these values involve very personal religious, moral, or political feelings. See Chapter 12 for a further discussion of teaching value lessons.

PRIMARY GRADES: SPACE-MAN-LAND

Man's perception of possible areas in which to settle is influenced by his culture and its level of technology.

Analytic mode (concept — cultural values)

The purpose of this activity is to lead students to make the generalization above, starting with the concept of cultural values. By comparing cultures that are based on different levels of technologies, the student will realize that if you have a different set of values, you might make a different choice; and secondly, that if you know what someone values, you would be better able to predict what choice he is likely to make.

1. Concept formation. "What are some things you like or need?" These could be written on the board on one side. Now the teacher could ask, "What are some things you don't care about or don't need?" These too would be written on the board on the other side. Now the teacher could ask, "What do we call these things?" and point to one side. After doing this also for the other side the students might supply labels like "good/bad" "like/dislike" "need/don't need." The teacher might slip in the word "value" when he says "like" in the discussion that follows.

2. Generalizing. The teacher could point out to the students that some of the things one person likes, the whole group likes, but that some of the things one person likes, only that person likes. The teacher can do this by asking a number of children, one at a time, what things he likes and checking with the class to see if they as a group also like the thing he likes. The teacher can repeat the generalization and use the terms "group likes" for some things and "individual likes" for other things, pointing to the appropriate things as they were listed on the board.

3. Observing and inferring. The teacher might then present pictures that show different subsistence patterns, for example, for hunters, gatherers, farmers, herders, factory workers, computer programmers, and so forth (service people). The teacher asks the children to describe what the people are doing. Then he asks what tools, clothing, homes, etc., the people might expect to have.

4. Classifying. When all the important things that the people need are on the board, the teacher might ask which one is most important to the man in the first picture. The teacher could list all the things that the children think might be important to that man because of the way he lives and provides his food and shelter. Then the teacher could ask the students to try to determine which things were "individual likes" and which things everyone in his group would probably like since they live under circumstances similar to the ones under which he lives. This activity could be carried on as long as it seems to be providing practice for the students in applying the concept of group likes.

For some children, the teacher could begin to refer to "group likes" as "group values." After some use of the word "culture" interchangeably with "group" the teacher could have a discussion with the students to compare the word "culture" and the word "group." Finally, then, the students would have derived the concept of "cultural value" and have become familiar with that label for it.

5. Generalizing. The children should study men from several different cultures to determine which things would be "individual values" they might have and which things might be "group" or "cultural" values. Then the children should be able to form two generalizations: First, that all peoples have similar needs that they may satisfy in different ways; and secondly, that because any one group may satisfy its needs in a different way, the members of the group may come to value different things than those of another group. The teacher can help students apply this generalization by asking them where each type of culture might choose to live. For example, the factory worker who makes televisions might choose to live in a region where the dirt on the ground is sandy (like near a beach), or where there is not very much rain. But the farmer would choose to live where the dirt has no sand and where there is a lot of rain. The teacher could ask questions like "Where would the man who gathers nuts and plants to eat want to live? Where would the man who hunts like to live?"

Integrative mode (topic: a gathering or herding culture)

The purpose of this activity is to demonstrate the whole totality of cultural interaction with an environment. The topic can be any cultural group for which materials are available; however, the purpose is best accomplished if the culture selected value living in an environment different from the one the children live in. For that reason a gathering or a herding culture is recommended. (An example of a possible culture to use is that of the Eskimo fishermen in Alaska.)

1. Inferring. The teacher might ask the students what they think would be important for them to know about Eskimos. They might respond that they

would like to know about their food, igloos, and their clothes. The teacher can help them think of more categories by asking "What do we know about where they live?" When the students are not sure, the teacher or other student might suggest they add "place they live" to the list.

2. Observing – inferring. Through children's stories, films, and pictures, the teacher can guide the children in finding out all they can about Eskimos. He can ask questions about an Eskimo carving in whalebone, like "What can you tell about Eskimos from their art work?" He can ask questions about how the Eskimos keep warm, and he can hold up pictures with examples or read stories that explain how. Each time more information is found it can be added to the data retrieval chart.

3. Generalizing. After looking at the chart that has verbal information and pictures, the students can be asked by the teacher to tell how the Eskimo has been able to adapt to such a cold place. As more and more reasons are suggested, the students should be able to derive the generalization that different cultures value different physical environments, and that environment can be affected by the way in which the people provide their food.

Policy mode or decision-making

The purpose of the decision-making activities here is to use the information about how other cultures may value different regions in different ways than we do in a decision-making situation.

1. Defining the problem. The teacher can suggest to the class that since they now have a greater understanding of how different cultures value regions in different ways, he wonders what they would do if two cultures wanted the same region for different reasons?

The setting might be a White House Conference where Indians from the Taos Pueblo request from the United States Government a region that has religious importance to their people. The 48,000 acres lie north of Taos in New Mexico. A group of white "Anglos" want it to develop open-pit copper mining interests. The class divides into two groups representing these cultural groups.

2. Exploring values and proposing solutions. The teacher can help both the groups clarify their own values by having each list their alternatives, and then secondly, the consequences of each alternative in a chart like that used in the Primary Grade decision-making on the topic in Earth Sciences. (See Fig. 8.7).

3. Making decisions. After some discussion of the alternatives and consequences that are thought of by each group, the two groups can try to negotiate and agree on one alternative. It might be better if two small groups negotiate with some opportunity to discuss within their own group just what they want to say each time. The rest of the class might observe and be ready to discuss the methods people used to help negotiations, some possible things that hurt the negotiations, and some suggestions for better ways to negotiate.

A second group can try their hand at negotiating, and comparisons can be made between the two. The teacher might ask if observing the first group and

hearing the discussion helped the second group in their negotiation. A third group could go to the library after the first session, so they wouldn't hear the discussion that may have helped the second group. The third group could then try their hand at negotiating, and the teacher could ask again if students thought the discussion helped the second group. (Tapes can be made of each attempt to negotiate so that points that come up in the discussion can be checked.) In this way not only do the students attempt to determine a policy, but they also get a chance to experiment and learn about how people can best learn negotiation skills. (Preferably, the students could set up their own experiments the next time they want to check something out.)

UPPER GRADES: LOCATIONAL THEORY

Locations functioning as distributors of goods and services within a region are usually centrally located and are part of a hierarchical system with this function.

Analytic mode (concept – central place)

1. Concept formation. The teacher could begin by asking the students to think of their own city and to imagine where they would go to get the following items: toothbrush, apple, chair, car, tractor, computer. (The first two things might be easy to buy on the local business street near your home. The chair and car might be in the central business district, and the tractor and the computer would probably need to be bought in another city.)

The teacher asks next, "What patterns do you see in this information?" (The common things can be bought closer to where you live and the larger, more unusual items need to be bought farther from where you live, more towards the central area of the city or even in another larger city.)

2. Generalizing. Now that the students perceive the pattern, the teacher suggests, "Let's see how this same pattern might work with the function, size, and location of cities in a region." The students might hypothesize that this same pattern is also found in the location of cities, from large cities to small villages. The common items can be purchased in the small villages, the middle ones in the towns, and the large, unusual items can be bought only in the large cities. The teacher could ask here, "What do you call that when you rank something from small to large?" (A hierarchy)

3. Inferring – generalizing. The teacher moves on from the idea of a hierarchy to the implications of that hierarchical size order. To help the students visualize and verify the relationships of cities in the pattern, the teacher could bring out three telephone books from cities of three different sizes and ask, "What can you determine about each place by just looking at the size of the phone book or at the yellow pages of the phone book?" (The larger the population, the larger the selection of goods and services. Also, the smaller places are probably close enough to a larger one so that people would go to the larger one for the special, less frequently purchased items.)

4. Observing. For the next activity the students locate the nearby cities on a state map. They can use short dowels or rods. Place a thumb tack up from the underside of the map on the locations of the nearby cities and towns. Then use the graduated rods to indicate population, the longest being the largest population. Push each rod down onto the point of the tack. If the map is placed on cardboard first and taped down on the floor with masking tape, the rods should hold.

5. Generalizing. The students should be able to observe that the largest cities are centrally located and that the smaller towns and villages are "nested" within the hierarchy. The teacher could ask, "Now that we can see the location and the population of these cities at the same time, what pattern do you see in this region? What would you infer would be the routines of daily life in these cities? How much interaction of people from other cities would you expect? Do you think any of these places have specialized functions? How can you find out?"

In these activities the students have formulated the hypothesis that larger cities provide a larger selection of goods and services. They have focussed on one particular region to see whether their hypothesis held, and it did, at least in that one region. They can't generalize very well from their limited example, but they have seen at least one example close-up of the pattern of city sizes, functions, and locations in a Central Place scheme.

Policy mode and decision-making

1. Defining the problem. The teacher could ask the students to imagine themselves as members of an Urban Planning Commission. It is their task, the teacher informs them, to determine the policy for the development of some spill-over towns that will receive the extra population that is still coming into the central place city. Their funds are unlimited. Their opportunity is, therefore, to develop an ideal model of a community or community network, that has natural beauty and potential for fairly large size if they want it that way. What will they choose to develop? What will it look like? But most importantly, how will it be related to other cities in the central place hierarchy if it can be related in any way the board chooses?

2. Proposing solutions. The teacher can suggest they determine the possible alternatives, the consequences of each by reading about New Town Development projects in the United States and in the United Kingdom (Glasgow and London) before they determine their policy. The class can break up into small boards that each take on the assignment, or different members of the class can simulate the positions different political figures (public and private) might take in a situation of this kind. There could be large contractors who want to build elaborate high-rise condominiums, and there could be minority leaders who propose the new housing in the community be scaled to stay within the reach of the lower classes. There are industrial tycoons who wish to buy or lease land for tremendous industrial parks. In addition, there are representatives from all modes of transportation who are eager to obtain a monopoly in that area. A

shopping center corporation is hoping for a large tract to develop. Some private people get into the act, also. One group wants pedestrian ways inside the community where motor vehicles are excluded. This group wants the motor vehicle roads to be limited to the outer fringes of the community. Another small private group wants large areas to be left in their natural state – they're afraid the suburbs from the central place area will grow out to the new complex within 30 years, resulting in solid concrete several thousand square acres wide.

3. Making decisions. In order to win this simulation game the board has to satisfy more of the constituents of the region than any of the other boards who are attempting to determine policy for the new development. The other boards are those who play the simulation game during the same time period as the first.

One thing to watch for as strategies are evaluated is whether the newer boards learn better ways to handle their responsibility. Better is defined again as satisfying more people than the record winning number from all remembered previous games played by members of the same class within one semester.

INTERMEDIATE GRADES: HISTORICAL GEOGRAPHY

Through time, functions of locations may change because of technological developments.

Analytic mode (concept – technological development)

The purpose of this activity is to help students derive the concept of technological development and the generalization that through time these developments can significantly change the functions of locations.

1. Observing – inferring. The teacher might show pictures of regions with different levels of technological development. One might show a factory, another a farm tractor, another a mine train, another a NASA base, and another of stores and transportation systems in an urban area.

2. Generalizing. From these pictures the teacher could ask, "What can you tell about the use of machinery in industry and in agriculture in these regions?" (Different regions have different amounts of machinery.) The teacher can say this, utilizing the concept to be developed, "Was there a difference in the level of technology in the different regions, then?"

3. Classifying. The next question could be, "What kinds of technological stages can be seen if you divide the pictures into categories to represent each stage?" "What relationship exists among the different stages?" "For example, is it possible for a region to change from one stage to another?" "What might be the conditions where a region might change?"

4. After helping clarify the relationships among the stages, the teacher might ask, "What effects might occur in a region if a new machine were invented to fly individuals without a plane, given that this region had an oversupply of

labor and that some company had capital to invest?" In this way the students would be able to derive the generalization that technological development can change the functions of a region.

Integrative mode

The purpose of this activity is to demonstrate the interrelationships involved in, first, the knowledge that oil existed in Alaska, and second, that technology has begun to reach the point where the oil could be piped to the mainland.

1. Gathering information and inferring. First have the students skim encyclopedias and library books describing Alaska as it has been for the last fifty years. Have them determine what kind of information would be most relevant to them for understanding the various factors related to the physical, economical, social, historical, ecological, and political situation of Alaska.

2. Classifying data. Use the model of a data retrieval chart in previous activities in the integrative mode, and have the students set up the chart according to the categories about which they want information. (See whether students begin to use these charts more or less on their own.)

3. Integrating. Have the students use the data retrieval chart to determine the interactions of factors that have made Alaska the unique place that it is. Ask what patterns of interactions they see.

4. Inferring. Add the dimension that exists today to the dimensions the students have recorded, the knowledge that technology is at the point where piping the oil out of Alaska seems feasible. Ask the students how this might change the function of Alaska from what it has been for the last fifty years. Have the students research this new dimension, including the technical and ecological problems, and add the new material to their charts.

Policy mode and decision-making

The function of this activity is to have students focus on the ecological issues involved in the removal of oil from Alaska.

1. Defining the problem. Have the students simulate the various positions that private and public political figures represent on the ecological issues involved in the oil in Alaska.

Present the following problem to the students who represent the oil concerns:

> There is a new technique for reducing the chance that pipes might split due to the cold temperatures of the tundra, or that pipes might sink because of the heat the pipes radiate. This method requires two extra outer pipelines and various fluids that flow between the layers of pipes inside pipes. However, this new technique tremendously increases the cost of the oil extraction. Ask the person or the group representing the oil companies to research this possibility and determine a policy regarding it.

2. *Gathering data and making decisions.* Present the following problem:

Describe some of the ecological hazards and likely problems, for example, that animals might swarm around pipes that would be carried above ground for the warmth the pipes radiate. Evaluate the economic benefit that would accrue if the oil were extracted. Just suggest these positive and negative aspects. Have the students divide up to locate more detailed information, and then let them take a stand one way or the other in debates which will be taped. Carefully analyze all the tapes and ask the students what arguments were most effective, and what behaviors of the debaters facilitated decision-making or jeopardized the possibility of agreement.

SUMMARY

In this chapter we considered the role of the geographer and the five traditions of his discipline: physical, spatial, cultural, regional, and historical. We examined the place of geography among the social sciences and saw that it ranged widely in the continuum, close to the physical sciences at one end, and close to the humanities at the other. The regional method was seen as the principal research method of the geographer. It was approached in two quite different ways, the broad area study and the topical or systematic approach. In practice, however the geographer actually uses both approaches. Quantitative methods and the use of maps, globes, and special cartographic projections constitute the special techniques and tools of research.

In discussing geography as a generalizing discipline, we pointed out that the geographer, perhaps because of the nature of his discipline, has tended to concentrate more upon individual studies than upon the development of general laws or theory. Out of these extensive studies of individual regions of the earth have come a large body of concepts, a group of generalizations of somewhat restricted application (mostly at the regional level), and a comparatively small body of theory. Three of these theories were discussed briefly: location theory, central place theory, and spatial structure and organization. A large number of concepts selected from the general area of urban geography were discussed in detail. Some of these were chosen along with a set of generalizations, and a detailed exposition was given as to how they could be taught in the primary, intermediate, and upper grades. They were organized within a pattern of the five traditions of geography discussed at the start of the chapter, and utilized the teaching strategies of social science inquiry, valuing, and decision-making developed in this book.

DISCUSSION QUESTIONS AND EXERCISES

1. Summarize briefly each of the five traditions in the discipline of geography, and show how each contributes to the study of place and space. How can each tradition be reflected in elementary school geography?

2. Compared with the other social science disciplines, geography has many concepts, comparatively few high-order generalizations, and only a very limited body of theory. How can you explain this situation?

3. What are the methods of investigation of the geographer? How do they lend themselves to developing empirical generalizations? What limitations are involved?

4. Geography has held, along with history, a predominant place in the social studies curriculum. What changes have occurred in the past decade that may change that situation?

5. Examine a social studies curriculum in a local school district. Does it reflect evidence of some of the newer trends in the development of geography education described in this chapter? In what areas is it deficient?

6. Look over a sampling of social studies textbooks from a local school district. What place is given to geography? What emphasis within geography does it reflect? To what extent does it provide materials for social inquiry, valuing, and decision-making as suggested in the activities accompanying this chapter?

7. Identify briefly each of the following terms and explain their meaning in the discipline of geography.

a) physical geography

b) regional geography

c) cultural geography

d) man-land tradition

e) spatial geography

f) historical geography

g) the regional method

h) megalopolis

i) location theory

j) central place theory

k) spatial structure theory

l) cartography

m) projection

n) site

o) situation

p) environment

q) spatial interaction

r) circulation

s) sphere of influence

t) central place

u) urban sprawl

v) central business district

w) social variation

z) cultural diffusion

y) ecological system

z) environmental perception

FOOTNOTES

1. Phillip Bacon, "Changing Aspects of Geography and the Elementary Curriculum," *Social Education* **31**: 609-611, Nov., 1967.

2. The first four are adapted from William D. Pattison, "The Four Traditions of Geography," *Journal of Geography*, **63**: 211-216, 1964. The fifth tradition, historical

geography, is adapted from Phillip Bacon, "An Approach to Social Studies Through Historical Geography," in *New Viewpoints in Geography*, Preston E. James (Ed.), *29th Yearbook*. Washington, D.C.: National Council for the Social Studies, 1959, pp. 144-161.

3. Derwent S. Whittlesey, "The Regional Concept and the Regional Method," in P.E. James and C.F. Jones, (Eds.), *American Geography: Inventory and Prospect*. Syracuse: Syracuse Univ. Press, 1954, pp.20-21.

4. Preston James, "Geography" in Gordon B. Turner (Ed.), *The Social Studies and the Social Sciences*. New York: Harcourt, Brace and World, 1962, p. 48.

5. See especially George W. Casey, "Systems, Model Building, and Quantitative Methods," in *Focus on Geography*, Phillip Bacon, (Ed.), 40th Yearbook, National Council for the Social Studies. Washington: The Council, 1970, pp. 173-196.

6. Phillip Bacon, *op. cit.*, p. 150.

7. Bernard Berelson and Gary A. Steiner, *Human Behavior* (Shorter edition). New York: Harcourt, Brace and World, 1967, pp. 6-7.

8. Jan. O.M. Broek, *Geography: Its Scope and Spirit*, Social Science Seminar Series, R.H. Muessig and V.R. Rogers, (Eds.), Columbus: Charles H. Merrill, 1965, p. 78.

9. *Ibid.*, p. 79.

10. For an excellent discussion of these problems see Wellman Chamberlin, *The Round Earth on Flat Paper: Map Projections Used by Cartographers*. Washington, D.C.: National Geographic Society, 1950.

11. For a brief introduction to the uses of some of these techniques, see George W. Casey, "Systems, Model Building, and Quantitative Methods," in *Focus on Geography*, Phillip Bacon (Ed.), 40th Yearbook, National Council for the Social Studies. Washington: The Council, 1970, 173-196.

12. Richard Hartshorne, *Perspectives on the Nature of Geography*. Chicago: Rand McNally, 1959, p. 147.

13. The discussion which follows was adapted from Hartshorne, *op. cit.*, pp. 149-53.

14. Hartshorne, *op. cit.*, p. 148.

15. George W. Casey, "Systems, Model Building, and Quantitative Methods," *op. cit.*, p. 193.

16. Walter Christaller, *Die Zentrallen Örte in Süddeutchland*. Jena: 1933. Translated as *Central Places in Southern Germany* by Carlisle W. Baskin. Englewood Cliffs, N.J.: Prentice Hall, 1966.

17. For a good statement of Central Place theory's usage in urban geography see Richard L. Morrill, "Towns as Central Places," in his book, *"The Spatial Organization of Society*. Belmont, Calif., Wadsworth, 1970, Chap. 4.

18. Jean Gottman, *Megalopolis: The Urbanized Northeastern Seaboard of the United States*. Cambridge, Mass.: M.I.T. Press, 1961, p. 26.

19. Larry Ford, "Geographic Factors in the Origin, Evolution, and Diffusion of Rock and Roll Music," *J. Geography*, **70**: 455-464, November, 1971.

20. For an excellent review of this new field, see Thomas F. Saarinen, "Environmental Perception," in *Focus on Geography: Key Concepts and Teaching Strategies*, Phillip Bacon (Ed.), 40th Yearbook. Washington: Natl. Council for the Social Studies, 1970, pp. 63-99. Saarinen provides many practical examples and activities for the classroom teacher.

21. Selected from State Curriculum Commission, Social Studies Framework for the Public Schools of California. Sacramento: Calif. State Dept. of Educ., 1962. Reprinted with permission.

22. Morrill, Richard L., *The Spatial Organization of Society*. Belmont, Calif.: Wadsworth, 1970, p. 165.

23. *Ibid.*, p. 173.

24. Lorrin Kennamer, Jr., "Emerging Social Studies Curricula: Implications for Geography," in *Focus on Geography*, Phillip Bacon (Ed.), 40th Yearbook. Washington: Natl. Council for the Social Studies, 1970, pp. 379-405.

25. For a comprehensive review of these and other projects, see Norris M. Sanders and Marlin L. Tanck, "A Critical Appraisal of Twenty-Six National Social Studies Projects," *Social Education*, April, 1970, **34**: 383-449.

26. A number of these units have been published under the title *Geography for an Urban Age*. New York: Macmillan, 1969. Others are available from the Association of American Geographers.

27. Ronald R. Boyce and Phillip Bacon, *Towns and Cities*; Phillip Bacon, *Regions Around the World*; William B. Conroy, Phillip Bacon, and Ronald R. Boyce, *The United States and Canada*. All are from the Field Social Studies Program, San Francisco: Field Educational Publications, 1970.

28. The terms "analytic mode," "integrative mode," and "policy making mode" are adapted from the work of John U. Michaelis, chairman, Statewide Social Science Study Committee. Proposed K-12 *Social Sciences Education Framework*. Report to the Curriculum Commission and the State Board of Education. Sacramento: State Dept. of Education, October, 1968.

POLITICAL SCIENCE: STRUCTURE, CONCEPTS, AND STRATEGIES

THE NATURE OF POLITICAL SCIENCE

We can often characterize a behavioral science by describing its unique perspective and organizing concepts. We described sociology as the study of human *groups* and anthropology as the study of *culture*. It is difficult to define the nature of political science by describing either its perspective or key concepts, because there are many different types of political scientists. They ask very different kinds of questions, have different research aims, and employ a wide variety of key concepts. Any attempt to identify *the* structure of political science would be futile because of the diverse approaches within the discipline.

However, we can legitimately ask, "What elements unite the diverse approaches which make up political science?" The answer to this question can vary greatly, depending upon the orientation of the political scientist asked. The way that the nature of the discipline is viewed varies as much as the methods and concepts within it.

A number of political scientists define the discipline as the study of the *legal government of the state*. Charles S. Hyneman writes, "The central point of attention in American political science . . . is that part of the affairs of the state which centers in government, and that part of government which speaks through law."[1] This view of the discipline is rejected by those political scientists who claim that it is too confining because it does not reflect the fact that political scientists study many informal groups and processes (such as interest groups, lobbying, bargaining, and logrolling) which are not a part of legal government. Another problem with this statement is that there are many different definitions of the *state*. One writer has noted 145 in the literature.[2]

Some political scientists describe the discipline as the study of *the struggle of competing groups for power*. Watkins writes, "The proper study of political science is not the study of the state or of any other specific institutional complex, but the investigation of all associations insofar as they can be shown to exemplify the problem of power."[3] Like the concept of the state, *power* is variously defined, and thus the boundaries of the discipline are not clearly specified by this concept. The *power* definition is unacceptable to many political scientists because they feel that it does not specify unique behavior for them to study, since power exists in all institutions. "The definition is too broad, for political science is not interested in the power relations of a gang or a family or church group."[4] While this definition is in one sense too inclusive, it is also too restrictive because "Political life does not consist exclusively of a struggle for [power] . . ."[5] Although the *power* definition has not been universally accepted within the discipline, it is quite popular and is endorsed by many political scientists. Two of its most eminent proponents are Harold Lasswell and George E.G. Catlin.

One of the most acclaimed definitions of political science was formulated by David Easton, a leading political theorist. Easton defines political science as the "study of the authoritative allocation of values for a society."[6] He suggests that men have competing values, demands, and aspirations which they would like to become a part of public policy and enforced in society. The political system is the process by which men decide which demands and goals will become public policy.[7] Such a system prevents struggles between competing individuals and groups that would disrupt society. For example, some individuals and groups are violently opposed to abortion; others strongly support it. The political system provides a means for deciding which policy toward abortion a state will enforce and regard as law. During the 1960's and 1970's, abortion was legalized in a number of states. In the states in which it has been legalized, those groups opposing abortion have accepted the state's legal policy, even though they may never personally become involved in abortion programs.

Easton has developed a theory related to his conception of the nature of political science, called the *systems approach*. We will later briefly review this approach to political science. Writes Easton:

> Every society provides some mechanisms, however rudimentary they may be, for authoritatively resolving differences about the ends that are to be pursued, that is, for deciding who is to get what there is of the desirable things. An authoritative allocation of some values is unavoidable. . . . A policy is authoritative when the people to whom it is intended to apply or who are affected by it consider that they must or ought to obey it.[8]

Easton's definition delineates the boundaries of the discipline more clearly than do the *state* and *power* concepts. Using it, the scientist studies *all* the processes by which competing goals and demands are resolved into public policy, and does not study just legal government or formal institutions. For example, if a researcher were trying to determine how the Civil Rights Bill of 1964 was passed, he would not merely study the formal ways by which the bill

became law, but would study the informal acts that influenced its passage, such as the lobbying, logrolling, filibustering, and demonstrations which took place. Easton's definition is more precise than the *power* concept; it does not suggest that the political scientist study *all* competing goals and values within a society, but only those which are enforced by legitimate public authorities. Like all conceptualizations of the discipline, it has not escaped criticism:

> Some political scientists find Easton's position unclear, saying they do not understand what he meant to identify in his statement that political science is the study of "authoritative allocation of values for a society." Others who think they understand him differ as to whether Easton only offers a new statement of just what political science has been for a considerable time, the study of legal governments, or whether Easton proposes an extension of the area of attention to matters not previously within the assignment of political scientists.[9]

The definitions of political science which we have reviewed (the study of the legal government of the state, the struggle for power, and the authoritative allocation of values for a society) reflect the diversity of methods and approaches which are germane to the discipline. While all these definitions have competed for acceptance within the profession, each has been only partially accepted. Although all of them have found a place within the discipline, none reigns supreme. What Sorauf has said about various approaches to the study of politics is equally true of definitions:

> . . . in the skirmishes within political science there have been neither victors nor vanquished. As new approaches have appeared, they have been absorbed into the discipline without expelling or displacing any of the older traditions or approaches. Consequently, political science became an amalgam of different and often conflicting approaches to the study of politics.[10]

A discussion of some of the main approaches and orientations will illuminate the diversity of aims and methods which exist within political science.

APPROACHES IN POLITICAL SCIENCE

The normative approach

The first political scientists were armchair theorists who were primarily concerned with describing the ideal political system, one that would result in the best possible life for man. These theorists were mainly interested in value questions, such as "What should be the proper political system?" rather than empirical questions. They considered themselves philosophers and attempted to advise political leaders and to influence public policy. Political philosophy (as this approach is sometimes called) is still a viable part of modern political science. The goal of political philosophy is quite different from the goal of empirical science, which is to describe institutions and behavior, and not to

judge and make prescriptions. A large part of political philosophy consists of the examination of the ideas of the great political thinkers such as Aristotle, Plato, Locke, and Marx. These theorists are studied in order to derive ideas about the best type of political system.

Political philosophy is sometimes called *political theory*. The proponents of this method are quite critical of more empirical trends in the discipline. They feel that such approaches tend to ignore value questions – the most important questions facing man – and to study trivial, narrow questions whose answers will not contribute to the improvement of man's life. However, empirical political scientists do not ignore value questions, but instead study values by *describing* them just as they do other behavior. They attempt to avoid advocating certain values or forms of government as the *best* for society.

The legal-institutional approach

The first professors of political science were members of law faculties; thus a strong legal tradition has existed within political science since it first emerged. In this approach, an attempt is made to understand a political system primarily by describing and analyzing the laws, codes, constitutions, and other documents that are a part of legal government. In order to discover the functions of the legislative, executive, and judicial branches of American government, for example, the legalist studies the American Constitution.

The institutional approach, closely related to the legal method, concentrates on describing the functions of various governmental bodies and officials, such as the roles of judges, jurors, and the Congress. The roles of formal institutions are described in great detail, but little attention is given to the individual voter, the personalities of leaders, or to informal political institutions, such as interest groups and other organized lobbyists.

While many insights can be gained about a political system by studying its legal codes and formal institutions, the information which can be gained from this approach is greatly limited because laws are variously interpreted by different authorities and in different time periods. Also, the effect on the political system of informal groups and the personalities of political leaders is as great – if not greater – than the effect of formal codes and institutions. It is true that the Constitution greatly influences the roles that the Supreme Court and the President play in the shaping of public policy. However, the Supreme Court of 1896 (in the Plessy vs. Ferguson case) interpreted the meaning of the Fourteenth Amendment quite differently than the Supreme Court of 1954, which ruled that school segregation is "inherently unequal" (segregation was upheld in the 1896 decision). The legal powers of the President were no different in the 1930's than they were in the 1950's, but Franklin D. Roosevelt exercised much more executive power than Dwight D. Eisenhower. An approach which largely ignores the role of individuals and personalities in the shaping of public policy – as this approach tends to do – cannot provide an intelligent and sophisticated understanding of how a political system actually works.

The legal-institutional approach has always dominated American political science. Most school and college textbooks use this approach. Not only have the proponents of this method tended to ignore the roles of individuals in the shaping of public policy, but they have retarded the theoretical development of the discipline because their research goal has been primarily the accurate *description* of laws and formal institutions, and not the formulation of empirical laws and theories about the political behavior which occurs within them. In textbooks using this approach, legal documents such as the Constitution, and the duties and powers of such authorities as the President and Senators, are described in copious detail. The student is required to memorize these documents and duties. This practice has not only given students a distorted and stilted image of our political system, but it has tended to bore them to death.

Students should certainly be knowledgeable about the great legal documents of major political systems, but they should realize that legal and institutional factors of politics describe *opportunities* for certain political acts but are not accurate predictors of political behavior. As Krislov has perceptively noted, ". . . institutions and other legally prescribed modes of behavior are . . . opportunities for action in a political system, which may or may not be utilized depending on other factors in the personalities and needs of the actors themselves."[11]

Closely related to the legal-institutional method is the *historical* tradition. When political science first emerged as an area of study, it was primarily political history, and was taught in history departments. It consisted largely of the "history of political parties, of foreign relations, and of great political ideas."[12] The historical development of the great legal documents and formal institutions was also extensively described. The historical tradition shaped the development of empirical political theory much as it influenced the growth of theory in history and anthropology. Historians are primarily interested in describing unique events, and not in developing higher-level generalizations and theories about the past. This concern for the factual description of particulars became pervasive in the legal-institutional approach in political science and retarded the development of higher-level generalizations and empirical theory. One insightful political theorist has called political scientists "historians of the present."[13]

They give detailed descriptions of contemporary political events, done in the narrative style of the historian. The results are often case studies . . . while he gives us much information about a particular political event, the historian of the present refuses to generalize, to compare and find the common elements of his and other narratives.[14]

The behavioral approach

In the years following World War II, a protest movement developed within political science which initiated unprecedented changes within the discipline

and started a bitter struggle between the newly trained and the more traditional political scientists (those who endorse the methods described above). The protest movement emerged because a significant number of young political scientists, such as Harold Lasswell, David Easton, and Robert A. Dahl, were very dissatisfied with the scientific status of the discipline. They were unhappy about its research goals, methods, and the body of accumulated knowledge.

The new scientists wanted the discipline to become an *empirical* science like the other behavioral and physical sciences. They wanted its goal to be the development of *theory*, which could be used to predict and control behavior. They attacked the aim of normative political theorists, who regarded their proper goal as the identification of the proper values and the "best" political system to lead to the "good life." These new scientists argued that this goal was antithetical to empirical science, which described institutions but did not make prescriptions. These new scientists were also dissatisfied with the research goals of the legal-institutional political scientists, who described legal codes and institutions, but refused to study the behavior of political actors and showed little interest in the development of higher-level generalizations and theory.

This new movement is known as the *behavioral approach* because its proponents are primarily interested in studying the *behavior* of political actors, rather than legal codes and institutions. While they are not disinterested in the legal duties of the President and of Senators, they are primarily concerned with developing empirical generalizations about their behavior.

> The behaviorist argues that, although an important aspect of politics, the institution as a thing in itself is not the real stuff of politics. It is the activity within and the behavior around the political institution which should be the main concern of the political scientist.[15]

The interest in empirical theory and concern for political behavior are not the only distinguishing characteristics of the behavioral approach. Proponents of this method advocate the use of new research techniques, such as opinion surveys, content analysis, the case study, and experimental studies. The quantification of data and the use of sophisticated statistical techniques are also used often by behaviorists. Most of their field research consists of voting studies. The first such study to appear was *The People's Choice*, which was published in 1944 and describes the presidential election of 1940. A more recent study, *The American Voter*, reports the 1956 election.[16] While these studies have not resulted in the development of a theory of voting behavior, they have produced some important low-level generalizations about who votes, the factors influencing voting behavior, and the formation of political attitudes (called political socialization). Writes Dahl,

> ... this series of studies has significantly altered and greatly deepened our understanding of what in some ways is the most distinctive action for a citizen of a democracy – deciding how to vote, or indeed whether to vote at all, in a competitive national election.[17]

"I can't go to vote! That's the night I bowl!"

Reprinted from *Instructor*, © October, 1969, The Instructor Publications, Inc., used by permission.

Iredell has reviewed some of these findin :

> A higher percentage of rich people vote than poor ones, a higher percentage of well-educated people vote than poorly educated ones, a higher percentage of Jews and Catholics vote than Protestants, a higher percentage of city people vote than country people, and a higher percentage of men vote than women. People between 35 and 55 are more likely to vote than either younger or older people.[18]

Behaviorists have also tried to unite political science more closely with the other behavioral sciences. They use many of the key concepts and research methods that are germane to psychology, sociology, and anthropology. Theories from these disciplines have been employed. They have made the goal of political research more consistent with the goal of research in other social sciences. Behaviorists believe that behavioral scientists must work cooperatively and jointly in order to create an empirical science of human behavior. They have also tried to make the concepts in this discipline more precise, measurable, and meaningful. However, they have been less successful in creating empirical concepts than they have been in some of their other endeavors.

We have contrasted the behavioral approach with more traditional methods in order to distinguish the different orientations within the discipline. However, the reader should not assume that in practice these methods are so clear-cut. All behaviorists don't agree about what the basic assumptions and methods of their approach are or should be. Almost every behaviorist must at some time during his research use information about legal codes, formal institutions, and the historical aspects of political behavior. Also, no traditional political scientist would totally reject the findings, assumptions, and research methods of the behaviorist. Each political scientist is to some extent both a traditionalist

and a behaviorist. However, we often categorize a political scientist as a behaviorist or traditionalist according to the dominant orientation evident in his work.

Earlier we quoted from Sorauf who correctly points out that in political science "there have been neither victors nor vanquished." The behavioral orientation has won a place within the discipline, but it has neither escaped criticism – often harsh – nor has it displaced the more traditional legal-institutional, historical, and normative approaches. However, the behavioral approach has polarized and created more reform and soul-searching within the discipline than any other previous method. The attacks on it have been severe; sometimes they are sound, but just as often they are shortsighted and emotional. Human resistance to change can be found among political scientists, as it is in all other groups in society.

The most serious attacks on the behaviorists have come from normative political theorists who believe that the discipline's primary goal should be to improve man's life by searching for the best possible political system and recommending it to the statesmen for implementation. These theorists accuse the behaviorists of neglecting *values*, and therefore of avoiding the most pressing questions which confront man. Russell Kirk has condemned behaviorists in unequivocal terms:

> The "great tradition" of politics ... has been normative; that is, the political philosopher has sought what T.S. Eliot calls "the enduring things," the standards for order and justice and freedom. And these political norms have been rooted in transcendent insights – in religious belief and in transcendent philosophical systems like that of Plato ... What, in effect, amounts to *moral nihilism* has been reserved for twentieth-century political science.[19] [Italics ours]

As we previously indicated, the claim that the behaviorists ignore values is inaccurate. They regard them as a kind of behavior.

The behavioral approach certainly has shortcomings, and many of the criticisms made about it are valid. Behaviorists, perhaps more than any other group of political scientists, are aware of the limitations of their methods and have stated them rather clearly. In their zest for information about political actors, behaviorists have not always appreciated the contributions that legal, institutional, and historical approaches can make to the development of political generalizations. The emphasis on the *individual* political actor has also prevented full consideration of the political group and the political system.

> ... [An] individual is not a political system, and analysis of individual preferences cannot fully explain collective decisions, for in addition we need to understand the mechanisms by which individual decisions are aggregated and combined into collective decisions.[20]

Other shortcomings within this approach reflect not so much imperfections in its methods, but its rather immature stage of development. The voting studies are rather fragmented and do not as a group constitute the beginnings

of a theory of political behavior. Most of the generalizations about voting behavior are low-level ones, although they have greatly contributed to our understanding of the American voter. Both high-level generalizations and partial theories will emerge as the movement develops.

The systems approach

Some political scientists have attempted to focus research in the discipline by conceptualizing the political process as an interrelated system. The political system is conceptualized as one of a number of interrelated but somewhat independent social systems which make up society. The orientation of this approach is essentially empirical, but it is more inclusive than the behavioral approach since it not only attempts to develop generalizations about individual political actors, but tries to explain how organized pressure groups influence the making of public policy. Systems theorists focus on developing generalizations about how the competing *demands* and *inputs* of political actors become public policy or *outputs*.

David Easton is probably the leading systems theorist. He sets forth his systems theory in his series of books, *The Political System* (1953), *A Framework for Political Analysis* (1965), and *A Systems Analysis of Political Life* (1965). According to Easton, the specific research tasks of the system theorist is to

> ... identify the inputs and the forces that shape and change them, to trace the processes through which they are transformed into outputs, to describe the general conditions under which such processes can be maintained, and to establish the relationship between outputs and succeeding inputs of the system.[21]

Figure 9.1 illustrates the relationship among the central concepts within Easton's systems theory.

HOW SCIENTIFIC IS POLITICAL SCIENCE?

In each chapter on the disciplines, we have used the criteria formulated by Berelson and Steiner to judge their scientific status. Consistency demands that we discuss the scientific status of political science. However, the discussion on the nature of political science suggests how difficult it is to judge the scientific status of the discipline as a whole. It is easier to compare the scientific status of *each* of the major orientations within political science because their aims and approaches are highly divergent and often contradictory.

As we have said, the goal of empirical science is the building of theoretical systems which can be used to predict and control behavior. The building of empirical theory is clearly not the goal in any of the more traditional approaches within political science. The aim of political philosophy is to describe the ideal political system; the legal-institutionalists regard the accurate descriptions of legal codes and formal institutions as their primary goal. The

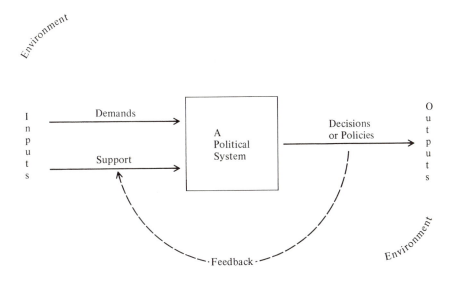

Figure 9.1

Reprinted with permission from David Easton, "An Approach to the Analysis of Political Systems," *World Politics,* Vol. IX, No. 3 April, 1957, pp. 383-400.

emphasis is on describing unique codes and institutions, and not on developing high-level generalizations about them. Many proponents of these approaches deny that high-level generalizations and theories can be developed in political science because man's behavior is so complex.

Only in the newer approaches to political science — the behavioral and systems orientations — is the expressed goal the building of empirical theory. While the newer approaches have theory construction as their goal, the discipline is largely void of tested theories, even though attempts have been made, and are still being made, to formulate and test partial theories. Notes Easton, "By and large, students in political science have not considered it worthwhile to allocate even a small part of their collective energies to systematic theory. . ."[22]

Empirical sciences are also characterized by public procedures, precise definitions, objective data collections, and replicable findings. Only in the newer approaches within this discipline are methods used which are so clearly explained that they can be repeated by other researchers. Concepts in all approaches are vague and ambiguous. Such terms as *state* and *government*, which are central to traditional approaches, and concepts such as *power, legitimacy,* and *authority*, essential to newer approaches, are often defined differently. However, the behaviorists make concerted efforts to make their terms precise, and to operationalize them for measurement purposes.

In all approaches within the discipline, objectivity is an expressed ideal, although proponents of the more traditional approaches do not always clearly differentiate between normative and empirical statements. Some political science concepts, which are supposedly empirical, often have normative connotations. Such terms as *communism* and *socialism* are frequently used to connote negative characteristics, while *democracy* and *capitalism* more often convey positive meanings.

On balance, political science seems to be one of the least empirical of the behavioral sciences, if we adhere to the criteria postulated by Berelson and Steiner. A number of leading political scientists consider the scientific status of the discipline depressing. Writes Easton:

> ... the condition of American political science is disturbing and disappointing, if not in absolute results at least in terms of what is possible ... When we look at the greater part of political research over the past several decades we cannot help but conclude that it shows evidence of still being in [its] earliest stage and what is disturbing, it seems to be perpetuating this condition today. It exerts little effort to raise itself to the next stage.[23]

Sorauf's description of the status of political science "On the eve of World War II" accurately characterizes it today:

> It was a heterogeneous, plural, and diverse discipline with little agreement about its central concerns, its methods, and its basic goals. It was a discipline uncomfortable in building theoretical propositions and perfecting methodologies ... it was a discipline without a clear intellectual identity.[24]

The basic struggle within the discipline is over goals — whether political science will become an empirical discipline or a normative one which makes prescriptions for society. The latter goal is clearly antithetical to the development of a theoretical science.

POLITICAL SCIENCE CONCEPTS

Throughout this book, we have recommended that the teacher select key concepts from each of the social science disciplines when planning social studies for the elementary and junior high-school grades. To aid the teacher in his planning, we have tried to identify for each discipline what its experts regard as its key or organizing concepts. For each of the disciplines, this has been a difficult task, since the author's research on the disciplines revealed that few groups of social scientists are able to agree about what the key concepts in their disciplines are. However, this approach was not abandoned because it is a sound one. The disagreement among social scientists about the key concepts in their disciplines does not suggest that the search for organizing concepts is invalid, but indicates the low level of scientific development of the social

sciences. Once they mature, their organizing concepts, generalizations, and theories will be easier to identify.

The level of concept development within a discipline reflects its scientific status; concepts are clear and operationally defined in more highly developed disciplines; they tend to be vague and ambiguous in disciplines which are experiencing their first attempts to become scientific. We previously noted that sociological concepts are more clearly defined than those in history and anthropology; this fact indicates that sociology has reached a higher stage of scientific development than history and anthropology.

Any attempt to identify *the* key or organizing concepts in political science is destined to be futile because of the great differences of the approaches within the discipline. Each approach, to some extent, employs a unique set of concepts. The concept of *natural law* is germane to political philosophy but is rather foreign to the systems approach. These characteristics of political science make it exceedingly difficult to select central concepts for instruction, as Patterson has pointed out.

> The remarkable diversity of the field, its internal conflicts, its lack of an agreed-upon coherent theoretical structure, its ambiguities, and its current growth in many directions, combine to make it complicated to use for reconstruction of social studies in the schools.[25]

Although political science presents special instructional problems, the conceptual approach recommended in this book can be used to teach children perspectives unique to the discipline and generalizations about political behavior. A selected number of concepts from each of the orientations within the discipline should be an integral part of the social studies program for the elementary and junior high-school grades. However, although some concepts from the traditional approaches should be taught (such as *constitution*), the teacher should select most of his concepts from the more modern approaches for two reasons: (1) These approaches build scientific generalizations about political behavior and (2) Traditional approaches are easily abused by teachers. When teachers use traditional approaches, the emphasis easily shifts to requiring children to memorize the duties and powers of various offices, and away from helping them to derive generalizations about political systems. The normative approach permits teachers to moralize, without evidence, about the merits of a particular institution – the values of which are not fully demonstrated. It also places undue emphasis upon the views of authorities, whether classical (Plato, Aquinas, Crotius, or Locke) or contemporary (Lippman, Lasswell, or Hyneman).

No attempt is made below to list *the* organizing concepts in political science for the reasons noted above. However, some important concepts are central to the different approaches. Most of those we will discuss are related to the behavioral orientation. Concepts which are central to the systems approach are not discussed because Fig. 9.1 graphically explains the key concepts of this method. The key concepts of the systems approach can certainly be used by classroom teachers to teach children major generalizations about political

Children should be introduced to political science concepts in the early grades. (Washington State Office of Public Instruction, Olympia)

systems. The concepts of *inputs, demands,* and *outputs* can be understood by young children.

Social Control

Social control is the regulation of human behavior by outside social forces and is maintained by the laws and rules that emerge within every society and institution. Every institution must have ways to control the behavior of its members in order to attain its goals and to maintain an environment in which individuals and groups can satisfy their wants and needs. The laws that govern behavior within a society are usually found in written documents such as legal codes and constitutions. Laws reflect the norms and values of a society. Those norms which are very important to a society usually become laws, and the violators of these norms are punished by the state. Americans, at least verbally, value human life and believe that every healthy American male has an obligation to serve in the armed forces. It is therefore illegal to kill someone and to evade the draft.

There are many opportunities in the elementary and junior high-school grades for the teacher to introduce this concept. Students can list the rules which they must obey in such institutions as the home, the school, and the church, and state which of these rules they consider important and which they consider unimportant. Through a study of rules and laws within our society,

children will discover that many laws and rules have outlived their usefulness and are no longer functional in our highly technological and overpopulated society. Some states that considered abortion laws dysfunctional in today's society repealed the laws prohibiting abortion. A careful study of laws throughout history will help students to discover how societies constantly abolish old laws and create new ones in order to satisfy current needs and to solve contemporary problems. However, there is often a long time-lag between the needs of society and the creation of new laws or the abandoning of old ones.

State

The concept of the state is central to traditional approaches in political science. Political science is often defined by traditionalists as the study of the legal government of the state. Although this concept has been defined in many different ways, it is sometimes defined as the institution which has ultimate responsibility for maintaining social order, usually within a geographically and legally defined territory. When studying this concept, students could examine the legal codes, constitution, laws and sanctions that the state uses to maintain social control. They could also be asked to hypothesize about what might happen in a society without an institution whose primary responsibility is the maintenance of order. When this concept is studied, the concept of a *law* could also be conveniently introduced.

Government

Closely related to the concept of the state is the concept of government. Government is an agency of the state that is used by it to maintain social control. It consists of "the legally based institutions of a society which makes legally binding decisions."[26]

Power

Power is the ability of one individual or group to influence, change, modify, or in some other way affect the behavior of others. The American Medical Association exercised power when for several years it successfully blocked the passage of a medical aid bill, thus affecting those who needed inexpensive medical care. Power is an important concept in political science; some political scientists define the discipline as the study of the struggle for power. Children may find this concept useful as they attempt to derive generalizations about man's political behavior.

Legitimacy

A government is regarded as legitimate when the individuals affected by its policy accept its authority as valid. "Out of their loyalty to it they enforce its decisions on themselves and free the political system from the impossible task of supporting every one of its decisions with naked force."[27]

Authority

Political leaders have authority when they are able to make decisions and laws that are legally binding for the individuals within a political system. Individuals or groups may attain authority in a variety of ways. They may be elected by the people, appointed by leaders, or take authority by force, as during a *coup d'etat* or revolution. For a political system to function smoothly, it is necessary for authority to be legitimate; otherwise, authorities have to expend too much energy enforcing their decisions.

Interest group

An interest group is a collection of individuals who share common concerns and goals; they organize in order to more effectively attain their shared aims. In this country, lobbying is their most frequently used political tactic. Groups such as the American Medical Association, the American Bar Association, and the National Education Association become active in politics when elections or issues arise which they feel may affect their interests.

Political socialization

The process by which an individual acquires his attitudes, beliefs, and perceptions of the political system is known as political socialization. Behavioral political scientists have shown a great deal of interest in this concept. Their research suggests that of the many institutions which affect the child's attitudes toward the political system, the family is the most important. An individual is usually a member of the same political party as his parents. Recent research suggests that a child's basic political attitudes are formed during his early years – when he is between the ages of three and thirteen. These findings have important implications for political studies in the elementary and junior high-school grades. A sound program must be implemented during these years if the school is to play a vital role in the political socialization of youth. By the time students reach high school it is almost too late.

Political culture

The attitudes, perceptions, and beliefs which individuals have toward politics is called *political culture*. Political culture is primarily "concerned with patterns of psychological orientation to political action."[28] Researchers have found that political cultures differ in various nations. In the United States, politics is regarded as dirty business, and politicians are thought of as dishonest people. Yet the American political culture is considered a "participant" culture because of the high level of involvement of Americans in politics, as compared to the level of political involvement in other countries. "The Italian culture is one of political alienation, low feelings of national pride, distrust of government, and little sense of obligation. The political culture in Mexico is characterized as 'a

combination of alienation and aspiration."[29] In order to derive generalizations about political cultures, children could compare and contrast the political cultures of different countries.

Political system

A political system consists of all the processes and institutions that result in the making of public policy. The struggle of competing groups for political power is a major aspect of a political system. The following components are essential to a political system, "the people who are governed, authoritative officials, a political (selection) process, a structure of government, a policy-making process, and authoritative policy. Power . . . may be widely distributed among all six components or may be concentrated in one or a few components."[30] The study of political systems will help children understand how all political elements are interrelated. The method of analysis formulated by David Easton (see Fig. 9.1) could be used by the teacher as a guide. Children should not only analyze our own political system, but should compare and contrast it with political systems throughout the world. They should learn that man everywhere has devised some form of political life.

POLITICAL SCIENCE GENERALIZATIONS

Much of what we have said about political science concepts is also true of political generalizations, since generalizations state relationships between concepts. Generalizations in political science, like those in other behavioral disciplines, vary greatly in their generability, empirical support, and their value for prediction. Many generalizations in the discipline are normative and value statements; these statements reflect the dominant normative orientation which has existed within the discipline since it first emerged. Many political generalizations are low-level statements that describe the characteristics of various laws and institutions. Most of the generalizations formulated by behaviorists are related to voting behavior; these are also primarily low-level empirical statements.

In selecting generalizations to guide political studies in the elementary and junior high-school grades, the teacher should select only statements that can be verified empirically. Most lists of political science generalizations prepared by curriculum committees contain many value statements. Such lists also contain numerous simplistic statements that the teacher should disregard. The following two statements are from a list of political science generalizations in a state curriculum guide: "Young people respect and obey parents and teachers," "Autocracy, or similar centralization of power in one man or body, develops when citizens shirk their responsibilities."[31] These statements are misleading and largely normative. Many young people, especially today, neither respect nor obey their parents very often. The latter statement is largely normative as well as overly simplistic. These statements strikingly demonstrate a fact which has been emphasized throughout this book: *structuring a curriculum around*

organizing concepts and generalizations does not assure an effective social studies program. Not only may inaccurate generalizations be chosen, but teachers may teach them using traditional methods that have proven ineffective. The following generalizations, however, are examples of types which may guide the scientific study of political behavior in the elementary and junior high-school grades:

In every society and institution, regulations and laws emerge to govern the behavior of individuals; individuals usually experience some form of punishment when authorities catch them breaking laws.

Rules and laws reflect the basic values within a society or institution.

Within every society, some individual or group is authorized to make binding decisions and to allocate values.

Many different types of political systems are used in various societies to determine public policy and to regulate behavior.

Dictatorships sometime arise to power when a nation has experienced a revolution directed against an old regime perceived as oppressive by the revolutionaries.

Organized interest groups attempt to influence the making of public policy when they believe that such policy will affect their goals.

Individuals are more likely to influence public policy when working in groups than when working alone.

Individuals and groups resort to extreme methods to change public policy when they feel that authorities are unresponsive to their needs or that legitimate channels for alleviation of grievances are ineffective.

Authorities may be violently replaced if they remain unresponsive to the demands of the public.

When authorities feel that the basic ideology and well-being of their political system is being threatened, they may take extreme action against individuals and groups, which denies them the basic rights guaranteed under the laws of the state.

Authorities tend to resist change which they feel will reduce their power and influence.

When their power is threatened, authorities sometimes create situations which give their critics the illusion of exercising influence, although the actual power remains within the control of the authorities.

Conflict arises within a political system when individuals or groups have competing goals and/or interpret the meaning of laws differently.

Leaders emerge when individuals are able to articulate and personify the wishes and goals of groups; leaders lose their power and influence when groups perceive their goals as different from those of their leaders.

Authorities attempt to legitimize their power in order to maintain control (i.e., convince their constituency that they have a right to rule because of divine right, the Constitution, etc.) and a stable political system.

POLITICAL STUDIES IN THE
ELEMENTARY AND JUNIOR HIGH SCHOOL

Political studies are usually either ignored or treated superficially in the early and middle grades, and taught with historical and legal-institutional approaches in the junior high school. Political studies are neglected and poorly taught largely because *the goals of political education are ambiguous, confusing, and contradictory.*

The most frequently professed goal of political studies is to develop patriotic citizens who are loyal to our nation and committed to the democratic ideology. However, "patriotic citizen" is rarely defined clearly. In order to perpetuate its dominant values and system of government, every nation-state must socialize its citizens in such a way that it inculcates its prevailing ideology. Thus, developing loyal and patriotic citizens is a sound goal. However, in this country political studies are often taught poorly because of the way that teachers and textbook writers have interpreted the word "patriotic." A patriotic citizen is usually regarded as one who regularly votes, obeys the law, respects the flag — waving it occasionally — and rarely criticizes our political leaders. He believes that democracy as practiced in the United States is the best possible form of government, not just for Americans, but for all people everywhere.

In their zest to develop such citizens, educators have written civic text-books that praise the wonders of the United States and describe, in candid 'detail, the flaws of other nations, especially the Communist countries. The imperfections in American society are given scant, if any, attention. The discriminations experienced by minority groups, women, and the poor, and the value conflicts that divide our society, are rarely discussed in junior high-school civic texts. In summarizing his study of civic textbooks, Massialas wrote:

> ... the following picture of America is given to the younger generation:
> (1) the government operates on the principle of the consent of the governed; (2) America is the best country to live in; (3) American citizens are the most rational voters; (4) the American form of government is the best and most appropriate for all societies at any stage of development; and (5) since America is both the most powerful and the most democratic state, it should be the world's keeper. In sum, "We are the greatest. . . ."[32]

If we examine elementary and high-school textbooks, we often find a glorious picture of the United States. They say that Americans may well be proud of the fact that their country stands as the great champion of freedom and democracy in world affairs, and that in general, we consider countries which favor liberty as friends of the United States. We are told that the

countries which favor communism and other forms of dictatorship consider the United States their greatest enemy. "It is a great thing for a free people to be known as the champions of freedom," states one book.[33]

Many classroom teachers have also joined the "conspiracy of silence" to shield America's shortcoming from students. Numerous teachers feel that if children are exposed to the ugly aspects of American life, they will become cynical and lose faith in the American creed. They argue further that childhood should be a pleasant period in one's life and that such facts will evoke unnecessary concern among children. Also, they argue, children will learn about our problems when they are adults, and this is soon enough.

For a number of reasons a sweet and light approach to the study of political problems is unsound. Although there are few sound reasons why kindergarten children should learn about the great political scandals which have historically cast dark shadows on American political life, children at an early age should learn to distinguish between the ideals of a political system and political reality. For example, students should know the rules and laws which govern their behavior in their classroom and at school; they should also know that individuals often break rules and laws and are often punished when they do. To teach children that all Americans actually have equal protection under the law is wrong. However, children should be aware of our ideals as well as our actual behavior. They should know that the *ideal* of our judicial system is equal legal protection for all citizens. When students become aware of both our ideals and actual behavior, they realize the job which must be done to make the two more consistent.

A political studies program which emphasizes our strengths and the flaws of other nations violates our goal — to develop a commitment to the democratic process. We cannot use authoritarian teaching strategies to develop an appreciation for democratic principles. The best way to help children learn democratic values is to expose them to a classroom atmosphere that is democratic, and to provide opportunities for them to participate in democratic action programs, such as student government. In a democratic classroom children are free to examine all sides of an issue, to disagree with the teacher, and to reach their own independent conclusions when discussing political issues. Only in this way can children develop a rational commitment to the democratic ideology.

The legal-institutional approach which has historically dominated political science is evident in civic texts and programs. This approach is highly consistent with the traditional approaches used to develop "patriotic" citizens. This fact might account for its wide acceptance among educators. In this method, the student studies the legal powers and responsibilities of various political posts, and the functions of the different branches of government. The emphasis is on memorizing facts and regurgitating them to the teacher. This approach gives the student an unrealistic conception of our political system because it ignores the role of individuals and political actors. To understand how a bill is actually passed, one cannot merely study the *Constitution*, but must know how competing pressure groups work to influence the shaping of public policy.

A sound and realistic program in political studies will help the child to become a more reflective future citizen and intelligent social activist. (Washington State Office of Public Instruction, Olympia)

Simulation games such as *Democracy* and *Napoli* can help children understand such informal processes as bargaining, logrolling, pledging support in return for another's support on other issues, wheeling and dealing, compromising, welching on promises, misleading others, and other devious activities. So much for traditional approaches to political education that may be unsound. We suggested that they are ineffective largely because the goals are ambiguous and confused.

What should be the goals of political studies in the elementary and junior high-school grades? *The goal of political studies should be the same as the goal of the entire social studies program. Political studies should help children attain understandings that will enable them to make sound personal and public decisions on issues which will affect their lives, the community, and the nation.* We stated this as the goal for the entire social studies program in Chapter 1. Every social science discipline has perspectives and concepts that can contribute to this goal.

Since the goal of political studies should be the same as the objective of the total social studies program, political science concepts and generalizations should be identified and taught in a sequential and spiraling fashion throughout the elementary and junior high-school studies program. While some traditional political science concepts should be selected, the emphasis should be on concepts that give children a more realistic picture of how a political system actually operates. Concepts such as *social control, power*, and *authority* should constitute a large part of the program in elementary political studies.

A concept such as *social control* (as manifest in rules and laws) could be taught to children in all the elementary and junior high-school grades. The teacher does not need to introduce new content in order to teach this concept; he can use the content samples that are traditionally taught in these grades. A generalization related to this concept, such as *In every society rules, regulations, and laws emerge to govern the behavior of individuals*, could be

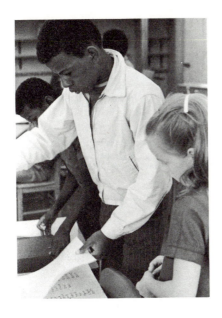

Students are more likely to accept the rules and laws which govern a social setting such as the classroom when they understand why forms of social control are essential. (Washington State Office of Public Instruction, Olympia)

selected to guide instruction. A related generalization could also be identified, such as *Individuals usually experience some form of punishment when they are caught breaking rules and laws.*

In kindergarten, for example, the teacher could ask the children to state some rules which they are supposed to obey at home, on the playground, in the classroom, and while walking home from school. Responses may include, "I have to go to bed at 7:00," "I cannot talk when others are reciting in class," or "I must wait until the light turns green before I can cross the street." The teacher can then ask the children what might happen to them if they are caught breaking rules and laws. Finally, he could ask them to hypothesize about why we have rules and laws, and what might happen in a society or institution which did not have any rules or regulations. The teacher might try a demonstration. For example, when the children walk in some morning, he can tell them that for a one-hour period all the rules within the classroom will be suspended. A discussion related to the generalization can follow the experiment. Children in the higher grades could derive the same generalizations by studying city, state, and national laws.

An experimental junior high-school social studies program, *Man as a Political Being* (developed by Educational Services, Incorporated) is based on the conceptual approach. Two organizing political concepts were used to structure the curriculum, *power* and *political culture*. Patterson describes the program as follows.

". . . children look at a wide range of human phenomena, all the way from power relationships in their own schools to power relationships in the

death of the Roman Republic. Some of [the questions which they study] are:

What is power in human society?

Why is power a part of human society?

What does power rely upon?

What are the values of power?

What are the evils of power?

How do people protect themselves against excesses of power?

How does power operate to survive?

What are the conditions under which power sickens and dies?[34]

When studying the concept of *political culture*, the children research these problems:

Why (e.g., in terms of place, time, economic development, etc.) are there different kinds of political culture?

How does the general culture or total way of life of a people affect the special patterns of behavior we call political culture? In turn, how does political culture affect the general culture?

What relationships are there — and why — between political culture and technology?

How do children learn a political culture?

What kind of political culture do we Americans live in, how did we come to it, and what may it be in the future?[35]

The teacher can study the materials in this curriculum when selecting political concepts to develop in his own social studies program. Many excellent examples of content samples are contained in this experimental curriculum.

TEACHING CONTROVERSIAL ISSUES

The most controversial issues in the social studies are likely to arise when children are studying such "closed area" topics as communism, racism, socialism, legal abortion, power, and forced bussing. It is appropriate that we discuss the teaching of such issues in this chapter.

In an era that abounds in ideological controversy, it is reasonable to expect our schools to be doing a conscientious job in training students to deal effectively and intelligently with such issues. However, there is abundant evidence that most schools are bypassing the responsibility of helping students resolve social issues rationally. We have already indicated how social issues are evaded in social studies textbooks. Not only are the teachers themselves reluctant to deal with controversial topics, but organized pressure groups often try to keep hot topics out of the classroom. During the 1960's a parent group fought vigorously to prevent a teacher's using James Baldwin's novel, *Another Country*, in a literature class. The incident created a storm of controversy and

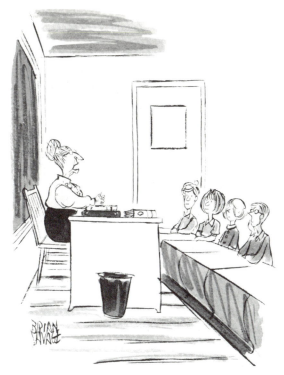

"The Board of Education requires me to give you some basic information on sex, reproduction and other disgusting filth."

Drawing by Brian Savage. Reproduced by special permission of *Playboy* magazine. Copyright © 1967 by *Playboy*.

brought to the surface some of the community's latent value conflicts. Implicit in the attempt to keep controversial topics out of the school is a refusal of academic freedom to both students and teachers.

Teachers are often unwilling to allow students to analyze concepts such as *communism, socialism,* and *Marxism* objectively. They tend to compare the most humane ideals of democracy with the darkest aspects of communism. What results is indoctrination. Teachers who indoctrinate students are trying to teach freedom and democracy with authoritarian methods. Students cannot learn democracy in an autocratic setting. Examining facts and issues in a free classroom atmosphere is the most effective way for children to learn to appreciate the values of democracy.

When studying social issues, students must be encouraged to examine original sources and to reach their own conclusions. Indoctrinating teachers lack a profound faith in democracy, for persons who really believe in the democratic process believe that democracy will sustain the most intense scrutiny. If students arrive at their own conclusions, their convictions will be strong and intellectual, and not merely emotional. Emotion easily gives way to persuasion. Sound, rational convictions will sustain the most intense challenge.

Unless we expose our students to our flaws as well as our achievements, we run the risk of making them cynics when they eventually discover the dark facts about our society. Many students become disillusioned when they discover in high school or college that Lincoln, despite his virtues, was more interested in maintaining the Union than in freeing the slaves. Students must understand that our nation, with all its strengths, has always had fallible leaders, many of whom defend blatant racism, support policies which ultimately lead us into futile wars, and some of whom have been caught red-handed dipping into the public purse. Nevertheless, the truth about our society will help students develop more faith in it, not less. Today's highly sophisticated and socially sensitive students will not swallow the myth that we are perfect and the greatest people on God's earth.

Whether in school or out, students eventually learn about the deep value conflicts which divide Americans. They are often stars and witnesses in the social conflicts of our times. Our young people, following their parents, have joined the exodus to the suburbs to "escape" the perceived negative effects of integration. The T.V. screen vividly documents the racial turmoil and bizarre crimes which are so pervasive in these troubled times. Teachers must help students to boldly confront these problems. Unless students, as tomorrow's citizens, are aware of the problems in our society, have accurate information about them, and work out effective ways to solve them, they cannot help close the wide gap between our ideals and actual behavior.

Most teachers lack a clear understanding of their proper role in the teaching of controversial issues. Their uncertainty to some extent reflects the value conflicts in our society. Some educators advocate indoctrination while others advocate the critical transmission of our cultural heritage as the best way to develop loyal and intelligent citizens. Many authors of methods textbooks advise teachers to use extreme caution in any discussion of social issues; they see the teacher's role as a neutral one. Other authors believe that it is impossible for a teacher to help children to rationally analyze social issues and conceal his opinion.

This writer believes that a teacher cannot and should not be asked to assume a neutral position when discussing such explosive topics as racism, legalized abortion, artificial contraceptives, and women's liberation. To demand that a teacher be neutral on such issues is, as Hunt and Metcalf cogently argue, to deny him the freedom and right to voice his opinion openly in a public forum.[36] While the teacher should freely express his opinions at an appropriate time, he should make sure that, before he does, the students have ample opportunities to arrive freely at their own positions. The teacher should make his opinion clear so that students can accept it for what it is, an *opinion*. Students should be free and encouraged to rationally challenge their teacher's opinions. They should learn to challenge any opinion, regardless of its source. Unless we start dealing with heated social issues openly and critically in the classroom, our students will be unprepared to resolve the value crisis in our society and the ideological warfare which is plaguing the globe. The very essence of democracy will be endangered.

Taking a stand on controversial issues

We suggested that a teacher should be free to take a stand on controversial issues. It is appropriate to re-emphasize and further clarify this point. It is inconsistent to urge children to take stands on social issues and yet not expect similar behavior by the teacher.

For too long, many educators have urged teachers to take a "neutral and objective position" when dealing with controversial issues. But all too often the so-called objectivity becomes little more than a sterile neutralism and a faceless fence-sitting, showing the teacher as a bland and opinionless person. Such a person cannot lead any human activity. As we have noted, teachers should feel free to express their views, but they should be certain that their students have ample opportunity to derive their own opinions on social issues without teacher influence. Teachers are often unaware of how cogently they influence students' beliefs. "My teacher says . . ." is one of the most obvious indicators of teacher influence on students, and is heard almost daily in every home with children. With older children it takes the form of a mild hero-worship in which children are readily disposed to accept the teacher's point of view, no matter how persuasive other points of view might be. Teachers must be aware of the twin evils: on one hand, direct indoctrination and propagandizing and, on the other, what we have called the faceless anonymity of the so-called objective, neutral position. Both extremes must be avoided.

Many school districts provide specific policy guidelines for handling controversial issues in the classroom. It is important that many sides of an issue be carefully studied and aired, that public speakers representing various points of view be invited to student assemblies and classrooms, and that all have equal opportunities to present their views or to share platforms so that students are able to question opposing views.

Most problems resulting from teaching controversial issues arise because teachers fail to involve parents, community representatives, and the school administration early enough in the planning stages of such studies. All too often the parents have little or no idea of the controversial issues involved in a proposed topic. They may be uncertain of their own value positions or of those held by one or more factions within the community. When the value positions within the controversy are not clear to everyone, the issues are clouded by the use of ambiguous words, emotional language, and hardened positions.

As a matter of just plain common sense, we urge teachers to be certain of the policy positions of their school board on the teaching of controversial issues. In the absence of school board policy on such issues, we suggest that parent and community groups as well as the school administration be fully appraised of the nature of the controversial issues well in advance. This is not intended to suggest that teachers should tread lightly on "sensitive toes." Instead, it is to suggest that when parents and administrators are fully informed in advance, any resulting criticism can be properly channeled toward a full and free discussion of the right to raise such issues in the classroom, rather than on the personality of a particular teacher.

In recent years, professional organizations such as the National Council for the Social Studies, the National Education Association, and the American Federation of Teachers have come to the aid of teachers who have been unfairly criticized for teaching controversial issues or who have been suspended or dismissed without adequate process of law. There is every indication that these organizations will play an increasingly more active role in defending the rights of teachers to freely express their views in the classroom and to teach controversial social issues.

STRATEGIES FOR TEACHING SELECTED POLITICAL SCIENCE CONCEPTS AND GENERALIZATIONS

We have already suggested how political science concepts and related generalizations can be identified and made a part of the total social studies program. Once the teacher has identified the concepts and generalizations which he wishes the children to master, he can devise appropriate teaching strategies. Children have many experiences which can be viewed from the perspective of the political scientist; the teacher should draw upon these experiences as much as possible when teaching the key ideas of the discipline. We have selected two generalizations related to the concept of *social control* (rules and laws), and suggested some strategies for teaching them. These generalizations are important because they indicate that in all societies man devises laws to control behavior, that individuals often experience negative sanctions when they break laws, and that conflict and disagreement frequently arise when individuals interpret the meanings of laws differently. An infinite number of ways could be devised to teach our sample generalizations. The strategies which we delineate are intended to serve as a springboard to teacher creativity.

GENERALIZATION: *In every society and institution, regulations and laws emerge to govern the behavior of individuals; individuals usually experience some form of punishment when authorities catch them breaking laws.*

Primary grades

1. Suggest that students organize a class activity in which all members of the class would be working toward one goal. For example, they might set up a classroom post office, a paper drive, or classroom government. Ask them to think about what things a group must do to keep all members of the group working toward one goal. These ideas will occur as the children are organizing their activity. After the organization has been set up and the goal achieved, ask the class to determine guidelines, based on their group experience, for setting up an organization. Emphasize the role of rules when individuals work together toward one goal.

2. Ask students to think about what they would do if they saw a fellow student breaking the school rule that prohibits students from throwing

A classroom project, such as a newspaper, can help students to understand why rules and laws are necessary if an institution is to attain its goals. (Shoreline School District, Seattle, Washington)

snowballs on school grounds during the lunch hour. Have the children role-play this situation. Choose students to play the role of the playground supervisor, the snowball thrower, and include a small group of students to act as onlookers. Ask another group to role-play the same situation, making clear that they may view the situation differently from the first group. After the role-playing experience, discuss the alternatives each role-play group presented, and the possible consequences of those alternatives. Suggest that sometimes different punishments may exist for breaking the same rule. Discuss the conditions under which such a situation might occur, relating it to the role-playing activity.

3. Choose illustrations from many societies which portray the lawmaking process. For example, school textbooks explain American representative government. Texts also provide case studies of other cultural groups such as the American Indian tribes. The role of the Council as a lawmaking body in the

Figure 9.2
Data Retrieval Chart

Type of authority	Who made the laws?	Who enforced the laws?	Who determined the punishment?	What were the punishments?
Squatter sovereignty				
Vigilante rule				
Wagon-train government				

Navaho tribe could be compared with that of the American Congress. Tradition in the culture of the Kwakiutl Indians of the Pacific Northwest determined many of their laws. Tradition as a source of laws could be compared to the American custom of changing and expanding laws as the times change. Children might compare the sources of laws in different societies. Then they could determine the possible consequences of breaking laws in different societies. A comparison and contrast of the consequences of breaking laws in different societies would help students understand that punishment occurs in all societies for breaking laws, but that punishments differ according to cultural traditions.

Intermediate grades

1. Divide the class into three groups to research the following topics:

a) Squatter sovereignty on the frontier,

b) Vigilante rule in western frontier towns,

c) Government for wagon trains.

Ask each group to focus on the way laws were made, who made them, who carried them out, who determined the punishment, and what the punishments were. Ask the committees to present panel reports on their topics, answering the above questions. Students should then prepare a chart (Fig. 9.2) showing similarities and differences of the three kinds of rule according to the indicated criteria.

Students are now ready to use their knowledge to compare and contrast, make a generalization, and apply it to a new situation. From the chart, students should be able to make some statements about the purposes and sanctions of law on the frontier. These statements, or generalizations, should apply to all three kinds of frontier rule. The generalizations may then be tested for their applicability to other situations by applying them to the 1971 situation in which the United States and the Soviet Union were engaged in establishing regulations for space travel and space stations.

2. Intermediate-grade children often participate in school government. An exploration of the history of this government might give them some insight

into the origin of rules in an organization familiar to them. A comparison of the reasons for the development of school government with those for the development of American government allows students to generalize about the need for laws at all levels of a society. Ask students to decide how they can obtain information about the development of the school constitution and the reasons for having a school government. They should define their problem carefully, so that it may serve as an effective guide in their search for information. They should decide whom they wish to interview, and what records they need to obtain. After they secure information according to their guidelines, students should be able to make statements about the assumptions on which the development of student government was based. For example, were the originators of school government assuming that fourth-, fifth-, and sixth-graders would be able to make decisions affecting mode of dress and conduct in the halls, or were they assuming that intermediate-grade students should have a school government to provide a channel of communication between principal, teachers, and students? (Students should be taught the process by which assumptions are determined if they do not already know it.)

Then, after a study of the United States Constitution, students should compare the assumptions upon which their student government was based, with the assumptions in the Constitution about the people's ability to govern themselves. For example, the school government was developed on the assumption that it would be a government of students of a certain age group in a certain geographic area. It was assumed that students were capable of controlling themselves in some areas but not in others such as in determining the curriculum. The United States government was developed on the assumption that all persons would be represented by the legislators who would make laws to ease the tensions that arise when many people live together in one country. It should be clear to students that the school government and the American Government were developed to govern groups which were different in size, age, and purposes.

On the basis of the comparison and contrast of assumptions on which both kinds of government were developed, students should generalize about the need for laws which may be applicable to just one group of people or to many groups of people, depending on the needs of the group.

3. Ask students to inquire from family or friends about the rules and regulations that exist in various places of business. Have them list these rules and regulations, and the types of businesses to which they apply. Businesses may be categorized according to the number of employees, the number of branches, the number of divisions within one branch, or the kind of work the organization does. Suggest that students relate the characteristics of the business to the number and rigidity of the rules they have set up to regulate the behavior of employees. For example, does a business with 10 employees have fewer rules and regulations than one with 100 employees? Does a small business enforce rules less rigidly than a large business? Using the school as another example of an organization, ask students to apply their conclusions about rules in business to rules in the school to determine whether their

generalizations are applicable to a different kind of organization. In showing that groups working toward one goal set up rules to govern themselves, bring out the difference in the degree to which rules are standardized according to the size of business and the number of employees.

4. Set up a mock trial in the classroom so that students may have a simulated experience in the operations of the law beyond being arrested by the police. Court cases can be obtained from casebooks, films such as the "Right to Legal Counsel," supplements to *Social Education*, or a present court trial in your community with which the children might be familiar. The issues should be easy to comprehend and should provide adequate material for the students' information. Choose a judge, jury, lawyers for both sides, and the defendant and plaintiff from the class members. A study of the duties of these different participants in the trial should prepare students for the roles they will be asked to assume. A trip to the local court for a jury trial would give students more firsthand experience with the operations of a courtroom.

After the class has held the mock trial, a debriefing time should be set aside to explore the students' questions and feelings as the trial progressed. Ask them how they felt in each of their roles. Then discuss how the roles and feelings of each participant in the trial differed. Ask students why lawyers, a judge, and jury are included in trials. Point out the regularity with which court trials include the above participants by asking students to follow other court trials reported in the newspaper or portrayed on television. Discuss the makeup of a court trial and its origin in law.

Upper grades

1. Ask students to name as many documents as they can which set provisions for some kind of government anywhere in the world. For example, the Magna Charta, Mayflower Compact, and a document that determines the rules for a particular corporation or university might be mentioned. Then ask them to group the documents, classifying them according to similarities. Ask them to carefully define each label they give the categories. Students should compare and contrast each category on the basis of a set of characteristics they determine themselves. For example, they may categorize according to the number of people the document governs, the geographic area to which the document pertains, the time in history that the document was written, and the strata of society to which the document applies. A data retrieval chart may help them to categorize their information and record it. On the basis of the information from the chart, ask the students to make a tentative generalization about the different groups in a society which are governed, and the reasons for laws at these levels. The generalizations may be tested with other content samples such as the constitution of a country, a state constitution, or a county charter.

2. An in-depth study of a community organized for a specific purpose will give students another perspective on the enactment of law and the different kinds of sanctions that are used to enforce laws. A study of the Oneida

community, a Utopian community which existed in New York State, could focus on the kinds of rules that governed the people there, why they were set up, and what sanctions occurred when the rules were broken. An oral report by an individual student on another Utopian community, such as Robert Owens' New Harmony, Indiana, or the Hutterites, would offer a basis for comparison of different kinds of Utopian communities. Then juxtapose the laws of these groups with laws set up by state, federal, and local government. Compare the legal jurisdiction of local and federal government with that of Utopian communities and the punishments which occur as a result of breaking the law.

3. Ask students who are interested to draw up a bill to be submitted to a state representative or senator on a current issue such as ecology or civil rights. Ask them to determine the steps in the process of writing a bill before they begin to gather information and actually write the proposal. Find out whether any lawyers in the community have offered to work with school children on a volunteer basis. Then, if possible, obtain someone to help students with the actual wording of the bill. Submit it to a member of the state legislature, perhaps in your own district. Share correspondence from the state legislator with the class. As the bill goes through the legislature, have the students follow the process and become familiar with the steps by which a bill becomes law. Ask the students who wrote the bill to share with the class the considerations they made as they drafted the bill. Focus on the synthesizing process they used to enable them to come up with a different plan than that which already existed.

4. Consider an issue relevant to junior high students in the context of law and punishment. Current concern about legislation against those who are caught in possession of drugs, and those who have been accused of pushing drugs should arouse student interest. Ask these questions:

a) When were laws against marijuana and hard drugs such as heroin and cocaine passed? (Consider both state and federal levels.)

b) What was the rationale for this legislation?

c) What were the punishments for breaking the law?

d) How have punishments changed?

e) Why?

Now have students compare drug legislation with conservation legislation. Choose three time-periods in American history such as 1870, 1920, and 1965. Divide the students into three groups to research the legislation that was passed in areas of conservation, those areas to be determined by the class. Divisions could be forestry, water standards, and animal life. Panel presentations by each committee can be followed by recording data relevant to all three periods. Comparison and contrast should provide areas of similarity and difference in the three periods. Conclusions about changes in conservation legialation along with punishments for law-breaking can then be compared with drug legislation changes. Develop generalizations about how legislative changes are affected by conditions of the times.

GENERALIZATION: *Conflict arises within a political system when individuals or groups have competing goals and/or interpret the meaning of laws differently; rules and laws reflect the basic values of a society or institution.*

Primary grades

Ask the students, "What are some of the rules you have at home for going to bed, for eating and for playing?" Responses might include: "Be in bed by 8:00, be in bed by 9:00, eat everything on your plate, eat everything you serve yourself, take at least one bite of everything on your plate, play in your own yard, no playing after dinner." List the responses on the board in the categories indicated and any additional ones that student responses suggest. Ask the following questions:

1. Why were there different times listed for going to bed?
2. Why are there rules for eating?
3. Why are there rules for playing?
4. What sentence could we write that would be true of rules in all our families? Rephrase the question as necessary to solicit the response, "While all families have rules, each family has different ideas about them."

Ask,

5. "What do these rules tell us about the importance of children to their parents?" Rephrase the question as necessary to solicit the response that reflects the idea that taking good care of children is an important value in our society.

Ask the students, "What are some rules at school that the principal and teachers think are important, but you feel are unimportant?" Write the responses on a chart such as this one:

School Rules Not Important to Me	Why
_____	_____
_____	_____
•	•
•	•
•	•

After the responses are recorded, ask the students why they think these rules are unimportant. Write their responses under the "Why" column. A sample response might be, "Don't talk in the hall." "Why?" "Because I like to talk to my friend and can never talk to him in class." You might plan and carry out an experiment related to some of the rules that the children have identified as unimportant. The following activity, relating to talking in the corridors, could be planned and carried out with another teacher and his class: Have the

students from another class walk by your classroom and talk loudly while your students are taking a spelling test. Afterward, ask each of your students to record whether or not the noise made by the other students affected his performance on the spelling test. On another day, the classes should switch roles. Have your class make loud noises near the door of the other class while the students in it are taking a test. Put together the observations made by both classes. Discuss the results and how the students feel about the school rule after the experiment.

The following activity will help children discover how conflict may arise when individuals interpret the meanings of rules differently. Ask several children to role-play a classroom situation which has the agreed-upon rule that no one should talk during the daily math test. The rule also states the punishment. The test paper of the person who is caught talking is automatically torn up by the teacher. While he is taking his math test one morning, Johnny breaks the lead in his pencil. He quietly asks Sue for an extra pencil. After the test, some members of the class insist that Johnny's test paper should be torn up. However, Johnny becomes upset and argues that the rule does not apply to him because he was not talking but was just asking for a pencil that he badly needed to complete his test. After the role-playing situation, ask each member of the class to tell whether he thinks Johnny's paper should be torn up. Help the students to derive the generalization that even though we may have laws to govern behavior, conflict often arises when individuals interpret those laws differently.

Discuss with the students the idea of "freedom of speech" as set forth in the First Amendment to the Constitution. Write the phrase "freedom of speech" on the board. Ask the following questions:

1. What is speech?
2. What is freedom? Give some examples. (A possible response might be "Doing anything you want to.")
3. Let's put the ideas of these two words together. What does "freedom of speech" mean? List responses on the board.
4. What are some things the idea of "freedom of speech" does *not* mean? (An example may be necessary here.)

Example

Boys and girls, if you are having trouble answering this question, listen to this story. Jane is in the first grade. She told all the children in her class that Sam always steals things from her desk, that she saw him take a banana from her lunch, that he stole her library book from the coat room, and that he even stole some candy from Mr. Jones' store. Soon the children were saying to Sam, "You are a robber." "I'm not going to play with you." "You can't touch my things, Sam" "You are a thief." Jane's teacher found out that Jane was lying. Ask, Is Jane's use of speech an example of what is meant by "freedom of speech?" Why or why not?

Give to each group of two children some pictures torn from magazines. Have them group these pages into examples of "freedom of speech" and "nonfreedom of speech." The discrimination made between pictures representing freedom and nonfreedom of speech will depend on individual interpretations of the pictures. Encourage the students to talk about this as they make their judgments. An example of nonfreedom of speech might show a father scolding his child without giving him a chance to defend himself. An example of freedom of speech might show a politician making a speech in a public forum. The students can cut out the pictures from the pages and glue them onto two labeled charts to develop collages representing the two categories discussed.

Intermediate grades

Select six children from your class. Divide them into two equal groups. Give Card 1 to one group and Card 2 to the other. Direct the students to read the cards and follow the directions written on them.

CARD 1. George is accused of stealing a typewriter from the school office and selling it to a pawnshop in order to buy a new football of special design, which his parents told him that he could not have. George is an "A" student and is on the student council. He is also captain of the baseball team and a real leader. Most of the boys and girls in his class respect him highly. George is known to be a friend to everyone and is always helping out the other guy. His parents are well known in the community; his father is a doctor. George says he is not guilty. Prepare a statement to present to the class on why George should or should not be charged with the crime.

CARD 2. Joe is accused of stealing an adding machine from the school office and selling it to a pawnshop in order to buy Christmas presents for his family. Joe is a very poor student who gets mostly D's and sometimes C's. He is often in the office for being late to school, not paying attention in class, and fighting on the playground. He is a sloppy dresser, wears dirty clothes, and doesn't participate in sports. His only friend is Mike, who lives in the same run-down apartment building in a poor neighborhood. Joe's father works in the flour mill. Joe says he is not guilty. Prepare a statement to present to the class on why Joe should or should not be charged with the crime.

Have each group read the case descriptions and present their arguments to the class. Have the class vote on the following:

1. George should be charged with the crime and brought before the appropriate authorities. Yes____ No____
2. Joe should be charged with the crime and brought before the appropriate authorities. Yes____ No____

Tape-record the session, and save the tape and results of the class vote for the next day's lesson.

Follow-up lesson

Play yesterday's tape directing students to listen for the facts and assumptions that supported or rejected charging each boy with the crime. These observations should be listed on a chart similar to the one illustrated below. Stop the tape after each case presentation to make suggested notations.

Supporting facts	Assumptions made from facts
George:	
Joe:	

Rejecting facts	Assumptions made from facts
George:	
Joe:	

Display a chart on which Section 1 of the Fourteenth Amendment to the *Constitution of the United States* is written, and ask the questions which follow.

Section 1. All persons born or naturalized in the United States, and subject to the jurisdiction thereof, are citizens of the United States and of the State wherein they reside. No State shall make or enforce any law which shall abridge the privileges or immunities of citizens of the United States; nor shall any State deprive any person of life, liberty, or property, without due process of law; nor deny any person within its jurisdiction the equal protection of the laws.

1. How does the data collected relate to this Amendment?
2. Did our actions yesterday violate this Amendment? Why or why not?

3. Were the assumptions made justified? Why or why not?
4. Why did yesterday's vote turn out as it did?
5. How does this vote reflect our value systems?

Write the First Amendment to the *Constitution of the United States* on the board:

> Congress shall make no law respecting an establishment of religion, or prohibiting the free exercise thereof; or abridging the freedom of speech, or of the press; or the right of the people peaceably to assemble, and to petition the Government for a redress of grievances.

Divide your class into research groups of five children each. Direct each group to formulate an interpretation of the meaning of this statement that reflects a unanimous decision of the group. In this interpretative statement they should give examples of what they think citizens can and cannot do without violating this amendment. After the students have completed this task, ask these questions:

1. What problems occurred in your groups when you were trying to reach a unanimous decision? Why?
2. What was the source of your problems?
3. If no problems occurred, why?

Type the data collected, and ditto the material so that each student can have a copy. Direct students to read all the reports and prepare for a discussion on the similarities and differences in interpretations. During a class discussion, ask the children to explain the differences and similarities in interpretations.

Ask your students to read the newspapers for a week and collect examples of articles that relate to the First Amendment. Have students mount these articles on construction paper and write a one sentence heading for the article saying "In this article the First Amendment is interpreted to mean that. . . .," Display these articles on a bulletin board. Direct students to read them as they are displayed. After numerous articles are collected, discuss them and ask the students whether they agree or disagree with the various interpretations of the amendment demonstrated in the articles, and why. Ask: "What in your life experience causes you to make that judgment?"

Upper grades

Have a group of three students collect and research the current laws in your state concerning drug usage. Have their findings duplicated for the entire class. Discuss the laws within the following framework: (1) statement of the laws themselves, (2) legal interpretation of the laws, (3) student interpretations of the laws, (4) society's behavior toward the laws, (5) reasons for society's behavior, (6) resulting conflicts, (7) possible ways to resolve conflicts, (8) values that the laws represent, and (9) values held by persons that conflict with the laws.

Have students research forced bussing as a method to attain school integration. Direct them to find five examples of methods used to carry out bussing in five different states. Then divide the class into debating teams, one for bussing and one against bussing. The rules for the debate are: (1) All debating must be done from a legal base; from the laws and governing documents at the national level and/or state level, (2) the debaters should state the laws and then tell how they either support or outlaw bussing, (3) students should point out when local and national laws conflict.

After the research is carried out, have the groups select formal spokesmen for their sides to direct the presentation of the material collected. Audio- or video-tape the presentations if possible. After the debates discuss the following questions:

1. What were the major differences in interpretations? (List on board.)
2. Why did the differences occur? (Rephrase this question as necessary to solicit responses focusing on the conflicting values within our society.)
3. Why does conflict occur in such instances as these?
4. What possible ways can you suggest to resolve some of these conflicts?

Activity for the next day. Hand out to each of the students a sheet of paper listing the laws and parts of the governing documents that the students used to support their ideas. Leave room on these sheets so that during the debate, while they listen to the tape replay, the students can write notes on the various interpretations made of these laws. The tape replay on the following day serves several purposes: (1) It can be replayed to check points, and (2) It allows students to focus on the variety of interpretations of the laws during a session separate from the debate itself. The emotional reactions generated during the debate should have cooled so that the students can discuss the laws objectively. Discuss the student observations of each law.

1. How do the interpretations relate to the Declaration of Independence and the Constitution? Are they consistent with these documents? Why or why not?
2. How can we explain the differences in interpretations?
3. How can these differences be resolved?

Have students research several controversial legal cases such as those involving The Chicago Seven, The Seattle Eight, and the attempt to fire Angela Davis from the faculty of the University of California. Direct students to consider the following points in their research:

1. With what laws have these persons come in conflict? Find the specific laws and their source.
2. How do these laws relate to the First Amendment of the *United States Constitution*?
3. What were the circumstances surrounding the conflict in which these people found themselves?

After research has been completed discuss:

1. What do these cases have in common?
2. How are they different? Chart the responses:

Alike	Different
•	•
•	•
•	•

3. On the basis of your research and the First Amendment, under what conditions is it legal to demonstrate and speak out on controversial subjects?

Have the students vote on the case for which they would most like to role-play a mock trial. Guide the students in determining the roles which should be included in the trial, such as judge, jury, defense attorney, prosecuting attorney, witnesses, and research teams. After each role has been determined give the students time to research their role in the trial and prepare for their performance. Then carry out the trial in its entirety.

There are a number of simulation games on the market that demonstrate conflict situations in government. Simulation is an effective way to have students deal with a conflict resolution situation because of the low-risk involvement for the students themselves. Two examples of self-contained simulation games are *Dangerous Parallel*, published by Scott, Foresman, and Company, and *Democracy*, published by Webster. *Dangerous Parallel* involves six teams of Ministers from six fictionalized nations who participate in a simulation of international negotiation and decision-making. *Democracy* represents the conflict a legislator must go through as he engages in the legislative process. For example, he may have a problem which involves resolving conflicts of personal convictions, desires of the constituency, and conflicting interest groups. These games offer many opportunities for effective classroom use.

Read the class selections from *I'm Really Dragged, but Nothing Gets Me Down* by Nat Hentoff. Mr. Hentoff tells the story of Jeremy Wolf, a high school senior, who is beset by deeply conflicting responsibilities – to himself, to his family, to his country. One of his major personal conflicts is that of trying to determine what he will do in regard to the draft.

Present the students with the following excerpts from the Military Selective Service Act of 1967:

Policy and Intent of Congress

A. The Congress hereby declares that an adequate armed strength must be achieved and maintained to institute the security of this nation.

B. The Congress further declares that in a free society the obligations and privileges of serving in the armed forces and the reserve components thereof should be shared generally, in accordance with a system of selection which is fair and just, and which is consistent with the maintenance of an effective economy.

Discuss this act in relationship to the dilemma in which Jeremy is involved.

1. What values do Jeremy's father and uncle hold for him in regard to this act and its interpretation?
2. How do Jeremy's values differ from his father's?
3. What are the sources of Jeremy's values?
4. What conflict situation evolves between the act and the values of Jeremy in the story?
5. What are the factors that lead Jeremy to his decision?
6. What consequences must he be ready to face as a result of his decision?
7. What factors will cause these consequences?

SUMMARY

Political science is a discipline with many different structures and traditions. It has been defined as the study of the legal government of the state, the struggle of competing groups for power, and the "study of the authoritative allocation of values for a society." The latter definition is accepted by many political scientists because it delimits or defines the boundaries and sets a focus for the discipline.

The earliest political scientists were normative theorists who felt that their main goal should be to describe the ideal state and the means by which it could be attained. The legal-institutional approach, another tradition within the discipline, focuses on describing political laws and institutions. In the period after World War II, a new tradition, known as the behavioral approach, emerged within political science. It emerged as a protest against the normative and legal-institutional approaches. The behaviorists regard theory construction as their primary goal, and believe that political scientists should focus their study on man's political *behavior*, and not upon laws and institutions. They feel that the legal-institutional approach is inadequate because it focuses on the description of particular institutions and not on the development of empirical propositions and theory. The behaviorists reject the normative tradition because they believe that it is antithetical to the development of an empirical science. The behaviorist movement has initiated intense soul-searching within political science, and has to some extent polarized the discipline's various factions. While the movement has profoundly affected political science, it has not been a victor. Although political science is becoming more theoretical and empirical, the older traditions are very much alive within the field today.

Each of the traditions within political science has concepts and generalizations that can be profitably incorporated into the elementary and junior high-school social studies program. However, the normative tradition, with its

"All right, Senator, let's try it again from where you look up with that quizzical little smile and say, 'Slush fund? Far from it! Why, staying in office has kept me poor as a church mouse.'"

Drawing by Donald Reilly. Reproduced by special permission of *Playboy* magazine; copyright © 1969 by *Playboy*.

emphasis on values, can best be used when students are studying valuing and decision-making problems. The legal-institutional approach has dominated the discipline as well as those components of political science which are studied in the schools. Although students should be familiar with the legal codes and constitutions which affect political actors, the emphasis in school political studies should be on the *behavior* of political man. Without a focus on behavior, students will get an unrealistic view of the ways in which our political system actually works, because laws are interpreted variously by different public officials and citizens.

Students should be introduced to political science concepts in the earliest grades, and they should gradually develop a better understanding of them in successive grades. To assure that students acquire political literacy in a sequential and developmental fashion, the teacher should identify the political science concepts and generalizations that he regards as essential for students to

learn and choose appropriate content samples, teaching strategies, and materials to develop those understandings at the beginning of the year or when a curriculum guide is structured. Without such deliberate and early planning, the teaching of political understandings will be incidental and ineffective.

In kindergarten, students can be introduced to such concepts as *power, authority*, and *legitimacy*. They can study *power* relationships in the family, and the ways in which *authority* in families is *legitimized*. In the other primary grades, they can study power relationships in the school, the community, and the state in which they live. In the upper grades, they can analyze power relationships in international politics. Since one of the goals of the social studies is to help students develop a sense of political efficacy and become adept in influencing public policy, political understanding must be one of the major outcomes of a social studies curriculum which focuses on decision-making.

DISCUSSION QUESTIONS AND EXERCISES

1. What is the unique nature of political science? How does the political science "perspective" differ from the ways in which other social scientists view human behavior? What implications does your response have for planning political studies in the elementary and junior high-school grades?

2. How has *political science* been defined by different political scientists? Why do you think that political scientists define their discipline differently? Which of the definitions of political science that are reviewed in this chapter do you think is the most useful? Why? Which do you feel is the least useful? Why? How might the definition of political science which a teacher endorses affect his planning of political studies for children?

3. What does Easton mean when he states that political science is the study of the "authoritative allocation of values for a society"? Give specific examples to illustrate your response. Plan a lesson to teach the essence of this definition to a group of upper-grade students.

4. Name the various approaches and traditions that exist within political science. How are these approaches alike and different, in terms of goals and research methods? Which tradition has most heavily influenced political studies in the elementary and junior high-school grades? Why? Which approach do you feel is most promising? Why? What implications does your last response have for planning political studies in the elementary and junior high-school grades?

5. The main struggle among the various factions of political science is over *goals*. What do you feel are the most appropriate goals for the discipline? Why? What implications does your response have for elementary school social studies?

6. Study several political science college-level books and tell whether the books represent the normative, legal-institutional, behavioral, or systems approach. List the key concepts, generalizations, and theories which are contained in the books. Select several of these key concepts and generalizations and illustrate, with a teaching plan, how you would teach them to elementary and junior high-school students.

7. Analyze several junior high-school civics textbooks. Tell whether the books represent the normative, legal-institutional, behavioral, or systems approach. Document your response with excerpts from the books. Assume that you are teaching in a school in which one of these texts was adopted. Illustrate, with a lesson plan, how you would teach with the text and yet help children learn concepts and generalizations which the text does not illustrate or discuss.

8. What is the scientific status of political science? What difficulties does the scientific status of the discipline pose for the curriculum builder who is trying to identify political science concepts and generalizations for inclusion in a social studies curriculum? How can these difficulties best be overcome?

9. Select a problem, such as one related to race relations, population, ecology, or women's rights, and illustrate, with a lesson plan, how historical, sociological, anthropological, geographical, and political science concepts and generalizations can help middle-grade students to gain a better understanding of the problem and thus to make more effective decisions regarding it.

10. Structure a lesson plan illustrating how middle-grade children can implement a community study to derive generalizations about the political attitudes and voting patterns of citizens in their community. What problems might students encounter in implementing such a study? How might these problems best be resolved?

11. Select one of the following generalizations and devise a series of activities (similar to the ones in this chapter) which can be used to teach it to children in the (a) primary grades, (b) middle grades, and (c) upper grades.

 a) In every society and institution, regulations and laws emerge to govern the behavior of individuals; individuals usually experience some form of punishment when authorities catch them breaking laws.
 b) Within every society, an individual or some group is authorized to make binding decisions and to allocate values.
 c) Many different types of political systems are used in various societies to determine public policy and to regulate behavior.
 d) Individuals are more likely to influence public policy when working in groups than when working alone.

12. Demonstrate your understanding of the following key concepts by writing or stating brief definitions for each of them. Also tell why each is significant:

a) normative approach

b) legal-institutional approach

c) systems approach

d) behavioral approach

e) state

f) government

g) power

h) legitimacy

i) authority

j) interest group

k) political socialization

l) political culture

m) political system

FOOTNOTES

1. Charles S. Hyneman, *The Study of Politics: The Present State of American Political Science*. Urbana: Univ. Illinois Press, 1959, p. 26.

2. David Easton, *The Political System: An Inquiry into the State of Political Science*. New York: Alfred A. Knopf, 1960, p. 107.

3. Vernon Van Dyke, *Political Science: A Philosophical Analysis*. Stanford: Stanford Univ. Press, 1960, p. 140.

4. Easton, *op. cit.*, p. 123.

5. *Ibid.*, p. 117.

6. *Ibid.*, p. 129.

7. Francis J. Sorauf, *Political Science: An Informal Overview*. Columbus: Charles E. Merrill, 1965, p. 4.

8. Easton, *op. cit.*, p. 132.

9. Hyneman, *op. cit.*, p. 138.

10. Sorauf, *op. cit.*, p. 10.

11. Samuel Kislov, "The Legal-Institutional Approach," in Donald H. Riddle and Robert S. Cleary (Eds.), *Political Science in the Social Studies*. Washington, D.C.: National Council for the Social Studies, 1966, pp. 43-44.

12. Alan C. Isaak, *Scope and Method of Political Science: An Introduction to the Methodology of Political Inquiry*. Homewood, Ill.: Dorsey, 1969, p. 32.

13. *Ibid.*, p. 33.

14. *Ibid.*, p. 33.

15. *Ibid.*, p. 27.

16. Robert A. Dahl, "The Behavioral Approach in Political Science: Epitaph for a Monument to a Successful Protest," in Martin Feldman and Eli Seifman (Eds.), *The Social Studies: Structure, Models, and Strategies*. Englewood Cliffs, N.J.: Prentice-Hall, 1969, p. 132.

17. *Ibid.*, p. 132.

18. Vernon R. Iredell, "Political Science," in John U. Michaelis and A. Montgomery Johnston (Eds.), *The Social Sciences: Foundations of the Social Studies*. Boston: Allyn and Bacon, 1965, p. 122.

19. Russell Kirk, "Segments of Political Science Not Amenable to Behavioristic Treatment," in James C. Charlesworth (Ed.), *The Limits of Behavioralism in Political Science: A Symposium.* Philadelphia: American Academy of Political and Social Science, 1962, p. 54.

20. Dahl, *op. cit.*, p. 133.

21. David Easton, "An Approach to the Analysis of Political Systems," in Feldman and Seifman, *The Social Studies: Structure, Models, and Strategies.* Englewood Cliffs, N.J.: Prentice-Hall, 1969, p. 140.

22. Easton, *op. cit.*, p. 65.

23. *Ibid.*, pp. 39-44.

24. Sorauf, *op. cit.*, p. 14.

25. Franklin K. Patterson, *Man and Politics: Occasional Paper No. 4.* Cambridge: Educational Services Inc., 1965, p. 19.

26. Isaak, *op. cit.*, p. 16.

27. Sorauf, *op. cit.*, pp. 3-4.

28. Patterson, *op. cit.*, p. 23.

29. Sorauf, *op. cit.*, p. 45.

30. John S. Gibson, "The Process Approach," in Riddle and Cleary, *op. cit.*, p. 65.

31. *A Conceptual Framework for the Social Studies in Wisconsin Schools.* Madison: State Superintendent of Public Instruction, Social Studies Bulletin No. 4, Curriculum Bulletin No. 14, pp. 10, 14.

32. Byron G. Massialas, "American Government: We Are the Greatest," in C. Benjamin Cox and Byron G. Massialas (Eds.), *Social Studies in the United States: A Critical Appraisal.* New York: Harcourt, Brace and World, 1967, p. 179.

33. Quoted in Frederick R. Smith and John J. Patrick, "Relating Social Studies to Social Reality," in Cox and Massialas, p. 114.

34. Patterson, *op. cit.*, pp. 21-22.

35. *Ibid.*, pp. 25-26.

36. Maurice P. Hunt and Lawrence Metcalf, *Teaching High School Social Studies.* New York: Harper and Row, 1955, pp. 431-453.

ECONOMICS: STRUCTURE, CONCEPTS, AND STRATEGIES

THE ECONOMIC PERSPECTIVE

Human behavior is viewed from different perspectives within each of the social sciences. A historian, sociologist, and political scientist would view the campus revolts of the 1960's differently. Each of the social sciences provides us with lens through which we can view the human drama; each enhances our insights and understandings. Economics, too, enables us to see human behavior from a unique perspective. The key concept in this discipline is *scarcity*, and the science focuses primarily on how man tries to satisfy his virtually unlimited wants with limited resources. The major principle of the discipline is that there are not enough natural and human resources to satisfy all of man's wants. (See Fig. 10.1.) Economists study how man uses limited resources to *produce, exchange*, and *consume goods* and *services*.

THE PRODUCTION-POSSIBILITIES CONCEPT

Economists often employ a hypothetical production-possibilities example to show how a society must make hard choices when determining what goods and services to produce with its limited resources. We will use such an example here to illustrate this important economic principle.

Society X has the resources and technological know-how necessary to produce a maximum of five bales of cotton *or* sixteen bushels of corn. To produce five bales of cotton or sixteen bushels of corn, Society X must maintain full employment at its current level of technology. It does not have the resources needed to produce *both* five bales of cotton and sixteen bushels of corn. If it decides to raise both cotton and corn, the quantities of each product must be less than the maximum amounts that could be produced if only one

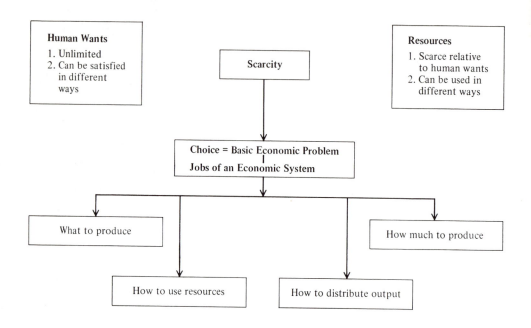

Figure 10.1

(Reprinted with permission from William D. Rader *et al., Elementary School Economics I, Teacher's Guide.* Galion, Michigan: The Allied Education Council, 1967, p. 98.)

crop is raised. Fig. 10.2 illustrates the various combinations of cotton and corn which Society X can produce. The table indicates that as the amount of one product increases, the amount of the other decreases. If one bale of cotton is produced, fifteen bushels of corn can be produced; if five bales of cotton are produced, no corn can be produced. Likewise, when sixteen bushels of corn are produced, no cotton can be raised.

Our table suggests that a society must sacrifice some products in order to produce others because of the limitations of both human and nonhuman resources. As one economist has stated, "Society cannot have its cake and eat it too. This is the essence of the economizing problem."[1] Figure 10.3 graphically illustrates the production-possibilities of cotton and corn in our hypothetical society. If Society X experiences some unexpected catastrophe, such as a destructive wind storm, extreme rainfalls, prolonged unemployment, or if its present level of technology declines, it will not be able to produce the maximum quantities of either cotton or corn.

Figure 10.2
The Production-Possibilities of Cotton and Corn in Society X

Production Possibilities	Cotton (in bales)	Corn (in bushels)
A	0	16
B	1	15
C	2	13
D	3	10
E	4	6
F	5	0

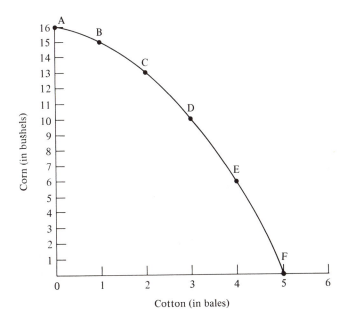

Figure 10.3
Production-Possibilities Graphically Illustrated

THE ECONOMIC PROBLEM

The basic economic problem faced by every society is how to best use its limited resources to satisfy its wants and to assure its existence. Every human society must solve three related economic problems: *What goods and services shall we produce and in what amounts? How shall they be produced? And for whom shall they be produced?*

Throughout history, man has used different methods to solve these perennial problems. In determining what to produce and how to produce it, some societies have relied heavily upon tradition.[2] Among the Hopi Indians of North America, corn was the most important crop, largely because traditionally corn had been raised and to some extent even venerated. Until recently in many of our Southern states, cotton was the dominant crop because of the "cotton" tradition in the South. In recent years, with the growth of Southern technology and the recognition by Southerners of the disadvantages of a one-crop economy, Southern farmers have begun to diversify their crops. Every society to some extent relies upon tradition to solve the three basic economic problems. Heilbroner notes how tradition can negatively influence an economy, *"Its solution to the problems of production and distribution is a static one.* A society which follows the path of tradition in its regulation of economic affairs does so at the expense of large-scale rapid social and economic change."[3]

In some societies public authorities determined what goods and services were produced.[4] Dictators such as Castro, Hitler, and Franco not only exercised political control within their nations, but to a great extent determined which goods and services would be produced and for whom they would be produced. Government control over the economy is more prevalent in Communist countries than in the United States. However, as Heilbroner correctly points out, in every society the government influences what goods and services are produced as well as how they are distributed. He cites as an example our taxes or ". . . the preemption of part of our income by the public authorities for public purposes."[5] The degree of government influence varies in different nations.

THE MARKET ECONOMY

In the same year that the Declaration of Independence was signed (1776), a book was published in Europe which signaled a revolution in the economic world. Adam Smith, the "father of economics," published *The Wealth of Nations*. Prior to the publication of this classic, the status of economic systems in the Western world had been largely shaped by a group of European writers known as the mercantilists. They felt that a sound economic system had to be tightly controlled by centralized authorities.[6] Without such control within an economy, they believed, the results would be confusion, depression, and chaos. Adam Smith's seminal book challenged the ideas of these influential writers.

Smith believed that the best type of economic system resulted when the government maintained a "laissez-faire" or "hands-off" policy. Manufacturers would be forced to produce the goods that consumers wanted because otherwise they would fold because of lack of sales. Only those goods which satisfied customers would remain on the market. Competition between producers and manufacturers would assure that prices would not become too high. Merchants who charged too much for their goods would go out of business because consumers would buy goods at those stores with reasonable prices. The government could best help the economy, Smith argued, by leaving it alone.

Smith's ideas are embodied in the *market economy*, the economic system, in modified form, used in the United States and in many other nations to solve the three basic economic problems. In a market economy, the customers largely determine *what* goods and services are produced, and the quantities in which they are produced. In the 1960's, the Edsel Ford had to be withdrawn from the market because of lack of sales, while the number of Volkswagens bought by American customers soared. Americans liked the Volkswagen but didn't care too much for the Edsel. However, our economy is not a pure market economy, but a *mixed* one. The federal government plays a large role in determining what goods and services are produced in the United States. Numerous diet drinks were forced off the market by the government in the summer of 1969 because they contained harmful chemicals called cyclamates. During the 1970 Christmas season, 39 unsafe toys were withdrawn from the market by government mandate.

Every reader of this book must know how heavily the subtle and often deceptive television, radio and other advertising influences the wants of American consumers. Many Southern housewives in the 1950's used only a small number of basic detergents and soaps for household chores. However, the average middle-class housewife today uses an infinite number of "specialized" cleaners and spot removers. The soaps used to clean the bathroom, the oven, woodwork, and to wash dishes are all different. These specialized desires and "needs" have been largely shaped by the commercials on the soap operas which many of today's housewives spend hundreds of hours watching each year. The tremendous impact which the anti-smoking commercials had on smokers during the 1960's and 1970's is another example of how consumer wants are shaped by the mass media. Thus, consumers, the government, and the producers themselves all play a role in determining *what* goods and services are produced in our mixed economy.

Business firms largely determine *how* goods and services are produced in the American economy. Their main goal is to produce the largest amount of goods and services for the smallest outlay of resources. Most large industries specialize in the products they make, and have a division of labor within their plants. By producing only a few kinds of items and using a production line technique to manufacture them, firms make maximum use of their resources. Our national government, as well as labor unions, to some extent influences *how* goods and services are produced. The government sets minimum safety standards and regulates the use of dangerous machines. Strongly organized unions, which are highly influential in our society, demand specific kinds of working conditions, hours, and salaries.

How do we determine within a market economy *who* will get the goods and services produced? To a great extent, the persons who contribute most to the production of goods and services also consume or use most of them. Two persons with comparable training and experience who do identical work at an automobile plant usually earn a comparable salary. They can buy about the same amount of goods and services each month. In principle, this is what happens in a pure market economy; the goods and services that a person receives are roughly comparable to the contribution he makes to the total production of goods and services for the society.

"Dad, I'm the only kid on the block without a credit card."

Drawing by Joseph Serrano. Reprinted Courtesy of *Parade Magazine.*

Often this does not happen in our mixed economy, but to some extent it does. A person's salary at an automobile plant might be determined more by the strength of his union than by the contribution he makes to the production of society's goods and services. Experience, level of education, and the influential persons whom he knows might heavily influence a worker's salary.

Because of certain values within our society, the federal government often intervenes to upset the "natural" working of the market economy. Disabled and retired workers, unwed mothers, unemployed workers, and public officials often receive a share of society's production pie even though they may contribute very little or nothing to the production of the goods and services which they consume. Federal legislation also prevents children from working in industry. They are perhaps the largest single segment of nonproductive consumers in the United States.

THE DEATH OF ADAM SMITH'S DREAM

Smith had urged the government to keep its hands off the economy. He felt that if left alone, the market system would result in a balanced, efficient, and just economy. When free market economies developed within Western societies, it was not long before it was fairly clear that Smith's ideas were overly optimistic. Because merchants tried to make the highest profits with the least amount of resources, their interests were often contrary to those of consumers. And because they were, merchants often used devious methods to get and keep sales; consumers often didn't have the choices that Smith thought they would have because monopolies emerged and merchants conspired to raise prices and to "beat the consumer." In this nation, railroads were among the first large monopolies, and the federal anti-trust laws unsuccessfully attempted to shatter such seats of power.

The government gradually assumed greater and greater responsibilities in the economic realm. The stock market crash of 1929 and the publication of John Maynard Keynes's *The General Theory of Employment, Interest and Money* in 1936 were two significant events which helped to legitimize government intervention. The great depression painfully revealed the ills which could plague a market economy. Keynes's book suggested that because of the tremendous freedom that customers and businessmen have in a market system, "the total demand for new goods and services will sometimes be too large and sometimes too small to keep us at full employment."[7] Thus, from time to time the government needed to intervene in order to spike up the economy. Even though Malthus and a few other writers had challenged Smith's laissez-faire theory prior to this time, it had survived all criticisms with the help of such influential writers as David Ricardo and John Stuart Mill. But the tragic fate of Smith's powerful legacy was imminent. The free market economy was gradually replaced by a highly mixed one.

IS ECONOMICS A SCIENCE?

Throughout Part 2 of this book, we have been using the criteria of a science set forth by Berelson and Steiner to judge the scientific status of the various social sciences. We suggested that a science is characterized by public procedures, precise definitions, and objective data collection. The approach to knowledge is systematic and cumulative, and the main goal is to build *theory* which can be used to predict and control behavior. We will use these criteria to assess the scientific status of economics.

The intellectual experiment: a public method

Unlike most other social scientists who make extensive use of the laboratory experiment and the structured interview, economists cannot conduct laboratory experiments, and the interview technique is not a major research strategy within the discipline. The most frequently used method in economics is the *intellectual experiment*.[8]

The economist tests hypotheses by *assuming* that all the variables are constant (or equal) except the variable whose effect he is trying to determine (the independent variable). Let's study an example. Professor Jones, an economist at State University, studies this problem, "What is the most important factor influencing consumer demand for compact cars? " He concludes that the *price* of compact cars is the most important factor. He bases his conclusion on the analysis of statistics that show the cost of compact cars and the number purchased within each of the last ten years. What factors did Professor Jones assume to be equal or constant? He assumed that the income of consumers, the quality of compact cars, and the price of larger cars were constant variables. *In other words, he assumed that of all the other factors which might influence consumer demand for compact cars, only the price varied.*

In the real world (which the economist *simplifies* for research purposes) other factors often do not remain constant. In applying his generalization, Professor Jones may find that even though the price of compact cars increased significantly the following year, the number bought also increased. Several new American compact cars hit the market, and the hourly wages of consumers reached a new peak. These factors brought about an unexpected increase in the number of compact cars purchased.

In determining the production-possibilities of cotton and corn in Society X earlier in this chapter, we *assumed* that Society X would not experience any natural catastrophes, that all workers would remain employed, and that its level of technology would remain constant. Because economic research is based on such tenuous assumptions, economic generalizations are often highly tentative and have low applicability. However, economic generalizations are not completely invalid, but are invalid under certain circumstances.

Economists often show the relationship between economic concepts with mathematical and graphic models. The production-possibilities example in this chapter is a highly simplified model. The *intellectual experiment* procedure is a *public* method because economists usually state the variables which they assume to remain constant or equal.

Nature of economic concepts

Economic concepts are probably more precise than those in any of the other disciplines which we have discussed. The meaning of such concepts as *scarcity, production,* and *exchange* are rather standard within the discipline. This can easily be seen by examining one of the several dictionaries of economics. There is also a great deal of consensus about what the key economic concepts and generalizations are. The tables of contents in most introductory economics textbooks look very similar.

Objectivity in economics

Since most economic data is quantitative (such as the prices of goods, the number of hours that employees work and hourly wage rates), data collection within the discipline tends to be more objective than in many of the other social sciences. Much of the data used by economists is compiled by such agencies as various departments of the federal government. Because of the use of models and the quantitative nature of economic research, statistics are often used to analyze data as well as to control variables which economists would otherwise be unable to control or hold constant. The quantitative nature of the data, preciseness of the concepts, and the intellectual experiment method make it possible for one economist to replicate studies done by others. As we noted in Chapter 5, the replication of research in a discipline such as history is difficult because of the vagueness of the concepts and the subjectivity of the method.

Economic analysis and policy economics

Determining whether a discipline's main goal is the development of theory is the most revealing test of its scientific status. Economists usually distinguish two major approaches within the discipline. One approach is called *economic analysis* or positive economics. Its main goal is the development of empirical theory. High-level generalizations about the *law of supply and demand,* the *law of diminishing returns*, and the *law of scarcity* are examples of the products of this method of inquiry. The other approach is known as *policy* or normative economics. The goal of policy economics is to use the generalizations and theories developed in economic analysis to solve social problems which are largely economic in nature. This approach deals with such problems as "Should we reduce income taxes in order to stimulate the economy?" and "How can we best manage the economy so that we have sound welfare programs?" Bach has outlined the steps in policy economics:

> *[1] . . . define the problem . . . [2] map out the main alternative ways of achieving the desired goals . . . [3] analyze carefully the alternative policies outlined in step two . . . [4] check your solution — both against flaws in your own analysis resulting from fallacies or blind spots, and against past experience*[9]

Economics is both a science and an applied discipline. *Economic analysis* is scientific because the goal is to develop empirical theory. *Policy economics* is an applied field because it deals with *value* questions as well as with scientific knowledge. In order to determine the goals of an economy (such as in Bach's step 2), we must make one value choice instead of another. *Thus value inquiry is an essential part of policy economics.*

There are difficulties inherent within a discipline that has both scientific and policy aspects. When an economist makes a statement or recommendation, it is often not clear whether he is speaking as a scientist; i.e., basing his statements on scientific knowledge alone, or whether his statements are derived from a combination scientific-valuing process, i.e., whether they reflect his personal biases. The dual nature of the field is largely responsible for the notorious reputation which economists have for disagreeing among themselves. Someone once said, "If you laid all the economists in the world end to end, they would still not reach a conclusion."[10] Although there is actually a great deal of agreement among economists about the nature of the discipline and its key concepts and principles, they have different values and ideas about what the proper goals of an economy should be, and they often, as is to be expected, disagree about policy issues. The public does not often make this distinction, largely because economists rarely make it themselves when they make public statements. When teaching economic studies in the elementary and junior high-school grades, the teacher should help students discover how economic analysis can help policy-makers determine the possible consequences of different courses of actions, but emphasize that citizens, not economists, must

determine the goals of the American economy. The economist has no special competencies nor does he have the right to determine the goals of an economic system. One economist has suggested that most Americans embrace the following economic goals: economic growth, full employment, price stability, economic freedom, and an equitable distribution of income and economic security.[11] While his analysis may be accurate, conflicts and disagreements over goals still occur because people interpret these goals quite differently.[12]

Levels of economic analysis

Economists derive generalizations about economic behavior at two levels. *Macroeconomics* focuses on large units, such as the economy as a whole or major divisions within it, "such as government, households, and businesses."[13] *Microeconomics* "is concerned with *specific* economic units and a detailed consideration of the behavior of these individual units. Here we talk in terms of an individual industry, firm, or household and concentrate upon such magnitudes as the output of a *specific* product, the number of workers employed by a single firm, the revenue or income of a particular firm or household, [or] the price of a particular product. In microeconomics we examine the trees, not the forest."[14] Generalizations which are valid in macroeconomics are not necessarily valid on a small scale of analysis. For example, the *fallacy of composition*, a common fallacy made when laymen talk about economic problems, is assuming that what is true for the part is also true for the whole. A small manufacturer who lowered his prices might increase his sales and therefore his profit because consumers tend to buy more goods when prices decrease. However, if *all* the manufacturers within an economic system lowered their prices, their sales would not necessarily increase. Total input into the circular flow of income would be lowered and wages would be lowered as a consequence. People tend to buy less when they make less money. Our example illuminates the importance of distinguishing these two levels of analysis.

ECONOMIC CONCEPTS

The key concepts, generalizations, and theories within a discipline, and its unique modes of inquiry, constitute what Jerome S. Bruner and other writers have called its *structure*. Helping children to master the key ideas which make up a discipline will enable them to use that discipline's perspective(s) to solve social problems more effectively. We have called the approach which involves identifying the key concepts within a discipline to guide social studies instruction the *conceptual approach*. This approach can and should be profitably used throughout the elementary and junior high-school social studies program, but it is often difficult to identify the key ideas within a discipline because of the great amount of disagreement among some social scientists about the key concepts within their disciplines. In previous chapters, we have seen how difficult it is to select key concepts from history and political science

when planning a conceptually oriented social studies program. Although economists often vehemently disagree about policy problems, the consensus about key economic concepts and generalizations makes it convenient for the classroom teacher or curriculum builder to select appropriate ones for the social studies program.

There is not only a considerable amount of agreement about what the key concepts in economics are, but their definitions are also highly standardized. Almost any economist would regard the law of *supply and demand* and the law of *diminishing returns* as key economic ideas, and he would define them in much the same way as other economists. For our discussion below, we have selected those key economic concepts that we feel elementary children can master without difficulty, and ones that will prove especially helpful to them as they attempt to make decisions on important social issues.

Scarcity

Just as *culture* is the main concept in anthropology, and *group* is the key sociological concept, *scarcity* is the most important concept in economics. All the other economic principles and theories are related to it. The essence of this concept is that while man has unlimited wants, the amount of resources within any society are limited. Thus there are never enough goods and services to satisfy all of man's wants. Consequently, man must make some hard choices when he decides what goods and services he will produce with his limited resources. When a society develops a higher level of technology and is able to create more and better goods and services, man's wants also increase. Writes Senesh, "The central idea of economics is the scarcity concept, namely that every society faces a conflict between unlimited wants and limited resources. Out of this concept a family of ideas emerge."[1][5]

Even though they may not have viewed them from an economic perspective, all children have had many experiences related to this concept. They have heard their parents discuss whether they should take a vacation next summer or paint the house, since they cannot afford to do both. A child might have to decide whether he will get a new bike for Christmas or a chemistry set, or whether to spend his weekly allowance to see a puppet show or a movie. Since all children have many experiences related to this concept, the teacher can use them to help pupils understand it. Role-playing and case study approaches are methods that can be used to draw upon the daily experiences of youngsters to teach them key social science concepts. Because scarcity is central to economics, we will discuss in the final section of this chapter specific strategies that can be used to effectively teach it. Senesh and other economics educators have been successful in teaching this concept to young children. We will later review some of the new programs in economic education.

Production

Production is the process of creating goods and services which satisfy human wants. Production is sometimes defined as "the process of increasing the

capacity of goods to satisfy human desires or of rendering services capable of satisfying human desires."[16] The farmer who grows cotton and corn, the worker who works on a Ford assembly line, and the housewife who cooks and sews for her family are all producers. Workers who produce services, such as doctors, teachers, and service station attendants, are also producers. When teaching this concept, the teacher should make sure that children grasp the idea that most members of society in some way contribute to the total production of the goods and services which we consume. Children are not likely to think of their teachers or themselves as producers. However, when they wash dishes, mow the lawn, and do other chores around the house they are producing a service for their families. Although economists are primarily interested in the goods and services that are produced for exchange, these other examples will help children understand this concept.

Goods and services

Goods are products that satisfy consumer wants. A service is work done that satisfies consumer wants. Books, food, toys, and automobiles are examples of goods; teaching, washing windows, and nursing are examples of services. As these terms are used in economics, they do not imply that a consumer must be pleased before we can consider products as goods, or work done, as services. As long as products are consumed by customers, they are considered goods. These two concepts are necessary to help children think about man's behavior from an economic perspective.

Consumption

Consumption is the use of material goods and services to satisfy human desires. Persons who drive a car, go to the doctor, or go to school are all consumers. This concept is important because children should realize that every human being, in order to survive, must consume goods and services, and that these goods and services must either be produced by themselves or someone else. When teaching this concept, the teacher can use historical and contemporary content samples to help children discover that while early American colonists produced most of the goods and services which they consumed, most of the goods and services that we consume today are produced by someone else. This situation makes today's consumers very dependent on other workers for the satisfaction of their material wants and needs.

Interdependence

Interdependence is relying on other producers for the goods and services needed to satisfy our wants, and helping others to satisfy their wants by participating in the production of the goods and services that they consume. In Colonial America, and in many preliterate societies, families were highly independent because they produced their own foods and most of the other goods and services which they needed. Early American farm mothers made many home remedies to treat their children's diseases, canned most of their

foods, and sometimes members of families delivered the babies. Because workers in highly technological societies are so specialized, most families cannot exist without relying heavily upon the goods and services produced by other workers. *Specialization* makes a society highly efficient, since each worker can master his specific task, but it also makes consumers highly vulnerable as we witnessed in 1970 when the mail carriers went on strike. For several weeks the nation was almost paralyzed, and if the strike had lasted longer, the situation would have reached crisis proportions. So many businesses depend upon the mail to function that a postal strike has severe repercussions in our society. Other strikes also endanger our economy. A railroad strike is so threatening to our economic system that the federal government usually intervenes when a railroad strike seems imminent, as happened in December of 1970. A strike of key workers in our society – and strikes have become increasingly frequent in recent years – reveals how much we are dependent on other workers. Children should be aware of the strengths as well as the shortcomings of our highly specialized society.

Division of labor

Division of labor consists of dividing the production of goods or services into smaller parts so that each worker does a specific and specialized job. This process often involves an *assembly line* technique. Usually each person who helps to manufacture an automobile makes or attaches only one part. Leiter states the advantages of this method: "Output rises because (1) time is saved, as each worker learns his task more rapidly and does not have to shift from one task to another; (2) special characteristics such as height, strength, and intelligence, may be employed more effectively in the performance of a task; (3) greater skill is acquired by constant repetition of the same operation; and (4) tools are utilized more fully."[17] We have already suggested some of the disadvantages of specialization and division of labor. Also, as Leiter points out, "division of labor lowers the morale of workers."[18] If a large number of workers help to make a product, it is difficult for any one of them to gain a great deal of satisfaction from its production. With increased specialization, the idea of "pride in workmanship" tends to go out the window. Specialization also creates a number of social problems for the individual which the teacher should explore with his pupils when this concept is being taught. The following activity can help children grasp this concept: "The class may organize two teams. One team executes a production process, such as making gingerbread boys on an assembly line, while the other makes them without using the division of labor. The timekeeper decides which of these teams has been able to produce a given amount in less time and with less waste of tools and materials."[19]

Exchange

Exchange is "the voluntary transfer of goods or the performance of services in return for other goods, services, or money."[20] In most market economies, money is the most frequently used medium of exchange. Money is not only a

The teacher can use money to help children to better understand our complex market economy. (Donald E. Miller, Mercer Island (Washington) Public Schools)

medium of exchange but is also "an indicator of the rate of exchange."[21] *Barter*, or the direct exchange of goods and services, was frequently used in preliterate societies and in early America.[22] This is an extremely important concept; children have had many experiences related to it. Most have bought items at the store, traded two small marbles for one steel one, or one comic book for another. Again, the teacher can use such techniques as role-playing and dramatization to draw heavily upon the experiences of the children when teaching this concept. For example, the children could have a "county fair." They could make items in their art and shop classes and trade them for items made by other children during the fair. They should try to make the best possible items with as few resources as possible, and market them at the highest possible price. This activity can teach children much about the law of supply and demand and the marketing of goods. For example, the child who wants too much for his items, or who produces items that are not wanted by other children, will be unable to trade. The children may also use such techniques as advertising to stimulate sales. A discussion of advertising and ethics could be initiated.

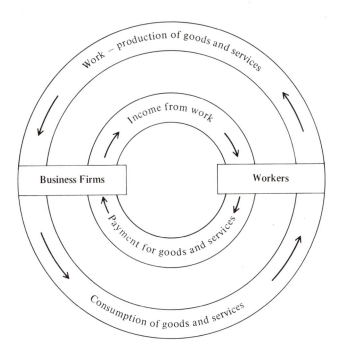

Figure 10.4
The Circular Flow of Income

The circular flow of income

Money flows from business firms to workers, and back to firms; the circle is continuous. When workers produce goods and services for business firms, they are paid for their work. When they buy goods and services, the money which they earned as salary for producing them is paid to the firms or to markets which sell goods. Thus income continuously flows, and the people who produce goods also consume them. Figure 10.4 illustrates this circular process. John E. Maher found in his work with children in school systems throughout the United States that even first-graders can understand this concept, that they enjoy it, and that teachers like to teach it.

ECONOMIC GENERALIZATIONS

Since the key concepts in economics can be readily identified, it is not difficult to find generalizations which show the relationship between economic concepts. Generalizations that can be used to guide economic studies in the

elementary and junior high-school grades are found in introductory economics textbooks, professional books on the teaching of social studies, and in many curriculum guides which have been prepared by school systems throughout the nation. The following generalizations are representative of the types which teachers can use to guide the planning of economic studies. They are reprinted from a state social studies curriculum guide:[23]

People are interdependent, and dependence has increased.

All families and family members in a community are dependent upon one another. Division of labor refers to the separation of production into various jobs.

Individual producers of goods and services exchange with others to get the goods and services they need to satisfy their basic wants.

The growth of interdependence increases the problems of adjustments for the individual in the society, and it also increases the need for coordination through organization-managerial direction and market mechanisms.

A conflict between unlimited wants and limited resources creates the need for decision making.

Choices are based on the individual's value system, but the value systems are to a large extent culturally derived. Needs and wants are therefore culturally derived.

Price is a measure of the relative scarcity and need for goods, service, or resources.

Money is an institution to facilitate the operation of an exchange economy.

When we spend money, it does not disappear; it continues to circulate as long as people do not hoard it.

Income is earned by producing goods and services.

Individuals who contribute to the production process receive a share of the goods and services produced.

Taxes are sometimes used to redistribute income.

Consumers determine what is produced in a free economy, considering all the available alternatives. Advertising and the mass media often influence choices.

Government has become increasingly a participant in the market economy. It is a competitor and also a creator of economic opportunities.

If customers buy less, the factory needs fewer workers which leads to unemployment.

Policies which an individual uses to promote economic stability for the family unit will not necessarily be effective when generalized to the economy as a whole.

Labor unions seek job security for their members (escalator clauses, pensions, seniority rights, guaranteed annual wages, etc.)

Part of increased productivity has led to an increase in leisure time which has created a demand for new goods and services.

ECONOMICS IN THE ELEMENTARY AND JUNIOR HIGH SCHOOL

The need for economic understanding

In the beginning months of 1971, our nation faced one of the most severe economic recessions in recent history. While unemployment levels reached new highs, the price of goods and services spiraled. Many consumers made less money but needed larger amounts to buy goods and services. In some cities the unemployment situation reached crisis proportions. Unemployment in Seattle, Washington, was nearly 10%. The aircraft industry suffered great drops in sales, and aircraft was Seattle's most important industry. The welfare rolls steadily grew in all our major cities, and a movement for welfare reform created an intense controversy in the Senate. The need for economic insight was especially acute during these critical months.

Even during periods of relative prosperity, the current economic problems divide large segments of the population, baffle policy-makers, and are sources of great unrest throughout our society. Part of our inability to find viable solutions to complex economic problems results from economic ignorance on the part of both citizens and public officials. Because of their confusion about the nature of economic issues, citizens often vote for candidates who make grand and unrealistic promises about economic reform. Frequently candidates make such promises out of ignorance, but just as often they make them merely to get votes and do not consider how they might implement the promised reforms.

To be able to judge the soundness of proposals for economic reforms, citizens must have a clear understanding of the nature of our mixed economy, and an awareness of the great complexity of modern economic systems. Because many students terminate their formal education when they leave the public schools, the schools must implement sound programs in economics education if the citizens of future decades are to intelligently influence economic policy and participate effectively in our political system. Almost all the social issues which our society faces have economic aspects, and the economic perspective will help us greatly to resolve them.

Although the economic point of view can help us in solving social problems, economics cannot tell us whether we should have a guaranteed annual income for all families, or whether income taxes should be reduced or increased. However, economic concepts and principles can help us to *predict* the possible consequences of a guaranteed annual income or of an increase in income taxes. The discipline cannot tell us what the consequences of these actions *will be*; as we have suggested, economic principles, in common with

These children created a corporation that made and marketed six different products. This kind of project can help children to become more knowledgeable about our economy. (Grand Coulee Dam School District, Grand Coulee, Washington)

other social science principles, depend on many variables. Nevertheless, even tentative knowledge can help us to make decisions on complex economic problems by illuminating the probable consequences of different courses of action.

Economic education is complicated by the fact that students, like adults, have many misconceptions about the economic system. Often social commentators, equally ignorant about economic matters, reinforce the common myths about the economy. Almost everyone is his own self-styled economic "expert." Economics and education probably have more "experts" than any of the other disciplines. For example, a common fallacy is made by laymen when they assume that what is good for their individual situation is also good for the economy as a whole. When our economy is depressed, individuals often argue that the economy would recover if the government would simply stop spending money. An individual can improve his economic situation by saving a significant portion of his income, but much unemployment results when the government limits spending because many people work in government-related industries. In some cases, it is necessary for the federal government to *increase* spending in order to stimulate a decaying economy.

Because money is such an important part of our lives (it is often said that money, not love, makes the world go 'round), reasoning on economic issues tends to become clouded by emotions. Citizens might be opposed to increasing

*"The good news, I'm in the vanguard of the fight against inflation - -
the bad new is, I'm fired."*

Reproduced with permission from the *Chicago Daily News*. Editorial
cartoon by John Fischetti.

taxes but would keep demanding more efficient and extensive services from the
city or federal government. Children should be helped to understand that more
extensive public services mean higher taxes. The *scarcity* concept will help
them to discover that you can't have your cake and eat it too. Citizens should
demand honesty on the part of public officials and the most efficient services
possible from the funds which are spent. However, expecting something for
nothing and demanding efficient use of scarce resources are separate matters;
economics will help children to make this distinction.

A sequential program in economics education

The need for economic understanding is too important to be left to chance.
While many gifted teachers help children to view traditional content from an
economic perspective, we can be assured that all children gain economic
understanding only if we plan a specific program of instruction. This does not
mean that a separate economics program should be implemented. We do not
recommend this approach to economics instruction in the elementary and
junior high school. Rather, the social studies staff or teacher should identify a
number of key economic concepts and related generalizations which can be
taught with the content samples that constitute the core of the social studies
program. *Economics is not specialized content, but a unique way of viewing*

Key economic concepts should be taught throughout the elementary
and junior high-school grades. (Seattle Public Schools, Washington)

the content that presently constitutes the social studies curriculum. The key
concepts and generalizations identified should be introduced in the earliest
grades and further developed in other grades. Children will gain an increasing
depth of understanding as they study concepts in successive grades in a
spiraling fashion.

There are many opportunities for the teacher to introduce and extend
economic concepts with content that constitutes the traditional social studies
curriculum. Let's consider how the concept of *scarcity* and a related
generalization, *every individual and society faces a conflict between unlimited
wants and limited resources*, might be introduced in kindergarten and further
developed in successive grades. The teacher could introduce this concept in
kindergarten with a role-playing situation. In the situation, Mother and Father
are trying to decide whether they should take a trip next summer or add a

needed room to the house. They do not have enough money to do both. The teacher could ask the children such questions as, "What is the problem in this situation?" "Why is there a problem?" "Why do you think that Mother and Father can't do both things?" "Have you ever had to make a choice between two things?" "What did you decide to do?" "Why?" "What helped you to decide?" "If you were Mother and Father, what would you do?" "Why?"

The study of *community helpers* in the next grade could extend this concept. The teacher could ask the children to name the services that the community provides (he might start by showing them pictures of the helpers in the community), to hypothesize about why more services are not provided, and to think of ways that the present services could be extended and improved. He could then ask them *why* current services are not better or more extensive. The teacher should help the children discover that a community has limited funds (derived from taxes), and that it cannot provide unlimited services, such as more street sweeping, more fire stations, or more policemen.

Topics such as foods, clothing, transportation, and Our State, traditionally parts of elementary social studies, also contain content samples which can further develop this concept. Investigating how people must make choices when buying clothing and why public transportation systems are inefficient in many of our cities, and becoming aware of the continuous search by state officials for additional funds to provide needed public services will extend the concept of *scarcity* in later grades.

The concepts of *production, goods, services, consumption, exchange*, and *interdependence* should also be built into the social studies program. To facilitate the teaching of these concepts and to extend children's understanding of an economic system, the teacher can pose the three basic economic problems – *What? How? For whom?** – and help the children determine, through their inquiries, how they are solved by different kinds of societies. The teacher should select societies which have different kinds of economies so that the children can derive the generalization that while all human groups have solved these basic economic problems, they have invented a wide variety of ways to solve them. A data retrieval chart, like the one illustrated in Fig. 10.5, could be made. The National Task Force on Economic Education emphasized the importance of children's knowing how different societies solve common economic problems.[24]

RECENT DEVELOPMENTS IN ECONOMICS EDUCATION

Vigorous efforts have been made in recent years to improve the teaching of economics in the public schools. One of the most significant developments in economics education was the publication of *Economic Education in the Schools, Report of the National Task Force on Economic Education* in 1961.[25] This report, sponsored by the American Economic Association and

*What goods and services shall we produce and in what amounts? How shall they be produced? For whom shall they be produced?

Figure 10.5
Data Retrieval Chart: How Societies Solve the Three Economic Problems

Analytical Concepts*	Economy of the United States	Economy of the Zuni Indians	Economy of the Soviet Union
WHAT *goods* and *services* are *produced* and in what quantities?			
HOW are *goods* and *services produced?*			
FOR WHOM are *goods* and *services produced?*			

*The analytical concepts in each question are italicized.

written by an eminent group of economists and educators, indicates that economists are vitally concerned about the study of economics in the schools. The report suggested the *need* for economic education: "Economic understanding is essential if we are to meet our responsibilities as citizens and as participants in a basically private enterprise economy. Many of the most important issues in government policy are economic in nature, and we face economic problems at every turn in our day-to-day lives."[26] The Task Force identified seven major areas of economics which it felt that every high school graduate should understand. These included the nature of economics and the economic perspective, the economic problems faced by all societies, the market economy of the United States, economic growth and stability, the distribution of income, the role of the United States in the world economy, and the nature of other economic systems.[27]

Although the report focused primarily on the teaching of economics in secondary schools, it emphasized the need for economic education in the elementary grades:

> There are many opportunities for building economic understanding from the time the child enters first grade until he graduates from high school. Interesting experiments now under way suggest that such simple notions as divisions of labor, prices, exchange in markets, and even profit can be grasped by elementary school children if they are built into carefully planned teaching materials and methods. Inescapably, children are exposed to such ideas in their day-to-day lives. The elementary grades provide an opportunity to clarify them, and to relate them to daily problems of family living, especially in the social studies courses children take from the early grades. We commend these experiments and recommend adoption of these techniques in the earlier grades as this becomes feasible.[28]

Research has rather firmly established the fact that elementary school children can understand and master some of the key concepts in economics.[29] If basic concepts are taught in the elementary grades, high school teachers can extend these ideas and thus more easily help their students gain an understanding of the seven important topics delineated by the National Task Force on Economic Education.

Another organization which has spearheaded reforms in economic education is the Joint Council on Economic Education. Its efforts to improve the teaching of economics in the public schools include a sound publications program as well as a curriculum development project called the Developmental Economic Education Program (DEEP), organized in 1964. Some of the Council's publications which are most helpful to teachers are *Economics in the Curriculum*[30] and a series of paperback books entitled *Economic Education Experiences of Enterprising Teachers.*[31] The first book, a DEEP project, is a valuable teacher's guide which is divided into two major parts, "Economic Ideas and Concepts" and "Grade Placement of Economic Concepts." The series of paperbacks, published in cooperation with the Calvin K. Kazanjian Economics Foundation, Inc., consists of prize-winning essays by elementary and secondary teachers. These articles describe how teachers have successfully taught economic concepts and generalizations. The articles are grouped by grade levels and are a rich source of ideas for classroom teachers. Currently seven volumes are in the series; one volume is published annually. John E. Maher, a senior economist at the Council, has published *What is Economics?* Written especially for classroom teachers, it is clear and precise, and includes a section on economic skills.

The Council's Developmental Economic Education Program (DEEP) is primarily a service organization for school districts. It provides consultant help to districts involved in curriculum reform in economic education, disseminates curriculum guides, and offers in-service workshops to cooperating districts. The organization consists of more than forty state and regional Councils, and more than fifty Centers for Economic Education on college and university campuses.

Several of the curriculum projects of the 1960's focused primarily on economics. One of the most notable is the program developed by Professor Lawrence Senesh at Purdue University. Senesh calls the curriculum implemented in his program, *Our Working World*, "organic." It is based on the premises that children should be introduced to the fundamental ideas of the social sciences, that these ideas should be developed in increasing depth in successive grades, and that the activities used to introduce social science concepts should relate to the everyday experiences of the children.[32] "This curriculum is based on the hypothesis that children's experiences are potentially so meaningful that the fundamental ideas of the social sciences can be related to them on every grade level."[33] The core of the program is organized around economics concepts (illustrated in Fig. 10.6), although the author contends that the program is interdisciplinary. He says, "The other social sciences, such as anthropology, geography, political science, sociology, and history, are . . . an integral part of the program."[34] Senesh feels that it is

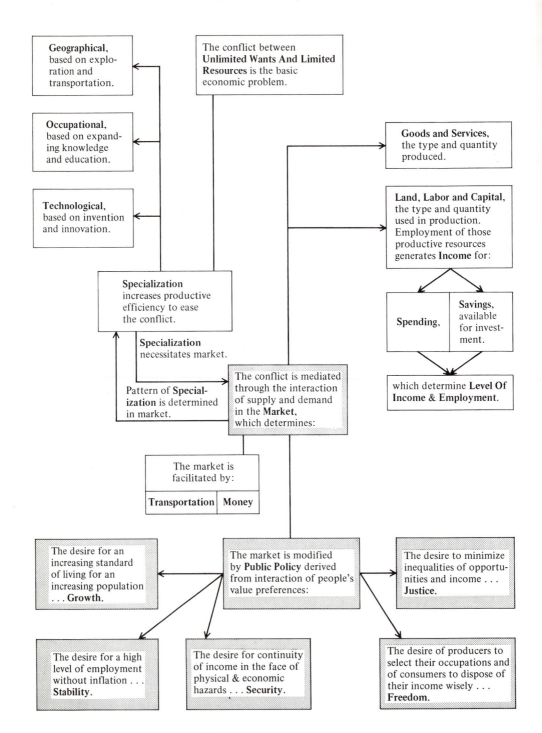

Figure 10.6 Organizing Concepts of the Senesh *Our Working World* Program*

*Reprinted with permission from Lawrence Senesh, "Organizing A Curriculum Around Social Science Concepts," in Irving Morrisett (Ed.), *Concepts and Structure in the New Social Science Curricula.* New York: Holt, Rinehart and Winston, 1967, p. 25.

imperative that teachers understand the fundamental ideas of economics before they can successfully implement his program.

Materials for grades one through three are now available; materials for the other elementary grades are currently being developed. The first grade program is entitled *Families at Work*. Such topics as how families provide services for their members, and how they divide their work and make economic choices are studied. Included in the materials are filmstrips, phonograph records, texts, activity books, and a teacher's resource unit.[35] The teacher's resource unit is packed with many activities and resources from which the teacher may select. The teacher's units constitute one of the strongest features of this program. The grade two program is called *Neighbors at Work*. *Cities at Work* is the grade three program. When trying to identify economic concepts and develop strategies with which they may be developed, the materials in this program will be immensely helpful. The teacher's guides include stories, poems, and many other helpful resources and ideas.

The Elementary School Economics Program, developed by the Industrial Relations Center at the University of Chicago, contains materials for teaching economic concepts to grades four, five, and six. The key concepts of *consumption, production,* and *exchange* are developed in the three grades. The program is based on three major assumptions: (1) young people have daily economic experiences, (2) economic education can be introduced progressively as children mature, and (3) economic concepts will strengthen other learnings in the social studies program.[36] The main objectives of the program are (1) "To develop in elementary school students an understanding of the basic processes of consumption, production, and exchange," and (2) "To develop in elementary school students an understanding of the relationship among these three processes."[37] The materials include a book of student readings, a student project book, a teacher's guide, and objective tests for each grade level. The teacher's guides consist of teaching objectives, activities, and discussions on the nature of economics. The student readings are lively and engaging.

STRATEGIES FOR TEACHING
SELECTED ECONOMICS CONCEPTS AND GENERALIZATIONS

In this chapter, we have stressed the need for students to understand economic concepts and generalizations in order to effectively solve personal and social problems and to influence public policy by participating in intelligent social action. Most of the pressing social problems which face us today — such as racism, war, and poverty — can be profitably analyzed from an economic perspective. If history can help us predict anything about the future, we can say with assurance that future social problems will also have economic aspects. Theorists such as Karl Marx and Charles Beard believed that economic factors were probably the most cogent influences on man's behavior. While we do not endorse this belief, we feel that economic understanding will greatly enhance man's ability to solve current and future social and personal problems.

To assure that children develop economic understanding, economic instruction must be deliberately planned, sequentially, for the elementary and

Making a product such as ice cream can help children to compare
the self-sufficiency of pioneers living on farms with the high
interdependence of Americans today. (Shoreline School District,
Seattle, Washington)

junior high-school grades. When planning social studies units, the teacher
should select concepts and generalizations that will enable the children to view
the problems being studied from an economic perspective. We have selected
two organizing economic concepts, *interdependence* and *scarcity*, two related
generalizations, and we will illustrate how these concepts and generalizations
can be taught in the elementary and junior high-school grades. These concepts
and generalizations were selected because they are central to the discipline of
economics. As in all the other chapters on the disciplines, the strategies we
describe are designed to be exemplary only and to serve as a springboard to
teacher creativity and inquiry. Some of the strategies discussed, however, can
be easily used in any sound social studies program in the elementary and junior
high-school grades.

GENERALIZATION: *All members of a society are economically interdepen-
dent; individual producers of goods and services exchange with others to get
the goods and services to satisfy their basic wants and needs.*

Primary grades

Have students compare the self-sufficiency of pioneers living on farms with the
interdependence of people in today's society by researching the following

questions: What was the source and process of obtaining butter in pioneer days? What is it today?

Lead the students into a discussion about how pioneer farmers obtained butter. Bring out the points that they would milk the cow, set the milk in a cool place to allow the cream to separate from the milk, and then place the cream in a churn and mix it until butter appeared. After churning, the butter was removed, washed, salted, and shaped. It was then used for eating and cooking. If it is possible to obtain whole unprocessed milk in your area, get some and bring it to school so that the students can see how the cream and milk separate. Then have students skim the cream from the top of the milk and place in an old fashioned churn if one is available, and churn the butter. If whole unprocessed milk and a churn are not available, purchase thick cream from the grocery store and place it in a jar. Students can take turns shaking it until butter is obtained.

Next show a film, filmstrip, or a series of pictures that illustrate how butter gets from cows to the pupils' morning toast. If there is a dairy or creamery accessible, plan visits to these places. After the children have seen a visual presentation illustrating how milk is produced and have taken a field trip, have them develop a pictograph for the bulletin board showing the people and processes involved in the journey of butter to their tables.

The students can also make a pictograph illustrating the processing and consumption of butter during pioneer days and compare the production of butter during these two periods.

Discuss the following questions:

1. During which period were more people involved in processing butter?
2. How did they help one another?
3. How would people in a pioneer town obtain butter?
4. How would we obtain butter if the plant workers who process it went on strike?
5. Is butter today better? Why or why not?

Have your students engage in a block-building contest. Obtain two sets of blocks. One child will work with one set of blocks and two children with the other set. The rest of the class will observe the two teams to see which team can build a structure more quickly using all the blocks. Before they begin building, have the observers make predictions regarding which team will be finished first and why. Repeat the contest several times to see whether their predictions are verified each time. If the child who is working by himself wins ask the students why this happened. A possible response might be that the two people were not working well together. Ask the students what they observed as advantages and disadvantages of working alone and with a partner.

Show a film, filmstrip, or a series of pictures depicting the construction of a modern-day house. Next put a large picture of a new house in the center of a bulletin board. Have the students list and discuss the kinds of workers who would be needed to build the new house. After these have been listed, have

students draw pictures of these workers, label them and place them on the bulletin board around the house.

Use the homemaking corner of your classroom to illustrate the interdependence of family members. If you don't have a homemaking corner, assemble some appropriate props for the following role-playing situation. Have students role-play a working father, a mother who stays at home, a new baby, and a school-age child. While the rest of the class observes, have the students act out their parts in the homemaking corner according to their own interpretations.

Ask the following questions and list responses on the board:

1. What jobs does each member of the family carry out?
2. How does each family member help the others?
3. Which family members do the most work? Why?
4. Are there other family members who could do more work? Who are they and what kind of work could they do?

Next change the composition of the family by eliminating the father role. Discuss how the jobs of the mother and children might change as a result of the elimination of the father role.

1. What additional work will the mother have to do? (Responses might be that the mother will have to get a job away from home or do special work for other people at home.)
2. If the mother cannot work away from home or at home for money, what can she do? (The idea of welfare can be discussed here.)
3. What other jobs might the child do at home to help the family?

Have students role-play this family situation. Observers will list their observations as in the first role-playing situation.

Change the composition of the family a third time by eliminating the mother role and reinstating the father role. Discuss the same questions as in the previous role-playing situation, and have the students act out their new family roles. The pupils will list their observations of jobs done by family members and how each member helps the others.

Discuss the similarities and differences among the different lists of family services. Ask "What could we say was true of each family situation?" Rephrase the question as necessary to solicit responses indicating that the students recognize the interdependence of family members for services.

Have your students plan a town to be constructed in your room. In the planning stages,

1. Pretend that you as a family are going to construct a town. What will you need in this town so that your family can live there and get along?

2. What kinds of businesses and services are needed? As the students begin to suggest businesses, guide their planning so that they include those services considered necessary for the existence of a town, such as a grocery store, clothing or variety store, post office, telephone service, gas station, and some

sort of delivery service for getting the goods to the town. Divide your class into groups representing the businesses listed. Have each business group make a chart illustrating the source of their supplies and the means of delivery.

Ask "What occupations would you want represented in your town? (Responses might include a doctor, dentist, teacher, and policeman.)

After you and the students have planned and discussed what you want your town to consist of, name the town and put it into operation in your room. Have students role-play the roles necessary for their plans. Develop role-playing situations. For example: Johnny Brown broke his arm playing in the park. His mother took him to the doctor who is out of supplies for fixing broken arms. To whom should the doctor go for help?

Develop other situations where the interaction of town members can be demonstrated, and have the students role-play the situations. After each role-playing situation, have students list the people called upon for services. Discuss how members of a city work together to help provide other members with the services and goods they need.

Intermediate grades

A number of the goods and services needed by modern-day families are more easily obtained when families get together to pay for them. These goods and services are usually paid for with tax monies or when the people use them. Such services might include providing water, roads, electricity, schools, fire protection, street cleaning, police protection, health facilities, parks, street repair, stop lights, and bus services.

Have your students interview their parents to find out how many and what kinds of goods and services mentioned above are used by their families. Have students also find out what percentage of their family's taxes go for what items and which services are paid for directly when used.

After students have collected this information, pool the information and chart it on one large chart. For example:

Goods and services	Source of revenue	Amount of revenue
electricity	direct payment, according to amount of killowats used	
schools	taxes	20%
.	.	.
.	.	.
.	.	.

Discuss the chart:

1. Why is it to the mutual benefit of the people in the community to pay for these goods and services together?

2. Are there some goods or services listed that are no longer useful to the community as a whole, and that should be dropped or replaced? Support your answer with facts.

3. Are there some goods or services not listed that should be added and paid for by the entire community? Support your answer with facts.

4. In some communities a service that has been paid for directly upon use has had difficulty maintaining itself financially. Tax support has been proposed and added in some cases. Thus the service is both tax-supported and paid for directly. One such example is the transit system in Seattle, Washington. A city transit tax of 50¢ was added to the city light bill. The city made riding the bus more attractive by adding several Blue Streak Lines which provided rapid service for those people who work in the city. Have students examine their chart to determine whether there have been similar problems in their community. Then determine how the community solved the problem to the mutual benefit of most of its members. Research on this problem may require some exploration of the newspapers to determine what kinds of problems have existed and what action was taken. There may be a problem for which the solution is currently being sought. If this is the case, have your students research it and make proposals for its solution.

Present your students with the following situation: Here are three men, each of whom has a problem. Mr. Cline owns a grocery store on the corner. It is just a small store so he does all the work required to run the store. The man who regularly delivers fresh vegetables to his store is ill, and the big delivery companies won't take his order because it is too small. He will loose customers if he doesn't do something because fresh vegetables of good quality are one of the main reasons people shop at his store. Mr. Cline calls his friend Mr. Hoboken, who owns his own truck, and asks for his help. Mr. Hoboken says that he can't help because his truck is broken down, and he probably won't be able to get it fixed for several weeks. The next day Mr. Hoboken's neighbor, Mr. Glass, comes to visit and says he lost his job as a mechanic two weeks ago and hasn't yet been able to find new work. He has run out of funds and wonders whether Mr. Hoboken would be willing to let him have food on credit.

Ask the students to think about how these three men could solve their problems without using money. Then have three students dramatize the roles of the men in the story, and show how they solved their problems.

Discuss the following questions:

1. Why were the men unable to solve their problems alone?
2. Was the solution acted out by the three players a logical one?
3. How does the solution illustrate the interdependence of workers?
4. What are some other ways you can think of that men are interdependent in terms of goods and services?

Read the following situation to your students: At the beginning of summer vacation, Charles Abernathy built a new doghouse for his dog, Rags. His

neighbor, Mr. Herman, liked it and asked Charles to build a similar one for his spaniel, Freckles. He told Charles he would pay him $10. Charles was very excited about this because he wanted to earn money for summer camp and maybe even enough to buy a Stingray bike. Before Charles completed the house for Freckles, another friend came by and asked Charles to build a dog house for his spaniel, too. Then Mr. Hildreth dropped by and asked Charles to build a house for his Great Dane that would be twice the size of the others he had built. Mr. Hildreth offered to pay him $20 for the job. Before long Charles had orders for 25 dog houses; 20 regular-sized ones and 5 double-sized ones. He began to worry then, because it had taken him about a week to make the first one, including the sanding and painting. How would he ever be able to build 25 doghouses by himself!

After presenting the situation to the students, divide the class into four groups. Direct the groups to come up with a very detailed solution to Charles's problem. The solution must be one that allows him to keep his commitment for building the doghouses and possibly to handle some more orders. After the groups have decided on a solution, have a spokesman from each group present his plan to the class. Discuss the merits of each plan and have the students vote for the one that would work best. Be sure to have the students give good reasons for their arguments for and against the various proposals.

Read the section in *Little House on the Prairie*[38] that describes the construction of a log cabin. Begin on page 56 with the following:

> For days Pa hauled logs. He made two piles of them, one for the house and one for the stable. There began to be a road where he drove back and forth to the creek bottoms. And at night on their picket-lines Pet and Patty ate the grass, till it was short and stubby all around the log-piles.
>
> Pa began the house first. He paced off the size of it on the ground, then with his spade he dug a shallow little hollow along two sides of that space. Into these hollows he rolled two of the biggest logs. They were sound, strong logs, because they must hold up the house. They were called sills.

Read through the first paragraph on page 65.

Show a film, filmstrip, or series of pictures illustrating house construction today. Have the students compare house building today with house building during the pioneer days of this story. Ask:

1. What are the main differences in the roles of the homeowner who wishes to build a house today and the log cabin owner who wanted to build a new log cabin?

2. What kind of work would each of them have to do in order to get their new houses constructed?

3. What kinds of workers would a person need today to build a modern home?

4. What kinds of materials would be in the modern house and the pioneer house?

Have the students list the kinds of materials necessary in house construction today. Then have each class member select something from the list and call a supplier of the item in the town where you live to find out where and from whom the supplier obtained the item. Then have students pool their information and chart the goods, services, and sources of goods used in the construction of a modern-day house.

Upper grades

Have the students plan a car wash in order to earn money for a cause that is important to them or in order to sponsor some event at your school. Planning should include discussion and preparation regarding the following points:

1. What would be the best location for the car wash? Why? (Students may need to investigate the parts of town in which people would be most likely to need their cars washed.)

2. What points will need to be considered in regard to selection of the place to hold the car wash?

3. Would it be better to have several locations? Why or why not? If so, what should those locations be?

4. What would be the most efficient way for the responsibilities to be shared? Why? Why not just have each individual do a car wash in the area around his home?

5. What are the best sources of the supplies necessary for carrying out the car wash?

6. What would be the best price to charge for the service?

7. What would be the most effective kind of advertising?

8. Where should the advertising be distributed?

9. How long in advance of the sale should advertising be out?

10. Develop a chart representing the interdependence of the operation and the services provided.

Tell your students that they will be playing a game in which half of them will be working in buying teams of two for the Vroom Airplane Company. They will be buying the following items: aluminum, engines, tires, and electrical wiring. They will be negotiating with representatives, teams of two, of other companies in the United States and in other countries.

Each company team selling a product will have a standard price per unit of measure for their goods. Each company team will have a recommended bargaining procedure. The major bargaining device is the promise to buy a certain number of planes. The company teams may negotiate within a range of $3-$10 for the cost per unit of measure and may promise to buy from 0-25 planes. The following are the standard prices and recommended bargaining procedures suggested by company presidents to their sales representatives.

1. Aluminum
a) Adanac: $7 per unit of measure

 If you buy from this foreign country, you receive an extra point because you will be furthering the international balance of payments.

 President of the company recommends you order 15 new Vroom planes.
b) Lubeck Aluminum, U.S.: $5 per unit of measure

 If you buy their aluminum, they will give you a bonus of aluminum serving trays for food service use on your planes.

2. Engines
a) Jolyes Joyce: $100,000 per unit of measure

 President of the country in which this company is located will purchase 13 Vroom planes if you buy their engines.
b) Standard Electric: $98,785 per unit of measure

 Will guarantee a sale of 15 planes, if you also purchase their electrical wiring.

3. Tires and related rubber components
a) Goodday: $2 per unit of measure
b) F.B. Richgood: $3 per unit of measure

4. Electrical wiring
a) Standard Electric: $10 per unit of measure
b) Housevesting: $11 per unit of measure

 Their subsidiary, Ajax Airlines, will buy 5 planes.

Give the students an opportunity to get the constraints of their roles well in mind. Direct each buying team and selling team to keep very careful and accurate records, subject to audit, in order to substantiate their business negotiations. Designate four areas of the room with signs for the four negotiating companies. The Vroom teams will travel to the "offices" of the selling teams for conferences.

After all the teams have made their purchases and sales, have each Vroom buying team present their business deal to the class who will vote for the winning team. The team that obtains the lowest *total* unit of measure, therefore the lowest cost of production, and sells the most planes is the winner.

If there is a major industry or business in the area in which you live, have your students write, and/or visit. Interview some of its representatives to determine some of the major supplies they use in production. Have the students ask:

1. Which supplies do employees of the company produce themselves?
2. Which supplies does the company order? From whom?
3. Where does the company get the materials for those items it makes itself?
4. Where do the suppliers get their raw materials?

When the students have collected this information, have them develop a large bulletin board illustrating the chain of goods and services that goes into the making of that product.

Have the students assume the roles of members of the population of a growing town, Dorado. Several members of the town council have been trying to persuade the rest of the members to work to get rail transportation into the town. Several members, however, are opposed. One of the reasons for their opposition is that the town will then become more dependent on outside sources for many goods and services. The council members in favor of rail transportation believe that Dorado has some products that are needed in other areas, and other towns have some products that are needed by Dorado to expand business and production. The chairman of the council has called a town meeting. The council members will debate the issue. Then there will be questions from the general citizenry. A vote of all town members in attendance will be taken at the conclusion of the debate.

Lead the class in a general discussion, getting the students to define the distinguishing characteristics of this imaginary town. Have them include the following information.

1. Geographical location and influences

2. Major businesses and industries of Dorado

3. Major businesses and industries in surrounding towns that would profit from the rail connection

4. Actual population

5. Growth projection

6. Kind of work force available for the new jobs that would be created

Then have the students select and research their roles, carry out the debate, and vote on the issue.

GENERALIZATION: *The conflict between unlimited wants and limited resources makes it imperative for individuals and societies to make difficult decisions about the utilization of scarce resources.*

Primary grades

Lay out some 10¢ candy, gum, and toys. Tell your children that five of them are going to play a pretend game, and the rest are going to watch. Have each child come up and point to all the items he would like to have. (Arrange the situation so that the other selecting children won't see what the first child points to, etc., because they will tend to point to the same things previous children have wanted.) Use a large piece of newsprint on which to record the number of things each child would like to have. Most will want all or almost all the items.

Now, using the newsprint record, show all the children how many things everybody wanted. For example:

Johnny wanted all five items. Joan wanted three items.

Susan wanted all five items. Andy wanted three items.

Jack wanted four items.

Discuss the observations by asking, "Did people want just one thing or more than one thing?" "What can we say about how much people want?"

Tell the children they're going to do this again, and pick five different people. Explain to the whole class that this time there's going to be an extra rule. This time each child will have to *buy* what he wants.

Ask them what they could give in exchange for what they want. When they say money, tell them that sometimes people use money and sometimes they don't. Ask, "What things have you used to get what you want?" (Make two columns, listing the things on the board and what they got with them.) All the things in column one that were used to get what a person wanted are called *resources*.

The teacher might now go back to this game and tell the class that each of the five students is going to get a nickel, and each item is going to cost a nickel. Have the children one at a time spend their money to buy what they want. (Again arrange the situation so each child can't see what the others have bought, but so the rest of the class can observe.) Keep track of the purchases on a second sheet of newsprint, and replace the item purchased.

With the entire class, look at the newsprint record. Ask the students "Did people buy just one thing or more than one thing?" How much did people want to buy?" (Line up the two newsprint records. Ask, "Could people buy as much as they wanted?" "Why or why not?" "What can we say about how much people want and how much they can get?" "What does it depend upon?" "Why?"

Ask about further implications by saying "If people can't have everything they want, what do people have to do?" (Make a choice, or decision.)

Students could role-play what happens when they're in a toy store. The teacher could show the class pictures of a toy store and of shelves of toys. There could be large toys and small toys. The teacher could explain the large toys cost $3 and the small toys cost $1 each. The situation could be that each child has $3.

The teacher could ask the student what choices they have by asking "What could you do with your money?" These could be listed as shown in Fig. 10.7.

Once the alternatives are suggested, the teacher could ask the student "What would happen if you selected Choice 1, i.e., to buy one $3 toy?" The consequences of each alternative could be described by the children and recorded on the chart by the teacher.

If the children are mature enough, have them consider the implied values; if not, go on to the next paragraph. Each consequence implies a particular value. The teacher could help his students make their choice by helping them

Figure 10.7

Alternatives (choices)	Consequences (what happens)	Implied value
1. One $3 toy	1. Better toy, maybe	1. Special quality
2. Three $1 toys	2. More toys	2. Greater quantity
3. Save the money	3. Will have money later to use in other ways	3. Provision for future needs

identify the value implied in each alternative (see Fig. 10.7). One question the teacher could ask to help clarify the values implied in each choice is the following: "What is good or important about Choice 1 that makes it a choice that you might make?" Once the alternatives have been specified the students can decide which one they would choose and *why*.

Now have the students look back at the pictures of toys. Ask them what they wanted, and whether they could buy all they wanted. Ask them, "What did you find out about what people get?" When each responds, ask him "Why is that?"

Intermediate grades

Have different students or groups of students write commercials for three brands of dog food. Each of the brands is described below. To simplify the task, the teacher could either write the commercials himself, or could simply provide the following descriptions: (a) is expensive, excellent quality, small amount, (b) is middle-priced, fair quality, bigger amount, (c) is low-priced, low quality, largest amount. The different students can deliver their commericals to the entire class.

Now have students specify each alternative and then each consequence, similar to the process described for the primary activities. Ask whether they need to consider any other information besides quality, price, and amount. If they don't request other categories of information; the teacher might ask them whether they like every kind of food. "Does this suggest another thing to consider?"

Tell them they just got the dog, and ask them what else they will need to get for the dog. Ask, "Does this information make a difference in which brand you buy? Why or why not?" The teacher could now help clarify the implied value for each choice. This could be done by asking, "If a person picked (a) what would you guess was most important to him?" Continue this line of questioning for each brand.

Now have the students decide what brand they will buy and *why*. Their answers and reasons may be shared. Ask the students to consider the consequences of their decisions. The teacher might ask, "What can you now say about what people want and what they can get? Why?" (This can be expanded by asking, "What do people have to do when they want things?" They have to make a choice about what to get.)

For students who have already experienced activities like the ones described above, the teacher could simply distribute a ditto of the following:

You have been working on a newspaper route and have been saving your money for a new bike or a camera; you haven't decided which. You've saved $20 so far, and could buy something now, or you could wait and save more so you could get a better bike or camera.

The rest of the ditto could guide the student through steps that may be important in deciding the question presented in the story.

1. What are the alternatives? (Use the chart below to record responses.)
2. What are the consequences of each alternative you have listed? (Use the 2nd column of the chart to record responses.)
3. Decide on one alternative and give your reasons.

Alternatives	Consequences
1.	1.
2.	2.
3.	3.
4.	4.

After all the students have completed the activity, the teacher could lead a class discussion on (a) how they felt while they worked the decision out and (b) what they learned while doing the activity. The following questions might help guide the students through this discussion:

a) How many things did you want to do with the money at first?
b) Could you do all these things with the money?
c) What did you have to do?
d) What does this tell us about what people want and what people can get?
e) Why is it like this?

The teacher describes the following situation to the students:

A city planner has investigated three possible uses for some vacant land; a park; a school, or a government building (like a post office or a fire station). He needs to make a recommendation to the planning commission on which use is best.

The teacher then asks the students to describe the city in which they live, and asks what kinds of things their city most needs.

The teacher lists the needs of their city vertically on the board. These, then, are the available alternatives. Then the teacher asks what will be the consequences of each alternative, and lists these. The students are reminded they have only one site to build on. The teacher informs them that the planner has called a public hearing so he can know the public's opinions before making a recommendation. Each student must make a decision and explain his reasons.

The teacher can choose any of a number of ways to deal with the students' responses. Basically, though, he can have the students share their ideas or he alone can see each student's idea. (On personal issues a third category is worth consideration—that of allowing the student to keep his decision and reasons to himself.)

For the generalization to be developed in these activities, discussion of the problem situation itself is important. The teacher might ask the students, "What things did you want for the city? What resources would be necessary? Did you have all the resources you needed to get all the things that you wanted for the city?" Finally, the teacher could ask, "What did you have to do then, since the city couldn't get everything you felt it needed?" (Make a choice or decision.)

Upper grades

The students could dramatize the situation of a girl taking her car in to be serviced. On her way to the service garage, she thinks of all the things she'd like to get for her car with the $100 she has. Have the students suggest what she might want, like new car seats, a paint job, new tires, have a squeaky brake fixed, etc.

Now show her talking with the mechanic about what he thinks the car needs. Have the students think of things he might want her to get, like new brakes, carburetor, spark plugs, battery, etc. As the two students dramatize a conversation, about what they each want for the car, the teacher could jot down their suggestions on an overhead projector.

Now the girl must decide what she's actually going to get for the car. First she examines the consequences of getting each thing. (These are listed in a second column next to each thing wanted.) Have each student decide what he would do in that situation.

Up to this point all the students have been involved in the dramatization. Now have them consider what has occurred. Ask, "How many things did the girl and the mechanic want for the car? About how many could the girl afford? What did she need to do?" To help them generalize, ask, "What can you say about people's wants and what people can get? What do people need to do, then?"

The teacher may set up the situation of a family with a particular income, and have the students determine a possible family budget. First, the teacher might ask the students to list all the items the family needs. Then they might list those extra things a family might want. The next task could be to estimate the approximate costs of each item. (The costs of several items might be given

by the teacher on a ditto, checked in a catalogue, or estimated by the students as a group.)

Then the students (individually or groups) could attempt to develop a plan whereby the family gets as many of the desired items as it can with the limited resources it has. This decision would entail consideration of the consequences of their choices. A discussion, which could follow, might focus on whether or not the family could afford everything it wanted. And then it might concentrate on what the family did as a result of working on a limited salary.

The situation for this set of exercises is the nation, its needs, and its resources. Ask the class, "What things do you think the government needs to provide for the people from tax money, etc.?" List these on the board.

Now instead of working with amounts of money, individuals can determine what *percentage* of the national budget should be spent on each category. Consideration should also be made of the consequences of each alternative before a choice is made. The teacher can help students compare the percentages they each proposed. He can ask whether everyone is in agreement. When the students realize they are coming up with different priorities, they can be given the task of working in small groups to reach a consensus. The purpose of this activity is similar to that of the others. Just as a person has unlimited needs and limited resources, so also a nation can have unlimited needs and limited resources. An additional parallel is that a nation needs also to make choices about what to get and what resources to spend.

The teacher might then ask the students to review what they have just done. He might ask, "How many things do we want the government to spend our money for and how much can it do considering its resources?" And finally, "What must the government of a nation do then when it wants more than it can get with its resources?" (Make choices or decisions.) "How is this the same situation individual people face with their wants and their limited resources?"

SUMMARY

Economics is primarily concerned with how man attempts to satisfy his unlimited wants with limited resources. The key concept in the discipline is *scarcity*; one of its major principles is that there are not enough resources for man to satisfy all of his wants. The production, exchange, and consumption of goods and services are also dominant concerns of the discipline. In their study of scarcity, economists try to determine how each society solves the three basic economic problems: What goods and services shall be produced and in what amounts? How shall they be produced? And for whom shall they be produced?

The major research method used in economics is the *intellectual experiment*. In using this strategy, the economist assumes that all the variables are constant except those whose effect he is trying to ascertain. Economic concepts are probably more precise than those in any of the other social sciences. Not only is there a great deal of agreement about what the key concepts in economics are, but the definitions of economic concepts are highly

standardized. The nature of economic concepts considerably facilitates the job of the curriculum builder when he tries to identify economic concepts for inclusion in the social studies curriculum. Furthermore, economic research tends to be more objective than research in any of the other social sciences because most economic data are quantitative. Highly statistical techniques are often used to analyze data in the discipline. We can identify two major approaches within the discipline, *economic analysis* and *policy economics*. The goal of economic analysis is to develop empirical generalizations and theory. The objective of policy economics is to use empirical generalizations and theory to solve the economic problems which society faces. While economists usually agree on their empirical generalizations, they often make highly conflicting recommendations in the policy area, because they have different values and ideas about what the proper economic goals of society should be.

Because of the complex nature of society, there is a tremendous need for the school to help children develop economic literacy and understanding. Almost all the social problems, so pervasive in our society, have economic aspects. Students will be able to make much more intelligent decisions about political candidates, referendums, and economic proposals if they understand the general principles of our economic system. The recession which our nation experienced in the early 1970's dramatically illustrated the need for citizens to understand the economic policies of the national government. During this period, inflation continued unabated while unemployment figures steadily rose. This economic crisis caused widespread confusion and alienation among our citizens.

Children should have experiences in the earliest grades which will help them to gain some understanding of economics. All the topics traditionally covered in social studies can be viewed from an economic perspective because economics does not consist of specific content but a unique way of looking at human behavior. When students consider the family, the community, the state, and the world, they can be helped to view the problems from an economic perspective. Economic concepts and generalizations can also help children understand more clearly many of the experiences which they have each day. Economics should help children to accept the fact that scarcity is a problem in the United States as well as in other cultures, and that the acceleration of affluency in our culture cannot continue unabated. Many students will be surprised to learn that while Americans constitute only 6% of the world's population, they consume 50% of its resources.[39] Economic facts like these will help students gain a new perspective on affluence in America.

DISCUSSION QUESTIONS AND EXERCISES

1. What is the economic "perspective"? What key concepts do economists use in studying human behavior? How does the economic perspective differ from the conceptual tools used by other social scientists to study man?

2. What are the three basic economic problems which must be solved by all societies? Illustrate, with a teaching plan, how children in the elementary

grades can use a data retrieval chart to derive generalizations which are related to these three basic problems.

3. How did the ideas of Adam Smith differ from those of the mercantilists? In what ways were Smith's ideas overly optimistic?

4. What was the central argument set forth in Keynes' *The General Theory of Employment, Interest and Money*? Compare and contrast the ideas of the mercantilists, Smith's, and Keynes'. To what extent does our present economy in the United States reflect the ideas of the mercantilists, Smith's, and Keynes'?

5. What is the *intellectual experiment*? Give examples of how an economist uses this method to study a problem. What are the advantages of this method? Disadvantages? Illustrate, with a teaching plan, how you would help children to understand this method of research.

6. What is the scientific status of economics? How does it compare with the scientific status of the other social sciences which you studied in Part 2 of this book? What implications does the scientific status of economics have for planning social studies units that have economic concepts and generalizations?

7. Compare and contrast *economic analysis* and *policy economics* in terms of goals and research methods. Why is it important to distinguish these two components of the discipline? What contributions can each make to the social studies curriculum?

8. What is the difference between *macroeconomics* and *microeconomics*? Give examples of each. Devise a teaching plan to teach this distinction to a group of elementary grade children.

9. Analyze a teaching unit in your curriculum library. What economic concepts and generalizations does the unit contain? What economic concepts and generalizations would you add to or delete from the unit in order to make it more effective? How else would you change the unit to increase its quality?

10. Evaluate an elementary economics curriculum project, such as the one developed by Senesh, and tell whether you think that the program contains a sufficient number of concepts, accurate concepts, and sound teaching and evaluation strategies. In what ways would you change the curriculum project to make it more effective?

11. Select a social problem and illustrate, with a teaching plan, how economic concepts can help children gain a better understanding of it and thus make more effective decisions regarding it.

12. Select one of the following generalizations and design a series of activities (similar to the ones in this chapter) that can be used to teach it to children in the: (a) primary grades (b) middle grades and (c) upper grades:

All members of a society are economically interdependent; individual producers exchange goods and services with others to get what they require to satisfy their basic wants and needs.

The conflict between unlimited wants and limited resources means that individuals and societies must make difficult decisions about the utilization of scarce resources.

Consumers determine what is produced in a free economy, considering all of the available alternatives. Advertising and the mass media often influence choices.[40]

Price is the measure of the relative scarcity and need for goods, services, or resources.[41]

13. Demonstrate your understanding of the following key concepts by writing or stating brief definitions for each of them. Also tell why each is significant.

a) production-possibilities concept

g) services

b) market economy

h) consumption

c) fallacy of composition

i) interdependent

d) scarcity

j) division of labor

e) production

k) exchange

f) goods

l) circular flow of income

FOOTNOTES

1. Campbell R. McConnell, *Economics: Principles, Problems, Policies* (Third Edition). New York: McGraw-Hill, 1966, p. 28.

2. Robert L. Heilbroner, *The Economic Problem*. Englewood Cliffs, N.J.: Prentice-Hall, 1968, p. 15.

3. *Ibid.*, p. 17.

4. *Ibid.*, p. 18.

5. *Ibid.*, p. 18.

6. Richard S. Martin and Reuben G. Miller, *Economics and Its Significance*. Columbus, Ohio: Charles E. Merrill, 1965, p. 17.

7. *Ibid.*, p. 62.

8. Lloyd G. Reynolds, *Economics: A General Introduction*. Homewood, Ill.: Richard D. Irwin, 1966, p. 8.

9. George L. Bach, *Economics: An Introduction to Analysis and Policy*. Englewood Cliffs, N.J.: Prentice-Hall, 1966, p. 14.

10. John E. Maher, *What is Economics?* New York: John Wiley, 1969, p. 5.

11. McConnell, *op. cit.*, p. 13.

12. *Ibid.*, p. 13.

13. *Ibid.*, p. 17.

14. *Ibid.*, p. 17.

15. Lawrence Senesh, "Organizing a Curriculum Around Social Science Concepts," in Irving Morrissett (Ed.), *Concepts and Structure in the New Social Science Curricula. New York: Holt, Rinehart and Winston, 1967, p. 24.

16. Harold S. Sloan and Arnold J. Zurcher, *A Dictionary of Economics*. New York: Barnes and Noble, 1961, p. 265.

17. Robert D. Leiter, *Modern Economics*. New York: Barnes and Noble, 1968, pp. 10-11.

18. *Ibid.*, p. 18.

19. Senesh, *op. cit.*, p. 27.

20. Leiter, *op. cit.*, p. 12.

21. *Ibid.*, p. 12.

22. *Ibid.*, p. 12.

23. The Colorado Advisory Committee on the Social Studies, *A Guide To Concept Development in the Social Studies*. Denver: Colorado Department of Education, 1967, p. 14.

24. Quoted in Ben W. Lewis, "Economics," in Bernard Berlson, *et. al.*, *The Social Studies and the Social Sciences*. New York: Harcourt, Brace and World, 1962, p. 124.

25. *Economic Education in the Schools*, National Task Force on Economic Education, Committee for Economic Development, New York, September, 1961.

26. Quoted in Mark M. Krug, John B. Poster, and William B. Gillies, III, *The New Social Studies: Analysis of Theory and Materials*. Itasca, Ill.: F.E. Peacock, 1970, p. 135.

27. James D. Calderwood, John D. Lawrence, and John E. Maher, *Economics in the Curriculum: Developmental Economic Education Program*. New York: John Wiley, 1970, opening page.

28. Quoted in William D. Rader, *et. al.*, *Elementary School Economics I, Teacher's Guide*. Galien, Mich.: The Allied Education Council, 1967, p. iii.

29. George G. Dawson, "Recent Research in Economic Education," in George G. Dawson (Ed.), *Economic Education Experiences of Enterprising Teachers*. New York: The Joint Council on Economic Education, 1970, Vol. 7, p. 91.

30. Calderwood, Lawrence and Maher, *op. cit.*

31. *Economic Education Experiences of Enterprising Teachers*, Volumes 1-7. New York: Joint Council on Economic Education, 1964-1970.

32. Maher, *What is Economics?*, *op. cit.* (see fn.10).

33. Norris M. Sanders and Marlin L. Tanck, "A Critical Appraisal of Twenty-six National Social Studies Projects," *Social Education*, Volume 34 (April, 1970), p. 417.

34. Lawrence Senesh, *Our Working World: Families At Work* (Resource Unit). Chicago: Science Research Associates, 1964, pp. 1-2.

35. *Ibid.*, p. 1.

36. Rader, et. al., Elementary Economics I, p. iii.

37. *Ibid.*, p. vi, footnote 28.

38. Laura Ingalls Wilder, *Little House on the Prairie*. New York: Harper, 1935, p. 56.

39. J.D. McAulay, statement made in review of book in manuscript form, 1971.

40. The Colorado Advisory Committee on the Social Studies, *A Guide to Concept Development in the Social Studies*. Denver: Colorado Department of Education, August, 1970, p. 14.

41. *Ibid.*, p. 14.

INTERDISCIPLINARY UNITS: CONCEPTS AND STRATEGIES

THE NEED FOR AN INTERDISCIPLINARY PERSPECTIVE

The main goal of the entire social studies program should be to help children develop the ability to make intelligent decisions so that they can resolve personal problems and, through social action, influence public policy. Sound decisions cannot be made in a vacuum; they must be based on *knowledge*. Decisions can be no better than the knowledge from which they are derived. The intelligent social activist must be able to identify and clarify his values before he can solve personal and social problems rationally.

Although knowledge is an essential component of decision-making, there are many ways of knowing (reviewed in Chapter 1). Intelligent decisions must be based on *scientific* knowledge. Rational decision-makers must not only utilize scientific knowledge, but must be able to use the scientific method to produce it. A student does not need to derive every concept or generalization that he uses, but he must know how the knowledge that he uses was derived, and be able to produce it himself when it is necessary and appropriate. Children who are unable to produce scientific knowledge cannot intelligently judge it.

Because each of the social science disciplines has a specialized body of knowledge and unique ways to view human behavior, the decision-maker should be able to see human events from the perspective of each discipline. Each social science discipline consists of a method of inquiry and a set of organizing concepts, generalizations, and theories which constitute its *structure*. The structure determines the questions that a discipline asks and influences its findings and conclusions. In other words, the structure of a discipline determines its unique perspective. By using the modes of inquiry and key concepts within a discipline, children will be able to view man's behavior from each special perspective.

In Chapters 5 through 10, the structures of the disciplines were discussed, and strategies for teaching children to view human behavior from their diverse perspectives were illustrated. The extensive discussions of the nature of the disciplines reflect the author's conviction that each discipline can provide us with ways of viewing human behavior which will deepen children's insights and help them to make better decisions.

Although the unique perspective of each discipline helps us to understand man's behavior, knowledge from any one discipline is insufficient for making decisions on personal and public problems, and for understanding the immense dimensions of human relationships. For example, social problems are too complex for economic knowledge alone to help us solve them. Political science concepts can at best provide us with a partial understanding of a complex nation such as Communist China, or a social phenomenon, such as a race riot. To effectively influence public policy, and to understand his social environment, the rational social activist must select, synthesize, and apply knowledge from all the social sciences, as well as from philosophy and the humanities.

The social scientist fragments the universe in order to study it more easily and advantageously; the social studies program should help children to view human behavior in a broad context. The behavior of the American family is neither economic nor anthropological, but it can be profitably viewed through the special lens of each of these fields. When planning interdisciplinary units, it is important for the teacher to realize that the social science disciplines are not specific in content, *but represent specialized ways to view the same human behavior*. Behavior is not fragmented; scientists fragment it for their own convenience.

While some units in the elementary and junior high-school grades may stress concepts and generalizations within a particular discipline (the concepts of a particular discipline, for example, may contribute most to the resolution of a particular social issue), social studies units should be primarily *interdisciplinary*. Children should view the problem or topic being studied from the perspectives of several disciplines.

The separation of the discipline chapters in this book is done to emphasize the contributions which each social science can make to an understanding of complex social issues, and not to suggest that any one discipline in and of itself is sufficient to resolve human problems.

DEVELOPING INQUIRY, VALUING, AND DECISION-MAKING SKILLS

Interdisciplinary knowledge is necessary but not sufficient for sound decision-making. The intelligent social activist must also identify and clarify his values, as well as synthesize his knowledge and relate it to his values so that he can determine a course of action (make a decision). Interdisciplinary knowledge (derived by an inquiry process), valuing, and the synthesis of knowledge and values constitute the process of *decision-making*. Thus social inquiry (the derivation of interdisciplinary knowledge), valuing, and decision-making each

consist of a cluster of highly interrelated skills. (See Chapter 1.) The student should have practice in developing each of these sets of skills, as well as experiences which teach him how to relate them.

The teacher may plan separate units and lessons to teach interdisciplinary *inquiry, value inquiry,* and *decision-making* skills, or he may build units to teach all three sets of skills. The long-range goal should be to help children become adept in the processes of decision-making and social action. Thus the teacher should as often as possible plan units and lessons that will give children practice in relating these sets of skills. However, for purposes of emphasis, this chapter discusses and illustrates strategies for interdisciplinary inquiry (social science inquiry), Chapter 12 treats value inquiry, and Chapter 13 illustrates how these skills can be combined to help children become intelligent decision-makers and effective social activists.

THE INTERDISCIPLINARY UNIT

The term *unit*, like so many in education, has been variously defined. However, most writers suggest that a unit is a series of related activities designed to attain specific changes in student behavior. The definition suggested by Michaelis is illustrative, "A unit of instruction in the social studies is a plan to achieve specific outcomes through the use of content and learning activities related to a selected area of study."[1] Complete agreement about the parts of a unit also does not exist. However, most specialists agree that it should contain these basic components: (1) a statement of topic or problem, (2) a statement of the objectives, (3) initiation activities, (4) developmental activities, (5) evaluation activities, and (6) culmination activities.

We suggested in previous chapters that social science units should ideally be structured around a number of organizing concepts. We will first illustrate how a conceptual unit can be structured within the framework of a traditional social studies curriculum because most readers of this book will probably teach in school systems that have traditional curriculums. We will then discuss building conceptual units within school systems which are not committed to a specific program or type of curriculum organization. Conceptual units should consist of the following components: (1) unit topic, (2) key concepts and generalizations, (3) sub-ideas, (4) objectives, (5) initiation activities, (6) developmental activities, (7) evaluation activities, (8) culmination activities, and (9) a resource bibliography.

SELECTION OF ORGANIZING CONCEPTS FOR INTERDISCIPLINARY UNITS

How the teacher selects the key concepts that will constitute his units depends to a great extent on the amount of freedom that he has. Many districts have curriculum guides which provide a basic framework for the local social studies program. Guides are usually intended to function only as guides, not as blueprints the teacher is expected to slavishly follow. The main purpose of a

"I want to thank each of you committee members for the most thorough, complete, and heaviest curriculum I've ever seen."
Reprinted from *Instructor* (c) October, 1971, the Instructor Publications, Inc. Used by permission.

curriculum guide is to assure that the instructional program is sequential and developmental. Curriculum guides may also contain suggested teaching strategies and instructional resources. Again, the teacher can use these materials in a way that will best enhance pupil growth and achievement. These comments are not intended to suggest that the teacher should ignore the guidelines which are provided by his school district; rather, the teacher should implement a program within his district's guidelines, one consistent with modern social studies theory and research. Theory and research suggest that units should be organized around key concepts and generalizations, and that children should derive social science ideas by using the modes of inquiry of the social scientist.

The social studies guides of most school districts specify a number of topics that the teachers of each grade are expected to cover. These topics usually reflect the "expanding environment" approach; in the primary grades, the child studies institutions with which he is most familiar and thus can comprehend most easily (see Fig. 11.1). Most often, the home, school, holidays, community helpers, and the local community are studied in the primary grades. In the middle grades the state, exploration, pioneer days, and the histories of the United States and the Western Hemisphere are studied. European and American history usually constitute the program for the junior high-school grades.

Figure 11.1
The Expanding Environment Approach to Curriculum Construction

The traditional social studies curriculum is based on the concept of the expanding environment. The child studies the human community which is closest to his actual experiences. As he moves through the grades, he studies increasingly larger communities. The teacher who is required to plan his units within this structure can use organizing ideas from the disciplines to help children better understand the communities in which they live.

As the child moves through the grades, he studies institutions and social phenomena which are increasingly more remote from his direct experiences. We will not undertake a critique of the expanding environment approach, but rather emphasize the fact that *the teacher can structure a conceptually oriented curriculum within the framework of a traditional social studies program*.

This approach is taken in the Taba Social Studies Project. The directors of this project identified eleven key concepts from the various social science disciplines, a number of related generalizations, and used content samples of

the traditional program to develop the key ideas identified. The eleven organizing concepts are: *causality, conflict, cooperation, cultural change, differences, interdependence, modification, power, societal control, tradition,* and *values*.[2] In the first grade, content samples are selected from the family, a traditional topic for the primary grades. Content samples are selected from the state, another traditional topic, for the fourth grade program. While the structure of the Taba Social Studies Program is drastically different from traditional social studies programs, the topics are quite traditional. Approaching curriculum reform using this approach allows us to maintain a degree of stability in the curriculum. Teachers will be able to use many of their available instructional materials and resources, and thus will be more inclined to implement new programs. There is also a legal reason for approaching curriculum reform within a traditional framework. The study of the history of the state and United States is mandated by most state governments.

The Project Social Studies Curriculum of the University of Minnesota also creates new learning experiences for children, although it uses much traditional content. For example, one of the second grade units which deals with families introduces the concepts of *culture, social organization, social process, location* and *site*.[3] However, this project also uses new content samples. The unit referred to above is entitled, "The Kibbutz Family in Israel."[4] Thus while the family topic is maintained in this program, new concepts are introduced and content is often drawn from other cultures as well as from our own. This project represents another fruitful approach to curriculum reform. A final advantage for initiating a new program within a traditional framework is that teachers will feel more secure and will be more likely to implement it. Lippitt and Fox found that teachers, not students, found it difficult to adjust to a new social studies curriculum.[5]

NEW WINE IN OLD BOTTLES:
TEACHING NEW CONCEPTS WITH TRADITIONAL CONTENT

We have suggested how two interdisciplinary social studies projects (the Taba and Minnesota Programs) organized a curriculum with key ideas, but used traditional content to develop the concepts. We recommend that teachers in districts that have a social studies curriculum guide or require that specific content be taught in the various grades, use this approach when building instructional units for the social studies program. We will later discuss how a teacher may proceed to build social studies units if he has no district guidelines he must follow.

The teacher who does have a social studies curriculum guide should begin planning his units for the year by carefully studying the topics that he is required to teach, such as the home, the school, community helpers, and United States history. He should then study a list of key concepts from the social science disciplines so that he can decide which ones can be most effectively and meaningfully taught with the content he is required to use. Key concepts from the social sciences can be found in many of the materials

Figure 11.2
Organizing Concepts in the Social Sciences

ANTHROPOLOGY	HISTORY	PSYCHOLOGY
Culture	Change	Self-Concept
Culture Element	Conflict	Motivation
Culture Complex	Revolution	Perception
Enculturation	Nationalism	Frustration
Culture Area	Civilization	Attitudes
Diffusion	Exploration	
Acculturation	Historical Bias	
Ethnocentrism		
Tradition		
Cultural Relativism		
Culture Universals		

ECONOMICS	POLITICAL SCIENCE	SOCIOLOGY
Scarcity	Social Control	Socialization
Production	State	Role
Goods and Services	Power	Norm
Interdependent	Legitimacy	Sanction
Division of Labor	Authority	Values
Exchange	Interest Group	Status (Status-Position)
The Circular Flow of Income	Political Socialization	Institution
	Political Culture	Community
	Political System	Society
GEOGRAPHY		Interdependence
Location		
Region		
Spatial Interaction		
Urban Spatial Pattern		
Internal Structure of the City		
Environmental Perception		

produced by the social studies projects of the 1960's, in social studies curriculum guides prepared by school districts, in methods books, and in introductory books to the various social science disciplines. In Chapters 5 through 10 of this book, some of the key ideas of the disciplines were identified and defined. These key concepts are listed in Fig. 11.2.

CRITERIA FOR SELECTION OF CONCEPTS

What *criteria* can the teacher use to select appropriate ideas for development? The teacher should first consider the prior experiences of the children. If they have been introduced to specific concepts in a previous grade, he should further

develop and expand these concepts, perhaps introducing new related concepts that will enhance their understanding of their social environment and help them become better decision-makers. He should also select concepts around which a great deal of data and content can be organized. While all key concepts within the social sciences can be used to organize and categorize a great deal of information, some concepts are more powerful than others, i.e., they are more encompassing. The concepts selected should have the "power to organize and synthesize large numbers of relationships, specific facts, and ideas."[6] This does not mean that low-order concepts should never be selected, but the goal should be to select the most powerful ones when all factors are considered. Both *scarcity* and *exchange* are key economic concepts, but *scarcity* is a much more powerful idea. Taba offers the following criteria for selecting organizing concepts for a conceptual curriculum:

1. Validity — Do they adequately represent ideas of the discipline from which they are drawn?
2. Significance — Can they explain important segments of the world today?
3. Appropriateness — Are they suited to the needs, interests, and maturational level of the students?
4. Durability — Are they of lasting importance?
5. Balance — Do they permit development of both scope and depth?[7]

Some consideration should also be given to the content that must be studied when key concepts are selected for study. Some content can be more profitably viewed from certain disciplinary perspectives than from others. For example, it is easier for children to grasp the concept of *culture* when they study American families as well as families in other societies. Students cannot fully appreciate how much we are creatures of our own culture until they have viewed other ways of living and behaving. The concept of *power* in political science can be understood more readily if children study an Indian nation than if they study community helpers, even though certain ideas about the political system can be learned when workers in the community are studied.

The teacher should also select concepts from as many disciplines as is practical and appropriate. In other words, all social studies units should be *interdisciplinary.* The only way to assure that units are interdisciplinary is to select concepts from several disciplines during the initial stages of unit planning. Good judgment and sound selection criteria are important because it will not be possible for the teacher to select concepts from each of the social sciences for every unit that he plans. Even though concepts from a particular discipline may not be identified initially, during class discussions the teacher can occasionally help the children view the content from other social science perspectives. However, only careful planning will ensure that specific concepts and ideas will be grasped by the children.

The teacher should use the five criteria we listed when trying to identify concepts he can develop with the content that he is required to teach.

IDENTIFYING SPECIFIC CONCEPTS FOR A UNIT

Helping children to view human behavior from the perspectives of the various social sciences will provide them with a sophisticated understanding of their social environment so that they can become rational decision-makers and social activists. They have many daily experiences that can be profitably viewed through the lenses of various disciplines. Without the conceptual tools of the social scientist, children may and often do study topics such as the family, the community, and the school and memorize a list of disorganized facts which are largely meaningless and quickly forgotten. However, if they grasp organizing ideas when they study these topics, they will gain an understanding that can be further developed with new content in later grades. This knowledge will contribute greatly to their comprehension of the world in which they live. An example will illustrate how a first-grade teacher, Mr. Jones, who is required to teach "The Family," might proceed to select key concepts from the disciplines in order to structure an interdisciplinary unit.

AN INTERDISCIPLINARY UNIT ON THE FAMILY

Mr. Jones studies a list of concepts such as those which are in Fig. 11.2. As he studies the concepts of each discipline, he asks himself this question, "Which concepts from this discipline will best help my students understand the family as a social institution and become better decision-makers and rational social activists?" He first looks over the key concepts of anthropology. Initially, he thinks that *culture* is a concept with which the children should certainly be familiar, but he decides that they can better understand this concept if they also study families in other cultures. At this time, he does not have the materials necessary to introduce the children to another society. He therefore decides not to introduce the concept at this time, but thinks that he will introduce *culture* when the class studies communities later in the year. By that time, his materials on the Hopi Indians will have arrived. He feels that the other anthropological concepts cannot be fruitfully introduced until the children are familiar with the concept of *culture*, since that is the most important concept in the discipline. Mr. Jones is quite familiar with the structure of anthropology and the other disciplines.

Next he studies the key concepts of economics which are listed in Fig. 11.2, reviews the meanings of these ideas, and definitely decides that the concepts of *scarcity, goods, services, interdependence, production*, and *consumption* are not only concepts which the children should know, but are ideas that can be very effectively developed with content samples drawn from the life of an American family. He feels that he already has selected enough concepts for a unit, but remembers that social studies units should be interdisciplinary and not just economics. He reviews the key concepts in geography and political science, decides that the only concept within these two disciplines which is most appropriate for his family unit is the political science

concept of *social control*. Certainly all children have rules at home which they must obey, and they should gain a better understanding of the concept of *social control*.

In studying the sociological concepts on our list, he immediately sees how the concept of *role* is intimately related to one of the economic concepts which he has selected, *interdependence*. He thus decides to select *role*. He also selects the concepts of *socialization, norm,* and *sanction* because these concepts are related to the political science concept which he chose, *social control*. If children study laws, they should know how they relate to norms and sanctions. He is tempted to add other concepts to his list, but he realizes that it is best for children to gain a working knowledge of a few concepts than to learn a large number of them superficially. Let's review the concepts which Mr. Jones identified and the disciplines from which they were selected:

Discipline	Concepts Selected
Economics	*scarcity*
	goods
	services
	interdependence
	production
	consumption
Political Science	*social control*
Sociology	*socialization*
	norm
	sanction
	role

Mr. Jones feels assured that his unit will be an interdisciplinary one because he has selected key concepts from economics, political science and sociology, even though he did not select concepts from *all* the social science disciplines. He does not feel that it is either practical or possible for him to try to teach concepts from all the disciplines in one unit. He will teach other units during the year, and at that time will introduce ideas from the other disciplines. He feels that children should be exposed to the ideas and ways of thinking which are used by all social scientists. As he looks over his list of concepts, he realizes a point which had been made by his professor in social studies methods; although the social sciences have unique ways of looking at human behavior, the concepts and key ideas which they use are far from being mutually exclusive. Political scientists often use key sociological concepts in their research. He notes how the political science concept of *social control* is related to the sociological concepts of *norms* and *sanctions*. The interrelatedness of the social sciences is far from being a disadvantage to the social studies teacher; rather, it is a great advantage because their interrelatedness makes it easier to plan units which cut across discipline lines.

Exhibit 11.1
Key Generalizations and Related Concepts

Key Generalizations	Related Concepts
1. Every individual and society faces a conflict between unlimited wants and limited resources. This creates the need for decision-making. (Economics)	*scarcity*
2. All members of a society are interdependent; individual producers of goods and services exchange with others to get the goods and services they need to satisfy their basic wants. (Economics)	*goods* *services* *interdependence* *production* *consumption*
3. In every society and institution, regulations and laws emerge to govern the behavior of individuals; individuals usually experience some form of punishment when authorities catch them breaking laws. (Political science)	*social control*
4. All human behavior is learned from other human beings through group interaction. (Sociology)	*socialization*
5. Every member of society must function in many different roles. (Sociology)	*role*
6. Norms and sanctions shape the behavior of group members. (Sociology)	*norms* *sanctions*

IDENTIFYING RELATED GENERALIZATIONS

We have explained how a teacher who is required to teach about the family in the first grade might go about selecting organizing concepts from the disciplines in order to structure an interdisciplinary unit. Once the teacher has identified key concepts around which his unit will be structured, he must proceed to identify key *generalizations* that show the relationships between the concepts which he has selected. *Organizing generalizations* guide the selection of low-order generalizations or sub-ideas, specific content samples, and teaching strategies. Generalizations which are related to organizing concepts can be found in the same sources as key concepts — introductory textbooks, methods books, and social studies curriculum guides. Like key concepts, key generalizations should be powerful; i.e., they should summarize in general terms many facts and a great deal of specific information. They should also be empirical statements that can be verified scientifically. They should not be value or normative statements. As we illustrated previously in this book, some lists of generalizations are normative statements which cannot be scientifically verified. Mr. Jones selects the organizing generalizations shown in Exhibit 11.1 which are related to the key concepts already identified.

IDENTIFYING SUBGENERALIZATIONS AND SUB-IDEAS

After the teacher has identified the organizing generalizations related to the key concepts that he wishes to develop, he should proceed to identify subgeneralizations that are related to the organizing ideas. Subgeneralizations are low-order statements that relate to the specific content with which the teacher is required to deal. Let's see how Mr. Jones might select low-order generalizations for his unit. (See Chapter 2 for a discussion of *levels* of generalizations.)

Organizing generalization

Every individual and society faces a conflict between unlimited wants and limited resources. This creates the need for decision-making.

Sub-ideas

1. Mother and Father often want to buy two or more things when they have only enough money for one of them.
2. Mother and Father often have to make hard choices when they are deciding how they will spend their money.
3. Mother and Father often have to save up their money when they want to buy something big like a car or house.
4. Mother and Father sometimes cannot buy the things they want.
5. Children often want more things than their parents can afford to buy them.
6. Children often want more things than they can buy with their allowances.
7. Children often have to make hard choices when they buy the things they want.

Organizing generalization

All members of a society are interdependent; individual producers of goods and services exchange with others to get the goods and services they need to satisfy their basic wants.

Sub-ideas

1. Father works to make money to buy the goods and services that his family wants and needs.
2. Mother cooks and cleans the house; her services help members of the family satisfy their wants and needs.
3. The goods and services that members of the family buy with the money Father makes are produced by other workers.
4. The work that Father does helps produce goods and services that help satisfy the wants of other families.

5. Children do some jobs around the house that help the family satisfy their wants and needs. However, children are primarily consumers.
6. All members of the family help one another.

Organizing generalization

In every society and institution, regulations and laws emerge to govern the behavior of individuals; individuals usually experience some form of punishment when authorities catch them breaking laws.

Sub-ideas

1. Father and Mother make rules for children about going to bed, eating, watching television, crossing the street, and playing.
2. Children are sometimes punished when they break the rules which parents make.
3. Mother and Father have rules which they must follow which are made by public authorities.
4. Every person must obey rules and laws.

Organizing generalization

All characteristically human behavior is learned from other human beings through group interaction.

Sub-ideas

1. Our parents teach us how to walk and talk.
2. Our parents teach us what foods to eat for different meals.
3. Our parents teach us how to dress for different occasions.
4. We learn what things to like and dislike from family members and other people around us.
5. Our parents teach us how to treat other people.

Organizing generalization

Every member of society must function in many different roles.

Sub-ideas

1. Mother does certain things around the house.
2. Mother does different things when she goes shopping or to a club meeting.
3. Father does certain things around the house.
4. Father does different things when he goes to work.
5. Children do certain things around the house.
6. Children do different things when they go to school or church.

7. Children act differently at a public place than when they are at home.
8. All family members are expected to act differently away from home than at home.

Organizing generalization

Norms and sanctions shape the behavior of group members.

Sub-ideas

1. Our parents expect us to do certain things around the house.
2. Our parents expect us to treat them in a certain way.
3. Our parents expect us to talk to them in a certain way.
4. Our parents like it when we do things we are expected to do and let us know it.
5. Our parents get angry and let us know it when we do things which we are not expected to do.
6. We expect our parents and other members of the family to treat us in certain ways.
7. We get angry when members of our family do not treat us in the expected ways and let them know it.
8. We are pleased when members of the family treat us in the expected ways and let them know it.

DETERMINING UNIT OBJECTIVES

As stated before, units may be organized to develop *inquiry* skills, *valuing* skills, or *decision-making* skills; other units can be planned to give children practice in developing each of these skills. Early in the planning stages of the unit, the teacher must determine which skills he intends to develop. *Ideally, each unit should develop skills in all three areas*, even though the emphasis in a particular unit might be on inquiry, valuing, or decision-making. For purposes of emphasis, we have chosen to illustrate in this chapter the development of a *social science inquiry* unit which is interdisciplinary. In Chapter 13 we will discuss how a single unit can develop skills in inquiry, valuing, and decision-making.

When the teacher identifies his key concepts and generalizations for a social science inquiry unit, he has already largely determined the objectives of his unit, although they have not been articulated. A major objective of a social science inquiry unit is to have the student *state* or *write*, in his own words, the organizing generalizations which have been identified by the teacher. The student should also be able to demonstrate an understanding of the key concepts in the unit. When the concepts are named, students can demonstrate their understanding by *identifying* exemplars and nonexemplars of the concepts. Often the teacher will not choose to teach primary-grade children the

labels for concepts used by social scientists, even though he expects them to understand the concepts. In such cases, the concept objective is for the children to recognize the concept when it is stated in familiar terms. For example, if the concept is *norm*, the teacher might ask the children to list things around the house "which you are expected to do." The children will be able to respond with exemplars of the concept of *norm*.

Another major objective of a social science inquiry unit is for the children to be able to use the *method* of social science inquiry to derive social science generalizations. Social science consists of *knowledge* (concepts and generalizations) as well as a *method* of inquiry. Because social knowledge is tentative and is subject to constant revision, it is extremely important for children to be able to use the method of the social scientist to derive knowledge. While children need knowledge on social issues, knowing the *method by which scientific knowledge is derived is vastly more important*. Thus, throughout the unit, the teacher should emphasize the *process* of knowing. (The method of science was discussed in considerable detail in Chapter 2.) Basically, it involves (a) formulation of the problem, (b) formulation of hypotheses, (c) conceptualization, (d) collection of data, (e) evaluation and analysis of data, (f) derivation of generalizations, and (g) inquiry into the methods used to solve the problem. The teacher will not be able to provide practice for the children in each of these skills during each unit; however, the goal should be to help them attain maximum proficiency in each of them. These steps in the process and the practice of them should be kept constantly in mind when units and teaching strategies are planned. The teacher might plan specific strategies to develop some of these skills during each unit. For example, during the family unit, the teacher might want to stress how we formulate hypotheses and test them.

The major goals of social science inquiry units which we have identified can be summarized as follows: (1) The student will be able to state or write, in his own words, the organizing generalizations of the unit. (2) The student will be able to identify exemplars and nonexemplars of the key concepts of the unit. (3) The student will be able to use the process of social inquiry to solve a scientific problem. These objectives are stated in very general terms. However, depending upon his purposes, the teacher can state them as specifically as necessary. For example, in his statement of objectives for our sample family unit, the teacher might want to write out each of the generalizations that the children will be expected to state in their own words, and to list the concepts that they will be expected to understand. Also, the inquiry skills can be stated much more specifically. For example, regarding the skill of hypothesizing, the teacher might state, "When given a problem and sources of data, the student will be able to state a testable hypothesis." This kind of specific statement could be made for each skill the inquiry process comprises.

ORGANIZING THE UNIT

When the organizing concepts and generalizations have been identified and the sub-ideas (or subgeneralizations) stated, the teacher can organize the unit in a logical and meaningful fashion. In looking over the concepts which Mr. Jones

identified in our example, we note that he identified the following concepts in the order indicated.:

(1) *scarcity* (2) *goods, services, interdependence, production, consumption* (3) *social control* (4) *socialization* (5) *role* (6) *norms, sanctions*

Mr. Jones feels that his unit will be more effective if he teaches first some of the concepts that he identified later, and then teaches those he selected earlier. For example, the children can better understand the concept of *scarcity* if they are acquainted with the idea of *role*. He decides that role is a basic concept which he should introduce before any of the other ideas. Since people learn their roles through a process of *socialization*, he decides to teach *role* next. Then *norms* and *sanctions* will be taught; they shape a person's behavior during socialization. *Social control* is also a part of the socialization process. The concept of *interdependence* will help children see the relationships between different roles. *Scarcity* is chosen as the last main concept to develop because Mr. Jones feels that it can be more easily grasped once the other concepts are understood. The prior experiences of the children and the relationships between the key concepts should be the main determiners of the organization of the conceptual-inquiry unit.

FORMULATING AND OUTLINING ACTIVITIES: THE DEVELOPMENTAL PHASE OF THE UNIT

The activities and teaching strategies are the heart of any unit. If the organizing concepts and generalizations have been carefully selected and stated, they should serve as an effective guide to the formulation of appropriate teaching strategies and learning activities. The activities and strategies should relate directly to the central ideas of the unit. No activity should be included within a unit unless the teacher clearly sees how it contributes to the development of the ideas and skills that he has identified. The sub-ideas related to the key concepts and generalizations are stated primarily to assure that activities are related to the key ideas and to guide in their formulation. Traditional units often contain a long list of activities and teaching strategies whose relationship to the central ideas of the unit is not clear. This practice can best be avoided by writing the key concepts and generalizations to be developed on one side of a sheet of paper and the activities or teaching strategies on the other side, as illustrated in Exhibit 11.2. The statement of the activities or teaching strategies can be as general or specific as necessary. In our example, we have stated the activities in fairly general terms, largely to conserve space. The activities can be stated in terms of student or teacher behavior; when they are stated in terms of teacher behavior, they are more accurately referred to as *strategies*. Thus, instead of stating, "Role-playing a situation . . . ," we would state, "Have the children role-play a situation . . ." The major strategies and activities which serve to develop the key ideas of a unit are referred to as the *developmental phase* of the unit.

Exhibit 11.2
Concepts and Activities for an Interdisciplinary Unit on the Family

Concepts and Generalizations	Activities
Role Every member of society must function in many different roles.	1. Reading about the things that parents do in different families. 2. Viewing pictures showing what different family members do when they are at home and away from home. 3. Listing some of the different things our family members do at home and away from home. 4. Viewing a filmstrip on what family members do at home and away from home. 5. Summarizing and generalizing about the many different roles of family members.
Socialization All human behavior is learned from other human beings through group interaction.	1. Viewing pictures of parents showing children how to do such things as tie their shoes, swim, ski, and eat properly. 2. Naming the specific things which our parents taught us. 3. Naming the different kinds of clothes which we wear to school, to church, and to play, and who taught us to dress in these ways. 4. Discussing how we treat other people and who taught us how to treat them. 5. Summarizing and generalizing about the things which we learn from other members of our family.
Norms, sanctions Norms and sanctions shape the behavior of group members.	1. Listing ways in which we are expected to speak to our parents. 2. Listing ways in which we are expected to treat our parents and grandparents. 3. Discussing other things which members of the family expect us to do. 4. Listing the kinds of things our parents do to us when we do things that they do not expect us to do. 5. Listing the kinds of things members of our families do and say when we do the things that they do expect us to do.

(Cont.)

Exhibit 11.2 (Continued)
Concepts and Activities for an Interdisciplinary Unit on the Family

Concepts and Generalizations	Activities
Norms, sanctions (Cont.)	6. Discussing why members of our family treat us differently when we do things which are expected and things which are not expected.
	7. Listing the kinds of things which we expect members of our family to do, and what we do and say when they do not do them.
	8. Summarizing and generalizing about family norms and sanctions.
Social control In every society and institution, regulations and laws emerge to govern the behavior of individuals; individuals usually experience some form of punishment when authorities catch them breaking laws.	1. Role-playing a situation in which Father demands that Bob turn off the TV and go to bed at 9:00 p.m.
	2. Discussing why Father made Bob go to bed at 9:00 p.m.
	3. Listing, in chart form, home rules for playing, eating, going to bed, etc.
	4. Hypothesizing about reasons for rules.
	5. Listing rules and laws which parents must obey.
	6. Summarizing and generalizing about laws and rules.
Interdependence *(goods* *services* *production* *consumption)* All members of a society are interdependent; individual producers of goods and services exchange with others to get the goods and services they need to satisfy their basic wants.	1. Listing jobs which pupils' fathers do.
	2. Discussing how the money which Father makes pays for the goods and services consumed by the family.
	3. Examining pictures of workers who produce the goods and services used by families.
	4. Discussing the goods and services produced by pupils' fathers and how they are consumed by other families.
	5. Drawing pictures of goods and services produced by other family members.
	6. Discussing how members of a family help one another.
	7. Reading a story about a family at work and at play.
	8. Summarizing and generalizing about interdependence and its related concepts.

Exhibit 11.2 (Continued)
Concepts and Activities for an Interdisciplinary Unit on the Family

Concepts and Generalizations	Activities
Scarcity Every individual and society faces a conflict between unlimited wants and limited resources. This creates a need for decision-making.	1. Role-playing a situation in which Mother and Father have to decide whether they will add a room to the house or take a summer vacation. 2. Discussing why parents in the role-playing situation above can't do both things. 3. Role-playing situations in which pupils have had to make choices. 4. Discussing why individuals always want more than they can afford to buy. 5. Summarizing and generalizing about scarcity.

INITIATING THE UNIT

The teacher should plan activities to begin the unit which will stimulate student interest and curiosity. An exciting beginning is one of the best assurances of a successful and meaningful unit. If children are bored at the beginning of a unit, the teacher must seriously doubt whether it will have the intended outcomes. Because of the great importance of the introductory phase of a unit, it deserves careful thought and planning. Sometimes teachers arrange materials related to the unit topic around the room in order to stimulate student interest and questioning. These materials might include captivating pictures, interesting books, and objects which the students can actually handle. The teacher can also read to the students an intriguing story related to the unit topic and encourage them to ask questions about it. A record might be kept of these questions. To initiate the unit in our example, the teacher might read a book about family life, such as Sydney Taylor's fascinating book about life in a Jewish family, *All-of-a-Kind Family*. A recording, filmstrip, or film loop can also introduce units effectively. A unit can also be introduced with a role-playing situation or a dramatic incident. The creative teacher will think of an infinite number of ways to capture student interest and stimulate curiosity during this very important phase of the unit.

EVALUATION ACTIVITIES

The teacher should plan evaluation activities which can be implemented throughout the unit. Evaluation should be an ongoing and not an "end of the unit" activity, although it might be appropriate to plan general kinds of evaluation activities for the termination of the unit. Since effective evaluation

A teacher can initiate an effective unit by reading the children an intriguing story related to the unit topic and encouraging them to ask questions about it. (Clover Park School District, Tacoma, Washington).

is an ongoing process, the teacher might find it helpful to indicate (perhaps with asterisks) which activities within the developmental phase of the unit are intended for evaluation purposes. Too often, evaluation is considered only as a paper and pencil test. While a test is a legitimate evaluation exercise, to think of evaluation as merely a written test is to conceptualize it much too narrowly. Evaluation should be thought of in broad terms, and the objectives of the unit should be kept clearly in mind when evaluating activities are planned. Checklists, rating scales, role-playing situations, and group discussions can all be used as effective evaluation exercises. For example, children may be presented with a problem, such as "What kinds of things do we learn from our parents?" and asked to act out the correct answer in a role-playing situation.

When inquiry skills are assessed, it will often be necessary to give children new data to determine whether they are able to state hypotheses, evaluate data, and test generalizations. To test students' ability to identify *roles* and to form generalizations about them, the teacher (for the unit in our example) may read a story about family life among the Hopi Indians and ask the students to describe the roles of the different family members and to state a generalization about these roles. A similar exercise could assess the children's understanding of the concept of *socialization*. If they understand this concept, they will be able to state ways in which the Hopi child's behavior is shaped by the norms and sanctions within his family.

CULMINATING ACTIVITIES

The teacher should plan activities that will summarize the various parts of the unit. During this phase of the unit, the major ideas which were studied are highlighted, reviewed, and interrelated. Culmination activities may consist of

A simulated TV show such as "What's My Line?" is an excellent culminating activity, (Seattle Public Schools).

reviewing data retrieval charts made during the unit, giving oral reports, conducting discussions, participating in role-playing situations, or presenting short skits that highlight the key ideas studied. In previous years, culminating activities often consisted of highly rehearsed pageants which were attended by parents and other members of the school community. However, while sharing may be desirable under certain circumstances, the emphasis of culminating activities should be on *summarizing the major ideas learned*, and not on entertaining parents and other children. The teacher, during the culminating activities, may also gain helpful ideas about concepts he may use in future units. He may realize that certain concepts and key ideas need further study and clarification. Thus, culminating and evaluating activities are not by any means mutually exclusive. The various parts of a unit are discussed separately for purpose of emphasis. In reality, the parts often blend together.

RESOURCE BIBLIOGRAPHY

During the early stages of planning, the teacher should start compiling lists of the resources that he will need to develop the key concepts and ideas of the unit. Some teachers have found it advantageous to collect source material even before actual plans are made. They keep folders in which they place all pictures, clippings, and other materials which relate to specific topics. This greatly facilitates planning and the initiation of a unit. When planning a bibliography, the teacher should consider more than written, factual material.

The arts and humanities can enhance social studies learnings.
(Northshore School District, Bothell, Washington).

Literature, art, and music are rich sources which can and should be used to help children grasp key ideas in the social sciences. The resources should also include the filmstrips, pictures, and films which the teacher plans to use. All resources should be gathered or requested well in advance. Anyone who has taught can tell his own disappointing story about how a lesson was ruined because the book or filmstrip that was needed at a particular moment was not available. Often these incidents result from poor teacher planning. A film may have been ordered too late or the specific location of a book was not rechecked. It is often helpful to have a written list of resources for both the teacher and the students. The teacher will frequently find it necessary to study a number of books on a topic before he can teach it successfully. Some teachers have found it helpful to duplicate the list of resources available to the students so that they may locate extra copies of resource material when they want to study the subject in greater detail than is done in class.

SUMMARY OF UNIT COMPONENTS

We can summarize the components of a unit, which we have discussed, as follows:

a. Unit topic
b. Key concepts and generalizations
 List of sub-ideas (subgeneralizations)
c. Unit objectives (should relate directly to key concepts and generalizations)
d. Initiation phase of unit (should stimulate interest and curiosity)
e. Developmental phase of unit
 Sub-ideas and activities
f. Evaluation activities
g. Culminating activities (should summarize major ideas of unit)
h. Resource bibliography

THE DAILY LESSON PLAN

Once his unit is constructed, the teacher has clearly in mind the major components of his social studies lessons for a period of weeks. However, the components of each day's lesson should be planned to assure effective instruction and meaningful learning experiences. The lesson plan should relate directly to the major unit plan. The main components of the daily lesson plan are (1) a list of the key concepts and generalizations which are to be developed, (2) a statement of the sub-ideas, (3) a statement of objectives, (4) a list of activities, (5) evaluation and summary activities, and (6) a list of resources. Like the unit, the daily lesson plan can be as general or as specific as is necessary. In general, the inexperienced teacher will find it advantageous to make more detailed lesson plans than the veteran teacher. The concepts, generalizations, and objectives of the daily lesson plan should be taken from those listed for the major unit plan. As a general rule, the teacher should not try to develop more than one concept and generalization during a daily lesson. Some lessons may only develop concepts; others can be planned to help children develop general statements about concepts. The following example illustrates how a teacher may develop the concept of *role* and a related generalization during a daily lesson:

Example of a daily lesson plan

1. *Key concept*: Role
2. *Organizing generalization*: We function in many different roles.
 Sub-ideas
 a) Family members function in different roles at home.
 b) Family members function in many different roles away from home.

3. *Objective*: The student will be able to state, in his own words, the organizing generalization above.

4. *Developmental Activities*
 a) Listing things parents do at home
 b) Listing things parents do away from home
 c) Listing things children do at home and away from home
 d) Discussing how roles may conflict
 e) Viewing pictures of parents functioning in many different roles
 f) Viewing pictures of children functioning in many different roles

5. *Summary and Evaluation Activities*
 a) Summarizing and generalizing about how we all function in many different roles
 b) Viewing pictures of a Hopi Indian family and naming the roles of family members
 c) Contrasting Hopi family roles with those in American families

6. *Materials and Resources*
 a) Childrens' experiences
 b) Pictures of parents and children engaged in many different activities (Field Picture Series)
 c) Pictures of a Hopi Indian family engaged in a variety of activities (from the book, *The Hopi Indian*)

CONSTRUCTING A SPIRAL CONCEPTUAL CURRICULUM

We have discussed how a teacher within a school district with a traditional social studies program can construct conceptual units within such a framework. We will now consider a different problem. Some schools and school districts lack a formal social studies curriculum or are so dissatisfied with the existing one that they wish to structure a totally new program. Often in such districts the social studies teachers will form a committee to build a curriculum, or individual teachers may be able to "do their own thing." Sequential development of concepts suffers when each teacher builds his own curriculum, thus a sounder program is developed when it is worked out by teachers who represent the entire district and all grades. Nevertheless, some readers of this book will find themselves in schools where they will have to structure their own social studies programs. Teachers in this situation can develop a sequential program which extends only throughout the year. This is better than no program at all. Our present discussion will benefit both those teachers who may become members of curriculum committees charged with the responsibility of building a social studies curriculum from scratch, and persons who may find themselves in situations where they must individually devise a social studies program for their students.

IDENTIFYING CONCEPTS FOR A SPIRAL CONCEPTUAL CURRICULUM

The first step in developing a spiral conceptual curriculum is to identify a number of concepts to which children will be introduced in the earliest grades and which will be further developed and extended throughout the grades. We have already discussed criteria for selecting concepts for interdisciplinary units built within a traditional framework. The criteria for selecting concepts for a spiral curriculum are not essentially different. However, it is important to re-emphasize the fact that organizing concepts should be powerful ones. This point must be given special attention when a committee is structuring a total curriculum. Concepts for a spiral curriculum must be of a hierarchical nature. We must be able to develop them at a higher level in each grade. "The concepts must be visualized as threads which appear over and over again in a spiral fashion but which always are moving to a higher level."[8] A curriculum committee may identify the political science concept of *power* as an organization concept for its curriculum. This concept could be studied throughout the elementary and junior high-school grades in a spiraling fashion, as indicated in Fig. 11.3. The following topics could constitute the grades:

8th grade — power relationships in preliterate cultures
7th grade — power relationships between Eastern and Western nations
6th grade — power relationships between Western nations
5th grade — power relationships at the federal level
4th grade — power relationships in the state
3rd grade — power relationships in the local community
2nd grade — power relationships in the school community
1st grade — power relationships in the family

AN INTERDISCIPLINARY SPIRAL CURRICULUM

We suggested that in planning units, the teacher should select concepts from as many disciplines as is possible and practical, but indicated that it is often not feasible to incorporate concepts from all the disciplines within any single unit. However, a social studies curriculum can and should incorporate organizing ideas from all the social sciences. If concepts from all the disciplines are incorporated into a curriculum, the curriculum committee should study the disciplines carefully in order to select the most important and powerful ideas. Only a limited number of ideas from each discipline can be incorporated into an interdisciplinary spiral curriculum. For example, a committee could profitably select *culture* and *socialization* from anthropology and sociology since these are the most important concepts in these two disciplines.

Once the key concepts for the curriculum have been identified, the committee may decide that while most of them will be introduced in kindergarten, others will not be introduced until the later grades. This may be done for a variety of reasons, including lack of suitable materials for the

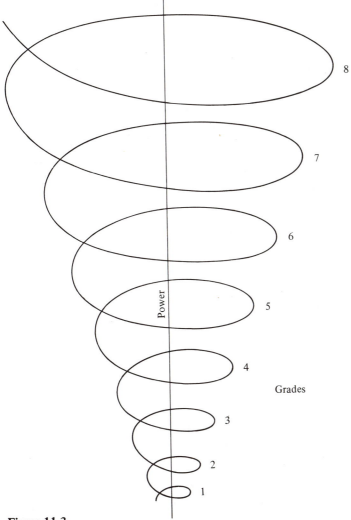

Figure 11.3
A Spiral Curriculum

The concept of *power* is developed throughout the grades at an increasingly higher level. The length of the loops indicates increasing depth of concept development through the grades.

primary grades or inappropriateness of specific concepts for young children. Each concept may not necessarily be taught in each grade, but it will reoccur throughout the curriculum. While this plan is sound, it is better if all concepts in the curriculum are expanded at each grade level, although each concept need not necessarily be taught in each unit within a particular grade. The Social

Figure 11.4
Key Concepts and Generalizations Identified by the New Park School District Social Studies Committee

Key Concept	Organizing Generalization	Discipline
Culture	Every society consists of a man-made system of artifacts, beliefs, and behavior patterns called "culture." This enables the individuals within it to meet the needs of their physical and social environment.	Anthropology
Scarcity	Every society must solve three related economic problems: What goods and services to produce, how to produce them, and for whom shall they be produced.	Economics
Interdependence	All members of society are dependent upon one another for the satisfaction of their wants and needs.	Economics
Authority	Within every society some individual or group is authorized to make binding decisions and to allocate values.	Political Science
Socialization	All characteristically human behavior is learned from other human beings through group interaction.	Sociology
Change	Change has been a universal condition of human society.	History
Location	Both cultural and physical factors influence the location of communities and other social institutions within a society.	Geography

Studies Curriculum Committee of the New Park School District may decide to organize a K-6 curriculum around the following key concepts:

Discipline	Key Concept
Anthropology	*Culture*
Economics	*Scarcity*
	Interdependence
Political Science	*Authority*
Sociology	*Socialization*
History	*Change*
Geography	*Location*

The Committee then identifies an organizing generalization related to each of the concepts. Once the organizing generalizations are stated, a number of related lower-order generalizations (sub-ideas) can be identified. The key concepts, organizing generalizations, and associated disciplines for our hypothetical social studies committee are illustrated in Fig. 11.4.

A conceptual curriculum allows the teacher to select content samples which are relevant to the lives of children from diverse racial and cultural groups (Washington State Office of Public Instruction, Olympia; Clover Park School District, Tacoma, Washington)

IDENTIFYING CONTENT SAMPLES AND TOPICS

The identification of key concepts and related organizing generalizations provides teachers with guidelines that will allow a maximum degree of flexibility and yet provide for the sequential development of concepts. However, most curriculum committees feel that it is necessary to provide teachers with suggested content samples and sub-ideas for developing each of

the key concepts. There are definitely some advantages to structuring the curriculum more tightly. By identifying content samples for each grade level, repetition of content coverage throughout the grades is minimized. Also, many teachers feel insecure with a skeleton curriculum guide; they want and need more guidance. Ideally, however, a curriculum guide that identifies only the concepts and generalizations to be developed in each grade would be potentially the most exciting. Once the teacher had met his class, he could choose content that would be most consistent with their needs, interests, and abilities. Also, the content could always be directly related to the most pressing social problems that confronted the school, the community, and the larger society at the time when the units are taught. Any content selected by a curriculum committee runs the risk of seeming irrelevant to the children who make up future classes. Such a highly flexible curriculum would also permit teachers who work in different cultural and socioeconomic areas of the school district to select content samples that are especially pertinent to the areas in which they teach. For example, teachers in the inner city and in suburbia might want to select different content to develop the concepts of *socialization* and *culture*. The inner city teacher might want to emphasize unique components of the Black culture for his units.

Despite the advantages which *could* result from a skeleton conceptual curriculum, it is more practical to recommend content and topics for each grade in order to develop the concepts that are identified by curriculum committees. Sub-ideas related to the key ideas, topics, teaching strategies, and materials should also be recommended. Although specificity may reduce teacher creativity, it is more practical to be as specific as possible when recommending content samples and strategies. For example, rather than suggesting that "other cultures" be studied in the 6th grade, the cultures might be named. Figure 11.5 illustrates the content samples which the New Park School District Social Studies Curriculum Committee might recommend for the development of the concepts that it identified. Figure 11.6 illustrates the spiral development of concepts within the curriculum.

UNIT PLANNING WITHIN A CONCEPTUAL FRAMEWORK

Once the key ideas and generalizations of a curriculum have been identified, a curriculum committee can begin to structure *resource* units. Resource units differ from *teaching* units in that the latter are specifically designed for a particular class, while the former include a large number of activities and ideas from which the individual teacher can select. Resource units for a conceptual curriculum can be organized in a variety of ways. Let's study Grade 4 in our example. The content for the grade consists of four preliterate societies. Seven concepts (*culture, scarcity, interdependence, authority, socialization, change,* and *location*) will be developed. The concept of *culture* is to be emphasized throughout Grade 4. The units for Grade 4 could be organized around concepts. Whatever approach is taken, *culture* should be studied in each unit, while some of the concepts can be studied in some units and not in others. Units could be organized as in Plan I or Plan II.

Figure 11.5
Scope and Sequence Chart for the New Park School District Elementary Social Studies Curriculum

Grades	Concepts	Content Samples
K	*interdependence scarcity change socialization	The American Hopi, Japanese and Eboe families
1	culture interdependence scarcity change *socialization authority location	The local community, a Black community, a Chicano community, an Indian reservation community
2	All concepts, emphasis on *change	Historical communities (Early America, Rome, Africa, Latin America)
3	All concepts, emphasis on *authority	The United States, Russia, Tanzania
4	All concepts, emphasis on *culture	The Semang, the Polar Eskimo, the Maoris
5	All concepts, emphasis on *location	Exploration (historical-modern)
6	All concepts, emphasis on *scarcity	The United States today

*Concept emphasized.

In Plan I, three units would constitute the year's program. *Culture* is developed in each unit; *authority* is developed in units 1 and 3; all the other concepts are taught in only one of the three units. The Grade 4 program could also consist of three topical units. In this case the units could be structured as in Plan II.

Plan I

Unit 1	Unit 2	Unit 3
Key concepts: *culture, scarcity, authority*	Key concepts: *culture, interdependence, socialization*	Key concepts: *culture, authority, change, location*
Content: Semang, Polar Eskimo, the Maoris	Content: Semang, Polar Eskimo, the Maoris	Content: Semang, Polar Eskimo, the Maoris

Figure 11.6
The Spiral Development of Concepts within the New Park School District Social Studies Curriculum

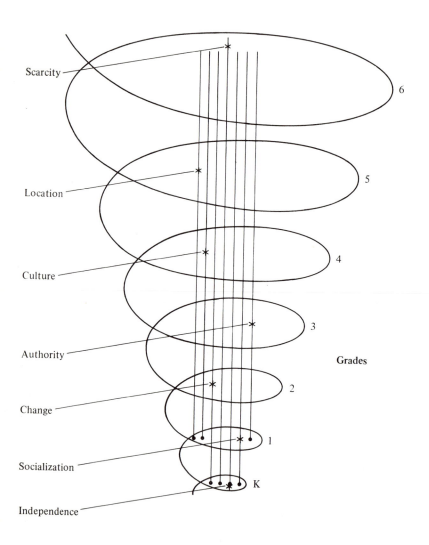

The curriculum is organized around seven key concepts from the various social science disciplines. Four of the concepts are introduced in kindergarten. All seven of them are studied in Grade 1 and in subsequent grades. While all the concepts are introduced in Grade 1, one specific concept is emphasized in each of the grades. The asterisks indicate concepts emphasized in the various grades.

Figure 11.7
Key Questions and Concepts for a Conceptual Unit

Analytical Concepts	The Semang	The Polar Eskimo	The Maoris
Culture What are the unique artifacts, beliefs, and behavior patterns? Beliefs Artifacts Behavior Patterns			
Scarcity What goods and services are produced? How? For whom? Goods and services How For whom			
Authority Who makes the binding decisions and allocates values? Who Decisions Values			

Plan II

Unit 1: *The Semang*	Unit 2: *The Polar Eskimo*	Unit 3: *The Maoris*
Key concepts: *culture* *socialization* *interdependence*	Key concepts: *culture* *authority* *scarcity*	Key concepts: *culture* *change* *location*

While Plan II would allow students to concentrate on one culture at a time and thus perhaps gain a more comprehensive understanding of it, Plan I will better facilitate the development of generalizations because comparisons can be easily made with data retrieval charts. Studying different societies is also more likely to maintain student interest. Figure 11.7 illustrates key questions which can guide the research activities for Unit 1 of Plan I.

USING PSYCHOLOGICAL CONCEPTS

We have discussed how the perspectives of the various social sciences can help children to become more adept decision-makers. In addition to the disciplines we described in Chapters 5 through 10, children can benefit from viewing many social problems from the point of view of the psychologist. Psychologists study man's behavior as well as the behavior of other animals. Psychology is more often characterized as a *behavioral* science than a *social* science because it is concerned with the behavior of all animals, the biological foundations of behavior, and the psychological activities which take place within the individual.[9] The social sciences are concerned primarily with man's relationship with other human beings. However, many aspects of psychology are "social." Psychologists study how individuals relate to other individuals, to groups, and the relationships between groups. These concerns of the discipline justify its inclusion in the elementary and junior high-school social studies program.

Psychology is most often defined "as *the science that studies the behavior of man and other animals.*"[10] Behavior consists of "those activities of an organism that can be observed by another person or by an experimenter's instruments."[11] Since its formal inception in 1879, when Wilhelm Wundt established the first experimental psychological laboratory, the discipline has had a strong empirical tradition. The *experiment* is one of the most frequently used research methods. Although psychology has a strong experimental tradition, movements have emerged within it, such as the *psychoanalysis* school, that are more subjective in their approaches. However, behavioral and experimental methods are preeminent within the discipline.

When selecting concepts from psychology for social studies units, the teacher should identify which concepts deal with the behavior of the individual and which relate to man's group behavior. Since social studies should help the individual understand his own behavior as well as that of other people, we can justifiably include within the social studies curriculum concepts relating to interpersonal relations. In the discussion below, we identify and define five key

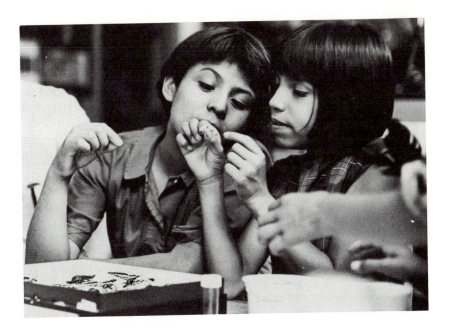

Psychological concepts can help students to better understand their relationships with other children. (Washington State Office of Public Instruction, Olympia)

psychological concepts that will help children better understand their social environment and become better decision-makers. No attempt is made to identify the structure of psychology, only five of its organizing ideas.

Self-Concept

An individual's feelings, attitudes, and evaluations of himself constitute his self-concept. Many psychologists consider the self-concept one of the most important variables which influences behavior. A girl who is average-looking but believes that she is attractive will often act in ways that cause boys to treat her as if she were attractive. A student who feels that he will never succeed in arithmetic often performs poorly in math, even though he might have the aptitude to do well in the subject. The teacher can use this concept to help children discover how our feelings toward ourselves profoundly shape our behavior. He could introduce the concept by reading selections from a children's book such as *The Soul Brothers and Sister Lou* by Kristin Hunter, a gripping story of a Black girl's identity search. He could ask such questions as, "How does Lou feel about herself?" "How do you know?" "Why does she feel the way she does about herself?" "How might she act differently if she had a different opinion of herself?" The teacher could help the children discover that our self-perceptions are highly influenced by the persons in our environment.

Motivation

Motivation refers to the factors which direct an individual toward certain goals.[12] Both physical and social factors influence the goals an individual seeks. Since all children are interested in knowing what makes people act the way they do, the teacher can use many role-playing situations to help them grasp this concept. Such questions as, "Why do some children always like to fight?" "Why do some children hate to read?" and "Why do some people always try to dominate a group?" are the kinds of questions which can initiate fruitful discussions of this central psychological concept.

Perception

The process that we use to view our environment is called perception. Our perceptions are influenced by our sense organs as well as by our needs, attitudes, and beliefs. It is extremely important for the teacher to help children discover how profoundly our perceptions are colored by interpersonal experiences. The teacher could start by using physical objects to demonstrate how our perceptions often distort reality. He could place a stick in a bucket of water and ask the children to tell how it appears, ask them to describe how a car on the street looks from the 10th floor of an apartment building, and the shape of the moon at different times of the month. He could then proceed to social examples. For example, he could read *The Jazz Man* and ask the children to describe what kind of man Father is. The children, depending upon their past experience, will perceive the character differently. Reading different accounts of the same historical events could also help develop this concept.

Frustration

When we get ready to take an examination and can't find a pencil, when we can't start the car and are late for work, or when we are unable to win the attention of an attractive member of the opposite sex, we become frustrated. In each case, some obstacle blocks our attainment of the goal we seek. Each day brings its frustrations, and man must constantly cope with them.

This concept will help children understand many aspects of their own behavior, as well as the behavior of persons in their social environment. When it is introduced, the teacher could help the children discover ways in which man handles his frustrations. Defensive reactions such as *withdrawal, aggression*, and *repression* could be discussed. Role-playing situations and literary works can be used to illustrate human frustrations and how they are handled.

Attitudes

A readiness or predisposition to respond in a predetermined way to some object is called an attitude.[13] The individual may be inclined to act positively or negatively toward the object. A person who tries to avoid all Jews, but who

enjoys Italians has a negative attitude toward Jews and a positive one toward Italians. Attitudes are distinguished from other emotional states because they are learned, tend to endure, and are directed toward specific objects, persons, and groups.[14] This concept is especially important in value inquiry, and more will be said about it in the next chapter. It is extremely important for children to understand how their own attitudes and those of other persons and groups are formed. The teacher should help pupils to discover that many of our attitudes are acquired from persons in our environment, and do not result from direct experience. For example, the teacher could administer an attitude scale to assess the children's attitudes toward some object or group, and ask such questions as, "Why do you think that you feel that way?" "Do you think that some kind of experience could modify your feelings?" "How might your actions be different if you had a different kind of attitude toward this object or group?" One important goal of value inquiry is to help children understand the source of their attitudes, how attitudes affect behavior, and the possible consequences of alternative attitudes and beliefs.

INTERDISCIPLINARY SOCIAL STUDIES PROJECTS

Several of the social studies projects which were structured during the 1960's have an interdisciplinary emphasis. One of the most carefully planned is the Taba Social Studies curriculum, which is now commercially published by the Addison-Wesley Publishing Company. This curriculum has objectives in four categories, (1) basic knowledge, (2) thinking, (3) attitudes, feelings, and sensitivities, and (4) academic and social skills.[15] The basic knowledge objectives are concerned with the development of eleven key social science concepts and related generalizations. The concepts are developed in a spiral fashion throughout Grades 1 through 8. For the *thinking component* of the curriculum, strategies are developed for teaching three different tasks: (1) concept formation, (2) inductive development of generalizations, and (3) application of generalizations and principles.[16]

The *valuing component* attempts to develop within children "the capacity to identify with people in different cultures . . . [and] the self-security that permits one to be comfortable in differing from others."[17] Open-mindedness, acceptance of changes, tolerance, and responsiveness are also goals of the valuing component. The research skills emphasized "include reading selectively, asking relevant questions, organizing information around study questions, and developing reasonable hypotheses."[18] The strategies for teaching thinking skills and the sequential way in which the key concepts of this curriculum are developed makes it in many ways a model conceptual curriculum. The valuing component, however, is somewhat inconsistent with this author's perceptions of the proper goals of social studies education. Value inquiry will be the topic of Chapter 12.

Project Social Studies of the University of Minnesota is another inter-disciplinary conceptual program. This curriculum includes materials for grades kindergarten through twelve. The entire curriculum is organized around the

Figure 11.8
Project Social Studies, University of Minnesota — Scope and Sequence*

Grade	Topics and Units
K	The Earth as the Home of Man 1. The Earth as the Home of Man 2. A World of Many Peoples 3. Our Global Earth 4. A Home of Varied Resources 5. Man Changes the Earth
1	Families Around the World 1. Hopi Family 2. Chippewa Family 3. Quenchua Family (Peru) 4. Japanese Family
2	Families Around the World 1. Boston Family of Early 18th Century 2. Soviet Family in Urban Moscow 3. Hausa Family in Nigeria 4. Kibbutz Family in Israel
3	Communities Around the World 1. Rural and Urban Communities: A Contrast 2. An American Frontier Community: Early California Mining Camp 3. Paris Community 4. The Manus Community (Great Admiralties) in the 1930's and 1950's
4	Communities Around the World 1. Our Own Community 2. A Community in the Soviet Union 3. A Trobriand Islander Community 4. Indian Village South of Himalayas
5	Regional Studies 1. The United States 2. Canada 3. Latin America
6	The Formation of American Society 1. Indian America 2. The Colonization of North America 3. Revolutionary America 4. National Expansion 5. Civil War and Reconstruction 6. The Completion of National Expansion
7	Man and Society 1. Overview: Introduction to Human Behavior and Sociological Reasoning 2. Man's Behavior: The Physical Basis 3. Socialization 4. The Family

Figure 11.8 (Continued)
Project Social Studies University of Minnesota — Scope and Sequence

Grade	Topics and Units
	5. Our Behavior in Groups and Crowds
	6. Intergroup Relations
8	Our Political System
	1. Overview of Our Political System
	2. Political Parties and Elections
	3. Executive Process
	4. Legislative Process
	5. Judicial Process
	6. Decision-Making at the Local Level

*Adapted with permission from Project Social Studies Curriculum Center, *Curricular Framework: Project Social Studies Curriculum Center*, University of Minnesota.(no date), pp. 1-8.

concept of *culture*, but concepts from the other disciplines are taught in various grades.[19] *Culture* is the only concept studied in kindergarten, but sociological concepts are introduced in Grade 1, and political science concepts in Grade 3. Concepts introduced in the early grades are further developed and expanded in later grades. However, *culture* is the only concept which is taught in every grade. While the Taba Program teaches organizing concepts with traditional content, the Minnesota Project introduces new concepts as well as new content samples. The topics and related units for grades kindergarten through eight are indicated in Fig. 11.8.

The Greater Cleveland Social Studies program, now published by Allyn and Bacon as *Concepts and Inquiry: The Educational Research Council Social Science Program*, is designed to be an interdisciplinary, conceptually oriented, sequential program for the elementary and high-school grades. The handbook for the program suggests that "concepts, skills, methods, and structure" should be emphasized in social studies education.[20] The program draws content from all the social science disciplines. The concepts are introduced in the early grades and expanded in later grades. Figure 11.9 is an excerpt from the *conceptual* chart for grades one through three.

Figure 11.9 raises some serious questions about the criteria used to select the key ideas for the curriculum. The chart actually describes a mixture of skills, organizing concepts, divisions of fields (such as political and urban geography), low-level concepts (such as tools), and phrases whose nature it is difficult to characterize, such as "Understanding oneself and others." Philosophy and religion belong to the humanities and not the social sciences. However, these disciplines were probably included because one of the teacher's guides suggests that the teacher should inculcate such values as "justice, loyalty,

Figure 11.9
Conceptual Chart for the Primary Grades (from *Concepts and Inquiry*: The Educational Research Council Social Science Program*)

GEOGRAPHY	SOCIOLOGY-ANTHROPOLOGY
Globe and map skills	Family: basic social group
Earth science in relation to social science	Education and socialization
Man and his environment	Primitive societies
Regions	Cultural differentiation
Natural resources	Classes and other groups in society
Circulation, or spatial interconnections	Social harmony and disharmony
Political geography	Demography
Urban geography	

PHILOSOPHY-RELIGION-PSYCHOLOGY	POLITICAL SCIENCE
The nature and importance of values	The nature of government
Norms and relativity	The nature of law
The nature of man	Constitutionalism vs. arbitrariness
Techniques of critical thinking	Political obligation
The nature of religion	Types of government
Understanding oneself and others	Domestic political struggles
	Political ideologies
	American government
	International politics

ECONOMICS	HISTORY
Demand and supply	Time, chronology, speed of change, periods
Division of labor, or specialization	History as clue to the present
Tools, or capital (surplus, savings)	Historical imagination
Exchange and trade	
Agriculture, manufacture, services	Civilization: its nature, rise and fall
Money, credit, banking	Historical evidence and its evaluation
Government and the economy	Interpretations of history
Labor-management relations	
Economic growth	

*Reprinted with permission from Social Science Staff of the Educational Research Council of America, *Communities at Home and Abroad, Teacher's Guide.* Boston: Allyn and Bacon, 1970, pp. 12 and 14.

"All right, class. Let's settle down and pay attention to what we're doing."
Reprinted from *Instructor* (c) February, 1970, the Instructor
Publications, Inc. Used by permission.

freedom, and truth."[21] The design of this curriculum would have been strengthened if the authors had built it primarily around key concepts from the social sciences, clearly distinguished skills and low-order concepts from organizing concepts, and distinguished the social sciences from the humanities. The program consists of helpful teachers' guides and impressive student textbooks that the teacher can profitably use with any sound social studies program. While *Concepts and Inquiry* is interdisciplinary, it seems difficult to characterize it as a sequential, conceptual curriculum.

THE TEACHER AS INQUIRER

Students must be able to use scientific methods to solve empirical problems in order to make sound decisions. We have discussed the scientific method of inquiry throughout this book and suggested strategies which can be used to teach children inquiry skills. Although the role of the teacher in the inquiry oriented classroom has been discussed at different points in the text, it is appropriate to highlight the role of the teacher in the scientific classroom.

To be able to guide pupil inquiries effectively, the teacher must first of all accept the scientific method as the most valuable way to attain knowledge, and *use the method himself when he is faced with a problem*. The teacher who frequently reaches conclusions on the basis of tradition, authority, or intuition will be unable to help children to attack social problems scientifically. The behavior which the teacher exhibits in the classroom heavily influences the attitudes, perceptions, and behavior of his students. If the teacher often reaches

The effective teacher in an inquiry setting must create a relaxed learning
atmosphere for the learner and support the pupil in his quest for knowledge.
(Shoreline School District, Seattle, Washington).

conclusions without supporting evidence, his students will not appreciate the
need for data when they make generalizations.

The effective teacher in an inquiry oriented classroom must be thoroughly
familiar with the method of science, and fully appreciate the tentative nature
and limitations of scientific knowledge. He must realize that in science we
cannot search for certainties and absolutes, and that scientific knowledge
changes when the assumptions, values, and goals of a society change. Many
teachers are unable to accept the tentative nature of scientific knowledge, and
are uncomfortable with knowledge which seems fluid and is subject to constant
reconstruction. The scientific teacher is more committed to *method* than to the
product of scientific inquiry. However, he realizes that action must be based on
current knowledge. Thus he fully appreciates the need for *facts, concepts*, and
generalizations. The effective teacher in an inquiry classroom values *method*
but realizes that in order for children to make sound decisions and to solve
scientific problems, they cannot derive *all* their knowledge independently.
Thus, he uses *deductive* methods of instruction when it is appropriate and
necessary.

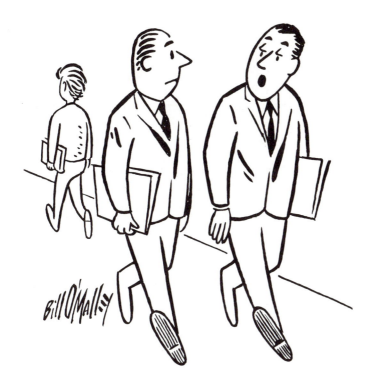

"Well, so far I've collected money, handled tickets, supervised the lunch-room, monitored the halls, made reports, and if I'm lucky — I might get in some teaching today."
Drawing by Bill O'Malley; (c) 1970, *Today's Education.*

The scientific teacher is patient. Telling children that the Hopi rain dances and water witching in our society are similar kinds of culture traits is much quicker and easier than letting them discover that relationship for themselves. Helping children to derive generalizations independently is very time consuming and often tries the patience, but giving children all the answers to their problems will not help them gain proficiency in the scientific process.

The scientific teacher is open-minded. He must be willing to give every student many opportunities to state his ideas and help him state them clearly and in a form in which they can be tested. "Cutting students down" when they give their ideas about problems may make them give up their search for intelligent solutions. This does not mean that students should be allowed to say whatever they wish, or that one student's opinion is as good as the next. The teacher should require students to give reasons and cite evidence to support their statements. However, the dogmatic teacher is detrimental to scientific inquiry.

While the scientific teacher is thoroughly familiar with the structure and nature of the social science disciplines, he is willing to admit to students that he

does not have all the answers to problems which may arise in the classroom. He is not a know-it-all. Write Massialas and Cox, "He acknowledges the fact that he also engages in reflective inquiry in an attempt to find truth as it finally appears. This attitude on the part of the teacher reinforces the psychological perplexity of the class and reaffirms the reality of the problem under attack."[22] Above all, the scientific teacher must be a *model inquirer in all his relationships with his students*. For example, he cannot penalize students without sufficient evidence, and make opinionated statements and expect students to elevate them to the status of scientific truth. The teacher whose actions contradict the method of science will not encourage students to become effective inquirers.

SUMMARY

This chapter highlights a basic point underlying the theory of social studies education presented in this book: Children must become intelligent decision-makers and effective social activists in order to resolve personal problems and influence public policy. Decisions must be based on *knowledge*; intelligent decisions must emanate from *scientific* knowledge. The scientific knowledge which the social activist uses to make intelligent decisions will reflect the perspectives of a number of social science disciplines, because social problems are too complex for a single discipline to provide enough evidence to help us resolve them. Chapters 5 through 10 illustrated how each of the social sciences can contribute to our knowledge of human relationships; the present chapter has demonstrated how the teacher can structure units that will teach children to view social problems from the perspectives of several disciplines. Steps to take in building interdisciplinary units within traditional frameworks and schools that are uncommitted to a specific program were discussed. The potential contributions of psychological concepts to decision-making were illuminated.

While interdisciplinary knowledge is necessary for sound decision-making and intelligent social action, it is not sufficient. The intelligent social activist must also identify and clarify his *values* before he can make rational decisions. The next chapter discusses the value component of the decision-making process.

DISCUSSION QUESTIONS AND EXERCISES

1. Why is it necessary for children to view social problems from the perspectives of several disciplines in order to make sound decisions?

2. Select a current social problem and develop a teaching plan that will help children to view the problem from the perspectives of history, sociology, anthropology, geography, political science, economics, and psychology. From each of these disciplines, list at least one key concept and related generalization that can help children to better understand the social problem.

3. Structure an interdisciplinary unit on a topic traditionally studied in the elementary and junior high-school grades — such as the family, the school, the neighborhood, or the community — that includes the following components: (1) unit topic, (2) key concepts and generalizations from at least four different social science disciplines, (3) sub-ideas which are related to each of the key generalizations and to the specific institution selected for study, (4) objectives stated in behavioral terms, (5) initiation activities, (6) developmental activities, (7) evaluation activities, (8) culminating activities, and (9) a list of resources for both the teacher and the pupils.

4. Work with a group of students to structure an *outline* of a K-8 interdisciplinary social studies curriculum for a hypothetical school district. The outline should indicate the key concepts and generalizations that will be developed, recommended content samples for developing the key ideas, and a list of the units for each grade or level. The rationale and criteria that the group will use to identify the key concepts and generalizations and content samples should also be stated.

5. Examine a school district social studies guide in the curriculum library of your college. Evaluate the guide using the following criteria questions: (1) Does the guide include key concepts and generalizations from all the social science disciplines? (2) Are the concepts and generalizations accurate? (3) Are the key ideas within the curriculum developed with appropriate content samples? (4) Are the key ideas within the curriculum developed at an increasing degree of complexity in successive grades? (5) Are the objectives related to the key ideas stated? (6) Are the objectives stated in behavioral terms? (7) Are the units within the curriculum divided in a way that will facilitate the learning of the key ideas stated? (8) Will the activities develop the major ideas stated in the curriculum? (9) Are sound evaluation strategies a part of the curriculum? (10) Does the curriculum contain a sufficient number of resources for both the teacher and the pupils?

6. How does psychology differ from the other social sciences? What makes psychology unique? What contributions can psychology make to the social studies curriculum?

7. Examine a college textbook on psychology. List some of the key concepts, generalizations, and theories contained within the book. Which of these major ideas can be profitably incorporated into the social studies curriculum? How?

8. Develop a lesson plan for teaching the following concepts to a group of elementary school children: *motivation, perception, frustration, attitude.*

9. What characteristics do you think that an effective teacher of inquiry skills should possess? Observe a social studies teacher in his classroom and tell whether you think that he is an effective inquiry leader. Give specific reasons to support your response.

10. Examine several of the national social studies curriculum projects which are interdisciplinary and evaluate them using the criteria questions stated in Activity 5 above.

11. Demonstrate your understanding of the following concepts and terms by writing or stating brief definitions for each of them. Also tell why each is important:

a) interdisciplinary

b) unit

c) initiation activities

d) developmental activities

e) evaluation activities

f) culminating activities

g) self-concept

h) motivation

i) perception

j) frustration

k) attitudes

FOOTNOTES

1. John U. Michaelis, *Social Studies for Children in a Democracy*. Englewood Cliffs, N.J.: Prentice-Hall, 1963, p. 209.

2. Mary C. Durkin and Kim Ellis, *The Taba Social Studies Curriculum: Four Communities Around the World*. Menlo Park, Calif.: Addison-Wesley, 1969, Grade Three, pp. v-vii.

3. Project Social Studies Curriculum Center, *Grade Two, Unit: The Kibbutz Family in Israel*: Project Social Studies Curriculum Center, University of Minnesota (no date).

4. *Ibid.*

5. Ronald Lippitt, Peggy Lippitt, and Robert S. Fox, "Children Look at Their Own Behavior," Reprinted in James A. Banks and William W. Joyce (Eds.), *Teaching Social Studies to Culturally Different Children*. Reading, Mass.: Addison-Wesley, 1971, p. 18.

6. Durkin and Ellis, *op. cit.*, p. v.

7. Hilda Taba, *Teachers' Handbook for Elementary Social Studies*. Reading, Mass.; Addison-Wesley, 1967, p. 18; also see second edition of this book, Hilda Taba, Mary C. Durkin, Jack R. Fraenkel, and Anthony H. McNaughton, *A Teacher's Handbook to Elementary Social Studies: An Inductive Approach*. Reading, Mass.: Addison-Wesley, 1971.

8. *Ibid.*, p. 14.

9. Floyd L. Ruch, *Psychology and Life*. Chicago: Scott, Foresman, 1958, p. 14.

10. Ernest R. Hilgard and Richard C. Atkinson, *Introduction to Psychology*. New York: Harcourt, Brace and World, 1967, p. 3.

11. *Ibid.*, p. 6.

12. Ruch, *op. cit.*, p. 123.

13. James O. Whittaker, *Introduction to Psychology*. Philadelphia: W.B. Saunders, 1965, p. 157.

14. *Ibid.*, p. 157.

15. Taba, *Teachers' Handbook*, p. 7-10.

16. *Ibid.*, pp. 8-9.

17. *Ibid.*, p. 9.
18. *Ibid.*, p. 10.
19. Project Social Studies Curriculum Center, *Curriculum Framework*: Project Social Studies Curriculum Center, Univ. Minnesota (no date), pp. 17-20.
20. *Concepts and Inquiry: The Educational Research Council Social Science Program.* Rockleigh, N.J.: Allyn and Bacon, undated, p. 1 (Handbook).
21. The Social Science Staff of the Educational Research Council of America, *Communities at Home and Abroad*, Teacher's Guide, Grade 2, First Semester. Boston: Allyn and Bacon, 1970, p. 3.
22. Byron G. Massialas and C. Benjamin Cox, *Inquiry in Social Studies*. New York: McGraw-Hill, 1966, p. 112.

REFERENCES ON UNIT PLANNING

Wilhelmina Hill, *Unit Planning and Teaching in Elementary Social Studies*. Washington, D.C.: U.S. Government Printing Office, 1965.

Lavone A. Hanna, Gladys L. Potter, and Neva Hagaman, *Unit Teaching in the Elementary School: Social Studies and Related Sciences*. New York: Holt, Rinehart and Winston, 1963.

John Jarolimek, *Social Studies in Elementary Education*. New York: Macmillan, 1967.

Bruce R. Joyce, *Strategies for Elementary Social Science Education*. Chicago: Science, Research Associates, 1965.

Theodore Kaltsounis, *Teaching Elementary Social Studies*. West Nyack, N.Y.: Parker, 1969.

John U. Michaelis, *Social Studies for Children in a Democracy: Recent Trends and Developments*. Englewood Cliffs, N.J.: Prentice-Hall, 1972.

William B. Ragan and John D. McAulay, *Social Studies for Today's Children*. New York: Appleton-Century-Crofts, 1964.

Dorothy J. Skeel, *The Challenge of Teaching Social Studies in The Elementary School.* Pacific Palisades, California: Goodyear, 1970.

R. Murry Thomas and Dale L. Brubaker, *Decisions in Teaching Elementary Social Studies.* Belmont, Calif.: Wadsworth, 1971.

Part 3

VALUE INQUIRY

INTRODUCTION TO PART 3

In previous chapters, we pointed out why higher-level, scientific knowledge is essential for sound decision-making. Although knowledge is essential for sound decision-making, it is not sufficient. The social actor must also be able to identify and clarify his *values* before he can take effective action to resolve personal problems or to influence public policy. Values profoundly influence man's behavior. Often values determine whether an individual accepts or rejects the knowledge that he obtains.

This part of the book sets forth a rationale for value education, reviews several policy-making and valuing models constructed by other authors, and presents a valuing model which the teacher can use to help students identify and clarify their values. Exemplary strategies for teaching value inquiry constitute a major part of the material in this part of the book. The theory of value inquiry presented stresses the need for teachers to help children learn a *method* for deriving their own values, and rejects didactic approaches to value education.

VALUING: INQUIRY MODES AND STRATEGIES

THE VALUE COMPONENT OF DECISION-MAKING

As we have stressed throughout this book, the main goal of the social studies program should be to help students develop the ability to make rational decisions, so that they can resolve personal problems and shape public policy by effectively participating in social action. To make intelligent decisions, the social actor must have *knowledge*. Part 2 of this book explored the nature of social knowledge and suggested strategies for helping children derive concepts and generalizations. While knowledge is an essential component of the decision-making process, it is not sufficient. To make a rational decision, the social actor must also identify and clarify his values, and relate them to the knowledge that he has derived. The valuing component is a very important part of the decision-making process, because values frequently determine what knowledge an individual will accept or reject. Value confusion often results in social action that is contradictory and bizarre.

THE NATURE OF VALUES

A standardized definition of *value* does not exist in either the social sciences or philosophy. However, a number of writers have provided definitions of the concept that are sufficient for our purposes. Our discussion is based on *Beliefs, Attitudes and Values* by Milton Rokeach. Rokeach defines *value* as a "type of belief, centrally located within one's total belief system, about how one ought or ought not to behave, or about some end-state of existence worth or not worth attaining."[1] Values, unlike attitudes and other beliefs, are not related to any specific things, persons, or groups, but are very general and influence a person's behavior toward a large class of objects or persons. A value is also a

standard for determining whether something is good or bad, and for judging one's own behavior and the behavior of other persons.[2] People learn their values, as they do most other beliefs and attitudes, from the persons in their social environment; most values are not reflectively and independently derived. The social origin of values accounts for the fact that people within a similar culture, social system, or occupation are likely to have similar values and beliefs. Thus the nature of a social system or culture restricts the number of value alternatives for individuals.

There are basically two types of values: *instrumental* and *root*. Root values are terminal values; they are the ultimate states which an individual hopes to attain. Instrumental values lead to the realization or attainment of root values. In other words, instrumental values are a *means* to an end — root values. For most people, money is an instrumental rather than a root value. Most people value money because it helps them attain higher-level values, such as happiness and status. Because there are different kinds and levels of values, they can be rank-ordered into a hierarchical relationship. In our example, respect and authority have a higher rank-order than money. Rokeach has also made a distinction between attitudes and different kinds of values in terms of numbers. According to Rokeach's analysis, an individual's belief system consists of "thousands . . . of attitudes toward specific objects and situations, but only several dozens of instrumental values and perhaps only a few handfuls of terminal values."[3]

VALUE PROBLEMS IN AMERICAN SOCIETY

In Chapter 1, we reviewed some of the personal and social problems in American society and argued that they result primarily from our inability to resolve the salient value conflicts of our time. The high crime, divorce, and suicide rates, the widespread use of illegal drugs, and the domestic violence of the past decade vividly illuminate the immense magnitude of the personal and social problems that Americans face in the present century. Literary writers, such as George Orwell and Aldous Huxley, and social commentators, such as Erich Fromm and Jules Henry, have described the value crisis in American society in rather frightening language. (We discussed the works by these authors in Chapter 1.) Numerous social studies educators have also commented on our value problems. Two recently wrote, "Value conflicts are numerous and destructive. And the confusion is so great that many people appear to have no values at all, or endorse so many conflicting values that they resemble the general who would ride his horse in all directions at once."[4]

Conflicting values are found within individuals as well as within the larger society. Both freedom and equality are parts of the American Creed, yet in practice these values often conflict. For example, a landlord who feels that he has the freedom to rent his property to whomever he pleases may discriminate against an ethnic minority group and thus deny them equality. Most Americans value a free market economy, yet often expect the federal government to intervene in the economy when it lags.

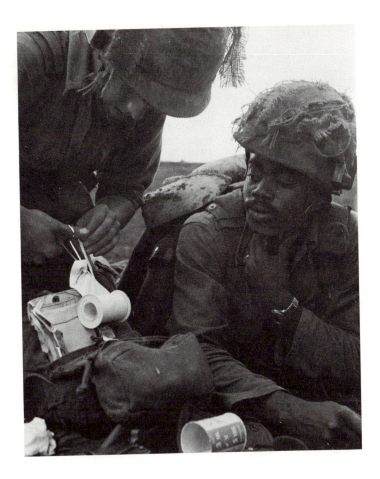

Conflicts such as wars make the value problems in American
society more obvious. (United States Army)

The value problems faced by our youth are especially acute. Perhaps more
than any other previous group in our nation's history, they are faced with an
infinite number of value alternatives from which they must choose, many of
which are contradictory. The mass media and the tremendous mobility within
our society expose our youth to a wide variety of life styles and belief systems.
Their problems are complicated by the fact that they are expected to move
from childhood to adulthood within a short time span, and therefore to live by
two different sets of standards.

The adult standards which they are expected to live by are often blatantly
violated by the grown-ups who try to enforce them. The diverse and
contradictory standards within American society make it very difficult for
young people to make intelligent choices when they are faced with value and
decision problems. In preliterate societies and in early America, moral choice

"Now stay with me and I'll show you what to like and what not to like."

Reprinted from *Instructor,* © October, 1970, the Instructor Publications, Inc. Used by permission.

was much less baffling, because fewer alternatives were available even though adults were probably as hypocritical then as they are today. We reject the notion that adults today are more morally corrupt than their counterparts in past centuries. If they indulge in more vices, it is merely because more are now readily available. History supports the contention that our ancestors were very fallible.

VALUE EDUCATION IN THE SCHOOLS

Because of the social and personal problems within our society that are rooted in value confusion, the school should play a large role in helping children to identify and clarify their values, and in making value choices intelligently. While the school has a tremendous responsibility to help children make moral choices rationally, there is abundant evidence that educators have largely failed to help students to deal with moral issues intelligently.[5]

Some teachers treat value problems like the invisible man, i.e., they deny their existence. They assume that if students get all the "facts" straight, they can resolve social problems. Such teachers may be said to practice the cult of false objectivity. Other teachers use an evasion strategy; when value problems arise in the classroom, they try to change the subject to a safer topic. A teacher whose class "studied the South" for four months was asked how she handled the race problem. She commented, "You know, it never came up."[6] When issues such as race relations, legalized abortion, and communism come up in class discussions, they are quickly and forcefully dismissed by teachers who employ the evasion strategy.

Probably the most frequently used approach to value education in the elementary and junior high school is the indoctrination of values that are

considered "right" by adults. Teachers who use this method assume that adults know what the "correct" values are for all times and for children from all cultural groups. Such values as justice, truth, freedom, honesty, equality, and love are taught with legendary heroes, stories, rituals, and patriotic songs. One valuing series has as its primary objective the teaching of eight specific values: affection, respect, well-being, wealth, power, rectitude, skill, and enlightenment.[7] This series consists of a number of story books and pictures designed to inculcate these values.

Although these values are not dysfunctional in modern society (this is not the point), this approach to value education is unsound for several reasons. In the first place, it assumes that most value conflicts and problems result because children are unable to distinguish "good" from "bad" values.[8] However, this is not the case. Children can rather easily distinguish the good from the bad. *Most value problems result because students must frequently choose between two good values*. For example, if a child's friend asked him his opinion of a very poor drawing, he must decide whether to be *honest* or *courteous*. To be honest would hurt his friend's feelings, and he would therefore not be courteous. When teachers use didactic methods to teach children contradictory but equally "good" values, conflicts are intensified when the students must choose between two good alternatives.

Didactic inculcation of values also denies students free choice and does not help them to develop a *method* for deriving and clarifying their own values. *Each generation should have the right to determine its own values*. Children should be taught a *process* by which they can derive their own values, because we have no reliable way to predict the values that a child will find functional in the world of the future. Write Raths, Harmin, and Simon, "Because life is different though time and space, we cannot be certain what experiences any person will have. We therefore cannot be certain what values, what style of life, would be most suitable for any person. We do, however, have some ideas about what *processes* might be most effective for obtaining values. These ideas grow from the assumption that whatever values one obtains should work as effectively as possible to relate one to his world in a satisfying and intelligent way."[9]

Didactic strategies are also unsound because there is no general agreement among adults about what values should be inculcated. And the same values are interpreted differently by various individuals and groups. Diverse goals and meanings have been proposed by various writers on moral education. Notes Chesler, "The problems with teaching eternal truths are that (1) everyone disagrees about what they are or what they mean, except when stated at a very general level; (2) everyone puts different priorities on their relative values; and (3) these truths may not be relevant to the way people and groups actually behave."[10]

Hunt and Metcalf commented on the limitations of didactic approaches to moral education, "The indoctrinative practices of moralism lead to hypocrisy in adults and cynicism in youth, as the former teach the latter values that adults no longer practice except in faint-hearted ways. A way out would be for

Students with clarified values are able to function effectively in their interpersonal relationships. (Clover Park School District, Tacoma, Washington)

society to teach its youth how to examine reflectively the value conflicts that characterize society. We cringe at doing this, because we fear that many of our institutions would not survive this kind of examination."[11]

Didactic strategies in value education are also invalid because we cannot expect standards to guide a person's life unless those standards have been *freely* chosen from alternatives, and after thoughtful consideration of the consequences of the alternatives. The individual must also be proud of the standards that guide his behavior.[12] If teachers and other adults force values upon students, the students will not prize the values, and the forced standards will have little influence on their behavior when they are out of the presence of authorities.

In an address at an annual meeting of the National Council for the Social Studies, Michael Scriven argued that it is *immoral* for teachers and other adults to force our cultural values upon our youth.[13] He suggested that such values may not be worth passing on, and that students should be taught how to decide on their own values. The wider culture does an excellent job of indoctrinating its values; the school, argued Scriven, should teach *resistance* to them. Scriven stated that each generation should shape its social and political institutions, and that we should open up the possibility for revolution in values and institutions. We have done an effective job of eliminating alternatives. We accept the spirit of Scriven's argument, and *believe that the goal of value inquiry, like the goal of social inquiry, should be to help children to reflectively derive their own values, and that we should not force our values upon them.* The approach we recommend does not assume that the teacher should be neutral or have no values; rather it requires that the teacher value above all else giving children the opportunity to develop their own beliefs and to learn to accept the consequences of their decisions. Reflective inquiry can contribute greatly to value clarification and consistent, purposeful social action.

The use of reflection can profoundly affect the quality of our value structure. Specifically, it can help us understand better what our values are. It can help us clarify our ends in our own thinking. The result will be

Value confusion can result in behavior which is detrimental for the individual. (Washington State Office of Public Instruction, Olympia)

greater consistency in values and greater ability to apply abstract values in concrete situations. A great deal of the present confusion and uncertainty concerning values might be erased with more widespread cultivation of an ability to assess values in terms of consequences.[14]

VALUING: MODES OF INQUIRY

We have suggested that teachers should help children to develop a *method* or *process* for clarifying and assessing their own values rather than teach them a set of predetermined values. This is the only approach to value education that is consistent with a democratic philosophy and that is educationally sound. While no standardized value inquiry model exists within social science or philosophy, several models have been devised which stress uncoerced choice. However, these models, unlike the value inquiry model that we will present, consist of both *valuing* and *decision-making* components. Although valuing is an essential part of the decision-making process, we conceptually separate these operations in order to illuminate their unique characteristics and to emphasize the importance of each process. Although we conceptualize these operations separately, the reader should bear in mind that in practice they are rarely divided, and that valuing is an intrinsic part of the decision-making process. However, we do believe that children can be given practice in analyzing and clarifying their values even though they may not at the same time be required to make personal and public decisions.

One of the most widely discussed decision-making models which has a valuing component is the model developed by the Columbia Associates in Philosophy.[15] This model assumes that values can be assessed and social issues resolved only when a dissenting group can identify a root value on which consensus can be reached. When a group has reached agreement on a higher-level value, the values in conflict can be considered in terms of whether they lead to consequences consistent with the higher-level value. Once a third or higher-level value is agreed upon by the group, the scientific method of inquiry can be used to determine which course of action or instrumental value will most likely result in the realization of the higher-value accepted by all members of the group.

An example will further clarify this strategy. Let's say a class was divided over whether it would endorse capital punishment in a popular trial, such as the 1971 trial of Angela Davis or Charles Manson. *The Columbia Associates model suggests that the group will be able to agree on some higher-level value such as "justice," and that they can determine which course of action (capital punishment or life imprisonment) will result in "justice." Thus "justice" would serve as the criterion by which lower-order values would be evaluated. Donald Oliver, James P. Shaver, and Fred Newmann have also developed a decision-making model which assumes that individuals can agree on root values within a society.

It seems to us that this approach to valuing and decision-making is severely limited because it makes this highly questionable assumption. A group may not be able to agree on a third value, and if they are able to agree on such a value, they may be unable to agree on what it implies in terms of concrete action, even though social inquiry can help discussants to predict the consequences of alternative courses of action. Massialas and Cox have summarized the Columbia Associates decision-making model with an example. Their summary is reproduced in Fig. 12.1.

A related model has been devised by Raup and his Associates.[16] In this model, the validity of value statements is established by group consensus. The group reaches consensus on values through interaction and discussion. This model is also based on the assumption that there are root and higher-level values on which groups can reach agreement. Values and policies are regarded as valid if a group can agree on them. The emphasis in this model is on social interaction. In commenting on this model, Massialas and Cox write, ". . . Raup seems to place undue emphasis on the social-personal process to the detriment of the intellectual process. The character of the participants, intergroup relations, and community consensus are not the only determinants of the validity and reliability of propositions. The acceptability of theory depends also on logical and natural criteria."[17]

Hunt and Metcalf have devised a teaching model for the clarification of values and the making of policy decisions. This model emphasizes the analysis of value concepts and the consideration of the consequences of value alternatives. Using this model, the students define value concepts, project consequences, appraise them using set criteria, and attempt to justify the

Figure 12.1
Massialas and Cox's Summary of the Columbia Associates' Decision-Making Model with an Example

ADJUDICATING JUDGMENTS OF VALUE

1. What value judgment is made regarding the occupation of persons in the United States?
 Given value judgment:
 White persons, particularly white Christians, should be given the more skilled jobs, the positions of executive authority in most businesses, high government offices, and professional positions.

2. What *opposing* value judgment is also made by many persons in the United States which is clearly contradictory to the value judgment *given* above?

3. If the *given* judgment were acted upon in the United States, what consequences are predicted in terms of the practices and policies which would be put into effect? What factual consequences would be expected to result if the *given* value judgment were acted upon?

4. Can you offer any *proof* that any of the above predictions for the *given* value judgment would actually take place?

5. If the *opposing* value judgment were acted upon in the United States, what consequences are predicted in terms of the practices and policies which would be put into effect? What factual consequences would be expected to result if the *opposing* value judgment were acted upon?

6. Can you offer any proof that any of the above predictions for the *opposing* value judgment would actually take place?

7. What *third* value would you propose as being relatively noncontroversial and logically appropriate to use for judging between the *given* and *opposing* values?

8. Which of the value judgments, the *given* or *opposing*, appears to be more clearly instrumental in achieving the *third*, relatively noncontroversial value?

9. In a concise statement support your choice of either the *given* or *opposing* value by giving the reasons for choosing the one and for rejecting the other.

10. In summary, assuming you have proved your case, state the relationship between the *given* or *opposing* value judgment and the *third*, noncontroversial value in the following formula:
 "If (either the *given* value judgment OR the *opposing* value judgment – NOT BOTH), then (the *third*, noncontroversial value) will be achieved."

Reprinted with permission from Byron G. Massialas and C. Benjamin Cox, *Inquiry in the Social Studies*. New York: McGraw-Hill, 1966, p. 166.

criteria used to evaluate the consequences.[18] Their model is reproduced in Fig. 12.2.

In Chapter 11 we discussed the Taba Social Studies Curriculum, which is an interdisciplinary spiral curriculum. This curriculum also has a valuing component, which is not an element of a decision-making paradigm. However,

Figure 12.2
Hunt and Metcalf's Decision-Making Model

I. What is the nature of the object, event, or policy to be evaluated? This question plainly poses a task in concept analysis. If the students are trying to evaluate the welfare state, they should define this object as precisely and clearly as possible.
 A. How is the welfare state to be defined intensionally and extensionally? By what criteria is it to be defined intensionally?
 B. If students disagree over criteria, and therefore in their definition of welfare state, how is this disagreement to be treated? Must they agree? Can they agree to disagree? Are there criteria by which welfare state ought to be defined? On what basis can we select among different sets of criteria?
II. The consequences problem.
 A. What consequences can be expected or anticipated from the policy in question? Is it true, as some have claimed, that the growth of the welfare state destroys individual incentive? How does one get evidence for answering this kind of question?
 B. If students disagree in their projection of consequences, how is this difference to be treated? Can evidence produce agreement? What is the difference between a disagreement over *criteria* and a disagreement over *evidence*?
III. Appraisal of consequences.
 A. Are the projected consequences desirable or not?
 B. By what criteria are the consequences to be appraised? How do different criteria affect one's appraisal of consequences?
IV. Justification of criteria.
 A. Can criteria for appraising consequences be justified? How?
 B. If students disagree on criteria, and therefore in their appraisal of consequences, how can this difference be treated? What relationship ought to exist between one's criteria and one's basic philosophy of life?
 C. Are students consistent in their use of criteria?

Reprinted with permission from Maurice P. Hunt and Lawrence E. Metcalf, *Teaching High School Social Studies*. New York: Harper and Row, 1968, p. 134.

the *goals* of the valuing model in this curriculum are not as open-ended as those of the models discussed above or as the one we will present. Taba had specific values in mind which she wished to inculcate in the children, such as "the capacity to identify with people in different cultures," "self-security," "open-mindness," "acceptance of changes," "tolerance for uncertainty and ambiguity," and "responsiveness to democratic and human values."[19] Although this curriculum has specific value objectives, the strategies employed within it stress helping children to derive these values reflectively. Thus, we feel that the Taba valuing model has much to commend it, although we reject its predetermined goals. The strategies used in this model provide children practice in exploring their own feelings and those of others, "considering various approaches to solving disputes among persons and groups, and analyzing the values held by people including themselves."[20] This model consists essentially of a series of questions. It is reproduced in Exhibit 12.1.

Exhibit 12.1
The Taba Curriculum Valuing Model*

CHART IV EXPLORING FEELINGS

Students are presented with a situation involving emotional reactions on the part of one or more persons. The teaching strategy consists of asking the following questions, usually in this order.[1]

Teacher	Student	Teacher Follow-through
What happened?	Restates facts	Sees that all facts are given and agreed upon. If students make inferences, asks that they be postponed
How do you think . . . felt?	Makes inference as to feelings	Accepts inferences
Why do you think he would feel that way?	Explains	Seeks clarification, if necessary
Who has a *different* idea about how he felt?	Makes alternative inferences and explanations	Seeks variety, if necessary. Asks for reasons, if necessary
How did . . . (other persons in the situation) feel?	States inferences about the feelings of additional persons	Seeks clarification, if necessary. Encourages students to consider how other people in the situation felt
Have you ever had something like this happen to you?[3]	Describes similar event in his own life	Insures description of event
How did you feel?	Describes his feelings. May reexperience emotions	Seeks clarification, if necessary. Provides support, if necessary
Why do you think you felt that way?	Offers explanation. Attempts to relate his feelings to events he has recalled	Asks additional questions, if necessary, to get beyond stereotyped or superficial explanation

[1] Sometimes only certain of the questions are asked. The teacher should omit questions if students have answered them spontaneously.

[2] These questions are repeated in sequence several times in order to obtain a variety of inferences — and later, personal experiences.

[3] If students have difficulty responding, you may wish to ask: "If this should happen to you, how do you think you would feel?" or "Has something like this happened to someone you know?" Another useful device is for the teacher to describe such an event in his own life.

*Reprinted with permission from Alice Duvall, Mary C. Durkin and Katharine C. Leffler, *The Taba Social Studies Curriculum: Grade 5 — United States and Canada — Societies in Transition*. Menlo Park: Addison Wesley, 1969, pp. xxviii-xxx.

Exhibit 12.1 (Continued)
The Taba Curriculum Valuing Model

CHART V INTERPERSONAL PROBLEM SOLVING

Students are presented with a problem situation involving interpersonal conflict.

Teacher	Student	Teacher Follow-through
What happened? or what did . . . you do?	Describes events	Sees that all events are given. Tries to get agreement, or if not possible, a statement of differences in perception of what occurred
What do you think . . . (a protagonist) should do? Why?	Gives response	Accepts response, seeks clarification, if necessary
How do you think . . . (others would react if he did that?) Why?	Makes inference and explains	Accepts. Seeks clarification, if necessary
Has something like that ever happened to you?[2]	Relates similar even in his own life	Provides support, if necessary
What did you do?	Relates recalled behavior	Seeks clarification, if necessary
As you think back now, do you think that was a good or bad thing to do?	Judges past actions	Encourages student to judge his own past actions. The teacher may need to prevent others from entering the discussion at this point
Why do you think so?	States reasons	Accepts reasons. If necessary, asks additional questions to make clear the criteria of values which the student is using in judging his actions
Is there anything you could have done differently?	Offers alternative behavior	Accepts. Asks additional questions to point up inconsistencies where they occur, e.g., "How does that agree with reasons you gave earlier?"

[1] These questions are repeated in sequence several times in order to obtain a variety of responses.

[2] If students have difficulty responding, you may wish to ask: "If this should happen to you, how do you think you would feel?" or "Has something like this happened to someone you know?" Another useful device is for the teacher to describe such an event in his own life.

Exhibit 12.1 (Continued)
The Taba Curriculum Valuing Model

CHART IV ANALYSIS OF VALUES

Students are asked to recall certain behaviors and are asked to make inferences as to what values are involved, and how they differ from the values of others involved in analogous situations.[1]

	Teacher	Student	Teacher Follow-through
2	What did they do . . . (e.g., to take care of their tools)?	Describes behavior	Sees that description is complete and accurate
	What do you think were their reasons for doing/saying what they did?	States inferences	Accepts, seeks clarification, if necessary
	What do these reasons tell you about what is important to them?	States inferences regarding values	Restates or asks additional questions to insure focus on values
3	If you . . . (teacher specifies similar situations directly related to student, e.g., "If you accidentally tore a page in someone else's book,") what would you do? Why?	States behavior and gives explanation	Accepts, may seek clarification
	What does this show about what *you* think is important?	States inferences about his own values	Accepts, seeks clarification, if necessary
	What differences do you see in what all these people think is important?	Makes comparisons	Insures that all values identified are compared

[1] Sometimes all questions are not asked. However, the question exploring the students' own values should *not* be omitted.

[2] This sequence is repeated for each group or person whose values are to be analyzed. Each group is specified by the teacher and has been previously studied.

[3] This sequence is repeated in order to get reactions from several students.

Oliver, Shaver, and Newmann have structured a policy-making and valuing strategy which is based on the assumption that most Americans are committed to values in the "American Creed," such as "justice," "equality," and "human dignity."[21] In their view, public controversy results primarily from conflicting values in the American Creed and diverse interpretations of these values. Some values within the Creed are more important than others; *human dignity* is the most basic American value. They propose a method whereby public controversy can be resolved through rational discussion.

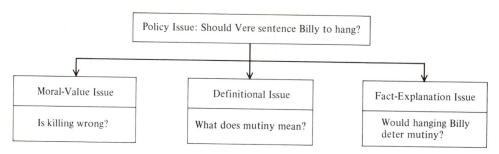

Figure 12.3
Newmann's Approach to the Analysis of Policy Issues*

Expanding their earlier work in a recent book, Newmann suggests that *policy* issues involve three components: (1) a moral-value issue, (2) a definitional issue, and (3) a fact-explanation issue.[22] (See Fig. 12.3.) He discusses several strategies for clarifying value statements. They are valid only if we assume that the discussants are committed to the American Creed values. Strategies which can resolve value issues include illuminating the relationship between specific and higher-order values, determining value conflicts resulting from inconsistencies in personal positions, and dealing with incompatible value frameworks.[23] The main criterion used to evaluate value positions is whether they are consistent with the American Creed root values.

While Oliver and Shaver note the difficulty of conceptualizing their method in terms of a model because of its immense complexity, they attempt "to *summarize* the major intellectual operations which can be made explicit in the analysis of political controversy and (2) to place the operations in some rough logical order."[24] Their summary follows:

1. Abstracting General Values from Concrete Situations
2. Using General Value Concepts as Dimensional Constructs
3. Identifying Conflicts Between Value Constructs
4. Identifying a Class of Value Conflict Situations
5. Discovering or Creating Value Conflict Situations which Are Analogous to the Problem under Consideration
6. Working toward a General Qualified Position
7. Testing the Factual Assumptions behind a Qualified Value Position
8. Testing the Relevance of Statements.[25]

The reader should examine the authors' works for a fuller explanation of the steps delineated in the above model or "series of operations," as the authors prefer to call it.

*Reprinted with permission from Fred N. Newmann (with the Assistance of Donald W. Oliver), *Clarifying Public Controversy: An Approach to Teaching Social Studies.* Boston: Little, Brown and Company, 1970, p. 43.

Raths, Harmin, and Simon formulated one of the most noted and useful valuing theories and related models that has been devised in recent years.[26] One of the authors' basic assumptions is that too many students suffer from acute value confusion, and that the school must teach students a method which will enable them to derive sound and clarified values. They suggest that victims of value confusion are often *apathetic, flighty, uncertain*, and *inconsistent*: they are often *drifters, overconformers, overdissenters*, or *role-players*.[27] Raths and Associates hypothesize that if children are taught to derive values using the process that they describe, "they will behave in ways that are less apathetic, confused, and irrational and in ways that are more positive, purposeful, and enthusiastic."[28] Their valuing model has no *specific* value goals; it is entirely open-ended. The authors believe that it is both unethical and unsound to impose a set of values on students. Whereas the valuing strategy formulated by Oliver, Shaver, and Newmann is concerned primarily with *public* issues and controversy, the Raths and Associates model deals with *personal* values. Raths and Associates delineate seven operations which they call a *process of valuing*. An individual must go through each operation before we can say that he has derived a value.[29] The processes are:

CHOOSING	(1)	freely
	(2)	from alternatives
	(3)	after thoughtful consideration of the consequences of each alternative
PRIZING	(4)	cherishing, being happy with the choice
	(5)	willing to affirm the choice publicly
ACTING	(6)	doing something with the choices
	(7)	repeatedly in some pattern of life[30]

A VALUE INQUIRY MODEL

We have discussed the nature of values, presented and defended a position regarding value education that emphasizes reflective inquiry and uncoerced choice, and reviewed several policy-making models that have valuing components. It is now appropriate for us to propose a valuing model that we feel is consistent with the theory of social studies education presented in this book, one that the teacher can use when teaching value lessons or giving children practice in the process of decision-making.

Our valuing model is consistent with the position of value education which we defended above. It is a model that enables children to identify the sources of their values and those of others, determine how values conflict, identify value alternatives, predict the consequences of alternative values, and *freely* choose from the values which they can identify. To successfully implement this valuing strategy in the classroom, the teacher must have a firm commitment to the belief that children must freely choose their own values, even though they should be helped to discover the consequences of different values, be consistent

"Let's play grown-ups. You'll be for busing and I'll be against it."
Drawn by Joseph Farris. Reprinted with special permission.

in their value choices, and willing to accept the consequences of and to act upon their beliefs. The teacher should encourage children to develop their own values, but he should demand consistency, and encourage students to accept the consequences of their values. A child who claims that he values equality but who is unwilling to accept the movements by oppressed groups to free themselves from social oppression must be helped to see the inconsistency of his beliefs. An individual who has inconsistent beliefs or who is unwilling to accept the consequences of his beliefs and values is irrational.

1. Defining and Recognizing Value Problems:
Observation — Discrimination

To intelligently reflect upon values and to resolve value issues, the student must be able to recognize the value components of decision-problems, and to distinguish definitional, value, and empirical problems. To illustrate the importance of recognizing the value components of problems, we will use a problem that we discussed in Chapter 2. In this problem, a black "militant" parent who is opposed to bussing has to decide whether he will have his children remain in the segregated school which they are now attending or allow them to be bussed to an integrated school. Before this parent can resolve his problem and make an intelligent decision, he has to recognize that the problem has a valuing component and determine what his values are regarding it. He also has to rank his values into a hierarchy, i.e., determine which are the most and least important to him. This parent may discover that he values the unique components of the black school culture, the safety of his children, and academic achievement. However, academic achievement is more important to him than the other values. After determining what he values most in a particular situation, the decision-maker can use factual information (part of the decision-making process) to determine the course of action that he will take. To teach children to identify the value components of decision-problems, the teacher must help them discover that value problems lie beyond the scope of social science. Empirical data can, however, help us to clarify our values, determine any inconsistencies, and predict probable consequences.

The teacher can use case studies, news stories, role-playing activities, open-ended stories, and factual information to teach children to recognize the value components of policy problems. After reading a problem story, the teacher could ask the students such questions as "What is the problem in this situation?" and "What things are important to the people in this story?"

2. Describing Value-Relevant Behavior:
Description — Discrimination

In this phase of value inquiry, the student names the behavior of the social actors in the problem situation or story. Every action or gesture should not be described, but only that behavior which is central to the problem under discussion. If the class is studying an open-ended story such as "Junior Prom,"[31]* the students should briefly describe the key behavior of the characters: Mrs. Richardson, Tiny Johnson, Janet Scanlon, and Eloise Ladas. They will not describe every word said by each character, but try to summarize their behavior in one or two sentences. They might describe Mrs. Richardson's behavior in this way: "Mrs. Richardson told the students what the problem was and tried to help them solve it." The teacher can ask questions such as these to help children accurately describe the relevant behavior in a problem situation:

*Reprinted on pages 562-564 of this book.

"What did the teacher do?" "What did the students do?" When the students are describing behavior, they should make as few inferences as possible. Children will need much practice in making careful observations and accurately describing what they have observed.

3. Naming Values Exemplified by Behavior Described:
 Identification – Description, Hypothesizing

In this phase of value inquiry, the children try to name the values which are evidenced by the behavior which they have described in Step 2. To facilitate this phase of inquiry, the teacher can list the behavior on the board in one column, and related values next to the behavior in another column. During this process the students will make inferences, and will not necessarily always agree on the values which they see in the behavior which they have described. While the teacher should encourage divergent thinking at this point, he should require that the children give reasons for the values they identify, because this phase of inquiry requires that the relating of behavior and values be as accurate as possible even though the pupils may have limited information about the individuals in the problem situation. The teacher can give children practice in this phase of value inquiry by reading case studies or news stories. After reading a case study of American young men who fled to Canada to avoid draft induction, the teacher could ask such questions as: "What does the behavior of these young men tell us about what they think is important?" "Do you think that their own safety was the most important thing to them?" "Do you think that they valued human life?" "Why or why not?"

4. Determining Conflicting Values in Behavior Described:
 Identification – Analysis

To help the children discover that there are many value conflicts within our society as well as within individuals, the teacher in this phase of inquiry asks the students to name the conflicting values that are exemplified by particular individuals and that are evident in the behavior of different persons. For example, the class may consider a case study involving a man who states that he is for freedom of speech but thinks that sex literature should be banned from the market. The teacher could ask the class, "Are this person's values consistent?" "Why or why not?" "What would he believe about sex literature if his values were consistent?" Another person in the same case study may state that sex literature should be available for those who want to buy it. The teacher could ask questions to help the children discover how the values of these two persons conflict. He could ask such questions as "How are these two persons' beliefs alike?" "How are they different?" "What would they both believe if their values were alike?" It is extremely important for children to be aware of the conflicting values within our society as well as those which exist within individuals.

5. Hypothesizing about the Sources of Values Analyzed: Hypothesizing

In this phase of value inquiry the children state hypotheses about the sources of the values which they have identified in Step 3. As with all hypothesizing, the teacher should require the students to give *reasons* for their statements. Hypotheses should be based on reason, and not be ignorant guesses. This part of the inquiry process is designed primarily to help pupils to discover that most of our values are "caught" from persons within our environment and are not independently or reflectively derived. Once children are aware of the sources of their own values as well as those of other persons, they can more easily evaluate the soundness and appropriateness of these values in various situations. Case studies and news accounts can also be used to give children practice in hypothesizing about the sources of values. While reading a case study about a man who closes his restaurant rather than serve Indian customers, the teacher could ask such questions as, "Mr. Lee obviously does not like Indians. Do you think that all white people dislike Indians?" "Why do you think that some people dislike Indians but others don't?" "How do some people learn to dislike Indians while others do not?" "Do you think that everyone who dislikes certain ethnic groups dislikes them because they have had bad experiences with them?" "Why or why not?" "Give some examples to support your answers."

6. Naming Alternative Values to Those Exemplified by Behavior Observed: Recalling

Children should know that there are within our society many value alternatives from which to choose. If they are to derive their own values and be proud of the choices they make, they must be aware of a wide range of alternatives. Without alternatives a person cannot make a choice. This phase of value inquiry is designed to help students to discover value alternatives. After reading a case study about American draft dodgers, the teacher could ask: "We concluded that these young men valued life, peace, and personal freedom. What are some different things that they could have valued or that other men their age probably value?" The children may include among their responses, "loyalty to their country," "the American way of life," and "democracy for under-developed nations." When students name alternative values, the teacher should help them identify values which are relevant to the problem under discussion. For example, the men in our example could have valued beauty, but this value would have had little influence on their response to the draft requirements.

7. Hypothesizing about the Possible Consequences of the Values Analyzed: Predicting, Comparing, and Contrasting

Important goals of value inquiry are to help children to

1. see that different values result in different consequences,

"My insistence on short hair is not intended as a violation of your civil liberties. . . . I want to see who sleeps during my classes."

Drawing by Joe Buresch; © 1971, *Today's Education.*

2. learn to accept the consequences of the values which they hold, and

3. consider the consequences of different beliefs.

The child who values personal freedom and safety above everything else must be helped to see how his values may result in actions which will deny freedom to others and endanger those whom he professes to love. Although the teacher is not justified in trying to force predetermined values on students, he has an obligation to help them consider different values and the different consequences that they may have. Factual information can help children to predict the possible consequences of different values.

By analyzing cases in which individuals exemplify certain values, the students can see and discuss their effect on other persons. When students hypothesize about the possible consequences of different values, they should cite evidence to support their claims. Predicting the consequences of holding various values can help children determine whether their values are consistent and whether they can live with the value choices they make. Often people cling to certain values because they have not thought reflectively about their possible consequences.

8. Declaring Value Preferences: Choosing

After the students have described the behavior of the individuals in the cases and situations studied, identified the values involved, determined how they conflict, and predicted the possible consequences, they should be asked to

declare their personal value preference. *This phase of value inquiry is extremely important and should be handled with utmost expertise.*

During the other phases of value inquiry, the teacher should be careful *not* to condemn values which are inconsistent with his beliefs. This is not to suggest that the teacher should remain neutral on value issues, but rather that he should not declare a value preference until the students have expressed their own value choices. If the teacher shows value preferences before the students make choices, the pupils will not honestly state their preferences, but will verbally choose values which they feel will please the teacher. While this is unfortunate, it is the case and the teacher must remember this fact.

Unless the teacher creates a classroom atmosphere which will allow and encourage students to express their true beliefs, value inquiry will simply become a game in which students will try to guess what responses the teacher wants them to make. However, once they are out of the classroom and among their friends, they will act out and freely express their true beliefs. If the students know that their teacher thinks that dodging the draft is immoral, the teacher will be unable to teach a value lesson about draft dodgers using the inquiry model which we presented and justified in this chapter.

Value preferences must be freely made within a tolerant classroom atmosphere, and after the student has thought reflectively about the consequences of different value positions. Only in this way will such value decisions influence their actions when they are out of the sight of authorities such as teachers and parents. We feel strongly that the value confusion which is pervasive among our youth results largely from the fact that authorities rarely give them sufficient choices and little freedom to derive and clarify their own beliefs. The widespread use of illegal drugs and the emergence of primitive religions in the late 1960's and early 1970's were symptomatic of the tremendous value confusion among our youth. Because they were unsure about what they believed and why they held certain beliefs, they indulged in one fad after another.

9. Stating Reasons, Sources, and Possible Consequences of Value Choice: Justifying, Hypothesizing, Predicting

While the teacher is obligated to help children derive their values within a permissive classroom atmosphere, he has a responsibility to help them determine the sources of their values and the reasons why they embrace them, and to consider their possible consequences. The rational social actor has clarified values, knows why he embraces his beliefs, and is aware of their sources and consequences. Once students are keenly aware of both the sources and consequences of their values, they are more likely to consider embracing other beliefs and to *act* on those which they hold. The child who discovers that his hatred for Jews is an irrational belief which he picked up from his parents may, after reflection, decide that he cannot both hate Jews and claim to value equality. To be rational, he must either change his attitudes toward Jews or accept bigotry as one of his values. It is not easy to change deeply ingrained

Figure 12.4
Banks Value Inquiry Model

1. Defining and recognizing value problems: Observation-discrimination
2. Describing value-relevant behavior: Description-discrimination
3. Naming values exemplified by behavior described: Identification – description, hypothesizing.
4. Determining conflicting values in behavior described: Identification – analysis
5. Hypothesizing about sources of values analyzed: Hypothesizing (citing data to support hypotheses)
6. Naming alternative values to those exemplified by behavior observed: Recalling
7. Hypothesizing about the possible consequences of the values analyzed: Predicting, comparing, contrasting
8. Declaring value preference: Choosing
9. Stating reasons, sources, and possible consequences of value choice: Justifying, hypothesizing, predicting

attitudes and beliefs however irrational they are. However, such beliefs will certainly not change unless the individual develops a commitment to change.

The teacher can employ a series of questioning strategies to help children justify their values and identify the sources and possible consequences of them. After a child has declared a value preference, the teacher can ask the following kinds of questions: "Johnny, you said that you hate Jews?" "Do you think that it's right to hate a group of people?" "Why do you think so?" "Why do you think that you hate Jews?" "What are some things that may happen when we hate a group of people?" "Do you think that you could accept the things which may happen as a result of hating a group of people?" *The teacher has to be very careful when asking questions like these so that he will not, in any way, abuse the student or punish him for freely expressing his beliefs.* Unless a student is able to express his beliefs freely and openly, the teacher will not have an opportunity to help him to reflectively examine them, and the type of value inquiry which we recommend will be doomed.

VALUE ANALYSIS AND CLARIFICATION

The operations which comprise the valuing model which we have discussed are summarized in Figs. 12.4 and 12.5. The teacher can use this model to teach children a *process* of valuing, and to help them identify and clarify their values. Although the steps within the model are discussed separately, in practice they will not be clearly divided, but highly blended and interrelated. For example, a teacher may ask a child to describe value-relevant behavior and to name the values it exemplifies at the same time. However, we have separated these operations in our model to emphasize the contribution that each can make to

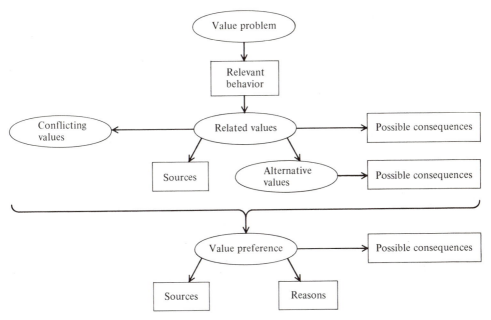

Figure 12.5
Operations of Value Inquiry Model, Graphically Illustrated

the clarification and derivation of values. While children should be given practice in all the operations the model comprises, within a particular valuing lesson the teacher may decide to deal with only one or several of the processes. The operations can be taught separately or as a unit. We believe that children need both types of practice in order to develop proficiency in the skills.

The teacher can use a wide variety of materials to give children practice in using the operations that are comprised in our value inquiry model. Descriptive content in the social sciences, classroom and playground incidents, literature, art, role-playing, open-ended stories, film clips, pictures, and news stories are among the diverse kinds of materials that can be used. The remainder of this chapter illustrates how some of the materials and strategies can be used to help children to deal reflectively with value problems. The techniques and materials discussed are exemplary only. The teacher will think of many other strategies which are equally as appropriate for teaching value analysis and clarification.

STRATEGIES FOR TEACHING
VALUE ANALYSIS AND CLARIFICATION

Primary grades

1. Children often have a dilemma about what to do when they find a stray animal such as a dog or a cat. A consideration of the following situation may help make the problem clearer to them.

Jerry was taking his dog for a walk when a little puppy came running up to him crying for affection. Jerry's own dog was very concerned about the puppy; his interest was shown by sniffing and licking the puppy. Jerry didn't want to leave the dog outside alone. Noticing that he had no collar or identification, Jerry decided to take the puppy home with him.

When Jerry's mother saw him coming home with another dog, she immediately became upset. The thought of another animal, a puppy to be housebroken and cared for, meant more commotion at home. And more important, no one would be home during the day because both mother and father worked, and the children were in school. But his mother didn't want to disappoint Jerry immediately. When he came into the house with both dogs, she calmly asked him where the dog came from. They sat down together to discuss what could be done about providing a good home for the puppy.

Ask the children to describe the main problem. What do Jerry and his mother have to do? After reviewing with the children exactly how Jerry and his mother acted toward the puppy, ask the children to name the values that both Jerry and his mother showed in their attitude toward the dog. What was the mother's main consideration when she saw Jerry and the dog? What did Jerry think was important?

Ask the children whether they noticed any conflict in the mother's values. Did she want to please Jerry by keeping the puppy, while at the same time trying to explain the reasons for not keeping the puppy so that Jerry would understand? What were some other values that Jerry and his mother might have held? Could Jerry have valued his mother's happiness more than the puppy's comfort and safety?

In order for the children to choose rationally among alternatives, they should discuss the consequences of each value. If Jerry and his mother both value humane treatment of animals, one consequence of that value might be taking in all mistreated animals, finding homes with friends, or setting up an organization which would care for lost and mistreated animals.

After the children have determined a variety of possible consequences for each alternative, they should make their choice about which value they prefer. A discussion could be centered around the children's choices, and then a review of the reasons and consequences for the choice each student made.

2. The following incident can be portrayed by pictures that the teacher might draw; the situation can be explained or role-played, or the filmstrip from which the incident was taken can be shown. (From the filmstrip series *Exploring Moral Values* by Louis Raths.*)

As Jim was walking along a street, a dollar bill fell out of his pocket without his knowledge. A classmate, Larry, was walking far enough behind Jim so that Jim wasn't aware of his presence, and yet close enough so he could see the bill drop. As Jim continued walking, Larry picked up the money.

*Filmstrip No. 12, *Exploring Moral Values*. Louise E. Raths, Warren Schloat Productions, Inc., Pleasantville, N.Y., 10570.

At this point, students should explain what problem is presented when Larry picks up the money. What is Larry's dilemma? Ask the students what Larry might think is important when he picks up the money. Is it possible that Larry's values might be in conflict? Could he value honesty while also valuing staying out of debt? A discussion of the source of Larry's values might bring out reasons for the conflict in values, and reasons that he values what he does. What role do parents play in providing a source for children's values? The school?

Ask students if Larry could have had other values which would determine what he could do with the money. If he valued friendship, Larry might decide to give the money to another person he wanted as his friend. A discussion of the consequences of each value will bring out both external results and internal feelings. For example, if Larry valued not being in debt to anyone, he would have had the satisfaction of paying back money he owed someone, but it would have been with money he did not rightfully earn.

Ask students to make their choice about which value they would prefer and feel pride about choosing. By asking students individually what the consequences of their choice might be, along with their reasons for that choice and the source of the value, you will encourage students to make rational decisions about the values they choose. Students can also draw pictures to indicate reasons, source, and possible consequences of their choice.

3. To help children identify values, pictures without captions can be used. Choose pictures which portray a value position. For example, a group of persons carrying signs and picketing would indicate that this group valued public demonstrations as a means of protest. Silent protest has taken place in our society historically, from the silent vigils in which members of the Quakers participated to various protests over the Vietnam war. Violent protest can be demonstrated with pictures of the Watts riots and the war protests by groups such as the Weathermen. Consequences of different positions held by those who value public protest should be considered by the children after the different values have been identified. It is not always necessary, however, for the children to choose which position they prefer.

Other pictures might portray children fighting on the playground with a large group of onlookers in the background. Children could identify the values of those who are fighting and compare them with the values demonstrated by the group of onlookers.

A person aiding an injured man on a city street with others walking by and not offering help would provide another example of a crisis situation in which a person's values were immediately evident.

Intermediate grades

1. Show students pictures of the last moon landing along with photos of conditions in the cities. For example, you might include pictures of a slum building adjacent to a new skyscraper, citizen-police confrontations, and newspaper headlines noting problems due to a decreasing tax base in the cities.

Include news articles stating positions taken by different U.S. Senators on the two issues of money for moon travel and domestic spending for social problems.

Ask students what each senator sees as the chief problem in the allocation of public funds. Have them explain what each senator's behavior has been in regard to the issues. Looking at speeches and voting records would provide the necessary information. Then ask the students to state the values indicated by each senator on the basis of his voting record and speeches. Note any conflict in values indicated by the senators. Do they seem to value space travel and their constituents' opinions, which differ?

Where do the values of the various senators originate? What incidents and events in American history may have provided a basis for the present emphasis on space travel? On what human values does the concern for revitalizing the cities depend? Have these values been operative at other times in American history?

Besides valuing international prestige and exploration, what other values could the senator who backs space travel have? Might he need another senator's help so much that he is willing to vote differently than his constituency desires on the issue of space travel? What other values might the senator choose who votes for rejuvenating the cities?

Consequences for each of a senator's values and possible alternatives should be considered. What will happen if space travel continues to be encouraged? Will American prestige continue to be high? Will it be worth the money spent to have space stations? Is moon travel really safe? What will happen if funds are appropriated for rebuilding cities? Will they be used for the benefit of the majority living in the cities? Are there ways of providing money for the cities without the help of the federal government? If the senator valued state and private funding for the cities, he might vote against a bill in the U.S. Congress.

The question of what elected officials value is important in determining whether they will accurately represent the people's interest. Through the above example, students not only become aware of values in public issues, but also learn how to find out what things the public representatives value.

2. The use of natural resources has been and will continue to be an issue with which all persons will be confronted. Positions on the use of resources range from total use for economic benefit to maintaining all natural resources in their natural form to preserve the environment.

Using lumber as an example of a natural resource which is fast being depleted, children could identify on a continuum the positions which an individual might take in relation to the appropriate use of trees and resulting products. For example, one end of the continuum would indicate the total use of present lumber supplies for housebuilding, furniture, paper manufacture, and the use of logs in wood-burning fireplaces. The other end of the continuum would indicate the position of the person who was in favor of leaving all trees on the land, reforesting all places where forest fires and logging have depleted

the tree growth, and finding synthetic materials for all products which are now made of wood. Ask children to become aware of positions on the use of lumber through newspaper articles, television programs, and their own school geography books. After they have done the necessary research, ask them to rank the positions on a continuum. For example:

total use of lumber to benefit economy	lumber usage for economic benefit, but also reforest extensively	find many ways to use lumber, but severely cut waste and reforest	use lumber for products only when other materials are ineffective	preserve all trees to maintain forested land and natural environment

Throughout this activity, children should be aware that they are looking at one value and the degrees of commitment one can have to that particular value. This activity will also help make clear to students that choosing a value involves more than a preference of one value over another. Sometimes students will have to determine how committed they will be to a value after they have chosen it.

Upper grades

1. Choose four students to role-play the following situation. A group of three students are in a field or out-of-the-way place smoking cigarettes. They are obviously experimenting to find the proper way to hold a cigarette. Inhaling the cigarette is difficult for them as evidenced by much coughing. Attempts to effect the casual air of an experienced smoker are clumsy.

Later, one of the three students arrives home and is greeted by his father. The student casually walks into the house, but doesn't get past the scrutiny of his father who immediately notices the smell of smoke on his clothes. The question as to whether the boy has been smoking is posed by his father. The boy promptly responds that of course he hasn't been smoking and goes to his room.

After the role-play scenes have been enacted, ask students what they think is the problem portrayed in these scenes. Then ask them to review carefully the behavior of the students and the father. Did the students seem to enjoy smoking? Did they think it was healthy to smoke? What value did the students show? What did they think was important about smoking? Was it an attempt to be like everyone else they know? Was it an attempt to defy the wishes of parents and teachers? What value was the father showing? Did he value health, and for that reason discourage his son from smoking? Or were there other reasons? Did the class observe any conflict in the students' values? Did any of the students value good health along with the image that cigarette smoking gives?

Ask students what the source of the values is that both the students and the father showed. Were these values obtained from parents, the media, a general image of what is acceptable in society? Are there any alternative values

that the students could have chosen? Are there other ways to gain social approval? Is the value of social approval a desirable value?

A discussion of the consequences of the values portrayed in this role-playing situation is necessary to help students determine what values they would choose. Always choosing social approval may assume that the group always knows what is best. In what situations might choosing the value of good health actually cause problems? Might an individual who had smoked for many years be endangering his health by abruptly breaking his smoking habit?

At this point, each student should be given a chance to choose what he would value in the above situation. He might place his value choice on a continuum. For example, on a continuum of smoking – no smoking, he might choose not to smoke. However, on a continuum of no peer approval to total peer approval, he might choose a point in the middle of the continuum, indicating a moderate degree of peer approval.

2. Show students pictures of Vietnamese children who have been severely wounded and sent to the United States for medical care, and then returned to Vietnam. Include articles from *Life* or daily newspapers about the children's experiences in the United States and their reactions to returning to Vietnam. Statements of organizations which sponsor medical care for war casualties, statements by Vietnamese on the issue, and reactions by the children themselves should be considered so that the total problem can be seen in all its facets.

Ask students to identify the values of the organizations financing the medical care. Do they value quality medical care? Do they value the children's mental well-being? What about the children? Do they value a happy life, wherever they may be? How do they feel after returning to their own family and home country? Do the organizations and persons providing medical help show a conflict in their values by providing medical care and a pleasant experience in a country which isn't war-torn, while at the same time planning to send these children back to a country riddled with unrest and generally unsafe?

A discussion of this issue will help children see the dilemma which occurs when people try to help others in one way, but may be hurting or endangering them in another way. It also brings up the conflicts which result when one country tries to help another country without considering all the consequences of the attempt.

3. Ask students to become familiar with the treatment of the Seneca Indian tribe by white Americans and the United States government. Particularly useful sources are a pamphlet entitled *Anthropology in Today's World* published by American Education Publications and a recording of songs about and by Indians by Oliver LaFarge.

The Seneca Indians live in upper New York and have survived as a tribe since the American Revolution. They were guaranteed their land in a treaty with George Washington, and have maintained their culture by hunting and

fishing while living at almost a subsistence level. A major threat to their landholding and livelihood occurred in 1961 when a dam was constructed in Pennsylvania that flooded 10,000 acres of Seneca land. Their attempts to block the construction of the dam were unsuccessful, although they obtained a large monetary settlement. Later in the sixties they also lost in an effort to stop the construction of an expressway through their land. The tribe has continued to maintain its cultural traditions. At the same time it has tried to gain more education for its members to improve their way of life and find ways to fight the encroachment of white American culture.

After a study of the history of the Seneca Indians, ask the students to identify the problem the Indians are having in trying to maintain their cultural integrity. A description of the United States government's actions toward the Senecas, along with the Seneca's attempts to fight those actions, should follow. Students could group actions according to the values which the actions exemplified. Students should determine whether, over the years, the values which the United States government and its white citizens acted upon have changed. Have the changing positions tended to conflict? Have the Seneca Indians shown any conflict in values since the American Revolution in the way that they have dealt with the American government?

A discussion of the source of the values shown by the whites and the Senecas could deal with the attitude English colonists had toward the land and nature. An exploration of the attitude of the Senecas toward nature would reveal a difference in the kind of respect and awe Indians and colonists had for the natural environment.

A study of the source of present Indian values and United States government values toward the Indian should provide possible alternative values to be adopted to help solve the conflict between the white man and the Indian. After a consideration of the consequences of each alternative value, students should make a value preference. The viability of this preference could be considered in the light of the experience of other Indian tribes in the United States. Students could then see how their value preference applied to individual situations, and whether indeed they have decided on a value which can be operative in many situations.

SUMMARY

Both scientific knowledge and clarified, rationally examined values are necessary if the social actor is to make sound decisions that will result in the resolution of personal and public problems. In recent years, the student protests and the widespread use of illegal drugs indicate that many of our youths are confused about what values to embrace and suffer acute value confusion. The value problems of youth are intensified by the wide range of conflicting values from which they must choose, and by the contradictions between the values which adults verbally endorse and those exemplified by their actual behavior.

Because of the widespread value confusion in our society, there is a desperate need for public institutions such as the school to help children develop sound and clarified values. The social studies program should help students to derive and clarify their values, because children cannot make sound decisions when their values are confused. Students must be taught a *process* for deriving their values rather than a set of values which educators regard as the "right" ones, because few values are functional for all times, places, and cultures, and we have no accurate ways to predict what values will help students to meet the challenges in the world of the future. In this chapter, we have reviewed several policy-making and valuing models which may be used to teach children a process for deriving and clarifying their values. A rationale for value education has also been presented, as well as a value inquiry model for implementing the theory of valuing. Suggested activities for teaching value clarification and analysis are presented in the final part of the chapter. The importance of value analysis and clarification in the decision-making process cannot be overemphasized.

DISCUSSION QUESTIONS AND EXERCISES

1. Examine several current newspapers and magazines, and list some of the social problems that are now faced by your community and the nation. State the value problems in our society that are reflected in these social issues. What implications do these social problems have for value education in the school?

2. Locate a case study in a recent publication about an individual or group who face a decision problem that has value components. The case may involve a white couple who are trying to decide whether to allow their children to be bussed to an intergrated school, a young man who is trying to decide whether to evade the draft, or an organization that is trying to decide whether it should support an urban renewal project which will displace slum residents but will result in a badly needed freeway. Using the author's valuing model presented in this chapter, develop around the case a valuing lesson plan to teach to a group of elementary school children.

3. Write an open-ended story that involves a problem such as cheating, tattling, or group rejection in a primary grade classroom. Using the value inquiry model presented in this chapter, develop a lesson plan around the incident. Make sure that the story contains an incident with which primary grade children can easily identify. If you would like to examine a collection of open-ended stories see the NEA publication, *Unfinished Stories for Use in the Classroom, Role-Playing for Social Values: Decision Making in the Social Studies* by Fannie R. Shaftel and George Shaftel, and *Intergroup Education: Methods and Materials* by Jean Dresden Grambs.

4. Pictures without captions are excellent tools for teaching value inquiry. Locate, in current magazines, a number of pictures that can evoke value questions. Mount the pictures and develop a series of questions (based on the

value inquiry model presented in this chapter) that you can ask children in order to develop their value inquiry skills.

5. Descriptive social science data can evoke value questions. Articles and accounts about the American Revolution, slavery, the Civil War, and contemporary social problems have much potential for value inquiry. Identify a selection in a social studies textbook and illustrate, with a teaching plan, how the selection can be used to help children augment their value inquiry skills.

6. Observe a social studies class that is studying a current social issue, and make a note of statements made by the students that could serve as springboards for value inquiry. These are the kinds of statements you should note: "I think that marijuana should be legalized," "Students should not be bussed out of their neighborhoods in order to go to school," "Indians should have special privileges." Also list the responses that a teacher could make in order to help students identify and clarify their values after statements of this kind are made.

7. Students and adults are often unable to distinguish *value* and *empirical* propositions, and as a result frequently use inappropriate methods to validate their statements. Develop a lesson plan for teaching children to make this distinction.

8. Assume that you are teaching a unit that focuses on the concept of *culture*. Develop for the unit a number of value inquiry objectives that are stated in *behavioral* terms. List the materials and strategies you would use to help the students to reach the objectives. What special problems does a teacher face in stating value inquiry objectives? How can these problems best be solved?

9. In your curriculum library, examine several of the social studies curriculum projects that were developed in the 1960's and evaluate their value components. Do the projects include adequate value inquiry objectives? Are the strategies for developing the objectives sound? In what ways would you modify the value components of these projects in order to make them more effective?

10. Demonstrate your understanding of the following terms and phrases by writing or stating brief definitions for each of them. Also tell why each is important.

a) values

b) beliefs

c) attitudes

d) instrumental values

e) root or terminal values

f) value inquiry

g) value conflict

h) value clarification

i) value statement or proposition

j) didactic strategies

k) Columbia Associates Decision-Making Model

l) Raths and Associates Valuing Model

m) The Taba Curriculum Valuing Model

FOOTNOTES

1. Milton Rokeach, *Beliefs, Attitudes and Values.* San Francisco: Jossey-Bass, 1969, p. 124.

2. *Ibid.*, p. 160.

3. *Ibid.*, p. 162.

4. Maurice P. Hunt and Lawrence E. Metcalf, *Teaching High School Social Studies: Second Edition.* New York: Harper and Row, 1968, p. 120.

5. Robert J. Havighurst and Hilda Taba, *Adolescent Character and Personality.* New York: John Wiley, 1949.

6. Nancy W. Bauer, "Guaranteeing the Values Component in Elementary Social Studies," in Jonathon C. McLendon, William W. Joyce, and John R. Lee (Eds.), *Readings on Elementary Social Studies: Emerging Changes.* Boston: Allyn and Bacon, 1970, p. 374.

7. Zelda Beth Blanchette, V. Clyde Arnspiger, James A. Brill, and W. Ray Rucker, *Teacher's Edition: The Human Values Series Teaching Pictures.* Austin, Texas: Steck-Vaughn, 1969, pp. 3-6.

8. This discussion about the choosing of two good values is based on the work of Hunt and Metcalf.

9. Louis E. Raths, Merrill Harmin, and Sidney B. Simon, *Values and Teaching: Working with Values in the Classroom.* Columbus, Ohio: Charles E. Merrill, 1966, p. 28.

10. Mark Chesler, "Values and Controversy in Secondary Social Studies," in C. Benjamin Cox and Byron G. Massialas (Eds.), *Social Studies in the United States: A Critical Appraisal.* New York: Harcourt, Brace and World, 1967, p. 273.

11. Hunt and Metcalf, *op. cit.*, p. 123.

12. Raths, *et al., op. cit.*, p. 30.

13. Michael Scriven, "The Social Studies in the 21st Century: What is Needed?" A paper presented at the 50th Annual Meeting of the National Council for the Social Studies, New York, N.Y., November 24, 1970.

14. Maurice P. Hunt and Lawrence E. Metcalf, *Teaching High School Social Studies.* New York: Harper and Row, 1955, p. 100.

15. Columbia Associates in Philosophy, *An Introduction to Reflective Thinking.* Boston: Houghton Mifflin, 1923, pp. 213-252.

16. R. Bruce Raup, George E. Axtelle, Kenneth D. Benne, and B. Othanel Smith, *The Improvement of Practical Intelligence: The Critical Task of Education.* New York: Harper, 1950, pp. 225-295.

17. Byron G. Massialas and C. Benjamin Cox, *Inquiry in the Social Studies.* New York: McGraw-Hill, 1966, pp. 171-172.

18. Hunt and Metcalf (Second Edition), *op. cit.*, pp. 133-134.

19. Hilda Taba, *Teachers' Handbook for Elementary Social Studies.* Reading, Mass.: Addison-Wesley, 1967, pp. 9-10.

20. Alice Duvall, Mary C. Durkin, and Katharine C. Leffler, *The Taba Social Studies Curriculum: Grade Five – United States and Canada – Societies in Transition.* Menlo Park, Calif.: Addison-Wesley, 1969, p. xxvii.

21. Their theory is discussed in these two books: Donald Oliver and James P. Shaver, *Teaching Public Issues in the High School*, Boston: Houghton Mifflin, 1966; Fred M.

Newmann (with the assistance of Donald W. Oliver), *Clarifying Public Controversy: An Approach to Teaching Social Studies*, Boston: Little, Brown, 1970.

22. Newmann (with Oliver), *op. cit.*, p. 43.

23. *Ibid.*, pp. 46-47.

24. Oliver and Shaver, *op. cit.*, p. 126.

25. *Ibid.*, pp. 126-130.

26. Raths, Harmin, and Simon, *op. cit.*, *Values and Teaching.*

27. *Ibid.*, p. 7.

28. *Ibid.*, p. 11.

29. *Ibid.*, p.28. Reprinted with permission from Charles E. Merrill.

30. *Ibid.*, p. 30.

31. Jean Dresden Grambs, "Junior Prom," in the author's *Intergroup Education: Methods and Materials.* Englewood Cliffs, N.J.: Prentice-Hall, 1968, pp. 60-62. Reprinted by permission.

Part 4

DECISION-MAKING AND SOCIAL ACTION

INTRODUCTION TO PART 4

In Part 1 we explored the nature of social knowledge, including the process by which knowledge is derived, and the products of social inquiry. Knowledge on which effective decisions are made must be scientific, higher-level, and interdisciplinary. While knowledge is necessary for sound decision-making, it is not sufficient. The rational social actor must also be able to identify and clarify his values. The nature of value inquiry was explored in Part 3.

Once the decision-maker has gained higher-level, scientific knowledge and clarified his values, he must synthesize his knowledge and values in order to determine the course of action he will take. The chapter which constitutes this section of the book focuses on how the decision-maker relates the knowledge which he derives to his values in order to make decisions and to determine the course of action he will take on social issues. In one sense this is the most important part of the book, because here the author demonstrates *how* all the other skills and knowledge components can be applied to help the social actor make rational decisions and intelligently shape public policy. Sample units and teaching strategies focused on social issues make up an important element of Part 4.

DECISION-MAKING AND SOCIAL ACTION STRATEGIES

THE ROLE OF SOCIAL STUDIES

We have argued in this book that the main goal of the social studies should be to help students develop the ability to make decisions so that they can resolve personal problems and shape public policy by participating in intelligent social action. Our belief about the proper role of the social studies is based on the assumption that man will always face personal and social problems, and that all citizens should participate in the making of public policy in a democratic society. The social studies curriculum which we recommend is not only grounded in the democratic ideology, but one of its basic assumptions is that maximum participation of citizens in the making of public policy is essential for the perpetuation of a free and open society. The theory rejects the idea that public authorities or academic specialists should determine the *goals* of social institutions. Their proper role is to facilitate the realization of the goals and values shaped by the wider populace.

Our theory also assumes that individuals are not born with the ability to make rational decisions, but that decision-making consists of a set of skills that can be identified and systematically taught. It also assumes that man can both identify and clarify his values, and that he can be trained to reflect upon problems before acting on them. We have identified the main components of decision-making as knowledge, value analysis and clarification, prediction, and the affirmation of a course of action by synthesizing one's knowledge and values.

We have suggested that students should not only become decision-makers, but that they should develop the ability to make *rational* decisions. An important question which we have a responsibility to answer is "How do we distinguish between a rational and an irrational decision?" In other words,

"What criteria do we use to evaluate the rationality of a decision?" In this book, we have delineated a *process* with definite steps that a decision-maker must take before we are willing to call his decisions *rational*. It is extremely important for the reader to realize that we are primarily concerned with the *process* of decision-making, not with the specific *products* of decisions. The careful reader may raise several legitimate questions about our position and wonder about the consequences for a society in which individuals are free to make uncoerced decisions. Such individuals may, for example, decide to violate essential societal mores and laws. In *principle*, a social actor who reaches a decision using the process which we describe in this book may decide to murder all his enemies. He might be acutely aware of his values, the possible consequences of his anticipated actions, and be willing to accept and live with those consequences.

This example forces us to make explicit other assumptions on which our theory and models are based, since we certainly do not wish to train students who deliberately violate essential norms and mores within our society. Our theory assumes that most social actors who make decisions, using the process delineated in this book, will act in ways that are consistent with major societal mores, goals, and values. We believe that most persons who habitually violate mores and laws do so primarily because they act before clarifying their values and reflecting about the possible consequences of their actions. Most such actions, we believe, are impetuous, spontaneous, impulsive, and irrational. While our theory assumes that *rational* decision-makers will act in ways consistent with the values and mores of their society, it is a theory that allows for social change. If the social actors within a society use the process which we describe to reach decisions, societal goals, values, and mores will be changed by intelligent social action when they no longer contribute to the satisfaction of human needs and aspirations, or when they no longer meet the current needs of the society. When goals and values become obsolete and dysfunctional, the public, through massive and effective social action, will construct new goals and values that are more consistent with current needs and beliefs.

Thus we feel that the social studies curriculum we advocate will prevent chaos and destructive instability within a society and at the same time provide means and methods whereby new generations can shape their own destinies, use those aspects of traditional society which are consistent with their needs, and create new, legitimate life-styles and values when it is necessary to do so. What is legitimate, normal, and valued is subject to reconstruction as each new generation develops. Each new generation, however, can use those aspects of the past which remain functional for current needs and purposes. Thus our theory advocates both stability and change within a society.

CRITERIA FOR RATIONAL DECISION-MAKING

Let us review the components of decision-making. By our definition, it consists of several processes, including the derivation of knowledge, prediction, value analysis and clarification, the synthesis of knowledge and values, and the

affirmation of a course of action. Although nearly all decisions are based on knowledge, valuing, and prediction components, *rational* decisions, as we use the term, must satisfy other requirements. There are many kinds of knowledge, and many ways of attaining it. To make a rational decision, the decision-maker must use the scientific method to attain knowledge. The knowledge must not only be scientific; it must cut across disciplinary lines. Knowledge from any one discipline is insufficient to help us make intelligent decisions on complex social issues. To make intelligent decisions regarding issues such as poverty, race relations, or war, the social actor must view these problems from the perspectives of several disciplines such as sociology, economics, political science, and history. The perspective of any one discipline is too limited to guide intelligent decision-making and rational social action.

The knowledge on which rational decisions are based must also be *powerful and widely applicable*, so that it will enable the decision-maker to reach the most accurate predictions possible. There are several levels of knowledge, and they vary in their capacity to aid in predicting and to help us organize our observations. *Factual* knowledge, which consists of specific statements about limited phenomena, is the lowest level of knowledge, and has the least predictive capacity. *Concepts* are words or phrases that enable us to categorize or classify a large class of observations, and thus to reduce the complexity of our social environment. Because of their structure and function, concepts in and of themselves do not possess predictive value. However, *generalizations*, which state the relationships between concepts or variables, enable us to predict behavior; the predictive capacity of generalizations varies directly with their degree of applicability and the amount of empirical support behind them. Generalizations that describe a large class of behavior and ones that have been widely verified are the most useful for making predictions. However, as we pointed out in Chapter 2, no social science generalizations are conclusive or completely verified.

Theory is the highest form of knowledge, and is the most useful for predictive purposes. A theory consists of a deductive system of logically interrelated generalizations. Although no grand or all-inclusive theories exist in the social sciences as they do in the physical sciences, numerous lower-level and middle-range social science theories exist, such as Durkheim's theory of suicide and Rose's theory of prejudice.

To make rational decisions, the student must be able to use the scientific method to derive higher-level generalizations and theories, since these forms of knowledge will enable him to make the most accurate predictions. *The most predictive generalizations are those which are related to the key or organizing concepts of the social science disciplines.* The identification of the key concepts within the social science disciplines enables the decision-maker to use the most powerful generalizations which constitute the social sciences, and which can make the greatest contribution to the resolution of personal and social problems. Chapters 5 through 10 suggest how the teacher can identify and plan learning experiences to help children master the organizing ideas of the disciplines and their related generalizations. One reason why we have not

dealt systematically with the teaching of social theory is because we feel that children can better grasp theory in the high-school and college grades. However, the organizing concepts and generalizations, which are taught in the elementary and junior high school, constitute a knowledge foundation upon which theory can later be developed.

Decisions have a valuing as well as a knowledge component. However, value teaching for *rational* decision-making, like knowledge mastery, must have definite characteristics. As we noted in Chapter 12, educators use various approaches to value education. These include indoctrination of what adults consider the "correct" values, the repression or superficial treatment of value-laden issues, and the teaching of values by examples. These approaches to value education do not help children to make rational decisions. To make intelligent decisions, the social actor must be taught within an uncoerced classroom atmosphere a *process* for deriving, clarifying, and reflecting upon the consequences of his values. Only when a decision-maker is acutely aware of his values and their consequences, and is willing to accept their consequences, can he make a rational decision and act intelligently to resolve personal problems and to shape public policy.

SEQUENCING THE DEVELOPMENT OF THE COMPONENT SKILLS OF DECISION-MAKING

The student must be able to derive interdisciplinary knowledge using an inquiry process, and form and clarify his values in order to make reflective decisions and to shape public policy. We will now consider how a teacher or curriculum specialist may plan the development of these skills, and the related decision-making skills — synthesis, prediction, and the affirmation of a course of action.

The way a teacher can develop these skills depends greatly upon the social studies curriculum within his district, his own interests, the resources available, and the backgrounds of the students. We must in candor say that many teachers will find themselves teaching in school districts where only social science inquiry units are a part of the approved curriculum. Other teachers will feel that while valuing and decision-making skills are important, social science inquiry should constitute the bulk of their social studies program. This book is designed to help teachers and curriculum specialists with different persuasions and points of view about the social studies curriculum. Those individuals who are primarily committed to social science inquiry will find Chapters 5 through 11 of primary interest. *However, value inquiry and decision-making skills can be taught within the framework of social science inquiry units.* The teacher can help children develop valuing and decision-making skills while teaching social science inquiry units. He can ask questions that constitute our valuing and decision-making models when they are studying social science content. For example, while the children are reading a selection on the American Revolution, the teacher can ask the following kinds of questions.

Valuing Questions

1. What did the British do? What did the colonists do?
2. What does the behavior of the British and the colonists tell us about what was important to them?
3. How were the things that were important to the British different from the things that were important to the colonists?
4. Why were different things important to the British and the colonists?
5. What are some other things that the British and the colonists could have regarded as important?
6. What do you think the colonists *should* have done? Why?
7. What do you think the British *should* have done? Why?
8. What would you have done if you had been a colonist? Why?
9. What would you have done if you had been British? Why?

Decision-Making Questions

1. What were the alternatives open to the colonists?
2. What were the possible consequences of each alternative in Question 1?
3. What were the alternatives open to the British?
4. What were the possible consequences of each alternative in Question 3?
5. What evidence can you give to support your belief that the alternatives that you state were possible?
6. How would you order the alternatives and their consequences in a way that is most consistent with your values?

Thus one approach that the teacher can take to developing inquiry, valuing, and decision-making skills is to teach the valuing and decision-making processes within the context of social science inquiry units. Another approach is to identify a number of vital social problems or issues, list social science concepts that are related to the issues, and plan separate units to teach the concepts and the analysis of the issues that are related to the concepts.

The students could apply the knowledge that they learn during the inquiry units when they decide upon pressing social issues. During the social issues units, they would develop proficiency in valuing and decision-making skills. Social action and participation projects could also be planned and implemented during the analysis of social issues so that the students could take action on some of the decisions which they make. Only by taking action on important social issues will students develop a sense of political power. For example, a teacher may decide to teach conceptual units that will help the students decide upon social issues related to a current war, race relations in the community, and the pollution of the earth and atmosphere. Concepts will be taught in the social science inquiry units that will enable the children to make intelligent decisions and to take rational action to help resolve these problems.

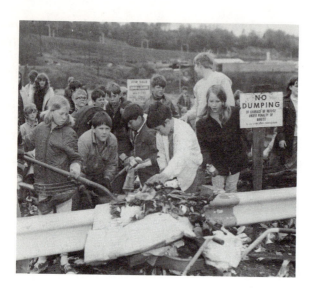

The study of social issues can lead to social action within the community. These sixth-grade students planned and implemented a street cleaning project after studying a unit on the environment. (Highline Public Schools, Seattle, Washington)

Such concepts as *power, international law, authority*, and *scarcity* might be developed in order to help the children analyze a current war. By studying the concepts of *power* and *authority*, the children will be able to determine who has the authority to declare and lead us into war, and how the wider public can exercise power to influence public policy regarding war. The concept of *international law* will help them to discover how international laws are made, and their usual consequences. Materials and activities related to the concept of *scarcity* will illuminate the ways in which wars affect the economy of a society. For example, the children may discover that wars often increase prosperity and that the termination of wars often results in widespread unemployment.

The concepts of *conflict, culture, discrimination, specialization*, and *power* can help children make decisions and take intelligent social action on problems relating to race relations in their community. *Scarcity, law, power, production, change* and *culture* are concepts which can contribute to an understanding of the pollution of the air and earth. Once the teacher has identified the social issues that he plans to teach during the year, he should use the criteria in Chapter 11 for the selection of concepts. These criteria suggest that concepts should be accurate, have the power to organize a great deal of information and data, and be suitable for the children. *While these criteria should be exercised,*

the relationship of the concepts to the social issues to be studied should be the most important criterion when conceptual units are planned primarily to give children the knowledge that they will need in order to make decisions and take action on social issues. For example, while the concept of *prejudice* is related to war in some cases, the concepts of *power* and *law* are much more directly related to international conflict. The struggle for world power and dominance is usually the root cause of war. Thus the concepts selected for conceptual units that are frameworks for the analysis of social problems should be directly and clearly related to the social problems to be analyzed. This point cannot be overemphasized.

It is appropriate to discuss the guidelines that a teacher may use in selecting content samples for the conceptual units designed to help children attain the knowledge they need to make intelligent decisions on current social issues. Let's return to our war example, and assume that the teacher has decided to introduce the concepts of *power, law, authority, scarcity,* and *legitimacy* prior to the decision-making unit on a current war. Although concepts and generalizations can be taught with a variety of content, it is best to select content which represents more than one area or region, different time periods, and content which is highly related to the social issue to be analyzed and decided upon. For example, the concept of *power* can be developed with content related to the struggles in the American Congress on domestic issues such as civil rights and welfare, but our example would be more effective if the content were related to struggles for international power. Content which represents different regions and time periods is more useful for teaching children to generalize. Thus, instead of studying only the conflict that occurred during the American Civil War, the children could also profitably study the French Revolution, the Spanish-American War, and World War II. Thus they would be able to test their generalizations through time, in different regions, and with different kinds of wars (domestic and international).

Although the content selected to teach the organizing concepts in a social science inquiry unit, which is designed as a framework for a decision-making unit, should be highly related to the social issue, it is important to point out that more than one criterion of appropriateness may be used. In our example, we suggested that domestic and international conflicts could be profitably studied if the social issue to be decided upon was related to a current war. However, a different criterion may suggest other kinds of content beside national and international conflicts. For example, in most decision-making units, the students may want to plan social action projects to implement some of their decisions. To plan effective social action strategies, they may study content and concepts related to ways to influence public policy. These may not be directly related to the content of the social issue being analyzed. In our example, the children may study the civil disobedience tactics used by Mahatma Gandhi and Martin Luther King, in order to be able to accurately predict the possible consequences of various action strategies on public policy and authorities.

We have discussed two major ways in which a teacher may plan units to teach inquiry, valuing, and decision-making skills. These skills may be

developed with deliberate questioning strategies within the framework of social science inquiry units. An alternative plan is to identify a number of social issues, structure conceptual units to give children the knowledge needed to make intelligent decisions regarding them, and to teach decision-making units related to the social issues at different points in the year.

Although both these plans have certain advantages or may be the only plans feasible for many teachers, we will propose another alternative that we believe is the most effective way to structure learning experiences to enable children to develop proficiency in social science inquiry, value inquiry, decision-making and social action skills. *Although we will discuss this organizational plan separately, the reader should realize that it is highly related to the plans discussed above and that the strategies which will be discussed can be used within the previously discussed plans.* The teacher will be able to adapt these procedures and our decision-making paradigm to his own unique teaching situation, or he can use the procedures exactly as we describe them. We believe that the most effective organizational plan is the approach outlined below.

IDENTIFYING IMPORTANT SOCIAL ISSUES AND PROBLEMS

The first step in planning decision-making units, using the method we consider most effective, is to identify social issues which are of concern to the students and which are unresolved in the local community and the larger society. The issue should be a pervasive one, and it should be of enduring interest. Decision-making units should not be built around problems that are narrow or of only temporary concern. The teacher can determine the pervasive social issues within a society by carefully studying the news media over a period of time, by being generally aware of the events within the community and society, and by listening to the students' conversations and class comments about their social world. The teacher can also use questionnaires and essays to determine what social issues are most important to his students. Although social issues frequently vary within various time periods, some have been of enduring concern in modern American society. These include war, poverty, racism, pollution, and the administration of justice, especially for the poor. While all these problems have been with us for a long time, some of them have only recently been widely recognized. Most Americans have recognized the immense magnitude of the problems of racism and pollution in our society only within the last two decades.

TEACHING DECISION-PROBLEM UNITS

Identifying the decision-problem

We will illustrate how a class may study a social issue, and through a decision-making process, decide what action to take regarding it. In a medium-sized industrial community called Riverdale, racial conflict has developed between blacks and whites. During last summer when a black family moved into a predominantly white Riverdale neighborhood, a racial confronta-

tion occurred in which several persons were injured, including two white policemen. A number of citizens have formed a group to campaign for an open-housing bill, but to date support for the movement has been meager. Race relations within the city are at best uneasy. In response to federal legislation, a movement has begun to integrate the public schools by cross-bussing, but an anti-school-integration movement emerged to defeat the attempts for integration and to recall the school board. The children in the sixth-grade class at Abraham Lincoln, an all-white school on the fringes of Riverdale, poses the problem, *"What action should we take regarding race relations in our community?"*

Social science inquiry (related knowledge)

Since scientific knowledge is one essential component of the decision-making process, the teacher identifies social science concepts and related generalizations which will help the children to make intelligent decisions about the issue. The teacher selects the concepts of *conflict* from history, *culture* from anthropology, *discrimination* from sociology, *specialization* from economics, and *power* from political science. Organizing generalizations related to the concepts are identified, and sub-ideas related to the organizing generalizations and to the content of black-white relations in the United States are stated.

Concept: Conflict

Organizing Generalization: Throughout history, conflict has developed between various racial and ethnic groups.

Sub-ideas

1. Violence and conflict occurred on the slave ships.
2. Slave codes and other repressive measures were passed to keep the slaves in bondage.
3. Slave rebellions occurred.
4. Many race riots occurred during the early 1900's.
5. Race riots occurred during the post-World War II period.
6. Race riots occurred during the 1960's.

Concept: Culture

Organizing Generalization: Many different racial and ethnic groups have contributed to and enriched American culture.

Sub-ideas

1. Black Americans have contributed to American government.
2. Black Americans have made contributions to the fields of science and medicine.

3. Black Americans have contributed to the field of education.
4. Black Americans have contributed to the field of literature.
5. Black Americans have contributed to the field of entertainment.
6. Black Americans have made many contributions to the field of athletics.

Concept: Discrimination

Organizing Generalization: Groups are often the victims of discrimination because of age, sex, race, religion, and cultural differences.

Sub-ideas

1. Black slavery was a form of discrimination.
2. Black Americans have experienced much discrimination in legal matters; the slave codes and laws such as the "grandfather clause" are examples.
3. Black Americans have experienced discrimination in the administration of justice; the widespread lynching in the early 1900's is an example.
4. Blacks experience discrimination in the areas of voting and government.
5. Blacks experience discrimination in jobs.
6. Blacks must often attend segregated and inferior schools.

Concept: Specialization

Organizing Generalization: When a society becomes highly specialized, efficiency in production is increased, but many unskilled workers are displaced.

Sub-ideas

1. As the production of crops became increasingly specialized and mechanized in the South, many blacks lost their jobs on the farm and went to the city to find employment.
2. Many blacks in large cities are unable to find steady employment because of their lack of specialized training and skills.
3. Many black workers are untrained because they often attend inferior schools.
4. Because many blacks are unskilled and face job discrimination, a higher proportion of them than whites are welfare recipients.
5. Because many blacks cannot find steady employment, they face many personal and social problems in our society today.

Concept: Power

Organizing Generalization: Individuals are more likely to influence public policy when working in groups than when working alone.

Sub-ideas

1. The abolitionists, by working effectively as a group, were able to arouse the moral conscience of Americans about the evils of slavery.
2. The black leadership organizations, which emerged near the turn of the century, were able to reduce the discrimination experienced by black Americans in such areas as employment, law, education, and transportation.
3. The civil rights movement of the 1960's reduced discrimination in employment, education, and transportation.

Organizing for instruction

After the teacher has identified the key concepts related to the social issue which he wishes the class to decide upon, and stated his organizing generalizations and related sub-ideas, he is ready to formulate his teaching strategies and specify his instructional materials for the social science phase of his decision-problem unit. The concepts and materials should also be organized in some logical fashion.

In our example, a teacher may wish to start the unit with the first key concept which we identified (*conflict*) because the sub-ideas related to this key concept deal with the earliest period of black-white relations in America, although decision-problem units need not be chronological. Nevertheless, they should have some kind of logical organization. Another teacher using the concepts in our example may wish to start with the key concept of *power* and discuss first the civil rights movement of the 1960's. When organizing his social issues unit, the teacher should consider the interests of the students, the availability of materials, his own interests, the relationships of the concepts, the content to be studied, and the social issue to be analyzed.

We illustrated in Chapter 11 how a teacher may organize social science inquiry units. The same form of organization is appropriate for the social science phase of social issues units. The teacher can divide a sheet of paper in half and write the key concepts and organizing generalizations on one side of the paper and the activities that are designed to develop the ideas on the other half of the sheet of paper. Since we discussed this form of organization in detail in Chapter 11, we will give only one example here. Exhibit 13.1 shows how a plan may look for developing the concept of *discrimination* and the related generalizations which we stated on page 490.

Value inquiry

After the students have had an opportunity to derive social science generalizations related to their decision-problem, they should undertake lessons that will enable them to identify, analyze, and clarify their values related to the social issue. For value inquiry exercises, the teacher may use case studies clipped from newspapers and magazines, open-ended stories, photographs, role-playing activities, or realistic cases which he may write. Much of the factual materials,

Exhibit 13.1

Key Ideas	Activities
Concept: Discrimination *Organizing Generalization*: Groups are often the victims of discrimination because of age, sex, race, religion, and cultural differences. *Sub-idea*: Blacks have experienced much discrimination in all phases of American life, including education, the administration of justice, and employment.	1. Reading selections from *South Town, North Town* and *Whose Town?* by Lorenz Graham. 2. Discussing the discrimination which the Williams family experienced in these books and how they coped with it. 3. Discussing the discrimination which David Williams experienced in school and how he coped with it. 4. Viewing a filmstrip on black slavery and listing ways in which it was a form of discrimination. 5. Finding copies of such documents as the slave codes and the grandfather clause, and role-playing how they affected the lives of blacks. 6. Compiling statistics on the number of blacks who were lynched during the early years of the 1900's. 7. Reading and discussing accounts of the discrimination that blacks experience in employment, school, and in the administration of justice today.

which are covered during the social science phase of the unit, may also be used to help the children to form and clarify their values. When teaching a decision-problem or social issue, the teacher should use valuing strategies that are directly related to the issue under discussion.

For example, in our exemplary decision-problem, it would be inappropriate for the teacher to ask the children value questions about such issues as water pollution and a current war unless the issues were directly related to black-white relations in the United States or to the black-white relations in the students' local community. A value discussion regarding legalized abortion might be related to the problem in our example because many poor black families wish to control the size of their families, but do not have the know-how or means to do so. However, this issue should not be focused upon in the valuing phase of the unit.

An appropriate valuing exercise for our example could be based on a picture showing a hostile group of white parents trying to stop a busload of black students from entering the school grounds of a predominantly white school that has a volunteer bussing plan. The teacher could ask the following types of questions in carrying out the valuing model presented in Chapter 12.

A. *Defining and recognizing the value problem*
1. What is the problem in this situation?

B. *Describing value-relevant behavior*
1. What is happening in this picture?
2. What are the parents doing?
3. What are the children doing?

C. *Naming values exemplified by behavior described*
1. What do the actions of the parents tell us about what is important to them?
2. What do the actions of the children tell us about what is important to them?

D. *Determining conflicting values in behavior described*
1. How might the values of the parents in the picture differ from those of the children in the picture?
2. How might the values of the parents in the picture differ from those of the parents of the children who are pictured?
3. What would the parents in the picture believe if their values were the same as the parents of the children in the picture?

E. *Hypothesizing about the sources of values analyzed*
1. From the picture, it seems that the white parents do not want black children to attend this school. How do you suppose they learned or acquired their feelings and beliefs about blacks?
2. The parents of the children in the picture obviously want their children to attend this school. What do you think were the sources of their beliefs and attitudes?

F. *Naming alternative values to those exemplified by behavior observed*
1. What are other things that the parents in the picture could think are important?
2. What are other things which the children could think are important?
3. What are other things which the parents of the children in the picture could think are important?

G. *Hypothesizing about the possible consequences of values analyzed*
1. What might be the possible consequences of the values held by the parents in the picture? (What might happen because of their beliefs?)
2. What might be the possible consequences of the values held by the children in the picture?
3. What might be the possible consequences of the values held by the parents of the children in the picture?

H. *Declaring value preferences (Choosing)*

1. What would you do if you were one of the parents in the picture? (The teacher might want the children to write responses to this series of questions anonymously in order to avoid abusing the students or invading their privacy.)

2. What would you do if you were one of the children?

3. What would you do if you were a parent of one of the children in the picture?

4. Do you think that the children in this picture have a right to attend this school?

5. Do you think that the children in this picture *should* attend this school?

I. *Stating reasons, sources, and possible consequences of value choice*

1. Why would you take the actions you recommended in Section H?

2. Why do you believe what you do about the children, the parents in the picture, and the parents of the children in the picture?

3. Why do you believe that the children should or should not attend the school in the picture?

4. What might be the consequences of your beliefs and actions in the situation that we have described? Why?

5. Could you accept those consequences?

As we indicated elsewhere in this book, the teacher might find it practical to raise value questions during the social science inquiry phase of a unit; however, we have separated our discussion of social science and value inquiry in this book because we feel that children should know when they are studying value questions and when they are researching scientific questions. This distinction is essential because the processes used to answer these different types of questions are quite different as we pointed out in Chapter 2. We do not mean to suggest that scientific information cannot help us to identify, form, and clarify conflicting values. However, scientific knowledge cannot tell us what to believe. It can, nevertheless, help us to identify the consequences of different values and beliefs, and make us aware of value alternatives.

When formulating plans for decision-problem units, the teacher should clearly indicate the strategies and materials that he will use to help the children to identify, form, and clarify their values regarding the issues. The valuing phase of the unit can constitute a separate but integrated component of the unit plan, and may take the form illustrated in Exhibit 13.2.

Decision-making and social action

After the students have derived social science generalizations and clarified their values regarding the social issue, the teacher should ask them to list all the possible actions which they could take regarding race relations in their community, and to predict the possible consequences of each alternative.

Exhibit 13.2

Value Inquiry	Activities
A. Recognizing value problems	1. Read and discuss selections from *North Town* and *Whose Town?* by Lorenz Graham.
B. Describing value-relevant behavior	
C. Naming values exemplified by behavior	2. View and discuss pictures of urban riots.
D. Determining value conflicts	3. Take and discuss a racial attitude inventory.
E. Hypothesizing about sources of values	
F. Naming value alternatives	4. Role-play and discuss a situation in which an all-white school is integrated.
G. Hypothesizing about consequences	
H. Choosing	5. Read and discuss a news story about a race problem in the local community.
I. Stating reasons, sources, and consequences of choice	6. Role-play a racial confrontation.

It is imperative that the alternatives and consequences which the children identify and state are realistic and are based on the knowledge that they have mastered during the scientific phase of the unit. Alternatives and consequences should be intelligent predictive statements and not ignorant guesses or wishful thinking. The teacher should demand that students give supporting *data* and *reasons* to support the alternatives and consequences that they submit. For example, a child who states that his class can solve the racial problems in his community by going from door to door and telling the residents about the problems would obviously be dreaming. This statement is not meant to suggest that information would not contribute to the resolution of the problem. In our example, it would be almost impossible for the children to think of alternatives that would *solve* the racial problems in their community. However, they could take effective action to improve the racial attitudes of the students in their school community, or *contribute* to the resolution of the racial problems in the wider community through some types of meaningful and effective social action projects.

The students can identify alternatives and possible consequences in a chart form as illustrated in Exhibit 13.3.

Determining a course of action

After naming alternatives and predicting their consequences, and identifying the knowledge that supports the alternatives and consequences, the students should then order the alternatives according to their hierarchy of values (see Chapter 12). Figure 13.1 illustrates the decision-making process.

The students should pose and answer this question, "Which course of action is most consistent with my most important values as identified and stated above?" The students should identify their values and order them into a hierarchy during the valuing phase of the social issues unit. A group of students

Exhibit 13.3
Alternative Actions and Possible Consequences

Alternative Action Regarding Race Relations in Our Community	Possible Consequences
1. Take no group action.	a. More hostilities may occur. b. More persons may be injured in racial violence. c. Blacks and whites may further separate and form separate societies. d. Our own school may become involved in a racial conflict over school integration. e. We will not be criticized by conservative factions in the school and wider community. f. Blacks may be denied more rights in our community.
2. Take group action to improve racial feelings in our classroom and school.	a. We may encounter hostility from administrators, other students, and teachers. b. If we proceed carefully, we may improve race relations in our school, but they will not necessarily improve in the wider community. c. We may interest other students and teachers in working to help improve race relations in the school or wider community.
3. Take group action to improve race relations in the wider community.	a. We might encounter hostility from community groups. b. We might enflame racial feelings from such groups. c. Unless we win the cooperation of our parents, they may work against or not support our efforts. d. By working carefully and wisely with civic and religious groups, we might be able to positively influence racial feelings in the community.
4. Take no group action, but individually act to improve racial relations.	a. Such action may have little effect on the racial problems in our community, but it may make us feel better because we may be acting in ways more consistent with our values than before. b. Our individual actions may influence the action of other individuals, and thus our efforts would have more influence.

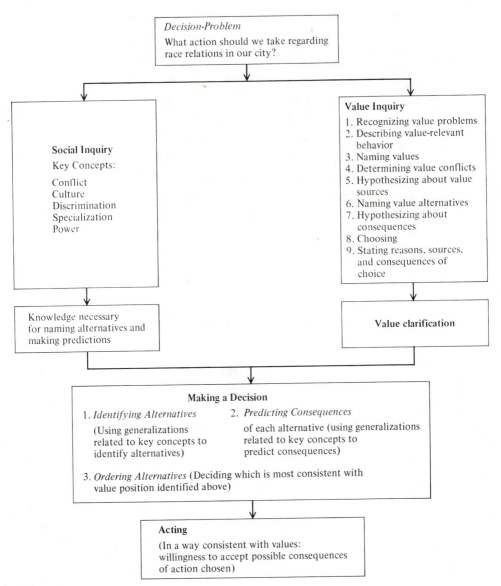

Figure 13.1
The Decision-Making Process

may decide that they value above all else the *worth and dignity of the individual*, and that their next most important value is *equality*. They should try to operationally define their values and relate them to the alternative courses of action that they have stated. They must resolve such problems as "Is taking no action at all when blacks are experiencing discrimination in our community consistent with our values about the worth and dignity of the

Although each child should be encouraged to think independently, students should have some opportunities to make and implement group decisions. (Washington State Office of Public Instruction, Olympia)

individual?" "Are we not denying the worth and dignity of the individual when we deny him equal opportunities under the law, to work and to go to school?" "How can we act in ways which are consistent with the values which we hold?"

Another group of students may conclude that they value above all else *majority rule*. Since the majority of whites in the community do not think that blacks should have certain jobs or live in certain neighborhoods, taking no action about the situation would be consistent with their values. (These students studied the results of a recent community racial attitude survey.) If a group of students reaches this conclusion after thoughtful reflection, the teacher's role is to help the students re-analyze the sources of their values, determine how they may conflict with other values that they hold or with American Creed values, and help them to identify the possible consequences of their beliefs. The teacher should also help the children determine whether they can live with the possible consequences of their values. *The teacher should not be a crusader either for racial equality or inequality*. Unless children are able to make uncoerced decisions within a free classroom atmosphere, the theory we describe in this book cannot be successfully implemented. It is not an easy theory to implement; but we feel that it is consistent with a democratic ideology and a commitment to human dignity, values which we endorse and upon which our theory is based. We should also point out that the social studies curriculum which we advocate has risks, since it is based upon a set of assumptions, many of which have not been scientifically verified. However, we feel that it is sounder than curriculums which are based upon opposing

"I sure am sorry to hear that about Lake Erie. I grew up around there."
Drawing by Herbert Goldberg.
© 1971, Phi Delta Kappa.

assumptions. In our judgment, these other curriculums have not trained the kind of students needed to perpetuate democracy in the present century.

Students should be encouraged to make their own decisions, to accept responsibility for them, and not to rely on others, including teachers, to make decisions for them. While students should be encouraged to think independently about social issues, there will be situations where children should and will make group decisions. Practice in some group decision-making is desirable, because in real-life situations the individual must often participate in group decision-making. Skillful group decision-making is essential for the survival of a democratic society. Also, if social action projects are to be planned and implemented, they will usually be undertaken in groups, although individuals may decide to take independent action on some social issues.

A decision-problem unit on ecology

We have illustrated how a class can study a social issue related to race relations and decide upon actions to take regarding it. In recent years, Americans have become acutely aware of the ecological problems within our society. Our next example deals with the question of water pollution, due in part to phosphates from detergents. The following unit identifies organizing concepts and generalizations chosen from various disciplines relating to ecology, and suggests pupil activities. Valuing strategies, alternative courses of action, and possible consequences that a class may state are illustrated in Exhibits 13.4, 13.5, and 13.6.

Exhibit 13.4

Concepts and Generalizations	Activities
Cycle	
The growth and death of plant, animal, and human life are constantly recurring phenomena.	1. Viewing pictures of the seasons to illustrate the cycle of growth and decay.
	2. Illustrating the ecological chain by identifying the relationship of plant to animal life in a lake.
	3. Comparing the plant growth in a healthy lake to the algae-ridden beds of a polluted lake. Discussing how the ecology chain has been broken.
	4. Viewing the process of photosynthesis through charts and observation of animals in an aquarium or other habitat.
	5. Observing how leaves, after they fall from the trees, easily become part of the organic matter of the soil and contrasting this phenomenon with trying to mix broken glass with the soil to illustrate the problem of increased waste.
Interdependence	
Man is dependent on animals, his physical environment, and other human beings for survival.	1. Studying how American pioneers settled the West by focusing on geographical characteristics of the places in which they settled, and how they obtained and used natural resources available to them.
	2. Finding examples of natural resources such as oil, lumber, and water, the conservation of which depend on man's ingenuity and planning ahead.
	3. Discussing the relationship among birds, trees, and soil, for sources of nourishment to plant, animal, and human life.
	4. Identifying an industry in the community that depends on the survival of other industries for its existence. Exploring the relationship among the industries.

Exhibit 13.4 (Continued)

Concepts and Generalizations	Activities
Technological Change Man has the ability to change the environment through his inventions.	1. Showing pictures of a city from its inception to the present. Observing building sizes, functions, and kinds of industries. Discussing the effect of technological change on the ways of life of the inhabitants over the years. 2. Observing changes in land features before and after a housing development has been built. 3. Comparing the effects of using waterpower (Northwest) and coal (Southwest) to generate electricity. 4. Comparing the way an average working man spent his time each week in 1970 with the way a working man spent his time in 1900. Illustrate the increase in leisure time.
Scarcity Scarcity of resources increases their cost because of decreased supply and increased demand.	1. Comparing the size of land parcels persons bought in a city in 1800, 1850, 1900, and 1970, with average income in the same years. 2. Comparing cost of electricity for the average home in the Northwest with that in Chicago and Texas. 3. Discussing the purpose and consequences of laws which demand that industries must filter and purify their wastes. 4. Observing old and new homes to determine how building materials have changed because of declining availability of certain resources and popularity of other materials. 5. Charting the amount of phosphates in detergents. Studying the effects of phosphates on the water supply and determining whether there has been an increase in the cost of water over the last ten years. Discussing whether scarcity of water supply is a threat to America and the world.

Exhibit 13.5

Value Inquiry	Activities
Recognizing value problems Describing value-relevant behavior Naming values exemplified by behavior Determining value conflicts Hypothesizing about sources of values Naming value alternatives Hypothesizing about consequences Choosing Stating reasons, sources, and consequences of choice	1. Studying a community whose major industry is threatened with closure due to increased pollution controls (see *Life Magazine*, March 26, 1971). 2. Viewing pictures of conveniences such as dishwashers, dryers, garbage disposals. Then showing pictures of air pollution around Albuquerque due to coal powered generators, and pictures of the New York City power outage to indicate possible results of heavy power usage. 3. Studying the controversy over the Supersonic Transport plane. Considering views of environmentalists, economy-minded legislators, and persons concerned with America's image in the world.

Exhibit 13.6

Alternative Action Regarding Water Purity in Our Community	Possible Consequences
1. Take action to improve water purity by publicizing support for a sophisticated sewage system.	1. Taxpayers may be angry at the possibility of a higher tax bill. 2. Towns in outlying areas would have fewer water pollution problems. 3. In the long run, this plan would be less costly to taxpayers.
2. Publicize a program to prohibit use of high phosphate detergents and other products which break the cycle of life in lakes and rivers.	1. Housewives may find few satisfactory alternatives to insure clean laundry. 2. The soap industry might work harder to develop phosphate-free detergents. 3. The campaign may be unsuccessful without legal sanction. 4. The average person may be unwilling to exchange convenience for long-term effects.
3. Take no action at present.	1. Water pollution will continue unabated. 2. The conveniences of life will not be disrupted. 3. A taxpayer's revolt will be deferred.
4. Pressure for legislation against industries which pollute waterways.	1. Legislators may be unwilling to threaten a powerful tax base and risk an economic decline. 2. The average taxpayer may be pleased to have pressure put on industries, rather than on him. 3. The cost to industry might be passed on to the taxpayer.
5. Start a campaign around the school to create an awareness of the water pollution problem.	1. We could easily become involved in such an effort. 2. We might feel a more immediate sense of accomplishment. 3. We have no assurance that the problem will be solved.

Concept: Cycle

Organizing Generalization: The growth and death of plant, animal, and human life are constantly recurring phenomena.

Sub-ideas

1. The seasons of the year show the process of growth and decay and rebirth.
2. A break in the cycle causes a break in the chain of life.
3. The process of photosynthesis is essential to continuation of the life cycle in plants, animals, and humans.
4. The level of oxygen in the atmosphere has remained steady because the rate at which it is provided by green plants is the same as the rate at which oxygen is used by organisms. The same has been true of carbon dioxide.
5. The rate of population increase historically has been cyclical; large population growth has been curbed by natural factors, one of which has been the exhaustion of food supplies.

Concept: Interdependence

Organizing Generalization: Man is dependent on animals, other men, and the natural environment for his survival.

Sub-ideas

1. Persons in a community provide goods and services for one another.
2. Farmers depend on good weather and adequate prices for their economic survival.
3. Adequate water to provide for the needs of persons living in the United States depends on man's ability to protect water quality and abundance.
4. Plants, animals, and humans depend for survival and regeneration on the balance of oxygen and carbon dioxide in the air.

Concept: Technological Change

Organizing Generalization: Man has the ability to change his environment through his inventions.

Sub-ideas

1. Dams have been built to produce electric power, making it available to many consumers.

2. The availability of various building materials and man's advanced knowledge of engineering and architecture have produced high-rise buildings, increasing population density.

3. Man has produced many conveniences for living, allowing him more leisure time.

4. Extensive manufacture and use of automobiles has increased mobility, changed the landscape, and caused extensive air pollution.

Concept: Scarcity

Organizing Generalizations: Scarcity of resources increases their cost because of decreased supply and increased demand.

Sub-ideas

1. Land prices have steadily increased since the United States was settled because of the expanded use of land and its limited supply.

2. Water for Southern California is being pumped from the Colorado River across the Mojave Desert and through the Sierra Mountains, because supplies near major population centers are inadequate.

3. The cost of electricity varies according to the availability of power sources to generate electricity.

4. Clean air and water are becoming costly to maintain as the government and industries are being forced to find new ways to purify their wastes.

5. A decreasing supply of lumber has increased its price and encouraged conservationists to pressure for saving our trees and replacing those that are cut down.

PROVIDING OPPORTUNITIES FOR SOCIAL ACTION

After students have made decisions on important social issues, we should, whenever possible and practical, provide opportunities for them to participate in social action projects to implement the decisions they have made, to help resolve social problems, and to help pupils develop a sense of political efficacy. Knowledge is of little value if it is not used to help resolve human problems in a period in our history when personal and social problems loom large. While the teacher and the school will not be able to provide opportunities for students to act on all or perhaps most of the decisions they make (this would be neither possible nor desirable), the school, by working in cooperation with public and private agencies, can provide opportunities for students to act on many decisions and issues which are important to them.

Traditionally, we have educated children for political apathy. Students have been taught that every citizen gets equal protection under the law, that discrimination exists only in the South, and that if they vote regularly and obey the law they can expect our benign political system to make sure that

they get their slice of the "American Dream" pie. The problems of blacks, Chicanos, American Indians, Puerto Ricans, poor whites and other oppressed groups have been deceptively evaded in such passive lessons about our political system. Writes Newmann:

> By teaching that the constitutional system of the U.S. guarantees a benevolent government serving the needs of all, the schools have fostered *massive public apathy*. Whereas the Protestant ethnic calls for engagement (to survive economically one must *earn* his living), the political creed breeds passivity. One need not struggle for political rights, but only maintain a vague level of vigilance, obey the laws, make careful choices in elections, perform a few duties (taxes, military services), and his political welfare is assured.[1] [First italics added]

It is especially important for us to help students develop the ability to make rational decisions and effectively participate in social action in times when rhetoric is frequently substituted for reason, and when simplistic solutions are often proposed as answers to complicated social problems. Wanton destruction is frequently the only response that many of our youth can make when archaic institutions stubbornly resist their just demands for change. The National Council for the Social Studies in *Social Studies Curriculum Guidelines* emphasize the importance of involving students in meaningful social action programs:

> Social participation in a democracy calls for individual behavior guided by the values of human dignity and rationality and directed toward the resolution of problems confronting society. The practices of the school and particularly of social studies programs have not provided for active and systematic student participation. Because social studies educators have usually limited their thinking to what has been described as "two by four pedagogy — the two covers of the textbook and the four walls of the classroom" — the potential applications of knowledge and thought have not been fully realized. A commitment to democratic participation suggests that the school abandon futile efforts to insulate pupils from social reality and, instead, find ways to involve them. . .[2]

> *Extensive involvement by students of all ages in the activities of their community is, then, essential.* Many of these activities may be in problem areas held, at least by some, to be controversial; many will not be. The involvement may take the form of observation or information-seeking, such as field trips, attending meetings, and interviews. It may take the form of political campaigning, community service or improvement, or even responsible demonstrations. *The school should not only provide channels for such activities, but build them into the design of its social studies program, kindergarten through grade twelve.* [Emphasis added]

Education in a democratic framework clearly requires that such participation be consistent with human dignity and with the rational processes. Such participation must be voluntarily chosen; no student

"Guess what the Dean just did? He locked 400 students in the chemistry building."

Bo Brown in *The Christian Science Monitor*. Reprinted by permission from *The Christian Science Monitor* © 1971, The Christian Science Publishing Society. All rights reserved.

should be required to engage in what he has not defined as desirable. Nor should social participation be undertaken without systematic, thoughtful deliberation. To do so would be to violate the values of human dignity and rational process. Educational institutions can make a significant contribution to society by providing students with the knowledge and experience necessary to be effective, singly or as part of organized groups, in dealing with social problems.[3]

In commenting on the National Council for the Social Studies publication quoted above, John Jarolimek stated in his presidential address:

The NCSS statement quite properly places the *action* component in proper perspective along with knowledge, abilities and valuing. It does not make the assumption that responsible involvement in social action will emerge spontaneously as a result of knowledge inputs alone. It takes the position that one learns to participate in social affairs by participating in them and that the social studies program must provide opportunities for such

participation. . . . In whatever way social participation is defined, it quite clearly means some degree of activism. *The intent of the NCSS statement must be interpreted to mean that the student is to be actively involved in social affairs outside the social studies classroom.*[4] [Emphasis added]

A rationale for social action

We have suggested that when students study social issues they should be provided opportunities to act on their decisions when it is reasonable and practical for them to do so. It is necessary to provide guidelines for social action projects and examples of social participation activities.

When a social issue has divided a community, such as race relations in our example, it is probably best for students to confine their actions to their classroom, school, or to local situations (such as a club or church) where they do not run the risk of being publicly abused or ostracized. If a group of students becomes involved in a heated racial controversy in a sharply divided community, the school and the students may become vulnerable to severe attacks from extremist groups. Despite this possibility, the teacher cannot stop an individual student or group of students from becoming involved in such an issue if they feel strongly about it. *The teacher's primary responsibility is to help students become acutely aware of alternative courses of action* and the possible consequences of their action.

However, when students become independently involved in social controversy, they should act as individuals and not as agents of the school. Because the public school is so vulnerable in our society, it cannot survive if teachers and administrators do not exercise sound judgment when social participation activities are planned for students.

The most reasonable course of action for the children to take in our first example may be for them to formulate a race relations program or black studies curriculum in their school. They may start by working jointly with the principal, teachers, parents, and other persons in the school and neighborhood. Although the class, as a group, may decide on a course of action, no student should be forced to participate in an action project that he feels is contrary to his values and beliefs.

Since the school is a social institution with problems which mirror those of the larger society, students can be provided much practice in shaping public policy by working to eliminate problems in their classroom, school, or school system. They might start by studying and analyzing the problems within their classroom. To help children develop a sense of political efficacy by working to resolve social problems within the school, the teachers and administrators must be committed to the belief that children should be active participants in the making of school and other public policies.

Unless teachers and principals are willing to allow children a role in the making of classroom and school policies, student social action projects are doomed. Children who lack political effectiveness in their own school will be ineffective in shaping public policy in the wider community. Obviously, there are school policies which children cannot and perhaps should not be allowed to

Before he takes action on any social issue, the student should
think seriously about the possible consequences of his actions.
(Washington State Office of Public Instruction, Olympia)

make or influence. School administrators and teachers must also conform to
rules and laws which are made by higher authorities. However, when such issues
as racism, bussing, drug abuse, dressing codes, and cafeteria food selection arise
within the school, students can and should be allowed and encouraged to
participate actively in the making of school policy. The nature and extent of
their participation should be determined by the issue, and the maturity and
knowledge which the students have about the issue.

Teachers should demand that student decisions be based on knowledge,
that students be aware of the possible consequences of their decisions, and be
willing to act on them and to accept their consequences. Students must also be
aware of the legal and moral limitations on the action within the school that
can take place. This does not mean that the law governing the school should
not or will not be changed as a result of intelligent and concerted social action.
However, students, like all other citizens, must work for change within the laws
of the society.

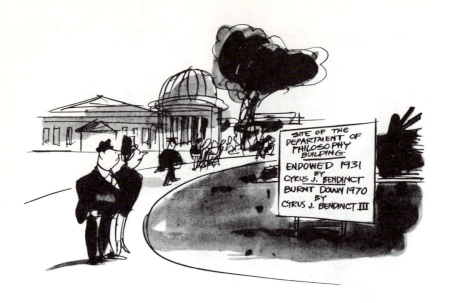

Drawing by Kenneth Mahood. Copyright © 1971, Saturday Review, Inc.

Social action that is irresponsible, irrational, or illegal cannot be supported by the school. Although our position regarding laws and social change may seem overly conservative to some readers, this position is warranted because of the widespread irresponsible and illegal protest which took place on our high school and college campuses during the latter years of the 1960's. Many persons who were supposedly working for social change and for a better and more humane society, blatantly violated the rights of other individuals and the values which they professed. In some cases public buildings were bombed, and people were killed. Social activists who use tactics that are contrary to the values which they claim they are working for are by our definition irrational and irresponsible. The school, by working cooperatively with other public and private agencies, should provide students opportunities to engage in meaningful social action projects in order to influence public policy and to develop their own sense of political efficacy. The teacher has a responsibility to help students see how their actions may be inconsistent with their values, and to discover how it is inconsistent to claim to value human dignity and to use inhuman tactics in professed attempts to bring about humane conditions within a society. The teacher also has a responsibility to help students realize that they must be willing to accept responsibility for their actions and beliefs.

Too many young people during the 1960's and 1970's, we believe, not only protested in ways that were inconsistent with the values they professed, but

they were often reluctant or unwilling to accept the consequences of their actions. One legal consequence of murder in our society, whether by bombing or with a pistol, is some form of extended punishment. Individuals who believe that bombings will bring about humane conditions within a society (and we disagree), should be willing to accept the consequences of their beliefs and actions.

SOCIAL ACTION PROJECTS

In our discussion above, we have already indicated some types of social participation activities in which students may become meaningfully involved in order to shape public policy and develop a sense of political efficacy. Such activities, we suggested, may often begin in the school since the school is a social institution which often mirrors the problems of the larger society. Racism, drug abuse, class stratification, theft, and arson are the kinds of problems which schools have. Students can take concerted action on these problems, especially after examining them from a social science perspective and analyzing their own values regarding them. Only after going through these processes will they be able to make rational decisions and take intelligent social action. Other social action projects, especially for more mature students, can take place in the wider community. Social action may take the form of observation, participation, or leadership. The school can work with such agencies as the local police department, fire department, civil rights and charity organizations, and political organizations. The levels of involvement in such activities can be diverse. *The primary purpose of such activities should be primarily to provide students with opportunities to develop political efficacy rather than to provide community services*, although both goals can be attained in the most effective types or projects. Writes Newmann:

> Depending upon the constraints of the situation and the student's interest, his involvement could range from detached study and observation in the field to apprenticeship, to leadership. It will be necessary to learn to use conventional lines of influence: election campaigning, behind-the-scenes lobbying, testifying, letter-writing, publicity campaigns, canvassing — as well as more subtle and dramatic techniques. Whatever the project, *the purpose for including it in an educational program is to help the individual operate more effectively within the political system, not to provide charity or service to the community*, though individuals should be free to choose that sort of project if they wish.[5] [Emphasis added]

Student participation in social action activities within our society is not without precedence. However, the most dramatic and effective social action by American students has usually been undertaken by college students. Ever since black students initiated the civil rights revolt in 1960, one of the most cogent and effective components has been comprised of students. Throughout the black revolt of the 1960's, students, both black and white, remained active and influential. They helped to desegregate restaurants, interstate transportation,

schools, and swimming pools with such tactics as sit-ins, freedom-rides, and swim-ins. Student effectiveness in the civil rights movement of the 1960's is one of the most dramatic indications of the potential of student power in America. The student role in this movement should be carefully studied by any group of students who are planning social action projects.

College and high school students have also become involved in other social controversies in recent decades. As the war in Vietnam became increasingly unpopular during the 1960's, student protest groups formed on college and high school campuses throughout the nation. The protest became intense, and many observers believe that President Nixon's decision to scale down the war was to some extent influenced by student protest.

Protest by students during the 1960's also resulted in enlightened curriculum reforms in public schools and colleges. The history and culture of blacks, Indians, Chicanos, and other ethnic minority groups have been largely excluded from school and college curriculums. The protest by junior-high-school, high school, and college students was a large factor which initiated reform movements to include the study of all American groups within the curriculum. Student action protesting the pollution of the air and earth made many Americans acutely aware of the tremendous pollution problems which our nation faces, and helped to rally support for antipollution legislation.

In reviewing ways in which junior-high-school, high school and college students have participated in social protest, we do not mean to suggest that all or even most of their actions were rational or even of maximum effectiveness. However, we must emphasize the fact that students will become involved in important social issues in the community and nation whether the school facilitates that involvement or not. (Schools did little if anything to facilitate the involvement of students in the issues we have been reviewing above.) *Furthermore, schools should accept this fact, and help students to decide on rational courses of action, and become involved in projects in which they can experience the maximum degree of political effectiveness.*

We have suggested that much of the student protest during the 1960's was irresponsible, irrational, and illegal. We believe that much irresponsible protest occurred largely because the school and other institutions (such as the family) did not help the students involved in irrational protest to reflectively analyze the problems within our society, to clarify their values, and to plan intelligent and effective social action strategies. However, despite the fact that the school and other institutions did little to help students plan rational action strategies, much effective protest and social change resulted from the student protest movements of the 1960's and 1970's. Such protest would have been more effective and less wasteful of human and physical resources if students had been equipped with more rational decision-making skills.

We do not suggest that the only meaningful kind of student participation in the community is political protest. Students can also participate in other kinds of action projects. A group of students at Howard University planned a project in which they bussed low-income Southern children who badly needed dental care to the Howard campus in Washington, D.C., and treated them.

Tutoring young children can be an effective and meaningful social action project for students in the junior high-school grades. (Shoreline School District, Seattle, Washington)

Students can work with police departments and other agencies to help inform potential drug users about the harmful effects of drugs. In some cities, young adults helped to set up and man drug treatment centers. A group of students in one community organized a family planning information center where poor families could obtain information about birth control and abortions. The Black Student Union at the University of Washington in Seattle organized and manned a free day-care center for the children of low-income families. In some communities students have worked with organizations such as the American Cancer Society to plan and initiate anti-smoking campaigns aimed at other students and the wider public.

At a private school in Chicago, a group of junior high and high school students planned a project whereby they implemented self-help and recreational programs for young children in an inner-city school. Some of the students in this school also started a tutoring project for inner-city students who were having academic problems. A group of students at the University of Washington (Seattle) planned and implemented a store-front school for school dropouts, many of whom were former students at ghetto schools.

At Case Western Reserve University in Cleveland, a group of students joined a project, headed by Ralph Nader, that handled complaints of

consumers who had difficulties with their automobiles. The project was quite successful in helping to put pressure on salesmen to fulfill contractual responsibilities. In one city, students set up a nonpartisan political information center where voters could obtain objective information about candidates. In other cities groups of students have actively campaigned for particular candidates and issues. A partisan project is legitimate, as long as other students with different opinions and beliefs have equal opportunities and encouragement to campaign for other causes and candidates.

Although community help, civic, and informational projects can be effective types of participation activities, students must become involved in some kinds of political activity if they are to gain a sense of political effectiveness. Too many individuals within our society experience an acute sense of political alienation and helplessness, and do not participate at any level in political affairs.[6] Student action can help to resolve many social problems within our society. Students can take action to expose the abuse of consumers by the various industries, and put pressure on elected officials to better the consumers' predicament. Students can take similar kinds of action to expose the inhuman conditions in many hospitals, prisons, and inner-city schools. An antipollution campaign by elementary grade students, whereby they inform residents of the extent of pollution in their community and actually take action to help alleviate the situation, would be a meaningful activity. Students could start the fight against pollution in their own classrooms and schools.

Elementary students can also take steps within their community to improve automobile safety. In one community, a group of students installed seat belts for drivers for only the cost of the materials. Students, especially on holidays when automobile deaths accelerate, could prepare literature and make speeches at public places to encourage drivers to drive more safely. They could sponsor such projects jointly with organizations such as the National Safety Council. The creative teacher will think of many ways to involve students in meaningful social participation activities. Our comments are meant merely to suggest possibilities. *Students can do much through social action to improve the environment of their school, which is a real and viable social institution with many of the problems of the wider community and nation.* This point cannot be overemphasized. We offer the following *guidelines* for teachers and students who are planning social action projects.

GUIDELINES FOR SOCIAL ACTION PROJECTS

1. The activities should be *meaningful* experiences, not merely projects in which students become involved just to say that they are participating in social action projects.

2. The *primary* goal of social action projects should be to provide experiences for the students whereby they can attain a sense of political effectiveness, and not just serve the community. However, the most effective projects contribute to the attainment of both goals.

3. Charity and other kinds of community help experiences are legitimate and potentially meaningful activities, although the projects should, as often as possible, help children to gain a sense of political effectiveness.

4. Students should participate in social action activities only after they have studied the related issue from the perspectives of the social sciences, analyzed and clarified their values regarding it, identified the possible consequences of their actions, and expressed a willingness to accept them.

5. When problems within the school can be resolved through student action, participation in school activities should have priority over participation in projects in the wider community.

6. While group decision-making is legitimate and often desirable, no individual student should be required to participate in an action project that he feels is contrary to his values and beliefs.

7. The experience and age of the students should be considered when action projects are planned and implemented. Young children should confine their actions to their classroom, school, and family, or to other primary groups or secondary institutions in which they feel secure and which are supportive of their actions.

8. When social action projects are planned, the support of other teachers, students, school administrators, related community agencies, and members of the community should be solicited.

9. Students who wish to participate in social action projects should be allowed to have schedules that are conducive to such participation. The concept of the school should be broadened; activities needn't necessarily take place within the four walls of the schoolroom.

10. When a community is seriously divided over a social issue and feelings within the community are intense, action projects should be confined to the classroom, school, family or to other institutions which are supportive of their actions and in which students are secure.

11. Social action projects planned by students should not violate the laws and mores of a community.

12. Social action projects planned within the school should be consistent with pervasive American values and norms.

13. When social action projects are planned, the teacher should make every effort to help the children identify all the possible consequences of their actions, especially those actions which may have adverse consequences, either for the individual or the group.

14. Students who wish to engage in individual projects should not be discouraged, but should be helped to realize the fact that group action is usually more politically effective than individual action.

15. When social action projects are planned, the teacher should make every effort to minimize any physical, emotional, or psychological damage to the students. This can be accomplished largely by soliciting the cooperation of other persons in the school and wider community, and by carefully considering the possible consequences of different courses of action.

16. Social action projects in the social studies program should be nonpartisan. Although groups of students may decide to campaign for a particular candidate or issue, children with other beliefs and goals should have the option to plan parallel projects to support their beliefs and political choices.

SUMMARY

In this chapter, we further clarified our beliefs regarding the proper goal of the social studies program in the elementary and junior-high-school grades. We emphasized again that the main goal of the social studies curriculum should be to help students develop the ability to make decisions, so that they can resolve personal problems and influence public policy by participating in rational social action. The *assumptions* that underlie our theory were also made explicit. Our theory assumes that in a democratic society, students must be trained to make rational decisions so that they can take intelligent social action to influence public policy. Decision-making skills are acquired and not inborn, and should be developed sequentially within the social studies program. The theory also assumes that students can learn to identify and clarify their values, to reflect upon problems before acting on them, and to make rational decisions that are consistent with pervasive societal norms and values. However, while valuing stability within a society, we advocate a social studies curriculum that promotes change. We assume that when societal values and norms become dysfunctional, they will be changed by massive and effective social action. Thus values, norms, beliefs, and life styles are subject to reconstruction in each generation.

We further delineated the processes of rational decision-making and intelligent social action. To make a rational decision, the social actor must use concepts and generalizations from several disciplines, knowledge that has high predictive value, and that constitutes the structure of the social science disciplines. He must also identify, form, and clarify his values and consider as well alternative values and their consequences. When a social actor acts intelligently to influence public policy, he has mastered knowledge related to the issue, clarified his values regarding it, and is acutely aware of and willing to accept the possible consequences of his actions. Action which does not satisfy these criteria is irrational.

We suggested that students must become meaningfully involved in realistic social action projects if they are to develop a sense of political efficacy. We stated a rationale for social action projects, reviewed examples, and provided guidelines for such projects. The next and final chapter presents a rationale and strategies for evaluating social science inquiry, valuing, decision-making, and social action skills.

DISCUSSION QUESTIONS AND EXERCISES

1. On what assumptions is the theory of social studies education, presented in this book, based? To what extent are these assumptions normative ones? To what extent are they supported by empirical evidence? Which of the author's assumptions do you accept? Why? Reject? Why?

2. How does the author distinguish between *rational* and *irrational* decisions? Do you feel that this distinction is a useful one? Why or why not?

3. Why does the author claim that he is primarily concerned with teaching students a *process* (or method) of making decisions? Why isn't he more concerned about the *products* of the decisions which social actors may make?

4. What categories (kinds) of knowledge will best help students to make sound decisions? Explain.

5. What role do values play in decision-making? What are the implications of your response for teaching decision-making skills?

6. What alternate unit plans can a teacher use to help children gain proficiency in decision-making skills? Which plan do you think is most effective? Why? Most practical? Why?

7. Identify a current social issue and construct a decision-making unit for children in the elementary or junior-high-school grades. Include key concepts and generalizations that are related to the issue from the following disciplines: history, sociology, anthropology, geography, political science, economics, and psychology. Plan strategies for teaching value inquiry. Also include strategies for teaching children how to relate the key ideas to their values in order to make decisions. List possible courses of action which students might take on the issue, and their possible consequences.

8. What criteria can a teacher use when selecting key concepts and generalizations for a decision-making unit? Which of these criteria are the most important? Why? Least important? Why?

9. Study the guidelines for social action which the author lists on pages 514-516. With which of the guidelines do you agree? Why? Disagree? Why? Make your own list of guidelines for social action, and tell why you think each is important.

10. What problems might a teacher encounter in trying to build and implement units that focus on social issues? How might these problems best be resolved?

11. Demonstrate your understanding of the following terms by writing or stating brief definitions for each of them. Also tell why each is important:

 a) decision-making

 b) rational social actor

 c) social action

d) social knowledge

e) categories of knowledge

f) higher-level, interdisciplinary knowledge

g) value inquiry

h) social science inquiry

i) political efficacy

FOOTNOTES

1. Fred M. Newmann, "Political Socialization in the Schools: A Discussion," *Harvard Educational Review*, Vol. 38 (Summer, 1968), p. 536.

2. The National Council for the Social Studies Task Force on Curriculum Guidelines (Gary Manson, Gerald Marker, Anna S. Ochoa, Jan Tucker), *Social Studies Curriculum Guidelines* Washington, D.C., National Council for the Social Studies, 1971, p. 14.

3. *Ibid.*, p. 15.

4. John Jarolimek, "Concerning the Matter of Activism in Social Studies Education," *Social Education,* Vol. 36 (February, 1972), p. 150.

5. Newmann, *op. cit.*, p. 541.

6. See Robert E. Lane, *Political Life: Why and How People Get Involved in Politics.* New York: The Free Press, 1959; Lester W. Milbrath, *Political Participation: How and Why Do People Get Involved in Politics?* Chicago: Rand McNally, 1965.

Part 5

EVALUATION

INTRODUCTION TO PART 5

This book has stressed the need for the teacher to help students develop the ability to make sound decisions so that they can take effective action to influence social and political institutions to effect social change. In Part 1 we presented and defended a rationale for a social studies curriculum focused on decision-making, and we delineated the basic components of the decision-making process. Part 2 consisted of a detailed discussion of the knowledge components of decision-making. Part 3 focused on the valuing component. Part 4 illustrated how the synthesis of scientific knowledge and clarified values can result in reflective decision-making and social action.

To assure that the skills which constitute the decision-making process are mastered by his students, the teacher must have sound ways to evaluate pupil achievement and his own behavior. This part of the book presents a number of strategies which can be used to evaluate teacher and student behavior. While evaluation should be a continuous process in the instructional program, we focus on the topic here in order to emphasize its importance.

Sound evaluation techniques cannot be devised without effective objectives. The chapter which constitutes this part of the book delineates ways in which behavioral objectives can be structured, and presents a number of strategies and techniques for systematically observing, recording, and analyzing classroom behavior and interaction. Specific ways to evaluate social science inquiry, value inquiry, decision-making, and social action skills are described and illustrated.

Chapter 14

EVALUATION STRATEGIES

How well have the students learned? How close have we come to meeting the goals or objectives for instruction? What progress has Chris, Bob, or Allison made? Has Paul improved in his ability to form concepts? Has the new experimental project — being tried by several teachers on a pilot basis — been successful? To what extent have the criteria been met? Questions such as these are the concern of *evaluation* of social studies instruction.

Evaluation is a technical aspect of instruction. Its purpose is to develop as much precise and objective information about the instructional process as possible in order to (1) assess the effectiveness of instruction; (2) determine the accomplishment of instructional goals, (3) provide feedback to the teacher about the instructional processes, and (4) provide information on which important decisions about students' progress, curriculum changes, and instructional goals can be made. Considered from a systems approach, evaluation is that part of the teaching-learning process that provides the continuous feedback of data to keep the system in adjustment and balance (see Fig. 14.1). Tests, observational reports, anecdotal records, sociograms, collections of student's work, class diaries, committee reports, logbooks, and teacher-made tests are all types of evidence data upon which evaluation is based. It must be remembered, however, that in the final analysis, evaluation is a judgmental act. The teacher's task, then, is to (1) formulate goals that are clear and precise, (2) set criteria that are appropriate and attainable, (3) gather data about the instructional process that is as accurate and objective as possible, and finally (4) report that data to students, parents, and administrators in ways that are clear and meaningful. Given such conditions, evaluation fulfills an important role in the teaching-learning process. The remainder of this chapter is divided into sections, each of which deals with the teacher tasks listed above.

The student often wonders about his academic and social progress
in school. A sound evaluation program should provide the pupil
with constant feedback. (Washington State Office of Public
Instruction, Olympia)

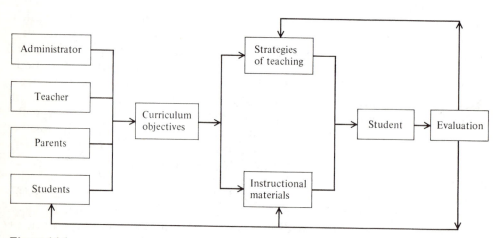

Figure 14.1
Evaluation as Part of a Systems Model of the Teaching-Learning Process.

BEHAVIORAL OBJECTIVES: A TECHNIQUE FOR EVALUATION*

One of the newer trends in the teaching of social studies is the effort to specify instructional goals in clear, precise terms. It is based on the assumption that the clearer and more precise are a teacher's objectives, the more effective will be the instruction and the more likely that student learning will occur. This approach seeks to specify objectives, in terms of the student's performance or behavior, that are readily observable and measurable, and that can be easily evaluated by a criterion measure of acceptable performance. Thus the name, behavioral (or performance) objectives. In the past, one could pick up almost any social studies guide or teacher's manual and find instructional objectives written in familiar terms:

- to *know* the major rivers, capital cities, and chief products.

- to *understand* the growth of large cities.

- to *appreciate* the importance of transportation routes to the settlement of the West.

Although such terms as to *know*, to *understand*, or to *appreciate* were commonly used, they provided little help to the teacher as to what learning activities were actually intended, or how one was to know if or when the goal had been satisfactorily accomplished. Because the terms were so ambiguous, they meant many different things to different teachers. Evaluation on the basis of some common criterion was virtually impossible. In contrast to the vagueness of this older style, the behavioral objective employs a precise formula for writing instructional objectives. Each must contain the following elements:

1. The person who is to perform the particular learning behavior (e.g., the student, the learner, the class, a small group, a committee).

2. The specific behavior required to demonstrate accomplishment of the objective (e.g., to write, to name, to construct, to locate).

3. The learning outcome or product by which the accomplishment of the objective can be evaluated (e.g., a statement of fact or a generalization, a contour map, a simple grid system).

4. The conditions under which the behavior is to be performed (e.g., with the aid of an atlas, using data from the 1970 census).

5. The criterion or standard used to evaluate the accomplishment of the performance (e.g., correct to the nearest mile, four out of five correct).

*The material in this section was adapted from Ambrose A. Clegg, Jr., "Developing and Using Behavioral Objectives in Geography," in *Focus On Geography: Key Concepts and Teaching Strategies,* (Phillip Bacon, Ed.), 40th Yearbook, Washington, D.C.: National Council for the Social Studies, 1970, pp. 291-303. Permission to reprint portions of this material is gratefully acknowledged.

When students make reports and presentations, behavioral objectives can help the teacher evaluate their mastery of important social studies learnings. (Seattle Public Schools, Seattle, Washington)

Using this format, you might state a behavioral objective in social studies as follows:

> Given data from the 1960 and 1970 censuses, the students will be able to construct a bar graph showing the change in population for the following cities: New York, Chicago, Detroit, Cleveland, St. Louis, and Seattle. Data will be correct to the nearest ten thousand.

From this brief explanation, and the above example, one can see more easily the basic purposes for writing instructional objectives in behavioral terms. Exact specifications help to delimit the scope of available content and require that curriculum designers and teachers make explicit decisions about what to include and what to exclude. Such explicitness also makes the learning process and its outcome open to inquiry so that both objectives and methods can be modified if outcomes are not achieved. But perhaps of greatest value is that the statement of the objective contains the elements needed for evaluation of the learning outcomes in the initial definition of the task. Content, materials, learning process, outcome, and assessment are all linked together in a

single statement designed in advance of the instruction. Instead of being a casual afterthought, evaluation measures for determining the accomplishment of the objective are equally as important as the selection of content and materials.

As novel as all this may seem, the concept of writing instructional objectives in behavioral terms is really not new at all. Behavior descriptions were carefully developed by the evaluation staff of the Eight-Year Study.[1] Kearney's[2] study on *Elementary School Objectives* and French's[3] *Behavioral Goals of General Education in High School* both worked out comprehensive sets of social, intellectual, physical, and emotional goals stated in behavioral or performance terms. Bloom[4] and Krathwohl[5] have developed taxonomies, or systems, for classifying educational objectives for the cognitive and affective domains. They identify specific skills and processes of learning, and relate each to observable measures of behavior. Stemming from quite a different tradition, the principles involved in the writing of materials for programmed instruction require very clear specification of the desired student response and the appropriate stimuli (frames) needed to produce that behavior.[6] However, if any single factor could be cited as perhaps the most influential in the trend toward writing objectives in behavioral terms, it would probably be the publication of Mager's[7] little volume, *Preparing Instructional Objectives*. Popham[8] later amplified Mager's work with a filmstrip and audiotape package. Both of these have since been widely used in pre-service and in-service teacher training programs. The development of behavioral objectives, including a number of controversial issues surrounding their use, is discussed at length in the report of a symposium sponsored by the American Educational Research Association.[9]

Developing behavioral objectives in social studies

The technique of writing behavioral objectives is at best only a technique. It is a *means* to a more precise method of stating instructional objectives; it is not an *end* in itself. A number of appropriate ends or goals of social studies education have already been suggested in the preceding chapters. Briefly stated these take the form of:

1. Content (or product) objectives which involve the development of important facts, concepts, and generalizations selected from the various social science disciplines.

2. Learning process objectives which include a wide range of cognitive and affective activities such as comparing, contrasting, predicting, forming hypotheses, valuing, and decision-making. Also included are particular skills such as interpreting map symbols, locating a place by its grid coordinates, or locating data in specialized reference books.

For example, "As a result of this lesson, the students will be able to use the latitude and longitude coordinates given in an atlas and locate correctly the following cities on a slate globe: London, New York, Tokyo." Note that the intended outcome in this example is the ability to locate the cities correctly by

interpreting and applying the coordinate system. It is a combination of both a content and a process objective. It is also a relatively simple example that can be handled by children in upper elementary school grades who have had previous concrete experiences with locating places on a grid or coordinate system. As noted above, there is a wide range of content and process objectives that involves complex and sophisticated learning operations. Some of these are listed below.

Stating an objective in behavioral or performance terms means that the objective must tell what the student is doing when he is demonstrating his achievement of the objective. This action must be readily observable and easily recognized by another teacher, student, or some other competent outside observer. To accomplish this, a precise action verb is used in the infinitive form to state what the student will be able to do. Such verbs as to *write*, to *measure*, to *draw*, or to *interpret* symbols convey the intended meaning of a terminal behavior far better than such ambiguous but commonly used verbs as to *know*, to *understand*, or to *appreciate*. There must be no confusion or uncertainty among observers, including the teacher himself, about the objective's intended outcome. The chief purpose of having an observable outcome is to make sure that the objective has been accomplished and student performance can be adequately assessed and evaluated.

It should be noted that many philosophic and psychological arguments have been raised about the matter of requiring an overt, observable performance as evidence that learning has taken place.[10] It can be argued that complex and powerful mental operations may occur while a person shows no outward sign of change. Nevertheless, the point of view presented here is that we can *infer* that some kind of learning has occurred from the evidence of a student's ability to perform some certain action which (presumably) he could not do before. We assume that this observed behavior is the result of a learning process.[11]

Listed in Fig. 14.2 are a number of strong action verbs classified as cognitive or affective processes or as social studies skills. These are only samples; many others can be gleaned from the chapters in other parts of this book.

Having identified a strong action verb and an appropriate social studies content objective, we now face the simple matter of combining them to form the basic outline of a behavioral objective: the introductory stem, the verb, and the resultant product. A sample listing is presented in Fig. 14.3.

Specifying the conditions under which the terminal behavior will occur is the next, and perhaps easiest, step in writing the instructional objective. This step identifies the curriculum materials to be used, the limits that might be placed on the task, or the basic data to be used in the development of some higher-order process.

A variety of curriculum materials for any subject can be specified. These might include an atlas, gazeteer, encyclopedia, or an almanac in which census data is reported. Other kinds of tools or materials might be a globe, a relief map, a magnetic compass, or perhaps an inexpensive Instamatic camera for making 35 mm. colored slides while on a site visit or a field trip. With primary

Figure 14.2
A Sample of Strong Action Verbs

Cognitive Processes	Affective Processes	Social Studies Skills
to recall	to prefer	to construct (a model)
to recite	to choose	to draw (a map)
to describe	to believe in	to interpret (symbols)
to identify	to react positively or	to locate (countries)
to compare	negatively toward	to identify (time zones)
to contrast	to respond to	to measure (distance)
to evaluate	to judge as good or bad	to determine slope (from a
to solve	to approve	coutour map)
to apply	to comply with	to translate (color codes)
to observe	to acclaim	to show distortion of
to analyze	to react with pleasure	various projections

Figure 14.3
Combining an Action Verb and Social Studies Content

Stem: As a result of this lesson (or unit of study), the students will be able to. . .

Action Verb	Content or Product Objective
recall	the names of the continents
compare	population distributions
develop the concept of	population density
apply	the principles of a grid coordinate system to a hypothetical country
estimate	population growth
point out	areas of greatest distortion on a Mercator projection
explain why	windward slopes receive greater precipitation than leeward slopes
judge as good (or bad) *or* make an ethical judgement about	a system of land tenure
react with sympathy	to evidence of hunger or poverty
be moved to action	to improve environmental quality
prefer (or choose)	a flood control project over the preservation of a district as a wilderness area or wild life preserve (or vice versa)
develop the generalization that	man's use of the land in a given region is a function of the attitudes, objectives, and technical skills of the population

grade children, large rolls of wrapping paper and vivid tempera paints are ideal for helping them to make simple maps of their neighborhood or town. Older students can learn to work with marking pens on transparencies for an overhead projector. More advanced students can make transparencies with several overlays. The following is an example of a behavioral objective in which specified curriculum materials are called for.

The student is able to prepare a map of the population density of the Seattle area based on the 1970 census data, using tempera paints to identify different levels of density.

Another way of specifying the material or conditions under which the behavior is to be performed is to provide a list of "givens" that the student must use in some special way. Most often this is a means of providing (or assuming) a basic input of data as the basis for undertaking some more complex or higher-order task. For example,

- given the following climatic conditions. . . .
- given a list of mineral resources. . . .
- given data on cost per acre and yield per acre. . . .

Or

Given data on the rainfall in Singapore, the student will be able to determine the months in which the wet monsoon occurs.

Or

The students will make comparisons and contrasts and develop a generalization in their own language which approximates the following: "Man's use of the land is determined by its physical features as perceived by man as a function of his attitudes, objectives, and technical skills." To form this generalization, students will use the comparative data previously recorded on a chart developed by the class on the cultures, natural resources, and the physical conditions of the land, taking the material from data on four sample countries in Latin America.

Note that in this last example the terminal behavior is the development of a generalization. The intermediate task of making comparisons and contrasts is also specified as a further guide to the processes to be used in arriving at the generalization. The type of data to be used is specified, but the teacher or student is referred to some previously developed chart or compilation for the exact details.[12] Generally, the list of "givens" is short and is stated first, as in the earlier examples. Where the conditions are more detailed, however, the objective is written in two sentences to avoid awkward phrasing or a long Ciceronian sentence that would put the operational verb at the very end.

Another variant is to make only a brief reference to the material to be used, focusing the major attention of the objective upon a new, higher-order process. For example,

Using data similar to that gathered above, students will test out the validity of the above generalization by applying it to another country in Latin America (or to a country in some other part of the world).

Occasionally a teacher may want to limit the types of data or the materials to be used. This is helpful to focus attention on a specific skill when it is first being learned, or as a means of demonstrating proficiency in its use. For example,

The student is able to:

- present an oral report aided only by 3 X 5 notecards.
- locate and draw the continents in their approximate location (or label the major oceans) without the use of an atlas or a globe.
- estimate the maximum height of the Pyrenees mountain range, using only a contour map.

Criterion of acceptable performance

In order to be complete, the behavioral objective must state a criterion measure for evaluating the student's performance. This is usually thought of as

At what level did he perform the task?

How well did he perform?

The criterion measure is a precisely stated, readily observable measure. It is often stated in terms of some minimum level of acceptable performance. This can take the form of the number of correct responses, e.g., four out of five. A time limit could be specified, e.g., the task is to be completed within 30 minutes, or within two class periods. Or to borrow the criterion measure often used in programmed instruction: 90 percent of the students will score 90 percent or better on the final test. (This criterion measure is often difficult to attain, especially with newly developed materials being used for the first time: 80/80 might be a more reasonable goal.) Finally, the degree of accuracy could be prescribed: e.g., correct to the nearest whole number or to the nearest degree of longitude.

Criterion measures can also be specified for process goals, though typically we are less accustomed to doing so. When students group observations or events in the process of conceptualizing, the criterion is that all items do, in fact, possess the same attribute at least in some degree. Similarly, the naming or labeling of the category requires only that the concept word or phrase be sufficiently abstract or general to include all the items in the group and their common properties. To be sure, one cannot be rigid in evaluating the performance on either of these processes. Students often develop groupings that are not mutually exclusive, and some items could appropriately fit in more than one category, depending upon the attributes involved and how the student has defined the common properties. Students can also conceptualize the same data quite differently, depending upon the perceptions an individual has in viewing the data. For example, the development of natural resources in Africa

Well, you let Artie Brown's dad out-smart you again."
Drawing by Joe Buresh; copyright ©
1970, *Today's Education.*

or Asia by Western nations has been referred to variously as economic expansion or as imperialism, the latter carrying strongly affective overtones. Similarly, conflicting conceptualizations are evident when data on wages or farm crop income are labelled as "minimum subsistence level" by one government bureaucrat but "poverty level" by a concerned welfare worker. In all these cases, the teacher should encourage such divergent responses, but insist upon "logical sufficiency" as the essential criterion for the validity of the different groupings or the concept names. In the same way, the criterion for the generalizations that students develop is that the inferences and generalizations are warranted logically by the data presented.

Each of the above examples illustrates some minimum level of mastery. Given the need to individualize instruction and to provide higher levels of accomplishment for various students, several other approaches to setting criterion measures are possible. The simplest approach is to increase the quantities in the examples specified above: nine out of ten responses correct, 100 percent accuracy, or the same task completed in a shorter time. Such measures test for greater retention, accuracy, or speed of learning, but the learning task remains essentially the same. There is no qualitative increase in the intellectual level of learning (the process goal), or in the social studies product or content goal.

Qualitative increases in the level of learning may be accomplished by specifying more complex, sophisticated, and higher-order processes of cognitive or affective learning. An excellent guide for writing instructional objectives at higher levels that is keyed directly to the levels of the cognitive and affective taxonomies was developed by Metfessel and others.[13]

Another approach to setting different levels of performance is to require a more creative approach to the task. For example, the criterion measure may be to present two or more *different* approaches or solutions to the same problem,

"So he's not the smartest boy in school. You're not the president of the company."
Drawing by Francis R. Brummer (RUM); © 1971, *Today's Education.*

rather than to seek a single, convergent solution. Using some of the higher-level thinking processes, students may be asked to provide two or more alternate solutions in a decision-making situation, each of which might be equally feasible or would solve the problem, although one might be preferable to the other.

A note of caution should be entered here. In specifying different levels of performance, the teacher should be sure that the terminal behavior remains the same. Oftentimes when we expect students to "perform at a higher level," or to "be creative," we really are expecting them to perform different and usually more complex tasks — though we never say so explicitly. Consider the following example:

> Students will be able to interpret the data from a bar graph correct to the nearest hundred people per square mile. To obtain a higher grade, students will be able to project an estimate of the population density for the same area for 1980, using data from the 1950, 1960, and 1970 censuses.

It should be evident that although these tasks may be closely related, they really require quite different skills and abilities. The first calls for interpretation of data; the second calls for a prediction or extrapolation made from a series of other known data points. In the final analysis the student is really performing two different tasks that should probably be taken up separately.

Norm-referenced vs. criterion-referenced evaluation

The problem of setting different levels of performance for a task is almost invariably linked with the problem of establishing a norm-referenced evaluation system. The criterion-referenced evaluation associated with behavioral objectives is usually a "go/no go" system. The performance is either attained or it is

not, within the limits of the accuracy prescribed. The norm-referenced evaluation measure, however, asks how well a particular student performed in relation to the others in his class or group. This measurement is usually in the form of a numerical rank order in the class, a percentile ranking on .a standarized test, or more often some form of an A, B, C, D scale. Letter grading systems frequently carry with them, at least implicitly, a number of assumptions of the normal curve related to the distribution of these grades. Specifically, the number of A grades is sharply limited compared to the number of C grades that can be given. Thus, the assessment of student performance and the school grading policies often operate from different bases. Confusing, too, is the fact that the criteria for letter grades are seldom stated explicitly. They tend to be private criteria, based on the teacher's intuitive judgment of what constitutes a desired degree or level of excellence. In contrast, behavioral objectives attempt to specify readily observable examples of the desired performance, using publicly stated criterion measures. Thus, we have the dilemma of trying to mix criterion and norm-referenced systems of evaluation. The most practical alternative is to simply list the objectives in brief checklist form and check off student progress. While this solution side-steps completely the question of norm-referenced grading, the authors see the traditional letter-grading system too fraught with unspoken assumptions about the nature of learning and the philosophy of education. If one *must* have letter grades, then we would prefer to see them *clearly* and *publicly* tied to a qualitatively different set of behavioral objectives progressing from minimum to maximum performance, or, more palatably put, from good (C), to better (B), to best (A). But in truth, the problem of the value judgments associated with the letter grades from A to F has not been resolved; it has merely been disguised, or at best made more tolerable. At least the criteria for the grades have been made public, which is a step in the right direction.

SUMMARY OF EVALUATION OBJECTIVES

In this section we discussed the development and use of behavioral objectives as one of the newer trends in teaching social studies. It was emphasized that the instructional objective be stated in terms of the student's performance or behavior, that it be readily observable and measurable, and that it could be evaluated by a criterion measure of performance. A format given for writing behavioral objectives included the following elements: (1) the persons involved, (2) the specific behavior required, (3) the learning outcome, (4) the conditions under which the behavior would be performed, and (5) the criterion or standard of acceptable performance. Examples and techniques for writing each were given. Many illustrations were also provided giving samples of learning processes and content objectives. Relationships to different levels of cognitive and affective learning were also pointed out. Finally, criterion measures of acceptable performance were discussed, including possible ways of specifying higher levels of accomplishment.

The teacher must observe the pupil in a wide variety of activities in order to properly evaluate his mastery of social studies learnings. (Shoreline School District, Seattle, Washington)

GATHERING DATA ABOUT THE INSTRUCTIONAL PROCESS

As we have indicated in the previous sections of this chapter, there are many kinds and sources of data that represent valid measures of the instructional process. We suggested that both the *processes* and the *products* of learning are valid goals and that measures of these can be easily specified by the teacher. Class discussions captured on a tape recorder, the list of tentative generalizations written on a chart, the mural painted by several students and displayed at the back of the classroom, are all simple and informal measures of learning that are most often overlooked by classroom teachers. It is important to emphasize this point since most teachers tend to feel that the only valid

measures of learning are pencil-and-paper type tests. While formal measures such as objective tests, attitude surveys, and standardized tests are important and will be discussed in some detail later, they should not preempt the wide variety of other less formal means of gathering data that are readily at hand. Two easy methods for systematically gathering data about students are first, an anecdotal record, and second, a checklist of individual progress. A third, more comprehensive approach involves the use of specially designed instruments for recording systematic observations of various aspects of teacher and student behaviors in the classroom. Each of these will be discussed below.

Anecdotal records

An anecdotal record is a continuous log or diary of a student's progress written in narrative form. In contrast to the checklist or test, its form is free-flowing and allows the teacher to add considerable illustrative detail, particularly of a diagnostic nature. Here is an example:

Sept. 21: Steve seemed to recognize that latitude and longitude were a more elaborate grid-coordinate system, but did not see how the Mercator map resulted in distortion at upper latitudes. I will have him compare Greenland on several different map projections tomorrow.

Sept.22: Steve was amazed today at the amount of distortion of Greenland when he compared Greenland on a globe, with a Mercator projection, and with an equal-area projection. He was quite excited when he discovered similar distortions in maps of Chile.

Sept. 25: Introduced polar projections today. Steve immediately saw the distortions this time near the outer reaches of the map. Was confused by the rearrangement of the lines of latitude and longitude. Seems to be having trouble relating them to the equivalent lines on the globe.

As can be seen from the above example, the chief benefit of the anecdotal report is the detail with which a student's progress can be recorded. But this same benefit is also its chief weakness. Writing anecdotal reports on a large number of students tends to be time-consuming and difficult to keep up. A reasonable compromise is to keep an anecdotal record for each small group of students as they proceed with their task. Wherever possible, mention is made of the accomplishments of specific individuals. For example,

Oct. 14: Karen's group decided to build a relief map of the reservoir and water shed area out of paper-mache. There was much argument about the scale of the map and how much detail could be included. George had difficulty reading the contour map; gave up. Mark tried to help him but they quarreled about whose job it was.

Oct. 17: Helped Karen's group get materials ready for making paper-mache. Mike had worked out the scale problem, using one inch equal to one mile, and sketched the basic layout. Everyone seemed to enjoy "gooshing and mooshing

As a result of this unit of work on _____ ,
(topic)

_____ is able to.
(Student's name)

		Comments
1. Recall the names of the seven continents.	X	
2. Compare the population distribution patterns of New York, Chicago, and Seattle.	X	
3. Develop the concept "population density."		
4. Apply the principles of a grid coordinate system to a hypothetical country.	X	See attached map completed in class

Figure 14.4
Individual Progress Report

around" in the bucket of wet paper-mache. George dabbled for a while and then wandered about the room.

Oct. 19: The relief map had dried sufficiently to permit painting. Terry worked out a color key to show elevation. Mike seemed pleased that his scale plan had worked out quite accurately. Clean-up was bedlam; Karen was absent, and no one wanted to assume any responsibility.

Here one gets more of the flavor of how the group was operating and its progress (or lack of it!). Reports tend to be less specific about individual students, with emphasis on only a few in the group. The selectiveness of what is reported is also a limitation.

One of the chief dangers of anecdotal reporting is the tendency to become subjective about students by imputing motives to their actions and injecting inferences and personal feelings about their behavior. If an anecdotal record is to have any value as a device for evaluation of instruction, it must be as objective as possible, yet one frequently finds all kinds of gossipy and prejudicial comments in official school records. Furthermore, a teacher should not attempt to play amateur psychologist or therapist. He is not trained for this. Should there be symptoms of deviant behavior, these should be recorded as objectively as possible and reported to the school guidance counselor.

When carefully prepared, the anecdotal record offers a good source of data about the progress of both individuals and groups. It is most useful for the detail it provides and the insights it can give for diagnosis and developing plans for teaching.

Checklists

Another simple measure for gathering data on instruction is the checklist. In essence, it is an abbreviated form of the behavioral objectives that were developed earlier in planning the instructional program. As shown in Figs. 14.4

As a result of this unit of work on _____ ,

the students are able to.

(topic)

	Chris	John	Mark	Robert	Connie	Matt	Stuart	Carolyn	Allison	Joey	Jay Dee	
1. Compare population distribution.	✓	✓	✓	✓	✓	✓	✓	✓	✓		✓	
2. Explain the concept of "population density."	✓		✓	✓			✓			✓		
3. Apply principles of the grid coordinate system.	✓			✓		✓		✓			✓	

Figure 14.5
Class Progress Report

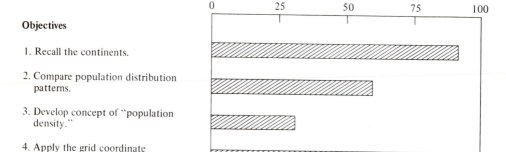

Figure 14.6
Graph Showing Percent of Objectives Accomplished

and 14.5, the chart can be adapted to record both individual and group progress. An "X" or a checkmark in the student's column indicates that he has achieved the particular objective. The checklist also gives a good record of performance on a variety of different level objectives and is an informative device for reporting a student's progress to his parents. A master list compiled by the teacher provides similar data about all individuals in the group, thus offering evaluative data for determining whether or not curriculum objectives have been accomplished. Thus, the teacher can see at a glance which parts of a unit of work have been successfully achieved and which have not. The class report (Fig. 14.5) can form the basis for regrouping of students for re-teaching. Reports such as these can easily be converted to somewhat more formally prepared graphs for better visual presentation simply by calculating the percent of students that has completed each objective successfully (see Fig. 14.6). If

Reprinted from *Instructor* © August-September, 1971, the Instructor Publications, Inc. Used by permission.

one is teaching for mastery, then levels of 80 to 90 percent accomplishment should probably be the goal. Where achievement is less than that, the teacher should make careful assessment of the situation to determine the probable source of the difficulties.

Needless to say, the primary purpose of charts such as these is to aid in evaluation of the instructional program. Teachers should be careful to interpret properly the progress of individuals in terms of objectives accomplished and not as "high" or "low" compared with an entire class. When discussing a particular child's performance with his parents, the teacher should mask out the names of other children on group progress charts to prevent unfavorable comparisons. For such purposes, the graphs showing the percent of objectives accomplished (Fig. 14.6) might be more appropriate.

Systematic observation of classroom behaviors

During the past decade a relatively new approach to studying the teaching and learning process has gained increasing popularity. It consists of making a series of systematic observations about certain aspects of what occurs in the classroom, recording them on a chart or matrix, and then analyzing and interpreting the data in terms of the teacher's stated objectives. While such techniques have been common to the educational researcher for many years,

what is new is the way in which these procedures have been simplified and made readily usable by the average classroom teacher to provide feedback on his own teaching behavior. Perhaps the best known of these systems is the Ned Flanders[14] method for analyzing the kind and amount of verbal interaction between the teacher and the students, based on a set of ten categories of verbal behavior. These include categories of teacher talk, such as giving praise and encouragement, accepting student ideas, questioning, lecturing, giving directions, and criticizing; and categories of student talk, such as responding to the teacher, and self-initiated talk. The important point is that these behaviors are carefully defined in operational or behavioral terms to ensure a common understanding of each of the ten categories (see Fig. 14.7). The system requires an observer to record an observation at the rate of one every three seconds, or about 20 observations per minute, to provide a continuous, systematic observation of all the verbal behaviors that occur in the classroom. These are then tallied and presented on a chart or matrix for comprehensive analysis. Percentages for the amount of teacher or student talk during the lesson and the percent of time spent giving directions or asking questions can easily be calculated. When related to the teacher's own instructional objective, this method provides reliable feedback data about accomplishment and the possible source of difficulty if the objectives were not achieved. For example, the teacher who wished to have a high degree of student involvement in a discussion on valuing, but who lectured more than 60 percent of the time could hardly be said to be meeting his own goal. With the use of a tape recorder any teacher can record his own classroom sessions and analyze them himself, using the data as a self-assessment of his own teaching behavior.

Many spin-offs have been developed from this basic procedure for systematically analyzing classroom behavior.[15] Several have already been referred to and discussed in detail in Chapter 4 on "Questioning Strategies." In terms of the type of inquiry strategies developed in this book, one of the most useful systems is the Content Analysis system developed by John H. Hansen.[16] It is based on a set of thirteen categories, ten of which involve cognitive inquiry processes adapted from Hilda Taba's work and three of which are miscellaneous activities (see Fig. 14.8). In reality, there are only five basic categories arranged in pairs on the basis of *seeking* and *giving*. The odd numbered categories, 1, 3, 5, 7, 9, represent a *seeking* of some one of the inquiry processes; the even numbered categories, 2, 4, 6, 8, 10, a *giving* or responding.

A sample episode of classroom dialogue is presented in Exhibit 14.1 to illustrate how an observer might code a lesson. The transcript is arranged so that each line represents about a three-second interval of dialogue. The numerical coding is given in the center column, and at the right is a brief identification of the cognitive process involved, in which the behaviors listed in Fig. 14.8 are used. In an actual setting an observer would use the category numbers to record his observations on a worksheet every three seconds in one of two vertical columns, one for teacher action and one for student action. An example of a completed worksheet is given in Fig. 14.9. (A worksheet in which the columns are 20 cells long has been found useful to gauge whether one is

Figure 14.7
Flanders' Interaction Analysis Categories* (FIAC)

Teacher Talk	Response	1. *Accepts feeling.* Accepts and clarifies an attitude or the feeling tone of a pupil in a nonthreatening manner. Feelings may be positive or negative. Predicting and recalling feelings are included.
		2. *Praises or encourages.* Praises or encourages pupil action or behavior. Jokes that release tension, but not at the expense of another individual; nodding head or saying "Um hm?" or "go on" are included.
		3. *Accepts or uses ideas of pupils.* Clarifying, building, or developing ideas suggested by a pupil. Teacher extensions of pupil ideas are included, but as the teacher brings more of his own ideas into play, shift to category five.
	Initiation	4. *Asks questions.* Asking a question about content or procedure, based on teacher ideas, with the intent that a pupil will answer.
		5. *Lecturing.* Giving facts or opinions about content or procedures; expressing *his own* ideas, giving *his own* explanation, or citing an authority other than a pupil.
		6. *Giving directions.* Directions, commands, or orders to which a pupil is expected to comply.
		7. *Criticizing or justifying authority.* Statements intended to change pupil behavior from nonacceptable to acceptable pattern; bawling someone out; stating why the teacher is doing what he is doing; extreme self-reference.
Pupil Talk	Response	8. *Pupil-talk–response.* Talk by pupils in response to teacher. Teacher initiates the contact or solicits pupil statement or structures the situation. Freedom to express own ideas is limited.
	Initiation	9. *Pupil-talk–initiation.* Talk by pupils which they initiate. Expressing own ideas; initiating a new topic; freedom to develop opinions and a line of thought, like asking thoughtful questions; going beyond the existing structure.
Silence		10. *Silence or confusion.* Pauses, short periods of silence and periods of confusion in which communication cannot be understood by the observer.

*There is *no* scale implied by these numbers. Each number is classificatory; it designates a particular kind of communication event. To write these numbers down during observation is to enumerate, not to judge a position on a scale.

From Ned A. Flanders, *Analyzing Teacher Behavior*. Reading, Mass.: Addison-Wesley, 1970, p. 34. Reprinted with permission.

Figure 14.8
Content Analysis

1. Seeks Information	Specific information is sought with no demand for any action other than presentation.
2. Gives Information	Specific facts *are* given — most one word answers, dates, unexplained data, lists, etc.
3. Seeks Labels and Groups	Naming, classifying, categorizing and grouping of information is sought.
4. Gives Labels and Groups	Specific facts are classified, categorized, or grouped.
5. Seeks Interrelationships	Requests for responses which explain or organize data already known.
6. Gives Interrelationships	Explanations or organization of information already presented.
7. Seeks Inferences and Generalizations	Asks for comparison, contrasts, consequences, etc., which demand inclusion of information not already stated.
8. Gives Inferences and Generalizations	Provides (specifically or through implications) comparisons, contrasts, consequences, principles, generalizations, etc.
9. Seeks Predictions and Hypothesis	Requests to apply known information to situations in order to predict events, outcomes, etc.
10. Gives Predictions and Hypothesis	Use of information and deduction to predict unknown facts, events, actions, etc.
11. Procedural Remarks	Those statements which are made in class which are intended as agreement, disapproval, management, reiteration, feeling, encouragement, etc.
12. Focus	Those statements which are made to keep students working towards the proposed objectives.
13. Nonverbal	All classroom activity which is nonverbal or does not contribute to the lesson (confusion or out-of-focus remarks).

Reprinted with permission from John H. Hansen and Arthur C. Hearn, *The Middle School Program* © 1971 by Rand McNally & Company, Chicago, Table V, p. 90.

Exhibit 14.1
A Sample of Classroom Dialogue Coded According to the "Content Analysis System"*

Dialogue	Code	Analysis
T. For the last few days we've been reading several case studies, "The Youngers Buy a House," "The Case of Adam Henry," and "The Case of Johnnie Scott" from the *Negro Views of America* booklet.[17]	12 12 12 12 12	Focusing statement
T. What are the basic topics these cases emphasize?	1	Seeks information
S. Prejudice.	2	Gives specific fact
S. Poor housing.	2	Gives specific fact
S. Couldn't most of the topics be put under one main heading?	3	Seeks classification
S. Well, education was bad.	2	Gives specific information
S. Some people didn't get enough to eat.	2	Gives specific fact
S. The police didn't help; in fact they sometimes caused incidents.	2,2	Gives specific information
S. Lots of people didn't have jobs.	2	Gives specific fact
T. Where was the setting for the three case studies; that is, where in the United States did each take place?	1 1 1	Seeks specific facts
S. All of the places mentioned, Chicago's Southside, Harlem, and Watts are ghettos. The cases illustrated problems of the ghetto.	4 4 4	Categorizes specific facts
T. Why did Mrs. Younger want to buy a house?	1	Seeks specific information
S. The apartment was too small.	2	Gives specific fact
S. Weren't there more important reasons than that?	1	Seeks specific facts
T. Yes, psychological reasons too.	2	Gives specific fact
S. She thought the move would help to bring the family together.	2	Gives specific fact
S. They wouldn't have to worry about roaches anymore.	2	Gives specific fact
S. (student laughter, head nodding)	13,13	Nonverbal activity
S. She wanted a place with a garden and sunshine.	2	Gives specific information
S. A home is a better place to raise children, she said.	2	Gives specific information
T. Did all the family agree with her decision?	1	Seeks specific information

*This sample dialogue, the worksheet in Fig. 14.8, and the statistical analysis of the dialogue were prepared by Shirley R. Petery, University of Washington.

Exhibit 14.1 (Continued)
A Sample of Classroom Dialogue Coded According to the "Content Analysis System"

Dialogue	Code	Analysis
S. No, not at first. Walter and Beneatha wanted the money for other purposes.	2,2	Gives specific facts
T. The family was somewhat concerned at first about the neighborhood in which the house was located. But in time everyone, even Walter and Beneatha, was enthusiastic about the prospective move and the new home.	12 12 12 12 12	Focusing statements
T. Why did Mrs. Younger buy a house in an all-white neighborhood?	1	Seeks specific fact
S. It was the best buy she could get for the amount of money she had.	2	Gives specific fact
T. Did any problems result from her actions?	1	Seeks specific fact
S. Yes, the neighbors complained.	2	Gives specific fact
T. Why did they do, specifically?	1	Seeks specific information
S. They tried to make the Youngers change their minds about the house.	2	Gives specific fact
S. All the Younger family wanted was to find a better place to live.	6	Explains previously presented information
T. Who was Mr. Lindner?	1	Seeks specific information
S. He was the head of the "New Neighbors Orientation Committee."	2	Gives specific information
T. What reasons did Mr. Lindner give to promote the idea that blacks should "live in their own communities"?	1 1	Seeks specific facts
S. They would be happier.	2	Gives specific fact
T. Yes, go on – be specific.	11	Agrees and encourages
S. He's right, that's what Mr. Lindner said.	11	Agrees and reiterates
S. A common background is important according to Mr. Lindner.	2	Gives specific fact
T. How did the Youngers react to Mr. Lindner?	1	Seeks specific fact
S. At first they were friendly.	2	Gives specific fact
S. When they found out his purpose, they were very angry.	2	Gives specific information
T. You're right, they behaved in probably the same way any of us would react in a similar situation.	11,11	Agrees and reiterates
S. The case is a good example of how prejudice operates. The whites didn't know the Youngers and didn't want them around.	6 6	Organizes and explains previously presented information.
S. But the Youngers moved anyway.	2	Gives specific information

Exhibit 14.1 (Continued)
A Sample of Classroom Dialogue Coded According to the "Content Analysis System"

Dialogue	Code	Analysis
T. In Harlem, according to Adam Henry, life for the people "can't get no worse." What examples did he give for this statement?	1 1 1	Seeks specific facts
S. The buildings were falling apart.	2	Gives specific fact
T. How were the people treated?	1	Seeks specific fact
S. The shopowners overpriced their goods, and the people had to pay because they had no place else to buy things.	2 2	Gives specific information
T. Was this normal procedure?	1	Seeks specific information
S. Yes, these were all examples of people taking advantage of the poor, who couldn't change their situation.	6 6	Organizes and explains previously presented information
T. What terms could we use to classify the kind of life one might have in Harlem?	3 3	Seeks classification of information
S. Miserable.	4	Categorizes information
S. Depressing.	4	Categorizes information
S. Adam called it a life of "garbage and broken bottles."	4	Categorizes information
T. Yes, it was a self-defeating existence.	11	Agrees and reiterates
T. Another aspect of Harlem life which Adam discusses is education and the school situation. What terms could we use to classify the kind of education he knew about?	3 3 3 3	Seeks classification of information
S. Inadequate.	4	Classifies facts
S. Adam thought it was worthless.	4	Classifies facts
T. Who are the "headbreakers"?	1	Seeks specific information
S. Rather than helping the people, the "headbreakers" or police seem to take advantage of the Harlem citizens. They seem to try to antagonize them.	4 4 4	Groups specific facts
T. We've discussed life in Harlem from Adam's viewpoint — the poverty, the dirt, and decay, the violence and misery, the self-defeating circumstances. Adam says, "I don't care about nothing. Just no one cares. . ."	12 12 12 12	Focusing statements
T. What do you think the consequences of such a life might be? Is the situation entirely pessimistic?	7,7	Asks for consequences which demand inclusion of information not previously stated

Exhibit 14.1 (Continued)
A Sample of Classroom Dialogue Coded According to the "Content Analysis System"

Dialogue	Code	Analysis
T. What black organization's activities are mentioned by Adam?	1	Seeks specific information
S. It seems to me that life in Harlem would get worse. The Black Muslims didn't seem to be doing much besides talking.	8,8	Provides consequences
T. According to Adam, would anything help to solve slum problems?	1	Seeks specific information
S. This case study came from a 1966 novel. Since then, if I remember right, there were race riots in Harlem — businesses were burned, and some people were killed. Afterwards, some new buildings were put up, and there were some other changes. Maybe violence is necessary.	8 8 8 8	Provides consequences and generalizations
T. Do you mean that violence should be used to achieve a goal?	1	Seeks specific information
S. Not always, but maybe sometimes.	2	Gives specific information
T. Would Adam be in favor of violence, or would he be opposed to it?	1,1	Seeks specific information
S. Compared to the Black Panthers and other revolutionary groups, Adam seems to be less violent. He wants to be left alone.	8,8	Provides comparisons
T. A "you go your way and I'll go mine" attitude?	1	Seeks specific information
S. Adam's not happy, but there's not much he can do about it.	6	Explains information previously presented

*This sample dialogue, the worksheet in Fig. 14.8, and the statistical analysis of the dialogue were prepared by Shirley R. Petery, University of Washington.

Time: 13 minutes, 12 seconds.
Total number of observations: 264.

Figure 14.9
Content Analysis Worksheet

Figure 14.10
Content Analysis Totals

Teacher Talk — 45.5%

Category	1	2	3	4	5	6	7	8	9	10	11	12	13
Tallies	45	6	8	1	10	-	12	2	-	-	11	25	-
% of Total	17.0	2.3	3.0	.4	3.8	-	4.5	.8	-	-	4.2	9.5	-
	22.7				9.1						4.2	9.5	
	Total TG* — 3.5%								Total TS* — 28.3%				

*TG — Teacher Gives
 TS — Teacher Seeks

Student Talk — 54.5%

Category	1	2	3	4	5	6	7	8	9	10	11	12	13
Tallies	2	69	1	13	-	10	-	42	-	-	4	-	3
% of Total	.8	26.1	.4	4.9	-	3.8	-	15.9	-	-	1.5	-	1.1
	32.2				19.7						1.5		1.1
	Total SS* — 1.2%								Total SG* — 50.7%				

*SS — Student Seeks
 SG — Student Gives

recording observations at the rate of one every three seconds or about 20 per minute.)

When the recording is completed, the tallies for each category are counted and recorded separately for teacher talk and for student talk as shown in Fig. 14.10. These data provide a great deal of information about the quantity and quality of the content of the lesson. For example,

1. The teacher talked 45.5% of the time. Most of this was spent "seeking."
2. The students talked 54.5% of the time, virtually all of it providing answers.
3. 54.9% of the time was spent in concept formation processes (teacher and student categories 1 through 4 combined). Of this 21.2% was spent seeking and 33.7% was spent giving information.
4. 28.8% of the time was spent in forming inferences and generalizations: TS — 8.3% SG — 19.7%.
5. No time was spent on predicting or hypothesizing.
6. The teacher spent 9.5% of the time establishing or re-establishing focus.

Figure 14.11
Classroom Interaction Sequences

Teacher Category Followed by Student Response
 1

Category Tallies	2	4	6	8	Total 31
	22	2	2	5	

Student Category Followed by Teacher Response
 2

Category Tallies	1	2	5	7	8	11	12	Total 27
	18	1	1	3	1	2	1	

Student Category Followed by Teacher Response
 8

Category Tallies	1	2	5	11	12	Total 12
	7	1	1	2	1	

Still further information can be obtained from the basic worksheet shown in Fig. 14.9. If we ask, "What followed certain teacher (or student) actions?" we can get a picture of the cognitive interaction or sequencing of activities that occurred in the classroom. By examining the worksheet we can see where the shifts in action occurred and note those categories that appear most often. For example, what happened after the teacher asked for information and how often? Such information is organized in Fig. 14.11 and can be described as follows:

1. Students responded 31 times following teacher category 1.
a) 22 times by giving information
b) 2 times by giving labels and groups
c) 2 times by giving interrelationships
d) 5 times by giving inferences and generalizations

2. The teacher talked 27 times following student category 2.
a) 18 times by seeking more information
b) 1 time by giving information
c) 1 time by seeking interrelationships
d) 3 times by seeking inferences
e) 1 time by giving inferences and generalizations
f) 2 times by making procedural remarks
g) 1 time he focused discussion

3. The teacher talked 12 times following student category 8.

a) 7 times he sought information
b) 1 time he gave information
c) 1 time he sought interrelationships
d) 2 times he repeated
e) 1 time he refocused

Using feedback data for evaluation

Objective data on the qualitative and quantitative aspects of both teacher's and students' verbal behavior, or the analytic aspects of "what followed what?" provide a little-used but highly reliable source of data for a self-assessing mode of evaluation. There is a growing body of evidence that techniques such as these help teachers and students to see realistically what it is that they are doing in the classroom. Most teachers seem wholly unaware of just how much of the time they are talking or that their teaching patterns tend to be restricted to a rather small repertoire of techniques that are used continuously, regardless of the size of the group, the differences among students, or the differences in material or curriculum content. Methods of analysis as described above or a simple graphic display as shown in Fig. 14.12 can provide a ready source of data for the question "How well did I (or the students) do today? How close did I come to accomplishing the goal that I (we) set?"

Diagnosis and prescription

If teachers can honestly satisfy themselves that they have met their objective on the basis of the data gathered and presented above, then they can report this to both children and parents. If, on the other hand, the data indicates that they have fallen short of their goal, they can review a worksheet (Fig. 14.9) or a graphic display (Fig. 14.12) and attempt to locate the source of the difficulty. Perhaps too little factual data had been developed before the teacher sought an inference or an interrelationship. Were students' attempts to make inferences or draw a conclusion overlooked because the teacher was too quick to resume a lecture pattern? After a student made a generalization, did the teacher ask the student to support it with relevant data, or perhaps to clarify the relationships he was attempting to make? Diagnostic questions such as these are helpful in trying to determine just what went wrong and where things need to be improved to attain the desired goal. Once such a diagnosis has been made the teacher can then determine what kind of presciption he needs to draw up for himself. For example, if relationships are not clearly expressed in a generaliza-tion, the teacher might say, "I will try to seek more interrelationships when students make generalizations." Using the coding system shown in Fig. 14.8, you might state this determination as "Student 8's to be followed by more teacher 5's." The prescription can then be written in a shorthand notation as $S8 \rightarrow +T5$. When another lesson is taught, the data can be analyzed in the same fashion to see whether the prescription has been met and what results occurred.

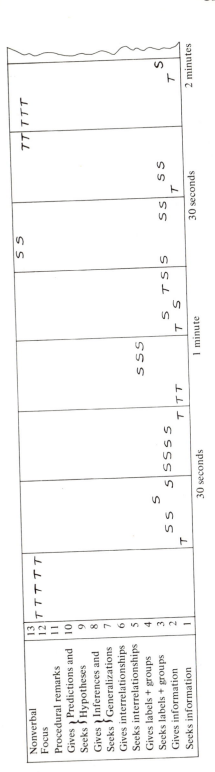

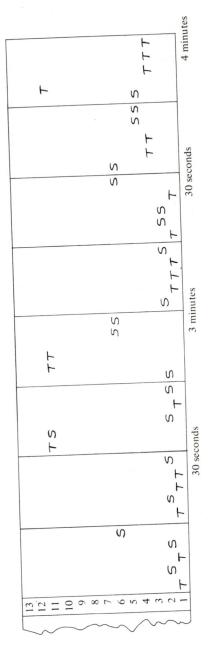

Figure 14.12
Time-Line Display of Classroom Interaction Sequences. (Four-minute sample from Exhibit 14.1)

The emphasis in this section has been upon the use of the content analysis instrument as a tool for *self-assessment*, not as a device for rating teacher effectiveness. The evidence to date seems to indicate that greater and longer lasting changes occur in teacher behaviors when the teacher himself sees the need for such a change and begins to seek help to bring about such changes. The use of externally imposed schemes tends to produce only short-lived effects. A teacher can adapt or modify the coding scheme or the methods of presentation of data to suit his own purposes as long as the categories used can be defined objectively and in behavioral terms (see the first part of this chapter), and the teacher is honest with himself in recording the data.

Another approach is to team up with a colleague who is familiar with the system and observe, code, and analyze each other's teaching. This provides greater objectivity through the use of a friendly but outside observer. The colleague, being less personally involved, may also be able to offer clearer insights in the diagnosis and thus be able to help in defining the prescription for change. More importantly, the authors have found that a team set-up offers a strong "life support system" for teachers involved in innovation or change. Together they can provide moral support toward their common goal, consolation when everything seems to have fallen apart, and enthusiasm and encouragement to persist in the effort. Our experience suggests that teams of two or three members seem to operate most effectively and productively if extended coding and analysis are involved. While there are many desirable reasons for having a human observer present to observe and code during a lesson, a good audio-tape recording can capture the vitality of the verbal dialogue and save it for replay. One soon becomes accustomed to the extraneous sounds of moving chairs, airplanes overhead, and other classroom noise which the human ear filters out during a live observation. Experience indicates that most people can become competent observers and develop a high degree of inter-rater reliability after about two to four hours of training and practice in using a particular observational system.

Other conceptual systems for observation

We have discussed at some length the use of Hansen's Content Analysis system for observing and analyzing an inquiry type lesson. You can develop any number of similar systems by using the same general approach for systematic observation. In other chapters of this book, we discussed value inquiry and decision-making strategies, and showed how they can be used in social studies classes. We can use these same strategies to form the basis for other observational instruments simply by using the specific steps indicated as a set of categories for use in coding. For example, the following steps of the value inquiry model presented in Chapter 12 could easily be substituted and coded in the Teacher or Student columns of a worksheet or displayed in a continuous time-line plot.

Categories for Value Inquiry Observation

1. T/S Defines or recognizes a value problem.
2. T/S Describes the value-relevant behavior.
3. T/S Names specifically the value(s) exemplified by the behavior described.
4. T/S Determines the conflicting values in the behaviors described.
5. T/S Forms a hypothesis about the source of values analyzed.
6. T/S Names alternative values to those exemplified by the behaviors observed.
7. T/S Forms a hypothesis about the possible consequences of the values analyzed.
8. T/S Declares a value preference; chooses one value over another.
9. T/S States reasons, sources, and possible consequences of value choice.
10. T/S Procedural remarks.
11. T/S Focusing statements.
12. T/S Silence or confusion.

Evaluating classroom questions

Similarly, the types of questions asked by the teacher and the responses given by students can also be recorded and analyzed using the categories from Bloom's *Taxonomy of Educational Objectives*[18] or those used by Gallagher and Aschner.[19] Both classifications were discussed in detail in Chapter 4.

Categories of Bloom's Taxonomy	Categories used by Gallagher and Aschner
1. Knowledge	1. Cognitive-Memory
2. Comprehension	2. Convergent Thinking
3. Application	3. Divergent Thinking
4. Analysis	4. Evaluative Thinking
5. Synthesis	5. Routine
6. Evaluation	

A simple instrument for recording the types of questions asked was presented in Chapter 4, Fig. 4.6. Tallies are kept of the type of question asked, and then frequencies and percentages are calculated. Another approach is to record the sequence of questions asked in a time-line display similar to that shown in Fig. 14.12. Both these methods can be modified to include data on the students' response to the teacher's question. For diagnostic purpose it is very important to know what happens after a teacher asks a particular type of question, say a divergent question. Do students provide a variety of creative responses to the question, or do they tend to look for a single "right" answer? Is a high-level question followed by a high-level response? Does the teacher

"*Oh, my teacher and I communicate, all right . . . she looks at me a certain way and I understand what I'd better do.*"

Drawing by Joe Buresch. © 1970, *Today's Education.*

have a clearly defined strategy of questioning, as evidenced by the pattern of questions and responses shown on a time-line display? Both these approaches to analyzing classroom questions, the classification chart presented in Fig. 4.7 and the time-sequence method shown here in Fig. 14.12, have proved useful for giving the teacher some kind of objective data about his own teaching behavior and for helping him assess for himself whether or not he is meeting his instructional goals.

It should be apparent that no one set of categories for observational analysis is sufficient for the task of evaluation. "Adapt and modify" should be the teacher's motto. The ten categories described in the Flanders system (Fig. 14.7) are very useful for obtaining data on the general patterns of interaction between teacher and students; Hansen's Content Analysis method focuses upon the processes of social science inquiry. As shown above, the same techniques can be easily adapted to the strategies of value inquiry and decision-making described in Chapters 2, 12, and 13 of this book.

No one system is adequate for analyzing every phase of classroom instruction. Instead, the teacher is encouraged to adapt and modify the techniques described here or invent his own system to meet specific needs.

Most experts have found that ten categories is a convenient number to use. A set of ten categories provides a wide enough range to make a meaningful analysis, and it provides an easy number to memorize and distinguish between when observing and recording in a classroom. Although increasing the number of categories may refine the precision of an instrument for research purposes, it also makes the instrument more cumbersome to use. In addition, it becomes difficult for an observer to remember and distinguish between 15 or 20 categories without a great deal of special training. Although the Content Analysis system shown in Fig. 14.8 has 13 categories, in reality it consists of

only five basic processes arranged in "seek/give" pairs, plus three additional general purpose categories, a total of 8 categories to remember.

In this section we have presented a number of techniques for systematically observing, recording, and analyzing classroom behaviors and interactions. We have shown how the conceptual aspects of a stragegy of teaching can be used to form a set of categories useful for observing and coding classroom activities as a means for obtaining objective and systematic feedback data for self-assessment or evaluation of one's own teaching. These data can be presented in tabular form or displayed graphically, depending upon how one wishes to organize and analyze the data. We have also shown how the technique of observational analysis can be readily adapted to the strategies of social science inquiry, value inquiry, and decision-making, the three strategies that have formed the central theme of this book.

TEACHER-MADE ACHIEVEMENT TESTS

Many times teachers want to give a test to help in assessing student learning of particular content. Typically, a test is used at the end of a unit of instruction as one means of evaluation. Shorter tests are often used to see how well certain content was learned or to determine whether re-teaching may be needed. Since many of the technical aspects of achievement testing are beyond the scope of this book, we shall discuss this type only briefly, but we will provide illustrations of sample test items. Additional references devoted entirely to the principles of test construction can be studied in your college library.*

Most teacher-made tests use objective type questions or require short, essay responses. The objective test items include true-false, multiple choice, matching, and fill-in questions. Essay questions, or more often short paragraphs of a few sentences, provide opportunities for a more individual or personal response and allow the student to synthesize a number of factors. Despite their widespread use, good test items are difficult to prepare. In addition, a number of research studies have shown that teachers tend most often to ask questions at the lowest cognitive levels, that is, questions that require only the *recall* of a memorized answer, to the virtual exclusion of all other levels of questioning.[20] While factual knowledge is essential to all higher learning processes, the failure to provide test items that tap such processes results in an incomplete and misleading evaluation of achievement, particularly when the instructional objectives call for the accomplishment of higher levels of instruction. A number of sample test items written at the various levels of Bloom's *Taxonomy* are presented in Exhibit 14.2. Each is keyed to a social science concept that formed an organizing focus of a unit of study on water resources.

In the following sections we shall discuss ways in which a teacher can evaluate social science inquiry, value inquiry, decision-making, and social action skills.

*See especially, Robert L. Ebel, *Measuring Educational Achievement* (Englewood Cliffs: Prentice-Hall, 1965); Jon C. Marshall and Loyde W. Hales, *Classroom Test Construction* (Reading, Mass.: Addison-Wesley, 1971).

Exhibit 14.2
Sample Test Items Written at Various Levels of Bloom's *Taxonomy*

Taxonomy Level and Concept	Test Item
1. Knowledge (watershed)	A watershed is a a) wet region of land b) building for storing water c) marshy area d) land area which drains into a stream or river or lake e) land area near a swimming pool
2. Application (land form)	The best name for this group — *mountain, plateau, hill* — is a) region b) landform · c) area d) town e) watershed
3. Application (river system)	Man can control the flow of water by a) planting trees and building dams b) building dams and filtering water c) using water meters and planting trees d) filtering water and planting trees e) none of these
4. Comprehension (landforms)	Which of the following have caused *natural* changes in land forms? a) roads and highways b) glaciers and fast streams c) dynamite and rainfall d) running water and irrigation e) none of these
5. Comprehension (supply and demand)	As more people draw upon the same water supply, the amount of available water tends to a) increase b) decrease c) remain the same d) evaporate e) none of these
6. Application (watershed)	Which of the following would you consider when searching for a water supply for a large city? a) the closest stream and pure water b) a natural lake c) pure water d) an abundant supply and pure water e) none of these

Exhibit 14.2 (Continued)
Sample Test Items Written at Various Levels of Bloom's *Taxonomy*

Taxonomy Level and Concept	Test Item
7. Analysis (population)	Population decreases in a community most likely result from a) decline in the number of businesses b) better schools in the community c) better jobs elsewhere d) decline in businesses and better jobs elsewhere e) none of these
8. Analysis (supply and demand)	Examine the conclusions given below. Using the charts in Exhibit 14.3, decide which *statement* is the best conclusion. a) City A is a rapidly growing community and does not have enough water for the people. b) City B is entitled to help from the state as it has the greatest need for a new water supply. c) City C is experiencing many problems with water shortage.
9. Analysis (supply and demand)	Choose the statement which explains your conclusion. a) City A is near to us and we have relatives there. If they want more water they should have it. b) The governor lives in City B, and therefore they need help from the state to provide them with a new water supply. c) Many people have moved into City C, and the rainfall has been constantly decreasing. d) All three cities need more water due to growth in population. e) All three cities are experiencing water problems due to decreasing rainfall.

Factory and Fish

A committee has been working on a problem of what to do about a large factory in their town. This factory is polluting the river, and as a result many of the fish in the river have died. Some of the townspeople think the factory should be made to move out of town. Other townspeople feel the factory is more important than the fish. There are many people in town who work there.

Taxonomy Level and Concept	Test Item
10. Evaluation (technology)	What do you think the committee should do? Choose the best solution. a) The factory should be made to move out of the town. b) The factory should be allowed to stay and operate as it is. c) The factory should be allowed to stay if it installed a purifying plant.

Exhibit 14.2 (Continued)
Sample Test Items Written at Various Levels of Bloom's *Taxonomy*

Taxonomy Level and Concept	Test Item
11. Evaluation (technology)	Choose the statement below which best explains the solution you chose.

 a) The plant should be made to move. If it moves, there are other jobs in other factories for the workers. They will only have to travel a short distance.

 b) The factory should be allowed to stay. The job is more important than the fish. Fishermen can fish in other streams.

 c) They should install a purifying plant. No matter where the plant moves, it will have to do this, as no one will allow the plant to pollute the river.

 d) The town should help to pay for the purification plant as many townspeople fish in the river.

 e) Make the plant move, as we don't want factories dirtying our town. Besides, the more factories, the more people and we might have to build a new school.

Taxonomy Level and Concept	Test Item
12. Synthesis (supply and demand, river systems, watershed, landforms, technology, population)	Suppose that a large city is in need of a new water supply. Briefly describe the factors that you would consider in searching for this supply.
13. Synthesis (supply and demand, river systems, watershed, landforms, technology, population)	Suppose that you are told by the Selectmen that they think your town will not have an adequate water supply in 10 years. Outline a plan to test whether their belief is true or false.

From Alberta P. Sebolt, "The Construction of a Test for Concept Learning and Identification of the Cognitive Processes Required," *Curriculum Model No. 1: Water Resources.* Resource Learning Laboratory Title III-PACE, Sturbridge, Massachusetts. Experimental Education, Revised, January, 1970. Reprinted with permission. (ERIC Document No. ED 040 892.)

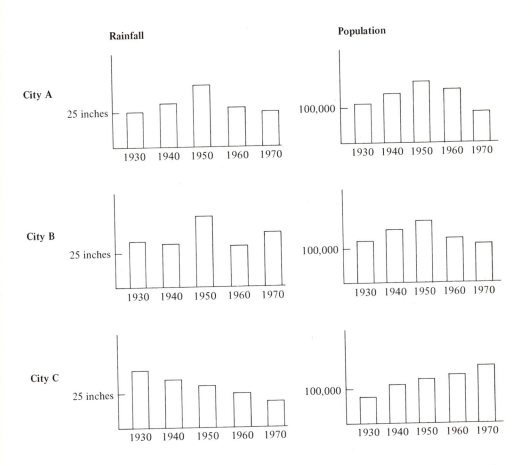

Exhibit 14.3
These are rainfall and population graphs for three different cities. Each of these cities has asked the state to help them find a new supply of water. The state says they can help only some of the cities this year.

Evaluating social science inquiry

As we have emphasized throughout this book, we are concerned with helping students (a) to gain proficiency in the *method* of social inquiry and (b) to master the *products* of social inquiry, which consist of facts, concepts, generalizations, and theories. A sound evaluation program should appraise the student's ability to use the scientific method of inquiry to derive these forms of knowledge. Using the model of social science inquiry developed in Chapter 2 as a guide for planning evaluation activities, the teacher can appraise the pupil's ability to

1. formulate problems in clear, researchable terms
2. state and identify researchable hypotheses

3. list, group, and label data (process of conceptualization)
4. identify and collect appropriate and relevant data
5. determine the accuracy, reliability, and validity of data (evaluation and analysis)
6. see relationships between concepts in data and state them in empirical sentences (generalize)

Below are sample behavioral objectives and evaluation exercises based on this model; they can be used by the teacher to evaluate the student's ability to derive scientific knowledge.

1. To formulate researchable problems

Behavioral Objective: When given a list of questions, the student will be able to identify those which will best guide scientific inquiry.

Exercise: Below are a number of questions. They vary in the degree to which they can provide directions to a researcher. Check the question which will best help focus research activities.

 a) What caused riots?
 b) What caused riots in the United States?
 c) What were the major causes of the racial riots that took place in large United States cities in the 1960's?

2. To formulate testable hypotheses

Behavioral Objective: When given a list of hypotheses, the student will be able to identify those which are empirical and testable and those which are not.

Exercise: Below are three hypotheses. They vary in the degree to which they are empirical and testable. Check the hypothesis that is most empirical and clearly focused.

 a) Unemployment, political alientation, and poor housing conditions were the major causes of the racial riots that took place in large United States cities in the 1960's.
 b) Riots took place in the 1960's because whites did not treat blacks in the right ways.
 c) Racial riots took place in the 1960's because blacks should have not moved to the large cities.

3. To conceptualize

Behavioral Objective: When given a list describing a class of behavior, the student will be able to state a concept term which accurately classifies the behavior class.

Exercise: What concept term can best describe this class of behavior?

a) In most American families, father works on a job as well as does most of the outdoor work around the house.

b) American men are usually expected to be courteous to females.

c) Men and women did different things in Hopi society.

d) American farm children were expected to work and contribute to the family.

4. To collect appropriate data

Behavioral objective: When given a scientific problem and a list of kinds of data, the student will be able to identify the types of data that will help an inquirer solve the problem.

Exercise: A researcher is studying this problem, "How does *culture* affect the behavior of the individual? Which of the following content samples will *best* help him?

a) a description of American society.

b) a description of Hopi society.

c) a description of Eboe society.

d) descriptions of American, Hopi, and Eboe societies.

5. To determine the accuracy, reliability, and validity of data (evaluation and analysis)

Behavioral objective: When given two conflicting accounts of a historical event, the student will be able to state four ways in which he could determine which document is more valid and reliable.

Exercise: Below are two conflicting accounts of slavery. List four things that you can do to determine which account is more accurate.

Account One

All colonies had regulations to govern the slaves' behavior. These regulations were called Slave Codes. The purpose of the codes was to control the slaves in order to keep them from starting rebellions. The codes in colonies where there were large numbers of slaves were generally more severe than the codes in colonies where there were fewer slaves.

Under the slave codes, blacks were not allowed to own property or weapons. They could not form groups unless a white person was present. They could not buy or sell goods, or leave the plantation without permission of their master. In towns and cities, blacks were required to be off the streets by a specified hour each night. A slave could not testify in court against a white person. A slave who was charged with a crime against a white person was therefore unable to defend himself. Any slave who violated the laws was likely to be severely punished, perhaps by death.

Slaves in the South were not allowed to marry. Sometimes they were not even allowed to choose their own mates. Children could be separated from their parents when the parents or the children were sold to new owners. Some children born to slave mothers had white fathers. These children were classified as slaves.[21]

Account Two

Slave treatment. While there were some incidents involving the abusing of slaves, public opinion and state law generally assured the slaves of good treatment. Plantation owners usually cautioned their overseers against using brutal practices. Naturally, there were some abuses on large plantations, especially when the owners did not live on them. Most people, however, favored kind treatment of slaves.

The courts were especially watchful in the interest of the slaves. In 1818 the state supreme court freed two slaves who had been sold . . . by a resident of Indiana. They were freed on the grounds that slavery was not legal in the state of Indiana. Also, a . . . white man was sentenced to hang for murdering a slave in 1821.

A planter usually took a keen interest in his slaves, attending to both their spiritual and their physical needs. It was the planter who ordinarily assumed the responsibility for the souls of his slaves. Sometimes "Sunday schools" were held on the plantation by the planter's wife, and the Negro slaves usually attended their master's church, where they sat in a "slave gallery."[22]

6. To derive generalizations

Behavioral objective: When given a group of data, the student will be able to write a testable generalization which states the relationship that can be derived.

Exercise: Study the data in the following table and write a one-sentence generalization that can be derived from the data. Tell how you can test the generalization that you have derived.

Suicide Rates in Selected Countries, 1965
(per 100,000 population)*

Denmark	38.7	Venezuela	12.7
France	30.5	Colombia	12.2
Japan	29.5	Mexico	3.4
United States	22.4	Philippines	2.0
New Zealand	18.2	Nicaragua	1.8
Hong Kong	16.2		

*Based on data reported in the *Statistical Abstract of the United States*. Washington, D.C.: U.S. Government Printing Office, 1969, p. 81.

The skills delineated and illustrated above are primarily concerned with the *process* of social inquiry (deriving concepts and generalizations). Some evaluation activities should focus on testing the student's ability to *apply* concepts and generalizations. Such activities may take a variety of forms. Students may be given a description of an incident such as a race riot, a war, or a rock festival and asked to list the key concepts and generalizations (from various disciplines) that best explain the behavior of the individuals taking part in the incident or action. When testing a student's ability to apply concepts and generalizations, you should emphasize new situations and data. If a pupil has been introduced to the concept of *role* by studying the American family, the teacher can test his understanding of this concept by giving him new data related to the roles of individuals within another culture. If a student is able to apply concepts and generalizations to new situations, then the teacher can be assured that he has mastered them.

Value inquiry

Helping students to gain proficiency in value inquiry and valuing is one of the main objectives of a decision-making social studies program. To appraise a pupil's mastery of the skills which constitute value inquiry, the teacher can use the value inquiry model presented in Chapter 12 as a guide to planning the evaluation exercises. The steps of this value inquiry model are as follows:

1. Defining and recognizing value problems.
2. Describing value-relevant behavior.
3. Naming values exemplified by behavior described.
4. Determining conflicting values in behavior described.
5. Hypothesizing about the sources of values analyzed.
6. Naming alternative values to those exemplified by behavior observed.
7. Hypothesizing about the possible consequences of values analyzed.
8. Declaring value preferences: choosing.
9. Stating reasons, sources, and possible consequences of value choice.

Below are objectives and evaluation exercises based on our value inquiry model. The teacher can use these as samples for appraising the pupil's ability to inquire into values:

1. Defining and recognizing value problems

Behavioral objective: When given a list of empirical and value problems, the student will be able to identify those that are value oriented.

Exercise: Below are listed several problems. Check the problem which is most highly value-centered.
 a) What roles did American women play in colonial America?
 b) What were the major causes of the Vietnamese war?

c) How should I vote on the proposed freeway?

d) What effects does tension have on a person's ability to think?

2. Describing value-relevant behavior

Behavioral objective: When given a case study or problem story, the student will be able to identify and state the behavior of the characters that tells something about what they value.

Exercise: Read the following story, "Junior Prom," and briefly describe the *behavior* of each major character which tells us something about the values that he endorses.

<div align="center">

JUNIOR PROM
By Jean D. Grambs*

</div>

Mrs. Richardson looked at the three serious faces watching her from across her desk. There was Tiny Johnson, president of the junior class — a good, hard-working president, not the brightest thing in the world, but honest and likable. Next to him was Janet Scanlon, secretary of the junior class, blonde, fluffy, but sharp as a whip. Maybe a little too sure of herself, and perhaps rightly so, with a father who was an Eminent Man, president of the State College, no less. Next to her was Eloise Ladas, chairman of the Junior Prom committee. Her dark eyes and smooth olive complexion showed her Greek inheritance. Her father, Pete Ladas, was a history teacher in the high school who made a particular point of dwelling on the glories of ancient Greek history both in class and out.

"It isn't that I want to interfere with your plans," Mrs. Richardson started to say. "Well, perhaps that is exactly what I do want to do . . ." and she smiled at the rather grim 17-year-olds facing her. They did not smile back. None of them seemed on the verge of saying anything.

A little urgently, Mrs. Richardson continued: "Now the Junior Prom isn't just a dance for our own school. It is something everyone in town hears about. It is one of our biggest occasions in the spring. Of course, we all want it to be a big success. And I know you have already worked a long time on your plans and getting committees started on decorations and all that." She looked hopefully at Eloise; maybe she would say something, but her dark eyes just looked at Mrs. Richardson without a flicker of warmth.

"It wasn't just my idea to ask you to reconsider your plans," Mrs. Richardson went on, beginning to feel that the task ahead was going to be a harder one than she had thought. "Of course, as sponsor for the junior

*From Jean D. Grambs, *Intergroup Education: Methods and Materials*. Englewood Cliffs, N.Y.: Prentice-Hall, 1968, pp. 60-62. Reprinted with permission.

class, I am in a way responsible for what you do. I didn't think I had to oversee your work, because I know that you are conscientious and responsible." A little flattery might, just might, bring a responsive smile from the three students. But they still didn't respond.

"Mr. Perkins, who is as fine a principal as any in this district, was the one who first mentioned the problem to me this morning, you know, when your posters advertising the dance were put up. He felt that we should talk about it and see what is to be done." Mrs. Richardson stopped. She leaned back in her chair. It was time for one of the students to say *something*. She wasn't going to do all the talking.

Tiny Johnson straightened his six-foot-three length and glanced at the two girls. He was pretty sure they were waiting for him to speak first.

"I don't get it, Mrs. Richardson," Tiny said. "Here we go, making our plans, we have everything fixed up for the best Junior Prom this place has seen, and then someone starts talking about 'prejudice' and 'stereotypes' and 'hurting people's feelings.' Honestly, Mrs. Richardson, they just miss the point."

"They sure do," said Eloise, a little breathlessly. "I guess I know a bit about prejudice and stereotypes, because we are Greeks, and you should hear some of the things people say sometimes. But just because we pick a fiesta theme for our dance and have some Mexicans with sombreros over their faces sleeping under a cactus for our poster, then we get put on the carpet and accused of all kinds of things."

"We thought it was a real cute idea," Janet spoke up. "With a Mexican fiesta theme, we can have real gay decorations and play a lot of rhumba music and that sort of thing. It's something different. We even thought we might have enchiladas and tamales for sale at the refreshment stand, if we can get some of the Mexicans to cook for us." She looked triumphantly at the other two, and they nodded in agreement; these had been their ideas, and they liked them very much.

"That's exactly the point," Mrs. Richardson said. "The Mexican students — and they really aren't any more Mexican than Eloise is Greek; you are all Americans, you know — object to having posters with Mexicans depicted as lazy and always sleeping in peasant clothes under a cactus. It isn't any more true of modern Mexico than it is of the Americans of Mexican descent who live here in town."

"But heck, Mrs. Richardson," said Tiny, "there aren't more than ten or a dozen Mexican kids in our school; most of them go to the San Angelo High School. I don't see why they should care. No one's making fun of them. It's just a good idea for a dance is all."

"And all the posters are made, and all the programs are ordered and due from the printers today — why, we have already spent all the money we

have for the dance. We couldn't possibly work up another theme!" Janet's voice rose shrilly as she made her devastating points.

"Why do they have to be so sensitive, anyway? Are we going to let a few kids spoil the fun for all the rest of us – why, we expect about two hundred at our dance if it is a good one, and this one was going to be a good one." Tiny glared at Mrs. Richardson as he began to realize the full import of what she was saying.

"But, Mrs. Richardson," Janet implored, "isn't there anything we can do?"

And that, thought Mrs. Richardson to herself, is exactly what she wanted to know, too.

3. Naming values exemplified by behavior described

Behavioral Objective: When given a description of an individual's behavior, the student will be able to state the values that are related to that behavior.

Exercise: Look at the behavior you described in the exercise above. Now *name* the values which you think are related to each character's behavior.

4. Determining conflicting values in behavior described

Behavioral objective: When given a case study or problem situation, the student will be able to state the ways in which the character's values conflict.

Exercise: Read the following case study of Norman Cutler and name (a) his values, (b) ways in which his own values conflict, and (c) ways in which his values conflict with those of his parents.

THE CASE OF NORMAN CUTLER*

Some people, assured of a secure place in American society, reject its values to search for something else.

"Whole Life. That will be my gift to the world," said Norman Cutler aloud as he lifted a tin cup of tea in the air. "To Whole Life and the new day."

It was midnight. As usual, Norman Cutler was greeting the day while soaking himself in a tub so small that his knees almost touched his bearded chin. It was also his time to contemplate. . . .

At the age of 23, Norman Cutler was what respectable people – whom he referred to as "moo-cows" – call a beatnik, hippie, bohemian, or just plain bum. He lived alone in a cramped "pad" in New York City's East Village. East Village was a seedy, low-rent district of old tenements and dreary

*From Donald W. Oliver and Fred M. Newman, *"The Immigrant's Experience: Cultural Variety and the 'Melting Pot'."* Middletown, Conn.: American Education Publications, Public Issues Series/Harvard Social Studies Project, 1967. Reprinted with permission.

streets. It was the home of artists, writers, and varied intellectuals, as well as apple-cheeked students "making the scene" for a few months.

Norman Cutler was an artist. His hair was ratty and fell to his shoulders. His beard looked like a toilet brush. His clothes were always sloppy. Sometimes he wore sandals and sometimes he went barefoot. He had no car, no bank account, and he didn't read newspapers.

Norman's early life, however, had been quite another story. His mother was a teacher and his father a successful businessman, running his own real estate firm. They had a large, white Cape Cod home in a wooded suburb of Boston. Mr. Cutler was active in the Chamber of Commerce and other civic organizations. Mrs. Cutler was a prime mover in the Parent-Teacher Association, and was always entertaining some ladies group or other. The Cutlers were one of the "old Families" in the community.

At an early age Norman had displayed a quickness of mind as well as a sturdy stubborn streak. Everybody took these as earmarks of a born leader. The studious type, Norman displayed brilliance in music and mathematics. He graduated from high school as valedictorian. In his senior year he had sifted through more than a dozen scholarship offers before deciding on Cornell.

At the urging of his father, Norman studied economics at the university. Almost as a matter of course, he regularly ranked near the top of the Dean's List. Hardly a conversation went by that the Cutlers did not mention this fact. It was their way of saying, "Our boy is going to make it big."

But after the midyear break of his junior year, a change came over Norman. He began to stay alone in his room. He didn't turn in class assignments. Then he stopped going to class altogether. Finally he notified the university that he would not return after spring vacation.

"WHOLE LIFE? Whole Life? You want to create what?" his father had roared. "You quit school to do what?" Norman did not expect his father to understand. After all, as much as he loved him, his father was himself a moo-cow, always striving for more money, more prestige, more this, more that . . . and all for what?

Yet Norman did his best to explain to his father that he was going away to create a new art medium, whereby man could see and appreciate his Whole Life. By combining music, painting, and cinema, he hoped to arrive at an artistic answer to what man is and what he should be. For, Norman had explained, just as art imitates nature, so does nature — that is, human nature — respond to art.

Norman's father slumped in a chair, yanked his tie loose, and fumbled for a cigarette. Mrs. Cutler started crying and ran into the kitchen, her face buried in her apron. Norman went upstairs and packed. He left home early the next morning.

Three years had passed since then. Norman had plunged into his work with feverish intensity. His tiny room was littered with tapes and recordings of cricket chirps, and the small talk of bartenders, the gurgle of water from his bathtub, and an unbelievable range of noises from his own voice. The walls were covered with all kinds of paintings, splashed with all kinds of colors. Already Norman had produced a movie featuring a two-sided screen and his sounds and paintings. The fact that the film was banned as "in poor taste" led him to believe that he was onto something really profound.

Norman felt that he was on the verge of a great new artistic experience. It was now only a matter of time before his artistic concept of Whole Life would be perfected. Meanwhile he would continue to support himself by washing dishes in a local diner. That was an ideal job. It didn't intrude upon his mind, and he could eat all he wanted.

Sure, he was poor, and his poverty was frequently uncomfortable. In the summer his pad was stifling; in the winter it was freezing. But Norman considered this a small price to pay for the solitude needed to think and create; a small price for the joy of living with a vision.

Norman didn't consider himself a dropout from society. With his brilliant mind, he knew he could be outstanding in any career he chose. No, he was a holdout, a holdout for something better than a life based on things that for him had no meaning. He would strive for Whole Life.

Meanwhile, Mr. and Mrs. Cutler more and more avoided contact with the community. They were sure everyone was talking about their son. In desperation they finally moved to California. Mr. Cutler told everybody that the doctor had recommended a milder climate.

At first, the Cutlers toyed with the idea of telling their new neighbors that they had no children, but couldn't go quite that far. Instead, they told people that they had a son back East, a graduate of Cornell, who was doing well as a "commercial artist." They talked about him as little as possible. And whenever the neighbors asked questions about him, they quickly changed the subject. The Cutlers wrote Norman that they hoped he wouldn't make any unexpected visits, because it might be embarrassing for all concerned. They expressed confidence that he would understand. He did.

5. Hypothesizing about the possible sources of values analyzed

Behavioral objective: When given a case study or problem situation, the student will be able to write testable statements (supported with data) about where the person may have acquired his values and beliefs.

Exercise: List five reasons *why* you think that Norman Cutler in the case you read above believes and feels the way that he does.

6. Naming alternative values to those exemplified by behavior observed

Behavioral objective: When given a list of values, the student will be able to state values which are different from those listed.

Exercise: Study the list of values which you named in Exercise 3 above. For each of these values, list *two* different values which the character in the story could have endorsed.

7. Hypothesizing about the possible consequences of values analyzed

Behavioral objective: When given a list of values, the student will be able to state the possible consequences which could result when a person or group endorsed the listed values. The student should also give data to support his predictions.

Exercise: List the values (in two different lists) which you named in Exercises 3 and 4 above. Make a column to the right of each of your lists. Label the column, "Consequences." Under that column, list at least two possible things which could result from each of the particular values. State data to support each of the possible consequences which you list.

8. Declaring value preferences

Behavioral objective: When given a problem situation or a case study, the student will be able to state the course of action which he would take to resolve the problem.

Exercise: Study carefully the decision-problem which is posed in the open-ended story, "Junior Prom." State which course of action you would take if you had to resolve the problem. Make your statement as clear and as brief as possible.

9. Stating reasons, sources, and the possible consequences of value choice

Behavioral objective: When given a case study or a problem situation, the student will be able to state the *reasons* why he would take a particular course of action in order to resolve the problem, *why* he endorses his beliefs, and the possible consequences of his value choice.

Exercise: Study the response which you made in Exercise 8. List the *reasons* why you would make your decision. State the possible consequences of your choice, and give evidence to support the consequences which you predict. Also state why you think that you embrace the values that you endorse. For example, do you think that you learned them from your parents, teachers, or friends?

The above exercises illustrate how a teacher may evaluate a students' value inquiry skills, using the value inquiry model presented in Chapter 12. The emphasis in these activities should be on testing the student's ability to use a

process for analyzing values, and for deriving and clarifying his personal beliefs. While the teacher has a responsibility to help children develop consistent beliefs, he must be very careful to avoid condemning values which are inconsistent with his own or "pushing" values which he prefers in the evaluation of student's value inquiry skills.

Evaluating decision-making skills

We have discussed and illustrated ways in which the teacher can evaluate social science inquiry and value inquiry skills. Since social inquiry and value inquiry are both components of the decision-making process, when a teacher evaluates a student's mastery of these skills, he is to some extent determining the student's ability to make sound decisions. However, some evaluation activities should be designed specifically to appraise a pupil's ability to take a decision-problem or social issue and to synthesize knowledge and values in order to decide upon a course of action to take. Also, some means should be devised whereby the student and teacher can evaluate social action projects.

The teacher can use the decision-making model presented in Chapters 1 and 2 (on which this book is based) to guide the planning of evaluation activities designed to appraise the student's ability to make sound decisions. The outline below is based on this decision-making model. The teacher can present the pupil with a decision-problem, and ask him to

1. list the concepts and generalizations which will help him to make a sound decision regarding the issue;
2. list alternative values which are related to the issue, and the values which he would endorse;
3. list alternative courses of action which could be taken regarding the issue, and their possible consequences (data should support each alternative listed);
4. order the alternatives in a way which is most consistent with his value position identified earlier;
5. list the course of action he would take to resolve the issue.

Using the decision-making processes listed in Exhibit 14.4, you can develop a simple evaluation instrument to appraise the student's ability to make decisions.

Evaluating social action skills

Although the results of social action projects will not be easy to evaluate, some effort should be made by the teacher and the pupils to determine the extent to which social action projects are effective. The ultimate test of the effectiveness of a social action project is whether it achieves the major intended outcomes. Often these outcomes will not be immediately apparent. In our sample decision-making units in Chapter 13, alternative courses of action consisted of

Exhibit 14.4
Form for Evaluating Decision-Making Ability

A. Decision-problem: _____

B. Related knowledge (identify concepts and generalizations):

C. Value position (clarification and identification):

D. Identifying alternatives: Predicting consequences of each:

_____ _____

_____ _____

_____ _____

_____ _____

E. Ordering alternatives (Which is most consistent with value position identified above?):

1._____

2._____

3._____

4._____

F. Acting (In a way consistent with values, willingness to accept possible consequences of
 action chosen):

various ways to change the racial attitudes of students within a school and to
alert the community to the problem of water pollution.

Several approaches to evaluation might be considered. If the project on
changing racial attitudes took place within a single classroom or grade level, it
might be possible for students to construct a pre-project and post-project atti-
tude questionnaire to attempt to determine what changes in personal views and
attitudes took place. Change in behavior might be revealed by data gathered
about the increase or decrease of incidents of name-calling and fights, and
evidences of increased cooperation and effective working relationships in the
classroom. When the project involves the community, as in the water pollution

example, it may be difficult to gain direct evidence of the effectiveness of the program since many other factors may have been at work. Nevertheless, positive activities started and planned by students, such as the cleaning up of a river bank or a roadside, the operation of a glass or can recycling station, or the staffing of a foodbank center all offer tangible evidence of accomplishment. It is difficult, however, to fully assess the impact of student involvement in activities that require political decisions by a city council or by voters at the polls. The decision to establish a wild-life preserve around a school or to build a county swimming pool adjacent to the high school may have been more strongly influenced by real estate interests or the Chamber of Commerce than by students.

In Chapter 13 we also stressed the strong involvement of students in decision-making within their own school. Evidences of this may easily be obtained provided we make an honest appraisal. Is there a Student Council or some form of school governing body? Is it truly functional, or is it merely window dressing? How often does it meet? Who controls the agenda items? Do students really run for office or are they appointed by the teachers or principal? What happens to issues raised by students? If passed, are steps taken to implement them or are they quietly buried? How is student input gathered on issues that concern them, such as dress codes, menu-planning for the cafeteria, rules for bringing bicycles to school, conduct in the cafeteria, use of the playground, and the like. We would be less than honest if we did not suggest that most students in elementary and junior high schools soon become cynical and disenchanted about participation in student government because of the way such organizations are frequently controlled and manipulated by teachers or administrators. All too often the external form and the attendant hoopla passes for student involvement in school government. Thus we must stress the need for genuine honesty in seeking evidences of student participation in school affairs and a critical evaluation to determine whether or not such participation is truly meaningful.

Other important possible outcomes of a social action project are a greater sense of political effectiveness by the participating students and better skills in organizing and implementing social activities. Students may also become more interested in social studies after such projects, better able to see how social science can be relevant to real life, and gain a better understanding of the relationship between knowledge, values, and the resolution of social issues. Another important outcome which can result from social action projects is a better understanding of the difficulties involved in changing public institutions. As this book has stressed, it is possible for citizens to influence and change public institutions, and students should be aware of this potential influence. However, equally important, they should know that it is not easy to change institutions, and that effective organization and persistency is necessary to affect public policy. Although this knowledge is important, the teacher should encourage pupils to become involved in those social action projects in which their possibilities for success are maximized. Too many unsuccessful attempts to influence public policy can result in political alienation and dysfunctional

disillusionment with American democracy. The social studies program should help children develop a sense of political power. Neither sugar-coated stories about our political system nor one-sided lessons about its ills will result in positive outcomes.

The teacher can use paper-and-pencil tests, discussions, and role-playing activities to appraise the student's sense of political power, ability to plan and execute a social action project, interest in social action projects, and his ability to see how social science knowledge, values, and action on social issues are related. Questions like these can be used to appraise a pupil's sense of political effectiveness: "What public policies within your school or community do you feel should be changed?" "Do you feel that you can in any way help to bring about the changes that you think are desirable?" "What steps can you take to bring about these changes?" "Will you take any of these actions?" "Why or why not?" To evaluate the student's ability to plan and execute a social project, the teacher can give a group of children a social problem, such as "What actions can I take regarding poverty in my community?" and ask them to plan and execute a plan of action, through role-playing and simulation activities, and to evaluate the outcomes of the action. When evaluating the simulated social action, the teacher should ascertain whether the role-playing and simulation activities, which the students design, are realistic and practical and whether the students drew upon social science data to guide the planning of their action.

The teacher should also observe to determine whether the students discussed and dealt with the value components of the problem. He can devise a checklist similar to the ones discussed in this chapter to evaluate social action projects. Although evaluation in this area will of necessity have to be exploratory and highly flexible, vigorous efforts must be made to determine whether social action projects are helping students to develop a sense of political power and to apply their knowledge to *real* problems which are of great concern to them.

SUMMARY

This chapter has dealt with a variety of techniques for evaluating instruction in social studies. Evaluation was defined as a technical aspect of instruction. Its purposes are to (1) assess the effectiveness of instruction, (2) determine the accomplishment of instructional goals, (3) provide feedback to the teacher about the instructional processes, and (4) provide information on which important decisions about each student's progress, curriculum changes, and instructional goals can be made. Since evaluation cannot be made unless a teacher's instructional goals are clearly specified, a number of techniques were presented for writing objectives in behavioral terms. Emphasis was placed upon identifying the intended outcome in terms of an observable and measurable student performance or behavior. Criterion measures for judging acceptable levels of performance were suggested. The conflict between norm-referenced evaluation measures (such as letter grades of A, B, C, etc.) and criterion-

referenced evaluation was discussed, along with the use of public and private criteria for determining grades or acceptable performance. A number of ways of recording student progress in the form of charts, checklists, and anecdotal records were discussed and illustrated.

Techniques were also illustrated for making systematic observations and analyses of classroom behavior. A sample classroom dialogue was provided to show how it could be coded by using certain of the social inquiry processes discussed in this book. The data was then recorded, analyzed, and plotted graphically in a time-sequence display to show the various interactions and the extent to which an inquiry strategy of instruction was effectively used. Illustrations were given for modifying this basic procedure in order to analyze strategies for questioning, valuing, and decision-making.

Consideration was given to teacher-made achievement tests and a number of sample test items were presented showing how they could be presented at various levels of Bloom's *Taxonomy*.

Lastly, a number of specific exercises were given to show how both the process and the product of social inquiry, value inquiry, decision-making, and social action skills could be assessed in the classroom.

DISCUSSION QUESTIONS AND EXERCISES

1. Examine a curriculum guide from a local school district. How are instructional objectives expressed? If the objectives are not written in behavioral terms, try to rewrite some of them, using the principles presented in the first part of this chapter.

2. The terms "to know," "to understand," and "to appreciate" appear often in statements of objectives, yet they are not found in the list of "strong action verbs" given on p. 527. Can you explain why?

3. What are some of the problems of writing behavioral objectives with *different* criterion measures of performance? Assume that you are planning to teach a social science inquiry lesson in a primary grade. Write several behavioral objectives that represent different levels of performance.

4. Plan a social science inquiry lesson on some one of the many possible topics suggested in this book. Arrange for a group of five or six colleagues to serve as students for this mini-lesson. Ask someone to serve as an observer, or make a tape recording and be the observer yourself later. Using the Content Analysis system, record and analyze the teaching session following the procedures suggested in this chapter. What activities occurred most often? What followed after each? How often? Using the data derived from the observation, would you say your behaviors were consistent with your behavioral objectives? If not, what changes do you need to make in order to achieve your goals?

5. Arrange to visit a classroom in a nearby school. With the teacher's permission, observe and code the lesson, using the Flander's Interaction System, and a time-line display similar to that shown in Fig. 14.12. What pattern of

interaction do you observe? Who does most of the talking? What role do students play?

6. Arrange to have someone read aloud Jean D. Grambs's open-ended story of "Junior Prom" reprinted on pp. 562-564. Using the categories identified for value inquiry observation on page 551, record and analyze the valuing process going on. Evaluate Mrs. Richardson's role in helping the students to clarify their own values.

7. Arrange to visit a nearby classroom and, with the teacher's permission, observe and code the frequency and type of questions used by the teacher, using the categories of the Bloom *Taxonomy* and the instrument shown in Fig. 4.6. What evaluation might you make of the questioning strategies used or the pattern reflected after you have analyzed the data?

8. Read the case study of Norman Cutler on pages 564-566. Name (a) his values, (b) the ways in which his own values conflict, and (c) the ways in which his own values conflict with those of his parents. List five reasons why you think Norman Cutler believes and feels the way he does.

9. Evaluate the decision-making processes that are evident in the Junior Prom story on pages 562-564.

10. Demonstrate your understanding of the following key concepts by writing or stating brief definitions for each of them. Illustrate each with an example.

a) evaluation
b) behavioral objective
c) performance objective
d) terminal behavior
e) criterion measure
f) norm-referenced evaluation
g) criterion-referenced evaluation
h) public criteria for evaluation
i) private criteria for evaluation
j) minimum level of acceptable performance
k) anecdotal record
l) systematic observation
m) verbal interaction
n) time-line display

FOOTNOTES

1. Wilford M. Aiken, *The Story of the Eight-Year Study*. New York: Harper, 1942, pp. 98-100.

2. Noland C. Kearney, *Elementary School Objectives*. New York: Russell Sage Foundation, 1953.

3. Will French and Associates, *Behavioral Goals of General Education in High School*. New York: Russell Sage Foundation, 1957.

4. Benjamin S. Bloom, (Ed.), *Taxonomy of Educational Objectives: Handbook I – Cognitive Domain*. New York: David McKay, 1956.

5. D.R. Krathwohl, B.S. Bloom, and R.B. Masia, *Taxonomy of Educational Objectives: Handbook II – Affective Domain*. New York: David McKay, 1964.

6. Robert M. Gagné, "The Analysis of Instructional Objectives for the Design of Instruction." *Teaching Machines and Programmed Learning, II*, R. Glazer, (Ed.). Washington, D.C.: National Education Association, 1965.

7. Robert F. Mager, *Preparing Instructional Objectives*. Palo Alto: Fearon, 1962.

8. W. James Popham, *Systematic Instructional Decision-Making*. Los Angeles: Vimcet Associates, 1965.

9. W. James Popham *et al.*, *Instructional Objectives*. American Educational Research Association Monograph Series on Curriculum Evaluation, No. 3. Chicago: Rand McNally, 1969.

10. See, for example, Elliot W. Eisner *et al.*, "Educational Objectives: Help or Hindrance?" *School Review* **75**: 250-282; No. 3, 1967. Also, P.W. Jackson and E. Belford, "Educational Objectives and the Joys of Teaching." *School Review* **73**: 267-291, No. 3, Autumn, 1965. Many of these arguments are debated in Popham, *Instructional Objectives, op. cit.*

11. Robert M. Gagné, "Educational Objectives and Human Performance," *Learning and the Educational Process*, Krumboltz, J.D., (Ed.). Chicago: Rand McNally, 1965, pp. 1-24.

12. The concept of a "data retrieval chart," associated with the Taba strategies for developing generalizations, is an excellent means of organizing and displaying data from several samples or areas of study. See Chapter 4 for a more detailed discussion of this technique.

13. Newton S. Metfessel, W.B. Michael, and D.A. Kirsner, "Instrumentation of Bloom's and Krathwohl's Taxonomies for the Writing of Educational Objectives," *Psychology in the Schools* **6**: 227-231, No. 3, July, 1969. For a similar classification scheme adapted to writing classroom questions see G.A. Manson and A.A. Clegg, Jr., "Classroom Questions: Keys to Children's Thinking?" *Peabody Journal of Education* **47**: 302-307; No. 5, March, 1970.

14. Ned A. Flanders, *Analyzing Teaching Behavior*. Reading, Mass.: Addison-Wesley, 1970.

15. Edmund J. Amidon, and John B. Hough (Eds.), *Interaction Analysis: Theory, Research, and Application*. Reading, Mass.: Addison-Wesley, 1967. Many variants of the basic interaction analysis system are described and their uses illustrated in this book. For an extensive collection of observational instruments, see Anita Simon and Gil S. Boyer, (Eds.), *Mirrors for Behavior: An Anthology of Classroom Observational Instruments*. Philadelphia: Research for Better Schools, 1967. A second collection of such instruments was published under the same title, 1969.

16. John H. Hansen, "Content Analysis," unpublished paper, College of Education, Univ. Oregon, 1969.

17. Donald W. Oliver and Fred M. Newmann, "Negro Views of America: The Legacy of Oppression," Public Issues Series, Harvard Social Studies Project, American Education Publications, Middletown, Conn., 1967.

18. Benjamin S. Bloom, (Ed.), *op. cit.*

19. James J. Gallagher, and Mary Jane Aschner, "A Preliminary Report on Analyses of Classroom Interaction." *Merrill-Palmer Quarterly of Behavior and Development*, **9**: 183-194, July, 1963.

20. Ambrose A. Clegg, Jr., "Classroom Questions," *Encyclopedia of Education*. New York: Macmillan, 1971, pp. 183-190.

21. James A. Banks, *March Toward Freedom*: *A History of Black Americans*. Palo Alto: Fearon, 1970, p. 57.

22. John K. Bettersworth, *Mississippi Yesterday and Today*. Austin, Texas: Steck-Vaughn, 1964, pp. 143-144.

INDEXES

NAME INDEX

Adoff, Arnold, 69
Aschner, Mary Jane, 146, 147, 551

Bach, George L., 361
Baldwin, James, 330
Banks, James A., 33, 459-467, 497
Becker, Carl L., 154, 157
Benedict, Ruth, 223-224, 229-230, 235
Berelson, Bernard, 51, 66, 155, 171, 196, 255, 264
Bierstedt, Robert, 199-200
Billington, Ray Allen, 173-174
Bloom, Benjamin, S., 132-133, 143, 146-148, 525, 551
Blumer, Herbert, 197
Boas, Franz, 228
Bonham, Frank, 69
Borg, Walter, 59
Botkin, B.A., 141
Brinton, Crane, 73, 121, 169, 171
Broek, Jan O.M., 265
Brubaker, Dale L., 441
Bruner, Jerome S., 25-26, 80, 200, 242, 362
Budd, Richard W., 60

Carey, George W., 273
Catlin, George E.G., 309
Cherryholmes, Cleo H., 108, 111
Chesler, Mark, 449
Chinoy, Ely, 107, 197
Chrisfaller, Walter, 275
Clark, Kenneth, 166
Clegg, Ambrose A., 146, 172
Cohen, Morris R., 48
Coleman, James S., 46

Commager, Henry S., 156-157, 158, 161, 1, 170
Comte, Auguste, 199
Cox, C. Benjamin, 177-178, 452-453
Crowder, William, 237-238

Dahl, Robert A., 313
Darwin, Charles R., 106, 228
Donohew, Lewis, 60
Douglass, Frederick, 141
Dow, Peter B., 243
Durkheim, Emile, 73, 106, 200

Easton, David, 309-310, 313, 316-318, 323
Einstein, Albert, 106
Elkins, Stanley, M., 163
Faris, Robert E.L., 195-197
Farley, George T., 146
Fenton, Edwin, 164
Festinger, Leon, 119
Fichter, Joseph H., 197-198
Flanders, Ned A., 90, 538
Fox, Robert S., 401
Franklin, John Hope, 141
Frazer, James Sir, 228
French, Will, 525
Fromm, Erich, 6, 9, 10, 446

Gallagher, James J., 146-147, 551
Gee, Wilson, 49
Golding, William, 10
Goldmark, Bernice, 17, 18, 44
Gottschalk, Louis, 157, 168, 169-170
Grambs, Jean Dresden, 474, 562
Guilford, J.P., 132, 146, 148

SUBJECT INDEX